A HISTORY OF

Far Eastern Art

Fifth Edition

Sherman E. Lee

A HISTORY OF
Far Eastern Art

Fifth Edition
Sherman E. Lee

Edited by
Naomi Noble Richard

Prentice Hall

Project Manager: Eve Sinaiko
Art Director: Samuel N. Antupit
Designer and Associate Designer: Lydia Gershey
 and Yonah Schurink, Communigraph
Picture Editor: Neil Ryder Hoos

Library of Congress Cataloguing-in-Publication Data
Lee, Sherman E.
 A history of Far Eastern art / Sherman E. Lee—5th ed., PH ed.
 / edited by Naomi Noble Richard.
 p. cm.
 Includes bibliographical references and index.
 ISBN 0-13-183063-5
 1. Art, East Asian. I. Richard, Naomi Noble. II. Title
 N7336.L43 1993
 709'.5—dc20 93–7267
 CIP

Title page and pages 17, 79, 189, and 285 show details of *Ink Bamboo*,
1308 C.E., by Li Kan (1245–1320 C.E.). Handscroll; ink on paper;
h. 14¾" (37.5 cm), l. 93½" (2.38 cm). China, Yuan dynasty. Nelson-Atkins
Museum of Art, Kansas City

Published in 1994 by Prentice-Hall, Inc.

Prentice-Hall, Inc.
A Division of Pearson Education
Upper Saddle River, New Jersey 07458

Send inquiries to:
 Marketing Manager
 Humanities & Social Sciences, Prentice-Hall, Inc.
 One Lake Street
 Upper Saddle River, N.J. 07458
 http://www.prenhall.com

Printed and bound in Japan

Contents

PART ONE

Early Culture and Art: The Stone Age, the Bronze Age, and the Early Iron Age

PART TWO

The International Influence of Buddhist Art

PART THREE

The Rise of National Indian and Indonesian Styles

PART FOUR

Chinese, Korean, and Japanese National Styles and Their Interplay

Preface

If one began the study of Oriental art in the 1930s, as the author did, one often heard the query still current among students in the 1960s: Where can I find a general survey of the art of Eastern Asia? What book can be recommended to the art major in college, or to the interested layman who is aware of the Orient but unable or unwilling to plow through the ever more forbidding number of general works—studies of the art of China, or India, or Japan? Books in each of these categories may include numerous references to the arts of other Asian countries, but only as incidentals. The main relationships become lost in the forests of national interest and book space requirements. Even more frustrating are those general works that cater to the minority interest in the "mystery" of the East, or to the guilty conscience of those who deplore the West's assumedly materialistic attitudes. These introductions are legion and can be countered only by reference to such an obscure and specialized source as "Chinese Civilization in Liberal Education" (in *Proceedings of a Conference at the University of Chicago,* Chicago, 1959), in which Dr. Alexander C. Soper III has written the sanest and most telling, if curt and fragmentary, account of the place of Chinese art in the liberal arts.

A general introduction to Far Eastern art, although it is apt to be doomed by the results of new research and wider knowledge, has been badly needed; the usefulness and succession of comparable surveys of Western art have underscored this lack in regard to the art of the Orient. Interest alone demands a launching pad, however unstable, to the higher reaches of specialized knowledge; and scholarship needs occasional broad panoramas to modify or correct, thus automatically providing the grounds for new locations of the framework or new directions for the vehicle. It is, in my opinion, more important for the layman or beginning art historian first to know the place of great Indian sculpture or Chinese painting in the art of the Far East, and of the world, than to begin studying these contributions merely as documents of the national history or the religion of their respective areas.

But the works of art in their own contexts indicate their outer relationships only too clearly. The international flavor of classic Buddhist art, in India, Java, Central Asia, China, or Japan—is apparent in its forms, just as the national character of later Cambodian art is as clear as that of certain so-called derivative phases of Japanese art. Again, a broad view, especially of style, is of the greatest importance in recognizing that the art of the Orient, like that of the Occident, is not a special, unique, and isolated manifestation. Related art forms appear on an international stage as often as isolated national styles develop on a contracted geographic stage. Seen in this light, without romantic mystery as well as without the paraphernalia of esoteric scholarship, the art of Eastern Asia seems to me more readily understandable, more sympathetic, more human. We can never see a Chinese work of art as a Chinese does; much less can we hope to know it as it was in its own time. On the other hand, we should not, unless for some really valid reason, violate the context of the work of art. But here are thousands of still meaningful and pleasurable works of art, part of our world heritage—and we should not permit them to be withheld from us by philologists, swamis, or would-be Zen Buddhists. What are they? How are they to be related to each other? What do they mean to us as well as to their makers? These are proper questions for a general study.

So far no one student has commanded the disciplines necessary to present such a broad survey in really satisfactory form. Since the Second World War the fields of Oriental history, political science, economics, and art have burgeoned, but it is unlikely that such paragons of learning could be forthcoming soon. Any effort inevitably will have numerous shortcomings, some of them perhaps fatal; but, if the effort is worth a try, then at least some of these shortcomings should be faced and either controlled or baldly admitted. The present work makes no pretense to provide more than the briefest historical or religious background to the works of art. In many cases the subject matter, when it is of a particularly esoteric nature, has

been slighted or ignored. But questions of style, of visual organization, of aesthetic flavor or comparison, have been emphasized. Since the one really unique and unforgettable quality of a work of art is its visual appearance, and since as Focillon said, the artist's "special privilege is to imagine, to recollect, to think, and to feel in forms," it seemed only logical to me that forms should be the principal concern of the book. Furthermore such matters interest me more than others.

There is one other aspect of Far Eastern art that has not been limited in the present work. Numerous media were used by the Oriental artist. It is quite impossible to know Chinese art without knowing such so-called minor arts as ceramics and jade. Lacquer is very important in Japan. In India, architecture, per se, is of more limited interest than in Japan. This study presents the various *styles* of Far Eastern art in the media used by the artists in the most creative way. Thus, there is much on Indian sculpture but little on Indian ceramics. Contrariwise, late Chinese ceramics are emphasized while late Chinese sculpture is conspicuous by its well-deserved absence. The same selectivity is applied to the choice of styles for discussion. Though conservative modes are of considerable interest as foils or points of departure for more progressive styles, their persistence beyond a certain point can only be called ossification, and one can indulge in the satisfaction of dropping the vestigial remainder; thus the slighting of the Kano school in Japan or of the court-academy painters of the Ming and Qing dynasties.

Other omissions and weaknesses are less deliberate. They involve the shortcomings of the author's acquaintance with some of the many and complex areas of Far Eastern art. The sections on Javanese art, the art of the steppes, or on Mughal painting fall into this category. Recent excavations on the Chinese mainland are numerous, excellent, and fruitful sources for future knowledge. But still, I feel that the present effort is worth the making; this is not an encyclopedia, a complete history, or a handbook of iconography, but an *introduction* to the creative art of Eastern Asia.

The plan of the book is simple. It begins with the early East Asian cultures, Neolithic and Bronze Age, with special emphasis on the Indus Valley civilization, which is related to the other ancient urban river cultures of Mesopotamia and Egypt, and on the great bronze culture of early China. This section is followed by a study of the rise of Buddhist art in India and of its influence throughout eastern Asia. The following sections trace the rise of "national" art styles in India, Southeast Asia, Indonesia, and East Asia. The latter section, with major emphasis on China and Japan, stresses the alternating national and international character of East Asian art. The modern art of the East is omitted on the grounds that its creative side is more a part of worldwide internationalism than of the tradition of art presented in this volume.

Further reading for those so inclined is suggested by a general bibliography and by a specific list of significant sources for each chapter.

The author is much indebted to the various persons who helped in gathering photographs and information, and with the burdensome task of typing, proofreading, and compilation. Particular acknowledgment should go to Mrs. Margaret Fairbanks Marcus for her patient and critical reading of the draft; Dr. Thomas Munro, Mr. Edward B. Henning, and Mr. Milton S. Fox all read the manuscript and offered excellent advice, which was usually heeded; Mr. Wai-kam Ho was most instructive with regard to early Chinese material. My book owes a great deal to the diligence and expert craftsmanship of Mr. Philip Grushkin, Mrs. Susan A. Grode, and Miss Harriet Squire, of the Abrams staff. Mrs. Nancy Wu Stafstrom, Mrs. Susan Berry, and Mrs. Margarita Drummond bore the brunt of preparing the list of illustrations and arranging for photographs, while Miss Louise G. Schroeder was responsible for the equally onerous task of typing and retyping. I am particularly indebted to Messrs. Junkichi Mayuyama, Inosuke Setsu, and Manshichi Sakamoto for most of the Japanese photographs, while Dr. J. E. van Lohuizen, Dr. Benjamin Rowland, and Mr. S. E. Tewari were most kind and helpful with certain rather difficult Indian material. To these, and many others unnamed, the author proffers humble and sincere thanks. Finally, and by no means least, he is grateful to his wife, who endured his late hours and by no means unexpressed frustrations with the work in progress.

S.E.L.

Preface to the Fifth Edition

Completely reviewing and revising this history was the work of several years, and brought satisfaction mingled with discomfiture: satisfaction in finding that the original overall concept still seems both valid and useful—for general readers, for beginning students, even for specialists interested in relationships between their own and neighboring purviews. The national arts of East Asia are as interconnected as they are distinctive, and the interconnections generally receive but passing attention in books devoted to the arts of a single nation.

Discomfiture came with the author's realization, abetted by the suggestions of judicious and well-informed critics, that the book needed not minor adjustments and amplifications but major additions and revisions to remedy the lacunae and unconscious biases of earlier editions. This necessitated careful reexamination of the arts of Chinese Buddhism, of Korea, and of Kashmir and Ladakh. It also required, throughout, the review and reassessment of old publications, the close reading of new ones, and the rechecking of all factual data under the indefatigable stimulus of my editor, Naomi Noble Richard. New discoveries in the years since the fourth edition also required new interpretations, notably regarding the Old and New Stone Ages in China and Japan. New finds will undoubtedly continue to revise our interpretations of these cultures, but our present account is as up-to-date as current knowledge permits.

For more than a century the teachers and students of East Asian art and culture have presented the achievements of "exotically" different and greatly varied cultures to interested readers in the West. Thanks to their efforts, the faiths, ideas, and material cultures of Hinduism, Buddhism, Lamaism, Confucianism, Daoism, Shintoism, and other doctrines are now more widely known and perhaps better understood and more influential than ever before. The marvelous cultural diversity of Asia and the fascinating interrelationships within that diversity are increasingly being brought home to us in the West, as in the recent commemorative exhibition *Circa 1492: Art in the Age of Exploration*. Teachers, students, and museums have introduced East Asian concepts of aesthetic categories and criteria of aesthetic excellence to the attention and understanding of the West. For all this we are greatly indebted.

No list of names could do justice to all the people who have advised or contributed to this revision. Julia Moore and Neil Ryder Hoos of Harry N. Abrams, Inc., however, contributed greatly to the making of this book. James Cahill, Lena Kim, and John and Susan Huntington were most helpful in resolving last-minute problems regarding illustrations. John M. Rosenfield, Howard Rogers, Elinor Pearlstein, Rekha Morris, and James Ulak, among others, provided specialists' knowledge that was both accurate and understandable to this aging generalist.

Particular thanks are owed the Asian Cultural Council, under the leadership of Mrs. John D. Rockefeller 3rd and Richard Lanier, for the Council's annual award for 1990, permitting the additional travel and research necessary for completion of a complex task. Their support and encouragement were crucial.

Naomi Richard, particularly, deserves the most sincere homage from the author for her patience, perception, and power of argument in all details, and for adding her synthesizing talents in the historical resumés introducing the individual chapters. We have worked together before and may do so again, in a relationship sometimes daunting and unnerving but always challenging and demanding, symbiotic and fruitful. Peace now was well earned.

Finally, a dedication to my dear wife, Ruth, the most patient of all, provider of much-needed sympathy and sensible arbiter of close decisions and disputes. Five times she has endured the writing and rewriting of this book, and now can rest assured that "just once more" will not come again.

S.E.L.

A Comparative Time Chart for Far Eastern Art

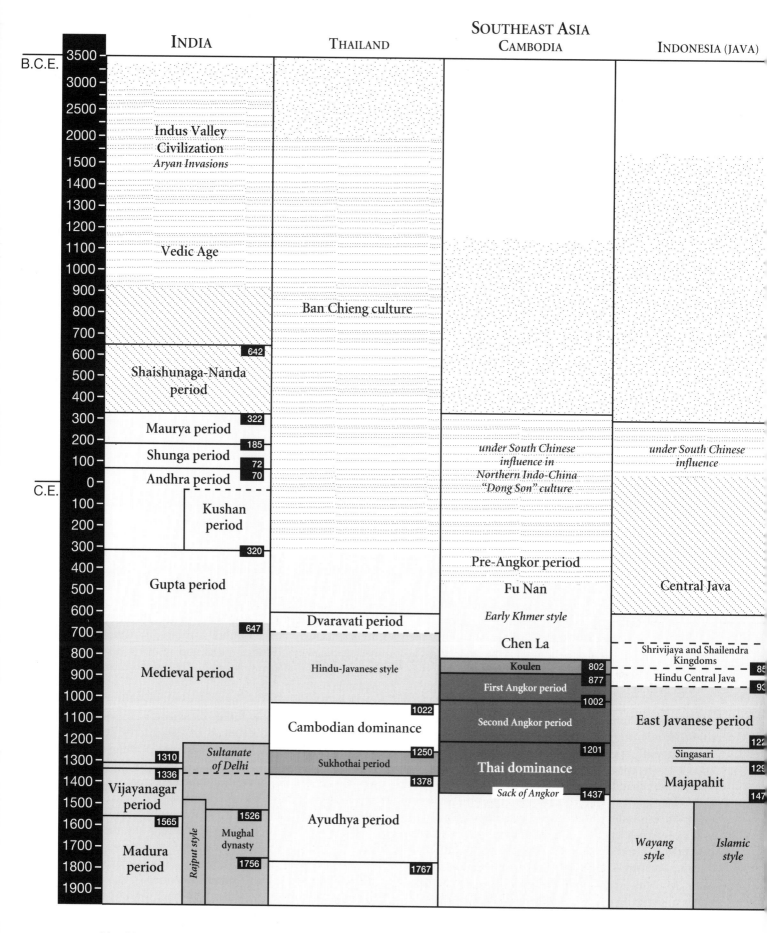

Matching tints across the chart indicate cultural continuities across geographical and political boundaries.

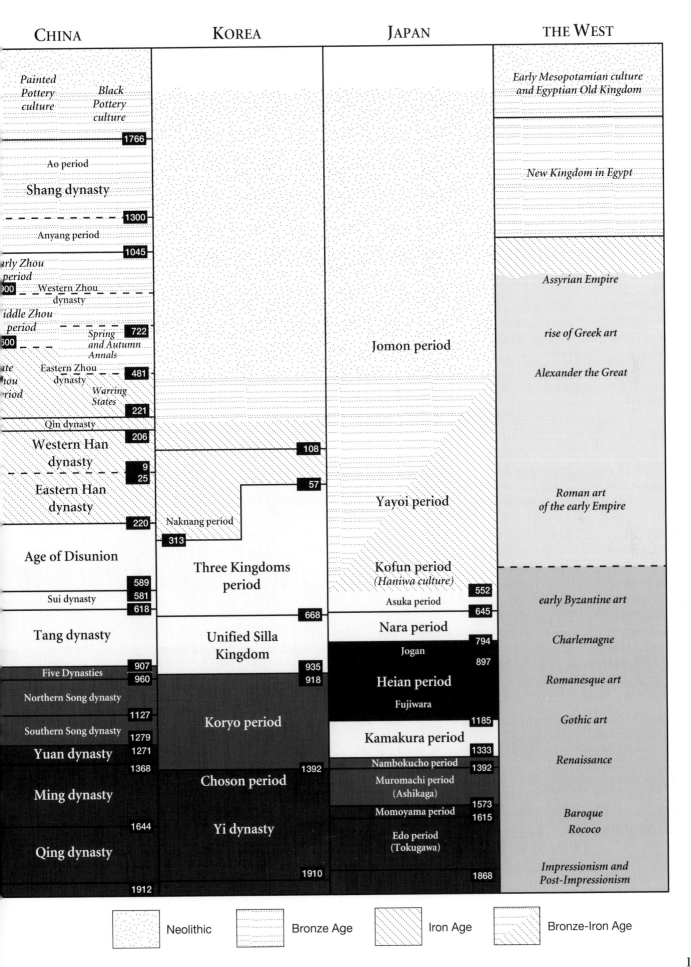

CHINA	KOREA	JAPAN	THE WEST

CHINA

Painted Pottery culture *Black Pottery culture*

1766

Ao period

Shang dynasty

1300

Anyang period

1045

Early Zhou period

Western Zhou dynasty

Middle Zhou period

722 Spring and Autumn Annals

481 *Eastern Zhou dynasty*

Late Zhou period *Warring States*

221

Qin dynasty

206

Western Han dynasty

9
25

Eastern Han dynasty

220

Age of Disunion

589
581 Sui dynasty
618

Tang dynasty

907 Five Dynasties
960

Northern Song dynasty

1127

Southern Song dynasty

1279

Yuan dynasty 1271

1368

Ming dynasty

1644

Qing dynasty

1912

KOREA

108

Naknang period

313

Three Kingdoms period

668

Unified Silla Kingdom

935
918

Koryo period

1392

Choson period

Yi dynasty

1910

JAPAN

Jomon period

57

Yayoi period

Kofun period
(Haniwa culture)

552
Asuka period
645

Nara period

794
Jogan
897

Heian period

Fujiwara

1185

Kamakura period

1333

Nambokucho period 1392

Muromachi period (Ashikaga)

1573
Momoyama period 1615

Edo period (Tokugawa)

1868

THE WEST

Early Mesopotamian culture and Egyptian Old Kingdom

New Kingdom in Egypt

Assyrian Empire

rise of Greek art

Alexander the Great

Roman art of the early Empire

early Byzantine art

Charlemagne

Romanesque art

Gothic art

Renaissance

Baroque Rococo

Impressionism and Post-Impressionism

Neolithic Bronze Age Iron Age Bronze-Iron Age

Chronological Tables

Indian Art

Pre-Buddhist period: early times–c. 322 B.C.E.
 Indus Valley Civilization: c. 2500–c. 1500 B.C.E.
 Aryan Invasions: c. 2000–c. 1500 B.C.E.
 Shaishunaga-Nanda period: 642–322 B.C.E.
Period of Buddhist dominance: c. 322 B.C.E.–after 600 C.E.
 Maurya (Ashoka) period: 322–185 B.C.E.
 Shunga period: 185–72 B.C.E.
 Andhra period: c. 70 B.C.E.–3rd century C.E.
 (Satavahana dynasty: 220 B.C.E.–236 C.E.)
 Kushan period (including Gandhara):
 late 1st century–3rd century C.E.
 Gupta period (including Harsha): 320–647 C.E.
Medieval period: c. 600–c. 1200 C.E.
 Pallava period (eastern peninsular India, conquering
 southward): c. 500–800 C.E.
 Chalukyan period (western peninsular India,
 conquering eastward): 550–end of 12th century C.E.
 Rashtrakutan period: 753–c. 900 C.E.
 Pala and Sena periods (west Bengal, Bihar,
 Bangladesh): c. 730–c. 1197 C.E.
 Medieval Kingdoms of Rajputana and the Deccan
 (north): 8th century–c. 1190 C.E.
 Chola period (eastern peninsular India): 897–after
 1200 C.E.
Later Medieval period: 1200–1756 C.E.
 Sultanate of Delhi (north): 1206 C.E.–14th century
 Vijayanagar period (south): 13th century–1565 C.E.
 Madura period (south): 1646–c. 1900 C.E.
 Mughal dynasty: 1526–1756 C.E.
 Rajput style (north): c. 1500–c. 1900 C.E.

Southeast Asian and Indonesian Art
Thailand

Ban Chieng culture:
 Neolithic c. 3500 B.C.E.–c. 1600 B.C.E.
 Bronze Age: c. 1600 B.C.E.–600 B.C.E.

Dvaravati period (Indian influence): 6th–10th
 century C.E.
 Hindu-Javanese style: c. 700–c. 1000 C.E.
Cambodian dominance: 1022–c. 1250 C.E.
Sukhothai period: c. 1250–1378 C.E.
Ayudhya period: 1378–1767 C.E.
 Ayudhya and Lopburi schools

Cambodia

Pre-Angkor period (Early Khmer; Indian influence):
 Fu Nan: ?–c. mid-6th century C.E.
 Chen La: c. 6th century–802 C.E.
 Koulen (Transitional period): 802–877 C.E.
First Angkor period: 877–1002 C.E.
Second Angkor period: 1002–1201 C.E.
Sack of Angkor: 1437 C.E.

Java

Central Java: 7th and 8th centuries C.E.
Shrivijaya (Shailendra dynasty dominance from
 Sumatra): c. 750–c. 850 C.E.
Hindu Central Java: c. 850–c. 930 C.E.
East Javanese period: c. 930–1478 C.E.
Muslim conquest: 15th and 16th centuries C.E.
Wayang (Native) style: 15th century C.E. to date

Chinese Art

Xia dynasty (Erlitou): trad. c. 2205–c. 1766 B.C.E.
Shang dynasty: c. 1766–1045 B.C.E.
 capital at Ao: c. 1766–c. 1300 B.C.E.
 capital at Anyang: c. 1300–1045 B.C.E.
Zhou dynasty: 1045–256 B.C.E.
 Western Zhou dynasty: 1045–771 B.C.E.
 Eastern Zhou dynasty: 771–256 B.C.E.

Period of Spring and Autumn Annals: 772–481 B.C.E.
Period of Warring States: 481–221 B.C.E.

Stylistic dating of Zhou period:
Early Zhou period: 1045–c. 900 B.C.E.
Middle Zhou period: c. 900–c. 600 B.C.E.
Late Zhou period: c. 600–221 B.C.E.

Qin dynasty: 221–206 B.C.E.
Han dynasty: 206 B.C.E.–220 C.E.
 Western Han dynasty: 206 B.C.E.–9 C.E.
 Eastern Han dynasty: 25–220 C.E.
Age of Disunion (incl. Six Dynasties): 220–589 C.E.
 Northern dynasties: 317–581 C.E.
 Northern Wei dynasty: 386–535 C.E.
 Northern Qi dynasty: 550–577 C.E.
 Southern dynasties: 420–589 C.E.
Sui dynasty: 581–618 C.E.
Tang dynasty: 618–907 C.E.
Five Dynasties: 907–960 C.E.
Song dynasty: 960–1279 C.E.
 Northern Song dynasty: 960–1127 C.E.
 Southern Song dynasty: 1127–1279 C.E.
Liao dynasty: 916–1125 C.E.
Jin dynasty: 1115–1234 C.E.
Yuan dynasty: 1271–1368 C.E.
Ming dynasty: 1368–1644 C.E.

Stylistically significant reigns:
Yongle: 1402–1424 C.E.
Xuande: 1425–1435 C.E.
Chenghua: 1464–1487 C.E.
Zhengde: 1505–1521 C.E.
Jiajing: 1521–1566 C.E.
Wanli: 1572–1620 C.E.

Qing dynasty: 1644–1912 C.E.

Stylistically significant reigns:
Kangxi: 1661–1722 C.E.
Yongzheng: 1722–1735 C.E.

Qianlong: 1735–1795 C.E.
Jiaqing: 1795–1820 C.E.

Korean Art

Neolithic, Bronze, Iron Ages: c. 6000 B.C.E.–300 C.E.
Naknang (Lelang; Han Chinese dominance): 108 B.C.E.–313 C.E.
Three Kingdoms: 57 B.C.E.–668 C.E.
 Koguryo: 37 B.C.E.–668 C.E.
 Paekche: 18 B.C.E.–663 C.E.
 Old Silla: 57 B.C.E.–668 C.E.
Unified Silla Kingdom: 668–935 C.E.
Koryo period: 936–1392 C.E.
Choson period (Yi dynasty): 1392–1910 C.E.

Japanese Art

Archaeological age: c. 10,500 B.C.E.–646 C.E.
 Jomon period: c. 10,500–c. 300 B.C.E.
 Yayoi period: c. 300 B.C.E.–c. 300 C.E.
 Kofun period (Haniwa culture): 248–646 C.E.
Asuka period: 552–645 C.E.
Nara period: 645–794 C.E.
 Early Nara (Hakuho) period: 645–710 C.E.
 Late Nara (Tempyo) period: 710–794 C.E.
Heian period: 794–1185 C.E.
 Early Heian (Jogan) period: 794–897 C.E.
 Late Heian (Fujiwara) period: 897–1185 C.E.
Kamakura period: 1185–1333 C.E.
Nambokucho period (Southern and Northern Courts): 1333–1392 C.E.
Muromachi (Ashikaga) period: 1392–1573 C.E.
Momoyama period: 1573–1615 C.E.
Edo (Tokugawa) period: 1615–1868 C.E.
 Early Edo period: 1615–1716 C.E.
 Late Edo period: 1716–1868 C.E.

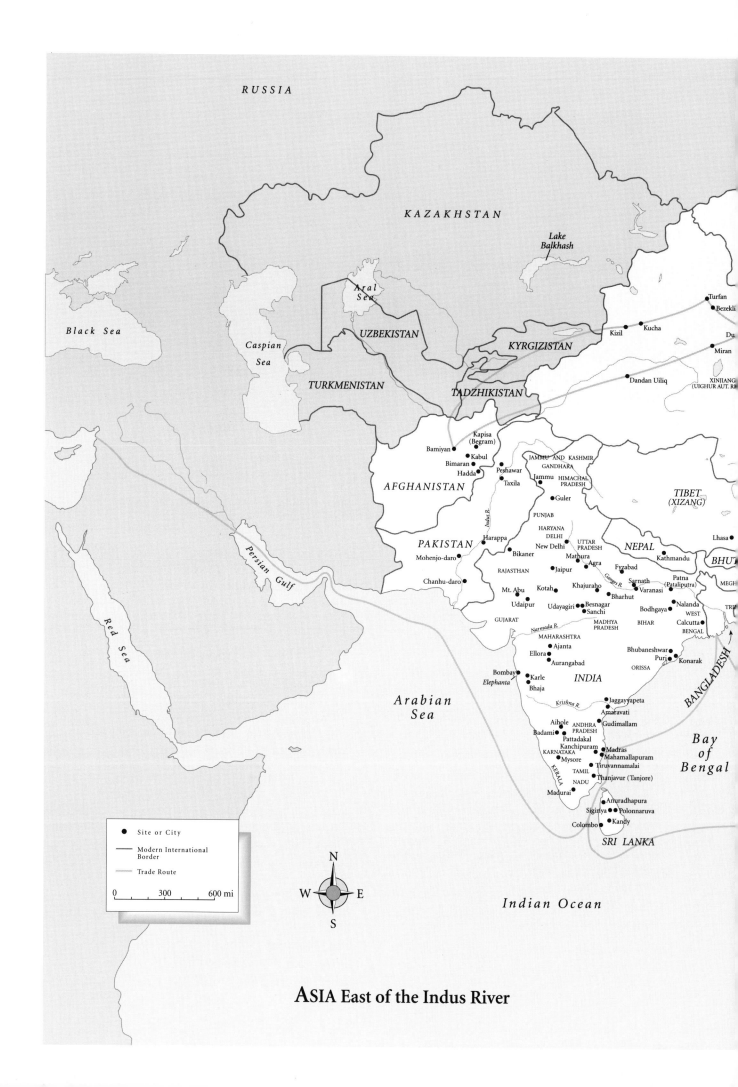

RUSSIA

KAZAKHSTAN

Lake Balkhash

Black Sea

Aral Sea

UZBEKISTAN

KYRGIZISTAN

Caspian Sea

TURKMENISTAN

TADZHIKISTAN

Turfan
Bezekli

Kizil • Kucha

Du

Miran

Dandan Uiliq

XINJIANG
(UIGHUR AUT. RE

Kapisa
(Begram)

Bamiyan • • Kabul

Bimaran

Hadda

Peshawar

JAMMU AND KASHMIR

GANDHARA

Jammu HIMACHAL
PRADESH

TIBET
(XIZANG)

AFGHANISTAN

Taxila

• Guler

Persian Gulf

PUNJAB

Lhasa

Red Sea

PAKISTAN

Harappa

Mohenjo-daro

Chanhu-daro

Bikaner

HARYANA
DELHI

New Delhi UTTAR
PRADESH

Mathura

Agra

NEPAL

Kathmandu

BHUT

Fyzabad

Indus R.

RAJASTHAN

Jaipur

Ganges R.

Sarnath

Varanasi

Patna
(Pataliputra)

MEGH

Mt. Abu

Kotah

Khajuraho

Bodhgaya

Nalanda

TRI

Udaipur

Udayagiri Besnagar

Sanchi

Bharhut

WEST
BENGAL

Calcutta

GUJARAT

Narmada R.

MADHYA
PRADESH

BIHAR

*Arabian
Sea*

MAHARASHTRA

Ajanta

Ellora

Aurangabad

Bhubaneshwar

Puri

Konarak

ORISSA

Bombay

Elephanta

Karle

Bhaja

INDIA

Krishna R.

Jaggayyapeta

Amaravati

BANGLADESH

*Bay
of
Bengal*

Aihole

Badami

ANDHRA
PRADESH

Gudimallam

Pattadakal

Kanchipuram

KARNATAKA

Mysore

Madras

Mahamallapuram

Tiruvannamalai

TAMIL

Thanjavur (Tanjore)

KERALA

NADU

Madurai

Anuradhapura

Siginya • Polonnaruva

Colombo Kandy

SRI LANKA

Indian Ocean

Site or City

Modern International
Border

Trade Route

0 300 600 mi

N
W E
S

ASIA East of the Indus River

Guide to Pronunciation

The letters of the *pinyin* and Wade-Giles romanizations approximate in pronunciation the italicized letters in the words in the "equivalent" column. *Pinyin* is used throughout in the text. Wade-Giles appears in brackets immediately after the *pinyin* in the index.

pinyin	Wade-Giles	equivalent	pinyin	Wade-Giles	equivalent
f	f	*f*ee	eng	eng	s*ung*
h	h	between *h*ot and I*ch* (German)	i	i	between d*i*n and d*ea*n, except after *s, ss, sz, sh, ch, ch', zh*
l	l	*l*ad	(s)i	(ss)u	hidd*e*n
m	m	*m*ight	(sh)i	(sh)ih,	
n	n	*n*o	(ch)i	(ch')ih,	b*urr*
r	j	between *r*ust and *j*eune (French)	(zh)i	(ch)ih,	
s	s, ss, sz	*s*eat	ia	ia	*y*acht
x	hs	between *s*eat and *sh*eet	ian	ien	between *y*en and *yan*k
w	w	*w*alk	iang	iang	h*e* + *ang*
b	p	*b*ought	iao	iao	*yow*l
p	p'	*p*ie	ie	ieh	*y*en
d	t	*d*ot	in	in	between *in* and d*ean*
t	t'	*st*arling	ing	ing	*sing*
g	k	*g*old	iong	iung	j*ung* (German)
k	k'	*c*ut	iu	iu	between *you* and L*eo*
c	ts', tz'	po*ts*	o	o	*o*ff
z	ts, tz	pa*ds*	ong	ung	j*ung* (German)
j*	ch	*g*in	ou	ou	*sew*
zh*	ch	*j*olt	ou	u	*sew*, after *y*
q*	ch'	*ch*eap	u	u	t*oo*
ch*	ch'	*ch*alk	u	ū	d*u* (French), after *j, q, y, x*
sh	sh	*sh*oe	ua	ua	*wa*nt
y	y	*y*oung	uai	uai	*wi*ne
a	a	h*a*rd	uan	uan	*wa*nt
ai	ai	p*ie*	uan	ūan	d*u* (French) + *yan*k, after *j, q, y, x*
an	an	*wan*t, except after *y*	uang	uang	*wan* + *sing*
yan	yen	between *y*en and *yan*k	ui	ui, uei	*weigh*
ang	ang	*Ang*st (German)	ue	ueh	d*u* (French) + *yet*
ao	ao	cl*oud*	un	un	between *un*der and Ow*en*
e	e	between t*a*ken and d*u*n	uo	o, uo	*tow*ard
e	e	*o*ff, after *h, k, k'*			
ei	ei	*eigh*t			

*Pinyin *j* and *zh*, *q* and *ch* are not distinguished in Wade-Giles transcription but differ in pronunciation: *j* and *q* are "dry" sounds, pronounced with tongue flattened against the upper palate; *zh* and *ch* are "wet," spoken with the tip of the tongue curled up to touch the upper palate.

INDIAN LANGUAGES (mostly SANSKRIT)

Vowels in general are pronounced as in Italian; short *a* is pronounced as *a* in "Americ*a*," never as *a* in "m*a*n." *G* is always hard, as in "*g*o." *H* is pronounced as in "lo*ch*"; *kh* and *gh* in Persian words (e.g., "Mughal") are pronounced somewhat like "lo*ch*." In Indian languages, *h* following another consonant (e.g., *Bh*utesar, An*dh*ra, *Kh*ajuraho) should be distinctly sounded. Other consonants are pronounced approximately as in English. Diacritical marks appear only in the index.

JAPANESE

Vowels in general are pronounced as in Italian. Consonants in general are pronounced as in English. *G* is always hard, as in "*g*o." Two vowels in sequence are always pronounced separately (never as a diphthong):

Taira: f*a*ther + b*een*
Koetsu: *ou*ght + *e*nd

Macrons, which appear only in the index, indicate that the vowel is to be held somewhat longer: Onjō-ji.

In general, all syllables receive equal stress.

KOREAN

Korean is romanized according to the McCune-Reischauer system. Vowels and consonants are generally pronounced as in Chinese. The following are peculiar to Korean:

Korean	equivalent
ŏ	b*u*t
ŭ	p*u*t
ae	s*a*t
oe	*ö*ffnen (German)
ŭi	q*u*eer

NOTE TO THE READER

Those works are *in situ* for which no museum or collection is named in the caption. The present location of art objects in Asian collections, particularly those in private collections, is often hard to ascertain, but every effort has been made to provide correct information. Chinese, Korean, and Japanese personal names are cited in traditional form: surname followed by given name. Measurements are not given for objects that are inherently large (architecture, architectural sculpture, gardens, temple sites). Dates in the captions are based on documentary evidence, unless preceded by "c." Inclusive period dates are listed in the comparative time chart and chronological tables at the beginning of the book. A list of photograph credits for the illustrations appears at the end of the book. The notes, indicated by superior numbers in the text, appear in a separate section preceding the bibliography. All diacritical marks are omitted from the text and appear in brackets in the index. Parenthetic C, J, K, and S indicate Chinese, Japanese, Korean, and Sanskrit, respectively.

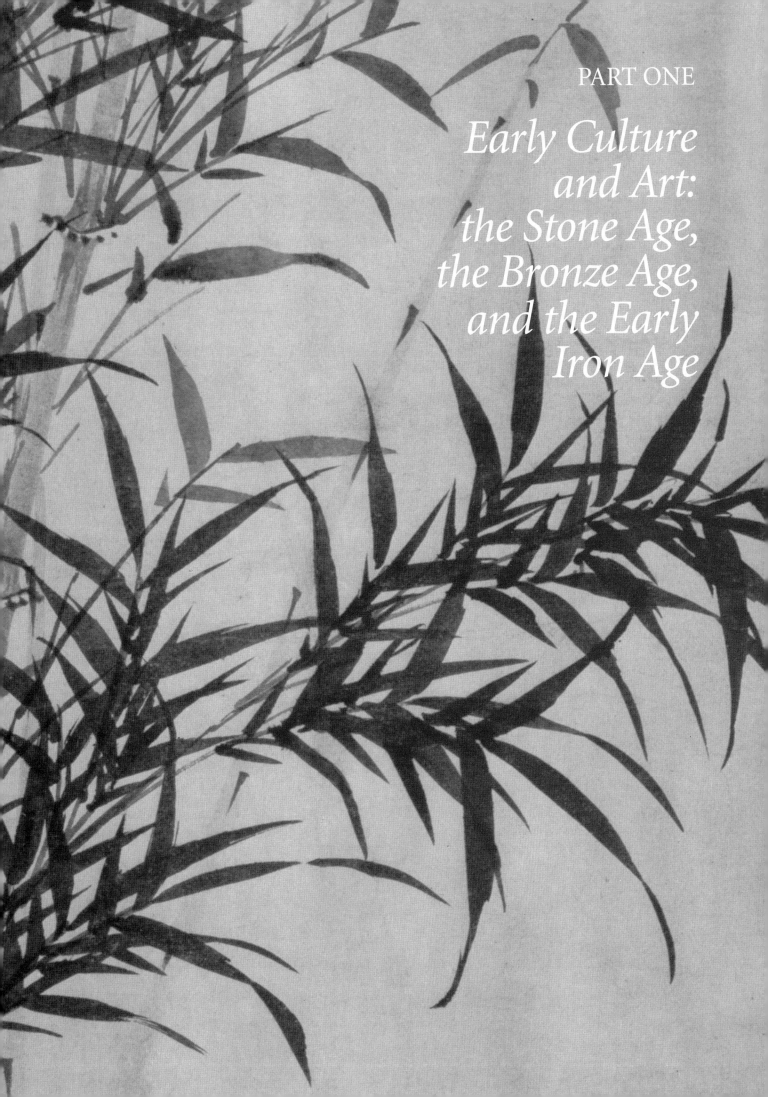

PART ONE

Early Culture and Art: the Stone Age, the Bronze Age, and the Early Iron Age

1

Urban Civilization and the Indus Valley; Neolithic and Pre-Shang China; Ban Chieng Culture

Many books on Oriental art have adopted the now classic opening statement, "Asia is one," with which Okakura Kakuzo began his book, *The Ideals of the East.* The statement is far from true. Asia is not even one continent geographically; and the idea that the cultures of Asia are one, that there exists such a thing, for example, as the "Oriental mind," or that all the peoples of these regions are united by a highly developed metaphysical approach to life, is false. In his many writings Ananda Coomaraswamy developed with great insistence the view that Chinese, Japanese, and Indian artists all worked within a single metaphysical framework. This attitude is understandable, even though it is biased. Asian countries, remote from far Western centers of culture and evolving in isolation from all but superficial contacts with them, were ravished by adventurers who represented only an unfortunate aspect of the Western world. Such intrusions made Asians particularly aware of their traditional ideals. They forgot the discrepancies, the contrasts, and the multiple factors that were also a part of their heritage and spoke only of what they treasured most and liked to believe was their unique contribution, in contrast to the assumed aggressive materialism of the West. Such error is all too human and is present in Christian attitudes toward "savages," in Muslim opinion of the Hindu, or in the peculiar serenity of the Chinese, who called their country the Middle Kingdom, believing that it was the center of the universe.

This book does not accept these attitudes, and begins with the idea that Asia is not one, but many. It is a collection of peoples, of geographic areas, and, finally, of cultures. Each has its own assumptions, its own views and uses of art. There are, of course, influences and counter-influences; there are interweaving patterns derived from the spread of religions, from the migrations of peoples, and from the effects of trade and commerce. We are, then, confronted in Asia with many different entities. It is impossible, for example, to speak even of Chinese art as if there were one "mystique" behind the whole. We have to speak of Chinese art of the Bronze Age and of Chinese art in the more sophisticated periods of the Tang and Song dynasties. We shall see those Japanese arts that are partially derived from Chinese art; but then we must examine even more carefully those arts that are uniquely Japanese and radically different, not only in appearance but in motivation, from those of China.

With this approach in mind, we can survey the arts of the countries and regions of eastern Asia: India and Nearer India—that is, Nepal and Sri Lanka; Farther India—including Cambodia, Thailand, and Burma; Indo-

nesia—including Java and Sumatra; and China, Korea, and Japan. The art of Tibet, which is preeminently Buddhist, shows important connections to both India and China. Central Asia contains many monuments of Buddhist art, and was a most important transmitter of influences from India and the Western world to the Far East.

Asian art begins with the emergence of the human species in both Java and China. The earliest Hominidae developed a half million or more years ago, and the first evidences of human, purposeful effort are the rude stone choppers found in the dwelling areas of Java, Lantian, and Beijing (Peking) man. These Early Stone Age artifacts are the first in a series of stone implements that progresses through Mesolithic flaked hatchets, points, and flaked scrapers to the honed stone and polished jade implements and beads of Neolithic Chinese origin. The investigation of Stone Age culture in Asia is still in its beginnings; and until the undoubtedly numerous remains from India, Central Asia, China, and Indonesia are found, studied, and related, a general summary would be meaningless. The last decade alone has seen a great proliferation of material remains from all areas of China, materially altering previous prehistorical studies and conclusions.

But the great transition that really begins for us the story of art in Asia is that same transition that begins the story of developed civilized art everywhere in the world: the transition from a nomadic, food-seeking, hunting culture to a village and finally to an urban, food-storing, surplus-using culture. This evolution did not occur in China until perhaps 2500 B.C.E., and in the Indus Valley of northwest India perhaps just before 2200 B.C.E. With this change we enter also into the realm of complex art forms.

INDUS VALLEY CIVILIZATION

In the Indus Valley Indian and English excavators found an extraordinary culture, one of the most recent discoveries of a major civilization. In the early 1920s the excavations were haphazardly conducted, and the importance of the site was not realized until Sir John Marshall dug at Mohenjo-daro and at the second city, Harappa. The culture, sometimes called the Mohenjo-daro or Harappa culture, is now most often referred to as the Indus Valley civilization. In the early 1930s, to the excitement of the archaeological world, remarkable finds were made, and excavations interrupted by World War II are now continuing. Here was a full-blown urban culture comparable in extent and quality to those of Mesopotamia and Egypt. The surviving fragments of script have only now been partially and tentatively deciphered, and we are just beginning to learn an appreciable amount about the life of these cities.

An aerial view of the excavations at Mohenjo-daro reveals that subsidiary buildings and structures were axially oriented with relation to certain main streets, indicating that the city was highly organized politically and socially and not just an agglomeration of dwellings along

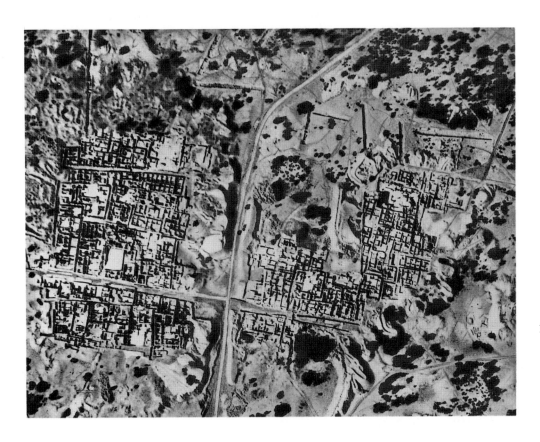

1. *Mohenjo-daro, now in Pakistan.* Aerial view. Indus Valley civilization

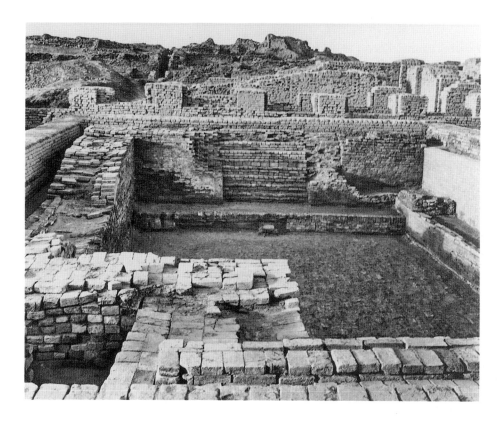

2. *Great Bath.* Mohenjo-daro, now in Pakistan. Indus Valley civilization. Brick; h. 8' (2.44 m), l. 39' (10.89 m), w. 23' (7.01 m)

a road or river (*fig. 1*). Not only was its plan an orderly one; it had a highly developed irrigation and sewage system as well. There were numerous buildings of some size, such as the so-called Great Bath (*fig. 2*). What this structure was used for we do not know, but there have been some fascinating speculations. Some have suggested that the inhabitants of Mohenjo-daro kept aquatic reptiles or animals in the pool; others guess that it was a place where wealthier citizens bathed. In any event, it was a sizable public structure with a most elaborate drainage system to keep the water fresh. Cubicles and rooms around the tank were perhaps intended for use by priests or bathers. The Great Bath was a large and important structure, implying a socially and technically advanced society.

In the early years of the excavations, fortifications and citadels seemed conspicuously absent at both Mohenjo-daro and Harappa. Utopian idealists were tempted to hope that they had found the perfect society, composed of a peace-loving people, warriorless and classless—a prototype of the ideal state. But in 1946 Sir Mortimer Wheeler began to excavate at Harappa and found the citadel. He studied a large and previously ignored mound, cut across it very carefully, and found the fortress. Here the military rulers of the Indus Valley had lived; and here, as their piled-up bodies suggest, they had met their end, probably at the hands of Aryan invaders, about 1500 B.C.E. Indus Valley civilization was at its peak from about 2200 to 1800 B.C.E., and sometime between 2000 and 1500 B.C.E. waves of Aryan invasions utterly destroyed it.

Numerous important works of art were found at both Mohenjo-daro and Harappa. The fine-grained limestone bust of a man, approximately seven inches in height, has traces of color on the trefoil pattern of the robe (*fig. 3*). The type of representation is of interest because it appears to be related to some of the early Sumerian figures, particularly those found at Tello and Ur. The figure, a formal, dignified sculptural achievement, calls to mind a deity, priest, or important official, and is therefore referred to as "High Priest." The suggestion has been made that the downcast eyes portray a yoga disciple in contemplation, but this hardly seems likely. It is a formal and hieratic sculpture. This is of interest, as two radically different types of sculpture are found in the Indus Valley: one, this formal type, and the other a highly naturalistic, "organic" type. The latter style can be seen in the red sandstone torso from Harappa, about four inches high (*fig. 4*). Some skeptics deny that this sculpture is of the period and believe it represents a considerably later style, of perhaps the second or first century B.C.E. The consensus, however, is that the figure does date from the Indus Valley period, and this is not difficult to believe in view of other objects that have been found. The Harappa figure is suavely modeled, with a tendency toward what we shall call organic style; that is, the forms seem natural and living, soft and flowing, rather than crystalline and angular in structure as are some inorganic forms. It shows intelligent study of the human body—what it looks like and how it works—and that study has been appropriately expressed in the material. This concept of organic sculptural style is particularly significant in later

3. *High Priest.* Limestone; h. 7" (17.8 cm). Mohenjo-daro, now in Pakistan. Indus Valley civilization. National Museum, New Delhi

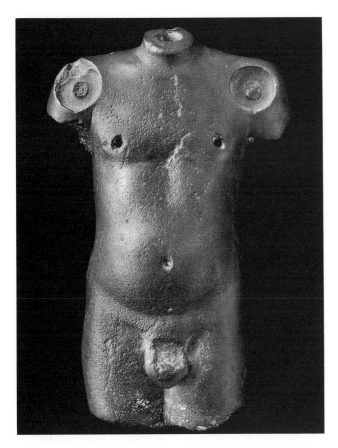

4. *Nude male torso.* Red sandstone; h. 3¾" (9.5 cm). Harappa, now in Pakistan. Indus Valley civilization. National Museum, New Delhi

Indian sculpture. No one has satisfactorily explained the curious circular drill impressions in the shoulders. Perhaps they were meant for the attachment of movable arms; or, less likely, they are symbolic markings. Only two stone figures of this organic type were found; the other is in a dancing pose.

In early Egyptian and Mesopotamian art, artists apparently disregarded or lacked interest in the way the body looks and moves, and attempted to make it timeless and static, frozen in space. This Indus type, however, seems much more of the moment, more immediate in the reaction of the artist to the subject and in the communication of that reaction to the spectator. The whole effect is rather like the feeling of surprising immediacy one receives from Magdalenian painting of bison, deer, or antelope. The Indus Valley sculptor seems to have breathed the shape and form of the human body into stone, even causing it to appear soft. To what extent this organic style is influenced by clay modeling it is impossible to say, but some such influence seems likely.

The work that provides a link between the organic and the more formal, hieratic styles of the Indus Valley culture is a copper figure of a dancing girl from Mohenjo-daro (*fig. 5*). The excavation reports indicate quite clearly that it was found with Indus Valley ceramics and other materials. Further, the head, particularly the way in which the eyes and the nose are modeled, recalls the limestone "High Priest" of figure 3. But in the modeling of the back and the side one sees the same organic style as is found in the red sandstone torso of figure 4. This sculpture was certainly influenced by clay modeling, for of course the figure had to be modeled in clay or wax before it could have been cast in bronze. The elaborate asymmetrical hair style much resembles those found in later Indian sculpture, and the use of bangles and the nudity of the figure are also in keeping with later Indian practice. The type and pose of the little dancer may be related to clay fertility images, such as those found throughout the ancient Near East. A considerable point has been made of the Negroid features of the dancing girl, which seem to confirm the theories of certain ethnologists on the movements of ethnic strains in India. She may represent one of the Negroid peoples still found in south India, where they presumably migrated when forced out of northwest India by the Aryan invasions of about 1500 B.C.E. or slightly earlier.

The usual implements of an early culture—all kinds of bangles, beads, toys for children, copper knives and spindles, all the impedimenta of the kind that pile up in one's storeroom—were found in the Indus excavations. Among them are extraordinary large storage jars with painted designs of birds and animals in an organic style, which seem to be related to even earlier Neolithic potteries of the region (*fig. 6*). The geometric patterns in these designs seem to be derived from plant life.

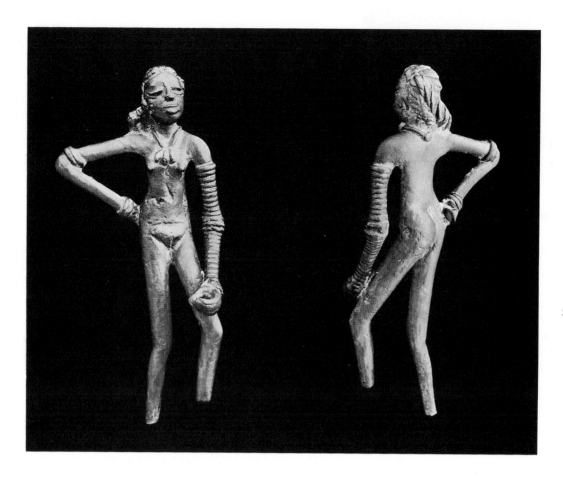

5. *Dancing girl.*
Copper; h. 4¹/₄"
(10.3 cm). Mohenjo-
daro, now in
Pakistan. Indus
Valley civilization.
National Museum,
New Delhi

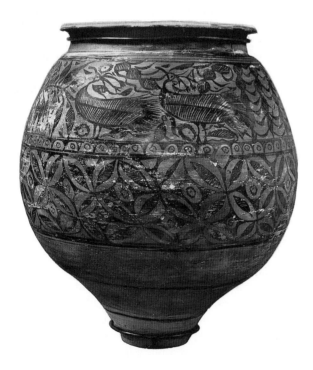

6. *Storage jar.* Earthenware; h. 20³/₄" (52.7 cm). Chanhu-daro,
now in Pakistan. Indus Valley civilization. Museum of Fine
Arts, Boston

The most distinctive creations of the Indus Valley artist are the stamp seals found in considerable quantity and inscribed with legends, mostly undeciphered, in the Indus Valley script. They are carved in fine-grained steatite, coated and then fired, and most of them are rectangular stamps rather than the cylinder seals characteristic of Mesopotamian cultures. Carved in intaglio, the designs on Indus Valley seals often have an animal as their principal subject. A few have figures, alone or with animals. One famous seal displays a seated figure in a yogi-like pose (*fig. 7*), and another presents a combat between a cow-headed female and a tiger. But the characteristic seals are those depicting bulls, mostly bulls with big humps (*fig. 8*). In subject matter one or two of the seals showing combat scenes are like those found in Mesopotamian sites. Stylistically, however, they differ. The seals of the Mesopotamian region tend either to be geometric, as in the very earliest examples, or to move in the direction of a highly stylized expression that cleverly uses drilling and incision to give an effect of movement and a degree of naturalism. On the other hand, the Indus Valley seals are painstakingly and fully modeled, with sleek outlines and very few traces of the tool or technique. The Indus carver tended to obliterate the evidences of technique in order to achieve a stylized but naturalistic effect, while the Mesopotamian artist seemed to delight in playing with tool marks. The Mohenjo-daro seals are midway between the organic figures and the hieratic figures of the "High Priest" type.

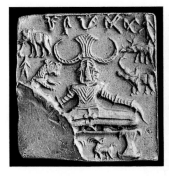
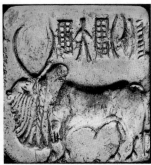
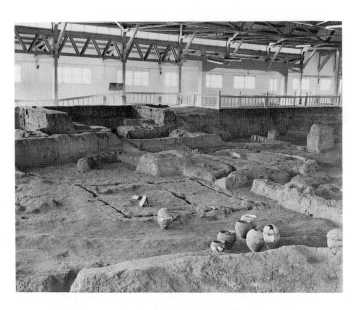

7. (above left) *Square stamp seal.* Design: Shiva(?), with inscription. White steatite; w. 1 3/8" (3.5 cm). Mohenjo-daro, now in Pakistan. Indus Valley civilization. National Museum, New Delhi

8. (above right) *Square stamp seal.* Design: Two-horned bull, with inscription. Steatite; w. 1 1/4" (3.2 cm). Pakistan. Indus Valley civilization. Cleveland Museum of Art

9. *Banpo, Shaanxi, China.* Part of excavated village, now preserved as Banpo Museum. Neolithic period, Yangshao culture, c. 4000 B.C.E.

Indus Valley seals also provide us with a means of correlation with the early cultures of Mesopotamia, and allow us to date the Indus Valley civilization with some certainty. Seals of the Indus type have been found in Mesopotamia in Akkadian sites at levels that allow us to date the Indus Valley civilization at least as early as 2500 to 1500 B.C.E. The Indus Valley culture does not appear to be as old as the Mesopotamian culture or the Egyptian "river culture," and may well have received stimuli from these, but it is still one of the four great river-cradles of civilization: the Nile, the Tigris-Euphrates, the Indus, and the Yellow River. To the last of these we now turn.

Neolithic and Pre-Shang China

Beginning in 1928, systematic excavation transformed the Shang dynasty from myth to historical reality, and continuing excavation has fleshed out our picture of the evolution of Shang life and bronze technology. In recent decades archaeology has also revealed a pre-Shang bronze-working tradition that may well correspond to the heretofore legendary Xia dynasty.

The earliest stages of bronze technology at least antedate 1600 B.C.E.—hard evidence for the pre-Shang Xia people referred to in Chinese records. Erlitou, between Luoyang and Zhengzhou in northern Henan Province, has yielded not only ceramics and worked jades but also simple, thin-walled bronze vessels which can be seen as Xia prototypes for the developed and complex Bronze Age artifacts of the Shang dynasty.

Archaeology has also afforded a broad and complex picture of Neolithic China. The uncovering of many thousands of sites throughout China has overturned ear-

lier assumptions that Chinese Neolithic culture was confined to a central "heartland," and has confirmed the wide range of Neolithic cultures as well as the extraordinary technological sophistication of these cultures. The schema of a Neolithic China divided geographically and/or chronologically between Painted Pottery and Black Pottery cultures is now recognized as an oversimplification. New finds have identified at least five extensive and geographically distinct pottery-producing regions, each of them home to diverse but related pottery cultures or sequences of cultures. These regions include the Henan-Shanxi-Shaanxi "heartland"; the northwest, principally Gansu Province; the east and northeast, including Liaoning; the eastern coastal plain as far south as northern Zhejiang Province; and the southern region, including southern Zhejiang, Fujian, Jiangxi, and Guangdong provinces, whose ceramics seem more closely related to those of Neolithic Southeast Asia. The cultures of these regions, in turn, diffused over time and space, influencing their successors and their near and distant neighbors. The same finds have also shown that jade working was a major hallmark of certain of the Chinese Neolithic cultures.

Painted Pottery Culture

Production of Neolithic Painted Pottery wares began and died out at different times in different parts of China. Probably it arose first in the Henan-Shanxi-Shaanxi heartland, especially the area encompassing Yangshao in Henan Province and Banpo in Shaanxi (*fig. 9*). The latter site, excavated beginning 1953, can be dated by carbon-14 tests to soon after 5000 B.C.E.

Banpo Village was situated on a protected bend of the Wei River in what is now an eastern suburb of Xi'an. Its inhabitants lived in pit-dwellings, at first conical, later

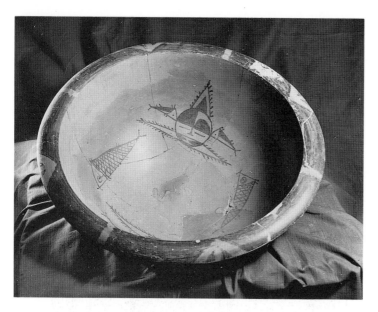

10. *Bowl.* Painted Pottery, red earthenware with black slip decoration; h. 7" (17.8 cm), diam. 15" (38.1 cm). Banpo, Shaanxi, China. Neolithic period, Yangshao culture, c. 4000 B.C.E. Banpo Museum

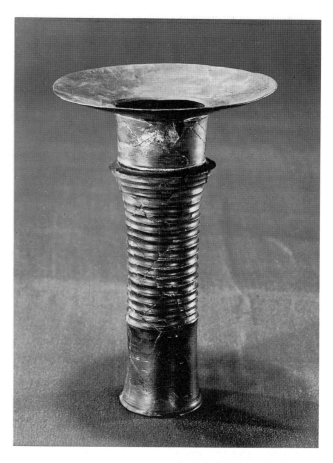

11. *Gu beaker.* Black Pottery. Thin biscuit; h. 6¼" (15.9 cm). Weifang, Shandong, China. Neolithic period, Longshan culture, c. 2000 B.C.E.

round, oblong, or square, with peaked reed roofs. They produced quantities of pots, many of them painted with black-on-red designs of geometric figures, human masks, fish, and occasionally animals (*fig. 10*). Often the naturalistic motifs are geometrically rendered, or combined with geometric motifs, or both. Numerous of the painted pots were funerary urns, and many of these bear representations of cowrie shells, which have been found in the sites of the Yangshao culture. In many parts of the world the cowrie has been used as money and worn as an amulet because of the magical properties attributed to it, especially those associated with birth and fertility.

This Painted Pottery culture expanded early eastward to Yangshao (4000–3000 B.C.E.). More slowly it extended to the west as far as Gansu and Qinghai provinces (from 3500 B.C.E.). Later Gansu Painted Pottery sites, such as Banshan, have yielded astonishing quantities of boldly potted full-blown jars (*cpl. 1, p. 113*), with vigorous geometricized decoration featuring spirals, cowrie shells, and checkerboard, eye, bird and animal, and water-wave patterns. The developed phases of these Painted Pottery cultures included a mixed hunting-herding-farming economy, the manufacturing of jade implements and ornaments, a numbering system, and possibly the beginnings of writing—all elements of great significance in the later development of Chinese civilization.

Black Pottery Culture

The Neolithic culture of eastern China, whose earliest remains date from about 4300 B.C.E., culminated in the Black Pottery, or Longshan, culture, which extended from Shandong west to Henan Province, and has been dated as early as 2700–2500 B.C.E. In Henan, Black

Pottery remains lie above, and hence are later than, artifacts of the Yangshao Painted Pottery culture. Named for its distinctive burnished black pottery (*fig. 11*), this eastern culture is also characterized by building platforms and rudimentary walls made of pounded earth.

Black Pottery shapes, particularly the beaker vessel (*gu*), are distinctive, and indicate a technique totally different from that used to make Yangshao pottery. The full-bodied painted pots and the coarse utilitarian gray wares of the Yangshao culture were coil built, then beaten with a paddle to shape and smooth them. For Longshan black wares the dark clay was shaped on a slow turntable, using wood or bamboo cutting tools, allowed to dry leather hard, then burnished and fired to an almost shiny black. Embellishment was restricted to ridges, openwork, and occasional bosses; there is no painting on Black Pottery, though Yangshao type Painted Pottery is also found at Longshan sites. The characteristic Black Pottery shapes are high-footed, thin-bodied, and elegant, and some of them, notably the *gu* beaker, were carried over into Shang bronzes. Some excavations in Shandong have also revealed luxury type vessels, such as the tripod with handle and spout (*gui*), made of well-levigated whitish earthenware. These may be forerunners of the white earthenware copies of bronze vessels (*see fig. 25*) made during late Shang.

Also linking Longshan Neolithic culture specifically

12. *Cong prism.* Jade; h. 2⁷/₈" (7.2 cm). Sidun, Wujin County, Jiangsu, China. Neolithic period, Liangzhu culture, c. 2000 B.C.E. Nanjing Museum

13. *Li tripod.* Earthenware; h. 6" (15.2 cm). Anyang, Henan, China. Late Chinese Neolithic type. Buffalo Society of Natural Sciences, Buffalo, New York

14. *Bird.* Jade; h. 4¹/₈" (10.5 cm). China. Neolithic period. Nelson-Atkins Museum of Art, Kansas City

with the Shang bronze culture of the Henan-Shaanxi heartland area are the use of pounded earth for walls and platforms and the practice of divination according to cracks produced by heat in animal bones or plastrons.

Eastern Coastal Plain Cultures

Before the spate of excavations in recent decades, the essential stimulus for the development of Chinese Bronze Age culture was thought to be the interaction of the early Yangshao and Longshan cultures. We now must modify this scenario. In the Liaoning area of Manchuria in the northeast, and extending through the Shandong peninsula into Jiangsu Province, a full Neolithic culture emerged by about 4000 B.C.E. Over the next millennium this culture developed divination by burned or heated bones and the working of jade into heavy "bracelets" with stylized animal decoration.

In the coastal area from about present-day Shanghai south into Guangdong Province recent finds have been even more amazing. In the Shanghai area highly complex jade working can be dated to just after 3000 B.C.E. From imported jade boulders large rectangular prisms with cylindrical inner surfaces (*cong*) were carved, then decorated with rectilinear patterns. These were further embellished with engraved interlace spirals and circles, often defining eye, nose, and mouth "masks" which were to become major elements in the Shang iconographic vocabulary (*fig. 12*). This remarkably dexterous and imaginative aesthetic vocabulary, created in one of the hardest of stones, requires an advanced incising and grinding technique and infinite patience. It is far ahead of any other known Neolithic sculptural accomplishment.

These are the outstanding achievements of Neolithic

China. We must also acknowledge a class of plainer ceramic wares found in quantity in all the regions of Neolithic China—gray earthenware in basic utilitarian shapes such as bowls, urns, and especially the *li* tripod (*fig. 13*). In appearance the *li* suggests three urns with pointed bottoms, leaning against one another. At the hands of an imaginative potter this became a tripod with hollow legs, a design whose utility lay in allowing the heat

Year B.C.E.	Central Plain, or Heartland	Northwest	Lower Yellow River Valley and Northeast (south to Jiangsu Province)	Manchuria (Liaoning); eastern Inner Mongolia	Southeast Coastal Plain (Hangzhou Bay area)
5000	Banpo, Shaanxi Province		Dawenkou, Shandong Province		Hemudu, Zhejiang Province Songze, Zhejiang Province
4000	Miaodigou	Majiayao, Gansu Province		Hongshan	
3000		Banshan, Gansu Province	Longshan, or Black Pottery Culture		Liangzhu, Zhejiang Province
2000		Machang, Qinghai Province			
1000					

(Yangshao spans the Central Plain column from c. 4000 to 3000 B.C.E.)

15. *Chronology of Chinese Neolithic Cultures*

of the fire the greatest possible access to the contents of the *li*. Solid-leg tripods (*ding*) were also made, but probably slightly later. Again, the persistence of the *li* and *ding* in Shang bronze shapes indicates the continuity of Chinese culture from Neolithic to Shang.

Small-scale sculptures in the round have been discovered throughout Neolithic China, some appearing on the market from isolated clandestine excavations but most (and more recently) turned up in controlled excavations. Materials include clay, stone, jade, turquoise, and bone. One of the most appealing of these sculptures is in Kansas City (*fig. 14*), a four-inch-long unpolished jade "lump" formed very simply, following the original shape of the jade pebble. With indications of wings and head, and a circular pit for the eye, a bird was created—very simple, very stylized, yet monumental in appearance. Other such small sculptures depict more imaginary or chimerical creatures.

Although archaeological evidence has precluded a neat chronological sequence for Neolithic China, it has also made possible a consensus on relative dates (within several centuries in either direction) of the pottery produced by China's Neolithic cultures (*fig. 15*).

All of these cultures and their subgroups contributed to the remarkable fusion of technology, iconography, and visual style that formed the art of the Shang dynasty. What catalyzed the epochal changes from Neolithic to Shang was most likely a kind of "multiplier effect." In the region of present-day Henan Province the invention of metallurgy and the emerging pictographic writing system converged with the whole assemblage of Neolithic capabilities: pounded earthworks, intricate jade working, high and humble ceramics in distinctive Chinese shapes, a growing vocabulary of symbols and ornament (including fearsome masks, fish, birds, and serpents), and a developed art of divination which prepared the imagination for mastery of these complex and potentially powerful elements invented and developed by Chinese Neolithic cultures.

KOREA

Until about 3500 B.C.E. the Neolithic in Korea seems to have produced little in the way of ceramics or the polished stone implements characteristic of Neolithic sites the world over. Thereafter and for many following centuries

16. *Jar.* Comb-pattern earthenware; h. 18¼" (46.5 cm), diam. 12⅞" (32.8 cm). Amsa-dong, Seoul, Korea. C. 3000 B.C.E. Kyunghee University Museum, Seoul

"comb-pattern" earthenware was produced, the most famous site being Amsa-dong in present-day Seoul (*fig. 16*). One cannot but note the close resemblance of this ware to Incipient Jomon and Early Jomon pottery in Japan, though the Jomon wares are largely cord-patterned and the Korean wares rely more on incising or combing, reserving cord patterns for linear accents around the vessel rims. Relationships have also been proposed to the Neolithic ceramics of Manchuria. Comb-patterned earthenware was followed by a sequence of plain earthenware, which lasted until the Bronze Age and the beginning of closer relationships with China and Japan.

JAPAN

Japanese Neolithic artifacts, particularly the pottery, are truly impressive. The Jomon (cord pattern) phase, named for the low-fired, hand-built earthenware vessels with decorative patterns made by rolling a cord over the soft clay, lasted from 10,500 to 300 B.C.E. For this extraordinary duration of the Neolithic period—so much longer than in neighboring Korea—no explanation is yet available.

The Jomon is generally divided into six periods:

Incipient Jomon	(c. 10,500–c. 8000 B.C.E.)
Initial Jomon	(c. 8000–c. 5000 B.C.E.)
Early Jomon	(c. 5000–c. 2500 B.C.E.)
Middle Jomon	(c. 2500–c. 1500 B.C.E.)
Late Jomon	(c. 1500–c. 1000 B.C.E.)
Final Jomon	(c. 1000 B.C.E.–c. 300 B.C.E.)

Incipient Jomon shows plain and rather heavy earthenware, but its successors, Initial and Early Jomon, featured earthenware decorated by means of cords wrapped around pads in various configurations, producing diverse and complex surface patterns. The mouths of the vessels began to be manipulated for decorative effect—scalloped or appliquéd with ropes of clay. The most inventive ceramics were produced in Middle Jomon, when fantastic effects were achieved with decoration in extremely high relief (*fig. 17*). Such pots appear to be growing before our eyes, their bizarre ornament expanding into space. Later Jomon works return to less exuberant, more tightly organized surfaces. Jomon figurines, made concurrently with the vessels, bear the same curious knotted and corded decoration. Some are female figurines, perhaps "mediums," whose depiction emphasizes fertility, and this corresponds with the implications

17. *Vessel.* Earthenware; h. approx. 12" (30.5 cm). Japan. Middle Jomon period. Tsunan-machi Board of Education, Niigata Prefecture

18. *Figurine.* Earthenware; h. 10" (25.4 cm). Japan. Jomon culture. Tokyo National Museum

19. *Footed jar.* Painted earthenware; h. 9¹/8" (23.2 cm). Ban Chieng, Thailand. C. 3rd millennium B.C.E. Cleveland Museum of Art

of the numerous phallic objects in stone and clay from the Middle Jomon period (*fig. 18*).

BAN CHIENG

Recent discoveries at Ban Chieng in Thailand have revealed an early Bronze Age culture that must have been prevalent in an area comprising at least present-day northern Thailand and Cambodia. Painted pottery with unusual designs unrelated to those of China or any nearby culture was executed, first in incised and red-painted gray wares and later in red or brown slip on buff earthenware covered with a cream slip (*fig. 19*). Numerous bronze implements, vessels, and sculptures have also been found, with geometric patterns based on whorls and parallel linear designs (*fig. 20*). These are dimly related to some slightly later bronzes found in south China. The luxury use of iron as a supplement to bronze ornament in the middle phase of Ban Chieng is a remarkable occurrence that awaits future study. Various dates, some of them influenced by wishful thinking, have been proposed for this Ban Chieng material, but the earliest Neolithic artifacts date to 3500 B.C.E., with a classic Bronze Age coeval with China's at 2000–1600 B.C.E. and with Neolithic painted survivals as late as 600 B.C.E. All of this is a startling development and one that is still in the process of exploration, evaluation, and future publication by archaeologists from Thailand and the University of Pennsylvania.

20. *Head of a Man.* Bronze; h. 3¹/2" (8.9 cm). Ban Chieng, Thailand. C. 1st millennium B.C.E. Cleveland Museum of Art

2

Chinese Art from the Shang through the Middle Zhou Period

Historical texts from the Zhou dynasty onward record in great detail the sequence of Shang and Zhou kings as well as a less certain record of an even earlier Xia dynasty. In the nineteenth century Western interest in China's history brought Western skepticism to bear on these records, which were dismissed as only legendary. In the late nineteenth and early twentieth centuries numerous chance finds were made in the "wastes of Yin," at Anyang in Henan, of marked and inscribed animal bones and tortoise plastrons (the lower shell). The inscriptions were in pictographs related to developed Chinese characters, and the markings were burns and cracks resembling those found on similar materials from the Longshan sites of east China. The finds from Henan were thought by some to be forgeries, by others to be "dragon bones" useful for medicinal purposes, and by a few to be meaningful if puzzling relics from China's distant past. At the same time bronze vessels were being clandestinely excavated from the same area, and these were collected and described as "Zhou" relics. In 1928 controlled excavations were begun by the Academia Sinica at Anyang in Henan, and bronzes, inscribed bones and plastrons, jades, stone sculptures, and ceramics were found in royal tombs and in settlement areas. The authenticity of the inscribed bones (oracle bones) was established and with them the historical existence of the Shang dynasty with its last capital—Yin—at Anyang. These excavations continued through 1937, and were resumed by the People's Republic of China beginning in 1950. Such magnificent works were found as those illustrated in figures 26 and 35. Other materials were excavated in clandestine diggings and appeared on the world art market.

Scholars grappled with the wealth of new material and, thanks to Bernhard Karlgren, who first demonstrated the distinctions between Shang and Zhou, and Max Loehr, who presented a chronological bronze sequence anticipating an early and middle Shang culture prior to that of Anyang, a Shang dynasty reaching back to the mid-second millennium was confirmed. But the weight and extent of evidence for these hypotheses has proved astonishing. Archaeologists of the People's Republic of China have accomplished a continuing series of excavations and many salvage finds throughout China. These have not only confirmed a sequence for Shang dynasty materials from before 1600 B.C.E., but have all but confirmed the historical existence of the preceding Xia dynasty (traditionally 2205–1766 B.C.E.), an emerging bronze culture of still uncertain dates. The extent of early Chinese civilization

has been enlarged not only chronologically but geographically, for Neolithic and Shang sites have now been encountered as far north as Baode (Shanxi), in eastern China, south of the Yangzi River (particularly in Hunan Province), and as far west as Sichuan Province (*see fig. 40*). This geographical extension of our knowledge of Shang culture and art has greatly increased the complexity of the archaeological picture and is additional confirmation of what must now be quite clear—that the development of decorated ceramics and of bronze technology was an indigenous Chinese process, accompanying the development of a distinctive language, already anticipated as early as Neolithic Banpo.

SHANG

The accepted sequence of Bronze Age cultures for pre-Shang and Shang is described in terms of the following type-sites:

Erlitou (central Henan): before 1600 B.C.E. and perhaps equivalent to the first Shang capital, Bo (Early Shang)

Erligang 1 and 2 (southeast corner of Zhengzhou, Henan): 1600–1300 B.C.E. and probably equivalent to the second Shang capital, Ao or Xiao (Middle Shang)

Anyang (northern Henan): after 1300–1045 B.C.E. and the last or seventh Shang capital, Yin (Late Shang)

If the Xia are still somewhat problematical, the Shang are not. Who were they? We must distinguish at the outset between the Shang kingdom and what is generally referred to as Shang culture. The Shang kingdom, or state, was a single political unit ruled from a sequence of capitals in present-day Henan Province and surrounded by client or rival states, some of whose names are mentioned on the oracle bones. The evidence is now overwhelming that they were native Chinese, people of the Central Plain culture and inheritors of the combined wealth of knowledge and inventions of three preponderant Neolithic cultures, Yangshao, Longshan, and Liangzhu. At their dominant location in the central plain they began the most highly developed bronze technology of the ancient world, and this technology was acquired by the surrounding states. With the bronze technology came other Shang techniques, practices, and styles, which the neighboring polities adopted in varying combinations and modified to suit local needs and preferences. Shang culture, then, extended far beyond the borders of the Shang kingdom, and encompassed many local variants. Moreover, Neolithic culture may well have endured, in various parts of China, well into what we conventionally call the Shang period.

Bronze making necessarily implies urban centers, with a highly organized population and considerable class distinctions between the work force and the elite who commanded and directed their labors. These implications have been confirmed by excavations that have revealed the pounded-earth foundations of city walls and palatial rectangular buildings and, somewhat apart from these, the foundations of much smaller structures whose debris suggests specialized workshops, workmen's dwellings, and storage pits. Enormous underground chamber tombs have also been uncovered, richly furnished with bronzes and other treasure. They are likewise furnished with hecatombs of human and animal sacrifices, and sacrificial victims were found as well in the foundations of the city walls and palatial structures. Obviously only a ruling elite could enforce such sacrifices or organize the sizable labor force required to make the buildings and the bronzes.

Bronze was used primarily for weapons, for chariot fittings and horse trappings, and above all for the ritual vessels, containers for wine, water, and food, with which the king and nobles performed sacrifices to ancestors and other spirits on whom the well-being of the realm depended. Possession of bronze, therefore, conferred spiritual as well as physical ascendancy. Those who commanded the bronze supply ruled, and those who ruled commanded the bronze supply.

The Shang kingdom and some of the related polities practiced divination, like the Longshan people, by applying a heated tool to tortoise plastrons. The shapes of Shang bronzes and ceramics are also heavily indebted to Neolithic cultures. Elements of their writing and iconography are related to the Yangshao culture, as is the continued use of the *li* tripod. But the emergence and dominance of the Shang dynasty is marked by powerful innovations: the invention and development of a written language, the creation of a complex bronze technology with an accompanying refinement of ceramic processes (*see figs. 33, 34*), and the organization of a warlike civilization relying on horse-drawn chariots to control the living and large chamber burials (*see fig. 22*) with accompanying human sacrifice to propitiate the dead.

Although we know increasingly more about the material culture of the Shang, we know far too little about their religion and the extraordinary vocabulary of animal designs dominating their artifacts of jade, stone, wood, and bronze. There is little doubt that these ornaments have meaning and symbolic value, but the nature of this fabulous bestiary is still unknown, despite contorted efforts to explain it by reference to the moon or a phallic deep structure. We do know the questions asked on the oracle bones, for the script is clearly an early but still well-developed form of classical Chinese. These questions indicate a belief in an overlord we can equate with a supreme deity, as well as in various spirits. There was probably a shamanistic cult, with an important and active

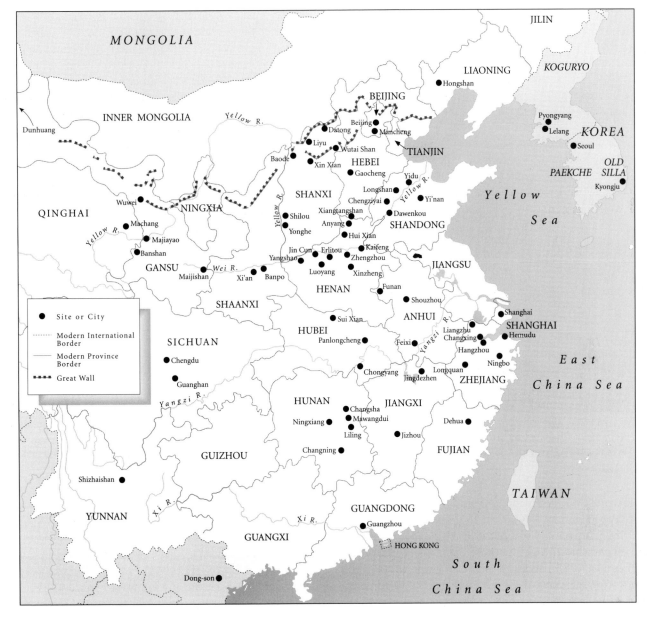

21. *China and Korea, showing Neolithic and Bronze Age sites*

priestly class that included the rulers. The oracle bone questions are primarily concerned with the hunt, war, and agriculture: Will the chase tomorrow be successful? Will the forthcoming battle be won? Will this season's crops flourish? We cannot yet know the meanings of what is obviously a complicated symbolism, but we can reasonably assume a highly developed animism combined with a concept of a supreme deity, a belief in magic, and a belief in control by propitiation through the sacrifice of animals and humans. The interpretation of the king's dreams, including visions of ghosts and spirits, plays a part in the oracle bone texts. Let us consider Shang funerary architecture, sculpture, ceramics, and jade, with examples largely from their final and most

developed phase, the art of Anyang. A map (*fig. 21*) shows the principal sites: Zhengzhou, probably the second capital; Anyang, the last; and the more recently discovered and outlying sites as far as Ningxiang in Hunan and Sanxingdui in Sichuan.

Anyang, from about 1300 B.C.E., was the center of Shang ritual culture. Humble burials have been found there as well as royal, but the number, size, and magnificence of the royal burials, compared even with the earlier burials at Zhengzhou, seem to give a special significance to the tombs of Yin. Figure 22, an aerial view of the tomb of Fu Hao, consort of Wu Ding, the twelfth ruler of Shang, conveys some sense of the enormous size of the Anyang tombs—and Fu Hao's, over thirteen by eighteen

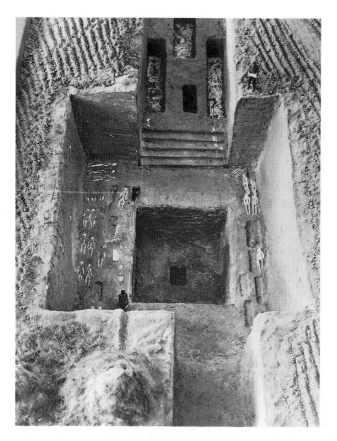

22. *Royal tomb.* Wuguan Cun, Anyang, Henan, China. Shang dynasty, Anyang period, c. 1200 B.C.E. or slightly earlier

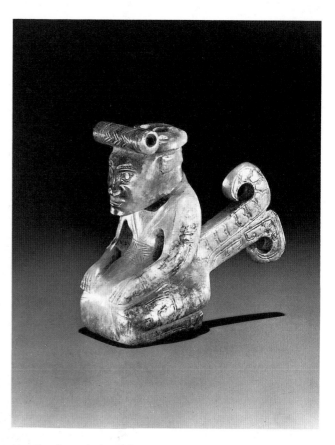

23. *Figurine.* Jade; h. 2³/4" (7 cm). Tomb of Fu Hao, Anyang, Henan, China. Shang dynasty, Anyang period, c. 1200 B.C.E. or slightly earlier. Institute of Archaeology, Beijing

feet, was by no means the largest. Some were over sixty feet deep. The floor level of Fu Hao's shaft-grave housed the royal corpse and most of the utensils and implements buried with her. Below the corpse was a small pit holding the remains of six sacrificed dogs, and along the perimeters lay the skeletons of sixteen humans. The tomb of Fu Hao is the only undisturbed royal Shang tomb yet excavated, and its wealth is a sure indication of what other discovered tombs once contained: over 440 bronzes, including 200 vessels; nearly 600 jade, stone, and bone carvings (*fig. 23*); and some 7,000 cowrie shells, which, as in so many areas of East Asia and the Pacific, were the coin of the realm.

The riches of this tomb bespeak the extent to which other tombs were looted from Song dynasty times until today. Grave robbers used long copper or bronze probes to locate the salable metal objects they sought and then dug them out, in the process damaging or destroying their archaeological contexts.

We know, mostly from the evidence of imprints in the soil, that decorated wood architectural members were in use, but we have little else to tell us of Shang architecture. Tentative reconstructions of post-and-lintel structures, with gabled, thatched roofs, standing on raised foundation platforms of pounded earth, suggest a simple

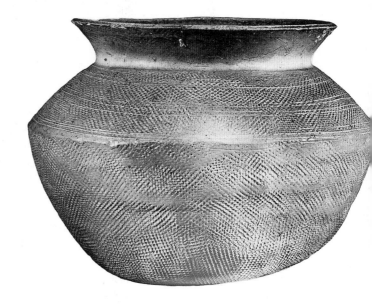

24. *Guan jar.* Proto-stoneware; h. 6¹/8" (15.6 cm), diam. 8³/8" (21.3 cm). Probably Zhengzhou, Henan, China. Shang dynasty, 16th–15th century B.C.E. Nelson-Atkins Museum of Art, Kansas City

bay system of architecture anticipating later developments in China, Korea, and Japan.

Coarse gray pottery for everyday use was found in the more ordinary living areas. But the extraordinary discovery of high-fired and glazed stoneware at Zhengzhou (*fig. 24*) pushes the horizon of Chinese porcelain development back over one thousand years, from 400 B.C.E. to before 1400 B.C.E. Nearly complete pots and shards have been found in unchallengeable archaeological contexts. The resemblance of these pieces to the much later developments in celadon is remarkable. Probably advances in ceramic technology indicate the discovery of suitable clays, and were stimulated by the use of ceramic models and piece-molds in bronze casting. The iron glaze appears to be ash-induced and intentional. Still a third type of ceramic is known from Anyang, a white earthenware of fine white and chalky clay (*fig. 25*), fired at low temperatures and covered with impressed and carved designs imitating those on developed Shang bronzes. The usual patterns are a fret interlock or squared spirals, with applied bands or handles embodying animal masks or designs. Bovine masks in high relief were applied to the surface of the jar in the Freer Gallery. Though numerous shards and incomplete pieces of the white ware have been found, intact examples are extremely rare.

Another innovation of the Shang dynasty is stone sculpture in the round or in high relief, usually of white marble, with decoration derived from the dominant bronzes (*fig. 26*). To judge from the mortises on the back of the owl pictured here and its companion tiger, these sculptures were used architecturally, as supports either for columns or for platforms of wood. The designs are carefully but strongly cut and show the same rigorous development of the enigmatic symbolic language of snake, mask, cloud-pattern, and dragon. The combination of elegant and refined detail with powerful silhouettes contributes to the awesome effect of these beasts with gaping mouths or fierce beaks.

These large sculptures are far less numerous, however, than the small-scale representations of the Shang vocabulary of images in jade amulets and/or ornaments. Regardless of our interpretations of their meaning, these representations are our clearest clues to recognition of the individual elements of the language of Shang ornament. Here one can see the conformation of single units: fish, swallow, owl, man, tiger, elephant. And we can also see their elementary combinations and metamorphoses, less complex and subtle here than in the bronzes.

The use of jade was by now traditional; we have seen its importance in Neolithic contexts. So it should come as no great surprise that the superb Neolithic jade-carving technology found in the Liangzhu and Hongshan cultures is also manifested in a few Shang jades, hitherto incorrectly dated, notably the scepter(?) or finial(?) long in the Gelattly collection of the Smithsonian Institution

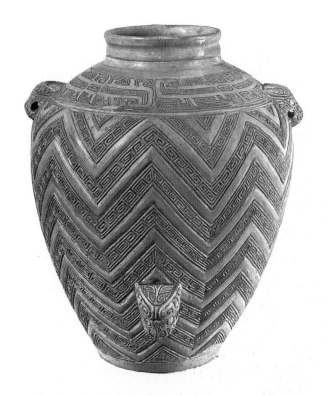

25. *Vessel.* White earthenware with impressed decoration; h. 13" (33 cm). China. Shang dynasty. Freer Gallery of Art, Smithsonian Institution, Washington, D.C.

26. *Owl.* Marble; h. 17³/4" (45.1 cm). Tomb 1001, Houjiazhuang cemetery site, Anyang, Henan, China. Shang dynasty. Academia Sinica, Taibei

27. *Two fragments of a finial(?) or scepter(?) with masks.*
Jade; (left) h. 3" (7.6 cm); (right) h. 3¹/8" (7.9 cm). China.
Early–middle Shang dynasty. Gelattly Collection,
Smithsonian Institution, Washington, D.C.

(*fig. 27*). Relief modeling in the humanoid mask with its tall curving headdress was combined with thread relief on the lower mask of the assemblage to create powerfully accomplished images of terrifying and awesome magic. Magic was inherent in the mask iconography that Shang culture inherited from the Neolithic artists and developed into an expression of propitiation to the supreme deities of the new Shang pantheon.

Late Shang jade workers expanded on the technique and repertory of their predecessors. The usual simplicity of Neolithic shapes persisted in long jade blades, necessar-

28. *Blade.* White jade; l. 17⁵/8" (44.8 cm). China. Shang dynasty. Metropolitan Museum of Art, New York

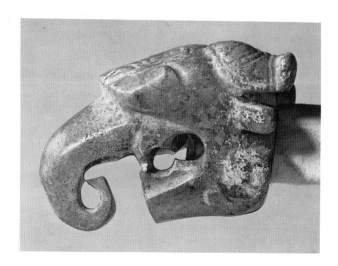

29. *Tiger-Elephant.* Jade; l. 1⁵/8" (4.1 cm). China. Shang dynasty.
Cleveland Museum of Art

ily sawed from a reasonably large boulder and then ground to their final shape, often with the addition of intaglio or, more rarely, thread-relief decoration of the most subtle type (*fig. 28*). Such a blade would have served no useful purpose, since jade is brittle and cannot withstand any sharp and severe impact. Rather we should see such an elegant jade as a ritual replica of usable bronze weapons.

The greatest number of these late Shang jades are representations of animals and, more rarely, humans, often in the round. The large number of jades from the tomb of Fu Hao includes representations of a proto-*feng-huang* (mythical bird), dragons, and birds, separately and combined, and elephants, hawks, and human figures, one of them with a birdlike tail (*see fig. 23*). Metamorphic intention can also be clearly seen in a composite head of a feline with large, sharp teeth, elephant's trunk, and bovine horns. The three elements are smoothly unified within

less than two inches of jade (*fig. 29*). It may seem surprising to find an elephant's trunk represented in north China, but a skeleton of the beast was found at Anyang, and even more exotic forms—whale and rhinoceros, for example—indicate the presence of a royal menagerie or park as a fitting adjunct to the Shang royal court. Though elephants may have ranged as far north as Henan at this time, the bronze figure of an Indian rhinoceros at the Asian Art Museum in San Francisco supports the probability of the existence of a royal zoo.

SHANG BRONZES

Although the development of art in the Shang dynasty must have involved all mediums, bronze was the major vehicle of cultural expression, and this fact, together with the deterioration and disappearance of the more ephemeral wood, ivory, textile, and lacquer, means that sequential order in Shang history is overwhelmingly documented by bronzes. Claims that pierced copper pendants or axes have been found at Longshan Neolithic sites remain to be fully proved, but there is little question that an indigenous bronze technology producing both weapons and utensils is datable at least to early Shang (c. 1600 B.C.E.) and very likely to Xia (c. 2000 B.C.E.). A few bronze vessels, including examples of the relatively complex *jue* type (related to the three-legged vessels shown fourth from the left in figure 32), have been found at Erlitou in the first documented phase of Shang culture. These thin-walled vessels are the immediate prototypes for the even more impressive vessels from the earliest phase (Erligang 1) at Ao (Zhengzhou), including the *li he* from the Asian Art Museum of San Francisco (*fig. 30*). The characteristics of these earliest vessels include thin walls, possibly derived from still earlier but as yet unknown sheet-copper types; thread-relief ornament, as one might expect from a design first incised on molds in imitation of incised ceramic techniques; close relationships to Black Pottery Longshan prototypes, expressed in the large, tapering, hollow legs. The ornament is abstract, like that on Neolithic ceramics, but with clear hints of an underlying mask or dragon design.

Weapons such as the ax and dagger also reveal part of the development of bronze technology and animal representation. The earliest knives are relatively simple, though some of the more elaborate examples from late Shang, related to Siberian knives of the Andronovo (1750–1300 B.C.E.) and Karasuk (1300–700 B.C.E. or later) periods, have handles ending in horse, deer, or ibex heads. But the axes of middle and late Shang (*fig. 31*) are purely Chinese—fearsome and terrible weapons accompanying the ritual sacrifices revealed in the royal tombs (*see fig. 22*). The decoration of the ax in figure 31 combines two elements usually seen singly, the *tao-tie,* which in modern

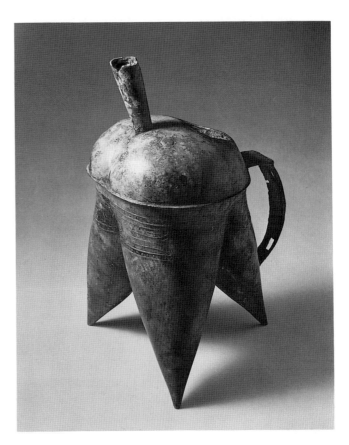

30. *Li he.* Ceremonial wine vessel; bronze; h. 9" (22.9 cm). China. Shang dynasty, 16th–14th century B.C.E. Asian Art Museum, San Francisco

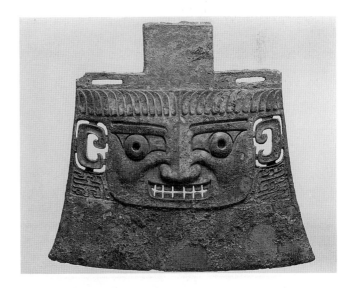

31. *Yue ax.* Bronze; h. 11⁷/₈" (30.4 cm), w. (at edge) 13³/₄" (35 cm). China. Late Shang dynasty. Museum für Ostasiatische Kunst, Berlin

Chinese means "ogre mask" or "glutton mask," and the *kui* dragon, a single-legged creature with horns, fangs, teeth, and usually a gaping mouth. The term *tao-tie* was applied to the Bronze Age motif by Chinese connoisseurs

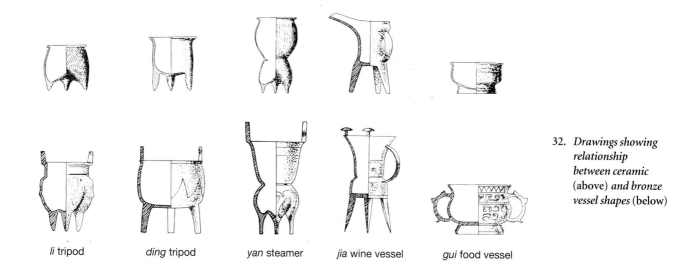

li tripod *ding* tripod *yan* steamer *jia* wine vessel *gui* food vessel

32. *Drawings showing relationship between ceramic* (above) *and bronze vessel shapes* (below)

and scholars of a much later time, and the misnomer has stuck, though the mask may represent many different animals—bull, tiger, or deer, among others, or a composite of some or all of these. From the ax in figure 31 a humanoid face, eyes bulging and teeth bared and clenched, glares straight out at the viewer. From the evidence of hundreds of decapitated human figures buried at Anyang

we may conclude that axes of this size and type were used for human sacrifice.

Before we look at individual bronze vessels, let us examine a drawing indicating the probable derivation of some of their shapes (*fig. 32*). The drawing includes only five of the large number of known shapes and variations. But these are the significant and common types most

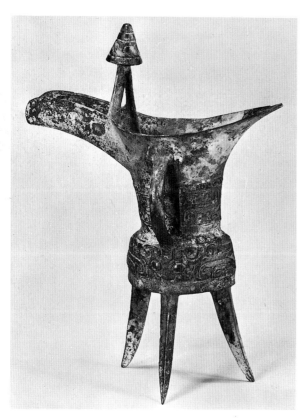

33. *Jue.* Ceremonial wine vessel; bronze; h. 9 1/8" (23.2 cm). Reportedly from Liulige, Henan, China. Early Shang dynasty. Seattle Art Museum

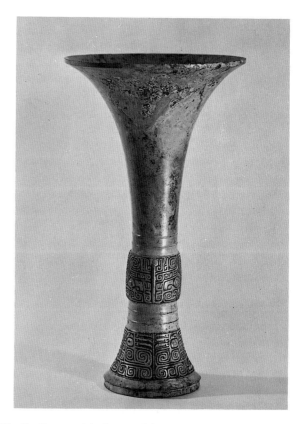

34. *Gu.* Ceremonial wine vessel; bronze; h. 10 1/2" (26.7 cm). China. Middle Shang dynasty. Cleveland Museum of Art

closely related to the ceramic shapes of early Neolithic China. At the top right is a ceramic type found in the Central Plain culture; below is a bronze *gui* vessel of the Shang dynasty. At top left is the hollow-legged *li* tripod, with the solid-legged *ding* tripod immediately to its right. Below them are their bronze analogues. The *yan* steamer and the handled *jia* display the same continuity, as do other vessels, but many unprecedented shapes appear in middle and late Shang, indicating the inventiveness of the bronze caster under the stimulus of an increasing demand for luxury products.

The stylistic development of bronze vessels, from Erlitou through Erligang (Zhengzhou) 1 and 2 and early to late Anyang, largely corresponds to Max Loehr's perspicacious division of Shang art into five phases. The first (*see fig. 30*) consists of simply shaped, thin-walled vessels decorated with narrow bands of thin relief lines, with the decoration carved into the ceramic piece-molds that shaped the vessels. The second comprises thicker-walled vessels made in more complicated piece-molds, their narrow bands of decoration now composed of wider, ribbon-like intaglio lines forming embryo *tao-tie* and *kui* dragons (*fig. 33*). The third shows a more complex and "dense" adaptation of style II (*fig. 34*). The fourth (*cpl. 2, p.114*),

first appearing at Anyang, displays great technical and stylistic innovation: The piece-molds that form the thick-walled, tautly shaped vessels are themselves shaped around model cores having both incised and applied low relief, and the major, animal, motifs are clearly differentiated from a closely packed and delicate squared-spiral ground, the so-called *lei wen,* or thunder pattern. The vessels of the fifth (*figs. 35–38*) and final phase, at Anyang and elsewhere in the now extensive Shang realm, exhibit markedly high relief, the ornament projecting into space, and are made from extremely complex piece-molds formed on models.

In all of this we must emphasize the exclusive use of the piece-mold technique, uniquely Chinese in the Bronze Age and developed to a point of virtuosity unknown in any other culture. Bronze casting in Central Asia, the Near East, and the Mediterranean employed the lost-wax process, a technique whereby molten bronze replaces a wax model inside a solid clay casing. The Chinese method was both more complex technically and more demanding of visual imagination, comparable to jade carving in its difficulty and in the skill and patience it required. Lost-wax methods were not used in China until their importation from the West at the beginning of the

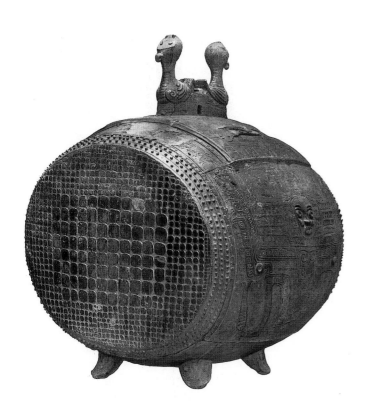

35. *Drum.* Bronze; h. 31³/₈" (79.7 cm). China. Shang dynasty, Anyang period. Sen'oku Hakkokan (Sumitomo Collection), Kyoto

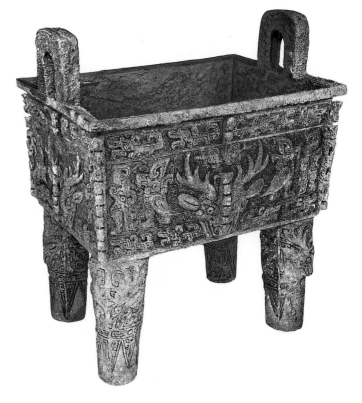

36. *Fang ding.* Ceremonial food vessel; bronze; h. 24¹/₂" (62.2 cm). Tomb 1004, Houjiazhuang, Anyang, Henan, China. Shang dynasty, Anyang period. Academia Sinica, Taibei

late Zhou period, at first probably in the manufacture of objects in precious metals.

The piece-mold technique required first the making of an exact clay model of the bronze vessel-to-be. When it had hardened, units of soft clay were pressed against it, taking on the negative impress of both its shape and its carved decoration. These could be "touched up" by carving or by the application of additional relief, or both, then fired to become the units of the mold. The surface of the model was then shaved down to become the core of the mold; the walls of the bronze vessel would exactly equal in thickness this layer that had been shaved from the model. The core was locked into place by spacers within the assembled piece-mold, which was held together by mortises and tenons. The use of fine rather than coarse clay made sharp detail possible and also reduced the likelihood of casting flaws produced by bubbling. One can imagine the complexity of the assembled mold used to cast such a complicated and large piece as that shown in figure 39.

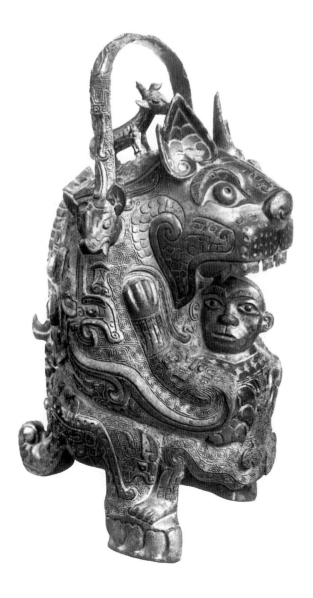

Where do the elements of developed Shang bronze shapes and decoration come from? The most persuasive theory is that of Li Chi, who conducted the early excavations at Anyang. Li believes that the bronzes derive, at least in part, from lacquer-painted wooden prototypes, whose fragmentary remains show designs precisely like those on the bronzes and suggest certain bronze shapes, notably the *fang ding* (square *ding*; *fig. 36*), the square *yi*, and the famous bronze drum in the Sen'oku Hakkokan (*fig. 35*), once unique but now matched by a slightly earlier example found in 1977 at the southern site of Chongyang in Hubei Province. The Sen'oku drum was cast as one unit, save for the removable lid. Its central decorative motif is a human being with a winged headdress; below that is a mask with two eyes in profile view. On the lid are two birds and an ogre mask. The meaning of the symbols is not known to us. The ends of the bronze are cast to simulate crocodile hide, suggesting derivation from an earlier wooden drum with crocodile-skin drumheads.

The *fang ding*, in Li Chi's hypothesis, is convincing evidence of the derivation of bronze vessels from wooden ones. It is a four-square vessel, as if made of boards of wood, with painted decoration, peglike legs, and loop handles on the sides (*fig. 36*). The decoration is easy to read and unusual. On each side of the vessel the main mask is a deer head, framed above and below with a band of little dragon-like monsters. On the long sides of the vessel the masks are flanked by two hook-beaked birds, perhaps owls, on either side. This tremendous specimen, over two feet square, was excavated at Anyang.

The Sen'oku Hakkokan provides us with another extraordinary bronze, for which there is no prototype among Neolithic shapes—a very complicated vessel in the form of a bear or a tiger squatting on its haunches, with its tail used as a third support, and surmounted by a deer on its head (*fig. 37*). The bail-like handle is composed of serpents and capped where it joins the vessel with the head of a boarlike animal. The *kui* dragon is a prominent part of the animal's side decoration. On its legs are snake forms and on its flanks even clearer indications of the snake in a diamond-backed form. Clutched in the forelegs and maw of the beast is the figure of a man with his head turned sideways. Whether this is a representation of the perils of the hunt or whether it is a representation, as Hentze and Waterbury believe, of the eclipsing sun as devourer, depends largely on one's disposition to believe in the universality of these myths. But there is no precedent for a vessel such as this. It is a Shang invention and embodies the principal elements that make up the Shang bronze style—the combination of many animals in one form, the metamorphosis of one animal into another, the

37. *You in form of bear(?) swallowing man.* Ceremonial wine vessel; bronze; h. 12 7/8" (32.7 cm). China. Shang dynasty. Sen'oku Hakkokan (Sumitomo Collection), Kyoto

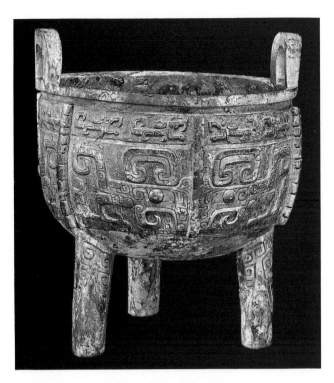

38. *Ding.* Ceremonial food vessel; bronze; h. 9¹/₂" (24.1 cm). China. Shang dynasty. Seattle Art Museum

desire to cover the whole vessel with a complex design, and the tendency toward powerful, sculptural forms that in later Shang bronzes tend to project into space.

We have illustrated many vessels to show a variety of shapes and a wide range of decoration. The three-legged *ding* (*fig. 38*) is a classic Shang form. Its design, a mask surmounted by a band containing four of the ubiquitous dragon-like monsters, is repeated three times. Each mask is centered, not about the legs of the vessel, but about an intermediary flange, with the four dragons confronted, two by two, on either side of the flange. The whole design is actually a symmetrical pattern exactly duplicated on each side of the flange. On the vessel's tubular legs is the cicada, a design found many times in jade.

A word about patina may be in order at this point. The beautiful greens and blues of the Chinese bronzes are completely accidental, the product of many centuries' burial in the earth and not the intention of the artist. The colors result from various oxides produced by the action of salts in the earth. Many bronzes, coming out of the ground, look like nothing so much as large, encrusted oysters. In the old days they were laboriously cleaned by the "excavator" or the dealer. Peaches were applied to the outside, and their mild acid weakened the incrustations,

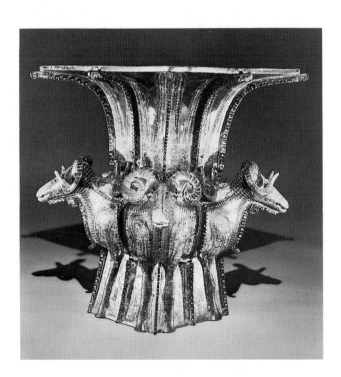

39. *Four-ram fang zun.* Ceremonial wine vessel; bronze; h. 23" (58.4 cm). Ningxiang Xian, Hunan, China. Late Shang dynasty. Historical Museum, Beijing

40. (right) *Fang jia.* Ceremonial wine vessel; bronze; h. 16¹/₈" (41 cm). China. Shang dynasty. Freer Gallery of Art, Smithsonian Institution, Washington, D.C.

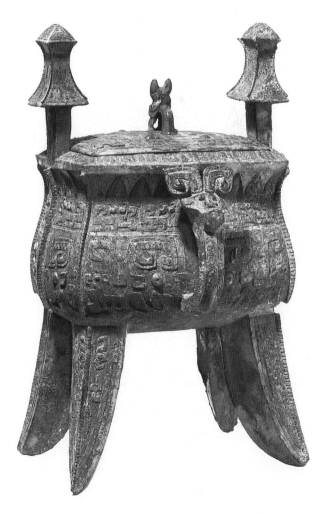

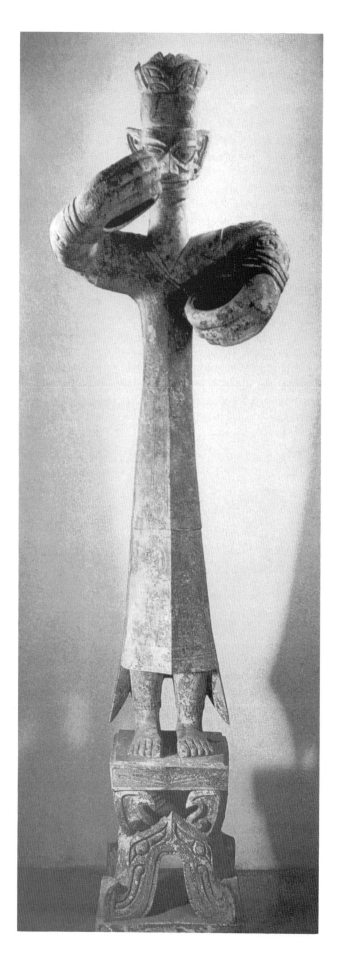

which then fell off when tapped with a hammer. The process was repeated until the design began to appear. Originally, of course, the vessels were a lustrous coppery bronze or silver color, some with inlays of a black pigment-like substance.

A *guang* in the Freer Gallery embodies Shang concepts of metamorphosis (*cpl. 2, p. 114*). A tiger-shaped cover changes at the back into the mask of an owl with eyes, ear tufts, and beak. Modern symbol seekers would prefer the bird to be a pheasant, symbol of the sun, but it has been ornithologically identified as an owl. The back of the vessel resembles a spoon-billed bird. The artist has combined three presumably incompatible elements—an owl, some other kind of bird, and a tiger—into one functional design. The neck of the second bird provides the handle by which one tilts the vessel and pours when the cover is removed. The ground of the vessel is elaborately developed with a pattern of squared spirals, sometimes called the thunder pattern. This provides a texture against which the low relief and the large design elements stand out. The casting is extraordinary for the precision and care required to achieve the small thunder-pattern motifs in intaglio. The walls of the spirals are quite perpendicular; the bottoms of the tiny channels are perfect grooves. The metal fills in the forms completely; very little plugging was done.

A tripod vessel, the *jue*, was apparently used, according to Yetts, for heating liquids to extremely high temperatures; its three legs were probably set directly in the fire so that the heat could reach the bowl. When the contents were sufficiently hot, it was lifted by the two posts at the top and tilted by the projecing point so the liquid would run out the spout opposite. A larger vessel, three- or four-legged, lacking the spout and projecting point of the *jue*, is the *jia*. The four-legged example (*fang jia*) shown in figure 40, also in the Freer Gallery, is perhaps the most magnificent one known. Its decoration keeps closely to the surface, so that the profile appears to be self-contained, and the casting is refined and perfect. The lid is surmounted by a bird, perhaps an owl.

A frequent shape among the Shang bronzes is the tall, trumpet-like *gu*, related to earlier pottery shapes of Neolithic times. Still another, called the *yi*, is used by Li Chi to demonstrate his theory of bronze derivation from wood; the shape of the *yi* being derived from that of a simple wooden house.

Recent excavations in the southwest, at Sanxingdui, north of Chengdu in Sichuan Province, have revealed a new category of Shang bronze art—life-sized standing figures of totemic or shamanistic type (*fig. 41*). The cast designs on their costumes include masks and animals

41. *Figure.* Bronze; h. of base 31 1/2" (80 cm), h. of fig. 71 5/8" (182 cm). Pit 2, Sanxingdui, Guanghan County, Sichuan, China. Shang dynasty, 13th–12th century B.C.E.

clearly related to the designs on jades and bronzes from the Shang capitals at Ao and Yin. The implication is obvious that, at least in this area, Shang technology extended to figural textiles, probably painted or embroidered. It is noteworthy that the area of Chengdu has been famed for its textiles throughout the history of dynastic China.

Like two other Shang centers, Funan in Anhui and Anyang (the last Shang capital) in Henan, the Sichuan site revealed underground chamber tombs and walls of a nearby substantial city, both built of pounded earth. It also revealed bronze vessels of the *zun* type, virtually indistinguishable from those found in Anhui and Henan. Missing, however, are human sacrifices and oracle bones with inscriptions in archaic Chinese, such as were found at Anyang. The fearsome faces of the huge bronze figures are unlike anything discovered to date in the north and east, and some jades from Sichuan are also unmatched elsewhere, as are the objects tentatively labeled "spirit-trees," which have been excavated but not yet assembled.

The kingdom of Shu in southwest China emerged into history only during late Western Zhou, but Anyang oracle bone inscriptions mention a rival polity called Shu, of which the city at Sanxingdui may have been an early capital. The site, in any case, is a further indication of the extent and variety of ancient Shang culture from 1500 B.C.E. until the fall of Anyang about 1045.

EARLY ZHOU

In a pattern familiar from other times and places, the ruling house of Shang was overthrown by provincial lords. The victors, who called themselves the Zhou people, had figured for some time in the Shang oracle-bone inscriptions, sometimes as allies or tributaries, sometimes as enemies. Prior to the conquest they had occupied the Wei River valley in Shaanxi Province, and even after the annexation of Shang they maintained their principal capital near present-day Xi'an, first at a place called Feng, then at Hao (or Haojing). A decade or so after the conquest a secondary capital was founded to the east, near present-day Luoyang in Henan. "Western Zhou" is a retroactive title, denoting the period when the principal capital was in Shaanxi.

Primitive communications precluded centralized administration of the newly enlarged Zhou domain. Instead, the conquerors retained control of their Wei River homeland and portioned out the rest, feudal style, among relations, allies, and already entrenched local chiefs, creating a considerable number of local courts. The bronzes, jades, ceramics, and other luxuries which these centers imported or produced reflect varying kinds of stylistic influence.

Extraordinary finds of richly inscribed bronze vessels provide strikingly exact information about the time of the Zhou conquest at Yin. A *gui* inscription begins, "Wu Wang vanquished Shang, it was in the morning, on the day *jia zi. . . .*"[1] David Nivison has correlated this time with the morning of 15 January 1045 B.C.E. It is significant that such an important bronze vessel was treasured for more than two centuries before it was buried, within other and later Western Zhou vessels, at Lintong in Shaanxi Province, not far from the western capital of Zhou.

Bronze casting employing Shang techniques and styles was known to the Zhou people well before the conquest. Vessels made in Shaanxi immediately prior to the conquest show declining technique and eccentricity of form, suggesting the waning of Shang influence. But the large number of early Western Zhou bronzes unearthed around the western and eastern capitals implies that Shang bronze workers were taken swiftly into Zhou employ and began producing for their new masters.

The Zhou rulers formulated, or were later credited with having formulated, the principles of societal relationships, both domestic and political, that endured for thousands of years as the foundations of traditional Chinese culture. These formulations are recorded in the great classics: the *Yi Jing* [Canon of Changes], the *Shi Jing* [Book of Odes], the *Shu Jing* [Book of History], the *Li Ji* [Book of Ritual], and the *Chun Qiu* [Spring and Autumn Annals]. The period also saw a gradual change in religious attitudes. Animistic elements declined, and first mention was clearly made of the concepts of heaven and earth. The already existing ancestor cult moved toward maturity. In general Zhou China was experiencing a process common in the development of early cultures: a change from a mixed agricultural-hunting society to an organized urban and feudal agricultural state, with the accompanying gradual change from animism to more abstract forms and concepts of religion.

With all these innovations, the Zhou did not obliterate the Shang or their culture. Rather, they absorbed much of Shang culture, adapting it to their own purposes, as evidenced by the continuity of bronze technique and the survival of many Shang bronze shapes and decorative techniques. With varying fortunes, the empire of feudal states they established endured almost a thousand years (c. 1045–256 B.C.E.). Artistically this time span divides into three major phases: early Zhou (c. 1045–c. 900 B.C.E.), middle Zhou (c. 900–c. 600 B.C.E.), and late Zhou (c. 600–221 B.C.E.), the last phase mostly encompassing the periods the Chinese call Spring and Autumn Annals (722–481 B.C.E.) and Warring States (481–221 B.C.E.).

Loehr shows in his stylistic sequence that Shang bronze style appears to develop from a rather tightly controlled decoration, kept within the contour of the vessel, toward a more baroque surface, bristling with decoration that appears to project into space. The shift from the Shang to the early Zhou style is to be seen in several ves-

42. *Fang ding.* Ceremonial food vessel; bronze; inscribed with name of King Cheng; h. 11" (27.9 cm). China. Early Zhou period. Nelson-Atkins Museum of Art, Kansas City

44. *Fish.* Jade; w. 3¹/₂" (8.9 cm). China. Early Zhou period. Cleveland Museum of Art

45. *Gui.* Ceremonial food vessel; bronze, l. 12¹/₂" (31.8 cm). China. Middle Zhou period. Minneapolis Institute of Art. Pillsbury Collection

43. *You.* Ceremonial wine vessel; bronze, h. 9" (22.9 cm). China. Early Zhou period. Freer Gallery of Art, Smithsonian Institution, Washington, D.C.

sels securely dated by their inscriptions. Most early Shang bronzes have no inscription, or at most a single character, such as a clan name. Later in the Shang dynasty two-, three-, and four-character inscriptions appear; by the time of the transition to Zhou there are long inscriptions, some of more than four hundred characters. A four-legged *ding* (*fang ding*) in the Nelson-Atkins Museum (*fig. 42*) bears an inscription of three characters, allowing us to date it to the very beginning of the Zhou dynasty in the reign of King Cheng, which began seven years after the fall of

46. *Pair of tigers.* Bronze; l. 29⁵/₈″ (75.3 cm). China. Middle Zhou period. Freer Gallery of Art, Smithsonian Institution, Washington, D.C.

47. (below) *Tiger.* Side view of one of pair, detail of fig. 46

Shang. It shows many elements of transitional style: The form of the vessel has now expanded into space, with flanges, mask, legs, and horns projecting in high relief. Even the handles, so tightly contained in the Shang *ding* (*figs. 36, 38*), are now crowned with horned animals, cast so that they project far beyond the outlines of the vessel.

Among the bronzes, early Zhou style is in general a continuation of the Shang, with omission of some shapes and variation in others. The *jia* and *gu* simply disappear; *yi* and *jue* gradually dwindle away. With middle Zhou comes a radical change in style and an apparent decline in technique. In the late Zhou period begins a renaissance of the decorative innovation and technical finesse, the flamboyance and intricate detail characteristic of Shang bronzes.

Let us first look at a typical early Zhou vessel. The *you* shape (*fig. 43*) existed in the late Shang period. It is a covered pail, and was evidently much in demand. The decoration of the main body of this vessel is particularly interesting, especially the two birds with flamboyantly upswept tails. This motif of the bird with upswept tail appears to be an early Zhou invention. In this vessel it replaces the more characteristic mask of the Shang dynasty. The masks are now small and confined to knobs in the middle of the sides and at the ends of the handle. There is also a slight technical decline, the details being less crisp than formerly.

In jade too the changes are clearly perceptible. Shapes become simpler. Shang types continue but new ones emerge as well, such as the white jade fish in the Cleveland Museum, which is simple and severe, recalling a Neolithic style (*fig. 44*). Other motifs in the old jade picture language—birds, cervids, and felines—lose their Shang ornamental engraving or raised relief and become smooth and intentionally simplified. By Middle Zhou ornament returns, but is related to the scale, leaf, and groove decoration of contemporary bronzes such as those in figures 45–47. The Seattle *bi* (*fig. 48*), which embodied

48. *Bi disk.* Jade; diam. 9⁵/8" (24.5 cm), d. ¹/16" (0.2 cm). China. Middle Zhou period. Seattle Art Museum

49. *Buffalo.* Bronze; l. 8¹/8" (20.6 cm). China. Middle Zhou period. Minneapolis Institute of Art. Pillsbury Collection

a basic ritual shape already two thousand years old, shows ornament artfully created in modified thread relief and shaped to conform to the traditional disk. Some of the cinnabar red (signifying immortality) with which this jade was colored before being buried remains in the grooves of the design, a clear testimonial that the *bi* continued to serve as a magical, ritual instrument—the symbol of Heaven.

MIDDLE ZHOU

The first major change from Shang modes occurs, not during the early Zhou period, which saw the continuation of Shang artistic practices, but at the beginning of the middle Zhou period, when a series of new vessel shapes with a new and very limited ornamentation appears (*fig. 45*). Where the Shang shapes seem vibrant and those of early Zhou either flamboyant or carefully balanced, the middle Zhou vessels seem ponderous and squat. They hug the ground; if we may judge weight by appearance, they appear very heavy. Their decoration assists this change. Some vessels have none and achieve aesthetic variety with the plain surface of the vessel or by horizontal grooving, which emphasizes their weighty and close-to-earth qualities. Even the masks disappear from the

handles, which are treated as simple rings. The total form is extremely austere.

A pair of bronze tigers demonstrates what happens to animal forms and their decoration in the middle Zhou period (*figs. 46, 47*). Clearly they are tigers, but the conformation of backs, bellies, and legs renders them earthbound and static compared with Shang representations of the beast. The decoration has lost its metamorphic character; it is consistent and all of a piece; the profusion of animal forms is gone. The whole representation is logical, unified, and naturalistic in point of view. The two tigers were probably architectural members, as there are openings in their backs and they are far too heavy and clumsy to have been used as vessels. Perhaps they were supports for the pillars of a throne or canopy.

Bronze animals in the round first appear, generally, in middle Zhou. A few naturalistic animal vessels date from the Shang dynasty, but from the middle Zhou period comes one of the first representations of an animal without an obvious functional purpose. The buffalo in figure 49 may have been an image, an aid to worship, or an aid to ritual as a representation of sacrifice. But above all it is a sculpture in the round and looks more naturalistic, more "real," than do the Shang buffalo. And though it has lost the vitality imparted by Shang technical dexterity, it possesses greater unity.

3

The
Late Zhou
Period

One of the most fascinating periods of Chinese art history is the late Zhou period, sometimes called Eastern Zhou, roughly contemporary with the historical periods called Spring and Autumn Annals and Warring States. It was a time of troubles and simultaneously of great intellectual and artistic ferment and growth. In the centuries since the conquest Zhou power had declined, till in 771 B.C.E. an alliance of "western barbarians" and rebellious appanages drove the Zhou from their principal capital in Shaanxi to the relative safety of Chengzhou, their secondary capital (near present-day Luoyang), in Henan Province. The Zhou feudal system was breaking up into a welter of shifting alliances and increasingly frequent and violent wars between competing baronies. The old rituals and philosophical traditions were changing. A mutual leavening of high and low intellectual traditions was taking place. More people were becoming familiar with writing and higher culture. Civilization was expanding, making south China an integral part of the high cultural orbit.

The two main streams of Chinese philosophy date from this time. Confucius was born in 551 B.C.E. Daoism first appears in a work called the *Dao De Jing* [Book of the Way and Its Power], attributed to one Lao Zi (Old Master), supposedly contemporary with or somewhat later than Confucius. Confucianism is explicitly nonmetaphysical and humanistic: The question it addresses is how best to live in the world, and its answer is a set of political and familial relationships, with a code of ethics for regulation of the system. It is a conservative and hierarchical system, with a remarkably evenhanded balance between extremes of optimism and pessimism, based as it is on the assumptions that human excellence is a matter of right conduct and that right conduct can be learned by some. Daoism ignores human society to ask what the natural world is, and to answer that it is the visible manifestation of the Dao, the Way—the "uncarved block" that contains within itself the matter and form of every physical phenomenon. On this answer Daoism bases its central teaching: that one must live in intuitive harmony with the Dao. For the breakdown of the social order in the Warring States period, Confucianism offered remedies, while Daoism offered escape. Humanistic Confucianism and mystical, pantheistic Daoism did not flourish in isolation; later Chinese dubbed the proliferation of late Zhou philosophers "the Hundred Schools." Among them, Mo Di (born c. 500 B.C.E.) taught a thoroughgoing pacifist utilitarianism as a corollary of universal love, and the Legalists, whose philosophy informed and justified the totalitarian Qin dynasty (221–206 B.C.E.), preached a

royal absolutism governing through strict laws and harsh punishments.

Of the many late Zhou archaeological sites, we will list only some of the more important ones in more or less chronological order: Xinzheng (Henan), Liyu (Shanxi), Jin Cun (Henan), Hui Xian (Henan), and Changsha (Hunan). The first four are northern sites and are to be dated approximaely as follows: Xinzheng, seventh–sixth century B.C.E.; Liyu, sixth–fifth century B.C.E.; Jin Cun and Hui Xian, fifth–third century B.C.E. Changsha is the most important site now known in the south. The material being excavated there dates from the fifth century to the Han dynasty (206 B.C.E.–220 C.E.) and provides an ever clearer picture of the culture of the Chu state, the dominant political entity of the south in the late Zhou period and one of the most innovative cultures of the time in material techniques and imaginative figural subject matter and symbolism. Hui Xian in north Henan is a recent excavation of the People's Republic, comparable in some of its materials to Jin Cun. Late Zhou thus provides us many sites over a wider geographic range than any preceding period, including numerous vessels in a mixed Chinese and Southeast Asian (Dong Son) style, from the Guangxi area above present-day Vietnam.

There is also a much greater variety of material, because the late Zhou period witnessed a marked expansion of Chinese techniques and knowledge of raw materials. Undoubtedly, some of this expansion was under stimulus from the West, as is indicated by the influence of the later Animal style and the importation of glass beads from the Mediterranean region.

ANIMAL STYLE

New animal motifs and ways of representing them appear with increasing frequency during the late Zhou period from the fifth century B.C.E. "Animal style" is a term coined by Mikhail Rostovtzeff to describe the stylized representation in relief or in the round of animals in profile, most often with legs drawn up under them or standing proudly erect in an almost heraldic pose. Another aspect of this style is the depiction of parts of animals, heads and haunches, as if representing dismembered ritual sacrifices. These works are often combined with geometric decor—spiral, fret, or interlace—and are usually ornaments rather than independent objects: horse trappings, finials, and other portable trimmings associated with the characteristically nomadic cultures of eastern Russia, Siberia, and Manchuria. We have seen some influence of the Animal style on Shang knife handles, but connections between China and the northern nomadic cultures do not now appear to have been extensive till early in the late Zhou period. In Siberia Russian archaeologists have established a well-defined cultural sequence: Afanasieva

50. *Drawing of tattooed man.* Front and back views. Tomb 2, Pazyryk, near Minusinsk, Asian Russia. 6th–5th century B.C.E. The State Hermitage, St. Petersburg

51. *Head of Griffin-Dragon.* Wood and leather; l. approx. 12" (30.5 cm). Pazyryk, near Minusinsk, Asian Russia. 5th–4th century B.C.E. The State Hermitage, St. Petersburg

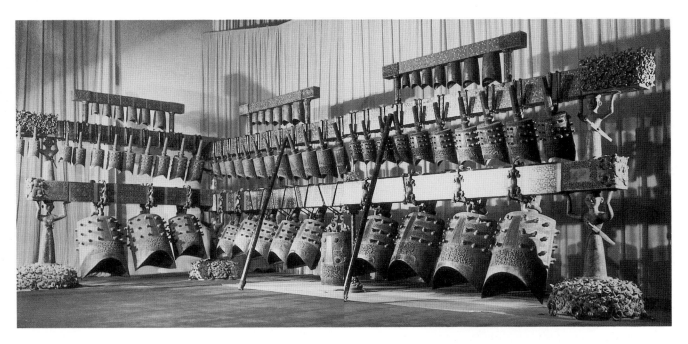

52. *Assemblage of 65 bronze zhong bells: 45 yong zhong, 19 niu zhong, 1 bo zhong.* Bells (exclusive of shank or suspension loop):
h. 60³/₈" (153.4 cm)–8" (20.4 cm); w. 447–5¹/₄ lbs. Bronze and timber frame: h. 9' (2.74 m), l. 25' (7.62 m). Tomb of Marquis
Yi of Zeng, Leigudun, Sui Xian, Hubei, China. Warring States period, dated to shortly after 433 B.C.E.

(c. 2000 B.C.E.), Andronovo (1750–1300 B.C.E.), and Karasuk (1300–700 B.C.E. or later). The Shang animal-headed knife handles are related to Andronovo and early Karasuk examples, but it is the later manifestations of Siberian Animal style that have the most distinct effect on Chinese art. Some of these later elements are to be found in the most interesting of all late Karasuk sites—Pazyryk, where influences to and from China are to be found.

The rich material from Pazyryk is kept at the Hermitage museum in St. Petersburg, and includes the body of a tattooed man, which had been preserved by the deep-freeze environment at twenty feet or more beneath the tundra (*fig. 50*). The torso, minus head and left hand, was tattooed with an allover pattern of Animal style designs. One animal is metamorphosed into another—a lion becomes a bird, or a lion's tail ends in a bird's head. The artist figuratively dismembers the animals, using parts to stand for wholes. Many of the motifs are comparable to those in figure 55 from north China. The wood and leather griffin-dragon from Pazyryk (*fig. 51*) is markedly similar to the bronze dragon head from Jin Cun (*see fig. 57*). Indeed, the whole development of naturalistic animal decoration in the late Zhou period reflects a now considerable understanding of the Animal style.

BRONZES

Some late Zhou bronzes bear cryptic and awesome symbols, intricately interwoven; other late Zhou bronzes achieve an equal complexity that may be well described as playful, elegant, even consciously aesthetic. The luxury common among the upper classes in the Warring States, and deplored by Confucius, emphasized a rich variety of materials—bronze, gold, silver, jade, lacquer, and silk. Musical ritual and performance were a peculiarly important aspect of late Zhou society. As early as the Shang dynasty both north and south China had produced massive clapperless bells (*nao*), which were stood mouth-upward and were sounded by striking. In later times the number of bells required for a performance multiplied, and though they remained clapperless and essentially similar to the *nao* bell in shape, they were suspended mouth-downward from a frame. Such *zhong* bells have been found in central China and as far west as Sichuan, in sets of graduated sizes that provided a sonorous, if slow-paced, recital. Each bell could sound two different notes, one if struck at the side, the other at the center. Their shapes were increasingly refined and their subtle elliptical cross sections carefully calculated to produce precisely the desired tones. Currently the most famous of such bells are the sixty-five buried in the tomb of Marquis Yi of Zeng and discovered in 1978, the bells still suspended from their frame (*fig. 52*). This group was assembled from at least three different carillons, and includes a single *bo* bell unrelated to either. An inscription on the *bo* bell gives a date equivalent to about 433 B.C.E.

Bells not only made music but also provided fields for visual art. Bosses, which were enlarged to ensure an even tone, were also made the location of complex deco-

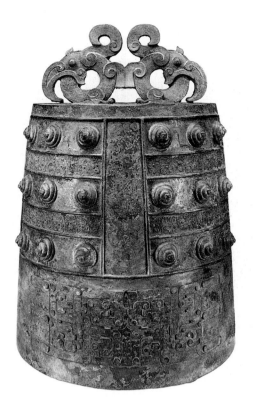

53. *Bo bell* (clapperless). Bronze; h. 26¹/8" (66.4 cm). China. Late Zhou period. Freer Gallery of Art, Smithsonian Institution, Washington, D.C.

54. *Inlaid ding.* Bronze inlaid with gold and silver; diam. 7¹/8" (18.1 cm). Jin Cun, Henan, China. Late Zhou period. Minneapolis Institute of Art. Pillsbury Collection

rative motifs such as coiled snakes (*fig. 53*). In figure 53 the suspension loop is made up of paired dragons or birds, while below the three bands of bosses is a revival of the Shang *tao-tie,* here treated playfully and decoratively.

55. *Finial.* Bronze inlaid with gold, silver, and white bronze; h. 5¹/4" (13.3 cm). Jin Cun, Henan, China. Late Zhou period. Cleveland Museum of Art

Parts of these *tao-tie,* in turn, develop into other animals such as snakes or birds, reintroducing the idea of metamorphosis. The flat, spiral ground of Shang is also revived, but with a singular modification—the "late Zhou hook," a spiral with a tightly raised curl at its termination, projecting from the surface of the vessel or bell. The motif is omnipresent in relief on bronze and jade.

Still another innovation of the period was the use of inlays of precious metal in bronzes. We have mentioned the use of black pigment as inlay in the Shang dynasty bronzes, but in the late Zhou period silver, gold, white bronze (an early type of specular metal), and even glass were used as inlays. A particularly fine example is in the Minneapolis Institute of Art—a three-legged *ding* with a typical late Zhou profile, completely modified from that of Shang or early Zhou (*fig. 54*). The *ding* is now rounded, and the legs conform to the softer structure of the vessel proper. The whole shape is roughly spherical. The horizontal grooves encircling the body, characteristic of middle Zhou vessels, are maintained but not used repetitively. This *ding* is especially important for the six dragons inlaid in gold on its cover, which is designed to be used also as a plate when stood on the three legs in the shape of reclining rams in high relief. The body of the vessel is decorated with an abstract pattern of interlocking triangles, further embellished with typical late Zhou hooks. One of the most beautiful of all late Zhou objects is a finial in the shape of a dragon biting and being bitten by a bird (*fig. 55*). It is an extraordinary tour de force. The long head of the dragon dominates the composition, but sitting on the dragon's lower jaw, clutching it with its talons and with its tail feathers curling under the dragon's chin, is a small bird tearing with its beak at the top of the dragon's snout. The subject combines animal combat and metamorphosis in a manner characteristic of late Zhou revival and innovation. The bird motif is repeated in flat, ribbon-like relief at the base of the dragon's head. Though only about six inches long, the finial is extremely complex in its organization, full of that peculiarly delicate, closely curling movement and rhythm characteristic of late Zhou style. It is elaborately inlaid with silver, gold, and some white bronze, with some of the inlays designed to imitate dotted glass beads.

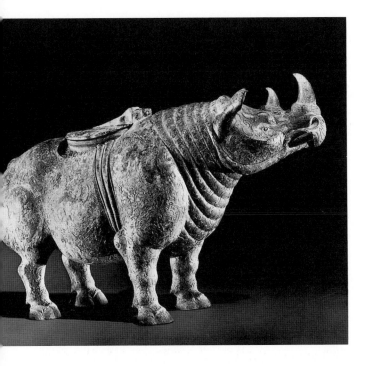

56. *Rhinoceros zun.* Bronze with traces of gold inlay and black glass eyes; original inlay presumably gold and silver; h. 13³/8" (34 cm). Xingping Xian, Shaanxi, China. Late Eastern Zhou period–Western Han dynasty. Historical Museum, Beijing

57. *Head of dragon.* Gilt bronze overlaid with silver foil; l. 10" (25.4 cm). Jin Cun, Henan, China. Late Zhou period. Freer Gallery of Art, Smithsonian Institution, Washington, D.C.

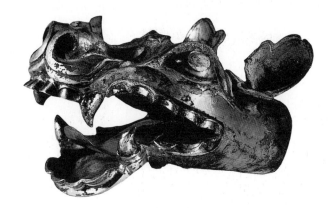

Sculptured Figures

In addition to innovations in material and technique, the period saw the rapid development of sculpture in the round, especially of animal subjects. The bronze rhinoceros (*fig. 56*), found in Shaanxi Province, is the best observed and most richly decorated of late Zhou–early Han sculptures. The animal is depicted far more knowingly, if less massively, than his Shang ancestor in the Asian Art Museum of San Francisco. At the same time the decoration has become playful, with a tendency to conscious elegance. The decorative rendering of the hide must have been particularly sumptuous; its brocade-like pattern is still clear, although only a small amount of gold from the original inlay has survived. The gilded bronze dragon head in figure 57 reveals sophistication in the handling of new processes such as gilding, and imagination in formulating a convincing dragon type that becomes, on the whole, standard from this time on. The late Zhou artist combined imagination and realism to produce a unified style.

Animal figures had been seen before, but sculpture in the round of the human form was extremely rare before late Zhou. At first figures were used on the lids of vessels, as parts of fittings, or as lamp bearers; later in the period they appear in the full round, perhaps as pure sculpture. The bronze figure of a dancing boy on a toad is most extraordinary, especially in the way that the figure is projected almost spirally into space (*fig. 58*). One of the most interesting sculptures, if only for its ingenuity, is the group of two wrestlers, of unknown provenance, in the British Museum (*fig. 59*). The two figures are identical but oriented in opposite directions, their hands joined as

58. *Boy on a toad.* Bronze; h. 4" (10.2 cm). China. Late Zhou period. Metropolitan Museum of Art, New York

59. *Wrestlers.* Bronze; h. 6³/₈" (16.2 cm). China. Late Zhou period. British Museum, London

60. *Interlocked T and dragon mirror.* Bronze; diam. approx. 7" (17.8 cm). China. Late Zhou period. Museum of Fine Arts, Boston

if executing a pas de deux. This interest in two figures complexly related is entirely new.

Mirrors

Thousands of bronze mirrors of numerous types are known from late Zhou, following at least one example from the Shang dynasty and several from middle Zhou. The reflecting side, naturally, was polished; the design occupied the mirror back. Mirrors were often buried with the dead, sometimes suspended over the body with the polished side down, thus simulating the sun and confirming the mirror as a cosmic symbol. Figure 60 shows a classic late Zhou mirror back, with a repeated dragon pattern on a ground of interlocked Ts. The stylish, dashing dragons in bandlike relief—three of them around a central lug—are ancestors of many of the later dragons of Chinese painting. Surely the dragons and interlocked Ts are symbolic as well as decorative, but we are uncertain of their meaning in this context. Certain of the symbols on other mirrors are more explicit than these.

A second mirror, reportedly from Jin Cun, Henan, is the most elaborate late Zhou specimen known (*cpl. 3, p. 115*). Of particular interest is its utterly refined inlay, composed partly of little dottings of gold and silver. The

figure on horseback brandishes a short sword like the Scythian *akinakes,* originating in Central Asia and used both in China and in the Mediterranean world. The warrior is attacking a tiger, shown completely in dotted and linear inlay, while the horse and rider are rendered partly in this technique and partly in larger areas of silver inlay. Here, for the first time, we have encountered Chinese pictorial art. Note that the horse and rider are in three-quarter view, revealing considerable interest in foreshortening and action and clearly indicating a growing skill in handling human and animal forms in movement and space.

JADE

The late Zhou style found a rich and sympathetic material in jade. It is no exaggeration to say that the jades of the late Zhou period are the finest ever made, aesthetically as well as technically. Even during the Qianlong reign, by popular opinion the zenith of elaborate jades, the late Zhou jade workers were not surpassed. Jade was the most precious and meaningful of all materials to the Chinese, and the elaborate, complex, and playful designs they imposed on it resulted in wonderful works of art.

Let us look first at a *huang,* a segment of a disk (*fig. 61*). One can see that a double dragon shape with hooked and scaled bodies binds the whole together. The surface reveals a major and a minor motif, interwoven in a delicate, curling relief, with some incising for the even finer details of eyes and scales. A plaque in the Freer Gallery

61. *Huang pendant.* Jade; l. 8" (20.3 cm). Hui Xian, Henan, China. Late Zhou period, late 6th–5th century B.C.E. Historical Museum, Beijing

62. *Tiger plaque.* Jade; l. 5⁷/₈" (14.9 cm). Jin Cun, Henan, China. Late Zhou period. Freer Gallery of Art, Smithsonian Institution, Washington, D.C.

63. *Bi disk.* Jade; diam. of circle 6¹/₂" (16.5 cm), maximum w. 8⁵/₈" (22 cm). Probably from Jin Cun, Henan, China. Late Zhou period, 5th–3rd century B.C.E. Nelson-Atkins Museum of Art, Kansas City

represents a feline creature whose body is covered with classic examples of the late Zhou hook, which is as characteristic of jade plaques as it is of bronzes (*fig. 62*). The justly famous jade *bi* from Kansas City epitomizes the magical technique and luxurious aestheticism of late Zhou (*fig. 63*). In it the traditional sobriety of the symbol of heaven has been transformed into an expression of feline-serpentine energy and movement, the bodies of the dragons echoing in outline and in surface pattern the curving hooks characteristic of the Warring States period. The honey-colored jade is pierced, carved, and polished with great technical virtuosity. This masterpiece was almost certainly discovered at Jin Cun in Henan about 1932–1934, along with such objects as those shown in figures 55, 57, and 62.

CERAMICS

In the turbulence of late Zhou times, not only were new styles and motifs created, but large numbers of new techniques and new materials were introduced. For the first time pottery figurines were used as occasional substitutes for the actual animals and objects previously interred with the deceased. At a grave site in Hui Xian in northern Henan, where dozens of chariots and horses were excavated, animal and human figurines of the same time were also found, some of gray and others of almost black pottery, executed in a lively and naturalistic style. The realistic figures of dogs, pigs, and other domestic animals look almost as if they had been cast from miniature animals. At the same site elaborately worked jades in pure late Zhou style were found. Clearly this was a transitional period, in which old and new modes were supported together.

The usual ceramic vessels were also produced—some gray pottery and, in the more provincial areas, red earthenware painted pots of Neolithic type. Some of these were so convincingly Neolithic that J.-G. Andersson mistakenly dated one group to about 3000 B.C.E., whereas they more nearly date from about 500 B.C.E. In the outlying areas, then, Neolithic techniques continued into the late Zhou and even into the Han dynasty.

But there was also a revival and real development of the Shang invention of stoneware with ash-fluxed glaze whose tint was derived from iron oxide. Examples from early and middle Zhou sites are known, but the widespread appearance of this stoneware, particularly in the south, occurs in late Zhou. The pot in figure 64 is very high-fired stoneware with a gray body burnt brown on the exterior, where exposed to the flame. It has vestigial loop handles and a shape resembling that of a bronze *jian*. The shiny olive substance on the shoulder and side is glaze. It seems probable that such a glaze became more common as potters learned to heat kilns to higher tem-

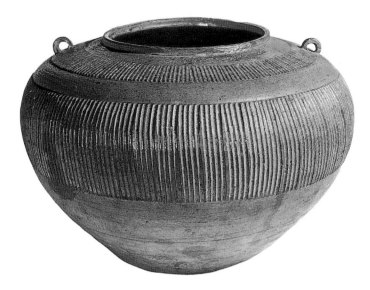

64. *Jar.* Proto-porcelain, Shouzhou type; diam. 12¹/₈" (30.8 cm). Anhui, China. Late Zhou period. Museum of Eastern Art, Oxford

peratures. Ash from the fire, settling by accident on the surface of the pots, would act as a flux, causing the silica in the surface layer of the clay to melt and thus producing spots of natural glaze. Upon this discovery the potters began purposely to agitate the fire so as to force a heavy deposit of ashes onto the upper surfaces of the pots. This more concentrated flux acted on more of the surface silica and thus formed a glaze. We base this hypothetical reconstruction on the fact that the glaze on these early wares is found mainly on the upper surfaces of the vessels. Later potters developed techniques of either dipping the pot into an actual glaze mix or covering the vessels with ash so that a glaze would coat the whole surface.

WOOD AND LACQUER

In addition to glazed ceramics we have, for the first time, actual remnants of worked wood—not simply imprints in the earth like those found at Anyang. The first discovery of these wood remnants was accidental. In the early 1930s workers digging roadbeds for railroad lines at Changsha in Hunan uncovered tombs containing astounding objects theretofore unknown in Chinese art. Many of these objects had been preserved in almost perfect condition by the constant dampness of the earth. It is change of humidity or temperature that damages such objects; where temperatures and humidity are constant, however extreme, objects are often well preserved. From ancient Egypt, with its very dry and hot climate, we have well-preserved objects of wood and other fragile and perishable materials. Constant extreme humidity has the same preservative effect. At Changsha objects of wood, bam-

boo, lacquer, and even cloth were preserved intact in the damp tombs. Some of the numerous artifacts recently excavated at this site include bamboo strips with notations in archaic script; an intricately carved wood panel coated with a layer of brown lacquer; and curiously doll-like wooden figures, carved and lacquered, perhaps burial substitutes or possibly images used in shamanistic practices. Fragments of paintings on silk are a small but significant part of these finds (*see fig. 67*).

The uses of lacquer and the techniques of working it were also innovations of the late Zhou period, probably originating in the south. One of the most remarkable of all the objects excavated at Changsha was found in 1934 and is in the Cleveland Museum of Art (*fig. 65*). This very large composition, called *Cranes and Serpents,* is the earliest extant Chinese wood sculpture, and one of the greatest. It is covered with designs painted in lacquer, imitating inlaid bronze designs. There is some disagreement as to how these birds and snakes were originally grouped. It was reported by the dealer who sold the piece that remnants of a wooden drum had been found with it, suggesting that the birds and snakes may have formed a drum stand, with the drum suspended from the necks of the birds as they stood back to back. Against this supposition it is argued that the arrangement seems highly unfunctional, for two such slender necks would snap if a drum suspended between them were hit. But recent excavations at Xinyang in southern Henan have recovered remains of a smaller lacquered wood drum stand with paired birds back to back standing on two felines. The parallel, despite the geographical separation, is too telling to ignore, particularly in view of our increased understanding of the homogeneity of Chinese culture as far back even as the Shang dynasty. A close examination of the Cleveland birds indicates that they are hybrids—eyed peacock feathers, cranelike profile—perhaps early versions of the *fenghuang* (conventionally translated as "phoenix"). Their bodies are of one piece of wood; tail feathers and wings (fashioned from flat boards), heads and legs are all made separately and attached. A detailed front view of the snakes shows the same design found on inlaid bronze tools and vessels (*cpl. 4, p. 116*). The two snakes are differentiated; one has a completely geometric pattern, the other a pattern simulating scales. Perhaps an early manifestation of the male and female principles of *yang* and *yin* is expressed in the paired serpents. The color scheme of the lacquer is not the common one of red and black, but a combination of red, yellow, black, and very dark blue, producing a rich and complex effect.

A more characteristic lacquered object is the remarkably well preserved bowl from Changsha, now in the Seattle Art Museum (*fig. 66*). It is made of a very light wood covered with a fine cloth to prevent warping. Over the cloth, lacquer was applied in two colors only—red and black—forming a design of dragons, birds, and ban-

65. *Cranes and Serpents.*
Lacquered wood; h. 52³/4"
(134 cm). Changsha, Hunan,
China. Late Zhou period.
Cleveland Museum of Art

66. *Bowl.* Lacquered wood, diam. 10" (25.4 cm). Changsha, Hunan, China. Late Zhou period. Seattle Art Museum

ners repeated three times around the cavetto, with a semi-abstract design of dancing bears and bird forms in the center. All of these lacquered vessels with intricate designs display extremely lively and highly abstract treatments of natural forms, as if the painter had already begun to use line for expressive purposes alone, as was characteristic of later Chinese painting.

THE BEGINNINGS OF BRUSH PAINTING

From the late Zhou period come the beginnings of brush painting, later to be so highly developed in China, exploiting the ability of the flexible brush to produce thick and thin lines and to represent movement by means of those lines. Only recently have a few fragments of this early painting come to light. The earliest examples were rather tentative paintings, such as an illustrated text on silk found at Changsha (now in the Freer Gallery of Art), an herbal-bestiary with representations of various plants and fantastic animals, including a three-headed man. It was probably made for a shaman and is not much of a painting, being rather stiff and crude, obviously a "cookbook" page not intended as a great work of art.

a flat surface; there is no indication of depth by overlapping or by relationships to other objects in space. They are "typical" pictographs for familiar concepts: priestess, magical beings. But the lines of ink, though even and wire-like, display some rhythmical feeling.

In a second and more fluently painted fragment, from a man's tomb in the same area, a man in aristocratic dress is portrayed in profile, riding a tautly reined dragon whose body forms the outline of a boat's hull (*fig. 67*). On the dragon's tail perches a crane, symbol of immortality and, like the dragon, often a vehicle of heavenly travel. Over the man's head is a tasseled parasol of the kind that shaded carriages of the aristocracy in the late Eastern Zhou period (*fig. 68*). A schematic fish below signifies that the dragon-boat is traversing water. The fanciful scene has been most persuasively imagined: the rider leans slightly backward in order to keep the reins taut, and the ties of his hat, like the tassels of the parasol, stream out behind with the swiftness of his passage. From earliest times dragon-boats or vehicles figure in Chinese literature as conveyances for heavenly deities, for the souls of the dead, or for "perfected humans" (*zhen ren*), who by means of magical elixirs and spiritual disciplines had acquired the power of celestial travel. Though the painting could represent any of these beings, its use as part of a pall over the coffin in the tomb suggests that it was intended to depict the soul of the dead man on his way to heaven. The following two excerpts from *Chu Ci* [Songs of the South], a famous collection of poems of the late fourth–early third century B.C.E., might be describing this very painting:

> A long gem-studded sword hangs at my side,
> And a tall hat I wear [the narrator is garbed for
> celestial travel]. . . .
>
> Riding his dragon chariot
> drawn like a god,
> he hovers and soars,
> roaming the vastness. . . . [2]

Another example is a design on a lacquered vessel called a *lian*, a cylindrical covered box (*fig. 68*). The design

67. *Man riding a dragon-boat.* Ink and colors on silk; h. 14³/₄" (37.5 cm), w. 11" (28 cm). Changsha, Hunan, China. Eastern Zhou dynasty, Warring States period. Palace Museum, Beijing

But we do have excavated paintings from Changsha, a metropolis of the southern state of Chu (613–221 B.C.E.), that bespeak a highly developed painting technique. Among them is a faintly preserved ink painting on silk, depicting a lady with a phoenix and a dragon. Painted with a brush and ink on coarse silk, the image shows a woman in profile in a long embroidered gown, reaching out to the mythical beast and bird. In the picture these three elements are related to each other only as designs on

68. *Lian.* Painted lacquer; h. approx. 6" (15.2 cm). Changsha, Hunan, China. End of late Zhou period, 4th–3rd century B.C.E. Provincial Museum, China. The design has been "unrolled," showing it as a continuous band.

69. *Painted shells with hunting scenes:* (left) *The hunt;* (right) *The kill.* W. 3¹/₂" (8.9 cm). China. Late Eastern Zhou or early Han dynasty. Cleveland Museum of Art

on this box has been schematically extended in the illustration to reveal the whole. On the left, moving over a small hill, is a two-wheeled chariot drawn by a single horse, followed by two riders, one on a white horse, the other on a green one. This scene of action is followed by one of repose: Here are trees, one in flower; two seated men, one in a small enclosure; and a man holding a wand or branch who stands facing the observer. Above and below these are designs painted in imitation of inlaid bronze. The representation of the horse at a flying gallop, derived from the Animal style, is extremely lively. The skillful but simple representation of the tree shows a level of brushwork indicating many years of prior development.

The Cleveland Museum of Art has two rare and exquisite painted low reliefs executed on clam shells (*fig. 69*). They are reputed to have been found in north China, and this seems most likely. After cleaning and restoration two scenes were revealed. The first shell shows the chase. A two-man, two-wheeled chariot drawn by four horses is pursuing a deerlike animal and a tiger. Below, a similar chariot is following a deer, with two little dogs, resembling dachshunds, running beside it. The other shell depicts the sequel to the first scene. The now-stationary four-horse chariot is seen head-on, with two

men still in it. Two men have appeared on foot, having dismounted from the other chariot, and are approaching a doe. One holds a long spear and one a knife. Two arrows are lodged in the doe's hindquarters. Below, one of the hunting dogs is chasing deer, while two bristling boars run nearby. There is an indication of landscape: two kinds of trees, one with three branches and one a stump with a protruding branch. Close to the latter is a halberd, thrust into the ground while its owner deals with the stricken doe. One can also make out, on each of the shells, a pole staff with three trailing pennons. This was a type of clan banner and can be seen also on the lacquer bowl in figure 66. A front view of a quadriga is most extraordinary in so relatively archaic a stage of painting. Here are late Zhou or early Han paintings revealing an advanced stage of accomplishment, showing a psychologically unified scene, involving actual events and spectators observing them. They are so unified in composition within the area of the shells that we have not stiff, geometric, static diagrams, but lively pictures, vivid representations with a brilliant use of silhouette.

The hunt is also a characteristic subject of some bronze vessels of the late Zhou period. Often it is less pictorially handled, as on vessels with panels of rather geo-

70. *Hu.* Bronze; h. 10" (25.4 cm). China. Eastern Zhou dynasty, Warring States period. Cleveland Museum of Art

metric, static hunting scenes in low-relief silhouette (*fig. 70*). But on an inlaid bronze tube in a Japanese collection, dating from the early Han dynasty, is as dynamic a hunt as that on the shells (*cpl. 5, see p. 117*). Some of the elements we have already seen: the running tiger, the horse at the flying gallop, the archer. But here we find greater wealth of detail: undulating hills and cloud-scrolls, the bear and the boar, the peacock preening his tail—a landscape filled with varied representations of animals and birds, including rare images of an elephant and a Bactrian camel. The depiction is full of life, in the interweaving, curling style characteristic of the late Zhou period.

Although we are concerned in this book with the visual arts, it should be noted that music, valued by Confucius above all other arts, the dance, and poetry all reached high levels of attainment in these years.

4

The Growth and Expansion of Early Chinese Culture through the Han Dynasty; Korea and Japan

The Chinese call themselves Sons of Han, the dynasty that saw the establishment of a Chinese world empire. The first empire had in fact been created by the state of Qin, in modern Shaanxi Province, which emerged as winner-take-all from over a century of endemic intrigue and warfare among the Warring States. In 221 B.C.E., when Chu fell and Qi surrendered, King Zheng declared himself Shi Huang Di, First Emperor, of China. Before his death in 210 B.C.E. he had begun the Great Wall and a network of roads, standardized the script, coinage, and weights and measures, and created the type of centralized bureaucratic regime that has governed China ever since. But he slaughtered his opponents, persecuted Confucians, and ruled with such punitive harshness that his empire crumbled in rebellion and defection less than four years after his death. By 202 B.C.E. the peasant Liu Bang, victor in the ensuing power struggle, was Emperor Gao Zu of the Han dynasty, named for Gao Zu's original power base in the Han River valley, where he had been crowned king in 206 B.C.E. Gao Zu was able to take over, stabilize, and enlarge what Shi Huang Di had put together. China's borders were extended from Vietnam in the south through Korea in the north, and from the China Sea deep into Central Asia.

The four centuries of Han rule were divided at about midpoint by a brief usurpation (8–23 C.E.) following on several generations of growing weakness. But by 25 C.E. a Han prince had regained the throne and established his capital at Luoyang, Henan, near his own power base. The era 25–220 C.E. is therefore called Eastern (or Later) Han, while the era 206 B.C.E.–8 C.E., when the capital was at Chang'an (present-day Xi'an) in Shaanxi, is retrospectively termed Western (or Former, or Earlier) Han.

Qin

The discovery in early 1974 of but a distant and small part of the burials surrounding the giant tumulus-tomb of Qin Shi Huang Di excites the imagination and gives a hint of the concentrated power and megalomania of the First Emperor. Originally over six hundred feet high, the man-made hill dominates the plain west of Mount Li near Xi'an. Almost half a mile from the hill well-diggers chanced on a part of the clay civil and military entourage buried around the central tomb mound (*fig. 71*). At least seven thousand life-sized clay figures of warriors and horses (*fig. 72*), together with wooden chariots, were discovered in military formation, symbolically guarding the approaches to the tomb. Originally richly polychromed,

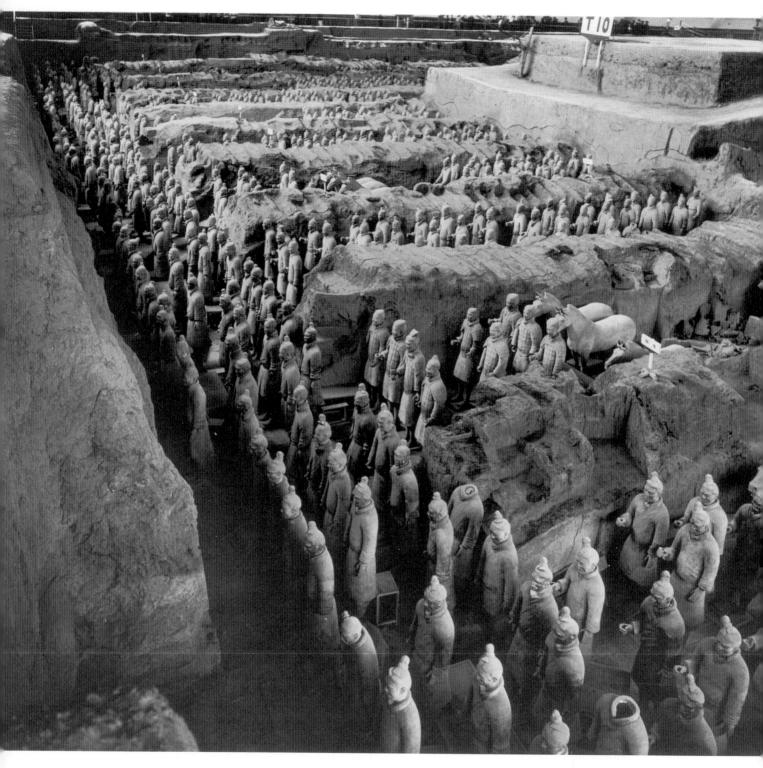

71. *Tomb pit with part of earthenware burial army of First Emperor of Qin.* Pit 1, Lintong, Shaanxi, China. C. 210 B.C.E.

the figures now reveal their material of fired gray clay, modeled with the same careful realism as the much smaller late Zhou figurines found at Hui Xian. The various provincial headdresses of the warriors are depicted in specific detail, and the small, closely coupled horses stand stiffly, ready for mounting or harnessing. More recently, reports of the finding of a veritable bureaucracy of life-sized civilian functionaries suggest that the whole area around the central hill contains a clay replica of the imperial court. Closer to the central tumulus a few smaller-than-life bronze images of chariots, charioteers, and horses have been found. One of the most astonishing of these is the four-horse covered carriage with driver, in gilt bronze, arresting for its masterful rendering of minutely realistic detail (*fig. 73*). Literary sources describe the central burial as furnished with an unbelievably rich assortment of tomb

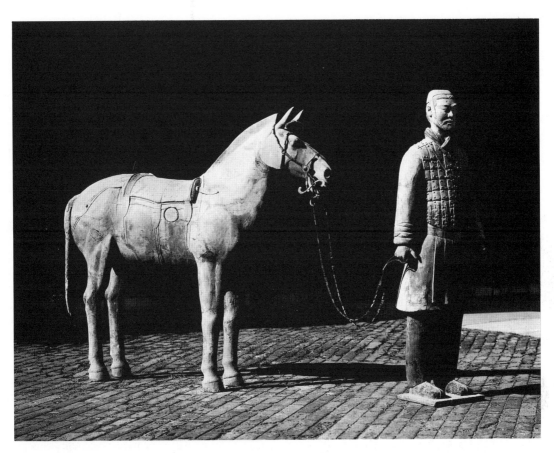

72. *Cavalryman and saddle horse from earthenware burial army of First Emperor of Qin.* H. of man 5'10¹/₂"
(1.79 m). Lintong, Shaanxi, China. C. 210 B.C.E. Shaanxi Provincial Museum

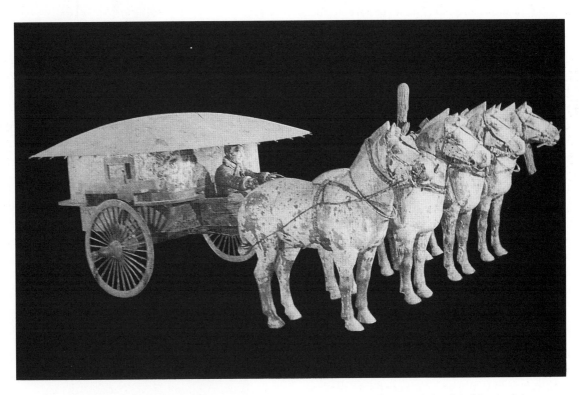

73. *Quadriga.* Bronze with painted and openwork decoration; overall: h. 41³/₄" (106 cm), l. 10'4³/₄" (3.17 m); horses:
h. approx. 36⁵/₈" (approx. 93 cm), l. approx. 45⁵/₈" (approx. 115 cm). Necropolis of First Emperor of Qin, Li Shan,
near Xi'an, Shaanxi, China. Qin dynasty, 246–210 B.C.E. Qin Shi Huang Mausoleum, near Xi'an

furniture, including a model of the Qin universe, complete with rivers in mercury and a representation of the constellations. The life-sized excavated figures definitively embody the realistic tendencies of preceding sculptural style and establish a standard hardly achieved by the succeeding tomb sculptures of the Han dynasty.

HAN

Han China, roughly contemporary with the Roman Empire, probably exceeded it in population, extent, wealth, military might, and prestige, and at least equaled it in historical import, becoming the prototype of organization and goals for all succeeding Chinese dynasties.

The Han empire may also be said to have established Chinese cultural patterns until modern times. In art and thought contributions of the late Zhou period were consolidated. Regional differences continued, particularly between north and south, but within a more unified cultural and political framework. Scholars reconstituted Confucianism, adapting it to contemporary concerns. A vast array of superstitions and cult practices, and an enduring preoccupation with immortality or longevity and the means to achieve them, engaged the Han populace, up to and including the emperors. Much of this fabric of myth, miracle, and magic was absorbed by Daoism. Equally with Confucianism, this fantastical popular lore supplied subjects and themes for much Han art—ethical examples and exemplars from Confucianism; a salmagundi of spirits, deities, oracles, and shamans in all shapes and forms from Daoism. Surviving texts of Han date, both Confucian and Daoist, are a great aid in interpreting Han art. Confucians and Daoists competed for the favor of the throne; the emperors more often than not were Daoist by personal inclination, but Confucianism enjoyed official precedence. China in the late Zhou period had not been totally isolated, but the Han empire was in contact with India, Southeast Asia, Central Asia, and the Mediterranean world. North China was urbane and civilized, while the farther reaches of the south still preserved much of the exotic lore and primitive practices of their non-Han inhabitants, and excavations suggest that the tenor of life was more emphatically Confucian in Shandong than in Sichuan. The scale and diversity of the Han empire are reflected in the variety to be found in Han art.

Han Architecture

The tomb-architectural tradition was maintained, though large mounds were coming into use for imperial or noble burials. Subterranean tombs also continued into the Han dynasty; some of the finest objects of the period have been excavated from such tombs in Korea and in the south, especially near Changsha in Hunan.

We have no actual remains of Han architecture, but enough clay models used as burial substitutes have survived on which to establish a fairly clear picture. One such model house (*fig. 74*), very large (about four feet high), is of gray clay covered with white slip painted with red pigments, and there are other examples of the type, some with a green lead glaze. They show us the post-and-lintel structures with tile roofs characteristic of China until the present day. In most Chinese buildings the considerable weight of the roof is not borne by the walls, but is distributed down through the bracketing system to stout posts or columns. The walls proper are simply screens of clay on bamboo matting strung between the columns beneath the lintels. The basic unit of the system is the bay, that is, the single cube of space formed by the four columns with their lintels. The size of the bay is determined by the length of the lintels, which can be no longer than the tree trunk from which they are made—a maximum of forty to sixty feet. The building can be made bigger, then, only by adding more bays. The palace is simply such a building, made up of a number of the highest and

74. *Tomb model: house.* Painted earthenware; h. 52" (132.1 cm). China. Han dynasty. Nelson-Atkins Museum of Art, Kansas City

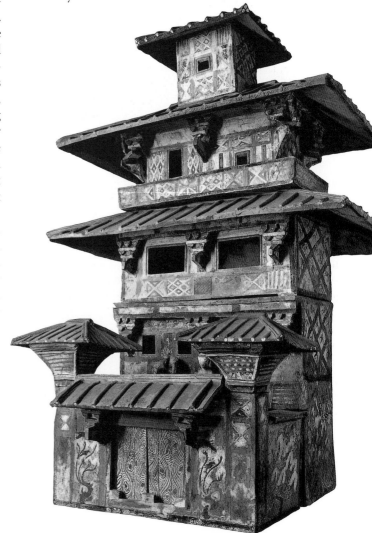

largest possible bays put together. Decoration was important and was achieved with inlays of metal, precious stone, and jade, or with colorful paint and lacquer. Contemporary literary descriptions portray the Han palaces as stupendously rich and sumptuous.

Town Planning

We also know something of the general layout of Han cities, whose arrangement became traditional. The city as a whole was geometrically oriented to the four cardinal directions. The emperor or (in provincial towns) his representative occupied the area north of the center of the city, which for geomantic reasons was sited, wherever possible, so that north of center was also the highest ground. Everything was oriented to the central authority, and the city became, in a sense, an imperial diagram of the universe, with the emperor taking the place of the sun above the center. The strict geometry of the plan echoes the jade shapes that symbolized heaven and earth, and the almost geometric social order advocated by Confucianism. Such an order was carried over into city planning. The informal, organic growth to be seen in a Japanese medieval town was uncommon in Chinese cities, although it might occur in small provincial villages.

The tower, as seen in the clay models, was important not only as a means of guarding cities but as one of the principal aids to hunting. It was used like a shooting box by archers who shot at birds attracted to it by bait. With the development of Buddhism, towers, now called pagodas, took numerous forms, their many roof lines influenced perhaps by King Kanishka's great stupa near Peshawar in Pakistan, with its thirteen-storied superstructure.

Han Painting

In Han painting the innovations and forward-looking styles of the late Zhou period continue and mature. At least two major styles are distinguishable, and a third, now becoming clear, may have to be taken into account. The formal, official style is rather stiff, geometric, almost hieratic, and stresses silhouette. The second, painterly style has already been seen in the lacquer bowl (*see fig. 66*) and the painted shells (*see fig. 69*) of the late Zhou period.

The excavation in 1971 of the tomb of the Marquise of Dai, near Changsha at Mawangdui in Hunan, has uncovered major original examples of Western Han painting. The tomb contained numerous well-preserved examples of early Han decorated lacquer utensils, a painted wooden sarcophagus (*fig. 75;* one of three ornate, nested coffins), and a number of textiles of various weaves (*fig. 76*), as well as the intact corpse of the well-fed marquise. The silk banner found draping the inner coffin (*fig. 77; cpl. 6, p. 118*) is accomplished in technique and complex in design. Its formal and balanced composition depicts the

75. *Sarcophagus of the Marquise of Dai.* Detail of outer coffin (of three); lacquered wood with polychrome designs of fantastic animals amid clouds; l. approx. 8'6" (2.45 m). Mawangdui, Changsha, Hunan, China. Western Han dynasty, c. 180 B.C.E.

76. *Embroidered silk fabric.* Three-color cloud pattern on plain terra-cotta-colored ground. Tomb of the Marquise of Dai, Mawangdui, Changsha, Hunan, China. Western Han dynasty, c. 180 B.C.E.

three world levels: the sky above with its mythical inhabitants—sun crow, moon toad, and celestial dragons; the earth in the middle with the marquise and her women attendants; and the nether regions with a burial grouping of ritual vessels and male (mourner?) figures, supported on serpentine beasts and earth spirits. In style the figures anticipate those on the painted basket from Lelang in Korea (*see figs. 80, 81*), with silhouettes similarly outlined in rapid linear brush strokes and a similar palette emphasizing red and yellow with accents of green and blue. This precious hanging painting gives us some inkling of the appearance of the large palace murals mentioned in Han literature.

The painted banner, however, is one of the very few Han paintings to survive. For the most part, stylistic developments in painting must be inferred from relief carving and lacquer painting of late Han. Usually one studies stone reliefs from rubbings, which are made by laying a thin layer of damp mulberry paper on the stone and pressing it into the crevices and carved areas. It is then lightly tapped with an inked pledget. The resulting "rubbing" can be reversed through a photographic process to achieve a black-on-white impression not unlike the original painting prototypes.

The formal style is epitomized by the famous reliefs at the Wu Liang Ci, the Wu family mausoleum in Shandong, called by the name of one of its occupants, Wu Liang, and dated about 147–151 C.E. Here the back-

77. *Drawing of painted banner, from Tomb of the Marquise of Dai.* Original: silk; l. 6'8³/4" (2.1 m). Mawangdui, near Changsha, Hunan, China. Western Han dynasty, c. 180 B.C.E. Historical Museum, Beijing(?)

78. (below) *Rubbing of stone relief.* H. approx. 36" (91.4 cm). Wu Liang Ci (Wu family shrines), Jiaxiang, Shandong, China. Eastern Han dynasty, c. 147–151 C.E.

79. *Banquet scene with orchestra.* Rubbing of stone relief. Yi'nan, Shandong, China. Eastern Han dynasty, late 2nd–early 3rd century C.E.

ground has been cut away to create the all-important silhouette in extremely low relief, the design is formal and static, the figures are carefully placed and spaced. Figure 78 shows two quite separate scenes. Below, a procession of chariots, mounted men, and footmen moves to the left. Over the heavy line that divides the two scenes and serves as ground line for the one above, a quite realistic scene of political homage is taking place inside the pavilion on the right, while an ancient legend is being enacted around the tree on the left. The Fusang tree has a stylized, almost late Zhou form, including the use of natural leaf forms as a decorative pattern and a trunk bent into an almost perfect late Zhou hook. Except for some overlapping—one of the most primitive ways of suggesting space—there is no indication of depth in this scene; everything is treated as if on one plane. Elsewhere at Wu Liang Ci depth is most crudely indicated, simply by placing one object or figure higher than another, with no indication of connection between foreground and background. In addition, almost no figures are shown in three-quarter view. The whole effect is archaic.

The iconography of the tomb is predominantly Confucian and extremely sophisticated and complex. Daoism is accommodated by reference to the legendary Queen Mother of the West (Xi Wang Mu) and the King Father of the East (Dong Wang Gong) and by lesser references to spirits, magical trees, and cult heroes. But the principal registers illustrate the main themes of Confucianism: order, hierarchy, filial piety, moderation, and virtue, as exemplified in Chinese history and in the Wu family record honored by the four shrines of the mausoleum. Figure 78 shows one of the most famous and complex of the reliefs. On the left the legendary archer Yi shoots nine of the ten sun crows around the Fusang Tree of the Sun, reducing the number of suns in the sky to one and thus preventing the threatened "immolation" of the earth—i.e., drought. In the large post-and-lintel building arriving dignitaries offer obeisance to their lord, whose eminence is indicated by his large size and central position, before proceeding to the banquet on the floor above.

The breed of horses that appears for the first time in these reliefs seems to have come from Central Asia. We read much about the excursions of the Han military into Central Asia for the express purpose of collecting horses—presumably these short-bodied, heavy-barreled specimens with large nostrils—from the nomadic peoples of that region.

Admirable later examples of the official style, with some influence of the freer painterly tradition of the south, are found in the tomb at Yi'nan, also in Shandong, dating from the late second or early third century C.E. These stone reliefs may well indicate the nature of the Han palace murals and the degree of maturity attained by the Han artist in composition (*fig. 79*). Judging from

80. *Scenes of Paragons of Filial Piety, from the Painted Basket.* Lacquer; l. 15³/₈" (39.1 cm). Lelang, Korea. Eastern Han dynasty. Central Historical Museum, Pyongyang

81. (below) Detail of fig. 80

these and other reliefs and from certain painted tiles, the human figure is handled with some ease and understanding and placed within a recognizable space.

One can see from the Yi'nan tombs that one important concept was already established by the third century C.E., and that is a systematic convention to indicate depth. All systems of perspective, however natural or "real," are nevertheless artificial. There are many of them, and the Yi'nan carvings are one early Chinese example. The diagonal tables lead back into a shallow space terminated by racks of hanging bells and musical jades. In the foreground, in the space defined by the slanting diagonal platform, are the musicians, ranged in echelon. The individual figures, though shown in three-quarter view, are stiff silhouettes, and the whole effect is formal, as is much Chinese figure painting of the immediately succeeding periods of Six Dynasties and Tang. One can imagine a

palace room decorated with balanced murals of banquet or hunting scenes containing carefully arranged and perfectly symmetrical perspectives.

The famous painted basket from the Chinese colony at Lelang in Korea is in the same formal, official style (*figs. 80, 81*). Lelang must have been a most important Han outpost, for many wonderful lacquers were found there in water-saturated, wood-lined subterranean tombs. The wicker basket with a lid is the most extraordinary of all the finds. The outside of the cover and the high interior sides over which the lid fits are painted with scenes of filial piety. It is interesting to find so appropriate a combination of official style and Confucian subject—a perfect meeting of form and content. We see somewhat the same handling of figures as in the tomb at Wu Liang Ci, though here the effect is more fluid and lively because we are looking at actual painting, even if in lacquer. Most of the

82. *Painted tile* (section). Polychrome painting on earthenware hollow tiles; h. 7¹/2" (19.1 cm), w. 7'10⁵/8" (2.4 m). China. 1st century C.E. Museum of Fine Arts, Boston

figures are silhouette-like, a few are in three-quarter view, and nearly all are isolated, with little overlapping. All occupy the same ground line, so there is no indication of depth. They appear, however, lively and animated. The inscriptions indicate the names of these paragons of filial piety, so we have again the full flavor of an official moralistic attitude. Filling the borders above and below are degenerated versions of the inlaid gold and silver decoration found on late Zhou bronzes.

In contrast to this official, formal style, and sometimes found alongside it, is a painterly style. Some lacquers from Lelang and Changsha offer most lively and suggestive renderings of movement in subjects consisting largely of mythical beings, dragons, and rabbits (*see fig. 75*). These figures seem to rush across the space, in part apparently propelled by the long lines behind and beneath, which suggest speed. This impression is also created in part by the brushwork, which is not calm and measured but extremely rapid and spontaneous. Here we have a treatment that seems to be applied particularly to themes involving everyday subjects or animals.

Painting on silk, of course, antedated the Han dynasty, as attested by late Zhou examples from Changsha, Hunan (*see fig. 67*). But the invention of paper circa 105 C.E. must have been a great stimulus to the development of brushwork, for paper is the most suitable ground

for that most flexible of all writing implements, the Chinese brush. On the famous painted tiles in the Boston Museum are numerous scenes, but one in particular shows what mastery of the brush had been achieved by the middle of the Han dynasty (*fig. 82*). The speed and flexibility of the brush are expressed in the line, and the brush stroke has become a means of defining character. The three-quarter view is skillfully used. The whole attitude and pose of each figure conveys something of the psychology of the person portrayed: the patient listener, the rather pompous talker, and the decorous and patient man waiting to get a word in edgewise. Notice too the skillful handling of the figure in three-quarter back view, who appears to be turning to the left within the shallow space. At the same time the placement of the figures in space is primitive. They all appear to be on the same ground line, and no setting is indicated. But great progress can be seen here toward the use of the brush in a typically Chinese manner for figure painting. From this to the famous scroll *Admonitions of the Instructress* (*see figs. 368, 370–71*), the earliest extant great Chinese painting, is no great distance.

A third type of painting can now be assumed from the evidence of some extraordinary molded relief tiles excavated from tombs in Sichuan Province in west China. One such tile, divided horizontally, shows two scenes:

83. *Rubbing of earthenware tile with scenes of hunting (above) and harvesting (below)*. H. 16¹/₂" (41.9 cm). Chengdu, Sichuan, China. Han dynasty. Richard Rudolph collection, California

Above, a stream full of ducks, fish, and lotuses winds into the distance, while two hunters on the bank shoot at flying ducks; below, five men harvest grain while a sixth brings lunch (*fig. 83*). The depiction is lively and naturalistic, not unlike the scenes on the painted shells (*see fig. 69*), in contrast to the static style of the stone reliefs at Wu Liang Ci and Yi'nan. Recession in space is confidently indicated by the diminishing size of animals and plants, by the spit of land extending diagonally behind the hunters, and by the harvesters in echelon. We may reasonably assume that some Han painters shared this organized and intuitive feeling for space and for the naturalistic handling of human and animal figures.

The close similarity between Han painting and pictorial decoration in stone is clearly attested by two tombs excavated in 1960–1961 in Mi Xian, southwest of Zhengzhou in central Henan Province, and judged to be contemporary. One is decorated entirely with carving and incising, the other with painted murals. Both are in advanced late Han pictorial style, related to the manner seen on the Painted Basket (*see fig. 80*), and both depict banqueting scenes with jugglers and musicians perform-

84. *Horse.* Stone; h. 6'2" (1.88 m), l. 6'3" (1.91 m). Tomb of Huo Qubing, Xingping Xian, Shaanxi, China. Western Han dynasty, c. 117 B.C.E. Shaanxi Provincial Museum

Han Sculpture

ing. Our rudimentary conceptions of Han painting will undoubtedly undergo revision as more such material becomes known.

Though small earthenware burial figurines have survived in great numbers, large formal sculptural monuments are exceedingly rare. Those we do have are in several different styles, but on the whole the extant material is dominated by a certain powerful if slightly crude naturalism, with occasional memories of the late Animal style. The combat motif at the tomb of Huo Qubing recalls Shang motifs and the Animal style. The sculpture of a horse with an incidental figure of a man at this tomb is solidly contained within the stone block (*fig. 84*). The direct realism of the horses from Shi Huang Di's tomb is modified here by more formal considerations. The horse, though in the round, is blocklike, and the stone is not cut away beneath. The ribs of the man and the muscles of the horse's legs are indicated by grooving rather than by modeling in relief. The head with the heavy cheek crescent is a characteristic Chinese rendering, even more noticeable later on. At the same tomb, in a carving in relatively low relief on the surface of a large boulder, a bear wrestles with a large ogre-like man with extraordinarily prominent incisors. As the

86. *Flying horse.* Bronze; h. 13¹/₂" (34.3 cm). Wuwei, Gansu, China. Eastern Han dynasty, 2nd century C.E. Historical Museum, Beijing(?)

85. *Funeral pillar of Governor Shen.* Stone; h. 8'9" (2.67 m). Qu Xian, Sichuan, China. Eastern Han dynasty, 2nd century C.E.

87. *Ritual object in the form of two bulls and a tiger.* Bronze; h. 16⁷/₈" (42.9 cm). Lijiashan, Yunnan, China. Western Han dynasty, 3rd–2nd century B.C.E. Yunnan Provincial Museum

shape of the horse follows the contours of the original four-square block, this figure follows the natural form of the original boulder. Such relative limitation—or better, such respect for the original material—is characteristic of most archaic sculpture. The development of sculpture, from a lack of desire to interfere with the stone to a growing virtuosity that delights in cutting into the block, is characteristic of most Western as well as Oriental sculptural styles.

The funeral pillar of the provincial governor Shen is a stone imitation of a tower with a tile roof (*fig. 85*). Under the roof are stone renderings of architectural bracketing and of scenes of combat: a nude warrior with a bow shooting at an oxlike animal, while being pursued in turn by a dragon; and a running figure with flying birds. The scenes occur on the surface of the architectural details: A monkey hangs under the bracketing, the

dragon cuts across the architrave. The sculpture has burst the bounds of the simulated architecture.

This vigorous and precocious naturalism has its epitome in the bronze figurines representing an equine entourage found in the tomb of a governor-general Zhang at Wuwei in Gansu, also of the second century C.E. (*fig. 86*). In our knowledge of Eastern Han sculpture, their realism of pose and movement is new and sophisticated. The swallow depicted beneath the rear right hoof of the galloping horse may refer to the name of the steed—the Chinese having a penchant for the poetic naming of the spirited horses they so much admired.

Far to the southwest a unique group of bronze objects and sculptures was found between 1955 and 1960 at Shizhaishan, not far from Kunming in Yunnan Province. Here from about the fourth century B.C.E. a provincial kingdom called Dian flourished, ethnically

88. *Tomb figurine: mastiff.* Earthenware; h. approx. 11" (27.9 cm). China. Han dynasty. Musée Cernuschi, Paris

distinct from Han China, to which it became subject in 109 B.C.E. The bronze figures of animals and humans are sleekly and naturalistically modeled and cast by the lost-wax process. Their manner owes something to the Animal style of Central Asia and may well have relationships with the bronze artifacts of the Dong Son culture of Southeast Asia. The bronze ritual object (*fig. 87*) is one of the most surprising objects yet found in the continuing excavations in China. The inventiveness of the composition—the arbitrarily hollowed major figure of the bull, its smaller counterpart in the interstice, and the vigorously attacking feline with parallel incised lines of decoration—creates an almost surrealistic modern effect. Human figure groups from Shizhaishan are also remarkable for their complexity and naturalism, but with an overall look that suggests both Chinese and Indian elements.

Han Tomb Figurines

The seated mastiff in the Musée Cernuschi is one of thousands of appealing animals in the Han ceramic menagerie of tomb figurines (*fig. 88*). Some are of clay alone, others of gray clay with a covering of white slip, and still others

89. *Tomb figurine: seated man cupping his ear.* Earthenware; h. 21⁵/8" (54.9 cm). Sichuan, China. Eastern Han dynasty. Palace Museum, Beijing

have an olive or deep green lead glaze that deteriorates on burial and becomes iridescent, an effect treasured by collectors and museums. The mastiff in gray clay with white slip decoration is admirable for its knowing naturalism. Sculptors of these figures knew animals so thoroughly—pigs, chickens, and other favorite subjects—that they produced them in a rough-and-ready naturalistic style with no thought of formal decorative development. Tomb figurines give us a glimpse of Han culture and are some of the best documents of the life of the folk.

Excavations in Sichuan have increasingly disclosed the amazing civilization of that western province, anciently called Shu, from Shang through early Ming times. Of all the finds, the most refreshing have been the many realistic and lively clay tomb figurines of Han date uncovered in recent years (*fig. 89*). These evince a keen interest in and zest for the activities of everyday life. Many

of them are entertainers—musicians, actors, story-tellers, jesters, jugglers, dancers—depicted in performance with a verve and naturalism sometimes transformed into caricature. In Sichuan, at least, the Han tomb was a jocund place. On the whole these figures are large—up to half life size—and their modeling shows little concern for finish but a truly amazing freedom and spontaneity. They are among the best examples of Han naturalism.

Han Metalwork

The discovery in 1968 of the rupestrial tombs of Prince Liu Sheng (d. 113 B.C.E.) and his wife, Princess Dou Wan, at Mancheng in Hebei, about eighty-seven miles southwest of Beijing, added a wealth of material to previously known significant Han metalwork. Their grave goods were an even more spectacular find than those of Fu Hao from Shang dynasty Anyang. In addition to the two now famous but aesthetically unrewarding jade burial suits, almost three thousand objects in various materials were found, including some of the most beautiful and elaborate metalwork, proof conclusive of the continuation of late Zhou technology and inventiveness into the early Han period. The gilt bronze lamp bearer (*fig. 90*) is not only an ingenious device—the lamp has a sliding door to control the amount and direction of light, and the smoke is vented to the rear via the servant's hollow sleeve—but also a convincing representation of a kneeling and offering figure. The realism of pose and garment owes much to the innovations of late Zhou and of Qin. The gold-inlaid bronze censer (*fig. 91*), with its pierced lid of mountains inhabited by birds, animals, and huntsmen, surely embodies an aristocratic taste for elegant technique, sophisticated representation, and knowing symbolism.

Mirrors too continue to be well cast, and the designs of the backs show new creativity. One, called the TLV type because of the apparent Ts, Ls, and Vs in the pattern, usually dates from Western Han and is an adaptation of a sundial design, thus making the back of the mirror into a cosmic symbol. All of the design elements—the mountain in the middle, the animals symbolic of the four directions, and the Ts, Ls, and Vs—are related to solar orientation, and the mirror, a source of light and insight, is a figurative sun. The fantastic animals of the four directions are portrayed in thread relief. Characteristic of Eastern Han are mirrors on which the cosmic diagram is treated more naturalistically. Some were cast in stone molds, a method largely limited to the Eastern Han period. Instead of the sundial design, a frieze of symbolic animals or figures might be depicted, in the official, formal style. In figure 92 the decoration consists of the deities of east and west, Dong Wang Gong and Xi Wang Mu respectively, and two horse-drawn carriages bearing figures, presumably Immortals. This mirror too is a cosmic symbol, but its design may derive from scroll or wall painting.

90. *Lamp in the form of a young girl.* Gilt bronze; h. 18⁷/₈" (47.9 cm). Tomb of Dou Wan, Mancheng, Hebei, China. Western Han dynasty, late 2nd century B.C.E. Hebei Provincial Museum

91. *Censer.* Bronze with gold inlay; h. 10¹/₄"(26 cm). Tomb of Liu Sheng, Mancheng, Hebei, China. Western Han dynasty, c. 113 B.C.E. Hebei Provincial Museum

92. *Mirror.* Dated to 174 C.E. Bronze; diam. 8¹/₄" (21 cm). China. Eastern Han dynasty. Freer Gallery of Art, Smithsonian Institution, Washington, D.C.

Han Ceramic Vessels

Han ceramic vessels served for daily use and as grave goods. The latter were most often lead glazed, a technique which appears to be an importation from the Mediterranean world. One of the most characteristic forms of lead-glazed burial pottery is the "hill jar," a cylinder on three bear-shaped legs, with a cover representing the magic mountain, the axis of the universe. The Chinese have always had great reverence for mountains, and mountains become the dominant element in Chinese landscape painting, called mountain-and-water pictures. On the hill-jar cover the waves of the world-sea lap at the base of the world-mountain. The bodies of such jars often show a frieze of animal combat or hunting scenes coupled with representations of Daoist sage-wanderers. These are executed in a style already seen on late Zhou bronzes. A rarer type of burial ceramic is covered with white slip and painted designs, closely related to the kind of painting on the painted tiles in figure 82.

For daily use, iron-glazed stoneware—the origin of later Chinese ceramics—continued to be developed and refined. Han potters learned to cover the whole pot with a uniform and rather thick glaze whose olive color was derived from iron oxide. This ware was produced in south China, not far from present-day Shanghai, and is called Yue ware (*fig. 93*). It is an important name. Yue, the first

93. *Basin.* Yue ware, with incised fish decor in center; diam. 13¹/₄" (33.7 cm). Shaoxing, Zhejiang, China. Eastern Han dynasty or early Six Dynasties. Percival David Foundation of Chinese Art, London

94. *Damask with design of mountains and birds.* Silk; w. 12" (30.5 cm). Noin-Ula, Mongolia. Han dynasty. The State Hermitage, St. Petersburg

of the classic Chinese wares, approached excellence toward the end of the Han dynasty and continued to be made from Han until early Song times—from the second through the tenth century C.E. It was the ancestor of the celadon tradition.

Han Textiles

We will examine only two samples of the textile arts, simply to know that they existed, and on a very high level. Sir Aurel Stein, Peter K. Kozlov, and others found remnants of textiles in Central Asia. Some, such as the one illustrated in figure 94, have stylized designs of mountains, trees, and birds. In this silk damask the two mountains are constructed in a rather geometric, stepped pyramid fashion, and the trees look like enlarged mushrooms. A bird sits on each mountain, on either side of the central tree motif, making a balanced, formal design—a distant ancestor of the great landscape tradition of later Chinese painting. Other complex weaves and embroideries have been found, many with allover patterns of hooks or interlocked diamonds recalling the bronze designs of the late Zhou period (*see fig. 76*).

KOREA

As a peninsula situated between China and Japan, Korea was a major transmitter of cultural influences from the mainland to the islands. It also was an originator at various times, including the later Bronze Age.

Settled agriculture and the use of bronze and iron reached Korea from China before the establishment in the third century B.C.E. of the first true Korean state, Choson. To secure China's borders against the nomads of Central Asia, Han Wu Di (r. 140–87 B.C.E.) overthrew Choson and incorporated Korea into the empire in 108 B.C.E. Chinese control proved ephemeral, however, except in the west, where Lelang (K: Naknang) and later Taifang (K: Taipang), heavily settled by Chinese immigrants, outlasted the Han dynasty by more than a century. Chinese characters were used for writing, and the Confucian classics became the enduring basis of Korean education. Many of the objects found at Lelang, like the painted lacquer basket in figure 80, were certainly imported from China.

Eastern and southern Korea were the setting of a remarkable royal culture, referred to as the Three Kingdoms, after the competing states of Koguryo, Silla, and Paekche, all founded in the second half of the first century B.C.E. and coexisting turbulently till Silla's triumph over the other two in the seventh century. Partly contemporary with these was an enclave of tiny leagued states at the southeastern tip of the peninsula, called Kaya (or Mimana, by the Japanese). Kaya maintained trade relations with Japan, and apparently some political-military alliance as well, till it was overrun by its much larger neighbors, Paekche and Silla, in 562 C.E. All these kingdoms were influenced by Chinese culture and institutions in varying

95. *Crown.* Gold; h. 17$^{1}/_{2}$" (44.5 cm). Gold Crown tomb, Kyongju, Korea. Old Silla period, 5th–6th century C.E. Kyongju National Museum

96. *Globular food jar with two lug handles.* Gray stoneware with accidental ash glaze; h. 11$^{1}/_{2}$" (29.2 cm). Kaya, Korea. Three Kingdoms period, 57 B.C.E.–562 C.E. Seattle Art Museum

respects and degrees. Silla, the most remote from China geographically, shows the greatest independence from China in its customs and its arts.

Silla gold work during this time was the most accomplished and spectacular in East Asia. Gold crowns with sheet, twisted, and granulated ornamentation (*fig. 95*) are unique products from royal tombs. Their basic structure, representing geometricized trees and relatively realistic antler forms, evokes shamanistic practices of the Siberian area, and their additional ornaments of comma-shaped jade and quartz beads certainly inspired the *magatama* ornaments found in Japanese Kofun tombs. These crowns owe nothing to Chinese types but were a major source for Japanese crowns and headdresses, including those on early Buddhist images.

Gray stoneware vessels from Silla tombs, in purely utilitarian (*fig. 96*) and symbolic figurative (*fig. 97*) shapes, are remarkable for their individuality and their anticipation of the later Korean ceramic tradition. Clearly Korean ceramics also influenced the earthenware and stoneware of the Kofun period in Japan, especially the almost identical Sue wares, the first high-fired stonewares of the island empire.

Utilitarian vessels whose shapes incorporate figural representation, such as the ewer in figure 97, are another Korean innovation, perhaps derived from a type of Neolithic ceramic urn in which part of the rim was mod-

97. *Ewer in the shape of a warrior on horseback.* Ash-glazed gray stoneware; h. 9$^{1}/_{4}$" (23.5 cm). Gold Bell tomb, Kyongju, Korea. Old Silla period, 5th–7th century C.E. Kyongju National Museum

eled as a human head. This type was known in China and Japan as well as Korea. But the incorporation of so complex a combination as a horse and rider is an especially imaginative creation. The ewer here shows a noble warrior; a second such ewer from the Gold Bell tomb at Kyongju probably represents a plebe or servant. Comparison with actual gilt bronze tack found in this and other burials proves the horse harness and trappings on the ewer to be accurate, if somewhat simplified, renditions.

Bronze mirrors and scabbards in styles distinctive to Korea have been excavated from tombs of about the second century B.C.E., just before the Three Kingdoms period. Their decoration of refined and detailed geometric patterns was created by engraving in the steatite molds. These and double-edged bronze swords (shaped somewhat like Western straight cavalry sabers) also find their echoes in Japanese material of the Kofun period. References in early Japanese historical texts (especially the *Nihon Shoki*) to Korea of the Three Kingdoms period, and to the importation of artisans from Korea at that time, are thus confirmed by the archaeological record.

JAPAN

The Neolithic Jomon culture was succeeded by an age termed "bronze-iron" by J. Edward Kidder, for bronze and iron appeared in Japan at virtually the same time. Its most characteristic culture is called Yayoi, after the Tokyo neighborhood where its refined pottery, typically plain but sometimes incised, was found (*fig. 98*). The cultural development of these peoples seems from archaeological investigation to have been stimulated by invaders from Korea bringing advanced agricultural techniques, most importantly wet-rice cultivation, which requires irrigation and therefore considerable social organization. Textile weaving also appears about this time, or a little earlier. The invaders also brought the art of bronze casting, as well as many bronze objects, including mirrors in Han style from China. Profiting by such advanced skills, the Yayoi peoples, or perhaps neighboring clans, cast bronze bells called *dotaku* (*fig. 99*). These are imposing in shape, and some have low relief decoration of houses, boats, animals, or scenes of everyday life—hunting, fishing, and cultivating—in an amusing, primitive "stick-figure" style. They have been found mostly in the Kyoto-Nara-Osaka region.

But the most intriguing arts of pre-Buddhist Japan are those of the Kofun (Old Tomb), or protohistoric, period, the age of ancient burial mounds and bronze tomb furnishings, which began perhaps in the third century C.E. and lasted in parts of Japan into the seventh century. This period saw the rise of the imperial Yamato clan, for whom most of the great burial mounds were made. It was a time of immense activity, when the

98. *Jar.* Earthenware; h. approx. 10" (25.4 cm). Japan. Prehistoric period, Yayoi culture. Tokyo National Museum

Japanese seized eagerly on the arts brought from the mainland but at the same time produced clay sculptures called *haniwa*, completely native in style and radically different from mainland burial figurines.

Characteristic of the later Japanese Bronze Age are large mound-tombs. An aerial view of the tomb of the emperor Nintoku, not far from Osaka, reveals a great keyhole-shaped mound or tumulus surrounded by three moats, the whole originally occupying a space almost half a mile long (*fig. 100*). Many objects of jasper, glass, jade, and gilt bronze are found in tombs of this type, including the well-known *magatama*, comma-shaped beads derived from Korea, often made of highly polished jade of jewel quality.

The architecture of the protohistoric period is far advanced over the Neolithic circular pit dwellings characteristic of the Jomon and early Yayoi phases. It contains much that we now consider typically Japanese, particularly the subtle but direct use of unpainted and undecorated wood, thatch or shingle roofing, wooden piles or columns to raise the structure, and a sympathetic adaptation of the architecture to the natural environment. Several existing Shinto shrines are traditionally associated with the protohistoric period, notably those at Izumo and Ise. Though periodically—and at Ise ritually—rebuilt, these two seem to be reasonably authentic documents of the early building styles. Izumo Shrine is the more "primitive" of the

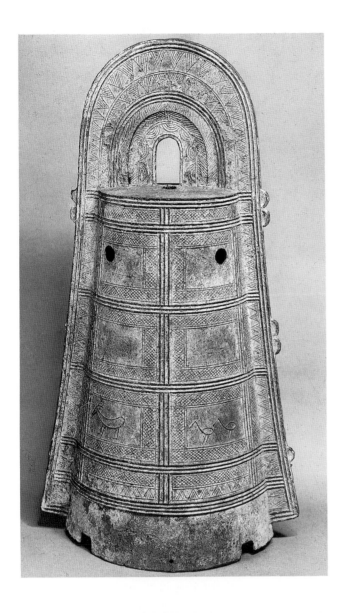

99. *Dotaku*. Bronze; h. 16¹/₂" (41.9 cm). Japan. Prehistoric period, Yayoi culture. Tokyo National Museum

100. (below) *Tomb of Emperor Nintoku*. Near Osaka, Japan. Aerial view. 5th century C.E.

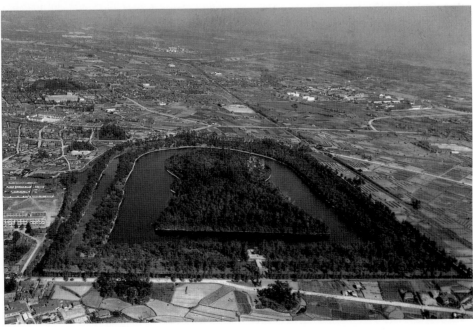

101. *Shrine.* Izumo, Japan

102. *Inner Shrine, Ise.* Sanctuary of the Shinto Sun Goddess, founder of the imperial line. Mie Prefecture, Japan. According to tradition, erected early 1st century C.E., ritually rebuilt of cypress wood some 60 times since. Last rebuilt 1973

103. *Haniwa: warrior in armor.* Earthenware;
h. 25" (63.5 cm). Japan. 3rd–6th century
C.E. Negishi collection, Saitama

two; it is entered on the short side and incorporates the casual asymmetry of a peasant dwelling (*fig. 101*). One cannot but remark on the similarity of these buildings to those still used in Indonesia, notably by the Batak of Sumatra.

The more balanced arrangement of the three buildings of the inner area at Ise (*fig. 102*), as well as the central entrances on the long sides of buildings, suggests an awareness of Korean or Chinese architecture on the part of the Japanese builder of the later protohistoric period. The magnificent setting in the Ise forest dominates the shrine, which seems an integral part of its surroundings. The later Japanese penchant for cloaking sophistication in unpretentious plainness, so evident in the arts of Zen and

in the tea ceremony, finds precedent in the simple, rustic buildings at Izumo and Ise.

Haniwa, meaning literally "circle of clay," were sometimes simply clay cylinders placed around a grave mound or tumulus to strengthen the sides of the mound and prevent earth washouts. Never used as furnishings within the tomb, they were placed tightly together, one against the other, like a picket fence around the grave mound. Some with a head at the top may represent the survival of a primitive type. But the *haniwa* that interest us are rather highly developed. The base remains cylindrical, but set on the base are many lively subjects: human figures singing in chorus, warriors in armor, coy ladies, animals, birds, and even houses (*figs. 103, 104*). Like the Han dynasty

104. *Haniwa: horse.* Earthenware; l. 26" (66 cm). Japan. 3rd–6th century C.E. Cleveland Museum of Art

figurines, which they do not at all resemble, these *haniwa* served as tomb guardians and attendants to the deceased rulers and aristocrats. They give us some idea of the early life of Japan. The technique of the *haniwa* maker was designed to emphasize the material, to use clay so that the object seems to derive from it. The material dominates the concept: tubes of clay, ribbons of clay, slabs of clay. In Chinese tomb figurines, on the other hand, the artist tends to dominate the material. In this difference we find one of the two fundamental distinctions between Japanese and Chinese art. A *haniwa* horse (*fig. 104*) is totally unlike a Chinese horse. The modeling of the head, like that of a toy horse, shows no indication of a cheekbone, no interest in the structure of the eyes or the nostrils. Rather, marks are placed here and there: this is a nose, this is an eye; but the mark is dictated by the nature of the material. To contemporary artists, the *haniwa* figures, with their bold, geometrical, simplified shapes, and their respectful use of clay, are among the most interesting of ancient sculptures.

Their red color, combed surfaces, and relatively large size distinguish *haniwa* sharply from Han burial figurines, usually smaller and lead glazed, and from Korean tomb furniture, which is gray to black and relatively high-fired. What *haniwa* have in common with the Korean figurines is simplified depiction and rough, rapid execution. This resemblance, and the presence in Kofun excavations of bronze mirrors imported from China or copied after such imports, suggests contacts with Korea and China. The Jomon and Yayoi traditions would have provided Japanese leavening for the imported representational style and methods.

PART TWO

The International Influence of Buddhist Art

5

Early
Art
in
India

At no time in history has the great Indian subcontinent been wholly unified politically. In the span of centuries discussed in this chapter—the sixth century B.C.E. to the end of the third century C.E.—only three polities enjoyed significant extent and duration. The first and largest was the empire of the Mauryas (322–185 B.C.E.), who for about one century ruled most of India from their capital at Pataliputra (modern Patna in Bihar), and whose most famous king is Ashoka (r. c. 268–231 B.C.E.), an enlightened and effective ruler and an enthusiastic convert to Buddhism. The second empire, less extensive, was created by the Andhra, or Satavahana, dynasts in the northwest Deccan, and at its height in the second century C.E. extended from coast to coast across the Deccan. Contemporary with the Satavahana kings were the Kushans, invaders from Bactria (present-day Afghanistan) who in the second century C.E., under their most famous kings, Kanishka I and Huvishka, ruled northern India to Varanasi or beyond, as well as extensive domains in Central Asia. It must be remembered that the chronologies and boundaries of even these states are most imprecisely known, and that their dynastic names are employed in this book for convenience only.

From the period between the destruction of the Indus Valley civilization and about the fourth century B.C.E. few significant objects remain, principally bronze weapons and small sculptures. This leaves a gap in our knowledge of Indian culture and art. For about a millennium society seems to have reverted to ruralism, but beginning about the sixth century B.C.E. a city architecture developed; the distinctive forms of palaces and dwellings, shrines and temples, are known to us from their representations in early sculptural reliefs at Bhaja, Bharhut, and Sanchi. Aside from their foundations these early structures were largely of wood and have disappeared. There undoubtedly was sculpture too, probably of wood and clay, as well as painting on perishable grounds. The literature of these centuries, the philosophical *Upanishads* and the great epic poems, the *Mahabharata* and the *Ramayana,* gives us much evidence of ideals, values, customs, rites, and ways of life. But of objects we have very few until the rise of Buddhism and its eventual adoption as a state religion by the emperor Ashoka, which generated a considerable production of sculpture.

Early Indian art is considered either Buddhist or Hindu according to its iconography, not its style. Sculpture workshops in the Maurya, Shunga, Kushan, and Gupta periods undoubtedly produced images for all sects, bringing the same general style to the service of quite different iconographies. Iconography may affect

style: Images embodying quietist concepts are generally peaceful in appearance, whereas the terrible manifestations of deity demand to be rendered dynamically.

Sculptural remains of the Maurya period are half Buddhist, half Hindu; those of the Shunga, Kushan, and early and late Gupta periods are predominantly Buddhist. Except in eastern India, the medieval periods are overwhelmingly represented by Hindu remains. Whether these ratios reflect contemporaneous patronage or accidents of survival and retrieval, we cannot tell. Over time, however, the classic style of the late Gupta period came increasingly to be applied to Hindu sculptures.

To treat Buddhist and Hindu works in separate chapters, as we do, does not imply stylistic difference or doctrinal precedence. Rather, this presentation reflects what we actually know about the art of India: that Buddhist art expanded to East Asia and declined in the land of its birth and development, while Hindu art, only modestly in evidence during the early Buddhist centuries, rapidly became an avalanche of creative imagery.

The Buddha's traditional dates are c. 563–c. 483 B.C.E. We know that he was a prince, probably from the region of Nepal, and that in his lifetime he was a great teacher of ethics. We do not know that he claimed religious leadership or attempted to form a religious order. But his world was undergoing rapid and violent political and social change, and in the resulting instability and uncertainty the Buddha's teachings must have become a source of great moral strength to the people who knew him. His relationship to earlier Indian thought, Brahmanism, was that of a reformer rather than a revolutionary. He attempted to modify, reinterpret, and revivify the teachings laid down in the earlier religious texts. He preached a very simple message: that the world was fundamentally illusory, impermanent, and painful, and that the only way of fulfillment was to escape from the Wheel of Existence, an escape to be accomplished through nonattachment, meditation, and good works. This message is contained in the historic Sermon of the Buddha in the Deer Park at Sarnath, near Varanasi, which corresponds in Buddhist tradition to the Christian Sermon on the Mount:

There is a middle path, a path which opens the eyes and bestows understanding, which leads to peace of mind, to the higher wisdom, to full enlightenment. What is that middle path? Verily it is this noble eightfold path; that is to say: Right views; Right aspirations; Right speech; Right conduct; Right livelihood; Right effort; Right mindfulness; Right contemplation.

This is the truth concerning suffering. Birth is attended with pain, decay is painful, disease is painful, death is painful, union with the unpleasant is painful, separation from the pleasant is painful.

These six aggregates which spring from attachment are painful.

This is the truth concerning the origin of suffering. It is that thirst accompanied by starving after a gratification or success in this life, or the craving for a future life.

This is the truth concerning the destruction of suffering. It is the destruction of this very thirst, the harboring no longer of this thirst.

And now this knowledge and this insight has arisen within me. Immovable is the emancipation of my heart. This is my last existence. There will now be no rebirth for me.[3]

Despite his idea that the world was illusory, he taught moral behavior, kindness, and love as means of coping with worldly problems.

The development of Buddhist thought after the Buddha's death is the story of a faith that commanded a powerful following with extraordinary rapidity. Soon after his death orders were formed for both men and women, although there was at first great objection to an order of nuns. The events in the Buddha's life were codified. Eight were chosen as being of particular importance: the story of his supernatural Birth from the side of his mother, Queen Maya; the story of his Renunciation of the princely life after encounters with a beggar, a sick man, a corpse, and an ascetic; his Meditation in the forest; his Assault by Mara, the demon of evil, in an attempt to force him to abandon his meditations; his final Enlightenment under the *bodhi* tree; the Preaching of the message of enlightenment at Sarnath; the great Miracle of Shravasti; and finally the *Parinirvana*, not a death, but an end to further reincarnation: he has become the Buddha.

As ethical mainsprings of his teaching, the Buddha adopted the ideas of karma and rebirth, both current in the India of his day. Good intentions, acted upon, generate good karma, evil intentions, regardless of the ensuing actions, beget evil karma. Accumulated karma determines one's next rebirth (whether as divinity, human, animal, "hungry ghost," or denizen of hell), and rebirths may be endless. Only right understanding, attained through the mental discipline of meditation, and right action, born of right understanding, create the karma that leads to enlightenment and an end to rebirths (nirvana). No deities or intercessors intervene in this process—one's liberation from the Wheel of Existence depends wholly on oneself.

This, in barest outline, is the essence of the Theravada (Teaching of the Elders) tradition of Buddhism, sometimes called Hinayana (Lesser Vehicle). Currently practiced in Sri Lanka, Burma, Thailand, Cambodia, and Vietnam, it is regarded by its adherents as closest to the original teachings of the Buddha. The Mahayana (Greater Vehicle) tradition, which originated in the first century C.E., accepts these teachings but subjects them to a differ-

ent emphasis. To the Theravadin ideal figure of the arhat, who has attained individual enlightenment through individual effort, Mahayana opposes the bodhisattva, who, having attained enlightenment, forgoes nirvana to help all sentient beings along the same path. Mahayana teachings quickly transmuted the bodhisattvas from exemplars and helpers into intercessors and saviors, whose supreme characteristic was compassion. The complex theologies and rituals developed by Mahayana brought Buddhism into relation with the whole scheme and tradition of Indian thought.

Buddhism, like Christianity, is a proselytizing religion, and it spread rapidly—thanks in great measure to the conversion of the Maurya (central Indian) emperor Ashoka (r. c. 268–231 B.C.E.) and the Kushan (northwest Indian) ruler Kanishka (r. c. 120–162 C.E.)—through Central Asia to China and Japan and across the Indian Ocean to Indochina and Indonesia. The majority of the later works of Buddhist art outside of India are products of the Mahayana faith.

Contemporary with the Buddha was another teacher, Mahavira (c. 548–c. 476 B.C.E.), who also preached a reformed faith, quite comparable to Buddhism, with certain major exceptions. These are, notably, a concept of a soul and free will not encompassed by Buddhism and an extreme dualism of spirit and body, which the Buddha did not acknowledge. Like Buddhism, this faith, called Jainism, developed into a complex theological system with esoteric overtones and complexities hardly thought of by its founder. The sculptural monuments left to us by Jainism are almost as important as those of Buddhism, particularly in the Kushan art of Mathura. But Buddhism became the great evangelical faith of Asia and consequently is the religion that has excited the imaginations of countless Orientals and Westerners.

Little is known of art just before the earliest productions of the Buddhist artist. Various forest cults, perhaps stemming from the Dravidian fertility cults of the Indus Valley civilization, must have used shrines and images, but these are now lost except for one or two isolated sculptures and literary references. The coming of Alexander the Great to the Indus River in 327 B.C.E. had little effect on India, which would not receive the impact of the Mediterranean world till the time of imperial Rome.

MAURYA ART

The earliest Buddhist monuments extant were produced in the Maurya period (322–185 B.C.E.), notably works ordered by the emperor Ashoka, who was himself converted and adopted the Buddhist Law of Piety as the law of his lands. To commemorate his conversion and to expand the teaching of the faith he ordered many stone memorial columns to be set up at points associated with

105. *Lion capital.* Polished Chunar sandstone; h. 7' (2.13 m). Ashoka column, Sarnath, Uttar Pradesh, India. Maurya period, c. 274–237 B.C.E. Museum of Archaeology, Sarnath

important events of the Buddha's life. These monoliths, in a smooth aristocratic style that had little effect on later Indian art, reveal the influence of Persia. Made of beautiful cream-colored Chunar sandstone, they were of considerable size. Great shafts with the edicts of Ashoka engraved near their bases were each crowned by an animal or animals on a bell-shaped capital recalling those of the Achaemenid empire of Darius and Xerxes in Persia. The capitals were highly polished by a process requiring considerable technical skill. This too is thought to reflect the official and hieratic style of Achaemenid sculpture, and has been called the "Maurya polish"; but many have questioned the accuracy of this designation, since the

technique could reasonably have continued beyond that period. The best preserved of these great columns is the one excavated at Sarnath and now kept at the museum there (*fig. 105*). Most of the columns have fallen, and the capitals have consequently been moved to museums. The Sarnath capital is bell-shaped and surmounted by a frieze with four animals and four wheels in relief which, in turn, is surmounted by four lions back to back. The lions themselves are remarkably like those of Persepolis and Susa, in Persia. The stylization of the face, particularly of the nose and whiskers on the upper part of the jaw, the rather careful rhythm and neat barbering of the mane, the representation of the forelegs by long, sinewy indentations and, especially, the stylization of the claws, separated by deep clefts, and the slightly hunched posture of the animals— all these are elements to be found in the representations of lions at Persepolis. The representations on the frieze are more unusual. The horse, the best preserved of the four figures in relief, has that sympathetic naturalism we have learned to expect from the Indian sculptor. Despite the stylization of its mane, the treatment of its body and legs shows a much less decorative intention than does the treatment of the lions above.

The subject matter is of great symbolic import because the lion is the symbol of royalty, and the Buddha, described in the texts as the lion of the Shakya clan, was himself of royal blood. The wheels on the frieze are symbols of the Buddha's Law, and later representations of the Buddha show his hands in the motion of teaching, or turning the Wheel, symbolic of his preaching the Sermon at Sarnath, where he "set the Wheel of the Law in motion." But the other representations are more difficult to explain. The animals represented may perhaps be those associated with the four directions, or they may symbolize lesser deities of the Hindu pantheon as it existed at that time. The horse, in particular, is associated with Surya, the sun god who travels across the sky in a chariot, as Apollo, the Greek sun god, did. The Brahmany bull, which in the illustration can just barely be seen on the right of the frieze, is associated with the great god Shiva, one of the two most important male deities of the later Hindu pantheon. The elephant was the vehicle of Indra, the lion of Durga. It has been suggested that the animals on the base represent such non-Buddhist deities at the service of the Buddha. The column from Rampurva has, in addition to the now familiar bell-shaped capital, a frieze of water flowers and plants, motifs that become extremely important in later Buddhist art. The frieze is surmounted by a bull whose body is carved in the round but whose legs emerge from the block, for the functional reason that freestanding legs could not have supported the weight of the stone body (*fig. 106*). This treatment does, strangely enough, recall certain Hittite and Persian versions of the bull, which treat the area below the stomach

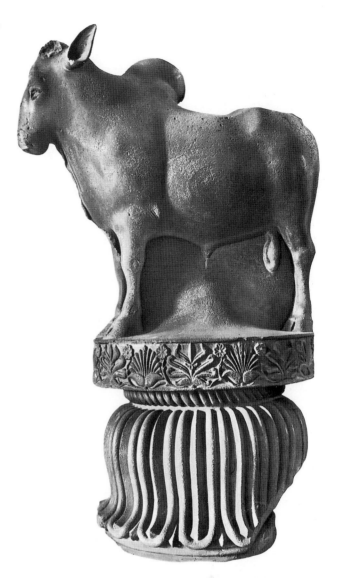

106. *Bull capital.* Polished Chunar sandstone; h. 8'9" (2.67 m). Rampurva, Bihar, India. Maurya period, c. 274–237 B.C.E. National Museum, New Delhi

as a block, on which the genitalia are shown in relief. But the style of the animal itself has none of the awesome and overpowering quality of works from the ancient Near East; rather it has a certain quiet simplicity and gentleness characteristic of later Indian representation of animals.

At the same time that works were being produced under imperial patronage in an official style with traces of Persian influence, other sculptures were produced having no precedents in the arts of the ancient Near East. They appear to be representations of nature deities, *yakshas* (male) or *yakshis* (female). Whether these images were placed at Buddhist sites and connected with Buddhist ritual it is at present impossible to say. The two key monuments of this native style are the Parkham yaksha (*fig. 107*), in the museum at Mathura, and the Besnagar yakshi (*fig. 108*), in the museum at Calcutta. Figure 107 is one of the most interesting and exciting of all pictures of Indian sculpture, for it shows the Parkham yaksha as it once may have stood, in the midst of a village and not within the protective walls of a museum. In the days of the king

107. *Yaksha.* Sandstone; h. 8'8" (2.64 m). Parkham, Uttar Pradesh, India. Late Maurya or early Shunga period, 2nd century B.C.E. Museum of Archaeology, Mathura

108. *Yakshi.* Sandstone; h. 6'7" (2.01 m). Besnagar, Madhya Pradesh, India. Late Maurya or early Shunga period, 2nd century B.C.E. Indian Museum, Calcutta

Bimbisara, a contemporary of the Buddha, says a Tibetan source, "one of the gate-keepers of Vaishali had died and been born again among demons. . . . He said, 'As I have been born again among demons, confer on me the position of a yaksha and hang a bell around my neck.' So they caused a yaksha statue to be prepared and hung a bell round its neck. Then they set it up in the gatehouse, provided with oblations and garlands along with dance and song and to the sound of musical instruments." One can sense something of the monumental grandeur of these early images. The large figure is of cream sandstone, now badly eroded. It is architectonic, frontally organized, massive in its proportions and, in a sense, held within the block of stone. One might also say it is contained in a tree trunk, because it is likely that most of the indigenous style sculpture of the period preceding the rise of Buddhist

stone sculpture was in wood. The Parkham yaksha and the Besnagar yakshi may well be translations into stone of a tradition of monumental wood sculpture carved from great tree trunks. The relaxation of the yaksha's left knee makes us wish we had some earlier work for comparison, because the bend naturally recalls the relaxation of the knee seen in Greek sculpture at the close of the archaic period. It is a first tentative gesture toward a more informal, less rigid treatment of the figure. The yaksha's paunch, or potbelly, is a constant feature of yaksha iconography, seen especially in Kubera, god of wealth and chief of all yakshas, and in the elephant-god Ganesha, a yaksha type.

The date of the Parkham yaksha is a much debated subject. There is a present tendency on the part of some scholars to place it later than the previously accepted date

109. *Chauri bearer.* Polished sandstone; h. 64" (162.5 cm) excluding base. Didarganj, Patna, Bihar, India. Maurya period, c. 3rd century B.C.E. Patna Museum

within the Maurya period. It has now been suggested by Walter Spink that it is a work of the Shunga period, some hundred years later. He points to such details as the heavy necklace as characteristic of Shunga forms. At the yaksha's right is a small stone figural fragment of medieval times. This relief of two figures was set up alongside the big yaksha as part of the village cosmology as late as the ninth or tenth century C.E., or even later. At the time of its discovery by an outsider who came to the village, the yaksha was included in daily ritual worship.

Again, we are fortunate to have a photograph showing the Besnagar yakshi outside the walls of the museum, a tall and powerful figure slightly smaller than the Parkham yaksha, rather sadly damaged but with the same general conformation as the yaksha. The left knee is very slightly bent, less so than in the Parkham yaksha, but the proportions of the figure are equally monumental. The

110. *Female figure.* Earthenware; h. 11¼" (28.6 cm). Patna, Bihar, India. Maurya period, c. 200 B.C.E. Patna Museum, Bihar

tremendous development of the breasts, the relatively small waist, and the large hips show one of the fundamental Indian representational modes. The female form must suggest its functions of life-bearing, life-giving, and loving. The exact date of the Besnagar yakshi is as open to argument as that of the Parkham yaksha. There are certain similarities—particularly in the headdress, the necklace, and the treatment of the girdle and skirt—to works as late as the first century yakshis at Sanchi. The weathered condition of both the Parkham yaksha and the Besnagar yakshi adds decades to their appearance and increases the archaic effect.

A carefully polished, voluptuous image, found at Didarganj, Bihar, holds the ceremonial whisk (*chauri*) that identifies her as an attendant to some eminent personage (*fig. 109*). This sculpture may well be the most sophisticated and courtly expression of Maurya—or slightly later—figural style.

In contrast to these monumental works in stone, which may be continuations of a wood-carving tradition, we must now consider an example of work in earthenware, because the influence of earthenware technique on Indian sculpture is of the utmost importance (*fig. 110*).

111. *Exterior of a chaitya hall.* Bhaja, Maharashtra, India. Late Shunga period, c. 1st century B.C.E.

BHAJA AND BHARHUT

Many of the earlier earthenwares come from excavations near Sarnath and Varanasi on the Ganges, as well as from other sites in north-central India where archaeological strata indicate a Maurya date. This female figurine is far more sophisticated than the Parkham yaksha and the Besnagar yakshi. Though the pose is frontal, the treatment of the skirt, the face, and the elaborate headdress contributes a mood of freedom and gaiety. She has a lightness and a plastic quality, something of the softness of clay, that is extraordinarily pleasing. It seems probable that in the Maurya period three different styles flourished: an official one, associated with the court; an indigenous, forest-cult style, rather rigid and archaic, for images of titular deities of trees, streams, or villages; and an emerging style of sophisticated sculpture, largely lost to us except for the terra-cottas, which was perhaps an urban product somewhere between the court style and the cult style. Certainly this extremely knowing young woman, with her panniered skirts, breathes an air different from either the animal capitals of Ashoka or the Parkham yaksha.

The Maurya dynasts were followed by the Shungas, a family reigning in north-central India from 185 to 72 B.C.E. Now there is more material more surely dated, and the beginning of an elaborate development of Buddhist sculpture. The first important Shunga site is the *chaitya* hall (nave church) and the *vihara* (the refectory and cells of the clergy) at Bhaja, near Pune, in the Deccan. Bhaja is a Buddhist monument, but the sculpture presents the Vedic deities of sun and storm, gods of the pre-Hindu religious environment in which Buddhism developed. One can see from the general plan of the *chaitya* hall why from the early nineteenth century it was called the Buddhist cathedral (*fig. 111*). There is a central nave, two side aisles, an ambulatory at the back, and a high, vaulted ceiling. Although this designation is visually apt, it is materially and functionally misleading. This *chaitya* hall and many others are carved out of living rock, but their prototypes were wood structures whose arched roofs were formed of boughs bent in a curve, lashed to upright beams, and thatched. The focus of the nave is a monu-

112. *Indra over the court of an earthly king.* Stone relief;
h. approx. 60" (152.4 cm). Bhaja, Maharashtra, India.
Late Shunga period, c. 1st century B.C.E.

ment, the stupa, that resembles the typically hemispherical Indian burial mound. The stupa commemorates the *Parinirvana,* or most exalted condition, of the Buddha. It is here a symbol of the Buddha and his teaching, and is the focus of the naves of nearly all remaining *chaitya* halls. The facade of the Bhaja *chaitya* hall is also carved to simulate wood construction, looking almost as if the *chaitya* hall were surrounded by a heavenly city of arched pavilions, long railings, and grilled windows. One can make out on one side the head, earrings, breasts, waist, and hips of a large yakshi. There were two such yakshis at Bhaja, good examples of the early use of fertility deities to glorify the Buddha. These were very quickly absorbed into the current of Buddhism, and we find extraordinarily sensuous sculptures on both Buddhist and Jain monuments. There is both a low and a high intellectual tradition, and the one cannot live without the other. One of the best demonstrations of this is in the iconography of early Buddhist art.

The *viharas* are small cells for monks, and at Bhaja they are carved into the cliff that flanks the *chaitya* hall to the east. One of the farther cells, *vihara* 19, has a porch whose entrance is flanked by two extremely interesting non-Buddhist subjects carved in low relief. These represent Vedic deities: Surya, the sun god, in his chariot, and Indra, bringer of storms, thunder, lightning, and rain, riding on his animal-vehicle, an elephant who uproots trees and tramples the ground (*fig. 112*). Below are people worshiping at sacred trees, while nearby and slightly higher others flee in terror of the storm. In the lowest register, at left, a music-and-dance performance is in progress before a ruler seated in the posture of royal ease. The style of this relief, with the mounted deity and the escort behind him who holds his symbols, is distinctively archaic, notably in the stiff shoulders and frontal posture of the deity. At the same time, the escort, the elephant, and the figures below display an active and free style, emphasizing curvilinear structure, with one form flowing smoothly into the other, rather like the Maurya earthenware. Bhaja is dated variously, from the end of the second century B.C.E. to the very beginning of the first, but the early first century B.C.E. seems preferable. Significantly, there is no representation of the Buddha, nor are there, aside from the stupa, any symbols of the Buddha.

The second great monument of the Shunga period is a construction; it is not carved from the living rock. This is the now largely destroyed stupa of Bharhut, Madhya Pradesh, of the late second or early first century B.C.E. The sculptures from Bharhut were found in the fields but have now been removed to the Indian Museum in Calcutta and to the Allahabad Museum. All that remains of the stupa are a part of the great railing, one of the gates (*torana*), and other fragments (*fig. 113*). In America some of these may be seen at the Freer Gallery in Washington, at the Museum of Fine Arts in Boston, and at the Cleveland Museum of Art. Bharhut is a good example of the imitation of wood construction in stone. Obviously a tower gate of this type, with several cross-lintels, is more appropriately constructed in wood than in stone. The advantage of stone is in its considerably greater permanence. The gates of cities or palaces were very much like this gate, except that they were constructed of wood. Bharhut is the first classic example of the use of aniconic (noniconic) symbolism, so called since it does not represent the figure of the Buddha; the symbols, in a sense, invoke his presence. Bharhut also exemplifies the incorporation of the male and female fertility deities, here better preserved than at Bhaja, into the service of Buddhism.

The form of the stupa was very simple: a burial mound surrounded by a railing of great height. The railing was divided vertically and horizontally, and at each junction between the vertical and horizontal members was a lotus wheel or a medallion in relief representing busts of "donors" and aniconic scenes from the life of the Buddha. The coping above has a lotus-vegetation motif, while the gate pillars proper repeat the motif of the Maurya bell column, with lions supporting the upper

113. *Torana (gateway and railing of stupa).* Stone; h. of gateway approx. 20' (6.1 m). Bharhut, Madhya Pradesh, India. Shunga period, early 1st century B.C.E. Indian Museum, Calcutta

architraves of the *torana,* which in turn is crowned by the Wheel, symbolic of the Buddha's Law. A detail of the sculpture on the stupa reveals characteristics we might well associate with wood carving. In this representation of the dream of Queen Maya, the mother of the Buddha dreams of a white elephant, symbolic of the coming of the Buddha to her womb (*fig. 114*). The scene, with its tilted perspective and the seated attendants seen from behind, is stiffly represented, simplified in a manner not like stone carving but like carved wood. Other scenes from the life of the Buddha are shown, as are numerous *jataka*s (tales of previous incarnations of the Buddha) and representations of vegetal and water symbols such as the *makara,* half fish, half crocodile. A characteristic motif at Bharhut is the lotus medallion enclosing the relief bust of a turbaned male. At the corner column of each of the *torana*s at Bharhut were representations in relatively high relief of

114. *Dream of Queen Maya.* Pillar medallion on stupa railing; h. 19" (48.3 cm). Detail of fig. 113

115. *Shalabhanjika: Chulakoka Devata.* Pillar relief of stupa; red sandstone, h. 7' (2.13 m). Bharhut, Madhya Pradesh, India. Shunga period, early 1st century B.C.E. Indian Museum, Calcutta

male and female deities, yakshas and yakshis. Several of the yakshis are incorporated into the woman-and-tree motif (*shalabhanjika*, lit., "tree female"), an auspicious and frequent subject in Indian art. The *shalabhanjika* Chulakoka Devata holds the branch of a blossoming mango tree with one hand and twines the opposite arm and leg around its trunk (*fig. 115*). The subject illustrates a familiar Indian belief that the touch of a beautiful woman's foot will bring a tree into flower, a ritual embrace still practiced in south India. The yakshis of Bharhut are singularly wide-eyed and confident, their gestures explicit and naive, the first of a long series of female figures that represent Indian sculpture at its best.

THE ANDHRA PERIOD: SANCHI, AMARAVATI, AND KARLE

The Satavahana dynasty (220 B.C.E.–236 C.E.) ruled over the Andhra region of central and southern India. Consequently its arts include monuments that vary in style. One, the greatest monument of the early Andhra period in central India, is Sanchi, in Madhya Pradesh. The other prime monument of the period is the group of stupas in south India, the most famous being Amaravati, in Andhra Pradesh. The stupa of Amaravati was constructed over a considerable length of time, from as early as the first century C.E. until after the fall of the Andhras in the third century. Most of the remaining sculpture from Amaravati is of the third and fourth centuries C.E. Sanchi, on the other hand, is primarily important for its sculptures of the second and first centuries B.C.E. and is the type-site for the early Andhra period.

Sanchi stands on a hill rising out of the plain just north of the Deccan Plateau, not far from Bhopal. On the hill are three stupas: stupa 1 is the "Great Stupa"; stupa 2 is the earliest in date, about 110 B.C.E., and also has a few sculptures of late Shunga date; stupa 3 is a smaller monument of the late first century B.C.E. and the first century C.E. Stupas may have enclosed relics of the Buddha, and great ones were erected at various holy places in India, such as hills and confluences of streams. Generally speaking, they all followed the same plan: a mound of earth faced with stone, covered with white stucco, partly gilded, and surmounted by a three-part umbrella symbolizing the three aspects of Buddhism—the Buddha, the Buddha's Law, and the Monastic Order. The umbrella was usually surrounded by a small railing at the very top of the stupa. This may reflect the old idea of the sacred tree with a protective railing, such as those we saw in the Bhaja reliefs. Around the mound proper a path was laid out so that the pilgrim to the holy spot could make a ritual clockwise circumambulation of the stupa, walking the Path of Life around the World Mountain. This path around the stupa was enclosed by a railing pierced by gates at each of the four directions. The railing and the four gates provided the occasions for rich sculptural decoration. The stupa, like so much Indian architecture, is not so much a constructed, space-enclosing edifice as it is a sculpture, a large, solid mass designed to be looked at as an image or diagram of the cosmos.

The Great Stupa at Sanchi was erected over a period of time (*fig. 116*). The illustration shows it as it exists today, after the Archaeological Survey of India achieved a careful and respectful restoration. The site is now beautifully planted and is one of the most lovely in all of India. The body of the stupa proper was constructed of brick and rubble faced with gilded white stucco. There is a massive Mauryan rail around the base, and a path above that level, on the stupa proper, with a railing of the Shunga

116. *The Great Stupa.* Sanchi, Madhya Pradesh, India. Shunga and early Andhra periods, 3rd century B.C.E.–early 1st century C.E.

period. Four gateways, all masterworks of early Andhra sculptors, quarter the Mauryan railing. We should recall that there are other Shunga relics at Sanchi, largely on stupa 2, down the hill from stupa 1. But any beginner studies Sanchi for the Great Stupa, whose famous gateway is that on the east. The stone of the Andhra gates is ivory white and gleams in the sunlight against the rubble-and-brick base of the stupa behind, contrasting with the deep brown and green of the rubble and moss where the stupa has been eroded and not restored. We have mentioned that the sculptural style of Bharhut was influenced by work in wood. From an inscription on one of the gates at Sanchi we have further evidence for the derivation of sculpture in stone from work in other materials. It speaks of one group of carvings as being a gift of the ivory carvers of Vidisha, a village not far from Sanchi. Some of these sculptures may well display a translation into stone of work in ivory, such as the plaque in the Musée Guimet showing two yakshis beneath a *torana*, very much like those at Sanchi (*fig. 117*).

The four gateways, or *toranas*, comprise identical elements. Each has two major posts or columns crowned by three architraves (*fig. 118*). Projecting from each post, above the topmost architrave, is a *triratna*, three-pronged symbol of the Buddha, his Law, and the Monastic Order. The *triratnas* are supported by lotus Wheels of the Law, and the three architraves are elaborately carved to illustrate *jatakas*, charming folk tales with homely morals in which the Buddha is sometimes incarnate as a human being, sometimes as an animal. They provide an engrossing picture of forest culture and lore. The capitals that crown the posts, just below the level of the architraves, resemble those we shall see at Karle, and are composed of four elephants with riders going counterclockwise around the column. The sculptured stories on the architraves are confined to the space between the extensions of the main pillars, while the parts outside these show single scenes from the life of the Buddha or previous lives of the Buddha, or symbols associated with Buddhism. The lower parts of the main pillars have representations of scenes from the lives of the Buddha on three sides, and their interior faces are carved with large guardian figures of yakshas, yakshis, and *shalabhanjikas*. It is significant that, as at Bharhut, the Buddha is not represented in figu-

118. *North gate of the Great Stupa.* 10–30 C.E. Detail of fig. 116

117. *Two yakshis below torana.* Carved ivory top of chest or stool (fragment); h. approx. 13½" (34 cm). Begram, north of Kabul, Afghanistan. 2nd–3rd century C.E. Musée Guimet, Paris

ral form. The symbolism is still aniconic, and the Buddha is represented by a wheel, footprints, a throne, or some other symbol.

The *shalabhanjika* brackets on the gates are of particular importance for their sculptural quality. The most famous one, principally because it is almost perfectly preserved, is the figure on the east gateway, dating from about 10 to 30 C.E. (*fig. 119*). The fertility goddess is posed rather like the Chulakoka Devata of Bharhut, one hand grasping the bough of a tree and the other arm entwined between two branches. Her left heel is against the base of the tree trunk, giving the ritual blow in the traditional marriage rite of the maiden and the tree, a motif we meet here for the second and by no means last time. The Sanchi *shalabhanjika,* however, is of a different cast from her sister at Bharhut. She is only slightly later in date but has progressed considerably in technical and compositional development. She is no longer simply a relief on the face of a pillar, standing woodenly, implacably holding off the observer with an almost Byzantine iconic stare. The body of the Sanchi *shalabhanjika* pivots in space, though the figure is still somewhat archaic in being largely confined to a frontal plane. Her pose is much more complex, contrasting the angularity of the balancing arm with the curving and voluptuous movements of the body. One sees more use of open space. The sculptor is beginning to cut away the stone to silhouette the figure against open air. Although functionally the figure does not support anything, being an imitation of wooden construction, it is at the same time a decorative sculpture and a simulated architectural bracket. The heavy shape of the tree is squared off at the top and developed as a right angle, and the thrust of the body appears to support the architrave above. On Buddhist monuments the supportive function of yakshas and yakshis was

119. *Shalabhanjika.* Bracket figure; stone; h. approx. 60"
(152.4 cm). East gate of the Great Stupa, Sanchi, Madhya
Pradesh, India. Early Andhra period, 1st century B.C.E.

120. *Monkey jataka.* Relief carving; stone; h. approx. 30"
(76.2 cm). Upper part of south pillar, west gate of the Great
Stupa, Sanchi, Madhya Pradesh, India. Early Andhra
period, 10–30 C.E.

primarily religious, not architectural. The great mass of
illiterate people who but dimly understood the teachings
of the Buddha could be comforted when they saw the
local tutelary deities, male and female, welcoming them to
the austere and abstract stupa.

A fine and completely illustrated book has been
written by Sir John Marshall on the sculpture at Sanchi,
showing its wealth of detail in the many panels with their
narrative content. Our illustrated panel is a good example
of a *jataka* scene; its treatment of the subject illustrates the
stage reached by narrative art in the early Andhra period
(*fig. 120*). A single panel is framed below by a railing and
at the sides by scrolling grapevines that give lush, rich
movement to the edges, expressive of the vegetative forces
of life. These enclose a picture plane crowded with figures,
in effect a map of an enclosure packed with people. A river
runs diagonally from top center to bottom right, thus pre-
serving a maplike view of a landscape whose details we see
in side view. The trees of the landscape are shown in their
most characteristic shape, the silhouette; hills and rocks
are presented in profile. The human and animal figures are
shown more or less frontally but on a ground line, almost
as if they were a separate composition within the land-
scape. The representations are individually accomplished
and subtle—the figures are at ease, the representations of
monkeys and their movements are highly convincing, even

groups of figures seen from the same point of view are
credibly rendered. Only the overall organization of these
units reveals a lingering archaic approach.

The story told here is that of the Buddha when he
was king of the monkeys. In this incarnation the Buddha-
to-be had as enemy and rival his wicked cousin, Deva-
datta. The monkeys were attacked by archers of the king
of Varanasi, and the Buddha-to-be stretched his huge
simian frame from one side of a river to the other so that
the monkeys could flee to safety across his body. But the
last to cross was Devadatta, who thrust his foot down as
he passed over and broke his cousin's back. The king had
the Buddha-to-be bathed, rubbed with oil, clothed in yel-
low, and brought before him. "You made yourself a bridge
for them to pass over. What are you to them, monkey, and
what are they to you?" The dying monkey replied, "I,
King, am lord of these bough beasts . . . and weal have I
brought to them over whom governance was mine . . . as
all kings should." Thereafter the king of Varanasi ruled
righteously and came at last to the Bright World. The
story is typical in showing the future Buddha as a royal
figure; he is usually a king or prince among men or ani-
mals. Further, as a bodhisattva (Buddha-to-be; one capa-
ble of Buddhahood who renounces it to do acts of salva-
tion for others), he offers himself again and again as a
sacrifice in order to save his fellow beings.

The composition has much in common with some Early Christian ivories—in the "feel" of the medium, the way the figures are carved, and the way they are composed. This bears out the inscription concerning the Vidisha ivory carvers. It is an art vibrant with life, full and abundant. It is a style for those who like their art rich and crowded.

Another important early monument is the Great Chaitya Hall at Karle, Maharashtra, previously dated rather too early (*fig. 121*). We now know from inscriptions on this *chaitya* hall that Karle was made between about 100 and 120 C.E., and is therefore an accomplishment of the mid-Andhra period, or rather of a minor kingdom related to Andhra. A general exterior view of Karle is not as impressive as that of nearby Bhaja, because at Karle much of the exterior stonework, including a

121. *Great Chaitya Hall.* Karle, Maharashtra, India. General view. Andhra period, early 2nd century C.E.

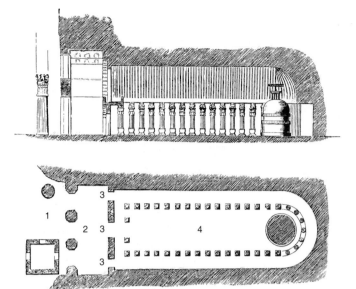

1 porch 2 narthex 3 entrances 4 nave

122. *Elevation and plan of the Great Chaitya Hall.* Karle,
Maharashtra, India

screen over the opening, has remained. This obstructs the view of the *chaitya* hall proper; further, a modern Hindu shrine has been erected in the court, which also tends to block the view. The hall at Karle is cut into a mountain some hundred miles southeast of Bombay, at the top of the Western Ghats which lead from the low-lying coastal plain up to the Deccan Plateau. The area is rather barren, looking not unlike certain sections of Utah and Colorado, with great vistas across the tableland and with mountains or buttes (ghats) rising directly from the plateau.

The idea of the cave excavated in the mountain appears especially characteristic of India and, through Indian influence, of the eastern part of the Asian mainland. In India the *chaitya* hall and the *vihara* are often cut into living rock. In Central Asia we find cuttings in the clay cliffs. In China there are a great number of Buddhist cave-temples; in Japan the type occurs hardly at all. Some very interesting psychological and aesthetic problems are raised by the cave complex. Unquestionably the Indian genius is primarily sculptural, and a sculptural quality extends as well to Indian architecture. Indians do not conceive of architecture primarily as an enclosure of space. They conceive of it as a mass to be modeled, to be formed, and to be looked at and sensed as a sculpture. Perhaps, then, the practice of carving in living rock is understandable. It is possible that primal ideas of fertility are involved, of penetrating the womb of the mountain, or of attaining security in the womb.

The *chaitya* halls at Bhaja and Karle, carved in living rock, serve us as models of the great freestanding *chaitya* halls, the earlier ones built of wood and the later ones of brick and stone, which are now totally lost or ruinous.

These exceptional structures are a true interior architecture, intended to house a congregation and made so that worshipers could perform a ritual circumambulation of the stupa at the inner end of the nave. The plan of Karle gives some clue to their arrangement (*fig. 122*). On the Karle plan we note a porch, a narthex or inner porch, and a threefold entrance—one into each of the side aisles and a main entrance into the nave proper. The nave is a simple, long space defined by the columns, which extend around the far side of the stupa to make an ambulatory (*fig. 123*). There are no chapels built out to the sides as one finds in medieval Western churches. The elevation shows the developed column type, with "vase" base and bell capital. By the light from the great horseshoe arch of the facade one can make out the form of the stupa at the end of the nave, and of the vault above, which is an imitation of wood and thatch construction. The main nave at Karle is most impressive, reaching a lofty height of forty-five feet. The vase bases are probably derived from earlier wood construction, which required columns to be placed in ceramic vases to keep out wood-devouring insects. The bell-shaped capitals of Karle, undoubtedly derived from the Ashoka columns, are surmounted by elephants and riders as at Sanchi. But here there are just two riders on each beast, facing out so that they are oriented only to the nave. The stone at Karle is a hard gray-blue granitic type, and the whole effect is somberly majestic, in contrast to the severity of Bhaja, where the columns, perfectly plain prismatic shafts with no capital or base, rise directly from the floor and move directly into the vault. At Karle we find much more elaborate figural forms, richly sculptured. The space of the interior at Karle seems to be more flexible, more flowing, than the comparatively static space we sense at Bhaja.

Only superlatives are adequate to describe the sculpture of the great period we now enter. The narthex screen at Karle is sculptured on the exterior with panels containing large-scale male and female figures somewhat questionably called "donors" (*fig. 124*). There are many other panels with routine Buddhist images ranging from the fourth century C.E. to the sixth or seventh century; but the only work that concerns us here is that of the first century C.E.—the donors. They are of noble type, but we know not whether they are actually donors or loving couples (*mithuna*). Seldom in the history of art have male and female forms been conceived on so large and abundant a scale, with sheer physical health seeming to brim from them in an ever-flowing stream. The quality of *prana*, or breath, which we must mention now and again in connection with Indian sculpture, is obviously present in these figures. Perhaps for the first time we sense that intake of breath when the dancer comes to the climax of his performance, when he come to the pose that strikes the final note, a pose prepared by a sudden inhalation that arches the chest and achieves perfection with the fullest

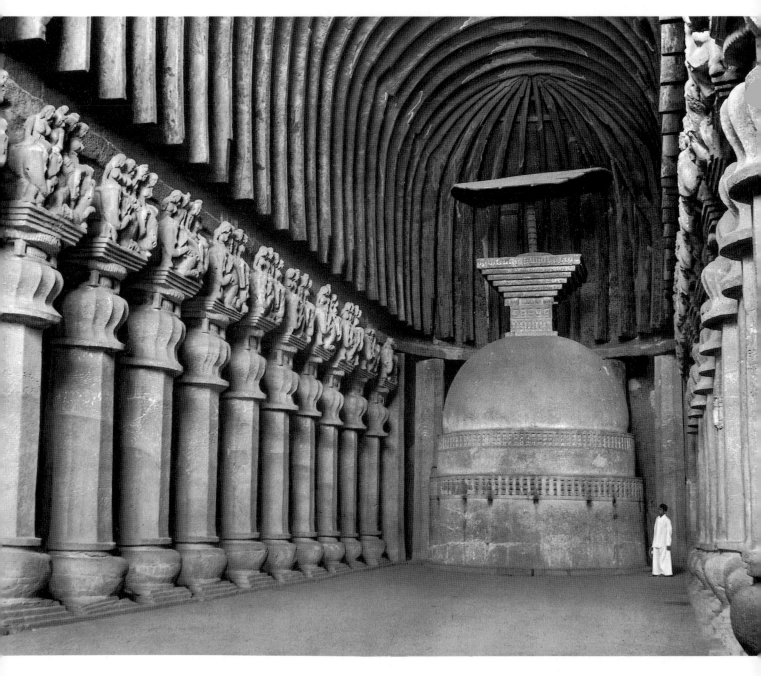

123. *Nave of the Great Chaitya Hall.* Karle, Maharashtra, India

expanse of the body. Breath and dance are very important in determining the look of Indian sculpture, the stance and the representation of the body. We can imagine the Indian sculptor studying closely not only performances but rehearsals of the various royal and princely dance companies. From the study of such long and elaborately developed bodily exercise to the heroically posed figures carved in stone is a logical development.

The donors at Karle, more than life size, are in their youthful prime, and their attire is princely. The man wears a turban and a twisted girdle about his hips; the woman wears heavy earrings and a pearl girdle and is draped from the waist down with very light cloth. We are overwhelmingly aware of the masculinity of the man—broad shoulders and chest, narrow hips, virile stance—and equally so of the femininity of the woman, with her large breasts and hips and small waist. At Karle we have, perhaps for the first time, the perfectly controlled expression of this Indian ideal and the masterly representation of male and female figures that continues almost without fail up to the tenth and eleventh centuries.

The donors are in fairly high relief and are not too

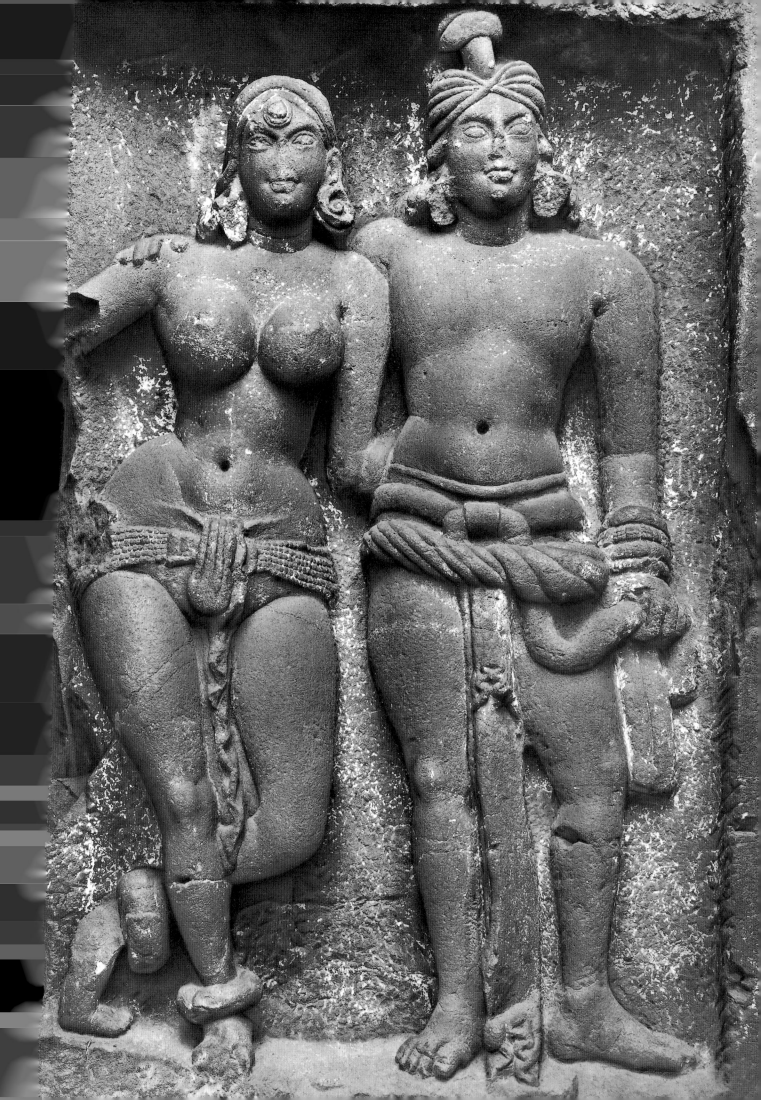

crowded in their assigned space. Though the lintel is close above their heads, it serves to magnify the scale of the figures. If there were any real space above them, they would appear smaller. Instead, they thrust upward, almost supporting the lintel above. The easy postures show no trace of the angularity seen in the arms of the Sanchi *shalabhanjika*. With the Chulakoka Devata from Bharhut and the bracket *shalabhanjika* from Sanchi, the donors at Karle stand chronologically third among the greatest monuments of early Indian figural sculpture.

We now move south to examine the remains of a series of stupas. These are of high quality, and greatly influenced artistic style in south India in post-Buddhist times, when Hinduism became dominant. This development was already under way by the fifth century. South India includes the region around the Krishna (formerly Kistna) River, inland from the sea some three or four hundred miles. The stupa of Amaravati in Andhra Pradesh is the type-site for this region, which contains two other well-known stupas: Nagarjunakonda and Jaggayyapeta. All three were built under the Satavahana dynasty, which ruled also in north central India and produced the Great Stupa at Sanchi. The dynasty endured much longer in the south than in the north, consequently leaving remains there ranging in date from the first century B.C.E. to the third century C.E. The most important works from Amaravati are in the Government Museum in Madras and in the British Museum in London. In general the style of Amaravati can be characterized as more organic and dynamic than anything we have seen before. In contrast to the somewhat geometric character of the more or less contemporary Kushan work in the north, a softer and more flowing manner seemed to flourish in the south. Surely it is no coincidence that the more flowing manner is characteristic of the native Andhra dynasty, as the more geometric is typical of the foreign Kushans.

All three of the Great Stupas in the Kistna region are largely ruined. In the nineteenth century they were threatened with complete destruction. Until the English stopped the demolition of the sculptures, they were burned for lime or used in other structures. But we are able to reconstruct the appearance of the stupa at Amaravati (and, by inference, those at Nagarjunakonda and Jaggayyapeta) from reliefs showing the stupa as it appeared in its final form. The most perfectly preserved of the representations of the Great Stupa of Amaravati is on a slab from one of the later railings, of perhaps the third century C.E., which shows us a great mound faced with brick or stone and finished with stucco (*fig. 125*). From the frontal representation on the slab we can infer a series of large reliefs around the base of the drum and

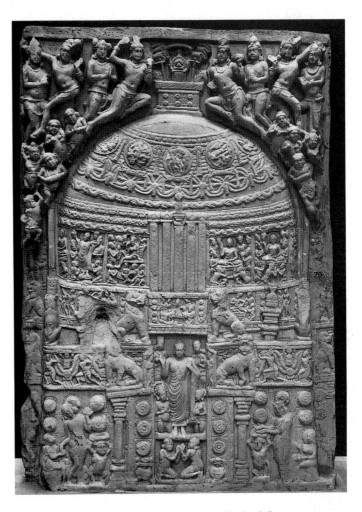

125. *Slab depicting stupa at Amaravati*. Marble; h. 6'2" (1.88 m). India. Late Andhra period, late 2nd century C.E. Government Museum, Madras

the upper balustrade, punctuated by a curious five-columned tower at each entrance. These correspond to the *torana* at Sanchi but have a completely different shape. Finally there is a very high exterior railing with a profusion of lotus rosettes, and with reliefs of yakshas bearing the lotus Garland of Life around the top register. The entrances also have lions atop pillars, with an architrave going back to the gate, thus making a kind of porch or enclosure leading to the stupa. At the focus of these entrances there are sculptured slabs with both aniconic and iconic representations of the Buddha. The usual symbols are often used to represent the activities of the Buddha—the Wheel of the Law for the Sermon, Footprints for the Presence, etc. Atop the stupa is a railing around the tree, here symbolized by a double parasol on either side of a central shaft.

From this slab one can see that the style has little in common with the Kushan style of the north. Here all forms are curvilinear and flowing, with the exception of architectural members. The angels flanking the stupa above, with their bent legs and arms, are treated in a relatively flexible manner. At the side of another fine slab we see aniconic imagery used again, in a depiction of the assault launched by Mara, lord of earthly passions, against

124. (opposite) *Couple*. Stone. Facade of the *chaitya* hall, Karle, Maharashtra, India. Andhra period, early 2nd century C.E.

126. *Cushioned throne, with the Assault of Mara* (detail). Relief slab; gray marble; h. 69³/4" (177.2 cm). School of Amaravati, late Andhra period, late 2nd century C.E. Musée Guimet, Paris

127. *Chakravartin, or Universal Ruler.* Marble; h. 51" (129.5 cm). Fragment of paneling from stupa at Jaggayyapeta, Andhra Pradesh, India. Andhra period, c. 1st century B.C.E. Government Museum, Madras

the meditating Shakyamuni, in an effort to prevent his Enlightenment (*fig. 126*). The Tree, Throne, and Cushions stand for the Buddha; the surrounding figures, some voluptuous and some grotesque, represent Mara's two successive attempts to distract the Buddha from his purpose, first by seduction, then by terror. In other such friezes the seated Buddha is actually represented, thus uniting the newly invented Buddha image with the older aniconic tradition.

Two reliefs illustrate the early and the late styles of Amaravati. Four stylistic divisions are usually recognized, but in a more general way we can distinguish an early and a late style. The famous slab from Jaggayyapeta in the museum in Madras, dates from the very beginning of the Andhra period, perhaps to the first century B.C.E. (*fig. 127*). It shows a subject often connected with Buddhism—a *chakravartin,* or Universal Ruler, for the Buddha was a *chakravartin.* The tall figure stretches his right hand toward clouds which pour forth a rain of square coins. He is surrounded by the Seven Treasures, the wheel (*chakra*) representing his universal dominion, his horse and elephant, his light-giving jewel, his wife, his steward or treasurer, and his minister or general.

A text later than the relief, the *Prabhandhacintamani* of Merutunga, describes the scene: "O King! When the cloud of your hand had begun its auspicious ascent in the ten quarters of the heavens, and was raining the nectar flood of gold, with the splendour of the trembling golden bracelet flickering like lightning" The style here is comparable to that at Bharhut, except for certain local characteristics, such as the greatly elongated and rather angular and wooden figures. The prince's costume, too, with its great beaded necklace, heavy rolls of drapery at the waist, and large asymmetric turban, is like costumes at Bharhut and stupa 2 at Sanchi.

The later style at Amaravati is a culmination of the tendencies of the Andhra school and is perhaps best exemplified in the well-known roundel from the railing, showing the Buddha taming the maddened elephant (*fig. 128*). The representation tells the story of the beast by the method of continuous narration, showing it first (on the left) trampling and dashing people to death, then (on the right) kneeling and bowing its head before the Buddha. In many ways this is the most advanced piece of sculpture to date, from the standpoint of complexity, handling of space, and representation of the human figure. Despite the device of continuous narration, the scene has visual unity. There is also a fairly successful attempt to indicate a shallow stage or setting for the drama, with the architectural details of a city gate at the left and buildings

128. *Buddha taming the maddened elephant.* Marble; h. 35"
(88.9 cm). Railing medallion from stupa at Amaravati,
Andhra Pradesh, India. Andhra period, late 2nd century
C.E. Government Museum, Madras

at the back from which people peer out of windows above
the balustrades. Scale is handled with sophistication, in
part owing to the inescapable fact that the elephant is
large and the figures small. The most distant figures have
been made smaller than the nearest ones. Psychological
unity extends from the whole scene to its parts, as in the
little group where a woman shies away from the elephant
and is calmed by the person behind her. Probably the
whole composition was influenced by the painting being
done at this time, represented by such works as the early
frescoes at Ajanta in Maharashtra (*see fig. 156*). The
tremendous naturalism, which encompasses pathos, vio-
lent activity, and calm inspection, is quite extraordinary.
Aside from the architecture and one or two of the ele-
phant's halters, there is hardly a straight line in the com-
position; everywhere there are slightly twisting or undu-
lating curves and fully rounded shapes. There are no flat
planes; everything is treated in an organic and sensuous
way. It is a style that will greatly influence the develop-
ment of south Indian Hindu sculpture in the Pallava peri-
od (c. 500–c. 750 C.E.).

STYLES OF THE KUSHAN PERIOD

The Buddha image was developed in the north under a
non-Indian dynasty, the Kushan, established in northwest

129. *Kanishka I.* Red sandstone; h. 64" (162.6 cm). Mathura,
Uttar Pradesh, India. Kushan period, c. 120 C.E. Museum
of Archaeology, Mathura

and north-central India by an eastern Iranian people of
Central Asian origin. We can see something of the impact
of these Kushan rulers on Indian sculpture in two very
important effigies, the first of King Kanishka I (r. c. 120–
162 C.E.; *fig. 129*), the second of the preceding king, Vima
Kadphises (*fig. 130*). Both effigies are now in the Mathura
Museum of Archaeology. The un-Indian appearance of
these images comes as something of a surprise. It must be
remembered that they were made after the time of Sanchi
and the "donor" figures at Karle. Certain elements in their
stark, geometric, and abstract style can be attributed to
the Scythian type costume of the ruling Kushans. They
wore padded boots and a heavy cloak covering the whole
body, often seen in Chinese paintings of the barbarians of
Central Asia. Still, once established in India, they are
unlikely to have commissioned their effigies in this cos-
tume unless the stark geometry of its outlines appealed to
them enough to be translated into permanent representa-
tion in stone. It certainly is true that these sculptures have
a completely different flavor from what we have seen

130. *Vima Kadphises.* Dated the 6th year of Kanishka's reign,
c. 127 C.E. Red sandstone; h. 6'10" (2.08 m). Mathura,
Uttar Pradesh, India. Museum of Archaeology, Mathura

to impose a foreign style upon the Indians, or that style was very quickly absorbed, just as the ruling class itself was absorbed into the great Indian mass. It is important to stress the difference between these sculptures and the native Indian tradition, because in the course of its development the Buddha image type seems to show an outside influence that must be accounted for.

As evidence that the development of the organic tradition of Indian sculpture continued unhindered despite the Kushans, we can point to three of the best preserved and most beautiful of the Mathura red sandstone figures, from Bhuteshar, a site near Mathura (*fig. 131*). They embody perhaps an even more frank and unabashed nudity than do the figures at Karle. They are in higher relief, with great emphasis on the organic and flowing character of the female body. This character is modified somewhat by rigid linear forms, particularly in the jewelry and lines of drapery; but in general these figures carry on the great voluptuousness of the sculptures at Karle. They are fragments from a railing enclosing a Buddhist or a Jain monument, but either religion hardly envisaged in its dogma even the decorative use of such fertility deities as these, probably modeled on court ladies of the time. Some wash their hair, some look at themselves in mirrors, most are adorned with elaborate jewels, wide coin belts, huge earrings, and anklets. Lengths of transparent cloth, gathered in loops at the hips, form their skirts. Their poses incorporate the flexed leg, some with the sacred tree, others without. All three of these female deities stand upon dwarflike yakshas symbolizing earthly powers. Elsewhere these corpulent yakshas are shown with vegetal motifs issuing from their mouths to make part of a great scroll pattern. They are vegetative forces, the lords of life, but here subdued by fertility deities. The upper register of these pillars is marked by a miniature railing. Above are narrative scenes, usually of amorous couples. Kushan art of Mathura shows a growing tendency to leave the background as a flat, open area, allowing figures to stand out in high relief against a simple ground and achieving an uncrowded and monumental style. In the Bhuteshar figures the face is stylized, with a certain geometric handling of the modeling and representation, perhaps influenced by the Kushan official portrait style.

Most of the stone sculptures of north-central India from the Kushan period are made of what is called Mathura or Fatehpur Sikri sandstone, common to the region south of Delhi where the great quarries are found. It is a smooth-grained red sandstone with some imperfections in the form of creamy white spots or streaks. Images of such stone were apparently made in the Mathura region and exported, because they are found widely distributed over the whole area of north-central India, including such great centers as Sarnath, until the late Gupta period, when cream (Chunar) sandstone became more popular.

developing in the organic Indian style. The line of the cloak is drawn as if laid out with a straightedge, and the repeat patterns of the long mace and the cloak edge are strongly emphasized. The statue of Vima Kadphises is poorly preserved, but still reveals geometric elements corresponding to those in the statue of Kanishka I.

Whether at Mathura in Uttar Pradesh or Gandhara in Pakistan, it is under the Kushan dynasty that the first representation of the Buddha appears. Significantly, these icons are almost the only works we have, aside from certain transitional Buddha images, in the rather harsh Kushan style. Most of the sculpture produced in the Kushan period follows the organic development we have seen from Bharhut to Sanchi. Either the ruling class was not sufficiently large or sufficiently dominant artistically

131. *Yakshi with a bird cage.* Railing pillar; red sandstone; h. 55" (139.7 cm). Bhuteshar, near Mathura, Uttar Pradesh, India. Kushan period, 2nd century C.E. Indian Museum, Calcutta

In addition to the yakshi motif used on the railings, we find decorative motifs, the lotus Stem of Life and the lotus itself. A more limited range of subject matter survives than that found in the earlier monuments, and this is not surprising, as Mathura, the holy city that Ptolemy called "Mathura of the gods," was razed to the ground by Mahmud of Ghazni (in Afghanistan) in the eleventh century. Aniconic representation, in which *jataka* narratives provided great variety, was abandoned, and iconic representation, with the Buddha image as the primary subject, became rather repetitious. Narrative elements began to disappear, replaced nearly always by a single human figure, whether the Buddha, yakshi, yaksha, or bodhisattva, standing erect or, more rarely, seated.

The question of the origin of the Buddha image has been overargued, in part because national sensitivities were at stake. The earliest major publication on the subject is by Alfred Foucher, the French scholar who wrote in the early twentieth century on the art of Gandhara and the development of the Buddha image. It was his thesis that the Buddha image was developed in Gandhara under the influence of Hellenistic art, particularly of the Apollo image. Against this, at a time of growing Indian national awareness, the Indian scholar Ananda K. Coomaraswamy, late curator of the Indian collections at the Museum of Fine Arts, Boston, published his thesis on the Indian origin of the Buddha image. Coomaraswamy gives a very thorough and convincing argument for an Indian origin evolving from the yaksha image, as convincing as Foucher's argument for a classical origin. Both were right. Unquestionably the Buddha image developed in the Kushan period and has both Indian and classical elements. Which came precisely first is a matter of the chicken or the egg, and is conditional on several reign-dated objects which can be dated three or four different ways, depending upon the particular calendar chosen. This highly technical problem need not detain us here. The development of the Buddha image was impelled by the growing elaboration of Buddhism and the concomitant need for icons. Furthermore, Buddhism undoubtedly had to compete with a growing Hinduism, a highly figural religion with numerous images of deities.

Rapidly developing Roman influence on the art of Gandhara, at the northwest frontier of the Kushan empire, may have stimulated development of Buddha images in human form throughout the large Kushan empire, from Afghanistan to Madhya Pradesh. Foucher thought the classical influence was Hellenistic, but it is clear that the main influence on Gandharan art is that of Rome at the time of Trajan and later.

The inscription on the image of the *Bodhisattva of Friar Bala* says that it is the gift of that monk and that it was made, again depending upon computations of reign period, circa 123 C.E. (*fig. 132*). The inscription declares the image to be a bodhisattva—a potential Buddha—but

132. *Bodhisattva of Friar Bala.* Red sandstone; h. 8'1¹/₂"
(2.48 m). Mathura, Uttar Pradesh, India. Kushan period,
c. 123 C.E. Museum of Archaeology, Sarnath

133. *Parasol from Bodhisattva of Friar Bala* (fig. 132). Red
sandstone; diam. 10' (3.05 m)

for all intents and purposes it is a Buddha image. This and
other early Buddha images share with the royal effigies of
Kanishka I and Vima Kadphises a strong geometry in the
shoulders, which are much more square than in the fig-
ures at Karle; in the linear drapery patterns and the very
straight, rigid edges of the cloth; in the profile of the legs;
and, if the face were well preserved, in the very sharp lin-
ear handling of eyes and mouth. These figures are almost
more abstract than the aniconic symbols of Tree, Wheel,
or Footprint, and they seem more forbidding, more awe-
some, more remote. The lion at the feet of the Friar Bala
image is an allusion to the Buddha as the lion among men
and to his royal origin. Behind this sculpture originally
stood a tall prismatic column capped by an impressive
stone parasol, another symbol of royalty, some ten feet in
diameter and carved with signs of the zodiac and symbols
of the celestial mansions (*fig. 133*). Thus the underside of
the parasol is a representation of the universe, and the
Buddha is lord of the sun and the universe. The complete
image must have been awe-inspiring. Its stylistic relation-
ship to the yakshas at Bharhut and Sanchi is sufficient to
establish that it is not chiefly a foreign invention, but at
the same time one can see something different here,
something more abstract, more universal. The rigid
frontality of the figure outdoes that of the Parkham yak-
sha some three centuries earlier. There is no slight bend of
the body, no bend of the knee; but such developments
were to come.

A Hindu image may suggest how the likenesses of
Hindu deities may have helped in the formation of the

134. *Parashurameshvara lingam.* Polished sandstone; h. 60"
(152.4 cm). Gudimallam, Andhra Pradesh, India. 1st
century C.E.

Buddha image, and may also point out the slight differ-
ences in style between them (*fig. 134*). This is a sculpture
of Shiva from Gudimallam, Andhra Pradesh, dating from
the Kushan period, probably in the first century C.E.
None but a Hindu may see it, for it is still used in temple
worship. The earliest known and clearly identified stone
representation of that deity, it shows Shiva both in figural
form and in the form of his principal symbol, the *lingam*

135. *Seated Buddha with attendants.* Red sandstone; h. 36 5/8"
(93.3 cm). Mathura region, Uttar Pradesh, India. Kushan
period, c. 124 C.E. Kimbell Art Museum, Fort Worth

(phallus), standing, like the fertility goddesses from
Mathura, on a dwarf yaksha. The surface is shiny because
the figure is daily anointed with oil. The Kushan geome-
try of the almond-shaped eyes is notable, but the forma-
tion of the torso, chest, and stomach is very different
from that of the Kushan Buddha. The whole image is
somewhat more organic, more naturalistic than a com-
parable Buddhist image in a similar pose. Perhaps images
like these, and the more popularly appealing yakshas and
fertility deities, influenced the development of the
Buddha image.

The standing image was not to be the major type.
The standard Buddha image was the seated one, usually
shown either in meditation or preaching the First
Sermon. In the Kimbell Art Museum is a remarkably well
preserved Buddha image in the form of a stela, a sculp-
tural figure backed by a mass of stone (*fig. 135*). The fig-
ure is dressed in the austere garb of a monk and seated in
meditation in the traditional posture of a yogi, with a
halo, symbolizing the sun, carved into the rock behind
his head. He bears the physical attributes of the Buddha:
the *urna,* or tuft of hair between the eyes; the lotus out-
line on the soles of the feet; the earlobes permanently
lengthened from the weight of the earrings he once wore
as a prince. On the Buddha's throne is the following well-

136. *"Bacchanalian" scene.* Red sandstone; h. 21⁷/₈" (55.6 cm). Mathura, Uttar Pradesh, India. Kushan period, 2nd century C.E. Museum of Archaeology, Mathura

carved inscription: "In the year four of Maharaja Kanishka, in the third month of the rainy season, on the twenty-sixth day, the Bodhisattva installed by the honorable Dharmanandi, a companion of the Buddhist monk Bodhisena . . . " (trans. Herbert Härtel). Flanking the Buddha are two attendants bearing ceremonial whisks (*chauri*). On the base of the throne, carved in relief, are two winged lions, symbolic of the Buddha's royalty, and two adorants flanking an edge view of a wheel, which symbolizes the turning of the Wheel of the Law. One sees again the somewhat geometric treatment of the drapery, the smooth arcs at the termination of the drapery on the legs, the emphasis on the linearity of the drapery below the body, the strongly arched eyebrows, and the spherical simplification of the hair. The image still has a rather un-Indian look when compared with most Indian sculpture. The Buddha's hand forms one of the *mudra*s—hand gestures with specific meanings in a prescribed and carefully organized system. The *mudra*s are extremely important in the language of the dance and of images, defining the particular aspect of deity represented. There are many different *mudra*s; this one, *abhaya mudra*, means "fear not." Other gestures include touching the earth (*bhumishparsa mudra*), calling on the earth to witness the failure of the assault and temptation by Mara, the deity of sin incarnate; and the gesture of turning the Wheel of

137. *Hercules and the Nemean Lion.* Red sandstone; h. 29¹/₂" (74.9 cm). Mathura, Uttar Pradesh, India. Kushan period, late 2nd century C.E. Indian Museum, Calcutta

the Law (*dharmachakra mudra*). In the Kimbell image the Buddha is attended by figures recalling yaksha types, one holding a fly whisk (*chauri*), the conventional attribute of a king's attendant. Still, the Buddha image is not yet fully developed by this time in the second century C.E. Such details as the treatment of the hair have not achieved their standard form.

In addition to Buddha images of this type, the Kushan period also produced a few works of a more narrative character. Two of the most famous and interesting are shown here (*figs. 136, 137*). One is a convivial scene recalling the bacchanalian depictions found on Roman pottery or Roman reliefs showing the potbellied Silenus. The second is a sculpture often called *Hercules and the Nemean Lion,* again reminiscent of a classical scene. It represents a man struggling with a lion beneath a tree. Regardless of its iconographic meaning, in sheer sculptural quality it is one of the greatest productions of the Kushan period and one of the finest statements of the masculine ideal in early Indian sculpture. Although the subject may derive from a classical source, the treatment of it, the proportions of chest and waist, and the heaviness of the legs are all Indian qualities rather than classical. It should be noted that the subtle modeling of the human figure, its relation to the lion, and the interweaving of forms in a single sculptural composition show a great advance over the sculpture just preceding the end of the second century, the date of this combat scene.

Jain sculptures, particularly those of *tirthankara*s (finders of the Ford, or Way) are in the very same style as the Buddha images, and in most cases cannot be distinguished from them except by the lozenge shape on the chest, the mark of the *tirthankara*. A few Hindu subjects are found as well, notably Krishna lifting Mount Govardhana, but they too are in the same style as the Buddhist sculptures.

Gandhara

The second dominant style of the Kushan period is that of the Gandhara region, in the area of present-day Afghanistan, Pakistan, and Kashmir. As we have seen, this region bordered directly on some of the post-Alexandrian and later kingdoms of Western origin and so had numerous contacts with the Mediterranean world. The art of Gandhara has been much admired by the Western world, and the reason is not hard to find. For persons accustomed to the classical tradition it was the most palatable art that India produced. It was called Greco-Buddhist art; but now, thanks to Benjamin Rowland's and Hugo Buchthal's studies, it is more properly described as Romano-Buddhist. The influences came not from Greece or the Hellenistic world, but from Rome and Roman styles of the late first and the second centuries C.E.

Important as evidence of Roman inspiration at this time are two small reliquary caskets. One, the Kanishka reliquary, bears an inscription giving a reign date (*fig. 138*); the other, the Bimaran reliquary, is named for the place where it was found (*fig. 139*). To determine the date and nature of this Western inspiration, we must know, in Western calendrical terms, the date of the first year of Kanishka's reign. But since there were at least three differ-

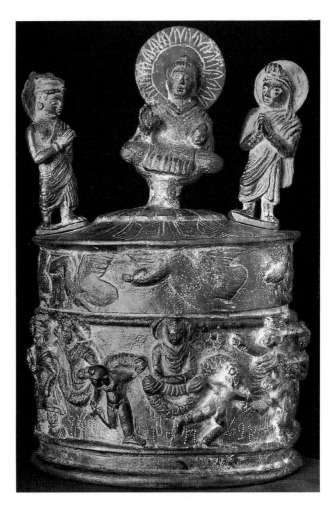

138. *Kanishka reliquary.* Metal; h. 7³/4" (19.7 cm). Shah-jiki-Dheri, near Peshawar, Pakistan. Kushan period, c. 120 C.E. Archaeological Museum, Peshawar

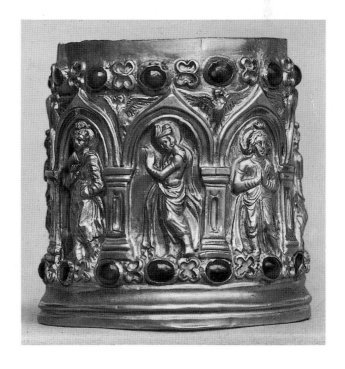

139. *Reliquary.* Gold; h. 2³/4" (7 cm). Bimaran, Afghanistan. Early 3rd century C.E. British Museum, London

ent methods of dating available to northern Indians at that time, various precise but rather different dates have been assigned to this casket. It is now generally believed to be a work of about 120 C.E. Foucher wished to put it back to the year 78 C.E., and so to establish the early presence of classical influence. There is no question that the reliquary of King Kanishka shows definite classical influences, as the little bands of erotes, or cupids with garlands, are taken directly from classical pottery and sculpture. But the presence of the Buddha image, and its type, confirm the second century date. We might even date the reign of Kanishka from the style of these figures rather than try to argue their date from the various calendars in use at the time. The Bimaran reliquary, a precious object of gold, provides evidence that fully confirms Roman rather than Greek or Hellenistic influence. This is the motif called by scholars of Early Christian art the *homme arcade*, a repetition of figures in arched niches found especially in Early Christian sarcophagi from Asia Minor, most notably in the famous sarcophagus with the figures of Christ and his disciples in the Archaeological Museum at Istanbul. As the *homme arcade* is a motif of the late first or the second century C.E., the date as well as the source is confirmed.

The characteristic art of Gandhara is executed in two major mediums: stone—a gray-blue or gray-black schist—and stucco. Most of the early sculpture is carved in stone; no sculpture in stucco is known from the first, second, and perhaps the third centuries C.E. A typical schist carving is the relief representing the Birth of the Buddha (*fig. 140*). Classical art is above all figural and the gods are represented in human form, so it was natural that in the art of Gandhara, influenced by Roman work, Buddhist deities were so represented. Few Gandharan aniconic sculptural representations of the Buddha are known, but an aniconic phase contemporary with that in the Mathura region is plausible, if not yet fully confirmed. Thus in figure 140 we see a Roman matron miraculously producing the Buddha from her left side as she holds the sacred tree. The pose—the hands pulling down the bough and the heel against the trunk—is in the Indian tradition, but not so the Apollo and barbarian types, or the stereotyped drapery derived from that carved on Roman sarcophagi. In general this is a "degenerated" Roman style and is of particular interest to historians of classical art and to students of provincial transformations of style. The style fascinated André Malraux, as did that of late Roman coins, because in them he saw the birth of a new style out of the degeneration of an older one.

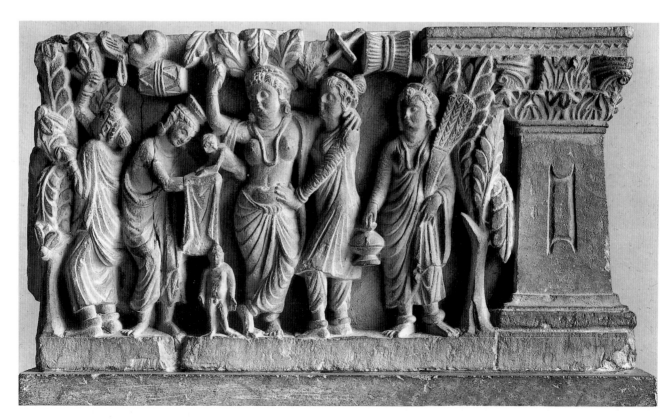

140. *Birth of Buddha* (fragment). Stone pedestal; l. 20$^{1}/_{2}$" (52.1 cm). Gandhara region. Late 2nd–early 3rd century C.E. Art Institute of Chicago

Also from Gandhara of the Kushan period is a Buddhist triad (*fig. 141*) whose central figure is Shakyamuni preaching, i.e., setting in motion the Wheel of the Law, as symbolized by the gesture of his hands (*mudra*). To his right and left, respectively, stand the bodhisattvas Maitreya (who will become Buddha in the future) and Avalokiteshvara. In the background, witnesses to the preaching, are the Hindu deities Brahma and Indra. Not only is this a complex and beautiful sculpture, but it bears an important inscription with a date most likely equivalent to 182 C.E. The Buddha's head is Apollo-like and his eyes are half closed, presaging the lowered glance customary in later images. In the flowering tree we see an exuberant display of virtuoso undercut stonework.

The flanking bodhisattvas are small-scale examples of the classic standing type seen in figure 142. Apart from the mustaches, their faces are those of Mediterranean gods or heroes, and they wear heavy classical jewelry and

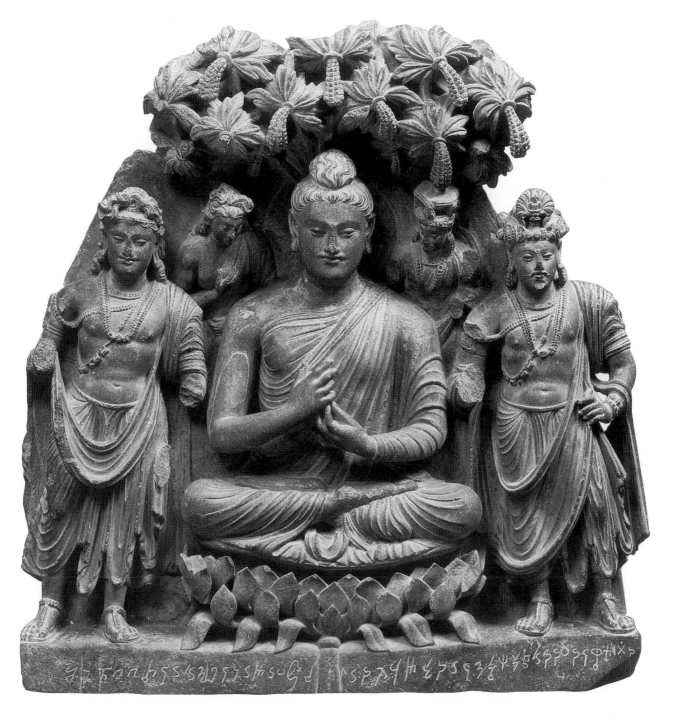

141. *Buddhist triad.* Dated to c. 182 C.E. Gray schist; h. 24³/₈" (62 cm). Gandhara region. Kushan period. Collection of Claude de Marteau, Brussels

142. *Standing bodhisattva.* Stone; h. 43" (109.2 cm). Gandhara region. 2nd century C.E. Museum of Fine Arts, Boston

143. *Adoring attendant.* Stucco; h. 21¹/₂" (54.6 cm). Hadda, Afghanistan. 5th–6th century C.E. Cleveland Museum of Art

boldly organized, rather geometric draperies. On the pedestal of figure 142 is a scene from the life of the Buddha. In such images the Gandharan style comes to be increasingly less indebted to Rome, and the northwest Indian sculptor is more on his own.

The other aspect of Gandharan style is found in stucco figures. One must succumb to the charm and technical virtuosity of these plastic images. The production of stone sculpture in Gandhara tends to end by the third or fourth century and the later work to be executed in stucco, as the native Indian genius for plastic and fluid forms reasserts itself. Combining stylistic traits familiar from stone sculpture with Gupta influences from Kashmir, the later Gandharan sculptor created in stucco unified and original works (*fig. 143*). There are, to be sure, traces of classical shapes influenced by Kushan geometry: the arched eyebrows, the sharpness of outlines about the eye, and the modeling of the forms of the cheek. The figure of a bearded man is a classical type and reminds one of works influenced by the school of Skopas, particularly in the

144. *Head of a bearded ascetic.* Stucco; h. 4³/8" (11.1 cm). Hadda, Afghanistan. 5th–6th century C.E. Musée Guimet, Paris

145. *Demon.* Stucco; h. 11¹/2" (29.2 cm). Hadda, Afghanistan. 5th–6th century C.E. Musée Guimet, Paris

psychological overtones of the knitted eyebrows, which form a heavy shadow under the brows (*fig. 144*). But the modeling of the mouth is plastic, claylike, formed as one's hand, working directly and instinctively, would achieve it, not as one works in stone, where the concept must precede the carving. One of the most famous Gandharan stuccos, in the Musée Guimet in Paris, is a representation of a demon, perhaps one of the followers of Mara attempting to distract the Buddha from his meditations (*fig. 145*). The fluid bend of his body bespeaks the touch of one who knows the use and handling of clay. The forms are no longer even semigeometric, and the texture of the drapery, produced by scratching the surface of the clay, is sketchy and evanescent in style. The various Gandharan sites from which the stuccos come range in date from the fourth century to as late as the eighth and ninth. The fluid style associated with stucco spread all over the northwest and is comparable in quality and motivation to that of the terra-cottas of north-central and central India. It is the great contribution of the Gandharan style to the history of Indian sculpture, however fascinating the hybrid work in stone may be.

6

The International Gupta Style

In 320 C.E., after the breakup of the Kushan empire, northern India was divided into a number of petty kingdoms. The king of one small principality, probably Chandra Gupta I (r. 320–c. 335 C.E.), possibly his son Samudra Gupta, established the Gupta dynasty. Samudra Gupta (r. c. 335–376 C.E.) continued to subdue neighboring states, creating a Gupta empire with its capital at Patna in Bihar. A succession of able warriors and gifted rulers blessed with long reigns brought peace and prosperity to a vital area in north India, extending from coast to coast. The Chinese pilgrim-monk Fa-Xian, who visited India between 405 and 411, was immensely impressed with the generous and efficient government of the Guptas and with the magnificent cities, fine hospitals, and seats of learning in their domains. He writes of the contentment of the people, the general prosperity, and says that "the surprising influence of religion can not be described." Although the Guptas were Hindus, they contributed to the support of both Buddhism and Jainism, and it is recorded that one of the last great rulers, Kumara Gupta I (r. c. 415–455 C.E.), built a monastery at the famous Buddhist center of Nalanda in Bihar.

It was a time of cultural expansion and colonization, which saw the influence of Indian art and ideas extending into Central Asia, China, Southeast Asia, and Indonesia. Bodhidharma, the famous priest, traveled to China. It is very possible that the poet Kalidasa was attached to the court of Chandra Gupta II (r. c. 376–415 C.E.). His great drama *The Little Clay Cart,* written in this era, gives a vivid picture of life in the city of Ujjain in western Madhya Pradesh, where it is believed the later Guptas often held court. The visual arts, especially sculpture and painting, reflect the secure and leisurely atmosphere of the time. It was indeed a classic, golden age. These were, however, the last great days of Indian Buddhist art, except for the Pala and Sena schools of Bengal. As Hinduism displaced Buddhism in India, the future of the art, like that of the faith, moved eastward.

Few freestanding Buddhist structures survive. Among them are a *chaitya* hall of brick at Chezarla, in the Kistna district of Andhra Pradesh, and a notable small fifth century shrine at Sanchi (temple 17), which stands near the Great Stupa. Temple 17 is a simple cell, like an early Greek temple, in which the shrine could be approached through a porch supported by stone columns (*fig. 146*). Behind this temple is a taller structure, temple 18, one of

146. *Temple no. 17.* Stone. Sanchi, Madhya Pradesh, India. Gupta period, 5th century C.E.

the very few constructed *chaitya* halls remaining in India. All that is left of it are some of the great columns and parts of the architrave. The outline of the foundations is no different from the plan of the early rock-cut *chaitya* halls. One must distinguish between the *chaitya* hall and the cell. The latter ultimately became dominant because a Hindu worshiper moves forward to confront the deity alone, while in Buddhist worship there was much group adoration, often by circumambulation of the stupa. The Buddhist *chaitya* hall was the most elaborate form of interior architecture to be designed in India as a site for worship, and the example at Sanchi is as full a statement as this form ever achieved in Buddhist art. The Hindu *mandapa,* though also extensive and fairly complex, is more like a gathering or waiting area than a hall for worship. The other remaining architectural monuments of the Gupta period are largely monastery complexes, the most extensive being the one at Sarnath, which covers about a square mile and comprises many similar single-cell units grouped around a variety of courts.

Mathura and Sarnath

Gupta sculpture, the classic artistic expression of Buddhism in India, established the standard type of the Buddha image. This was exported in two main directions—to Southeast Asia and Indonesia, and through Central Asia to East Asia. To think of the Buddha image is to visualize the Gupta type or its derivatives. There are two major regional styles in Gupta sculpture, with many secondary styles and regional variations of minor importance. One, the style of Mathura, represents a softened and leavened continuation of the harsh Kushan style; the other is the manner of the region of Sarnath, where the Buddha preached his First Sermon. Sculptures from the Mathura region are made of a moderately fine red sandstone, which can be worked in some detail but not to

ultimate refinement. The sculpture of the Sarnath region is of a cream-colored sandstone, the same sandstone used by the Mauryans for their columns and capitals, and capable of being worked to a high degree of detail and finish.

In the National Museum at New Delhi is a red sandstone standing image of the Buddha, which comes from Mathura about the early fifth century C.E., with stylistic remnants of Kushan geometry in the drapery and the markedly columnar legs (*fig. 147*). Also carried over from the Kushan style are the wide shoulders and swelling chest, quite different from Sarnath images, and a rigid frontality almost greater than in such early, pre-Buddhist images as the Parkham yaksha. The crisply geometric Kushan style is also evident in the eyelids, eyebrows, mouth, and neck lines, which are not free curves but carefully controlled geometric arcs that seem almost to have been laid out with a compass. But the roundness and softness of modeling of the face and neck are quite different from the more extroverted and powerful modeling of the Kushans. The overall quality of this new and classic expression of the Buddha is one of serenity and compassion. This quality differs from that of all preceding images and can be attributed to an extraordinary combination of individual characteristics of previous sculptures. The downcast eyes, so important for the concept of the image, may well derive from Gandharan art; the supple and quiescent smoothness of the body surely owes much to the indigenous organic tradition. The perfect fusion of all these physical traits with the now fully evolved concept of Buddhahood was responsible for the image's overwhelming success and its wide influence for over a millennium.

The source for the "string-type" drapery on this image, also found on Chinese and Japanese images, is much debated. Does it come from the Gandhara school, or is it Kushan work from Mathura? There seems to be no question that it appears in the third century C.E., on transitional images whose drapery is sometimes indicated as if

147. *Standing Buddha.* Red sandstone; h. 63" (160 cm). Mathura, Uttar Pradesh, India. Gupta period, early 5th century C.E. National Museum, New Delhi

148. *The First Sermon.* Stela; Chunar sandstone; h. 63" (160 cm). Sarnath, Uttar Pradesh, India. Gupta period, c. 475 C.E. Museum of Archaeology, Sarnath

by a series of strings arranged in careful parallel arcs on the surface of a nude body. Images from the sixth century and later display a softening of the style and a growing freedom in the treatment of details.

In the early fifth century C.E. images of the Mathura school begin to lose popularity, and most images of later date are in other material than red sandstone. Curiously, however, many of the cream sandstone sculptures at Sarnath were covered with red pigment to look like the red Mathura sandstone, perhaps because of the particularly holy traditions of the earlier images.

The most famous and most copied of all the Buddha images of the period is the fifth century Chunar sandstone image in the Museum of Archaeology at Sarnath. It represents the Buddha setting in motion the Wheel of the Law with his First Sermon in the Deer Park at Sarnath, a suburb of Varanasi, which was to become a great Buddhist center (*fig. 148*). The image presents the Buddha

Colorplate 1. *Burial urn.* Painted Pottery, hard-fired earthenware; h. 14¹/₈" (35.9 cm). Banshan, Gansu, China. Neolithic period, c. 2200 B.C.E. Seattle Art Museum

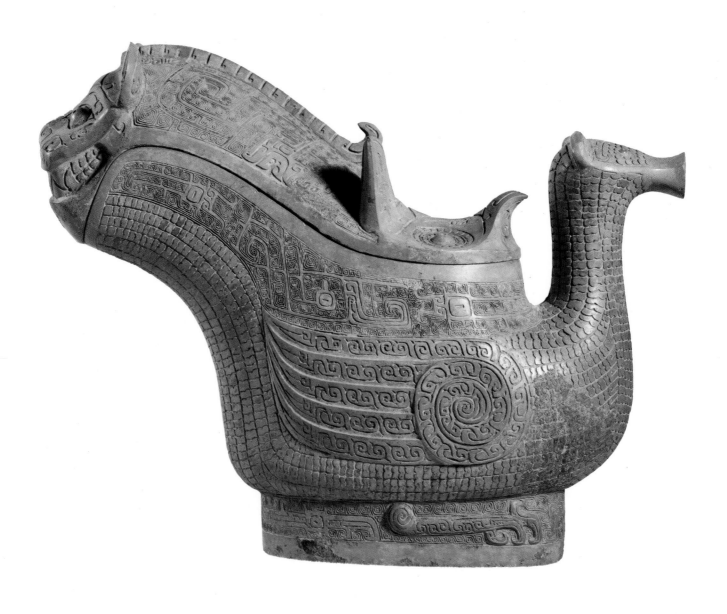

Colorplate 2. *Guang.* Ceremonial vessel; bronze; l. 12¼" (31.1 cm). China. Shang dynasty, Anyang period.
Freer Gallery of Art, Smithsonian Institution, Washington, D.C.

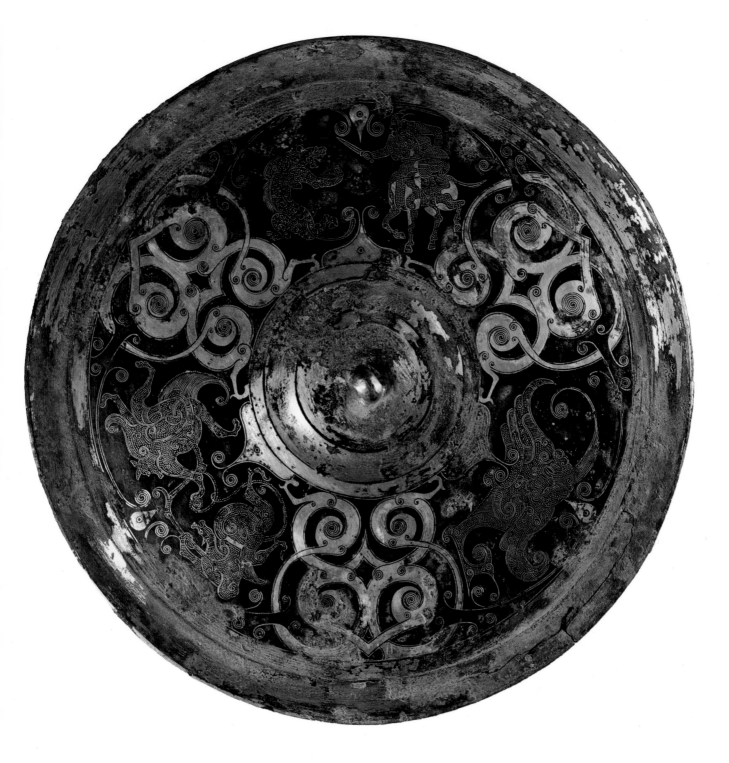

Colorplate 3. *Mirror.* Bronze inlaid with gold and silver; diam. 7⅝" (19.4 cm). Jin Cun, Henan, China. Late Zhou period. Eisei Bunko, Tokyo

Colorplate 4. *Cranes and Serpents.* Lacquered wood; h. 52³/4" (134 cm). Changsha, Hunan, China. Late Zhou period. Cleveland Museum of Art. Detail of fig. 65

Colorplate 5. *Tubular fitting with design of animals in landscape setting.* Bronze inlaid with gold and silver; h. 10 3/8" (26.5 cm). China. Early Western Han dynasty. Shu Mei Foundation, Shigaraki, Japan

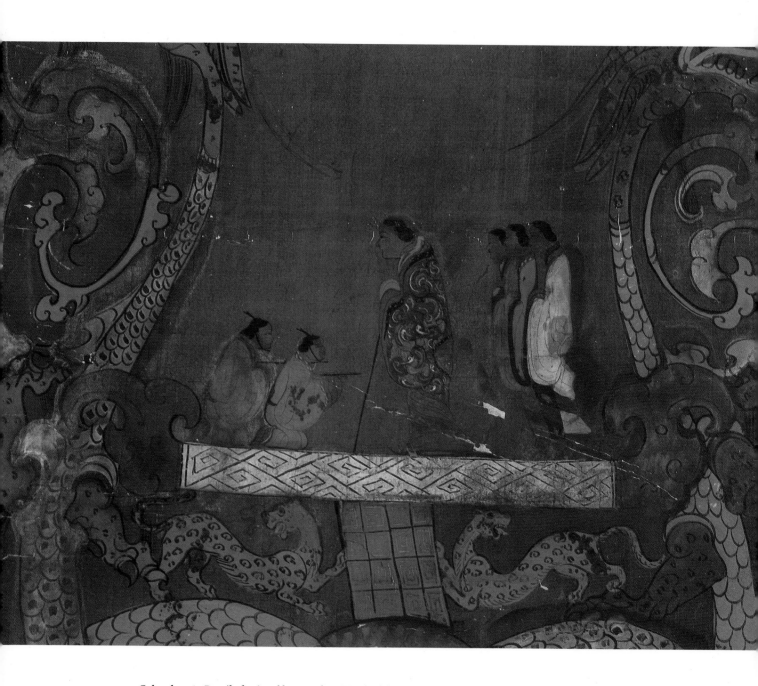

Colorplate 6. *Detail of painted banner, from Tomb of the Marquise of Dai.* Silk; l. 6'8³/4" (2.1m). Mawangdui, near Changsha, Hunan, China. Western Han dynasty, c. 180 B.C.E. Historical Museum, Beijing(?). See fig. 77

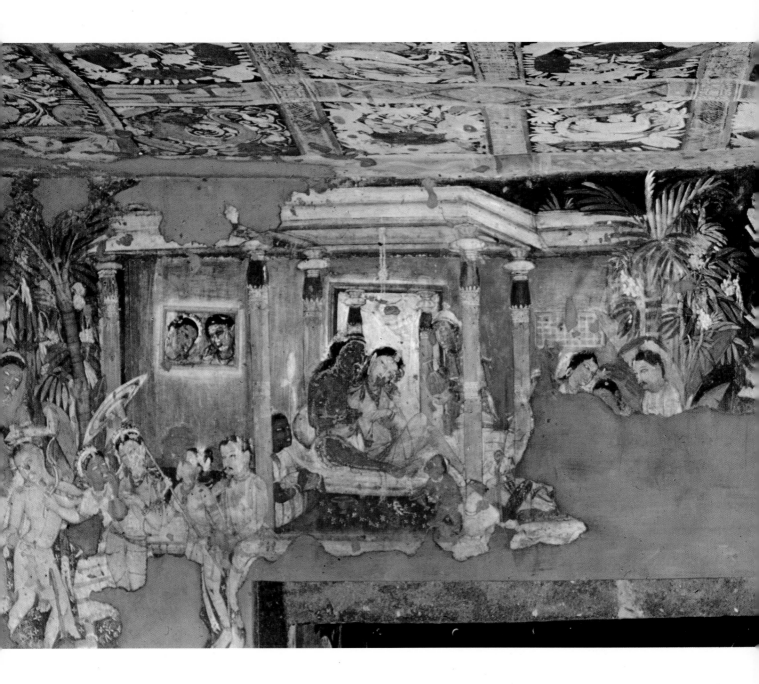

Colorplate 7. *Vishvantara jataka: palace scene.* Fresco. Porch of cave 17, Ajanta, Maharashtra, India. C. 500 C.E.

Colorplate 8. (following page) *The "beautiful bodhisattva" Padmapani.* Fresco. Cave 1, Ajanta, Maharashtra, India. C. 500 C.E.

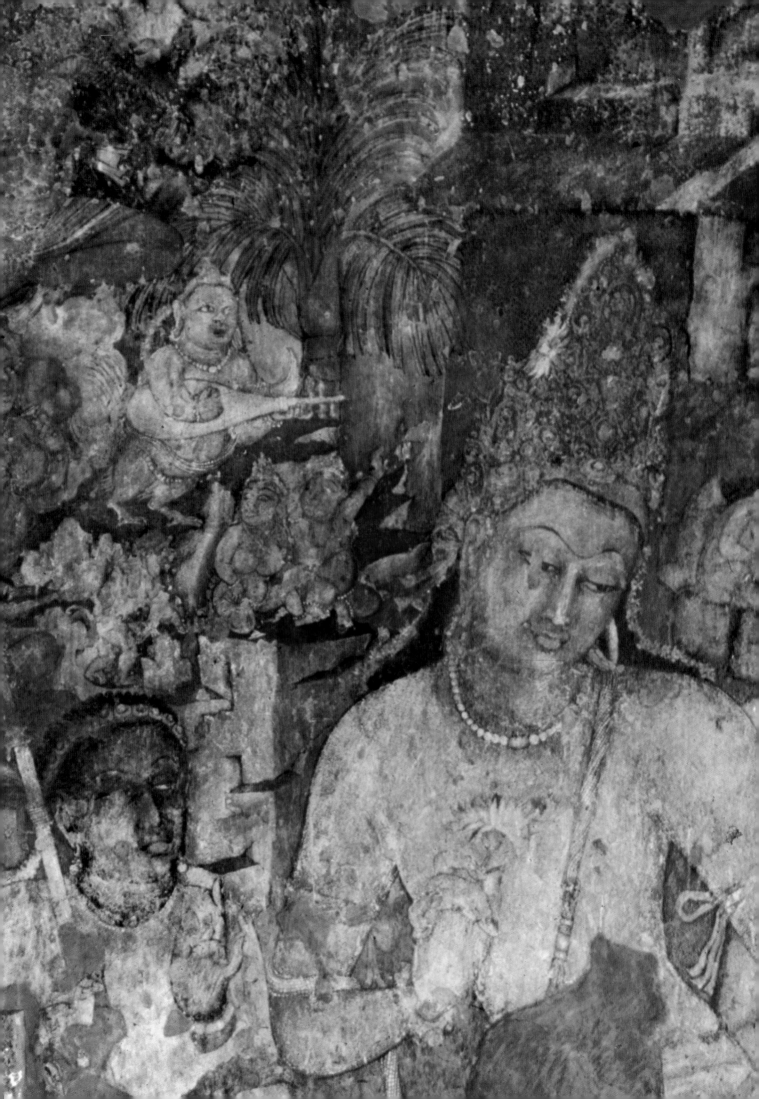

seated in the pose of the yogi ascetic, the soles of his feet up, his hands in *dharmachakra mudra*, the symbolic gesture of turning the Wheel of the Law, or teaching. He is frontally oriented, seated on a cushion, with drapery carefully fluted to suggest a lotus medallion. Beneath the cushion on the plinth of the throne is a representation of the Wheel of the Law seen from the front, a piece of virtuosity on the part of the sophisticated sculptor. The Deer Park is indicated by two deer, now damaged, on either side of the Wheel, flanked by six disciples in attitudes of adoration. The Buddha's throne is decorated with lions of a fantastic winged type, called leogryphs, who serve to indicate the lion throne of royalty. Behind his head and centered on the *urna*, the tuft between the eyes, is the halo, the sun wheel, indicating the universal nature of the deity, clothed in the sun. The halo is decorated with a border of aquatic motifs, principally lotuses, recalling the ancient fertility and vegetative symbols associated with yakshas and yakshis. On either side, like angels in Italian Renaissance painting, are two flying angels who rush joyfully in to praise the Buddha. This image is not as taut or as architectonic as the image from Mathura. The treatment of the hands with their elegant but rather limp fingers, the narrow chest, the face with its softer outline and double reflex curves instead of simple geometric curves, the foliage motifs—all combine to give the impression of a softer and more organic style. At the same time the frontal symmetry of the image and its precision of gesture tend to add an architectonic frame to the organic detail. The result is a style with its own characteristic traits, quite unlike the almost frenzied energy and movement of Hindu images of slightly later date. The flying and gesturing angel at the upper right is much freer than the main image. In this respect the stela resembles Italian altarpieces, in which the principal figures of the large panels follow rigid iconic modes of earlier years, while the secondary figures, either tucked in the sides of main panels or, more often, in the predella panels, show more advanced styles, with an adventurous handling of space, posture, and gesture.

The language of poetry and prose exerted great influence on Indian sculpture and painting. Religious texts, drama, and poetry are full of metaphor and hyperbole—the hero's brow is like the arc of a bow, his neck like a conch shell; the pendent arm of Maya, mother of the Buddha, hangs like the trunk of an elephant; the curl of the lips is like that of a reflex bow. It is such comparisons that the sculptor and painter translate from the literary trope into curves derived from geometry or volumes idealized from the more irregular forms of nature.

Establishment of classic image types tended to diminish the variety of subject matter. The rich iconography of the *jataka* tales at Sanchi, the donors, *jataka*s, and other subjects at Bharhut, the wealth of representational material on the Great Stupa at Amaravati, became but memo-

149. *Eight scenes from Buddha's life.* Stela; Chunar sandstone; h. 37" (94 cm). Sarnath, Uttar Pradesh, India. Gupta period, late 5th–6th century C.E. Museum of Archaeology, Sarnath

ries. In some of the stelae at Sarnath that show the developed Buddha image in scenes from the life of the Buddha, we begin to sense an impoverishment of imagination and subject. This is particularly true of Mahayana art, in which images are reduplicated within a single work; this practice ultimately reaches its most elaborate form in the Buddhism of Nepal and Tibet, with frightfully complicated and seemingly endless manifestations. One of the most famous stelae, at the Sarnath museum, represents eight important events of the life of the Buddha (*fig. 149*). These are, from the upper left downward: Buddha Turning the Wheel of the Law, an unidentified scene, the Temptation of Mara, the Birth of the Buddha with Queen Maya Holding the Bo Tree, the Buddha Calling the Earth to Witness, the Buddha Taming the Maddened Elephant, the Great Miracle of Shravasti, and the *Parinirvana* of the Buddha. Despite all the possibilities of this rich subject matter, there is an almost boring repetition of established motifs. Seated or standing, the various figures look very much alike; because of repetition the forms have degener-

150. *Ajanta, Maharashtra, India.* General view. 1st century B.C.E.–9th century C.E.

ated. The images are squat, devoid of the grace and proportion of the great seated image of the Buddha preaching. What is gained in the simplicity of each image and its clarity against a plain background is lost in the bareness of the almost nonexistent narrative description.

Ajanta

For later Gupta art the type-site is the cave-monasteries of Ajanta in the northwestern Deccan (*fig. 150*). Only there do we have any considerable remains of the great Gupta school of wall painting. Surviving art at Ajanta ranges in date from the first century B.C.E. to the seventh century C.E., and the painting shows complete mastery and wide range, but the sculpture, largely of the later Gupta period, reveals a considerable decline from the work produced in the early fifth century.

The caves are situated on the horseshoe bend of a stream in a somewhat wild and desolate region, even today the haunt of panthers and other wild animals. Probably it was chosen as a religious site because of its relative isolation, which made it a refuge from warfare and persecution as well as a place of pilgrimage—as the proportion of monks' cells to shrines tends to confirm. There are twenty-nine caves at Ajanta, numbered by scholars for purposes of reference. With great physical labor and vast expense the caves were carved from the living rock, most of them within a relatively short period and with the lavish support of the local (Vakataka) dynasty, over which the Gupta rulers exerted strong influence. The largest

151. *Chaitya facade.* Cave 19, Ajanta, Maharashtra, India. Gupta period, late 5th century C.E.

152. *Interior of chaitya hall.* Cave 26, Ajanta, Maharashtra, India. Gupta period, late 5th century C.E.

chaitya (cave 10) dates from the first century B.C.E. at the latest, but most of the *vihara*s (monks' living quarters) appear to date from the sixth and seventh centuries C.E. Even at this late date the Buddhist church was still able to produce a major work.

Ajanta posed few architectural problems for its makers. Being carved from the living rock, the caves are really sculptures. Although modeled on constructed *vihara*s or *chaitya* halls, the relatively late caves, such as cave 19 of the late fifth century (*fig. 151*), are likely to be more in the nature of free sculptural inventions than accurate models of constructed halls. By this time artisans were so used to working in the living rock and had so many precedents that they were able to indulge in reasonably free inventions. It is doubtful, for example, that the elaborate sculptured facade and interior of cave 19 duplicated a constructed *chaitya* hall. In cave 19 the ornate facade has a small porch flanked by monotonously repeated images

of the Buddha and a few guardian kings. The character of the *chaitya* hall as a great opening into the hill is denied by the embellishment of the porch, and so we are confronted with a cutting that does not as fully express the design of the interior as do earlier rock-cut *chaitya* halls.

The interior of cave 26 shows the great elaboration characteristic of later *chaitya* halls (*fig. 152*). The columns are carved with bands of spiraling devices; the capitals are highly developed too, and the friezes above are ornately carved with repetitive images. The stupa itself is no longer simply the representation of a burial mound but is placed on a high drum carved with images of the Buddha. The principal image shows the Buddha seated with legs pendent, turning the Wheel of the Law. The interior was heavily polychromed and must have had a rich, jeweled effect. The tendencies toward a detailed and more pictorial treatment of the interior are not unexpected, for painting is the great art of Ajanta.

The *vihara*s, which one would have expected to be simple, solitary, and devoid of ornament, are as elaborate as the *chaitya* halls themselves. Cave 17 has a low ceiling and a columned interior court surrounded by cells—that is, a communal living and cooking area surrounded by sleeping quarters (*fig. 153*). The main axis culminates in a cell with an image of the Buddha for communal or individual worship. On the ceiling are paintings of Buddha images and decorative designs of lotus flowers and fantastic animals. The interior is encrusted with color on the carved columns and on every available flat surface. One significant detail creeps into the later Gupta style, to become especially characteristic of Indian medieval art. (*Medieval* is used as a general term for the period of Indian art between the decline of the Guptas, about 600 C.E., and the foundation of the great Mughal empire in 1526; see p. 198ff.) Standing or flying figures of different sizes—dwarfs, yakshas, yakshis, and angels—are inserted in the corners of the capitals almost at random, as if the sculptor were at play (*fig. 154*). In these figures we sometimes find great movement and vigor, a freer spirit, and less monotony than in the rather repetitive main images. They are asymmetric in arrangement, and some are so located on the capitals that they almost deny the character of the architecture. This sculptural representation of movement or flight on the surface of the architecture indicates the direction in which Indian sculpture is moving at this time.

In addition to these architectural sculptures, a few of the finest of the exterior carvings at Ajanta can be considered purely as sculptures. Some are to be found at the sides of the porches leading to the *chaitya* halls or to the *vihara*s. One sculptor seems to have found a challenge worthy of his skill in the subject, not of a Buddha or bodhisattva or any deity of the main Buddhist hierarchy, but of a *naga* king and queen (*fig. 155*). The *naga* king, a serpent deity with a hood of seven cobras behind him, is attended by his queen, with a single hood, and by an attendant holding a fly whisk symbolizing the royal status of the *naga*. This delightful composition depicts the king seated beside his queen in a version of the posture called "royal ease"—right arm resting on raised right knee, the left leg pendent. The contrast between the elaborate jewelry of the king's headdress and the deep shadow caused by the *naga* hood is aesthetically extremely effective. The composition, with its subtle placement of the attendant in the shadow of the pillar, is a representation of husband and wife, male and female, in the best tradition of great Indian sculpture. The sculptor depicts the drapery of the king and the queen as falling over their dais in a simple incised pattern, with little ripples lightly cut into the surface to indicate drapery folds. Further, he achieves the ultimate of sophistication by carving rocks in the living rock, producing an aesthetic double-entendre. This effect is influenced by painting, for characteristic ways of indi-

153. *Columns before the central shrine.* Cave 17, Ajanta, Maharashtra, India. Gupta period, late 5th century C.E.

154. *Apsarases.* Bracket figures. Cave 16, Ajanta, Maharashtra, India. Gupta period, c. 480–490 C.E.

cating rock forms in the paintings of Ajanta are repeated here: a rather geometric series of interlocked steps.

The major art of Ajanta is painting, and it is only because of the relative isolation of the site (long known only to local villagers) that it is preserved at all. The paintings, executed from the first century B.C.E. to the late fifth century C.E., lasted until the nineteenth century in relatively good condition; their discovery was justly heralded

155. *Nagaraja and his queen.* Exterior niche, cave 19, Ajanta, Maharashtra, India. Gupta period, late 5th century C.E.

as one of the great artistic finds of all time. But more open exposure to weather and, even more, the treatment of early twentieth century restorers, has hurt them, and they are probably in less good condition today. The early *chaitya* hall number 10 boasts remnants of painting from the first century B.C.E.—an Andhra-Satavahana period fresco, of the same period as Sanchi, representing a *jataka* tale and revealing a surprisingly advanced stage of pictori-

al development (*fig. 156*). We illustrate but a drawing from the fresco; the now shadowy painting is an amazing production. Figures are not just drawn in outline but are modeled in light and shade, in a way similar to Roman and Pompeian frescoes. Brown predominates in the coloring of the figures, but the modeling of the heads and the emotions expressed in the faces indicate a control of advanced methods of representing psychological states

156. *Saddanta jataka: the queen fainting at the sight of the tusks.* Drawing of fresco. Cave 10, Ajanta, Maharashtra, India. Andhra period, 1st century B.C.E.

that is not to be found in the sculptures, which may well have been produced by a lower hierarchy of artists. The painters seem to have been far ahead of their colleagues in other arts. The composition represents numerous related figures in space far more convincingly than the *jataka* tales carved in stone at Sanchi. Not only is the fresco better in quality but also in development and complexity and in the artists' ability to solve problems of space and individual representation.

In addition to the fragments from the early Andhra period, there are many frescoes whose precise dates are much argued. The murals of cave 2, with Buddhist devotees coming to a shrine door (*fig. 157*), are of a radically different type from those in caves 1 and 17. The cave 2 group may be dated as middle Gupta, that is, the mid-fifth century C.E., though they may also be the handiwork of a different painting workshop. The figures are placed in a definitely indicated space bounded in front by a ground line with small dwarfs (*ganas*) moving in procession and behind by curious geometric rock forms. On this shallow stage space is indicated by overlapping figures and by placing the farther figure higher up. The placement of the figures in the limited space is simple, recalling the plain backgrounds of the Gupta sculptures. There is no great turmoil, activity, or movement except among the *ganas* in the lower right-hand corner. The modeling of the individual figures is accomplished by light and shade and is handled much differently from the modeling in slightly later frescoes. Here it occurs at the very edges of the contour: the arms, legs, and bodies are treated as tubes, the breasts as mounds, with large areas of flat light color edged by darker color. The closest visual analogy is that of a photographic negative, with its forced contrasts of light and

dark. The result is a curious but rather solid and simple effect. These figures with large light areas and sharp modeling at the edges are clearly differentiated one from the other, in contrast to later styles.

The developed late Gupta style of the late fifth century is most characteristically seen in the porch of cave 17, an entrance to a *vihara* (*cpl. 7, p. 119*). Above the door and to the left is a scene, set in a forest or parklike exterior, of a prince and a princess in a palace. In contrast to the rather quiet reds and soft blues of the paintings in cave 4, the general color scheme of this painting is almost hot: oranges, rather sharp blues, yellows, and greens with a warm orange tinge. The figures are represented quite differently from those in cave 2. There is little modeling, and in the female figure and one or two others there is greater emphasis on linear detail. But above all the composition is more intricate, with greater overlapping and compression of figures than in the noble and stately style of the earlier murals. This complexity is supported by the profusion of the jungle background. Indications of space are also more accomplished, with a stagelike palace setting rendered in a free perspective not based upon a rigid geometric scheme. We say "free" since there are many inconsistencies in the treatment of the perspective, which is practical rather than logical. At the same time early figure conventions going back as far as Sanchi, such as the large heads looming at the windows, are carried on. The procession with parasols, moving out to the left, reveals a greater use of overlapping than before. These figures are crowded, but there is little attempt to indicate depth by the archaic means of putting one figure above another. The whole emotional and psychological effect is one of sensuous movement, breathing something of that warmth found in

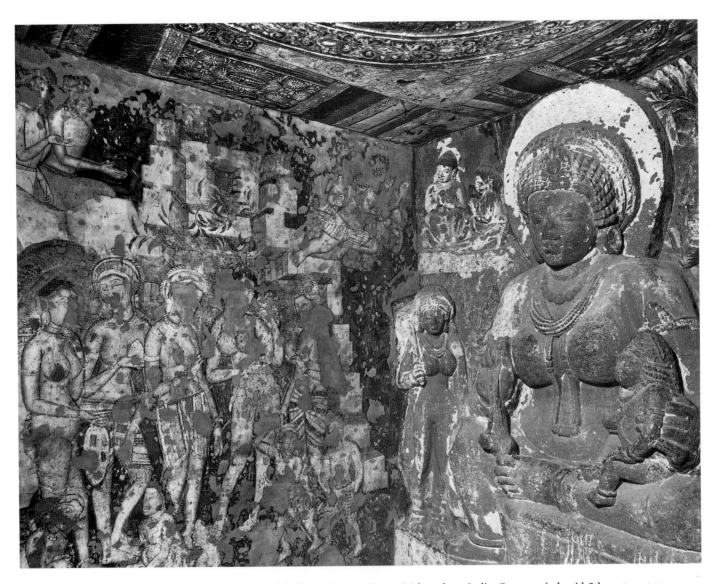

157. *Sculptured figure of Hariti and a portion of the fresco.* Cave 2, Ajanta, Maharashtra, India. Gupta period, mid-5th century C.E.

the Indian air, reinforced by the supple grace of the bodies. Judging from the remnants of Roman painting and the evidence they give for Greek painting, the paintings of Ajanta represent a greater achievement in narrative art, if perhaps one less rational in perspective or developed in representing deep space.

One detail of a charming princess in cave 1 epitomizes the painting style of Ajanta (*fig. 158*). It is from a *jataka* and gives some idea of the emotional and visual impact of the original. The detail reveals the difference between the modeling of this figure and that of the firm and noble figures of cave 2. Here there are no large areas of light color but a gentle modulation from dark to medium dark, except for the narrow highlights. The richness of the figure does not depend upon the modeling of the interior surfaces of the figure proper, but upon the adornment of those surfaces with ropes of pearls, headdress, and other jewelry. The loving exaggeration of the lower

lip harks back to pure Gupta style. The heavily arching eyebrows and the reverse curve of the eyes are formulas dear to the Gupta sculptor and painter. The warmth of the color is largely a falsification, resulting from the varnish used by restorers of the late nineteenth and early twentieth centuries. We can see something of the method of painting in this detail. Roughened stone was covered with a mixture of chaff and hair bound with plaster to produce a surface on which the underdrawing and then the final painting could be executed on the still slightly damp plaster.

The most famous figure at Ajanta is in cave 1, and has been often described as the "beautiful bodhisattva" (*cpl. 8, p. 120*). It is located at one side of a cell entrance and represents Padmapani holding a blue lotus. The figure is much destroyed from the waist down, but the noble torso and especially the head, with its beautiful countenance and downcast eyes, express that compassion and

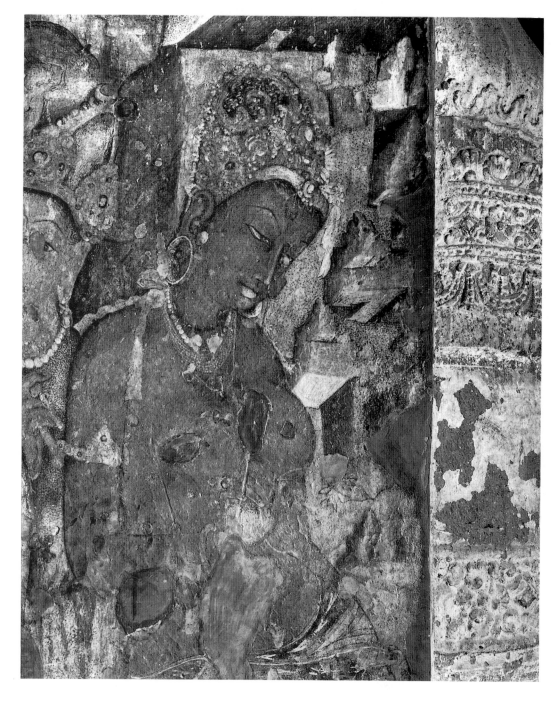

158. *The black princess.* Fresco. Cave 1, Ajanta, Maharashtra, India. Post-Gupta period, c. 500 C.E.

humility which are the great achievement of Buddhist art. Let it be added, though, that not all the figures at Ajanta are noble types. We find some figures that are grotesque and ugly, and others, including merchants, drawn from everyday life, representing the Gupta world as observed by its painters. A brief treatment of the Ajanta caves gives no idea of the complexity and richness of the subject matter, or of the variety of aesthetic techniques to be found at this great site.

At Aurangabad, just south of Ajanta and Ellora, slightly later caves of the mid- to late sixth century demonstrate the changes occurring in style and iconography in Buddhist art. An almost orgiastic scene of a god-dess(?) dancing to the music of female musicians (*fig. 159*) conveys a sense of energy by means of voluptuous modeling and vigorous movement, not unlike some of the Hindu niche groups at Elephanta (*see fig. 284*) of almost the same date. The complexity of the reliefs and their sexual emphasis signal the changes in Buddhism that we characterize as the beginning of the Medieval period. Theravada Buddhism disappeared except in Sri Lanka. Mahayana Buddhism became the prevailing faith for a time in Bengal and northeastern India, and has remained so to the present in the Himalayan regions. Elsewhere throughout India Hinduism was becoming ever more dominant.

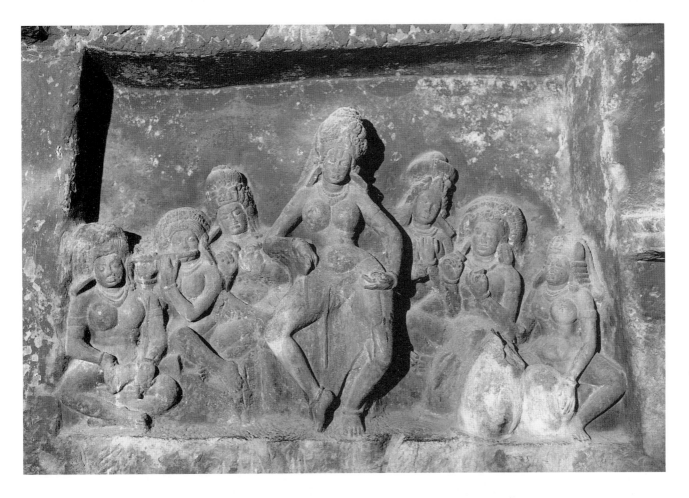

159. *Dancing goddess(?) and musicians.* Cave 7, Aurangabad, Maharashtra, India. Mid- to late 6th century C.E.

BUDDHIST ART BEYOND INDIA

The two important dynasties of the Bengal region are the Pala and Sena, spanning about 730 to about 1197 C.E., after which time the Muslim invasion had smashed the Sena rulers. The great achievement of the art of Bengal was to preserve the characteristic Gupta formulas with considerable quality over a long period, and to transmit them to Nepal, Tibet, Burma, Thailand, and Indonesia. This is not to say that the artists of Bengal did not produce masterpieces in their own right. One of the greatest achievements of the Pala artist, a representation of the Buddha in the earth-touching pose, made of the characteristic black chlorite stone of the region, shows the style at its best (*fig. 160*). Even in this noble and massive black stone the treatment of details of the halo, of the throne, and of the small figures below is so metallic that it would be difficult indeed to say from the photograph whether the image was made of metal or stone.

The tendency in Pala sculpture, exaggerated in the Sena period, was toward a detailed, metallic style in work-

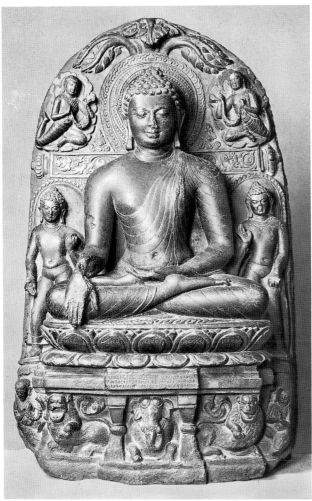

160. *Buddha Calling the Earth to Witness.* Black chlorite; h. 37" (94 cm). Bengal, India. Pala period, 9th century C.E. Cleveland Museum of Art

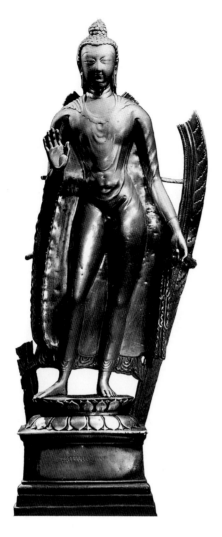

161. *Standing Buddha.* Brass; h. 38⁵/₈" (98.1 cm). Kashmir. 8th century C.E. Later Tibetan inscription of Lha-tsun Nagaraja. Cleveland Museum of Art

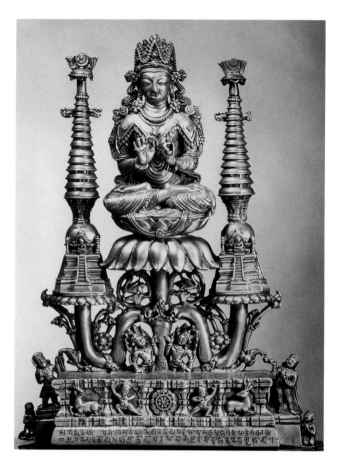

162. *Crowned Buddha Preaching.* Brass inlaid with copper, silver, and zinc(?); h. 13³/₄" (34.9 cm). Kashmir. 8th–early 9th century C.E. Asia Society, New York. Mr. and Mrs. John D. Rockefeller 3rd Collection

ing this hard, very fine-grained black stone. And so we are not surprised also to find numbers of small bronzes and images of gilt bronze, silver, and gold from the region. These were exported in some quantity. Indeed, they are found today throughout Farther India and Indonesia, and became the models for the native sculptors, especially the Javanese, in their first attempts to represent the Buddha image. The metal images usually turn up either from excavations or by chance export from monasteries in Tibet or Nepal. In the latter circumstance they are in excellent condition and look remarkably new, but the earth is not kind to the particular alloy used by the Bengali artist, with the result that the excavated pieces are severely encrusted. These metal sculptures, their undeniable variations and elaborations notwithstanding, depend on the Gupta style for their character and conformation.

Kashmir

Somewhat the same can be said of Kashmir and its environs in northwest India. As late as the sixth century stucco sculpture was being made there in the late Gandhara-

Hadda mode, but thereafter elements of earlier Bactrian-Iranian conventions, the Gupta style, and the developing energetic art of Medieval north India were gradually merged into a unified style. The subject matter, at first both Hindu and Buddhist, became increasingly dominated by the complex iconography of Esoteric Mahayana Buddhism, especially in Tantric forms that later became the standard icons of Tibetan Lamaism.

Kashmir's location, on the great trade and pilgrimage routes between India and Central and East Asia, made its art a major influence in the development of Buddhist art in China, Tibet, and (to a lesser degree) Japan. Two powerful rulers, Lalitaditya (r. second quarter of the eighth century C.E.) and Avantivarman (r. c. 855–883), were wealthy and indefatigable builders and patrons of the arts. Particularly the portable images made under their rule became models for foreign icon makers. The large Buddha in Cleveland (*fig. 161*), a classic Kashmiri image of the eighth century in the Gupta mode, also shows in its materials the rich visual intentions of the sculptors. The copper-zinc alloy (close to brass) produces a golden sheen that can easily be mistaken for gilding, and to this glowing

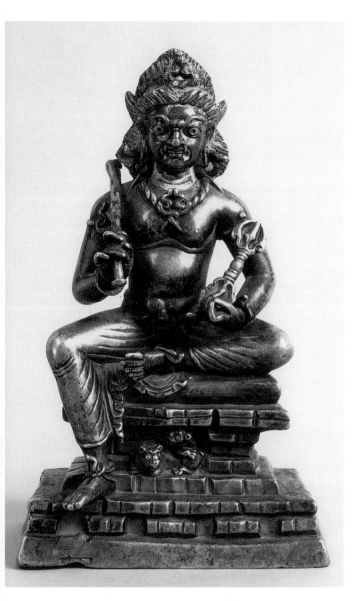

163. *Seated Thunderbolt Bearer (Vajrapani).* Brass; h. 8¹/₂"
(21.6 cm). Kashmir. 8th–9th century C.E. Cleveland
Museum of Art

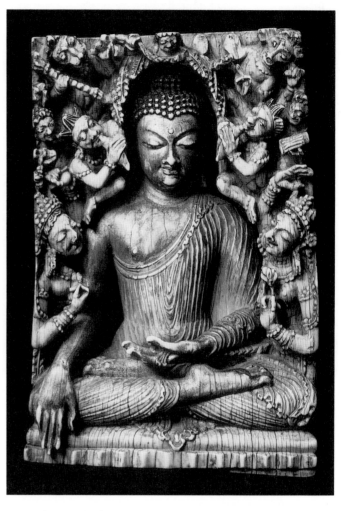

164. *The Assault of Mara.* Painted and gilded ivory; h. 5³/₈"
(13.7 cm). Kashmir. 8th–9th century C.E. Cleveland
Museum of Art

metal artists customarily added inlays of silver and cop-
per, not only to the eyes and lips respectively, but also to
the details of drapery, thrones, or other architectural ele-
ments (*fig. 162*). The eyes are usually heavy-lidded, and
the bodies are more elongated than in their Gupta proto-
types. In sharp contrast to the noble image of compassion
presented in figure 161 are images of deities of the Tantric
(also called *Vajrayana*) pantheon in their terrible aspects,
protecting the blessed and frightening the forces of evil.
Vajrapani (*fig. 163*) bears a club and a double *vajra* (thun-
derbolt), signaling his functions as guardian of knowledge
and faith. The necklace of serpents, the flamelike hair, and
the lion in the cave in his rocky throne add to his aggres-
sive and protective appearance. Traces of gold paint at the
neck and cinnabar in the hair indicate that this image, like
the Buddha with the later Tibetan inscription (*fig. 161*),

was transported early on to Tibet, where it became yet
another of the thousands of images long stored in that
remote stronghold of Esoteric Buddhism. Between this
Vajrapani and East Asian images of similar deities (*see cpl.
30, p. 332*) there is considerable resemblance, and the
influence of portable images from Central Asia, Kashmir,
and other parts of northwestern India on the Buddhist art
of East Asia can be confidently assumed.

A specialty of Kashmir at this time was the carving of
small portable altars in ivory framed in wood. Some of
these have survived, preserved in Tibet and Nepal. Their
exquisite carving and polychromy on an almost jewel-like
scale produced remarkable icons representing classic
scenes of the Buddha's life; no Tantric subjects are so far
known in this medium. Mara's Assault on the Buddha
(*fig. 164*), or the Buddha preaching, are the usual subjects

165. *Altar of the Du-khang shrine with main image of Vairochana.* Alchi, Ladakh, Kashmir. 11th–12th century C.E.

The Chos-'khor temple complex at Alchi, northwest of Leh in Ladakh, is the most notable survivor, a treasure house of well-preserved mid-eleventh century master-works. Three of its five buildings are of special importance: the Du-khang, Sum-tsek, and Lha-khang-soma, probably built in that sequence over no more than fifty years. The Du-khang's paintings are principally large Mahayana mandalas, with a predominantly blue palette and hundreds of figures executed in an almost miniature style. Perhaps the artists working here were manuscript illuminators, familiar with the iconographic requirements and capable of satisfying the monks and the elect. Sum-tsek is a three-story building in which three images tower over twenty feet feet high in bays on three sides of the central hall and altar. They are made of unbaked clay mixed with chaff, air-dried, coated with plaster, and painted—the customary medium in Central Asia. Each of these figures—Avalokiteshvara, Maitreya, and Man-jushri—is shown with decorated skirts (*dhoti*) richly covered with iconographically appropriate scenes (*cpl. 9, p. 201*). Maitreya's garment bears scenes from the life of the Buddha; they are basically Kashmiri in representation but are enclosed in roundels, thus simulating fabrics of Iranian design or derivation. Sumptuous colors—red, yellow, green, and blue—are present and were probably most seductive to the laity. Scenes of arhats or disciples and ascetics occupy Manjushri's *dhoti*. Vairochana, Supreme Buddha of the Center, was the principal icon on the Sum-tsek altar, as he is on the altar of the Du-khang. The Du-khang image, though much repaired and repainted, is heavily costumed and decorated, presumably in the style in which it was first made (*fig. 165*). The third important hall at Alchi, the Lha-khang-soma, reveals still another aspect of Western Himalayan art, the supple and linear iconic style associated with Bengali and Nepalese painting of the early eleventh century, such as we see in figure 168.

Alchi is signally important for preserving the ambience and substance of the Western Tibetan–Kashmiri artistic tradition, which included the Esoteric Buddhist tradition that was exported to Central and East Asia. Demolished in Central Asia, only partially preserved in China and Japan, this tradition still endures in Alchi, a mountain retreat within a society until recently resisting the radically different cultures of modern times.

Nepal and Tibet

Preservation of traditional society and of the later forms of Buddhism was the function of the rulers of Nepal and Tibet. Nepal, in the southern ranges of the Himalayas, was conveniently accessible from northern India, and the full Gupta style of the sixth century found willing and skillful practitioners there. The fine-grained gray-green stone of the Kathmandu Valley was well suited to the voluptuous

of the central panels; the attendant figures are among the most exquisite miniature productions of Asian art.

Now a part of Kashmir, the Himalayan province of Ladakh is two mountain ranges east of Shrinagar and thus relatively isolated. Its past history is significant politically as well as culturally, first as an independent kingdom during the tenth and eleventh centuries and then as a part of the considerably powerful Tibetan state. Ladakh's culture and art mirror its contacts through Kashmir to varied sources—Iran, India, Central Asia and, more indirectly, Nepal and Pala Bengal. The provinciality of its art appears most often in the brass images, many on a large scale, derived from the Kashmiri tradition but with traces of local deviations from classic proportions and the addition of floral garlands to the inherited drapery systems.

Wall painting in Ladakh is hardly provincial. The combination of physical isolation and the early eleventh century proselytization for Tibetan Buddhism by leading monks from Tibet and India, most notably Rinchen Sangpo (958–1055 C.E.) and Dipamkara Atisha (982–1054 C.E.), led to the preservation of several important temple complexes and their rich and complex wall paintings elucidating the new teaching.

166. *Bodhisattva Padmapani*. Bronze; h. 24³/₈" (61.9 cm). Nepal. C. 12th century C.E. Cleveland Museum of Art

elegance of both Hindu and Buddhist image types. In quality of carving and mastery of representational canons the Nepalese artist cannot be faulted. At times, especially under the influence of the small metal images coming from Bengal in the Pala period, the sculptures tend toward an exaggeratedly sinuous elegance. But the inventive treatment of drapery and the addition of semiprecious stones in necklaces, armlets, and headdresses enriches an already supple and compassionate manner (*fig. 166*).

Of all surviving Nepalese stone sculptures, the most important is almost surely the *Jalashayana Narayana* at Budhanilkantha village near Kathmandu (*fig. 167*). Called in Sanskrit *Vishnu Anantashayin*, this image is a manifestation of Vishnu (Narayana) supported by the World Serpent Ananta, conceived as floating on the World Ocean in the eons between destruction and creation (*see fig. 248*). A key Hindu conception, this image is still in continuous worship by Hindus and Buddhists alike. One gains some notion of the power of religious belief combined with royal authority in the seventh century from knowing that the twenty-one-foot image is carved from a single boulder brought from the hills to the Kathmandu Valley when the sculpture was commissioned by King Vishnugupta in about 641 C.E.

167. *Vishnu on the Serpent Couch*. (Nepali: *Jalashayana Narayana*; S: *Vishnu Anantashayin*). Dated by temple inscription to c. 641 C.E. Stone; l. approx. 21' (6.4 m). Budhanilkantha, near Kathmandu, Nepal

Nepal's Buddhism was thoroughly Mahayana and, later, Tantric. This system emphasized complex preparation for initiation, yoga practices under strict discipline of the *guru,* or teacher, and the equal importance of the female principle as the *shakti,* or energy, of the male deity. Images with several arms and heads are common. In these the delicate casting and accomplished gilding technique enhance the often miniature size and hyper-refined detail. When one thinks, for example, of the flowing organic forms of modern sculptors such as Jacques Lipchitz or Theodore Roszak and then observes the Nepalese images, with their fluid grace and metallic expansion into space by means of projections and apertures, one senses a true aesthetic achievement.

Formal contacts between China and Nepal and Tibet, beginning during the reign of Kubilai Khan (r. 1280–1295 C.E.), created strong reciprocal influences on metal-casting techniques and on painting styles. The often frenzied and deliberately fearsome later art of Tibet parallels Japanese Esoteric Buddhist art in many respects (*see figs. 169, 427, 530*). Tibetan art has attracted increasing attention with the emigration to India and the West of both clergy and ritual sculptures and objects after the annexation of Tibet by China in 1951.

No large-scale painting remains from the Pala or Sena dynasties. But eastern Indian manuscript illuminations preserve something of the Gupta and early medieval style of Ajanta in painting. The rare manuscripts are painted on long strips of palm leaf, usually with much text and few illustrations, and were the means by which the Gupta painting style, with its concepts of figure and space representation, was transmitted to Nepal and Tibet. A detail of a manuscript from eastern India shows some modeling around the edges of the body, the use of landscape setting, and a simple indication of space by placing an object above to imply that it is behind (*cpl. 10, p. 202, above*). In another detail from this manuscript are the same curious geometric rock forms that we saw at Ajanta. The vibrant palette is unlike the rather soft, subdued color of Ajanta.

A second manuscript, of Nepalese origin, based on the style of eastern Indian manuscripts exported to Nepal, has been dated to 1111 C.E., some fifty to one hundred years later than the first (*cpl. 10, p. 202, below*). It shows a greater sophistication, particularly in the handling of line. The modeling, in either color or shade, is almost flat. Indications of contour or of movement are given by exterior lines. In this manuscript we have representations of deities only, existing in the timeless setting of their own halos. There are no scenes representing landscapes, interiors, or any setting in space. It is a more iconic, hieratic art, dominated by the iconography of Mahayana Buddhism but, like the bronzes, full of grace and linear sinuosity in the figures.

Though large-scale early paintings from northeast

168. *The Tathagata Ratnasambhava. Thangka*; watercolor on cloth; h. 36¹/₂" (92.7 cm). Central Tibet. 13th century C.E. Los Angeles County Museum of Art

India are currently unknown, there exist some impressive and sizable works from Nepal and Tibet. Many of these are *thangka*s, icons in hanging scroll format, displaying the same style found in the illuminated manuscripts writ large. A superb icon (*fig. 168*) in the Los Angeles County Museum, though attributed to central Tibet, is in almost pure Nepalese style, attesting the importance of Nepalese and Pala artistic idioms in the formation of the later, distinctive Tibetan mode. The distinctive quality of these paintings, which provided the foundations for later Himalayan *thangka*s, derives from their warm coloration, emphasizing red, yellow, and orange, with minor notes of blue and green, from the concentrated facial expressions denoting religious intensity, and from the compellingly repetitive rhythms.

Tibet is a special case. Tremendous mountains with very high passes make a formidable but not insurmountable barrier to communication with the outside world. Harsh topography, together with meager population, makes for regionalism. Buddhism, flowing from India through Central Asia, was thoroughly established in China and had reached Japan centuries before penetrating Tibet.

In the latter part of the eighth century a Tibetan king invited Mahayana Buddhist monks into the land to propagate the religion and to build monasteries. Gradually the imported faith succeeded in absorbing the native cults of mountain, river, and other protective deities embodied in natural forms or forces (the Bön religion).

During the following centuries the fortunes of Tibetan Buddhism were closely tied to the varying political interests and personal inclinations of the ruling house—or houses, as Tibet by the tenth century had fragmented into regional kingdoms. Succeeding waves of Buddhist proselytizing, all with royal or aristocratic patronage, resulted in the foundation of several monastic orders, or sects, and many subsects, each with its lay adherents. Competition among these orders was not unknown, reflecting competition among their secular protectors.

Reincarnation became an established belief in the twelfth century, with leadership of a monastic order devolving on individuals formally recognized as reincarnations of venerated predecessor monks (called lamas, meaning "none superior"). Spiritual authority tended to become hereditary, and to accrue political authority. Some monastic lineages considered their leader in each generation to be a reincarnation of one of the great bodhisattvas, thus endowing authority with divine sanction. Not only theology and the religious establishment but the social order as well was organized into complicated hierarchies.

While the Mongol empire spanned Asia, monastic lineages governed Tibet in fealty to the khans. The breakup of their empire left the eastern Mongols feudatory to China's Ming dynasty (1368–1644 C.E.) but still a power to be reckoned with in Central Asia, and their mass conversion to Tibetan Buddhism in 1578 made them significant protectors of the faith. That same year saw the creation of the honorific title Dalai (Ocean) Lama, bestowed by the converted chieftain Altan Khan on the Tibetan monk responsible for his conversion. Many Chinese emperors of the native Ming and conquering Qing (1644–1912 C.E.) dynasties were enthusiastic patrons of Tibetan Buddhism, inspired partly by the charismatic qualities of visiting monks and partly by the political wisdom of conciliating the Mongols.

In 1642 another Mongol khan established the then Dalai Lama as temporal as well as spiritual ruler of Tibet. This sealed the conservative nature of the society and also the preservation of its art until the mid-twentieth century.

In Tibet, as in Ladakh, Esoteric Tantric forms of later Buddhism became dominant, but so much so that Tibetan art after the thirteenth century is unique in appearance and unmistakably the product of the Tibetan form of Buddhism, now called Lamaism. The earliest Buddhist temple surviving in Tibet is a wattle-and-daub structure at Kachu, some fifty miles east of Lhasa. It was founded by

Kong.co, a Chinese princess married to a Tibetan king, between 728 and 739. On its interior altar stand a twelve-foot unbaked clay image of Shakyamuni Buddha (728–739 C.E.) and accompanying bodhisattva and guardian figures (shortly after 822 C.E.) Together these images reveal that already the artistic currents in central Tibet were diverse. The main image is generally of Gupta type, not unlike some of the ivory images from Kashmir; the secondary images, dating from the next century, show clear connections with Khotan and Central Asia.

Succeeding centuries witnessed the further development of Mahayana Buddhism into Tantrism. Tantric, or Vajrayana Buddhism emphasizes yoga techniques, the universality of the Buddha-nature conveyed by enlightened beings and by Buddhist icons, and the image of sexual union as an expression of the coming together of Wisdom (female) and Compassion (male) and the annihilation of the self. The burgeoning of icons, both painted and sculpted, as aids to worship, was a necessary part of the development of Tantrism. After a "medieval" period, when Pala, Nepalese, Kashmiri, Chinese, and Central Asian idioms were studied and assimilated, a Tibetan mode emerged by the fifteenth century. It exerted some influence on the religious art of China, whose imperial court patronized Lamaism and exchanged embassies, artists, and artifacts with Tibet. Tibetan Buddhism stresses order, balance, multiplicity, hierarchy, and the terrible aspects of deities, especially guardian deities, and it expresses universality in rich, bejeweled symbolism. These elements therefore became essential attributes of the Lamaist style, expressed (with some continuing provincial variations) in images, mandalas, and worship patterns.

We have already seen the adaptation of Nepalese and Pala elements in the *thangka* (literally, "rolled-up cloth") showing Ratnasambhava, from central Tibet (*fig. 168*). Its state of preservation is extraordinary, and particles of mica added to the pigments give an unearthly brilliance to the image in candlelight. The rigid symmetry of the whole, combined with the supple movement of the individual silhouettes, produces one of the most stunning and moving of medieval icons. The terrible aspect of deity is well presented in the *thangka* of *Mahakala with His Companions* (*fig. 169*), an important and often-represented deity especially powerful in the protection of temples and monasteries in particular and of houses and institutions in general. The carefully balanced composition and the seemingly monumental scale of the central image become especially compelling as one focuses on the three glaring eyes, the devouring mouth, the necklace of decapitated heads, and the trampled nude figure, representing a *preta* (suffering ghost). Mahakala may well derive from the Hindu deity Shiva, in his terrible manifestation as Aghora (*see p. 237*).

*Thangka*s are usually painted on cotton that has been carefully sized with a mixture of animal-leather glue

169. *Mahakala with Companions. Thangka*; ink, color, and gold on cotton; h. 34¹/₄" (88.3 cm), w. 31⁵/₈" (80.3 cm). Central Tibet. C. 1450 C.E. Los Angeles County Museum of Art

170. *Moon stone.* Door step; granulite. Anuradhapura, Sri Lanka. 5th century C.E.

(often from the yak, the national animal of Tibet), chalk, and porcelain clay (kaolin) and then polished with a hard stone or shell. Pure mineral pigments are used: blue (azurite), green (malachite), red (cinnabar), yellow (orpiment), and orange (red lead). Ink is made from wood charcoal, as in China. These pure mineral and vegetable colors, and the painstaking techniques of preparation and execution, account for the unusual strength and wearing power of the seemingly fragile *thangka*. The long tradition of brightly colored religious art made adoption, circa 1500 C.E., of the blue-green-gold style of Chinese landscape painting (*see pp. 302ff.*) an easy matter. In the last four centuries brilliantly colored *thangka*s with figures of priests or lineage founders against landscape backgrounds became a classic Tibetan idiom.

Sculptures were cast in bronze, silver, and gold, almost always employing the lost-wax method, a complex process made even more so by iconographic requirements. Many-headed and multiarmed deities with numerous attendants and manifestations posed casting problems wonderfully solved by the Tibetan artist. One representation often misunderstood in the West is the Father-Mother (T: *yab-yum*) image, portraying a male and a female deity standing or sitting in sexual union. From the earliest appearance of the *yab-yum* type, Lamaist texts have made clear its meaning: the blissful union of Wisdom (Mother) and Compassion (Father), which annihilates the delusion of self. This was the goal of the Buddha and of Buddhism from its earliest beginnings. The *yab-yum*, begun in Mahayana and refined in Tantric

and Lamaist Buddhism, is one of the most original and compelling of religious images, and its embodiment in an effective sculptural image is one of the greatest accomplishments of art.

Sri Lanka

Sri Lanka (Ceylon) is at an extreme geographic remove from Nepal and Tibet, and its Buddhist art is a contrast to that of Bengal, Nepal, and Tibet. For its Buddhism is Theravadin, a relatively simple and evangelical form recognizing only the Buddha Shakyamuni—that is, the "historical" Buddha. Thus Theravada lacks the complicated iconography, the delight in multiplicity, and the complexity characteristic of the Mahayana school. The style of Sri Lanka is historically important, since it was exported by sea to such regions as Burma and Thailand, where even today the Theravada sects are dominant, while Cambodia, Indonesia, China, Korea, and Japan received and were dominated by Mahayana doctrines.

The early Buddhist art of Sri Lanka is much influenced by the southern school of Amaravati; and so in the famous moon stones (*fig. 170*)—stepping slabs leading to platforms at Anuradhapura—we find the same style as in the casing slabs from Amaravati. They are in the form of half-wheels, with concentric bands of representations alternating with bands of scrollwork. Around the center are petals, suggesting the lotus Wheel of the Law, then a band of sacred geese (S: *hamsa*), finally a band showing lions, bulls, elephants, and horses in strict alternation. A

171. *Seated Buddha.* Dolomite; h. 6'7"
(2 m). Anuradhapura, Sri Lanka.
6th–7th century C.E.

repeat pattern around the rim may represent flames. Under the austere doctrines of Theravada Buddhism, early Sinhalese artists produced one image in particular that ranks among the greatest known representations of the Buddha (*fig. 171*). Dating from perhaps the sixth century C.E., the image owes to Gupta formulas its simplicity, pose, and treatment of the curled hair, and to early Pallava work its erect posture and aristocratic visage. But the austerity or rationality of the image, and the corresponding lack of the sensuous qualities to be found in any Gupta sculpture, indicate its Sinhalese origin and give it a surpassing quality. The head shows none of the rather shallow prettiness to be found in some Gupta sculpture, but has a facial breadth achieved by the expansion of the cheekbones and of the powerful jaw. The enlargement of the ears adds to the scale of the head and allows it to crown in proper proportion the large and imposing body.

Some of the mystery of this figure derives from its being badly weatherbeaten. To like this great image for such a reason is to succumb to the "driftwood" school of sculpture and to confirm the taste of those who prefer their bronzes encrusted, their sculptures well worn, and their paintings well rubbed.

Remains of Gupta style painting are found in Sri Lanka on the great rock of Sigiriya, which was used as a fortress retreat circa 477–495 C.E. by the parricide King Kashyapa. A long cleft in the side of the cliff contains a fresco procession of heavenly nymphs (*apsaras*es), the lower parts of their opulent bodies obscured by conventionalized clouds (*cpl. 11, p. 203*). Their general style is similar to that of the fresco in cave 2 at Ajanta, but their distinctive orange and pale green color scheme and the somewhat exaggerated sensuality of the representation is unusual—perhaps somewhat provincial. These graceful

172. *Pattini Devi*. Gilt copper; h. 57" (144.8 cm). Eastern Sri Lanka. 7th–10th century C.E. British Museum, London

bronze image of more than ordinary size and is clearly based upon some elements of Gupta style. At the same time it has an absolutely individual and unique character. Observe the tense roundness of the breasts and of the face, the sensuous and flowing quality of the fingers and the hands, coupled with the emphasis upon the underlying structure of the hips and their relationship to the waist. This depiction of underlying structure is rare; it seems to be the product of an artist or studio working in an individual and free manner, neither anticipated nor repeated. The tall, very narrow headdress is an integral part of the total effect. To crown the full and voluptuous body with this thin, tall tower gives an added height and elegance. The drapery is handled neither as linear pattern nor as mass but in character with the modeling of the body, being just slightly modeled, with no sharp ridges or lines but rather with undulations that move along the thighs. A masterpiece such as this places the art of Sri Lanka near the top of any Oriental hierarchy of excellence.

South India continued to dominate the arts of Sri Lanka and from time to time extended its influence to political control. Some seventh century sculptures near Anuradhapura are almost indistinguishable from the Hindu sculptures of the Pallava period at Mahamallapuram (*fig. 173*), and Hindu metal sculptures of pure south Indian type have been found in quantity in northern Sri Lanka.

The last significant productions of the island are the large stone stupas, temples, and sculptures at Polonnaruva, dating from the twelfth century. These Theravada Buddhist images are noteworthy for their size. At the Gal *vihara* is a colossal scene, cut into the living rock, of the disciple Ananda mourning at the *Parinirvana* of the Buddha (*fig. 174*). The carving is based on a combination of earlier Sinhalese and Gupta sculptural formulas, but shows little interest in the sensuous grace of the latter style. All the shapes and details seem purified and, it must be added, mechanized, to a point where their appeal is primarily intellectual. We are fascinated in following the patient logic of the sculptor despite its exclusion of the warm, living qualities of the medieval mainland styles. Such images are of great importance in the development of Thai art, for the Theravada faith was common to both Thailand and Sri Lanka, and the latter played elder brother to the major Theravada country of Farther India.

Thailand and Burma

The two major influences on the Buddhist art of Farther India and Indonesia came from Sri Lanka and Bengal. Since Sri Lanka continued to be primarily Theravadin in its faith, its influence was largely confined to those farther countries of the same belief, notably Burma and Thailand. Bengal, by virtue of proximity and its status as a prime pilgrimage center, also shaped the art of Burma

and easily moving ladies may well, however, be characteristic of secular painting in the Gupta period. The lack of a landscape or architectural setting emphasizes the erotic appeal of the *apsarase*s. One could expect royally commissioned palace decorations to be motivated by a sensuous materialism in contrast to the combination of sacred and profane found in purely religious painting.

The same sensuous appeal is found in the somewhat later *Pattini Devi* in the British Museum (*fig. 172*). It is a

173. *Elephants among lotuses.* Granulite. Isurumuniya *vihara,* near Anuradhapura, Sri Lanka. Probably 7th century C.E.

and Thailand, and was the dominant influence on figural art in Malaya and Indonesia before the rise of national styles there. With few exceptions, however, the earliest sculptural influence in all of these regions was the Gupta image, whether earthenware, stone, or metal. The style of each region began with this type of image, and the gradual achievement of distinctive regional styles was largely the work of the local culture, leavened by subsequent exposure to the formulas of Bengal or Sri Lanka.

The early peoples of southern Thailand, like those of southern Burma, were predominantly Mon and professed Theravada Buddhism. Their Dvaravati kingdom, centered around Ayudhya on the lower Menam River, lasted at least from the sixth to the ninth century, when the rising power of the Khmer people of Cambodia, whose faiths were Hinduism and Mahayana Buddhism, reduced Thailand virtually to a cultural province with its center somewhat to the north, at Lopburi. Meanwhile, Thai elements from southwest China (Yunnan) and perhaps Tibet gradually moved southward into northern Thailand, acquiring from their Burmese neighbors literacy and Theravada Buddhism, and superimposing the latter onto a set of animist beliefs which are potent to this day. The decline of the Cambodian Khmer power during

174. *Ananda attending the Parinirvana of the Buddha.* Granulite; h. nearly 23' (7 m). Gal *vihara,* near Polonnaruva, Sri Lanka. 12th century C.E.

175. *Buddha.* Stone; h. 53¹/₄" (135.3 cm). Thailand. Mon-Dvaravati period, c. 7th century C.E. Cleveland Museum of Art

the later thirteenth century, hastened by Thai attacks, permitted the Thai to move southward and occupy all of Thailand. No empire or unified state resulted, however; only a number of small kingdoms, usually competing, sometimes loosely and partially confederated. The chief political and cultural centers were Ayudhya in the south, Sukhothai in the center, and Chieng-Mai in the north. All of these centers were in touch with Sri Lanka and its Theravadin religious tradition.

The first significant art of Thailand was sculpture, and it remained the favorite form of religious expression. The Mon-Dvaravati style of circa 600–800 C.E., here accomplished on a large scale in stone (*fig. 175*), is a consistent rendering of the Gupta manner of Sarnath, with its smooth, clinging drapery without folds and its subtle, flowing transitions from one shape to another. But much of the sensuousness and plasticity of the Indian technique is lost or ignored in favor of a greater emphasis on more austere profiles, anticipating the great simplicity and stylization of the classic Thai style of the fourteenth century. Another deviation from the Gupta way lies in the greater attention to linear detail, particularly about the features of the face. Double outlines around the eyes and mouth

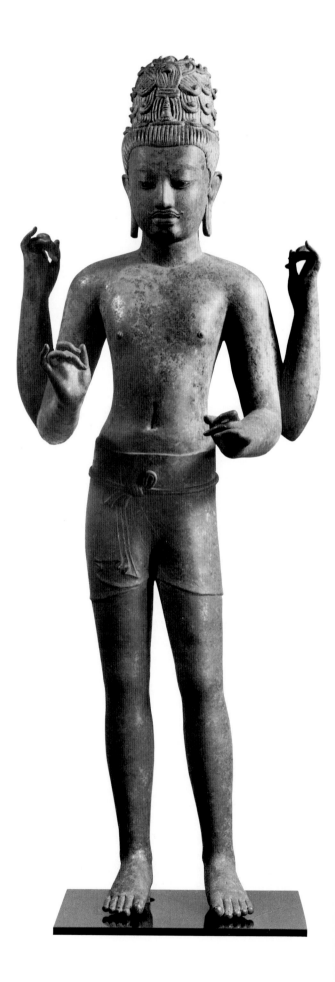

176. *Bodhisattva torso.* Bronze; h. 24³/4" (62.9 cm). Jaiya, Thailand. 8th–9th century C.E. Shrivijaya style. National Museum, Bangkok

177. *Maitreya Buddha.* Bronze, with eyes inlaid with silver and black stone; h. 38" (96.5 cm). Prakhon Chai, Thailand. 8th century C.E. Asia Society, New York. Mr. and Mrs. John D. Rockefeller 3rd Collection

hint at coming decorative qualities based on severe stylization. The emphasis on simplicity is in keeping with the growing importance of Theravada Buddhist culture in Thailand at this time. Under Khmer domination southern Thailand produced works little different from those being made in Cambodia.

One unusual find from Jaiya, now in the National Museum of Bangkok, is a notable exception to the prevailing simplicity of Mon art (*fig. 176*). This bronze torso of a bodhisattva is clearly the product of a different tradition and attests the wide influence of the great Shrivijaya empire of Java, Sumatra, and Malaya. Here the complex jewelry, the metallic quality, the momentary and melting expression of the attractive face, and the exaggerated hip-shot pose derive from the earliest Pala traditions of

Bengal. But this was not to be the line of development for Thailand after the decline, beginning about 1220, of Cambodian control.

In 1964 a buried trove of about three hundred bronzes was discovered by local villagers in a deserted Buddhist temple precinct near Prakhon Chai, a town on the Korat plateau just north of the Cambodian border. Prakhon Chai's early cultural affiliations (and perhaps political affiliations as well) were with two kingdoms: Fu Nan (which enters the historical record about the mid-third century C.E. and disappears around the mid-sixth), extending from the Mekong River delta westward along the Gulf of Siam; and its successor, Chen La (c. sixth century–beginning of ninth century), which controlled the same area from a center of gravity farther north along the Mekong. Initially both kingdoms were strongly influenced by northeastern and southern India, but these influences were soon absorbed and changed by the strong sculptural innovations of what became, beginning about the ninth century, the Khmer empire, centered in present-day Cambodia.

The finest of all these figures from Prakhon Chai is the Maitreya now in the Rockefeller Collection at the Asia Society (*fig. 177*). Made of a silvery bronze alloy (later called *samrit* by the Cambodians), the firm but flowing surfaces of the body and the high topknot seem related to Pallava traditions; the soft, organic treatment of the hands and the inlaid eyes are related to Pala Bengal techniques. But the image would never be mistaken for one or the other of these antecedents; rather, it stands at the beginning of a Cambodian tradition (*see pp. 265ff.*).

As Khmer power receded, the Thai peoples expanding from the north established a capital at Sukhothai in central Thailand. The nearby kilns of Sawankhalok produced quantities of stoneware, and by the fourteenth century the production of Buddhist images, principally of metal, equaled the ceramic output. The enthusiasm and vitality of the Theravadin rulers and monks seemed inexhaustible. Except for images of the *U-Thong* type, made in southern Thailand after the expulsion of the Khmers, it was as if the Cambodian phase had never been. The elaboration and masculinity of Khmer art was gone, replaced by the typical and highest expression of Thai sculpture imagery, the bronzes of the early Sukhothai school. Though painting certainly existed—witness the evidence of the incised stone panels from the Vat Si Chum at Sukhothai—the images of stucco and metal are more numerous.

Various traditions went into the making of these "high-classic" images (A. B. Griswold's term). The old Mon-Gupta style was surely not forgotten and was probably preserved in a few particularly holy metal or stone images. The simpler Pala Buddha images, especially those in meditating or earth-touching poses like the Cleveland stela (*see fig. 160*), were known to monks and travelers in

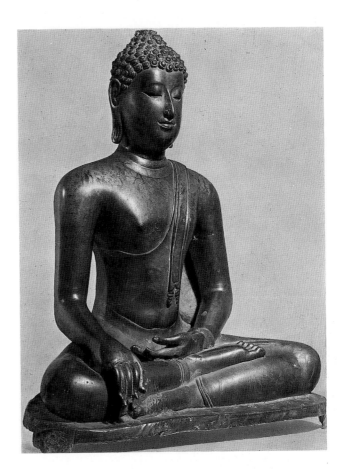

178. *Seated Buddha.* Bronze; h. approx. 30" (76.2 cm). Thailand. 14th–15th century C.E. Sinhalese type. Museum of Fine Arts, Boston

large examples and through the smaller ex-votos carried home from Nalanda as souvenirs. Sri Lanka was an especially important source, and tradition as well as history attests the close connections between the two countries. After all, Sri Lanka was the fount of Theravada Buddhism, and one particularly holy Thai image type is called "the Sinhalese Buddha," a form probably embodied in the fine image in Boston, with its distinctive nose, full cheeks, and limited linear emphasis about the eyes and mouth (*fig. 178*). Another important source was the Theravadin scripture, with its metaphorical descriptions of the various aspects of the Buddha figure—the golden skin, parrot-beak nose, petal-like fingers—and the signs of his godhood—flame, lotus, wheel, and curls "like the stings of scorpions." Priority for the emergence of the typical Thai Buddha image is variously given to Sukhothai or to Chieng-Sen in the north. The images from the latter region are remarkably close to some Pala sculptures. If they are earlier than the products of Sukhothai they are also less unified, less creative manifestations of still unabsorbed influences; if later, they are somewhat provincial manifestations of a Pala revival based on reverence for the images at the great temple at Bodhgaya, scene of the Buddha's meditation.

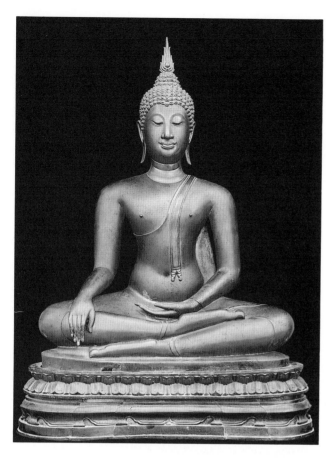

179. *Buddha Calling the Earth to Witness.* Bronze; h. 37³/₈"
(94.9 cm). Thailand. 14th century C.E. Sukhothai high style.
Collection H.R.H. Prince Chalermbol Yugala, Bangkok

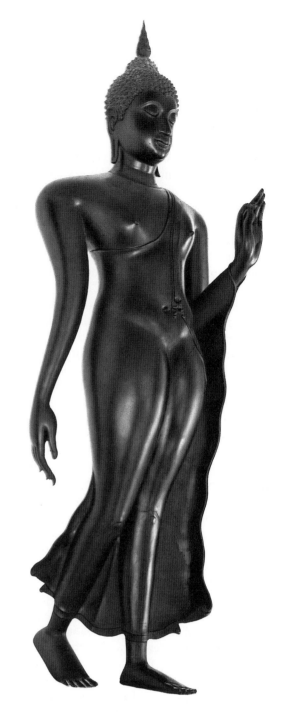

180. *Walking Buddha.* Bronze; h. 7'4" (2.2 m). Thailand.
14th century C.E. Sukhothai style. Monastery of the Fifth
King, Bangkok

In the Sukhothai style the fusion of the various source elements is complete (*fig. 179*). No clear trace of origin remains in this new and original image type. The influences disappear as if exorcised by fire, and the resulting diamond-sharp configuration recalls the abstraction of geometry. The dangers inherent in such a thorough stylization of linear elements and complete simplification of forms are many—coldness, rigidity, and emptiness are a few, and these soon appear—but at the moment of perfect balance in the fourteenth century the result seems a complete expression of Theravadin simplicity and asceticism.

The seated images are the most numerous, but one particular Sukhothai creation deserves special mention—the walking Buddha (*fig. 180*). Conceived as a representation of Buddha Shakyamuni as missionary, the image appears particularly unnatural at first glance, but here especially one must remember such literary similes as "arms like the hanging trunk of an elephant." The superhuman ease of the gliding pace is matched by the exquisitely estimated reflex curves of the fingers and the impeccably calculated undulating edge of the drapery falling from the left arm. "All passion spent" is here succeeded by the sculptor's poised, ecstatic vision.

Because of the great strength of Theravada Buddhism among the Thais during and after the fourteenth century, the tendency to repeat particularly successful sacred images was impossible to resist. A continuous stream of such images poured from the sculptors' foundries. Minor variations were invented and quickly exhausted. In the north a Chieng-Sen "lion type" is chiefly distinguished by a lotus-bud *ushnisha* (cranial bump, signifying wisdom) in place of the flame used by the sculptors of Sukhothai, and by the lotus pose being accomplished with the soles of both feet on the same level rather than, tailor-fashion,

one leg above the other. If this is a giant among minor variations, the aesthetic monotony of the immense production is evident.

One southern variation of the sixteenth century and after bears the name of Ayudhya, the Thai capital from about 1378 until 1767. In these images rejuvenation of the exhausted formula is attempted by means of ornament— crowns or heavily jeweled garments. A few restrained images achieve a decorative and elegant effect, but the inner life is gone and a growing superficial prettiness remains. Small wonder that some modern interior decorators find fragments of these images attractive as a means of achieving an acceptable "Oriental flavor." A glance back to the Mon-Dvaravati images and particularly to those of Sukhothai clearly reveals the unique contribution of the Thai to the international world of Buddhist art.

The history of early Burma (present-day Myanmar) is unclear, but the country seems to have been divided between the Pyu kingdom (fifth–ninth centuries C.E.) in the upper Irrawady River valley and a Mon people related to the Mon of Thailand in the lower Irrawady valley and along the coast. Various forms of Buddhism and Hinduism—and the arts pertaining to these—were practiced throughout. Buddhist stone sculptures from the Prome area in the early Pyu kingdom are basically indebted to Mon-Dvaravati types from Thailand (*see fig. 175*).

King Aniruddha (or Anawrata) of Pagan (r. c. 1040– 1077 C.E.), who unified the country, is said to have officially adopted Theravada Buddhism in 1057. The vast majority of medieval Theravadin images date from the resulting great efflorescence of Buddhist art. Pagan became the center of building activity, and more than five thousand "pagodas" (stupas), some intact, others ruined, are still identifiable there. Almost all are constructed of brick with carved stucco decoration. Their high, terraced platforms are topped by bulbous stupa towers, or by near replicas of the famous Gupta stupa at Bodhgaya in Bihar (Bodhgaya being the place where the Buddha attained Enlightenment, and therefore the greatest of all pilgrimage sites).

Stone sculpture of this classic Pagan period adorned the stupas with narrative reliefs of the Buddha's life and images of the Buddha, almost always seated and making the ground-touching (*S: bhumishparsa*) *mudra* of Calling the Earth to Witness. This motif may also have borne witness to the universal power of the sovereign and may therefore have been, at least in part, politically motivated. Though northeastern India was Mahayanist in its faith, the style of its stone and metal images was appropriated by the Burmese artists of this classic period. Small-to-medium-sized metal images, highly stylized, are usually made of a distinctive bronze alloy containing much zinc, which lends them a silvery sheen. Some remaining wall paintings also reflect the influence of Bengal and Nepal.

In 1287 Pagan was sacked by Kubilai Khan, and

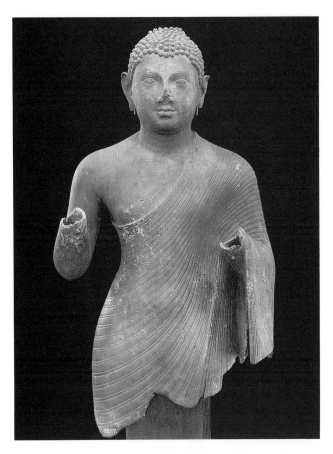

181. *Standing Buddha.* Bronze; h. 29.5" (75 cm). West Sulawesi, Indonesia. 4th–5th century C.E., Amaravati or Amaravati style. Djakarta Museum

Burma became an outpost of the Mongol empire. Succeeding centuries were dominated by internecine conflict between the Shan in the north and the Mon people of Pegu in the south, to the detriment of artistic creativity.

Indonesia

The principal vehicle by which Mahayana Buddhist imagery was transmitted to Indonesia was the Gupta and post-Gupta art of Bengal and Bangladesh. We must imagine the monks and traders of India and Indonesia traveling to and from their homelands. We know from inscriptions that the traders, devout Buddhists as well as sharp businessmen, commissioned works of art in the great centers, particularly in Bengal. Indonesians even built temples in Bengal as an act of homage or memorial. Lively commerce brought about great movement of people and of images. Historically, the introduction of Buddhism to Indonesia is associated with the Shrivijaya empire, whose capital was not on Java but on Sumatra. Some of the greatest of the early Indonesian metal images have been found on Sumatra and in Malaysia. The unusual find in West Sulawesi of a bronze Buddha image in Amaravati style of the third or fourth century is probably the earliest significant Buddhist sculpture known in Indonesia (*fig. 181*). Its

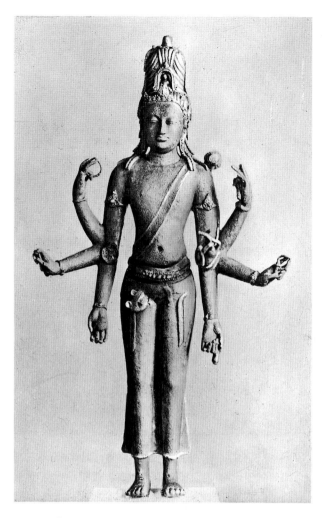

extraordinary quality, especially in the sensitive geometry of the drapery, the alert expression, and the observant rendering of the figure, leads some to assign its manufacture to Sri Lanka during the period of southern influence from Amaravati (fourth–fifth century). Others credit indigenous craftsmen of the seventh century. In contrast, the pure early Shrivijaya style is based almost completely on the Gupta style as transmitted through the early bronzes of Nalanda. An image such as this Padmapani (Avalokiteshvara as Lotus-bearer) from Malaysia can well be described in terms applicable to Gupta style (*fig. 182*). The fluidity of the figure is extraordinary and reveals the influence of clay technique. Fom such beginnings the Javanese developed a great style of their own and created one of the most significant monuments of Buddhist art.

The supreme example of Buddhist art in Southeast Asia and Indonesia is certainly the Great Stupa of Borobudur, situated on the central Dieng plateau of Java (*fig. 183*). The monument, carefully preserved and restored by Dutch archaeologists and being restored again today, is a fantastic microcosm, reproducing the universe as it was known and imagined in Mahayana Buddhist theology. It dates from about 800 C.E., and apparently was built in a relatively short period of time—a colossal achievement. Above a high plinth are five terraces of identical stepped-square plan, each smaller than the one below. From the topmost square rise three concentric circular terraces, likewise diminishing in size, holding among them seventy-two openwork stupas, each of which contains an image of Buddha in preaching *mudra*. Crowning the whole is a gigantic closed stupa, also containing a Buddha image, which Benjamin Rowland equates with

182. *Padmapani.* Bronze. Bidhor, Malaysia. 6th–7th century C.E. Perak Museum, Malaysia

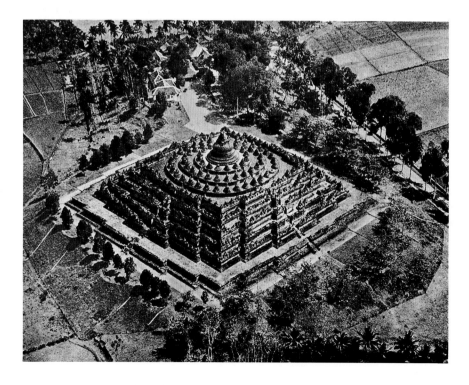

183. *Borobudur, Java.* Aerial view. Late 8th century C.E.

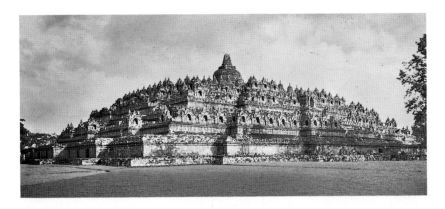

184. *Borobudur*

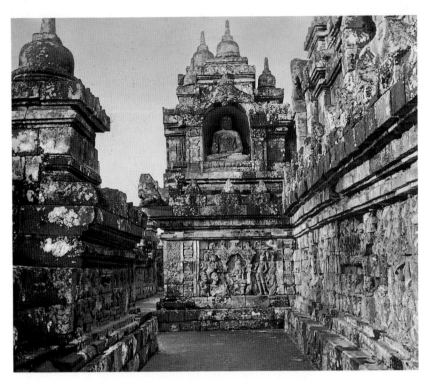

185. *View of the corridors from the first gallery of the west facade, Borobudur*

the god-king himself. The lowest terrace is approximately 408 feet on a side, and the whole monument is some 105 feet high. A staircase bisects each face from bottom to top. All five square terraces are walled, and the entire length of the walls is carved with Buddhist scenes in relief, punctuated by niches, each of which contains a large image of the Buddha appropriate to the direction in which he is facing. There are, in all, more than ten miles of relief sculpture.

For many years arguments raged as to the precise nature and meaning of the monument, but Paul Mus's book resolved these questions. Borobudur is a stupa, its profile that of a hemisphere crowned by a smaller stupa (*fig. 184*). The monument is oriented to the four cardinal directions and arranged vertically in accordance with Mahayana cosmogony. Reliefs, once below ground but now visible, represent the workings of karma in the cycles of birth and rebirth. It is not clear whether these were concealed for iconographic reasons or because the structure required buttressing. The lowest fully visible level of the monument illustrates the previous lives of the Buddha (*jataka* tales); on the next higher level are scenes

from the life of Shakyamuni. Higher still are reliefs illustrating Mahayana scriptures—episodes from the lives of various bodhisattvas and scenes of their blissful paradises. One proceeds from low to high, from base to pure. Even the divine world illustrated on the highest rectangular terrace is less blessed than that represented by the perfect circles of the three unwalled, stupa-crowned uppermost levels. The Buddha icon in the crowning stupa expresses a phenomenon also found in Hindu art in Cambodia: the cult of the *devaraja*, the god-king, in this case the Buddha on earth.

Borobudur is, then, a magic monument, an attempt to reconstruct the universe on a small scale. The interior is rubble faced with carved volcanic lava stones. Pilgrims enter the magical structure and perform the rite of circumambulation, which figuratively recreates their previous lives and foreshadows their future lives. While pursuing this pilgrimage, they see reliefs of the previous lives of the Buddha, the life of Shakyamuni, and the various heavens.

The corridors that surround the monument are open to the sky; there are no interior corridors (*fig. 185*). The

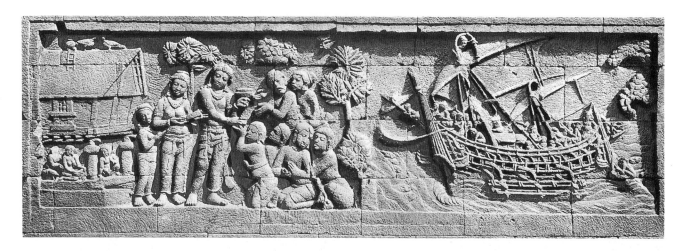

186. *Hiru lands in Hiruka.* Lava stone; w. 9' (2.7 m). Bas-relief no. 86, first gallery of Borobudur, Java. Late 8th century C.E.

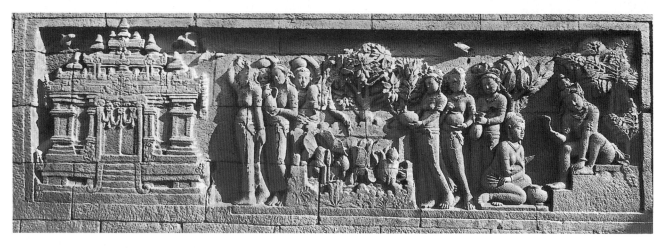

187. *Prince Suddana and his ladies drawing water from the lotus pond near the palace.* Lava stone; w. 9' (2.7 m). Bas-relief no. 16, first gallery of Borobudur, Java. Late 8th century C.E.

reproductions give some idea of the wealth of sculptural representations on both sides of the corridors. These reliefs are obviously influenced by Gupta style in their concept of figural representation. On the other hand, the narrative content is much richer than anything to be seen in the Gupta reliefs of India; and it is this aspect that seems particularly attuned to the native spirit. The development of later Javanese art is in the direction of a narrative style, even of a dramatic-caricature style, and will be considered when we come to the Hindu art of Java. Here, then, is pictorial representation, in a framed relief with numerous figures and with a firm concept of spatial setting (*figs. 186, 187*). The space may be limited, shallow, and may sometimes contain odd juxtapositions, such as

the ship apparently on the same plane as the figures on land, but in general the landscape settings and the overlapping of figures display a remarkably advanced complexity. The reliefs are also a great treasure house of information on the mores of the day. We find, for example, representations of early Indonesian houses like the primitive Dyak houses still to be seen today.

The serene reaches of the upper terraces with their many perforated stupas take us to the highest and most abstract levels of the Buddhist hierarchy. The seventy-two images contained within the stupas echo this clean and severe atmosphere (*fig. 188,* which has been removed from within the stupa). Derived from such Gupta prototypes as the famous Preaching Buddha of Sarnath, these Bud-

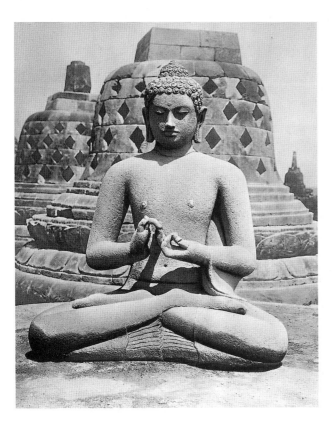

188. *Dhyani Buddha.* Lava stone. Borobudur, Java. Late 8th century C.E.

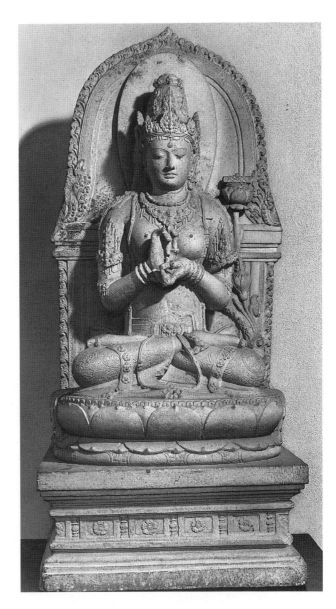

189. *Prajnaparamita.* Andesite; h. 49½" (125.7 cm). Chandi Singasari, Java. Early 13th century C.E. National Museum, Djakarta

dhas seem even more chaste, with intellectual overtones in keeping with their almost geometric environment. Straight lines are more in evidence, particularly in the profiles of shoulders, arms, and legs. One form moves smoothly into another, with no perceptible transitions. The usually benign, gracious, and appealing countenance of the Buddha seems more severe, concentrating on an unpeopled world, or rather on a heaven filled with multiplications of his own image. In contrast to the type of simplification practiced by the Thai image makers of the Theravadin tradition, the Javanese style with its Mahayana background is less decorative and sleek, with more of the substance of religious fervor. The Buddha image of the central stupa of the terrace, though unfinished, is compa-

rable in style with the others and, as we have seen, is considered to represent the *devaraja,* the god-king.

Although later developments of Javanese art are largely Hindu, some Buddhist images date from this period of sculptural elaboration. The most notable of these is the often-shown freestanding stela of Prajnaparamita, the goddess of transcendental wisdom (*figs. 189, 190*). The tradition that this image represents Queen Putri Dedes (d. 1222 C.E.), remains unconfirmed. The face and the nude parts of the torso show a smoother and ultrarefined continuation of the style seen at Borobudur, but the elaboration of the jewelry, costume, and throne back reveals the influence of metalwork, particularly of those Javanese wax-cast bronzes that depend for their effect upon the

190. *Prajnaparamita*. Detail of fig. 189

complication of numerous details achieved by the repetition of curling or droplike motifs. Something of the serenity and intellectuality of the earlier Javanese styles is preserved in the ramrod straightness of the torso and the clean, simple, straight lines of the lower part of the throne. These qualities, so appropriate for Buddhist art, are but a small part of later Javanese art, largely dominated by the vigorous development of a native pictorial style under Hindu religious inspiration. Again we witness the end of a Buddhist tradition in South Asia well before its decline in East Asia.

7

The Expansion of Buddhist Art to East Asia

BUDDHIST ART IN CENTRAL ASIA

Indian style and Buddhist iconography were transmitted eastward not only by sea and land to Southeast Asia as far as Indonesia, but also by land over the mountain passes of northwest India and Afghanistan and through Central Asia to China, Korea, and Japan. Central Asia in about the first century C.E. was not merely a pasture and hunting ground for nomads. Flourishing oases supported some agriculture and a patchwork of trading principalities with polyglot Indian, Iranian, Turkic, and Mongolian populations. These entrepôts dotted the foothills of the Tian Shan range to the north and the Kunlun Mountains to the south, skirting the Taklamakan Desert. Collectively they formed the great trading network called the Silk Road—actually three routes, all beginning at Dunhuang in China's Gansu Province and running west through Xinjiang. Along the northern route lay Bezeklik, Turfan, Kucha (Kuqa), and Kizil (Qyzil); the southern route passed through Miran and Dandan Uiliq. From the western end of the Taklamakan, trading caravans might continue westward, toward the Mediterranean world avid for silks. Or they might turn south, crossing the border of present-day Afghanistan toward Bamiyan and Taxila in the empire of the Kushans, where Buddhism was flourishing under Kanishka I (r. c. 120–162 C.E.) and Huvishka (r. c. 177–194 C.E.). It was most probably from this area at about this time that Buddhism entered Central Asia and spread eastward along the Silk Road.

The principal mediums of Buddhist art in Central Asia are sculpture and painting, particularly painting in a fresco technique on mixed clay and plaster walls, in caves cut into the cliffs or river banks. Four major stylistic elements coexist in this Central Asian region—a Romano-Buddhist style, a Sasanian style based on that of the Persian Sasanian dynasty, a mixed Indo-Iranian or Central Asian style, and finally a Chinese style representing a later influence moving in the opposite direction. We cannot overemphasize the importance of the Central Asian styles of painting in the development of Buddhist painting in China and Japan. They were the principal vehicles transporting the iconography of Buddhism, both Theravada and Mahayana. Except in the Kucha area, Mahayana became dominant in Central Asia, and Theravada did not significantly affect the Buddhism of China, Korea, and Japan. The many stylistic elements took hold for a time in China—permanent hold on Buddhist icons made for the temples, but only a temporary hold on sophisticated Chinese painting, which very quickly absorbed the Central Asian and Indian elements and reworked them

into a native idiom that was then exported back to Central Asia.

The most extraordinary object at Bamiyan is the colossal Buddha (*fig. 191*), remarked upon by all who saw it, including Xuan-Zang. The impact of the Bamiyan Buddha upon travelers caused its iconography and style to be transported back to China, both in the minds of those who saw it and in the form of small "souvenir" objects. It is a stiff rendering of a standing Buddha with string drapery and a face of a rather rigid northwest Indian type, judging from the terribly damaged remains. But the rhythmic geometry of the drapery, derived in part from Gupta and Gandharan elements, provided a prototype for numerous images, large and small, made in China and Japan. The huge image dwarfs the human figures of passing pilgrims. The niche is shaped as a halo (*mandorla*) around the body, and with the usual halo behind the head forms a double halo much copied in China and Japan, even in remote cliff carvings that recreated Bamiyan abroad.

At Bamiyan, inside the upper arch, is a smaller, 120-foot-high image. Over its main halo one can see the remnants of a fresco symbolizing the sun or the vault of heaven over the Buddha (*fig. 192*). The figure may be identified as Surya, the Hindu sun god, or Apollo, or, most likely, as Mitra, the sun deity of Vedic India (related to the Persian sun god Mithra). The solar deity, clothed body and head in the sun, drives a quadriga (chariot), attended by winged angels of two types. The two in human form, with symmetrical spreading wings that fall from shoulder to knee, are certainly derived from Persian and Mediterranean prototypes. The others appear to be *kinnari*s, deriving ultimately from Greek harpies, winged figures with birds' feet and the bodies and heads of human beings. These heavenly attendants are executed in a decorative and flat style, more in keeping with the Persian tradition than with the Indian style of Ajanta, which was carried into Central Asia as well.

The Romano-Buddhist style appears principally at Miran. It is particularly evident in a painted frieze of human figures bearing garlands (*fig. 193*). Their faces look like Fayum portraits of Coptic Egypt and are treated in late classical style, with wide, staring, almost Byzantine eyes. The motif of the garland bearer is also of classical

191. *Colossal Buddha.* Stone; h. 175' (53.3 m). Bamiyan, Afghanistan. 4th–5th century C.E.

192. *Sun god.* Copy of fresco. Bamiyan, Afghanistan. 4th–5th century C.E.

193. *Garland bearers.* Fresco; h. approx. 48" (121.9 cm). Dado
of shrine, Miran, Xinjiang, China. Late 3rd century C.E.
Museum of Central Asian Antiquities, New Delhi

origin. These frescoes bear the signature Tita (Titus?),
perhaps an itinerant painter from the late Roman Empire.
They represent the farthest eastward penetration of a
truly Mediterranean painting manner, though certain ele-
ments of that manner, such as shading, reached the
Chinese heartland.

The third Central Asian style, a mixture of Indian
and Iranian elements, is apparent chiefly at Kucha, Kizil,
and Dandan Uiliq. A remarkably well preserved fresco
from Dandan Uiliq showed seated figures in priests' robes
and a yakshi bathing in water between lotuses, with a
large measure of Indian influence apparent in her volup-
tuous outlines (*fig. 194*). Still, the nose is rather sharper
and the eyes slant much more than is customary in purely
Indian painting. The whole effect is eclectic, but unified
to a degree justifying a Central Asian designation. The
naiad at Dandan Uiliq happens to be the most striking
and aesthetically interesting of the numerous examples of
the style and is of interest also because this is probably the
farthest eastward extension of the nude female motif. The
subject seldom appealed to the Chinese and Japanese
except in offhand, informal sketches or as illustrations for
later erotic literature.

194. *Yakshi.* Fresco. Dandan Uiliq, Xinjiang, China. 5th–6th
century C.E. Destroyed

The Central Asian style makes much use of a "web" technique, the word being used to describe a netlike pattern that unites the composition. This stylistic peculiarity is typical of paintings from Kizil. The cremation of the body of the Buddha, an event following the *Parinirvana* and represented in later elaborations of Buddhist iconography, shows flames rising above the raised top of the coffin and the Buddha reposing peacefully within (*fig. 195*). Some traces of Indian style modeling in the slight shadow around the face give a modest illusion of volume. At the same time the small eyes, tiny mouth, and high, swallow-shaped eyebrows are characteristic of Iranian style. One can even see hints of Roman or Mediterranean style in some of the bearded disciples and guardian figures, who remind us of the various river and sea deities shown on Gandharan reliefs (*fig. 196*). But the distinctive color scheme owes little to Iran, India, or China: orange mixed with blues and malachite greens, and shading done in red on benign figures and in blue or black on guardian figures or demons. The schematization of anatomy in fingers, folds of the neck, and peculiar facial types suggests a distinctive Central Asian style. Frescoes of this type were executed by artisans of the region, and since frescoes cannot travel but artists can, it must have been these men, moving according to the demands of the monasteries on the pilgrimage routes, who spread these styles through Central Asia to East Asia.

Only by comparison with the Crusades can we imagine the religious enthusiasm that motivated the burgeoning of shrines along the pilgrimage and trade routes. Yet it was not a mass movement like the Crusades, but a succession of individuals or small groups who made the pilgrimage to see the homeland of the Buddha. A great many Chinese went to India; and of course Indian priests and Central Asian traders visited China. Most people in the modern West, with their automobiles, trains, and planes, seem to think that "travel" is a Western word and that few people ever went anywhere before these were invented. But the volume of travel in the ancient world was extraordinary. Remember the Roman trading station on the eastern coast of India or the one discovered in Thailand; consider that the most beautiful ivory of Andhra type was discovered in Pompeii, and that one of the finest late Zhou bronzes was recently excavated in Rome. Travel was a normal function in ancient society, and certainly so for monks and pilgrims and for those active in trade.

195. *Cremation of the Buddha.* Fresco. Kizil, Xinjiang, China. 6th century C.E. Museum für Völkerkunde, Berlin

196. *Mahakashyapa, from a Parinirvana.* Fresco; l. 27¹/₂"(69.9 cm). The Greatest Cave, Kizil, Xinjiang, China. 5th century C.E. Museum für Völkerkunde, Berlin

197. *Donor.* Fresco. Bezeklik, Xinjiang, China. 8th–10th century C.E. Museum of Central Asian Antiquities, New Delhi

The Chinese influence in Central Asia is slightly later in date than most of the images just discussed. It is an interesting example of a cultural phenomenon that might be called "backfire." We find the influence of Indian Buddhist art and of Iranian painting style amalgamated in Central Asia, moving to China, producing an impact there, and developing a varied iconography in a new Chinese style, which then, following the imperial ambitions of the Tang state, moved westward back along the same routes into Central Asia. For this phenomenon the most characteristic site is Bezeklik. Here a tenth century "donor" displays an almost pure Chinese style (*fig. 197*). The headdress is of Chinese type. Also purely Chinese are the peculiar facial proportion, with long nose, round chin, and conventionalized ears, and the flowing linearity of the design.

The eastern focus of the trade and pilgrimage routes was Dunhuang, the great staging center in the far northwest reaches of China. Here are hundreds of caves—called "Caves of the Thousand Buddhas"—filled with sculptured clay figures, frescoes, libraries of scrolls, manuscripts, and banners. In this Chinese outpost one finds a fusion of Central Asian elements with Chinese styles ranging in date from the fifth century to almost modern times, in a myriad of examples often well preserved by the dry, desert-like air. This rich trove is a happy hunting ground for the scholar and provides many clues to now lost sculptures and paintings from China's great urban centers. Some of this material will be mentioned in later considerations of Chinese and Japanese figural and landscape art. The Dunhuang material, though rich and varied, is sometimes provincial in character. The earliest works, from the Six Dynasties period, display an almost primitive fervor, quite different from the aims of artists in sophisticated Chinese centers.

BUDDHIST ART IN CHINA: PRE-TANG STYLES

The term "Six Dynasties" hardly describes the period of nearly four centuries (220–589 C.E.) between the fall of the Han dynasty and the reunification of the empire under the Sui. It was a time of political convulsion unequaled since the Warring States, of mass movement of populations, of the bloody rise and fall of many more than six dynasties and, withal, of cultural intermingling, absorption, creativity, and synthesis. Climate and topography have always divided China into north and south. The breakdown of Han rule and the "barbarian" invasions of the Six Dynasties period split it along the same line politically and culturally, bringing hordes of Central Asian invaders to settle among and rule over the Chinese of the north, and impelling vast numbers of Chinese refugees southward to impose their rule on and mingle their culture with the indigenous populations.

In both north and south Confucianism was in abeyance. Its ideology had failed to check the disintegration of the empire, nor did it provide solace in the ensuing chaos and destruction. Particularly among the Chinese emigrés in the south, Daoist quietism and emphasis on the life of the imagination exerted considerable appeal, and Daoism acquired its organization and its status as a religion at this time. But it was Mahayana Buddhism that surged over China like a mighty wave, reaching the north via the Silk Roads across the Central Asian homelands of the invaders, and the south about a century later by sea as well as overland.

It is traditional and fairly well established that Buddhism had been introduced into China before 65 C.E. But according to Chinese records, by the third century there were only five thousand Buddhists in all of north and south China. So Buddhism did not convert the Chinese at once and en masse by the merit of its doctrine. The rise of Buddhism in China is associated particularly with the Central Asian Tartars who, by 439 C.E., had succeeded in establishing control over all of north China. The rulers of the Toba people who achieved this control called themselves the Northern Wei dynasty (386–535 C.E.). Mahayana Buddhism was embraced by these "barbarians" of the north: like themselves, it was of foreign origin; its universalism provided a bond between them and their Chinese subjects; its rituals, as practiced by the astute Central Asian monks who brought the doctrines, offered magical protection to the ruler and the dynasty. It must not be assumed that even under these conditions Buddhism triumphed effortlessly. Competition between it and Daoism surfaced early, as did the rulers' perception of possible conflicts between church and state. One Northern Wei emperor of Daoist persuasion gave rein to severe anti-Buddhist persecution (446–452 C.E.). But his successors reversed that policy and compensated with renewed munificent patronage for the damage it had done.

Mahayana doctrines flourished also in the south, where they were somewhat differently configured to appeal to the upper classes of Han Chinese origin. The southern aristocracy for the most part perceived Buddhism not as a rival to Confucianism and Daoism but as a welcome metaphysical complement. Throughout China, Buddhism was seen as providing "a noble literature, a beautiful religious art, aesthetically satisfying ceremonials, the appeal of the peaceful monastic life in a troubled age, and the promise of personal salvation. . . ."[4] In north China by the latter half of the fifth century and in south China by the early years of the sixth, Buddhism had become a tremendous force.

During the Six Dynasties period Buddhism likewise became the great patron of the arts. In Chinese Buddhist art we can witness over this period a consistent development from an eclectic mixture of Central Asian and Chinese styles to a fully realized Chinese style, which was to become a second international style of Buddhist art, culminating in the style of the Tang dynasty (618–907 C.E.). Like the Gupta International style, it spread beyond national boundaries to become dominant over a larger geographic area, including principally China, Korea, and Japan. The precursors of the Tang style are numerous and difficult to follow. They have been merged, for purposes of clarity, into three main currents. This, like all such arbitrary schemes, conveys only an imperfect outline of the real process, which was by no means so simple. But in general one can speak of an Archaic style, lasting until about 495 C.E., whose type-site is the great cave-temple complex at Yungang (near Datong in Shanxi, where the Toba Wei had their capital until 494 C.E.); an Elongated style, which lasted from about 495 C.E. until the middle of the sixth century, whose type-site is a second cave complex at Longmen (near Luoyang in Henan, site of the new Wei capital); followed, in turn, by a Columnar style, particularly associated with the Northern Qi dynasty of 550–577 C.E., with a principal type-site at Xiangtangshan (partly in Hebei, partly in Henan). These three major styles of the Six Dynasties period were succeeded by a synthesized style at the time the country was unified, politically and socially, by the short-lived Sui dynasty (581–618 C.E.), which in turn was succeeded by the long and splendid Tang dynasty. These great sculptural styles are figural and represent a new emphasis for the Chinese genius. Before the rise of Buddhism the Chinese had carved few figures, though they had modeled many (e.g., tomb figurines). But the imagery and iconography of Buddhism, being predominantly Indian, teemed with figures. Mahayana Buddhism was certainly a major stimulus to Chinese achievement in stone and clay figural sculpture.

In general south China was not noted for its cave sites; an already traditional art of painting flourished more continuously and more fully there, as did animal sculpture and tomb sculpture of traditional Chinese type.

198. *Colossal Buddha.* Stone; h. 45' (13.7 m). Cave 20, Yungang, Shanxi, China. Six Dynasties period, 2nd half of 5th century C.E.

In the north, where foreign influence was greater, we find more Buddhist material, great cave sites, and probably greater artistic ferment and complexity.

Let us first consider the Archaic style and its representative sculptures. The colossal Buddha at Yungang gives some idea of the general nature of the first phase of the style (*fig. 198*). The tradition of carving into the living rock was probably imported from India. Little if anything like this had been known before in China. The colossal figure, with the drapery derived from the Bamiyan string pattern and the face showing traces of Gandhara style, gives the impression of a hybrid and stiff conformation.

Other colossal figures, some standing, are found in other caves at Yungang. They are related to the sculptures at Bamiyan and to predecessors (now lost) of the enormous images at Alchi (*see cpl. 9, p. 201*). The main pilgrimage route passed through Leh, only a few miles from Alchi, and such figures must have impressed and inspired the Chinese monks and merchants. This style is repeated in the great profusion of polychromed sculptures in the interiors. The porch to one of the caves shows a typical Central Asian proliferation of images by simple addition, without much symmetry; above we see a carefully worked out order, in the lower frieze an asymmetrically balanced mixture (*fig. 199*). The images seem to have been added

199. *Porch of cave 7.* Yungang, near Datong, Shanxi, China. Six Dynasties period, 2nd half of 5th century C.E.

200. (left) *Shakyamuni seated on the lion throne* (front of mandorla); (right) *Eight scenes from the life of the Buddha* (back of mandorla). Dated to 477 C.E. Gilt bronze; h. with pedestal 16" (40.3 cm). China. Six Dynasties period, Northern Wei dynasty. M. Nitta collection, Tokyo

one after the other, with no pre-existing plan, as donor after donor ordered and dedicated a carving. One might also note a trace of vulgarity in the coloring. Although much of the existing coloring is modern (at the bottom, for example), the original coloring, where it exists, is of similar quality. Bright blues, reds, greens, and whites were flatly applied, denying the sculptural form. The artists, largely of Central Asian origin or tutelage, were attempting to reproduce the paintings and clay images of Central Asia in sculptured stone. On the other hand, particularly in the flying figures of the ceiling, the flowing movements from one form into the other seem to be derived from native Chinese style, as seen in late Zhou and Han dynasty painting, inlaid bronzes, and lacquer. The term "archaic" seems appropriate for this style: In addition to being the earliest of Chinese Buddhist styles, its figures reveal the smiling countenance characteristic of archaic Greek art, which has so beguiled art historians that it has been christened "the archaic smile."

Relatively few metal images remain from the Six Dynasties period, and only one large one, with garments largely in a Central Asian string-drapery style; it is now in the Metropolitan Museum of Art in New York. But surviving smaller images combine the Chinese emphasis on linearity, as in the flames of the *mandorla* in figure 200, with the foreign elements we have seen at Yungang. This seated Shakyamuni on a lion throne, with the seven Adi-Buddhas symmetrically spaced on the inner part of his *mandorla*, is dated to 477 C.E. and is unusual in showing scenes from Shakyamuni's life in low relief on the back of the *mandorla* (*fig. 200*). War, neglect, and occasional anti-Buddhist persecutions, the most severe in 845 C.E., have destroyed countless Buddhist sculptures. Surviving portable metal images, such as this Shakyamuni, can begin to give us some idea of the wonders wrought by faith and described by pilgrims in these early centuries of Buddhism in China.

Buddhist painting of the fifth century also shows the

201. *Preaching Buddha.* Fresco. Cave 249, Dunhuang, Gansu, China. Northern Wei dynasty, 5th century C.E.

202. *Sculptured wall niche.* Dedicated 527 C.E. Cave 13, Longmen, Henan, China. Northern Wei dynasty

influence of Central Asia, as can be seen in the earliest of the wall paintings at Dunhuang (*fig. 201*). These seem even more archaic than the sculptures, even to the point of caricature, though much of what we now see is the effect of oxidation and deterioration of pigments and does not represent the artist's intention. Still, the artist has invested these figures with an almost frantic energy in his attempts to deal with such problems as the concept of modeling by light and shade. His eagerness reduces the more subtle Indian and Central Asian shading to a broad streak outlining the edges of the figures and the shapes within them. The result is more linear and energetic than any of the prototypes; it may well testify to the first shock of the meeting of Chinese painting style with the new Buddhist imagery and foreign techniques of representation, perhaps as early as 420 C.E. Comparing these truly primitive forms with the contemporary and highly accomplished linear style of such native painters at the southern courts as Gu Kaizhi (*see fig. 368*) gives some hint of the discrepancy between the old tradition and the new stimulus—a large gap which was closed with startling ease and rapidity.

The second style, which we have called Elongated, can best be seen at the type-site, Longmen, where carving only began after the Northern Wei rulers had moved their capital to nearby Luoyang in 494 C.E. Here were no Central Asian craftsmen working for Chinese or Tartar patrons. We find at Longmen a thorough assimilation by the Chinese artist of the first elements of Buddhist iconography and of Central Asian style. Linear movement is far more in evidence than in the Archaic style; the sculpture appears flatter and the movements on the surface of the sculpture, of the drapery, even of the halos and *mandorlas* behind the figure, are executed in very low relief, giving the effect of of a flickering, sinuous, and rhythmical dance (*figs. 202, 203, 205*). Careful and continuous repetition of forms causes the rhythmical effect. The figures have become much more slender and elegant. Their necks are longer; their faces are no longer of a Central Asian or Gandharan type. The poses are not static; they move. Guardian figures, no longer stiffly alert, bend and grimace. Angels are not flat silhouettes against a ceiling, but move within their outlines as well as in their silhouettes. A notable element of this style is the emphasis on the drapery. This assumes characteristic and repeated forms, especially a cascade or waterfall effect on seated figures. The artist obviously delights in the drapery falling over the knees and hanging down in carefully pleated folds below the legs. Such figures are repeated again and again, not only at Longmen but elsewhere, as in the more

203. *Shakyamuni triad.* Dated to 537 C.E. Stela; limestone; h. 30¹/₂" (77.5 cm). China. Eastern Wei dynasty. Cleveland Museum of Art

remote but equally beautiful caves at Maijishan, Gansu.

Perhaps we can see the style even more clearly in another form. Sculpture in stone was to be found not only in the caves but in the temple stelae. These were of two main types: one rising to a flame-shaped point and with high-relief images, the other a vertical tablet with figures carved in low relief or cut into niches. The pointed stela of the Eastern Wei Elongated style, dating from 537 C.E., is very much like the sculpture at Longmen (*fig. 203*). The archaic smile that we remember from Yungang is to be seen, greatly refined, more gracious and immediate. The eyes have a characteristic Chinese linearity. Wherever possible the long necks and waterfall drapery are emphasized in an entirely new and easy way. They are carved in extremely low relief, so low that they almost appear to be painted. A Chinese note is introduced into the primarily Indian iconography of a Buddha flanked by bodhisattvas,

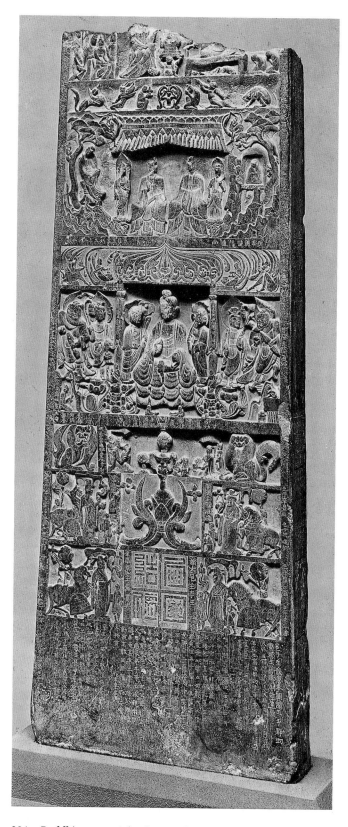

204. *Buddhist memorial stela.* Dated to 554 C.E. Gray limestone; h. 7' (2.1 m). Shanxi, China. Six Dynasties period. Museum of Fine Arts, Boston

the waterfall drapery, is here somewhat decadently executed. But the figures of the angels, demons, and lions are carved in a fully Chinese rhythmical style. The seal, the inscription, and the long dedicatory inscription are carryovers from the Chinese commemorative tablet. The tablet is simply divided into registers, and these in turn are divided into niches for figures, in an arrangement by no means always symmetrical. The lower registers display Chinese motifs: a donor, horses, and chimeras or lions. Trees flank a scene in a pagoda, providing a landscape setting and an example of pictorial influence on stone sculpture. The execution of landscape elements in stone relief was particularly significant in the development of Chinese painting.

The essential qualities of the Elongated style are perhaps most clearly seen in the gilt bronze ex-votos, or altarpieces, remaining from the sixth century. Like the scene in the pagoda (*fig. 204*), this altarpiece (*fig. 205*) represents the meeting of the two Buddhas, Shakyamuni, the historical Buddha, and Prabhutaratna. The story of this scene is related in the Lotus Sutra [*Saddharma-pundarika Sutra*]. Shakyamuni, seated on Vulture Peak, had begun to expound the Buddhist Law as it is presented in the Lotus Sutra, when a stupa appeared in the sky. Shakyamuni explained to the multitude that the stupa contained the relics of Prabhutaratna, a Buddha who had achieved Nirvana aeons before but had vowed to be present whenever the Lotus Law was being preached. Then Shakyamuni arose, "stood in the sky," and opened the stupa, revealing Prabhutaratna. Shakyamuni sat down beside him and continued his discourse.[5]

The bronze in the Musée Guimet in Paris shows the two Buddhas side by side, *mandorla*s with incised head-halos behind them, seated on a throne supported by lions flanking a caryatid. A design of a kneeling priest holding a censer is incised on the bronze base. In this altarpiece we find the elongated proportions, sharp nose, almond eyes, bewitching smile, waterfall drapery, and sawtooth drapery edges—another copybook motif—that occur again and again from about 510 to 550 C.E. Such gilt bronzes were made in some quantity as portable altars for family use or as offerings to temples; and very often they are inscribed and dated, this one to the year 518 C.E. The outer band of each *mandorla* is decorated with a flame pattern recalling the late Zhou hook-and-volute motifs, almost as if these latter had persisted and been adapted as a flame motif.

The third of the pre-Tang styles is called here Columnar. It evolved either through a specific kind of patronage or through a new wave of influence from India, probably from the Gupta period. The markedly linear character of the earlier sculpture in the round or in high relief is largely abandoned; instead we find stately, full-bodied, monumental sculptures on which jeweled ornament is applied to the smooth surface of columnar forms. The effect is highly architectonic, and quietly, reservedly imposing. A bodhisattva from the cave-temple complex at Xiang-

205. *Shakyamuni and Prabhutaratna*. Dated to 518 C.E. Gilt bronze; h. 10¹/₄" (26 cm). China. Six Dynasties period. Musée Guimet, Paris

for directly above the Buddha, in the outer band of the halo, we can easily discern a demon mask. This mask dominates the lotus scroll derived from Buddhist iconography. In many other stelae artists introduce the traditional Chinese dragon or winged lion. Even the medium, a hard, brown, spotted limestone, reflects native predilections for remarkable jadelike stones. These are evidences of the growing dominance of a Chinese idiom over the imported styles and iconographies.

The tablet-shaped stela takes its form from the traditional Chinese commemorative tablet, but in this example and in Six Dynasties sculpture generally it is adapted to the requirements of Buddhism, with many residual Chinese elements in iconography and style (*fig. 204*). In effect, the ingredients of a cave-temple are here placed on a Chinese inscribed tablet, but figures of acrobats and monkeys are depicted with quite un-Indian angularity, their long, slender figures moving in seemingly frenetic activity. The date of this stela is 554 C.E.; thus it is a late example of the Elongated style. One element of that style,

206. *Bodhisattva.* Stone; h. approx. 6' (182.9 cm).
Xiangtangshan, Hebei-Henan, China. Northern Qi
dynasty. University Museum, Philadelphia

208. *Amitabha altar.* Dated to 593 C.E. Bronze; h. 30¹/₈"
(76.5 cm). China. Sui dynasty. Museum of Fine Arts,
Boston

207. *Monster mask (pu shou).* Holder for door ring; gilt bronze;
h. 5¹/₄" (13.3 cm). China. Northern Qi dynasty. Cleveland
Museum of Art

tangshan typifies the style (*fig. 206*). The few details of or-
nament accentuate the smooth surfaces of the column-
like figure. The facial type is developed largely from the
Elongated syle; it is the torso that shows the radical change
in form. Whether attendants or caryatids, the monsters
executed in stone at Xiangtangshan are among the most
imaginative and sculpturally convincing products of the
period (*see fig. 365*). Like related types in gilt bronze (*fig.
207*), they are bizarre arrangements of volumes and voids
as well as being representational grotesques. They take
their proper place in the long history of Chinese secular
sculpture, though here they supplement a foreign imagery
and faith.

Various sculptures in stone and metal epitomize the
unification of style that took place during the Sui dynasty
(581–618 C.E.), but none does this better than the famous
bronze altarpiece in the Museum of Fine Arts, Boston,
dated to 593 C.E. (*fig. 208*). It represents the Buddha of
the West, Amitabha (C: Amitofo), seated beneath the jew-

eled trees of the Western Paradise and attended by two disciples and two bodhisattvas. A pair of lions and a pair of guardians flank an incense burner directly in front of the Buddha, these last set into holes in the bronze altar base. The Amitabha altarpiece is, first of all, a composition carefully balanced about a central axis. Individual figures show minor variations in pose, such as the inclination of the head of the bodhisattva on the right, but careful symmetry is the rule. The style is one of simplicity and restraint, with a harmony between major and minor figures not found in earlier compositions. There is no longer a discrepancy between the iconography and style of the major Buddha images and the qualities of the attendant figures. It is a mode based on the Columnar style of the Northern Qi dynasty. Very recent discoveries of tomb paintings and sculptures are indicating ever more strongly that the Northern Qi and Sui dynasties were instrumental in achieving the Sinicization and unification of the various influences entering China during the Six Dynasties period. From this fusion the great Tang style developed. But before we turn to the Tang International style, let us examine the extension of the Six Dynasties styles into Korea and Japan.

EARLY BUDDHIST ART IN KOREA AND JAPAN

Early Korean and Japanese Buddhist art is very much dependent upon Chinese achievements of the later Six Dynasties period. Overland movement of monks, artisans, and artifacts between China and Korea was crucial in the transmission, but communication by sea with the central Chinese coastal area was also very important, especially in Japan. The Buddhist art resulting from these contacts is high in quality and significant in quantity. Japan in particular has preserved an extraordinary number of Korean and native works of this period, and no full understanding of Chinese accomplishments in the sixth and seventh centuries can be had without study of Korean and Japanese materials of about that time.

The Three Kingdoms period in Korea saw the introduction of Buddhism into the three competing kingdoms of the peninsula: to Koguryo in the north circa 372 C.E., to Paekche in the southwest circa 384, to Old Silla in the southeast not until circa 528. The delay, which reflects not only Silla's greater distance from China but also its active resistance to the new religion, is also seen in the development of Buddhist art in Korea. Koguryo and Paekche were the first to embrace Buddhist art and to serve as agents of its transmission to Japan. By the time Silla, with the help of Tang China, had conquered both its neighbors (Unified Silla, 668–935 C.E.), even this last and least Sinicized part of Korea had embraced the Tang Chinese model of state and society. Confucian principles were

209. *Maitreya.* Gilt bronze; h. 30" (76.2 cm). Korea. Old Silla or Paekche period, 6th–7th century C.E. National Museum of Korea, Seoul

applied to administration, Confucian doctrine formed the subject matter of education, and Buddhism became the religion of the state as well as the people and a major influence on all Korean arts. The International style of the Tang dynasty swept all before it in the peninsula. Japan too, by the latter part of the seventh century, was strongly permeated by Buddhism and Chinese cultural influences as transmitted by Koguryo and Paekche.

But proximity to China and Japan was catastrophic for the survival of Korean Buddhist art. Chinese armies invaded Korea many times, usually seeking limited strategic advantages against the tribes of Manchuria, and the Japanese in the late sixteenth century launched two campaigns of conquest. These wars devastated architectural monuments and major sculptures. Only two large and famous bronze images remain in Korea. One, perhaps of Paekche origin, is in Northern Wei style (*fig. 209*); the other, perhaps slightly later, is in Northern Qi style and is almost identical with a red pine image at Koryu-ji in

Kyoto that was probably made in Korea. Numerous small gilt bronzes and a few clay reliefs remain, of which one is particularly appealing and important (*fig. 210*)—a standing figure of Avalokiteshvara in late sixth or early seventh century Chinese style. Its erect pose, detailed swags of jewelry, and stately drapery recall the style of late Northern Qi or Sui and anticipate the remarkable small sandalwood carvings of Eleven-headed Avalokiteshvara made in Tang China and Nara Japan. Because of their portability, such small gilt bronze and wooden images played a vital part in transmitting iconography, technology, and style among the three Buddhist neighbor nations.

Korean mastery of goldsmithing techniques, as evidenced by the gold crown from the tomb of that name in Kyongju (*see fig. 95*), was applied to the service of Buddhism as well as royalty, creating the pierced and gilded copper halos of important Buddhist images (*see fig. 217*).

To all intents and purposes, the early Buddhist art of Japan—the art of the fifth through ninth centuries—is Chinese art, first of the Six Dynasties period and later of the Tang International type. It is indeed fortunate that this is so, for recurrent warfare in China and Korea, both internecine and foreign, succeeded in destroying many of the great monuments of Buddhist art. There is almost no pre-Tang Buddhist architecture left in China or Korea. There are few, if any, remaining early images of wood, few large bronzes, and few images in precious metal or in other exotic materials. The list of early images in clay is brief indeed. But quite the reverse is true in Japan. There the combination of great good fortune and a marked reverence for the past, including the early monuments of Buddhism, has succeeded in preserving a considerable number of works in pure Six Dynasties and Three Kingdoms styles. From these we can gauge something of the richness and splendor of mainland sculptures in these phases.

Buddhism was introduced to Japan by a mission from Korea, traditionally in 552 C.E. As we have seen, one cannot overestimate the importance of Korea in the transmittal to Japan of the style of the Six Dynasties period. We know that the first generation of image makers in Japan were from the mainland and nearly all second and third generation artists had some continental blood.

Buddhism succeeded in Japan largely through the efforts of Prince Shotoku (574–622 C.E.), or Shotoku Taishi, "Crown Prince Sage Virtue." By skillfully mobilizing political support for his own pure faith, he succeeded in establishing Buddhism as the state religion, over the opposition of powerful supporters of the native Shinto, in a relatively short time. Shinto's ritualism and its multiplication of deities or nature spirits were no match for the religious sophistication of Buddhism and the amplitude and grandeur of the Chinese culture attending it.

The Japanese ruling class embraced Chinese culture almost in toto and with unparalleled alacrity. Writing,

210. *Standing Avalokiteshvara.* Gilt bronze; h. 12⅝" (32 cm). Korea. Old Silla period, early 7th century C.E. National Museum of Korea, Seoul

211. *Horyu-ji*. Nara Prefecture, Japan. General view. Asuka period, 7th century C.E.

employing Chinese characters, became dominant at this time, as did the customs and hierarchical organization of the Chinese court and the concept of city and temple planning along oriented geometric lines. All the orderly, logical, and rational elements that we associate with China were brought in with Buddhism. Temples were built in great numbers; sculpture was produced in quantity; and the result was a flowering of figural art.

One must always be conscious of a time lag in assessing the relation among Chinese, Korean, and Japanese styles. The Asuka period lasted from 552 to 645 C.E., but Japanese art of the period is in the Chinese style common from about 500 to 550. The type-site for the Asuka style, Horyu-ji (the suffix -*ji* means "temple"), the cradle of

Japanese art, probably was founded in 607 C.E. (*fig. 211*). The existing structure is not the original one; it was rebuilt in the early style at the end of the seventh century, after a disastrous fire. The golden hall (*kondo*), the pagoda, a part of the cloister, and the gate are in the original style but date from just after 670 C.E. Not only are these the oldest surviving wooden buildings in the world, they also resemble a Chinese temple complex of the Six Dynasties period. Early in 1949 a tragedy occurred. Part of the golden hall had been removed for repair, but the part left in situ was burned, and the great frescoes inside were severely damaged. The Japanese have reconstructed the hall to its original appearance, using new materials to supplement the timbers that had been removed.

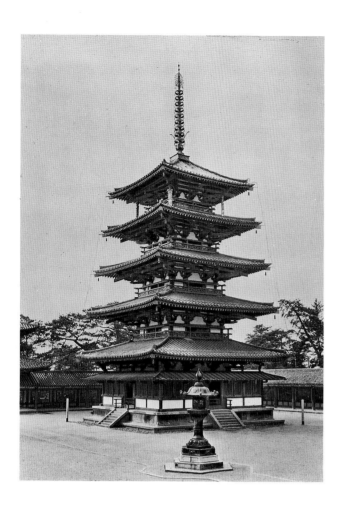

212. *Five-storied pagoda (goju no to) of Horyu-ji.* Nara Prefecture, Japan. Asuka period, 7th century C.E.

The beautiful and gently rolling hill country near Nara affords Horyu-ji an extraordinary setting, and the pine trees rising out of the sand of the courtyard add to the ancient, noble, and archaic air of the whole. The plan of the monastery is relatively asymmetrical, giving much prominence to the pagoda. From the gate the principal axis runs betweeen the pagoda and the golden hall to a lost refectory behind. The east-west axis transects the golden hall and the pagoda. The pagoda and the golden hall are symmetrically placed on either side of the north-south axis, but the two buildings are not, of course, identical. Later, in the Tang dynasty, a more rigidly balanced plan became typical, with the golden hall on a central axis and two pagodas symmetrically placed in subordinate locations either inside or outside the cloister.

The individual buildings of Horyu-ji are typically Chinese, standing on raised stone bases and using the bay system, post-and-lintel construction, tile roofs, and elaborate bracketing designed to transmit the thrust and weight of the heavy tile roof down through the wooden

213. *Kondo (golden hall) of Horyu-ji.* Nara Prefecture, Japan. Asuka period, 7th century C.E.

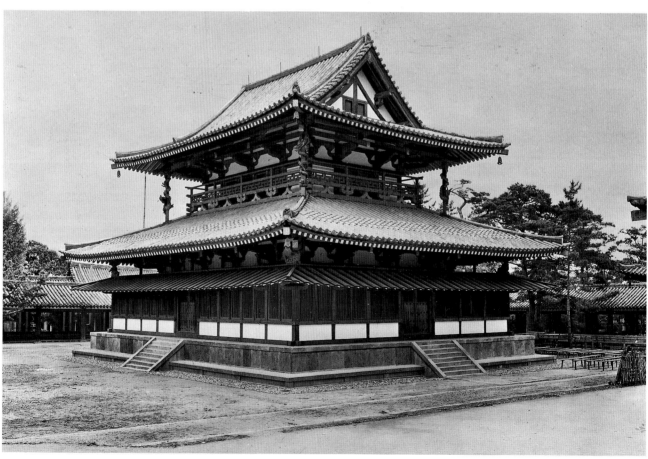

members into the principal columns that support the structure (*fig. 212*). The gate has a more flying, winged character, typical of Six Dynasties architecture, than does the *kondo*. The latter had a covered porch added in the eighth century and, in the seventeenth, dragon-encircled corner posts. These tend to obscure the early form and make it appear more squat and cumbersome than was originally intended. A closer view of the *kondo* shows the bracketing system with its complicated use of jutting members, carved in a linear, cloudlike pattern (*fig. 213*). All this adds to the springing and light effect characteristic of Six Dynasties style, in contrast to the somber and rather dignified style that succeeded it. The golden hall is oriented to the four directions, with a stairway on each side leading to a double door. The interior is similarly oriented, with the three main images on a central dais and three carved and painted wooden canopies over them. On the four interior walls frescoes were painted in about 710 C.E., showing the paradises of the four Buddhas of north, east, south, and west, with smaller wall panels of attendant bodhisattvas. These are the paintings largely destroyed in 1949, but fortunately they are thoroughly documented by photographs and color reproductions, though these are admittedly poor substitutes for the original.

Painting of the Asuka period is known to us principally through one monument in Horyu-ji known as the Tamamushi (Jade Beetle) Shrine, so called because the pierced gilt bronze borders around its base and the edges of its framework are laid over a covering of iridescent beetle wings (*fig. 214*). These shine through the gilt bronze openwork, producing an extraordinary effect. The Tamamushi Shrine is a wood-constructed architectural model meant to enclose an image. Resting on a large, high pedestal placed on a four-legged base, the entire shrine is more than seven feet high and in almost perfect condition, with no restoration or addition. It is not only a beautiful form in itself, important for its paintings, but it is also of great value for the study of architecture of the Six Dynasties period. Naturally the Horyu-ji buildings themselves have been repaired, roofs have been changed, and oftentimes the original lines of the structure have been lost. But the Tamamushi Shrine is a small and perfect example of Six Dynasties architecture in excellent preservation. Indeed, modern Japanese architects were able to reconstruct the golden hall's roof line more accurately by following this model. On the four sides of the pedestal are painted Buddhist scenes, two of them *jataka*s, or stories of the Buddha in a previous incarnation. Here (*fig. 215*), in

214. *Tamamushi Shrine.* Lacquer painting on wood; h. 7'8" (2.3 m). Horyu-ji, Nara Prefecture, Japan. Asuka period, 7th century C.E.

215. *The bodhisattva's sacrifice, from Tamamushi Shrine.* Detail of fig. 214

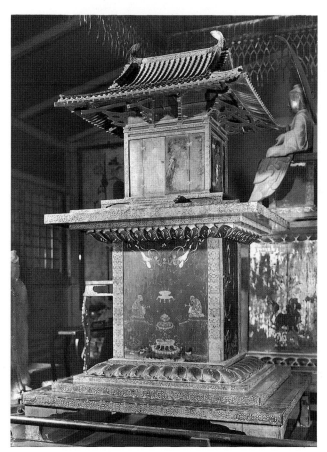

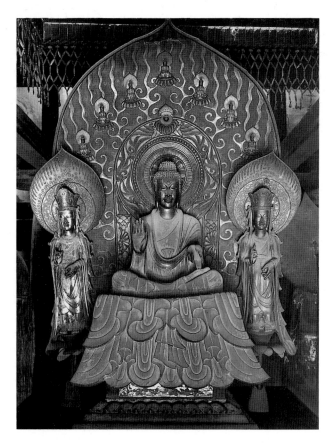

216. *Shaka triad.* By Tori Busshi (Master Craftsman Tori). Dated to 623 C.E. Bronze; h. 69¹/4" (175.9 cm). Horyu-ji, Nara Prefecture, Japan. Asuka period

order to save a tigress and her cubs from starving to death, the Buddha-to-be offers himself as food. The story is told by the method of continuous narration in three episodes. Above, the Buddha-to-be carefully hangs his clothes on a tree. He is then shown diving off the cliff toward a bamboo grove, the tiger's lair. At the bottom, partly veiled by bamboo stems, is the gruesome conclusion: the tigress and cubs eating the willing sacrifice. The representation is of great interest as one of the earliest examples of the painting of bamboo, an East Asian specialty, and because its general style, particularly the way in which the curious rock formation is constructed with ribbons of yellow and red lacquer, recalls nothing so much as late Zhou and Han inlaid bronzes. The whole construction of this cliff, with its linear accents and its hooks and bends, is in pure Chinese style. Note, too, that the human figure is long and slender, a perfect example of the Elongated style. Linear motifs are strongly emphasized throughout, in the clouds, in the falling lotus petals, and in the drapery that trails behind the bodhisattva as he plummets to the bamboo grove below. The whole effect is replete with naiveté and charm and shows tremendous technical control.

The largest remaining Chinese bronze image of the Six Dynasties period is perhaps four feet in height. At

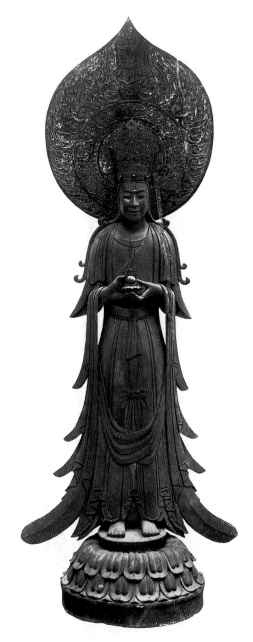

217. *Yumedono Kannon.* Gilded wood; h. 6'5¹/2" (1.97 m). Yumedono (Hall of Dreams) of Horyu-ji, Nara Prefecture, Japan. Asuka period, early 7th century C.E.

Horyu-ji there are several seated images, including the famous group illustrated here (*fig. 216*), almost six feet high. This Buddhist triad, by Tori, a sculptor of Chinese descent, was made in 623 C.E., and represents the Buddha Shakyamuni seated on a throne flanked by bodhisattvas, with a great *mandorla* behind. The image was made two years after the death of Shotoku Taishi and, as the inscription notes, was dedicated to the memory of the prince. It is in perfect condition, with considerable gilding remaining, and is a fine example of the Elongated style. If it were made of stone it might have come from a Northern Wei cave at Longmen. Though established in the north, the Elongated style permeated southern China and would have been transmitted to Japan via the south, specifically

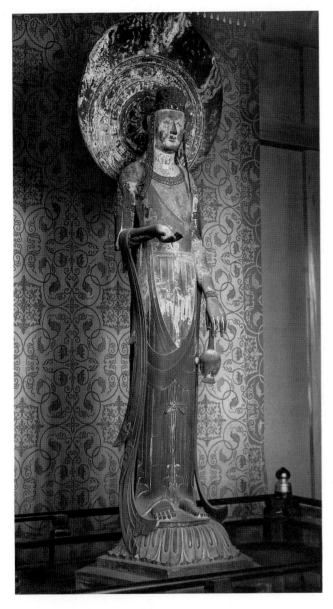

218. *Kudara Kannon.* Painted wood; h. 6'10¼" (2.1 m).
Horyu-ji, Nara, Japan. Asuka period, mid-7th century C.E.
Horyu-ji Museum, Nara Prefecture

Perhaps the most beautiful of all the great images at Horyu-ji is the wooden Kannon of the eighth century, housed in an octagonal hall called the Hall of Dreams (Yumedono; *fig. 217*). Kannon is the Japanese name for the deity called Guanyin by the Chinese and Avalokiteshvara by the Indians, the most popular of all bodhisattvas. The Yumedono Kannon has an extraordinary history. It was found in 1884 by a group of scholars including the American Ernest Fenollosa, later curator of Oriental art at the Museum of Fine Arts in Boston, carefully wrapped in cloth in its tabernacle, a secret image. Inside the wrappings lay the miraculously preserved image, some six to seven feet in height, with a halo that is one of the most beautiful examples in all the world of linear pattern carved in low relief. The figure had its original gilt bronze jeweled crown, with the jade fittings and gilding all preserved. Even such usually lost details as the painted moustache are clearly visible. The front view reveals the serrated drapery of the early Six Dynasties style and indications of the waterfall pattern and of the curling motifs of the hair at the side of the shoulders. The side view reveals the usual integrity of the Japanese artist in handling specific materials. We see an image that could not be anything but wood, despite the gilding. The serrated drapery derives its effect from its origin in a plank, first cut with a saw and then so finished that it retains, even in its finished condition, the character of sawn wood. Note, too, the flatness of the figure—how the hands are pulled together and compressed to the chest, maintaining a relief-like character, although the image is technically in the round. The Yumedono Kannon is, for this writer, perhaps the supreme example of the early Six Dynasties style in East Asia.

The second of the great wooden images at Horyu-ji is the so-called Kudara Kannon—the Korean Kannon. Kudara was the Japanese name for the kingdom of Paekche in Korea in the seventh century, and tradition assumes a Korean origin at least for the style if not for the image itself (*fig. 218*). In this image, while we have the same planklike character in the side draperies, we find a more columnar, trunklike quality in the torso, again most appropriate for wood. The Kudara Kannon is not in perfect condition; a great deal of the polychromy has been lost, and the rather spotty effect on the halo and on the body is due to this loss. But the tremendous elegance implicit in the elongation of the figure, and its individuality—greater than that of the Yumedono Kannon—make it unique. It is a little later in style than the image in the Yumedono, embodying the Chinese style of 550 or 560 C.E. rather than 520. As on the Yumedono Kannon, the support for the halo is wood carved to imitate bamboo.

In considering the sculpture of the Asuka period we cannot overlook an image quite different from the two that we have just studied. It seems particularly appropriate to its location, the little nunnery of Chugu-ji,

via the Liang dynasty (502–557 C.E.) with its capital at Nanjing, which is known to have been in contact with Japan. The waterfall drapery, the serrated edges of the side draperies on the bodhisattvas, the rather tall proportions, the type of the face, and the *mandorla* with its curling linear motifs are pure Liang in style. There is a slight tendency toward squatness in the proportion of the faces and in the relationship of the body to the feet, and this seems characteristic of some Korean and Japanese work of this period. Above the image is one of the three baldachins, or canopies, that were placed over the main images on the raised dais of this golden hall. It recalls the painted and carved canopies on the ceilings in such early Six Dynasties sites as Yungang and Longmen.

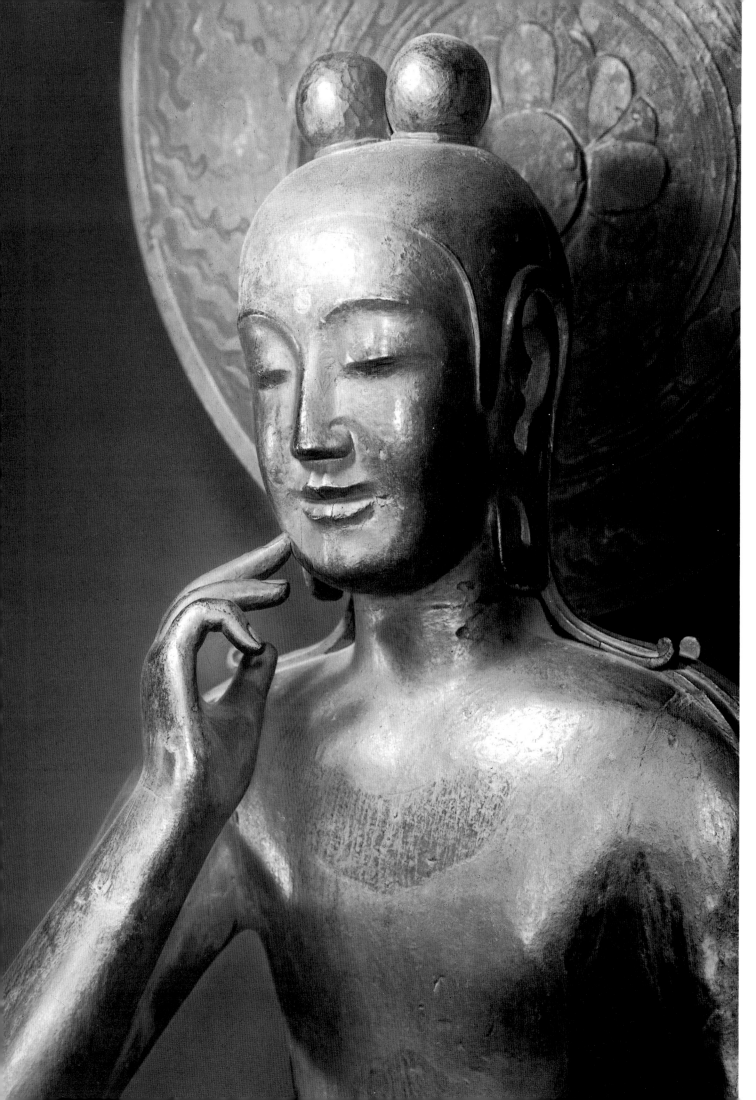

219. (opposite) *Miroku* (portion). Wood; h. 62" (157.5 cm). Chugu-ji of Horyu-ji, Nara, Japan. Asuka period, mid-7th century C.E.

an adjunct of Horyu-ji (*fig. 219*). The figure is properly referred to as the Chugu-ji Miroku (S: Maitreya, the Buddha of the Future). The Chugu-ji image has the elements of Six Dynasties style seen in the other sculptures—the waterfall drapery, the simulated bamboo pole holding the halo, the beautiful linear, flamelike pattern on the edges of the halo, the archaic smile, the serrated and curling edges of the hair as it falls over the shoulders. But it has quite a different flavor—one of infinite sweetness and softness, in short, a very feminine quality. The hand gesture of the Miroku, as he places his finger close to his chin in a posture implying meditation, is a thing of infinite grace. Still, such images as Maitreya and Guanyin must be considered masculine, not feminine. Even Guanyin does not begin to acquire a female aspect until the eleventh or twelfth century.

The carved wooden canopies over the main altar of the golden hall of Horyu-ji were decorated with an array of fabulous birds and angel-musicians. Some of these

220. *Angel musician.* Polychromed wood; h. 19¹/₂" (49.5 cm). Canopy of the *kondo (golden hall) of Horyu-ji,* Nara Prefecture, Japan. Hakuho period, c. 700 C.E.

were lost in the thirteenth century and replaced by contemporary copies; a few were removed in the nineteenth century and sold to fortunate Japanese collectors. The original sculptures in place, such as this angel (*fig. 220*), with its pierced halo, its linear and rhythmical development of repeated lines and gently swaying profiles, are characteristic of Chinese art in general and a demonstration of the truism that the Chinese are pictorial-minded. Their greatest sculpture looks more pictorial than sculptural; the Indians, on the contrary, are more sculptural-minded, and in the classic phase of their painting at Bagh and Ajanta they are concerned with the painted representation of sculptural forms in space. In its charm and delightful elegance this figure is related more to the Chugu-ji Miroku than to the earlier Yumedono or Kudara Kannon. There is good reason to believe that the angels do not date from 607 C.E., that is, from the earliest Horyu-ji construction, but from the end of the seventh century, when the canopies were probably put in place.

THE TANG INTERNATIONAL STYLE

Buddhist art of the Tang dynasty (618–907 C.E.) is rightly described as an international style, to which that of the Six Dynasties is but a somewhat heterogeneous preliminary. During the earlier period China was divided politically, in turmoil, and in the process of combining diverse racial, social, and religious components. The Sui dynasty, which had reunited the empire in 589 C.E., lost the Mandate of Heaven in the second generation. The second Sui emperor, whose ill-judged program of foreign conquests and massive forced-labor construction projects had alike cost numberless lives, fled before wholesale domestic revolts. The throne was seized by one of his military officers, the Duke of Tang, who inaugurated the Tang dynasty. Under Tang, the Chinese created a great world empire extending from the Caspian Sea to the Pacific, from Manchuria and Korea in the north into Vietnam in the south. At no other period before or after did China reach such powerful estate or exert such great influence. The capital, Chang'an, was one of the greatest cities the world had yet seen. Travel between East and West increased enormously under the protection of a unified and centralized empire. The empire developed integrated and sophisticated forms in its art, as in its literature and social organization. It was not an age of dawning faith, of pilgrims' fervor, but one of confident cosmopolitanism, born of mastery of the known world and society. Many foreign faiths were tolerated in Tang China—Buddhism, Nestorian Christianity, Hebraism, Islam, Zoroastrianism among them. Till the middle of the eighth century Tang went from strength to strength in domestic as in foreign affairs; through most of the ninth century, even after the

222. *Eleven-headed Guanyin* (fragment). Sandstone; h. 51" (129.5 cm). China. Tang dynasty, c. 8th century C.E. Cleveland Museum of Art

221. *Bodhisattvas.* Stone. Tianlong Shan, Shanxi, China. Tang dynasty, c. 700 C.E.

disastrous rebellion that tore the empire from 756 to 763, China still struck awed foreign visitors as the pinnacle of wealth, power, and civilized attainments.

The derivations of the Tang Buddhist style were threefold: first, India of the Gupta period; second, its own background of the Six Dynasties and the Sui period; and third, Central Asia and the Middle East. Never before or since have so many Middle Eastern motifs appeared in Chinese art nor, on the other hand, were so many Chinese motifs imported into the Middle East.

The type-site for Tang stone sculpture is the cave-temple complex of Tianlong Shan in Shanxi. In particular, cave 19 shows at its very finest the style achieved by the Tang sculptor (*fig. 221*). Its elements are clear. Where before we were conscious of religious fervor, of a more abstract and mystical handling of the figure, of linear pattern, and of elongation, here we are more aware of a unified and worldly approach. All the parts seem fused into a seamless whole. The modeling of the figures is fleshly and voluptuous, perhaps in part under the influence of the Gupta style of India. The forms flow one into the other; the curve, the sphere, and the tapering cylinder are the basic elements. The drapery is no longer, as it was in the Northern Qi and even in the Sui dynasty, applied on the surface of a volume beneath, but is integrated with the structure of the figure in a seemingly naturalistic way. This combination of a sinuous and sophisticated voluptuousness, together with direct, even realistic, observation of nature, is what makes the Tang style.

Few stone sculptures remain to exemplify the accomplished style that fully realizes the most sophisticated intentions of the Tang image maker. One of these, carved in a fine-grained sandstone, is an Eleven-headed Guanyin, probably from Shaanxi Province, the home of the Tang capital, Chang'an (*fig. 222*). This bodhisattva, one of the most popular and holy saviors of Mahayana Buddhism, is revealed as a benign but worldly being. The rounded face is a foil to the graceful linear geometry of its features and a contrast to the vigorous realism of the "angry" heads above, which express the terrible aspects of deity in defense of the path to salvation. No trace of the struggle for stylistic assimilation remains; instead, easy grace is matched by technical ease of presentation. It seems a fitting visual and tactile summation of the Tang ethos, a

fully realized language derived from a foreign art vocabulary. No one would mistake this Guanyin for a Gupta Avalokiteshvara, though the same terms might be used to describe either—sensuous, worldly, yet removed from stress and struggle.

Much of the idealization seen in this Guanyin derives from the veneration accorded the subject matter. More realistic and vigorous accomplishments of the Tang sculptor may be realized from such monuments as the small pagoda base now in Kansas City, on which the presence of guardians and dragons allowed the artist to indulge in the imaginative Chinese tradition of pre-Buddhist times (*fig. 223*). Such variety and technical mastery were eminently suited to the worldly temper of Tang China and of the comparable Nara period in Japan.

One of the best-preserved caves at Dunhuang (cave 196) presents us with a complete altar arrangement, normal in size, complex in composition, but particularly focused by reason of the concentration of the attendant figures on the Buddha, who is probably Shakyamuni, or perhaps Amitabha (*cpl. 12, p. 203*). In this relatively dense yet carefully balanced arrangement each figure on one side has its counterpart on the other. Overhead, a painted *trompe l'oeil* canopy reproduces textiles whose weaves and patterns we shall see preserved in the Shoso-in in Nara. On the altar are modeled sculptures of polychromed clay, on the walls and ceiling painted figures in dry fresco, all brightly and richly colored. This combination produces a nearly hallucinatory vision, in which the sculptures seem almost painting and the paintings become colored emanations from the flat surfaces. The splendor of such Tang art must have impressed all pilgrims, monastic or secular, and inspired all to emulate such a sophisticated yet compelling religious art.

223. *Pagoda base.* Stone; h. 27¹/4" (69.2 cm). China. Tang dynasty, early 8th century C.E. Nelson-Atkins Museum of Art, Kansas City

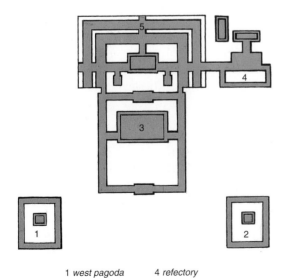

1 *west pagoda* 4 *refectory*
2 *east pagoda* 5 *monks' dormitories*
3 *Daibutsu-den*

224. *Original plan of Todai-ji.* 745–752 C.E. Nara, Japan. Nara period

The Tang International Style in Nara Japan

Buddhism was embraced in Nara Japan not merely as a personal faith, but also as an instrument to strengthen the dynasty against competing aristocratic clans at a time when the authority of the throne was still shaky and geographically circumscribed. By generously patronizing Buddhism and its monastic establishment, Japan's rulers invoked the protection of the innumerable and all-powerful Mahayana pantheon upon themselves and, by extension, upon the people whom they ruled. This process was neither ingenuous nor wholly cynical: the imperial family and their advisers were devout and zealous Buddhists, who also perceived clearly that unity, obedience, and loyalty could be promoted by presenting themselves as principal and most illustrious adherents of the popular faith. From this double motivation a spate of temple building and image making ensued.

We can see the development of the Tang temple plan in Japan at Todai-ji (*fig. 224*), whose formal name, Temple

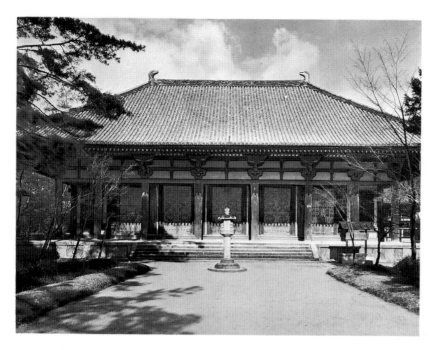

225. *Kondo (golden hall) of Toshodai-ji.* Nara, Japan. Nara period, c. 759 C.E.

for the Protection of the Nation by the Golden Effulgent Four Divine Kings, perfectly expresses the twin aspirations of its royal patrons. Its scale is huge—some five to six times the size of such small temples as Horyu-ji. Todai-ji's original image hall (*kondo*) was of such a size as to house a bronze Buddha image some sixty feet in height. Almost twenty acres were enclosed by the ambulatory. The pair of pagodas, now destroyed, were originally flanking the entrance but outside the enclosure, thus enlarging the plan still further. Such duplication was uncommon in Chinese temple layouts; a single large pagoda, often of brick or stone, was more characteristic on the mainland.

Tang and Nara were centralized and growing societies in their architectural planning as well as in politics. Individual temple buildings show the same tendency to expansion as the precincts. Observe the golden hall (*kondo*) of Toshodai-ji (*fig. 225*) in contrast to the same building at Horyu-ji (*see fig. 213*). Horyu-ji's tightly organized and rather small dimensions, its vertical development, and its feeling of lightness are dwarfed by the scale and mass of the later building. The Horyu-ji *kondo* is completely enclosed; at Toshodai-ji there is an expansion into space in the form of a porch. This was dictated by the interaction of religious and social requirements: the sacred images were not for the eyes of seculars anywhere, but at Toshodai-ji (in contrast to Horyu-ji) the noble or wealthy layman was considered entitled to shelter while he listened to the ritual within. Not only is the building immeasurably bigger than that of the preceding period, but the interior shows a more focused and unified handling of space (*fig. 226*). At Horyu-ji the altar was meant to be walked around in the traditional Indian rite of circumambulation. At Toshodai-ji the altar proper is backed by a screen, which permits the circumambulation but

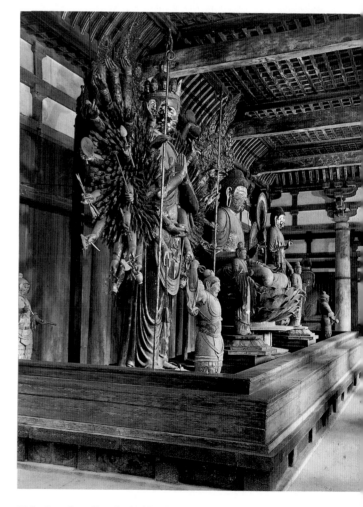

226. *Interior of kondo (golden hall) of Toshodai-ji.* Nara, Japan. Nara period, c. 759 C.E.

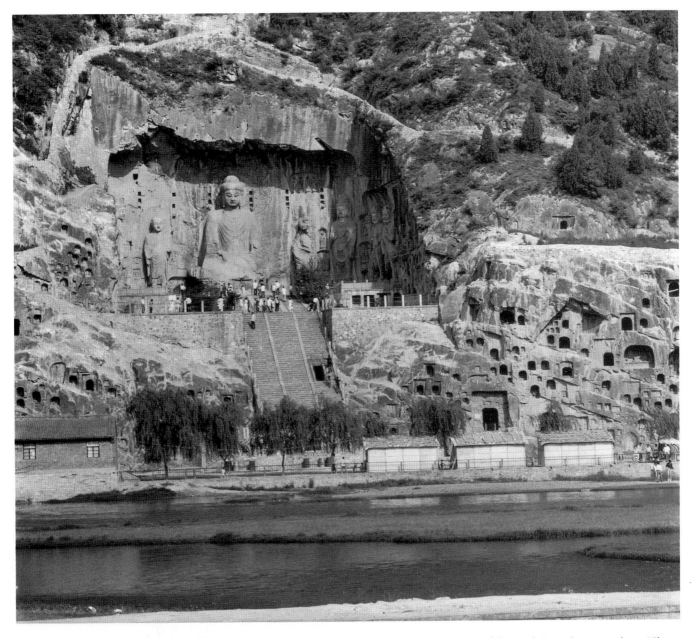

227. *Vairochana Buddha and attendants.* Limestone; h. of central image with pedestal approx. 44' (13.4 m). Fengxian grotto (cave 19), Longmen, Henan, China. Tang dynasty, completed 675 C.E.

focuses one's attention on a framed, frontal view of the images and the altar. Again, this is a more unified and visually logical concept than the preceding one. The various architectural members, columns, and bracketing are elaborate and massive. Both temples employ the same color scheme: white-dressed clay on the walls, the large members treated with red oxide, window lattices painted a rich green, the roof tiles gray.

The most impressive remaining Tang rupestrial monument is the Vairochana group in cave 19 (Fengxian grotto) at Longmen, just a few miles south of the Tang eastern capital, Luoyang, in Henan (*fig. 227*). The main image of the Supreme Buddha, flanked by disciples, bodhisattvas, and guardians, is about forty-four feet high overall, and the imposing, full-bodied figures are skillfully and

sensitively carved despite their colossal size. No wonder, for the group was a commission from the emperor Gao Zong, begun in 672 C.E. and completed in 675. Even the formidable Empress Wu participated, contributing a substantial amount from her private funds for the huge project.

The images are arranged as if disposed on the altar of a constructed temple. Originally the stone overhang was much deeper and was supplemented by timbering, as at Yungang over the great fifth century Shakyamuni (*see fig. 198*), so the icons appeared dark and mysterious. The present state of the cave, however, is far more conducive to the study of the great sculptural qualities of the group.

Although some stone and brick pagodas of the period remain, few wooden temples are preserved in China.

228. *Facade of Nanchan Si.* 782 C.E. Wood; h. approx. 30' (9.1 m), l. of facade approx. 45' (13.7 m). Wutai Shan, Shanxi, China. Tang Dynasty

229. *Altar.* Main hall of Foguang Si, Wutai Shan, Shanxi, China. Tang dynasty, 857 C.E.

Warfare, civil unrest, natural disasters, and periodic persecution of Buddhism took a heavy toll, especially the devastating imperial proscription of 842–845, when 4,600 temples and 40,000 shrines were destroyed. Only one surviving building antedates 845, the Nanchan Si of 782, at Wutai Shan in Shanxi (*fig. 228*). It is a simple building about 30 feet high, with three bays on each side (total length about 45 feet), made oblong by lengthening the middle bay on the north and south sides. Its substantial and weighty appearance, imbued with dignity, is typical of the mid-Tang, and contrasts with the buoyant lightness of late Six Dynasties style as evidenced in the small Tamamushi Shrine at Horyu-ji (*see fig. 214*). No canopy masks the timbering over the altar, whose carefully balanced arrangement recalls the Fengxian grotto (cave 19) at Longmen, created over a century earlier.

Also at Wutai Shan is the main hall of the Foguang Si of 857 C.E. This is a much larger building of seven by nine bays, about 50 feet high with a facade 123 feet long. Except for more numerous brackets and thicker non-bearing walls, in accordance with Chinese practice, the Foguang Si's main hall (*fig. 229*) much resembles Toshodai-ji's (*fig. 225*). As in the Japanese temple (*fig. 226*), there is a coved ceiling hiding the timbering and a screen behind the images on the altar.

We have seen an altar group; now let us look at some important individual sculptures. Certainly the most remarkable example of the early Tang style is the Japanese bronze Amida triad within the Tachibana Shrine, which is named for the lady of wealth and aristocratic birth who gave the shrine to Horyu-ji (*fig. 230*). It dates from about 700 C.E. This is some eighty years after the beginning of the Tang dynasty in China; but Japanese art in Chinese style is always subject to time lag, and thus the triad represents early seventh century Tang style. It is made of gilded bronze and is housed in a wooden tabernacle of the same time. Three major units make the composition: a flat base, a background screen in the form of a triptych, and the three main images, which sit or stand on lotuses rising from the bronze base. The total ensemble is approximately two and one-half feet high and remarkable for being a complete group of fairly large size, with its original base and background. Isolated figures of comparable quality might be found in Japan or, more rarely, in China, but to find such a complete ensemble intact is extraordinary.

In the center is Amida Buddha (S: Amitabha) sitting on a lotus, flanked by two bodhisattvas standing on lotuses. The Buddha's right hand makes the lotus-holding gesture, and the raised hand of each bodhisattva makes the gesture of reassurance. All of this is still slightly stiff, but in the early Tang style, immediately following the transition from the late Six Dynasties and Sui styles. Although gestures are gracious and an easy naturalism informs the faces and parts of the drapery, the figures are still frontal

230. *Amida triad, from Tachibana Shrine.* Bronze; h. of central figure 13¹/₈" (33.3 cm). Horyu-ji, Nara Prefecture, Japan. Nara period, early 8th century C.E.

231. *Screen of Amida triad, from Tachibana Shrine.* Detail of fig. 230

and a certain rigidity is evident in the drapery, in the poses of the bodies and, particularly, in the mouth of the central image.

The triptych screen behind the main images is executed in the most beautiful low relief, ranging from surfaces almost flush with the metal ground to a relief that projects, except in the small images of the Buddhas above, hardly more than a sixteenth of an inch or so from the surface (*fig. 231*). And yet within that very limited relief a

tremendous amount is achieved. The representation is pictorial in its general effect; everything flows with much more ease, much greater rhythm and suppleness than in the three principal sculptures, as if it were a translation of painting into metal. Across the bottom of the screen little octopi twine their tentacles around the stems of lotuses on which angels (J: *hiten*) are sitting. The octopi connect the screen thematically with the base, which represents a pond, cast like the screen in low relief.

Formal symmetrical balance governs the composition. The typical Japanese asymmetry is a later development; this composition is still purely Chinese. The Amida figure has a fiery halo, signified by flames at the very top of the screen. A fanciful cloud-and-hook pattern within the borders of the larger disk recalls, like so much late Six Dynasties decoration, the hooks and spirals of late Zhou inlaid bronzes. The central part of the halo is in the form of a lotus; the equation of lotus with sun is primary in East Asian iconography. Little waves strewn with lotus leaves ripple in low relief over the surface of the elegant base, from which large twisting lotus stems rise to support the three principal images (*fig. 232*). Despite the three dimensions of the main images, the ensemble tends to be pictorial, showing in this the influence of China, where sculpture often tends toward pictorial effects.

A prime example of the middle, or classic, Tang style in Japan is a bronze triad kept at Yakushi-ji (*fig. 233*). Such large-scale bronzes are now lost in China, but the few groups in Japan are superb examples of styles from the mainland faithfully repeated. Yakushi is the name of the Healing Buddha, sometimes one of the Buddhas of

232. *Base of Amida triad, from Tachibana Shrine.* Detail of fig. 230

233. *Yakushi triad.* Dated to 726 C.E. Bronze; h. of Yakushi figure 8'4" (2.5 m). Yakushi-ji, Nara, Japan. Nara period

the Four Directions, and his attribute is a medicine jar, which he usually holds in the palm of one hand. The main image of the principal hall at Yakushi-ji is a seated Yakushi, flanked by a pair of bodhisattvas often referred to as the Moon and Sun Bodhisattvas. They are very large figures, approximately ten feet in height, a scale no longer extant in China. Their halos are modern, with a lumpy cloud pattern, characteristic of late work, which contrasts crudely and offensively with the elegance and style of the figures. Time has turned the bronze greenish black, and it shines as if rubbed with oil. The bodhisattvas are not stiffly frontal but in a hip-shot pose, with a gentle sway of the body, one leg slightly bent and the other thrust forward. Their draperies flow more easily than those of an earlier period; the treatment of the hands is rounder and fuller, and the body too is fleshy. The linear notes in the drapery and faces have been maintained, but the lips are now fuller and rounder, not abstract and sharp. The faces have become slightly corpulent, in contrast to the long, thin faces of the early Six Dynasties and the moderate fullness of Sui and early Tang. The whole effect is both sensuous and mundane.

The transition from late Nara to the succeeding Heian period style (c. 800 C.E.) can be seen in a tranquil Nikko Bosatsu (Sun Bodhisattva), carved from a single

block of Japanese yew (*fig. 234*). Although somewhat less monumental than the mid-Nara period icons at Yakushi-ji, its fluid and undulating drapery combines with the subtle modeling of the body to produce a near perfect image of beatitude and compassion.

As an example of work in dry lacquer, no better image can be chosen than one of the four large Guardian Kings from the Sangatsu-do (Hokke-do) in Todai-ji (*fig. 235*). The dry lacquer technique (*kanshitsu*) employed here is peculiar. Over a roughly shaped clay model are applied layers of cloth soaked or brushed with lacquer, each layer being allowed to harden before the next is applied. The inner layers are usually hemp and the outer ones fine silk or, rarely, fine linen. When the approximate shape has been built up in lacquer-laminated cloth, a

234. *Nikko (Sun Bodhisattva)*. Wood; h. 18³/₈" (46.7 cm). Japan. Early Heian period, c. 800 C.E. Cleveland Museum of Art

235. *Guardian King*. Dry lacquer; h. 10' (3 m). Sangatsu-do of Todai-ji, Nara, Japan. Nara period, early 8th century C.E.

236. *Bonten (Brahma)*. Clay; h. 6'9¹/₄" (2.1 m). Sangatsu-do of Todai-ji, Nara, Japan. Nara period, early 8th century C.E.

237. *Priest Ganjin*. Dry lacquer; h. 31³/₄" (80.6 cm). Kaisan-do (founder's hall) of Toshodai-ji, Nara, Japan. Nara period, mid-8th century C.E.

coating of dry lacquer—a moldable paste of lacquer, sawdust, and starch—is applied, and in this the precise shape is modeled. When dry, it can be completed by coloring or gilding. Finally, the clay model is dug out and replaced by a wooden armature. Sometimes, unfortunately, the dry lacquer was replaced by a kind of stucco paste, which deteriorates rapidly. The combination of these two procedures—the laborious building up of form in layers of cloth and lacquer, with the final touches executed in a temporarily plastic material—produces fluid details on an intractable foundation, a tense combination characteristic of work in dry lacquer. Obviously the technique imposes predominantly tubular shapes, and so the extremities—appropriately enough in this case, since the figure is armored—appear to be cylinders and augment the appearance of stiffness already inherent in the medium. On the other hand, such details as the modeling of the veins in the hands, the wrinkling of the nostril, or the bulge of the eyebrow, are accomplished in a plastic medium with a fluidity that belies the underlying geometric form. One may well ask why such a time-consuming technique was used. The most generally accepted reasons are that images of this type were light, easy to handle and move, and not susceptible to attack by termites and wood ants. Certainly it is a laborious method of making sculp-

ture, and in China but few and often damaged examples remain. We must look to Japan for large and complete dry lacquer sculptures.

In Tang China many images were also modeled in clay, and for a fine expression of this technique we again look to Japan and to the high altar of the Sangatsu-do (Hokke-do). There, flanking the principal image of the Fukukensaku Kannon, are two images representing Bonten (S: Brahma) and Taishakuten (S: Indra). They are life-sized, and extraordinarily heavy because they are solid clay. In these figures (*fig. 236*) the fluidity of treatment of the face, drapery, and the bow hanging from the waistline reflect the plasticity of the soft clay in which they were modeled, a quality unattainable in wood or bronze. The pose of the figures, with folded hands and downcast eyes, has made them of special interest to photographers, and they have become two of the most famous sculptures of the Hokke-do. From China we have the fired clay tomb figures and the images from Dunhuang, sometimes provincial, but often showing complex Chinese altar arrangements in beautiful and well-preserved assemblies, as we have seen in cave 196 (*cpl. 12, p. 203*).

Another Nara image epitomizes that combination of secular feeling—in this case, ferocity—with religious awe that seems so typical of the Tang dynasty and of its style

238. *Western Paradise.*
Fresco. Dunhuang,
Gansu, China. Tang
dynasty, 2nd half
of 8th century C.E.

(*cpl. 13, p. 204*). The twist of the body, the bend of the
hip, the flow of the draperies around the figure, the open-
ings in these draperies, and the straining muscles of
the neck are combined in a way that summarizes the
dynamic interests of the Tang sculptor. This life-sized
image behind the screen of the Hokke-do portrays a
shukongojin (S: *vajrapani,* a *vajra,* or thunderbolt, bearer).
The conception is somewhat comparable to that of the
avenging archangel Michael in Christian iconography;
frightening evildoers and demons, the deity protects the
faith. The image is a secret one, kept in a closed tabernacle
that is opened only on rare occasions. But its magic
power, even inside the tabernacle, continues to emanate
in all directions.

The last illustration of sculpture in the Tang Inter-
national Buddhist style introduces a new category: the
portrait, executed in dry lacquer and polychromed (*fig.
237*). Priest Ganjin was the blind Chinese founder of the
great temple Toshodai-ji, a leading figure in the early his-
tory of Todai-ji, and a recognized authority on Chinese
secular culture as well. His image, like images of other
monks renowned for their holiness and their accomplish-
ments, was considered an aid to worship and right living.
The skin of the figure has a slight yellowish tinge. The
eyebrows are painted in, as are moustache hairs and the
stubble of the beard, but without that particularity which
is so characteristic of later types of Japanese realism. Like
most Tang portraits, the figure strikes us as both an indi-

vidual and a generalized type. From the time it was made,
the portrait of Priest Ganjin had much influence on
Japanese art, and the portrait sculpture of the Kamakura
period was to some degree inspired by it.

Buddhist painting in the Tang dynasty, both in China
and in the comparable period in Japan, encompassed two
major formats: the wall painting and the portable paint-
ing in hanging scroll and handscroll form. The wall paint-
ings decorated either temples or the interiors of caves, and
were painted both by anonymous artisans and by painters
of celebrated excellence. One of the greatest names in all
Chinese painting is that of the legendary Wu Daozi (act.
c. 710–760 C.E.), creator of Buddhist wall paintings and
reputed the greatest of Chinese figure painters. As the
works of the renowned painters have almost all vanished,
we must look for Tang painting style in the works of
anonymous artisans. The most sophisticated and beauti-
ful of Tang style wall decoration is in Japan, but there are
in China literally thousands of murals in some of the out-
lying provincial sites. Most important of these is the great
pilgrimage center and entrepôt Dunhuang, which we
have mentioned before. The representation of the
Western Paradise, with the Buddha Amitabha flanked by
two principal bodhisattvas, many minor bodhisattvas,
and other deities of Paradise, is from that site (*fig. 238*).
Most of the deities are seated on a high dais, protected by
canopies, flanked by pavilions, and fronted by a lotus
pond with platforms on which a celestial dance is in

progress. On either side are raised platforms holding other deities of the Western Paradise. The whole is a transcription in paint of passages from the *Sukhavati Vyuha* and *Amitayus Dhyana Sutra,* Buddhist texts that describe the Western Paradise and the pleasures of being there with the Amitabha Buddha.

When you have seen the seated figure your mental vision will become clear, and you will be able to see clearly and distinctly the adornment of that Buddha country, the jeweled ground, etc. In seeing these things, let them be clear and fixed just as you see the palms of your hands. When you have passed through this experience, you should further form [a perception of] another great lotus flower which is on the left side of Buddha, and is exactly equal in every way to the above-mentioned lotus flower of Buddha. Perceive that an image of Bodhisattva Avalokiteshvara is sitting on the left-hand flowery throne, shooting forth golden rays exactly like those of Buddha. Still further, you should form [a perception of] another lotus flower which is on the right side of Buddha. Perceive then that an image of Bodhisattva Mahasthama is sitting on the right-hand flowery throne.

When these perceptions are gained the images of Buddha and the Bodhisattvas will all send forth brilliant rays, clearly lighting up all the jewel trees with golden color. Under every tree there are also three lotus flowers. On every lotus flower there is an image, either of Buddha or of a Bodhisattva; thus [the images of the Bodhisattvas and of Buddha] are found everywhere in that country. When this perception has been gained, the devotee should hear the excellent Law preached by means of a stream of water, a brilliant ray of light, several jewel trees, ducks, geese, and swans. Whether he be wrapped in meditation or whether he has ceased from it, he should ever hear the excellent Law....

He who has practiced this meditation is freed from the sins [which otherwise involve him in] births and deaths for innumerable millions of *kalpas,* and during this present life he obtains the *Samadhi* due to the remembrance of Buddha.

And again, O Ananda, the beings, who have been and will be born in that world *Sukhavati,* will be endowed with such color, strength, vigor, height and breadth, dominion, accumulation of virtue; with such enjoyment of dress, ornaments, gardens, palaces, and pavilions; and such enjoyments of touch, taste, smell, and sound; in fact with all enjoyments and pleasures, exactly like the *Paranirmitavasavartin* gods....

And again, O Ananda, in that world *Sukhavati,* when the time of forenoon has come, the winds are greatly agitated and blowing everywhere in the four quarters. And they shake and drive many beautiful, graceful, and many-colored stalks of the gem trees, which are perfumed with sweet heavenly scents, so that many hundred beautiful flowers of delightful scent fall down on the great earth, which is all full of jewels. And with these flowers that Buddha country is adorned on every side seven fathoms deep.[6]

The Pure Land school of Mahayana Buddhism, with its Amitabha Buddha and his Paradise, appealed to the great mass of Tang people, and its iconography is most typical of the religious faith of the time. It pointed a relatively easy way to salvation: To be reborn into the Western Paradise one must simply worship Amitabha Buddha with faith. The mural, while it represents the Western Paradise of Amitabha, simultaneously expresses the Chinese concept of hierarchical order and also something of the sensuous and worldly ethos of the Tang dynasty itself. The composition is perfectly balanced, centrally oriented, the principal figures slightly higher and larger than the secondary ones. At the same time it emphasizes the pleasure-loving or sensuous aspects of this Pure Land and illustrates these with scenes that might have taken place in the court of a Chinese emperor. The foreground, for example, represents court musicians and between them a court dancer of Indian extraction performing on a court stage. The architecture is derived from the palace style of the Tang dynasty. Bordering the picture are continuous narrative representations of stories from the Lotus Sutra or from the life of Shakyamuni Buddha. A photograph distorts the values of the colors, because the figures that have oxidized to black were actually in paler pigments; the colors have, however, indeed darkened with age.

An example of the larger portable paintings of the Tang dynasty is the famous painting on hemp in the Boston Museum of Fine Arts. Called the *Hokke Mandala* (lotus diagram, or lotus picture), it was originally in the Hokke-do, or Sangatsu-do, of Todai-ji. It represents Shakyamuni Buddha attended by bodhisattvas and monks in a landscape setting (*cpl. 14, p. 205*). The setting of typical Western Paradise figures in the midst of a lush landscape is unusual, even though landscape developed rapidly during the Tang dynasty, and has led to much argument whether this picture is Chinese or Japanese. It has been considered to be Chinese with Japanese additions and restorations. The latest opinion, however, based upon careful infrared analysis of the picture which reveals most of the original state without repaint, gives some support to the argument that the picture is Japanese; if so, it must be an eighth or early ninth century example of the Tang style in Japan. The composition is fairly symmetrical, with a central figure flanked on each side by similar groups. Within these groups we find variations and this,

239. *Amida triad.* Fresco; h. 10' (3 m). *Kondo (golden hall) of Horyu-ji,* Nara Prefecture, Japan. Nara period, c. 710 C.E. Destroyed 1949. Exact replica in Horyu-ji Museum, Nara

together with the landscape setting, provides a less rigid conformation than the Paradise pictures of Dunhuang or similar paintings.

Another Buddhist hanging scroll of the ninth century, but Chinese, is the fragment in ink and color on silk discovered by Aurel Stein in 1907 at Dunhuang (*cpl. 15, p. 206*). At upper right the painting bears a title: *Bodhi[sattva] Guide of Souls.* In his right hand the supple and superbly clad bodhisattva holds a censer, in his left a flowering lotus and a white brocade temple banner; such censers and banners, dating from the Nara period, still survive in Japanese temples. The bodhisattva is guiding a saved soul, wafted along on stylized clouds or breezes, through a gentle rain of blossoms (symbolizing sanctity) toward the palaces of the Western Paradise at upper left. The "soul" is a lady, plump, chic, and dressed in the height of mid-Tang fashion—a type we shall meet again in Tang secular paintings. We have already encountered bodhisattvas of this type in contemporary sculpture, as attendant figures in the large bronze triad at Yakushi-ji (*fig. 233*).

But the classic examples—the greatest examples—of Tang style painting are the murals, now terribly damaged by fire, from Horyu-ji (*fig. 239*). You will remember that the golden hall had on its interior walls representations of the Paradises of the Four Directions (*see p. 167*). These were oriented to the four cardinal directions, with a varia-

tion required by the fenestration of the *kondo,* which necessitated rearrangement of the main iconic panels and those representing bodhisattvas. The murals were painted on clay walls supported by bamboo mesh hung between the columns of the building. They were painted with considerable color, much of which had vanished even before they were damaged, and with an additional emphasis on linear development. We see in the illustration the Paradise of the West as it was before the fire. The murals still exist, but the color was burned off most of them, so that in a few one can see a ghostly black-and-white image that seems to hover on the surface of the clay. They most likely date from about 710 C.E., and so they represent fairly early Tang style. The balanced composition uses a jeweled canopy with a gentle indication of hills behind, but not the great, complicated palace structures of the type we saw at Dunhuang. It is as if we had taken a detail of one of those and enlarged it, concentrating upon the three main figures. The linear development is of the highest importance. In the bodhisattva on the right—the one most often reproduced, in large part because of its splendid preservation—we find linear technique at its height. The line is relatively even in thickness, without that variation in width so characteristic of much of later Chinese calligraphy and Chinese linear drawing. It is rather a thin, even, wirelike line, applied with the greatest care and in a pat-

240. *Head of bodhisattva, from Amida triad.* Detail of fig. 239

tern that can only be called geometric. The parabola that makes the elbow, the reverse curve of the forearm, the arcs of the neck and the face, or the absolutely straight line of the bridge of the nose seem to indicate that the painters had a geometric conception of boundaries and used an even pressure on the brush (*fig. 240*). At the same time, this line is so subtly made that it serves to indicate depth or volume by means of the line itself, or by the turn of a line into another line. This is an extremely sophisticated device, but also somewhat conventional. The general characteristics of the shapes of the figures are comparable to those we have noted in Tang sculpture. The forms are rounded and fleshy; there is a gentle sway to the body; the face is slightly rotund; the whole effect is of that combination of worldliness and spirituality which pleases both the iconoclast and the believer.

The other painting format common during Tang was the portable handscroll, probably the principal means of spreading Tang style and Buddhist iconography to the far reaches of China and Japan. The handscroll presented both writing and pictures to priest and layman alike. The scrolls, some as long as thirty or forty feet, could be rolled up and carried easily in robe or luggage. When unrolled a foot or two at a time and read, with text below and illustration above, they provided an illuminated "bible" for both initiate and uninitiate. The best-preserved and most famous of illustrated Buddhist handscrolls in early style is the *Illustrated Sutra of Cause and Effect* (*Kako Genzai E-Inga Kyo*), existing in some rolls and fragments in Japan (*cpl. 16, p. 207*). The text is written in regular columns, in a fine, conservative, and legible style. The illustrations above display a slightly provincial air; they are not as sup-

241. *Birth of the Buddha, from Scenes from the life of the Buddha.* Fragment of border of large mandala; ink and color on cloth; w. 6³/8" (16.2 cm). Dunhuang, Gansu, China. Tang dynasty. National Museum, New Delhi

242. *Barbarian Royalty Worshiping Buddha.* Tradition of Zhao Guangfu. Handscroll; ink and color on silk; h. 11¹/4" (28.6 cm), l. 40³/4" (103.5 cm). China. Northern Song dynasty. Cleveland Museum of Art

ple as the Horyu-ji murals or some fragments of Buddhist painting from Dunhuang, but their color—bright oranges and malachite greens, yellows and azurite blues—conveys the sensuous worldliness so characteristic of Tang style, and contributes to their great charm. Note, too, the plump faces and the costumes derived from Chinese and Central Asian types. The scene reproduced, the *Assault of Mara,* is one of the key events in the Buddha's progress toward Enlightenment (*see fig. 126*).

Despite the provincial style and the slight naiveté of the conception, there is a general air of liveliness and of interest in the world—not just in religious narrative, but in landscape and in everyday happenings. It is the foreground conventions that betray provinciality. The artist simply made a few strokes over a blot of green to indicate a grass-covered area; this convention derives from the Chinese style, where it was more carefully worked into overlapping patterns indicating recession in depth. Here it is used simply as a kind of decorative note scattered over the surface of the ground. The trees too show a conventional treatment rather than one based on observation of nature. Figure painting at this time in China and Japan was more developed than landscape. The derivation of the painting style in this handscroll of the Sutra of Cause and Effect is quite clear: It comes from the curiously naive, cartoon-like style found also in subsidiary passages in the Dunhuang wall paintings and in the fragments that have been found in the library there (*fig. 241*).

These are the two farthest reaches of the International Buddhist style of the Tang dynasty—Dunhuang in northwest China, and Japan, far to the east. Stylistically the Dunhuang figures are almost identical with those in the Sutra of Cause and Effect, especially the little nude figure of the Buddha and the trees. Notice that in China, even in a provincial area like Dunhuang, the landscape, with its receding hills and mountains and great distant peaks, is more sophisticated than that achieved by the relatively unsophisticated Japanese artist in his little handscroll. What the great Buddhist scroll creations from the urban centers looked like we can only imagine from these charming provincial remnants or from Chinese examples of slightly later date, painted by traditional masters in the manner of late Tang (*fig. 242*).

243. *Seated Amitabha.* Dated to 706 C.E. Gold; h. 4³/₄" (12.2 cm). From stone pagoda of Hwangbok Sa, Kyongju, Korea. Unified Silla period. National Museum of Korea, Seoul

The Tang International Style in the Unified Silla Period

Of the many smaller states living in the penumbra of the mighty Tang empire, it was Korea, newly unified by Silla (Unified Silla period, 668–935 C.E.), which created the closest copy of Tang institutions and culture. Contact between the two countries, based on proximity, on Korea's autonomous-but-tributary status, and on intimate connections between the respective Buddhist establishments, all served to further Korean emulation of China and to catalyze a century-long golden age in Korean culture. Annual Korean embassies returned from the Tang capital with knowledge of Tang achievements and innovations. Great numbers of Korean Buddhists, laymen as well as monks, enhanced their influence as well as their knowledge by extended periods of study in China. An outpouring of Korean literature was written wholly in Chinese. As in Tang China, Confucian doctrines were

inextricably bound up in the political and educational systems, though Chinese administrative practices were much modified in Korea's more aristocratically based society. The predominating ethos, however, was Buddhist, and Buddhism was the principal impulse and matrix for Unified Silla's achievements in the arts. Like Japanese art of the Nara period, Korean art of the Unified Silla period reflects the dominance of the Tang International style.

Traditional Korean excellence in the art of gold working was applied to important Buddhist commissions, such as the gold image of Amitabha, exquisitely cast and worked in pure Tang style (*fig. 243*). This was found inside a gilt bronze reliquary in the pagoda of the Hwangbok Sa in Kyongju, and is dated by the inscription on the reliquary to 706 C.E.

Large castings in iron in fine mid-Tang style are also preserved, including the seated Shakyamuni Buddha from Powon Sa in Sosan, now in the National Museum, Korea. This monumental figure suggests what lost Tang images

244. *View of anteroom and circular main chamber, Sokkuram.* Constructed cave-temple; granite. Pulguk Sa, Mount T'oham, Kyongju, Korea. Unified Silla period, c. 774 C.E.

of iron (newly used for sculpture) might have looked like.

Almost no large bronze Buddhist images survive, but a great bronze bell, over ten feet high, cast in 771 C.E. in memory of King Songdok, is now in the Kyongju Museum. With its fine low relief of kneeling angels in floral clouds and its Tang style floral borders and medallions, it is as remarkable for technical mastery as for sheer scale and is one of the world's wonders of bronze technology.

The most interesting and original Buddhist site in Korea is the simulated cave-temple, actually constructed of granite, on a hilltop above the temple Pulguk Sa, near the capital city of Kyongju. Begun by the prominent government minister who had also undertaken the reconstruction of the Pulguk Sa, and completed by the state after his death in 774 C.E., Sokkuram is a unique architectural configuration but thoroughly Tang in its sculptural program.

A small rectangular antechamber is protected by guardian figures—the Two (or Benevolent) Kings, the Four Kings of the Cardinal Directions, and the Eight Demon Guardians. The demons on which the Four Kings stand are fine grotesques, and a most likely source of the enigmatic reliefs of earth spirits on the base of the bronze Yakushi image in Yakushi-ji (*see fig. 233*).

A narrow corridor joins this anteroom to the circular main hall, where the principal image is a seated Shakyamuni some eleven feet high, carved completely in the round. Most extraordinarily, however, his halo has been carved separately, on the wall behind him. Fifteen reliefs on the circular wall depict Brahma, Indra, three bodhisattvas, and Shakyamuni's ten original disciples (*fig. 244*). One of the bodhisattvas is an Eleven-headed Guanyin, a form rarely found in Korea. Above these reliefs ten small but deep niches originally contained a single figure each, but only seven seated bodhisattvas and Vimalakirti remain. The carving at Sokkuram is sure and strong but allows the quality of the stone to share in the aesthetic effect.

Korea was a dominant influence on Japanese culture in the seventh century, but by the eighth Tang China was at its artistic, social, and political apogee, and clearly set the direction for artistic production in East Asia. Both Korea and Japan enjoyed direct contacts with China by land and by sea and were able to participate in the success of its truly international style.

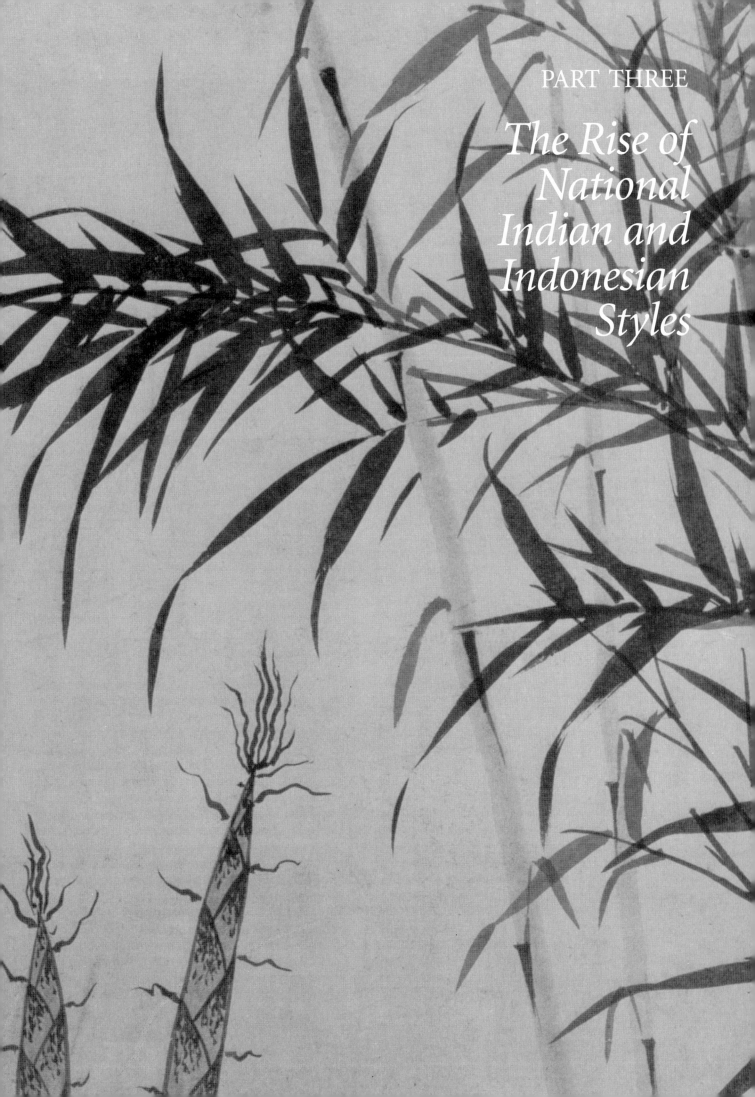

PART THREE

*The Rise of
National
Indian and
Indonesian
Styles*

8

Early Hindu Art in India

Ancient Indian culture may well have reached its zenith under the Gupta empire, particularly during the reign of Chandra Gupta II (c. 376–415 C.E.). The Chinese pilgrim-monk Fa-Xian, though interested primarily in Buddhism, which he found flourishing, noted also the general prosperity, peacefulness, and public safety, the benignity of the government, and the widespread practice of what we now call Hinduism. By the middle of the fifth century Central Asian peoples known as the Hephthalite Huns were raiding northwestern India. The Huns were driven out a century later, but not before they had destroyed the Gupta empire and all semblance of lasting unity or even hegemony.

Individual rulers such as Harsha (r. 606–647 C.E.), far-sighted, gifted, and forceful, might reconstitute the empire but could not perpetuate it. Another observant Chinese pilgrim-monk, Xuan-Zang, noted the general decline of public order despite Harsha's efforts, and of Buddhism despite Harsha's devotion.

From the disintegration of Harsha's empire until the Muslim conquests of the thirteenth century, India's history is one of division and chronic internal warfare punctuated by disastrous foreign invasions. At the height of their power, in the early ninth century, the Pala rulers of Bihar and Bengal extended their rule, and thereby their patronage of Buddhism, westward across northern India. In the eleventh century the Palas were supplanted by the strongly Hindu Sena dynasty. From 1206 C.E., when the first sultanate was proclaimed at Delhi, northern India was under Muslim rule.

Peninsular India was generally divided into eastern and western polities. The Chalukyan dynasts controlled the west till the end of the twelfth century. In the east the Pallavas were replaced in the ninth century by the Cholas. Chola power ended in the thirteenth century, and the Hindu kingdoms of the Deccan fell to the Muslims soon after. South of the Krishna River Hindu culture continued to flourish in the kingdom of Vijayanagar.

THE HINDU COSMOLOGY

We have been following for some time the development of international Buddhist art and its iconography, and the spread of a largely Chinese style in East Asia. Now we must examine the development of an image style indigenous to India and almost entirely associated with the Hindu faith. It was a style that did not survive export to Southeast Asia and Indonesia; there, especially in Cambodia and Java, distinctive regional styles developed.

245. *Stone bowl supported by female figure.* Sandstone; h. 38⅝"
(98.1 cm). Faizabad, Uttar Pradesh, India. Kushan period,
2nd century C.E. Bharat Kala Bhavan, Hindu University,
Varanasi

Hinduism is vastly complex. A proper foundation in
Hindu cosmogony or iconography would require mastery
of an immense literature in translation and many volumes
of philosophic or iconographic exegesis. Still, the art can-
not be understood without knowing something of the
faith; in the following brief picture of Hinduism we have
of necessity oversimplified but not, it is hoped, falsified.

Developed Hindu thought may be said to have two
distinct antecedents: Some aspects derive from pre-Aryan
elements of the population; other concepts, called Indo-

Aryan or Vedic, are associated with the invaders who
probably destroyed the Indus Valley civilization. In gener-
al, the pre-Aryan elements can be described as sensual,
and include qualities associated with the early fertility
cults whose deities were found in Indus Valley sites of
about 2000 B.C.E. They were frankly virile cults, involving
a personal devotion (*bhakti*) to and worship of male and
female deities associated with procreation, whose powers
were called on to induce fertility in all things, to stimulate
the very pulse of life itself. Beginning with simple repre-
sentations in pinched clay of fertility deities, the images of
these cults were later included in the service of Buddhism.
The Indian female ideal was the yakshi, like the one from
Faizabad, a fertility deity associated with the waters, who
holds in her hand a flask containing the water of life (*fig.
245*). On her head she bears a lotus capital; on the back
of the column grow vines and water weeds. Female char-
acteristics are emphasized forthrightly and with that
slight exaggeration which allows the image to give full
expression to the function of the deity. Emblems of fertili-
ty were oftentimes represented alone and very literally,
and served as symbols—the *lingam* (phallus) of the great
god Shiva, the *yoni* ("womb" or "origin," represented by
a downward-pointing triangle) of the Great Goddess,
Devi. Symbols such as these are pre-Aryan, and can be
traced back to the very beginning of Indian civilization.
The phallus symbol is common at Mohenjo-daro and
Harappa.

In contrast to these down-to-earth and intuitive ele-
ments are those derived from the Indo-Aryan tradition,
which can be described as formal or intellectual. Among
these are the concepts of hierarchy and caste, of levels of
society. For example, at Angkor Vat in Cambodia is a late
twelfth century bas-relief divided into two levels: Below is
the road to hell with its tortures; above, the road to heav-
en with its rhythmical and ecstatic procession of the saved
(*fig. 246*). Such concepts of hierarchy and caste, of the
saved and the damned, are in keeping with the Indo-
Aryan element of Hinduism, which emphasized religious
rites conducted by the Brahmin, or priestly, caste in con-
trast to the personal devotion of the pre-Aryans. Con-
nected with this formal, conceptual quality is the
mathematics of theology, the endless proliferation of "sig-
nificant" numbers, and the use of accretion as a means of
assimilation and explanation. Thus we have the sixteen
avatars of Vishnu, the many aspects of Shiva, the three
aspects of Being, the eight heroines in love (*nayikas*), and
many others. This Indo-Aryan element of Hindu thought
influenced later Mahayana Buddhism, with its emphasis
upon hierarchy, caste, and number and its attempts to
find the Buddha everywhere, at all times, throughout
eternity. Abstractions and the concept of zero, elements
associated with metaphysics and, to a lesser degree, with
mathematics, were also primarily Indo-Aryan contribu-
tions. The Indo-Aryan pantheon that we know by name

246. *Bas-relief of heaven and hell.* Sandstone. South wing, Gallery of Bas-reliefs, Angkor Vat, Cambodia. Second Angkor period, late 12th century C.E.

from the Vedas includes Agni, god of fire, especially the sacred flames of the altar; Surya, the sun god, whom we saw at Bhaja riding over clouds and dispelling the darkness of the old faith; and Indra, god of sky and storms, riding on an elephant over and above the tree-worshiping fertility cultists of the pre-Vedic tradition. The Vedic gods continue as lesser figures in the vast Hindu pantheon. Indeed, the roles and characters of some of them become absorbed by the slowly emerging Hindu deities who, growing by accretion, are a synthesis of popular and philosophical concepts, their various aspects and activities accumulated from myth and epic and the later Puranic collections of cosmic myths and ancient semihistorical lore. So Rudra, god of storms and the destructive forces of nature, was absorbed into the figure of Shiva; Varuna, god-on-high and, later, lord of the waters, into that of Vishnu. If the combinations of gods or the various aspects of one god seem bewildering, it must be remembered that to the initiated this multiplicity betokens one divine being whose energy is manifested in many forms, and that each of these forms has three aspects—serene or divine (*sattvic*), active (*ragasic*), and fierce and destructive (*tamasic*).

The various combinations of deities are instances of complexity. In one triad representing the three great gods of Hinduism, Brahma is the creator, Vishnu the preserver, Shiva the destroyer. In another, Shiva alone plays all three roles. One type of icon represents Shiva as both male and female (Shiva Ardhanarishvara, composed of the right half of Shiva and the left half of his consort, Parvati). Another similarly divided icon (Harihara) combines Vishnu and Shiva.

Originally and in theory, Brahma, the creator, four-headed (as on a temple at Aihole), facing the four directions, and all-seeing, was one of the most important deities (*fig. 247*). But in the days of developed Hinduism his position as a primary deity was not strong, and cer-

247. (opposite above) *Brahma.* Relief; stone; l. approx. 8' (2.4 m). Huchchappayagudi Temple, Aihole, Karnataka, India. C. 500 C.E. Prince of Wales Museum, Bombay

248. (opposite below) *Vishnu Anantashayana.* Relief; granite. Mahamallapuram, Tamil Nadu, India. Pallava period, 7th century C.E.

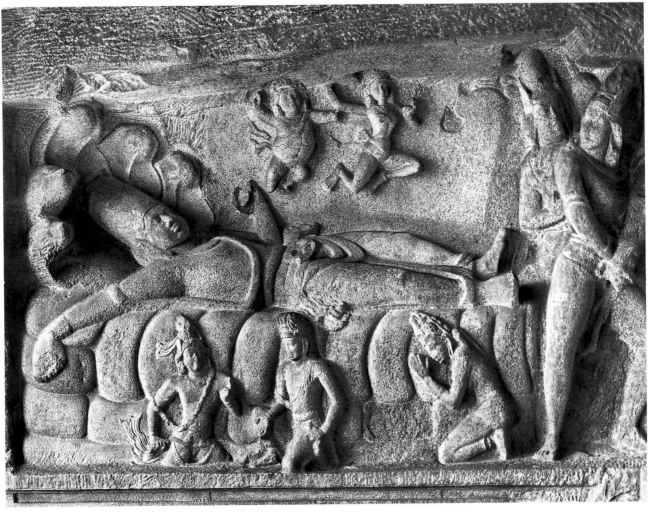

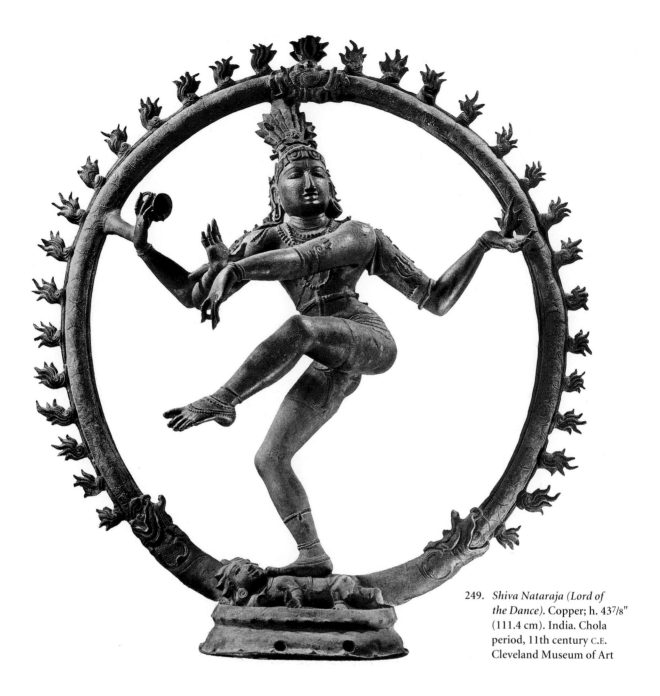

249. *Shiva Nataraja (Lord of
the Dance)*. Copper; h. 43⁷/8"
(111.4 cm). India. Chola
period, 11th century C.E.
Cleveland Museum of Art

tainly he is far from important artistically. In a well-known Vaishnavite sculpture of the seventh century C.E. at Mahamallapuram the myth of his creation is shown: Vishnu is lying on the waters supported by the coils of the serpent Ananta, just before Brahma issues from his navel to activate the world (*fig. 248; see also fig. 167*). Of the members of the great Hindu triad, Vishnu and Shiva are predominant. Vishnu had many avatars, or incarnations into various forms, including boar, lion, and fish, to save the world from one disaster or another. But one of his most important avatars is that of Krishna, the cowherd of Brindaban, a lyrical personification of universal love, whose exploits as the lover of village maids and conqueror of demons are celebrated in literature and in later art, especially in Rajput paintings of north India. The Krishna of the *Bhagavad Gita,* a work of the first century B.C.E.,

who as charioteer of the hero Arjuna revealed himself as the One God, was a more remote and abstract conception.

The third member of the triad, Shiva, is to his worshipers the supreme deity, encompassing all things. In the West Shiva is most famous in his manifestation as Nataraja, the lord of the dance. Figure 249 shows Shiva Nataraja dancing the cosmic dance, in which the universe becomes a manifestation of the light reflected from his limbs as he moves within the orb of the sun. A fine description of the meaning of this image is to be found in the first section of Ananda Coomaraswamy's *Dance of Shiva,* a lyrical presentation as well as a reasonably complete one from an iconographic point of view. When Shiva is represented as Mahesha, the supreme deity, he assumes all the functions of the three great gods. We find him thus in the great sculpture at Elephanta, a large carv-

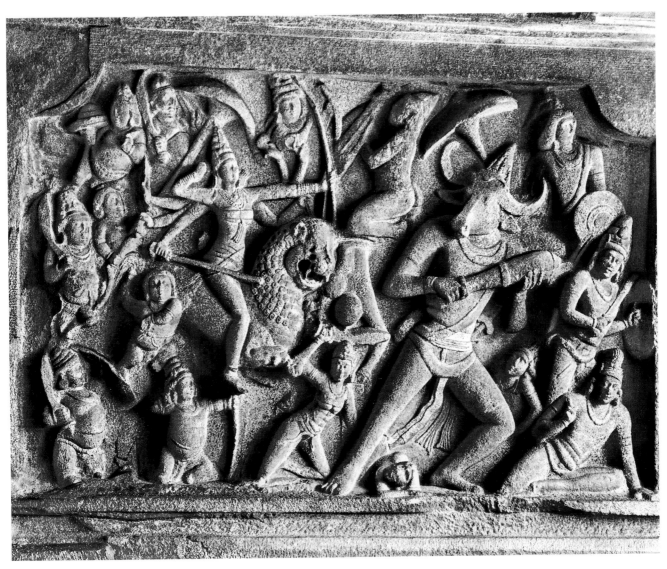

250. *Durga Killing the Bull-Demon.* Rock-cut relief; h. approx. 9' (2.7 m). Mahamallapuram, Tamil Nadu, India. Pallava period, 7th century C.E.

ing in the living rock, some eleven feet high (*see fig. 285*). On the left he is wrathful as a destroyer, in the center benign as a preserver, while on the right is his female aspect as creator and giver of fertility—the Beautiful One.

To the figures of the great gods must be added that of the goddess Devi, known under many names, whose worship as a supreme deity is as old as the Indus Valley culture. As Uma she is *sattvic*, the Great Mother; as Parvati she is the energy and consort of Shiva; as Durga she is active or *ragasic*; as Kali, goddess of death, she is *tamasic*. As Durga, for example, Devi is shown accompanied by her retinue of dwarf soldiers, riding on her vehicle, the lion, slaying the wicked bull-demon Mahisha (*fig. 250*). There are many lesser divinities, including Ganesha, the elephant-headed god of good fortune, and Kartikkeya, god of war.

Certain basic concepts are essential to any real understanding of Hindu art, and certain misconceptions must be avoided. The concept of image and worship has been clearly presented by Coomaraswamy. In theory, and to the most initiated and adept of the Hindu faith, the image is not a magical fetish, worshiped in itself, but stands for something higher—a manifestation of the Supreme Being. The Hindu use of images was first of all an aid to contemplative discipline, a way of achieving identification with deity. Early and impermanent images of paste and clay were replaced with those of more permanent materials, describing the deity and his powers as accurately as possible. These representations were much influenced by devotional descriptions in poetry and scripture. If several heads or numerous arms were required to hold the symbols and attributes of the deity and his powers, then they

were supplied. The end was realization of the deity's being, not the representation of a merely sympathetic human being. The distinction between image and idol was essential, but we must also understand that it was not clear to everyone, that to the average person the distinction was very hazy indeed. When a peasant went to Sanchi to worship the Buddha, the fertility deities at the gateway were most likely his principal concern; when an ordinary devotee prostrated himself before the image of Kali, the goddess of death and destruction, or before Shiva in his procreative aspect, he was doubtless confusing the image with the god—in short, he was touched by idolatry. Still, the distinction exists in theory and high practice.

A further and significant characteristic of Hinduism is the concept of macrocosm and microcosm, the desire to see represented on a small scale the huge scale of the universe. For example, the Kailasanatha Temple at Ellora, Maharashtra, is not simply a massive stone cutting, but an attempt on the part of architect and sculptor to visualize the universe in a monument ninety-six feet high, and to

orient and build that monument in such a way that it becomes a magical structure, one which contains the world within its compass. Thus the orientation of the plan is to the four directions, and in the cell of the temple—the unit for individual worship in the Hindu faith—there was buried a copper box containing "wealth of the earth, stones, gems, herbs, metals, roots, and soils." At this time the Earth Goddess was invoked: "O thou who maintainest all the beings, O beloved, decked with hills for breasts, O ocean girt, O Goddess, O Earth, shelter this Germ."[7] This, in the words of some Hindu texts, inseminates the temple and gives it life.

BEGINNINGS OF HINDU ART: THE GUPTA PERIOD

The development of medieval Hindu art was relatively rapid. Its foundations go back to Mohenjo-daro and the fertility cults of Indus Valley civilization of the second millennium B.C.E., and to such great remnants of early sculptural style as the Parkham yaksha, and the Besnagar

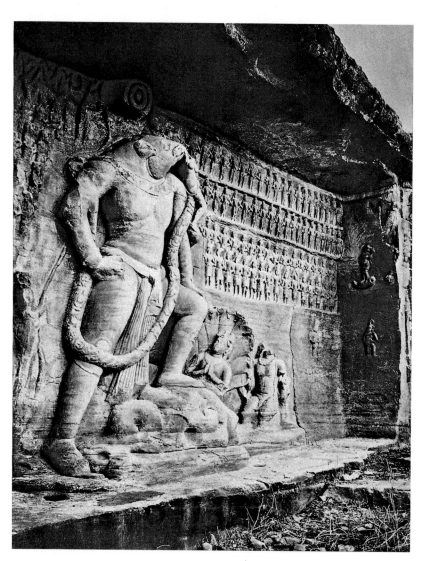

251. *Boar avatar of Vishnu.* Stone; h. 12'8" (3.9 m). Udayagiri, Madhya Pradesh, India. Gupta period, c. 400 C.E.

252. *Shiva triad and host, called the Parel Stela.* Stone; h. 11'5" (3.5 m). Parel, near Bombay, Maharashtra, India. Gupta period, 1st half of 6th century C.E.

yakshi (*see figs. 107, 108*). These were previously discussed as examples of forest deities placed at the disposal of the new Buddhist faith. We mentioned briefly the place of the then emerging Hindu deities as servants of Buddhism, and particularly the possibility that their symbols were present on the lion capital at Sarnath (*see pp. 82–83*). On the walls of a Buddhist monk's cell at Bhaja were Indra and Surya, Hindu deities. But our study of Hindu art as a form in itself begins with the Kushan period and with the famous *lingam* image of Shiva from Gudimallam, mentioned briefly above in the discussion of the Kushan period (*see fig. 134*).

In the Gupta period, beginning in the fourth century C.E., Hindu sculptures in stone and terra-cotta increase in number, as do buildings dedicated to the purposes of Hinduism, indicating that religion's growing strength. Buddhism was at its zenith from about the second century B.C.E. through the fifth century C.E.; then it gradually declined, to be found later only in limited areas, notably in northeast India and in Nepal and Tibet. Hinduism offered a traditional, practical, and worldly way of life and, with its old roots and vigorous image cult, appealed to the mass of the people.

The first great Hindu monument of the Gupta period is a relief of the boar avatar of Vishnu at Udayagiri in central India, not far from Sanchi (*fig. 251*). There is no stylistic distinction in this period between Hindu and Buddhist subjects. Both are handled in the relatively quiet style of the Gupta artist. The colossal relief carved in the living rock at Udayagiri is conceived in a form that recalls the Sasanian Persian reliefs of Shapur and Valerian, carved in the living rock at Naksh-i-Rustam. In the Udayagiri relief Vishnu is represented as a towering boar-headed human, supporting on his shoulder the Goddess of the Earth, whom he has rescued from the Serpent-King of the Sea at the lower right. A variety of small deities and angels, carved in relief on the back and sides of the shallow cave, witness the scene. The composition is relatively static and organized in a single plane along the wall. The pose of the main figure fits into this plane, while the rigid rows of small deities forming a geometric pattern reinforce the static effect.

Such a form was admirably suited to early Theravada Buddhist art, and to the expression of the serene and contemplative Buddhist ideal. Hinduism likewise espoused serenity and contemplation, but as one ideal among many. Other of its ideals required sculpture of tremendous dynamism, capable of portraying movement and the narration of great epics. Such a style did not evolve until the end of the Gupta period, then was further developed in the early medieval period, and continued until the eleventh or twelfth century C.E. Thereafter, except in bronze or wood, it declined.

The first monument showing the transition from Gupta to medieval style is the Parel Stela, a colossal marble image found by accident near Bombay some thirty or forty years ago (*fig. 252*). After excavation it was put into

puja, or worship, at a nearby Hindu temple, and therefore may not be seen by non-Hindus. But it has been thoroughly photographed, and so we are able to evaluate it as one of the greatest and most significant of Indian sculptures. The stela probably represents the three aspects of Shiva and their emanations. The three main images, vertically aligned down the center of the stela, wear the masculine and feminine earrings characteristic of all-embracing Shiva. Below are dwarfs, the usual attendants of Shiva. But even more interesting than the stela's iconography is its style, because here we see for the first time that quality of movement and expansion whereby the sculptor denies the nature of the stone and makes the images appear to grow out of the material and dynamically project beyond its edges. This effect is achieved in part by representing the figures in markedly erect pose, with chin thrust out and with indrawn breath increasing their chest size, all contributing to the psychological creation of what Heinrich Zimmer calls "expanding form." By the arrangement of numerous figures in a pattern suggesting movement and expansion, the main figures seem to grow as one watches them. Notice how the central figures rise almost to the top of the stela, and that the figures at the sides project to its edges. The repetition of the figures and of their parts, such as the knees or the patterns of hands and arms, creates an effect of rhythmic movement essential for Hindu art. The concept of such a dynamic deity as Shiva, or of such an active one as Vishnu, or of such a sometimes terrible and awe-inspiring deity as the great mother-goddess Devi requires forms capable of more than contemplative beatitude.

Such forms of expression, developing out of the Gupta mode, are called medieval, a term chosen only because in point of time and social organization they parallel the period we call medieval in the West. It is certainly an unsatisfactory, even arbitrary, term, but one now in general use.

Hindu sculptures have been found at Sarnath, carved in the cream sandstone associated with the Buddhist sculptures from that region, and there are Hindu sculptures of Gupta date from central India. Recent finds at Tala in Madhya Pradesh add much to the evidence of this early, dynamic phase of transition from Gupta to medieval art.

MEDIEVAL HINDU ARCHITECTURE AND SCULPTURE: CENTRAL INDIA

Two sites in central India are of importance for the development of Hindu architecture and sculpture in the late Gupta and early medieval periods: Badami and Aihole, in the Deccan. Here the early Chalukyan kings of Badami had temples carved and constructed, including for the first time elements that were to become fundamental in

the architectural vocabulary of the south. Although some of these were built before 600 C.E., the earliest dated structure is the Meguti at Aihole, of 634–635.

The architecture at these sites shows development beyond the single cell or the *chaitya* types previously seen in Buddhist architecture of the Gupta and earlier periods. The new style in architecture, whether carved from the living rock or constructed, is increasingly sculptural in character. Two temples at Aihole, dating from as late as the seventh century, still preserve earlier elements. In plan the Hacchimalagudi Temple (*fig. 253*) is a simple cell with a double ambulatory around it, entered through a porch. The temple is constructed on a post-and-lintel system derived from wooden architecture. We can easily imagine the probable origins of such a style: the combination of a stone or log base, wood post-and-lintel system, and thatched roof. The plan of this temple is the end of an early tradition, not its beginning. The ambulatory was abandoned and thus also the concept of any kind of public access to the main area of the shrine.

The Durga Temple, built about the same time, represents the beginning of a new way. It can be paired with the Buddhist cell-temple at Sanchi (*see fig. 146*) to demonstrate the derivation of the Hindu temple and to show changes significant for the future (*fig. 254*). It has a megalithic roof, that is, a single stone covering the main area, deriving from archaic architectural construction in stone. Its ambulatory has become a porch; that is, the porch is extended to surround the building, so that one can circumambulate the shrine outside rather than inside. The base has been elevated considerably, and this is of particular significance because it tends to remove the building from the realm of architecture to that of sculpture. And as we shall see, Hindu architecture must be considered primarily as sculpture. The towers will develop until they dominate the temple; the base will develop until it seems to dominate the lower part of the structure. The apse end of the Durga Temple shows the influence of the Buddhist *chaitya* hall, but with an outer ambulatory. The rudimentary tower is carved in great detail, with numerous representations including figures and miniature *chaitya* arches. We have seen such decorations on the Buddhist *chaitya* facades and in the caves; they will develop into fantastic ribbon-like ornaments in the later Hindu medieval style.

The sculpture at Aihole, which is over a century later than comparable sculpture from the Bombay region, such as the Parel Stela, is also more developed. An image of Vishnu seated upon the Serpent Couch is carved on the ceiling of the Vishnu Temple at Aihole (*fig. 255*). Here we can see a variant of the expansive quality in early Hindu sculpture. Where the Parel Stela seems to convey expansion by disposing a certain physical type in an unusual fashion over its surface, the Aihole sculptor, under the influence of clay technique, produces a more organic and fluid figure than any from the middle Gupta period. The

253. *Hacchimalagudi Temple.* Aihole, Karnataka, India. Chalukyan period, late 7th century C.E.

254. *Durga Temple.* Aihole, Karnataka, India. Chalukyan period, late 7th century C.E.

255. *Vishnu*. Stone ceiling slab. Vishnu Temple, Aihole, Karnataka, India. Chalukyan period, late 7th century C.E.

joints of the knees and elbows have lost any suggestion of bony structure and have become pliable, as if they were worked in clay or some other soft, plastic material, although the relief is in fact carved in sandstone. To look upon this sculpture like those purists of the modern school who demand above all integrity of material and ask of painting that it "look like paint" is to rule it out as sculpture—along with the late Greek and Roman figures that convey skin textures superbly in marble, or the works of Bernini, which simulate flesh or bark or whatever the sculptor wished. Hindu sculpture—and especially this medieval material—must be looked at as an art that denies or, better, transcends the material it is made of. Figures may seem to float off or on the surface of the stone; others seems to emerge from the stone. Compared with the Parel Stela, the composition in figure 255 is still relatively static, with the four figures flanking Vishnu in a rigidly balanced arrangement. But as the medieval style developed, the fluidity seen at Aihole in the individual figures was extended to the compositions as well.

Colorplate 9. *Avalokiteshvara.* Painted clay; h. approx. 24–28' (7.3–8.5 m). West alcove of Sum-tsek Shrine, Alchi, Ladakh, Kashmir. Mid-11th century C.E.

Colorplate 10. (above) *Four leaves and colophon page of Ashtasahasrika Prajnaparamita Sutra*. Scribe: Ananda Bhanaka.
Dated to c. 1065 C.E. Ink and color on palm leaf; h. 2³/8" (6 cm), l. 22¹/4" (56.5 cm). Eastern India. Pala period. Asia Society, New York.
Mr. and Mrs. John D. Rockefeller 3rd Collection
(below) *Cover and one leaf of Ashtasahasrika Prajnaparamita Sutra*. Dated to 1111 C.E. Ink and color on palm leaf; h. 2³/8" (6 cm).
Nepal. Cleveland Museum of Art

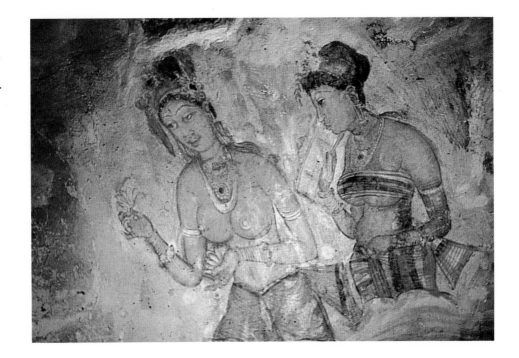

Colorplate 11. *Apsarases.*
Fresco. Sigiriya,
Sri Lanka. C. 479–497 C.E.

Colorplate 12. *Altar.*
Painted and gilded clay
sculptures, dry fresco
walls and ceiling. Cave
196, Dunhuang,
Gansu, China. Tang
dynasty, 8th century C.E.

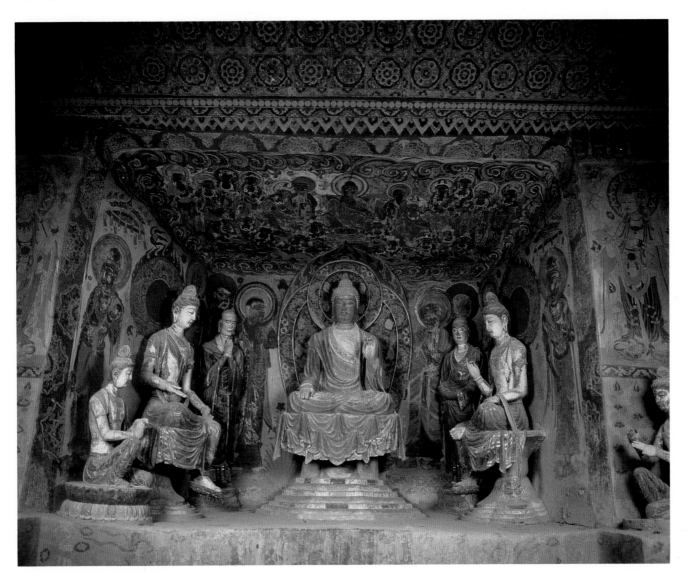

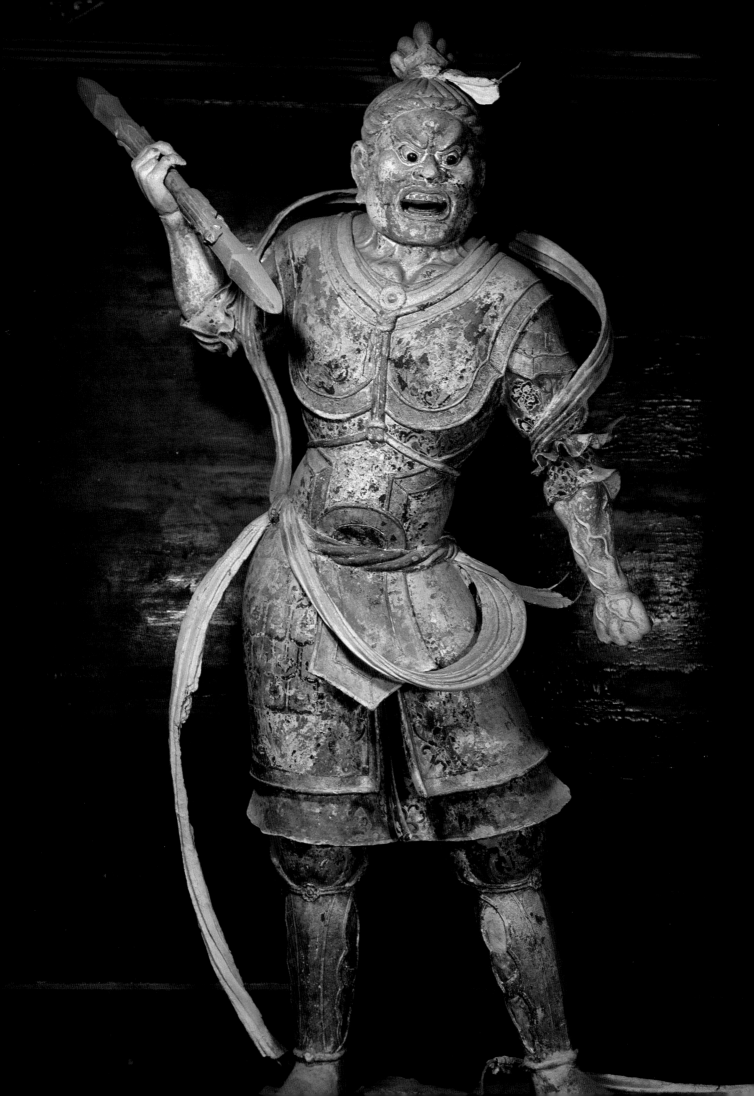

Colorplate 13. (opposite) *Shukongojin* (S: *Vajrapani*).
Guardian figure; painted clay; h. 68¹/₂" (174 cm).
Sangatsu-do of Todai-ji, Nara, Japan. Nara period,
mid-8th century C.E.

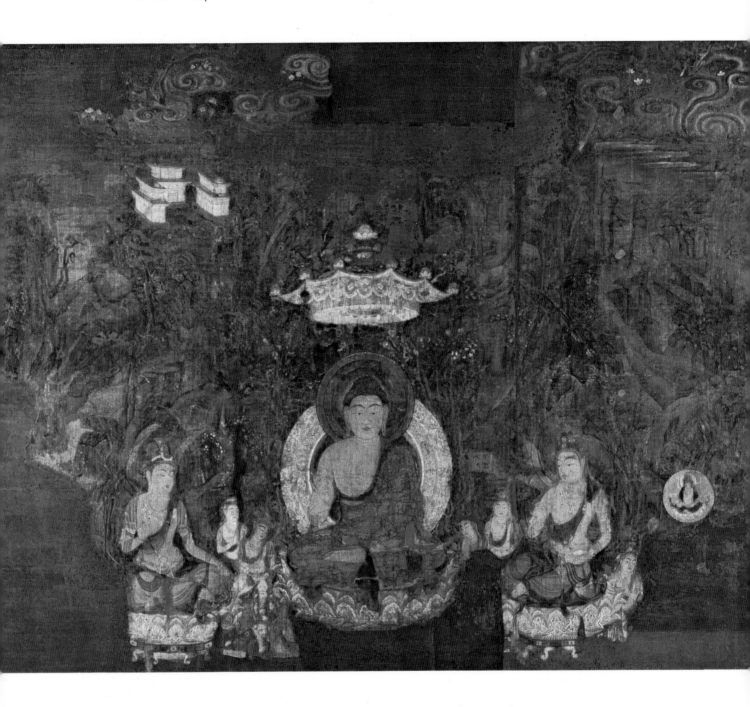

Colorplate 14. *Hokke Mandala.* Color on hemp cloth; w. 59" (149.9 cm).
Sangatsu-do of Todai-ji, Nara, Japan. Nara period, late 8th century C.E. Museum of Fine Arts, Boston

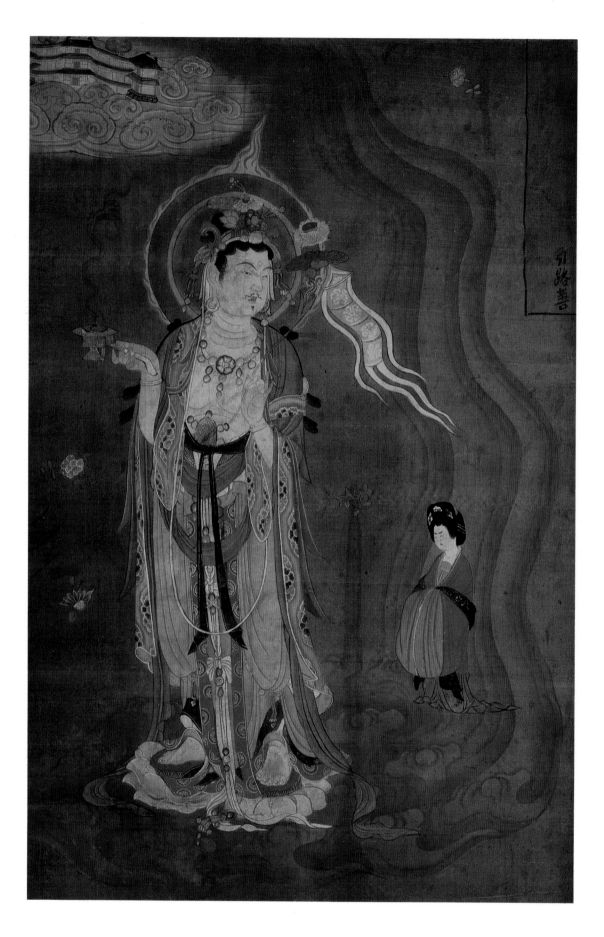

Colorplate 15. *Bodhisattva Guide of Souls.* Ink and colors on silk; h. 31³/₅" (80.5 cm), w. 21¹/₄" (53.8 cm).
Cave 17, Dunhuang, Gansu, China. Tang dynasty, late 9th century C.E. British Museum, London

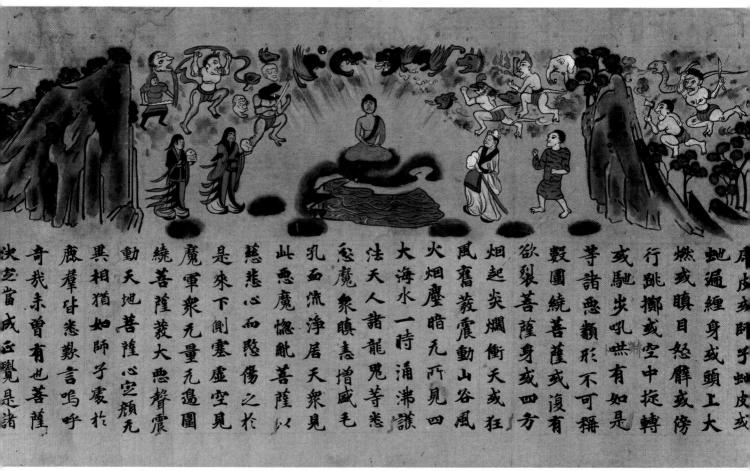

次　奇　鹿　異　動　魔　繞　是　慈　此　孔　慾　法　大　火　風　炤　欲　等　或　行　地　燃
芝　我　輩　相　天　軍　菩　來　悲　惡　面　魔　天　海　炤　舊　起　裂　諸　馳　跳　遍　或
當　未　甘　猶　地　衆　薩　下　心　魔　流　衆　人　水　塵　菽　炎　菩　惡　尖　擲　經　瞋
成　曾　忩　如　菩　无　菽　側　而　惱　淨　瞋　諸　一　暗　震　爛　薩　頰　吼　或　身　目
正　有　歎　師　薩　量　大　塞　愍　眮　居　恚　龍　時　无　動　衝　身　形　嚏　空　或　或
覺　也　言　子　心　无　惡　虛　傷　菩　天　增　鬼　涌　所　山　天　或　不　有　中　頭　辟
是　菩　嗚　震　定　邊　聲　空　之　薩　衆　盛　等　沸　見　谷　或　四　可　如　掟　上　或
諸　薩　呼　於　顏　圍　震　見　花　以　見　毛　恚　諱　四　風　狂　方　稱　是　轉　大　傍

Colorplate 16. *The Assault of Mara, from the Illustrated Sutra of Cause and Effect (Kako Genzai E-inga Kyo).*
Handscroll; ink and color on paper; h. 10³/₈" (26.2 cm), l. 45" (114.5 cm). Ho-on-in of Daigo-ji, Kyoto, Japan.
Nara period, mid-8th century C.E.

Colorplates 9–25　**207**

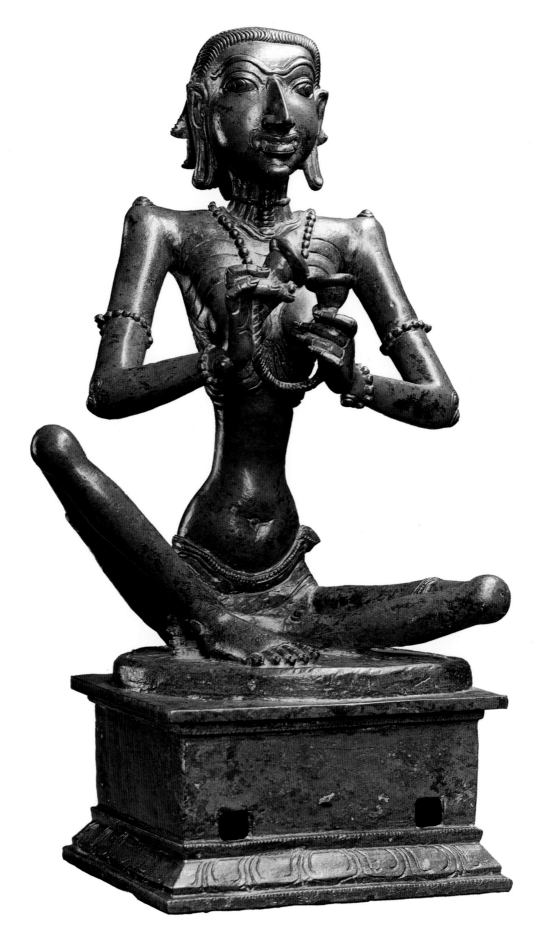

Colorplate 17. *Karaikkal Ammaiyar, devotee of Shiva.* Copper; h. 16¹/₄" (41.3 cm). India. 12th century C.E. Nelson-Atkins Museum of Art, Kansas City

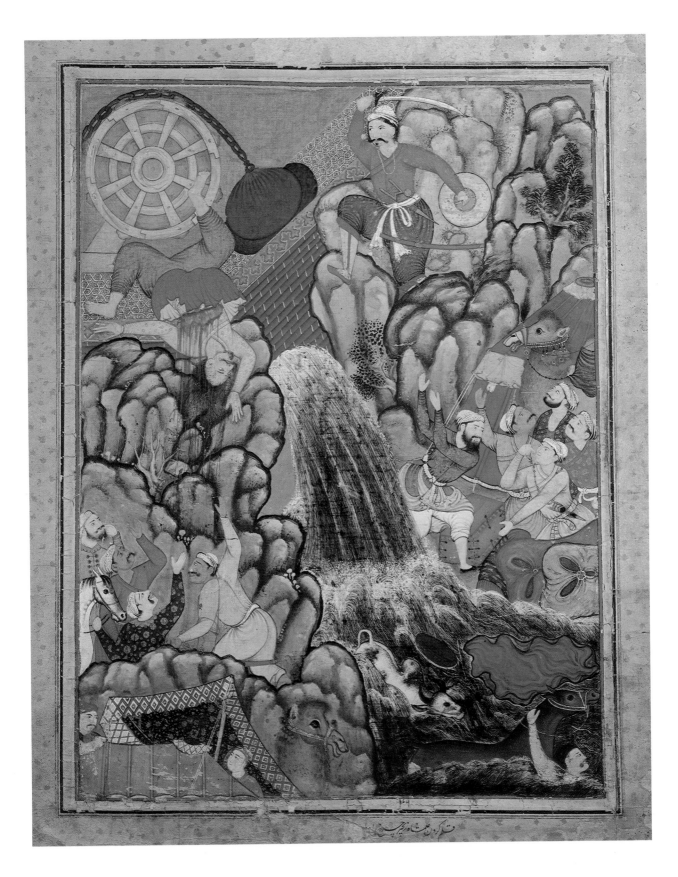

Colorplate 18. *Alam Shah Closing the Dam at Shishan Pass, from the Dastan-i Amir Hamza (Hamza Nama).* Color and gold on muslin; h. 32¹/₈" (81.6 cm), w. 25¹/₂" (64.8 cm). India. Mughal, school of Akbar, 1562–1577 C.E. Cleveland Museum of Art

پادشاه صورت و معنی است از لطف آله شاه نورالدین جهانگیر بن اکبر پادشاه

اگرچه در صورت شهان از زیر پیش قیام لیک در معنی بر درویشان کنیم نگاه

Colorplate 19. (opposite) *Allegorical representation of the emperor Jahangir seated on an hourglass throne.* By Bichitr. Color and gold on paper; h. 10⁷/₈" (27.6 cm). India. Mughal, school of Jahangir, early 17th century C.E. Freer Gallery of Art, Smithsonian Institution, Washington, D.C.

Colorplate 20. (right) *Sultan Ibrahim Adil Shah II Holding Castanets.* Miniature; gouache on paper; h. 6³/₄" (17 cm), w. 4" (10.2 cm). Bijapur, Karnataka, India. Deccani, school of Bijapur, c. 1610–1620 C.E. British Museum, London

Colorplate 21. *Madhu Madhavi Ragini.* Color on paper; h. 7¹/₂" (19.1 cm). Malwa, Rajasthan or Madhya Pradesh, India. Mid-17th century C.E. Cleveland Museum of Art

साधाराम

Colorplate 22. *King Parikshit and the Rishis*(?), from the opening of book 10 of the *Bhagavata Purana*.
Color on paper; w. 8¹/₂" (21.6 cm). Southern Rajasthan or possibly central India. C. 1575 C.E. Cleveland Museum of Art

Colorplate 23. *Gajahamurti (after the death of the elephant-demon)*. Color on paper; h. 9¹/8" (23.2 cm).
Basohli, Punjab hills, India. C. 1690 C.E. Cleveland Museum of Art

Colorplate 24. *The Ramayana: The Visit of Ravana to Shita in the Ashoka Forest in Lanka.* Color on paper; w. 33¹/₄" (84.5 cm). Guler, Himachal Pradesh, Punjab hills, India. C. 1720 C.E. Cleveland Museum of Art

Colorplate 25. *Krishna Awaiting Radha.* Color on paper; h. 7¹/4" (18.4 cm). Guler, Himachal Pradesh, Punjab hills, India. C. 1740 C.E. Cleveland Museum of Art

9

Early Medieval Hindu Art in South and Central India

PALLAVA ART AND ITS INFLUENCE

We are not far wrong if we think of Gupta sculptural style as a formative stage in Hindu art, while for Buddhism it was a classic style expressing most completely Buddhist ideals and iconography. With this in mind, we can turn to the development of medieval Hindu sculpture proper. We shall consider first the sculpture of southeastern India, the region below the Krishna (formerly Kistna) River, of which Madras is now the main city. From about 500 to about 750 C.E. this region was largely controlled by the Pallava kingdom, whose capital was Kanchi (present-day Kanchipuram), about fifteen miles southwest of Madras. Stylistic influences, which at first flowed from the Deccan to the south, so that Pallava architecture emulated that of Aihole, later reversed direction; the southern style in architecture and sculpture came to exert enormous influence on the medieval art of central India. The origin of Pallava sculptural style we have already seen in the Buddhist sculptures of Amaravati and the neighboring Jaggayyapeta. Its character is organic: the figures more fluid and fleshy than structural and bony, depicted in vigorous movement, with often varied and sometimes extremely exaggerated poses. At the time of the Buddhist stupas this style was still kept within bounds by the use of architectural frames enclosing closely packed compositions, devices persisting almost until the end of the Amaravati school. Not until then do we find large figures with some space around them within which they can expand and move.

The Pallava style, derived from Amaravati and further developed, is the dominant style of early medieval art in south India and is of great international importance. It was the Pallava kingdom that had contact by sea with Cambodia and with Indonesia, and it was through this commercial and religious contact, carried on by trade and by pilgrimage, that the influence of Pallava art was carried to Indonesia. Pallava sculpture and architecture are also important for their influence on the style of central India, an influence due in part to the warlike activities of Pallava rulers, but also to hearty respect for and imitation of a successful architecture that was even thought to be magical. A considerable number of constructed monuments dating back at least to mid-Pallava times are still extant. But more than that, we have at Mahamallapuram large stone models of even earlier types. Mahamallapuram is a spit of land on the Indian Ocean about sixty miles south of Madras, close to a white sand beach and the blue sea, with richly colored trees not far inland and salt-water inlets dividing it from the mainland. Mahamallapuram

256. *The Pandava (Five) Raths.* Mahamallapuram, Tamil Nadu, India. Eastern view. Pallava period, early 7th century C.E.

was a great pilgrimage site, and at the time of its flourishing, from the sixth through the eighth century, held numerous inns for pilgrims. The area was once populated by a considerable priestly class, like any of the great present-day pilgrimage sites in southern India. Now it is largely deserted except for frequent visitors and a cabin belonging to the Archaeological Survey of India.

Mahamallapuram

What distinguishes Mahamallapuram from other sites along the coast is the presence of great granite outcroppings, masses of rock thrusting up from the ground. Here was a material challenging to the sculptor and easily put to use, and the sculptors at Mahamallapuram carved a fantastic number of monuments in this living rock. One group, called the Five Raths (shrines), is an architectural museum, as if the designer had intended to produce five model shrines, each of a different type, showing the development of southern architecture from its origins to his own day (*fig. 256*). Such an intention was surely lacking, but happily the site provides just that. The Five Raths show the south Indian style in its early forms. From right to left, we see the development of this style, beginning with a simple shrine dedicated to Durga, having a pilaster at each corner and a stone roof imitating thatch. From the other side one sees a simple entrance to the shrine, all in a small structure not more than twelve feet in height, with the simplest proportions and the fewest elements, representing stage one in the development of the Hindu temple

(*fig. 257*). Although these elements are embellished with carved designs of tendrils and with images projecting from niches, the embellishments do not conceal the basic structure of a forest shrine—the simple cell.

The second building, the Arjuna Rath, shows an elaborated development of the cell type (*fig. 258*). It is still a square structure of post-and-lintel construction, but now we find a multiplication of sculpture around the sides of the building and an elaborately developed tower of a very specific type. The principal distinction between the northern and southern architectural styles lies in the towers. The southern tower resembles a simple forest shrine sitting on a base simulating a typical city wall with thatched lookout posts applied to its surface. It emphasizes a horizontal conformation and has a primarily architectural and horizontal rhythm, in contrast to the northern style, which emphasizes verticality and appears much more organic in character. The tremendous capstone is also characteristic of the south. This stone, though cut in a large mushroom shape, maintains an architectural character; in the northern style the cap is more like an actual organic growth on the top of the tower. The full development of the southern tower is seen in the Dharmaraja Rath (*fig. 259*). The vestigial wall has three levels, all with clearly visible buildings and lookout posts; there is a marked emphasis on the horizontal. The Bhima Rath, a communal hall modeled on the *chaitya* hall, with imitation thatched roof derived from parabolic wood-vaulted construction, is atypical for south India.

The term "stepped pyramid" may be used to describe

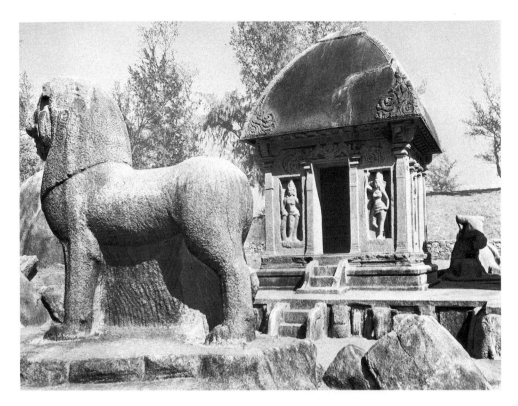

257. *Durga cell of the Pandava Raths*

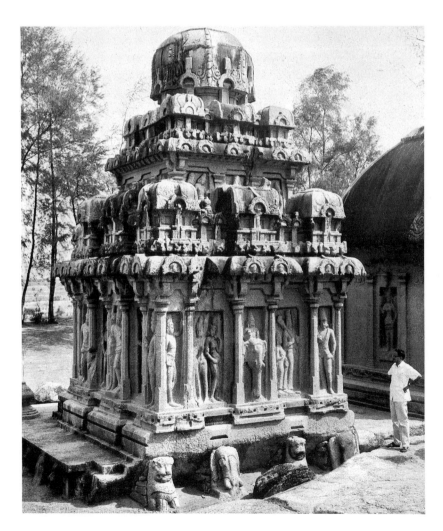

258. *Arjuna Rath of the Pandava Raths*

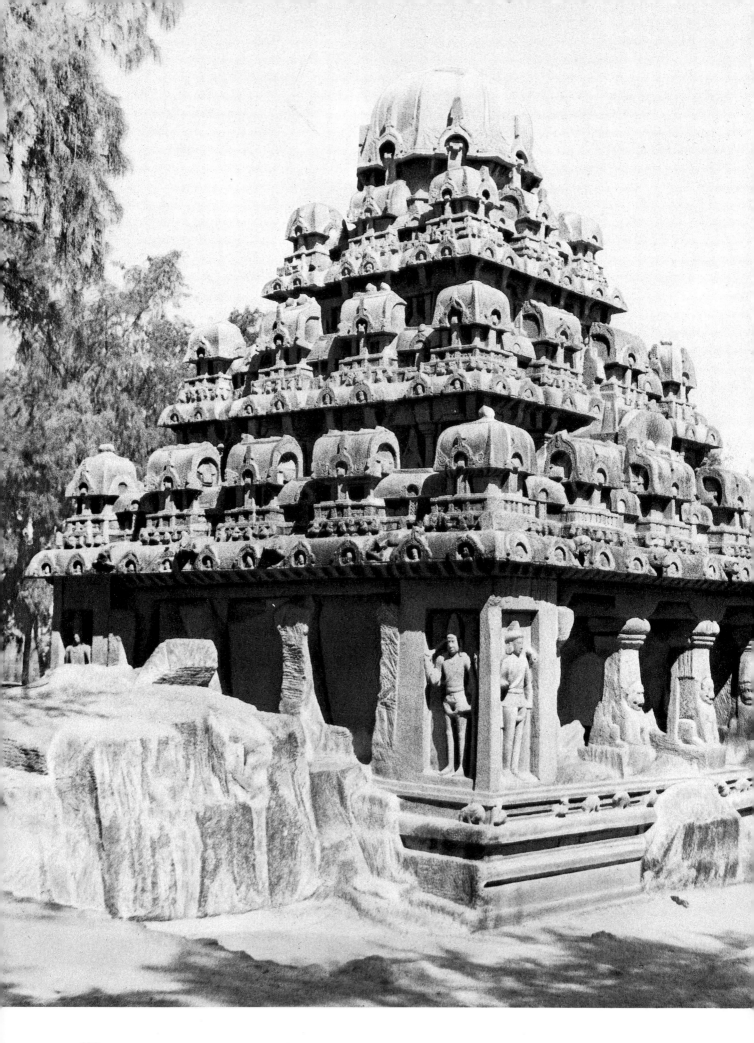

the tower of the south Indian style, and we shall call the railing around the tower, derived from the enclosing wall of a compound, "vestigial model shrines." These two elements, the vestigial model shrines and the stepped pyramid *shikhara,* or tower, are the basic elements of the southern style of architecture. There is one other architectural form found extensively in south India, a form corresponding to the Buddhist *vihara,* the cell cut into a great boulder or hill to house priests or, more rarely, as a place of worship. The small *vihara* at Trichinopoly (present-day Tiruchchirapalli, in Tamil Nadu), dating from 600 to 625 C.E., is the type-site for early Pallava sculpture.

The great sculpture at Mahamallapuram, the one that concerns us most, is the carving on two enormous granite boulders, often called the *Descent of the Ganges,* dating from the middle Pallava period, 625–674 C.E. (*fig. 260*). It is one of the most famous and most often published monuments of all Indian sculpture. One stands before a huge granite outcropping, some twenty feet high, with a natural cleft dammed so that the spring rains collect in the pond formed at the top. At the height of the rainy season water pours over the dam and runs down the rock into the low enclosed pool in front of it, causing the calcium and iron discolorations at the central cleft. These hydraulics are essential to the sculpture, for here we have something comparable to a fountain by Bernini. The water moving across the face of the sculpture at the crucial point of the composition gives movement to the surface of the stone and reinforces the suggested movement in the stone itself. Nothing is more indicative of the aims of the Hindu medieval sculptor than this combination of elements at Mahamallapuram. The iconography of this sculpture is much debated, but

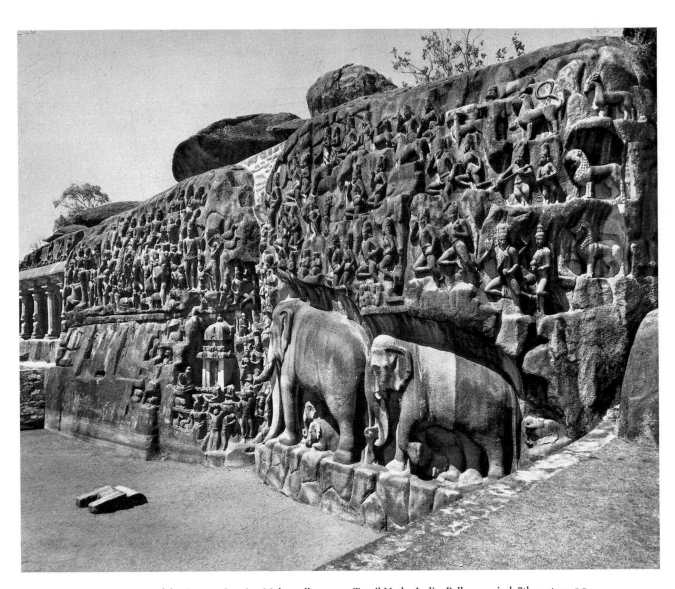

260. *Descent of the Ganges.* Granite. Mahamallapuram, Tamil Nadu, India. Pallava period, 7th century C.E.

261. *Ascetics and nagas, from the Descent of the Ganges*

262. (below) *Elephants, from the Descent of the Ganges*

current opinion inclines to its identification as the Descent of the Ganges or, alternatively, the Penance of Arjuna, or a combination of the two.

A petitioner, by performing austerities, receives a favor from Shiva. The petitioner is shown twice—once standing in an ascetic pose with one foot elevated and arms raised overhead, looking up at the sun; and once seated in contemplation before a shrine. Shiva is shown as the bestower of the boon, which is either the water of the Ganges River or, if the petitioner is Arjuna, the gift of

263. *The "Ascetic Cat," from the Descent of the Ganges*

264. *Buck and doe, from the Descent of the Ganges*

Shiva's weapons. Seldom in the history of art has so complete a sculptural composition in stone been achieved. It is a veritable microcosm: Deities of the river, elephants, bears, lions, gods, angels, humans—all the living beings of the world congregate on the surface of this great carving. From left and right they move toward the cleft, which is obviously the focus of the action and is bordered by representations of ascetics at the shrine and ascetics with Shiva on the banks of the river (*fig. 261*). The river itself is populated with *naga* kings and queens swimming upstream, their hands clasped in adoration of the god Shiva.

Partly because of the nature of the material this is one of the most extraordinary achievements of the Hindu sculptor. The granite is very hard; the carving in some places is slightly unfinished. But everywhere the forms are more simplified than usual and the effect is of a slightly stronger, stonier style than is usually found in the softer sandstones of the north and central areas. If we look at a detail, we may be able to see more clearly the elements of representation and of style. Notice, for example, in figure 261, among the people who have come to the river bank to draw water, the chest of the dominant man. Notice also, to his left and just above, the *naga* queen as she moves up the river. They all have that expansive quality which the Hindus call *prana,* or "inbreath." Notice too the representation of the animal world, for at Mahamallapuram we find a quality characteristic of Indian art in general: a sympathy for and understanding of the representation of animal forms, comparable in its way to Chinese painting of "fur and feathers." The elephants, ranging from the massive bull and the female to the baby

elephants sheltering beneath them, are a most successful representation of, let us say, the nature of elephants—of their mass, their bulk, their deliberate movement, and also of that expression which implies a degree of wisdom beyond their animal nature (*fig. 262*). At the foot of the bull elephant stands a cat with upraised forepaws, its ribs showing through the skin (*fig. 263*), and near the cat are rats in postures of worship. This is a key to the identity of the water coming down the cleft; the stream represents the River Ganges, one of the three great sacred rivers of India. The identification was made by Ananda Coomaraswamy and is based on an old folktale: A cat, pretending to be an ascetic, stood by the Ganges with upraised paws, gazing at the sun for hours; this convinced the rats and mice that he was holy and worthy of worship and so enabled him to procure food for more than the soul.

Some of the human figures derive from Amaravati; one sees behind them, so to speak, the flying angels of that earlier site. But the figures here seem much more natural and organic, with that quality of ease and amplitude so characteristic of developed Pallava style. The organization of the area beyond the central focus is relatively rudimentary and does not much surpass the arrangement of rows of figures in the boar relief at Udayagiri (*see fig. 251*); still, it is not as rigid. These ranks of celestial beings show more variety and flexibility than we find in earlier compositions. A detail at the lower left, of a buck and a doe by a river bank, displays a particularly interesting instance of that Indian sympathy for animal forms which reached its height at Mahamallapuram (*fig. 264*). Their tremendous simplicity, even stylization of form, recalls the works of some modern sculptors.

265. *Boar avatar of Vishnu.* Granite; h. approx. 9' (2.7 m). Varaha Mandapa, Mahamallapuram, Tamil Nadu, India. Pallava period, early 7th century C.E.

The granite cave-*mandapa*s (pillared halls) at Maha-mallapuram are filled with famous representations in relief of scenes from the legends of Vishnu and of Devi, the Great Goddess. Comparing the relief of Vishnu in the boar avatar from the Varaha Mandapa (*fig. 265*) with the same subject carved some two hundred years earlier at Udayagiri reveals the difference between Gupta and early medieval style. The monumentality and massiveness of the Gupta representation has been exchanged for a more human scale. The figure of the Earth Goddess more close-ly approximates life size as well as the size of the other figures. The attendant deities have been greatly reduced in number and enlarged in size. The relief in these *man-dapa*s at Mahamallapuram is relatively high but is kept very much to one plane, so that the figures in general are related to the surface of the stone beneath. There are,

however, some very curious and often striking exceptions. For example, considerable technical virtuosity is displayed in representing figures in a three-quarter view from behind, so that they are forcibly integrated with the rear plane of the stone. But in general we are conscious of a very simple and relatively balanced form of composition, with figures on a human scale and in a relatively quiet style quite different from that evolving in the north. Just as the architecture of the southern style appears solid, more architectural, with less movement and appearance of organic growth, so Pallava sculpture seems when com-pared with the art of central and north India.

We have so far considered only a fraction of the sculptures at Mahamallapuram. There is another repre-sentation, large-scale but unfinished, of the so-called *Descent of the Ganges.* Evidently it was abandoned because

266. *Shore Temple.* Granite blocks. Mahamallapuram, Tamil Nadu, India. Pallava period, 8th century C.E.

267. *Lion base.* Granite. Shore Temple, Mahamallapuram, Tamil Nadu, India. Pallava period, 8th century C.E.

the cleft in the rock did not function properly as a spill-way, and so the sculptors moved to the second and final site. The quantity of work produced in this hard stone in a relatively short time is extraordinary. Also at Maha-mallapuram, close by the shore, is a structure called the Shore Temple, which illustrates further development of the southern architectural style (*fig. 266*). It is not carved from the living rock but constructed of granite blocks. Probably it dates from the middle of the eighth century. Horizontality is still manifest, but there has been consid-erable vertical development in the tower. The building was surrounded by numerous sculptures: representations of Nandi, the bull of Shiva, in rows on top of the wall; and some remarkable representations of archers carved in low relief on the flanks of lions in the full round (*fig. 267*). One detail here is of great importance in the development of later Pallava and Chola architecture and is in keeping with the general tendency of Indian architecture toward a less architectonic treatment. This is the development of supporting animal figures into large sculptures whose dynamic pose seems to deny their supporting role. In the Shore Temple lions are used as architectural members, and they become almost a hallmark of later Pallava style at Mahamallapuram and especially at Kanchipuram, where there are many eighth and ninth century temples.

Kanchipuram and Pattadakal

A second great Pallava monument, perhaps not as fine as Mahamallapuram but of much greater importance for its later influence elsewhere, is the principal temple at Kanchipuram, the Kailasanatha, built just before 700 C.E.

268. *Kailasanatha Temple.* Kanchipuram, Tamil Nadu, India. Pallava period, early 8th century C.E.

(*fig. 268*). It is one of many Kailasanathas, Temples of the Holy Mountain dedicated to Shiva. Mt. Kailasa, high in the Himalayas, was the legendary birthplace and abode of Shiva. A series of three Kailasanathas afford one of the most remarkable sequences in all Indian architecture and sculpture. This sequence begins with the Kailasanatha at Kanchipuram, moves north to a second at Pattadakal, and ends with the greatest of all, carved in the living rock at Ellora in the northern Deccan. The Kailasanatha at Kanchipuram uses architectural elements that are to be repeated at Pattadakal and Ellora: a front screen with a main entrance gate, originally balanced on both sides by wall niches with images; a *chaitya* type structure placed athwart the gate as a tower; a porch behind the enclosing

269. *Virupaksha Temple.* Pattadakal, Karnataka, India. C. 733–734 C.E.

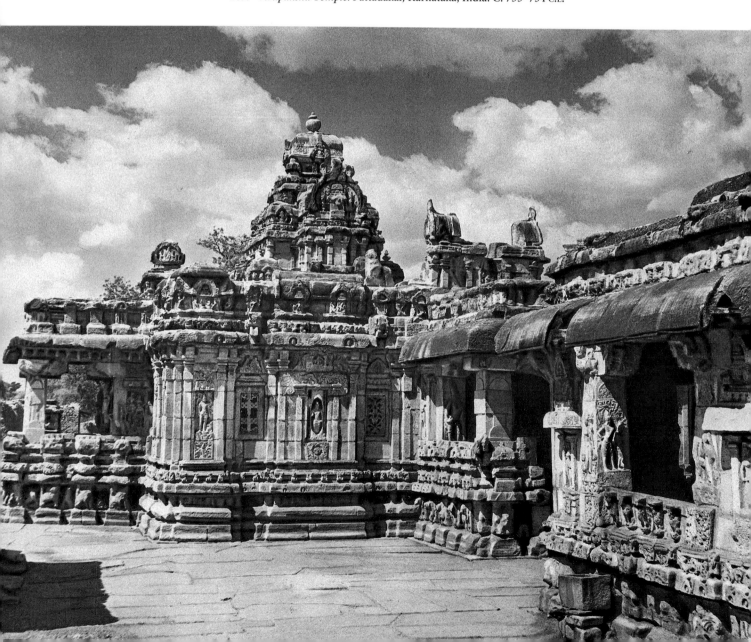

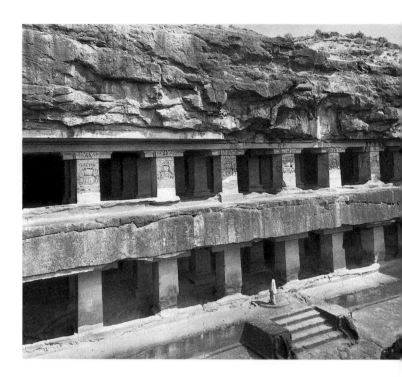

270. *Ravana ka Khai* (cave 14). Ellora, Maharashtra, India. C. 700–C. 750 C.E.

wall, attached to the main shrine; and a stepped pyramid tower of typical south Indian style. These elements of the Kanchipuram Kailasanatha are multiplied and elaborated at Pattadakal and Ellora: more mushroom shapes used on the surrounding walls; a greater and more realistic development of the horizontal vestigial enclosures on the tower; and a more elaborate development of the "brimming vase" (*purna-kalasha* or *purna-kumbha*) used as a decorative motif on the roof. But the plan of an enclosure with a main gate and a *chaitya* type tower over the gate, with the main temple inside, crowned by a stepped pyramid *shikhara,* is first established in these proportions and with this distribution at Kanchipuram.

The plan and elevation are copied almost literally at Pattadakal. The temple at Pattadakal is more often called Virupaksha, but it is also known as a Kailasanatha (*fig. 269*). It was copied by a minor Western Chalukyan monarch from the one at Kanchipuram, after his conquest of the Pallava capital. The illustration shows us a second important element of the plan, also present at Kanchipuram. Imagine that you are standing inside the enclosing wall. Directly ahead is the main shrine with its *shikhara,* and to your right, between the entrance gate and the porch, is a separate shrine for the bull Nandi, the vehicle of Shiva. Nandi is as usual a stone image placed in the Nandi Shrine, facing the image of Shiva in the inner shrine of the nave in the main temple. The porch itself has the simulated thatched roof characteristic of south Indian style. The construction is southern but was adopted many miles north, at Pattadakal; and we will see it once again even farther north, at Ellora. Note that the base, which is considerably increased and enlarged at Ellora, is at Pattadakal still relatively small in proportion to the rest of the building, as are the supporting animal forms. One further point: Note the repetition of images in niches, both on the main walls and on the corners of open buildings such as the Nandi Shrine. One must imagine them as representations of what is worshiped within, emanating from the interior of the building out to the presence of spectator or pilgrim. We can recognize, even at this distance, one or two representations of aspects of Shiva, for all three temples—at Kanchipuram, Pattadakal, and Ellora—are dedicated to him. The first two of these, Kanchipuram and Pattadakal, are constructed temples made of blocks of stone and, though large, are not as large as the last and greatest of them all.

INFLUENCE OF CHALUKYAN ART

Before we turn to the Kailasanatha of Ellora, the culmination of much of what we are studying in the southern style, we must look briefly at developments in central India before its creation. This is particularly necessary in sculpture, because a sculptural style was developing in the west central area of the Deccan under the Chalukyan kings which, when it was transferred to the north central area, was to influence the sculptural style imported from the south. While the architectural style of the south is preponderant in the region of the Deccan, the accompanying southern sculpture is changed, more often than not, by the style developed under the Chalukyas. The first Chalukyan dynasty, founded in 550 C.E., was superseded in 753 by the Rashtrakutan rulers who built the Kailasanatha at Ellora, but a Chalukyan branch family regained power about a century and a half later. Let us consider some of the earlier caves at Ellora, constructed under the Chalukyas in the seventh and eighth centuries C.E.

Ellora: The Early Caves

Ellora is an escarpment, a projection of volcanic stone like the stone found at Ajanta, jutting up out of the plain. It is situated not far from Aurangabad, one of the two great cities of Maharashtra, on that central plateau called the Deccan. Ellora is the great site for the Hindu art of central India, and one of the greatest monuments in the world. There are some thirty-three caves at Ellora: Twelve are of Buddhist type, dating from just before the seventh century to the eighth; four are Jain caves; the remaining majority are Hindu. Some are two-storied *vihara*s (which might be Hindu or Buddhist), and it is one of these, cave 14, Ravana ka Khai, that we illustrate (*fig. 270*). The light filters in from the front to the back, where the main shrine is located. In each niche around the square assembly area, which is supported by columns, we find repre-

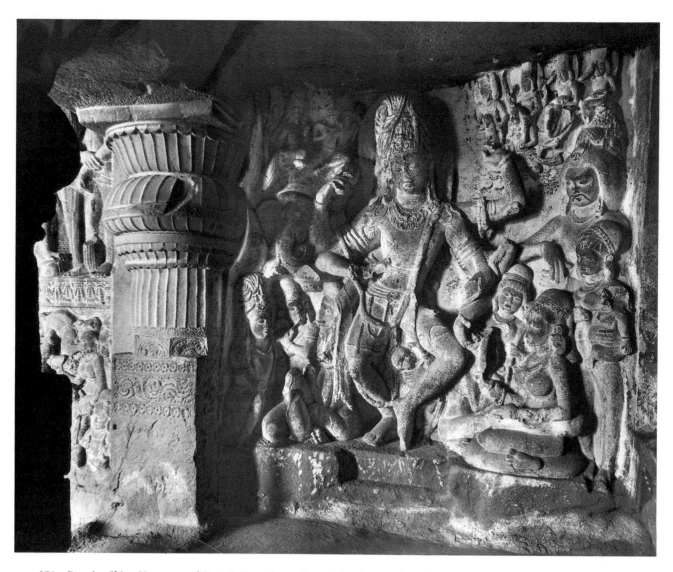

271. *Dancing Shiva.* H. approx. 8' (2.4 m). Rameshvara (cave 21), Ellora, Maharashtra, India. C. late 6th–early 7th century C.E.

sentations of aspects of Shiva carved from the living rock. The whole complex must be imagined as a sculpture—or rather as architecture in reverse, with the forms created by removing stone to "release" them.

Cave 21, Rameshvara, contains one of the earliest (c. 640–675 C.E.) representations of Dancing Shiva in any medium (*fig. 271*). The image is also of interest because it is derived from Gupta style and so is characteristic of the early Chalukyan period, before the arrival of southern influence from the Pallavas. This early Dancing Shiva is only mildly animated; nevertheless he moves, particularly through the arms, to a degree unknown in classic sculpture. But in contrast to later Dancing Shivas, the foot is hardly raised from the earth and the moving leg is not thrown high and across the body. The movement of the figure, though sinuous from the front, is strictly aligned to the plane of the wall facing the spectator. Figures frame the main image like a halo. The whole effect, although energetic and vital, is only beginning to be free from the rock, and achieves none of the frenzy to be realized a cen-

tury later. Like the Dancing Shiva, the representation of Shiva and Parvati seated on Mt. Kailasa above the demon Ravana (in cave 29, Dhumar Lena), albeit more energetic than Gupta work, is relatively restrained, and the figures preserve almost unfailing frontality (*fig. 272*).

The most significant transitional cave at Ellora, whose sculptures show the "energizing" of the Gupta style, is Das Avatara, containing a representation of Vishnu as Narasimha, his avatar as a lion (*fig. 273*). This composition, one of the most interesting in all of India, was produced by early medieval sculptors. We can sense the derivation of the eye and other parts of the face from Gupta sculpture. The manner in which the drapery clings to the surface of the rock recalls a little the late Gupta or early medieval sculpture of the *naga* king and queen at Ajanta. But with the Narasimha we are aware of an expansive force already seen in the Parel Stela. The figures fill the frame; the Narasimha's headdress reaches to the top, and the figure of a king fills the space to the right. The whole composition begins to burst its boundaries,

272. *Shiva and Parvati Seated Above Ravana on Mt. Kailasa.* H. approx. 8' (2.4 m). Dhumar Lena (cave 29), Ellora, Maharashtra, India. C. 580–c. 642 C.E.

273. *Lion avatar of Vishnu.* H. approx. 8' (2.4 m). Das Avatara (cave 15), Ellora, Maharashtra, India. C. 730–750 C.E.

274. (following page) *Kailasanatha Temple.* H. 96' (29.3 m). Ellora, Maharashtra, India. Early medieval period, Rashtrakutan dynasty, c. 760–773 C.E., with later additions

and the figures are not so tightly related to the rear plane of the rock. The king's body is turned, with head thrust out and arms stretched back. The figure of Vishnu is turned sideways, with the shoulders toward the onlooker, but the hips are seen from the side as the leg thrusts forward. The whole sculpture now seems to exist as a movement of figures in the rather deep, atmospheric space of the niche. They seem strangely trancelike when we know the story, one of the favorite subjects of the Hindu dancer: Vishnu turns into a lion to destroy a wicked king because of his impious actions. In later Indian art it is gruesomely shown, with the king stretched on the knees of Narasimha as the god tears out his entrails with his claws. In early Indian art, as here, though the subject can be frightening, it is treated lyrically and dramatically. The lion rushes toward the king, but his hand is placed on the king's shoulder lightly, delicately, almost as in a dance. Observe the king, the expression of his face, the movement of his body, not retreating, but swaying toward the figure of Vishnu in the measured, rhythmical movement of dance. Someday someone will make a thorough study of the relationship of Indian sculpture to the dance, because it is quite certain that many of the major elements of representation in Indian sculpture, especially of the medieval period, are derived from dance and dance-drama. The iconography is dictated by the faith, but the style is produced by the sculptor from observation of the dance.

Ellora: The Kailasanatha

The culmination of the early medieval style of the north central Deccan is found in the Kailasanatha of Ellora, begun by 760 C.E. under the successors of the Chalukyas, the Rashtrakutas, and almost completed by the greatest early king of that dynasty, Krishna I, who reigned from 757 to 783 C.E. (*fig. 274*). The Kailasanatha is at the northernmost point of penetration of southern architectural style, and indeed its architecture is almost purely southern. The sculpture, although influenced by Pallava style, is basically a continuation of the Chalukyan style found in Das Avatara, but carried to a higher pitch and in some carvings almost reaching a frenzy. No words express better the feeling one has on looking at this great monument than the words of Krishna I himself: "How is it possible that I built this other than by magic?"[8] It is literally a "magic mountain" in living rock, an achievement of sculpture rather than of architecture. Its chronology is much discussed since an article appeared in *Artibus Asiae*, in which Hermann Goetz attempted to apportion the construction of the temple over a considerably longer period of time than had previously been allowed. His argument is interesting but not widely accepted, and in general we must believe that the major part of the work at the Kailasanatha of Ellora was accomplished under Krishna I, even if some of it was finished by a successor.

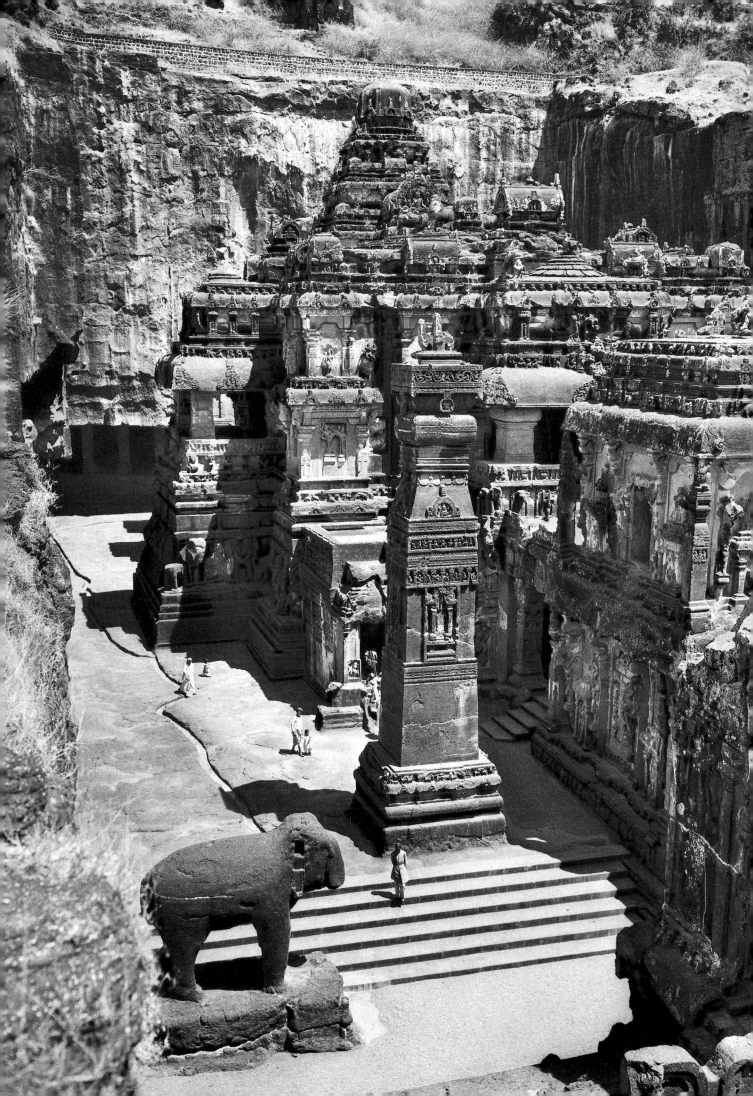

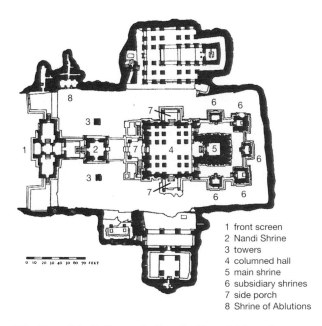

275. *Plan of the Kailasanatha Temple.* Ellora, Maharashtra, India

1 front screen
2 Nandi Shrine
3 towers
4 columned hall
5 main shrine
6 subsidiary shrines
7 side porch
8 Shrine of Ablutions

276. *Ramayana friezes and Nandi Shrine, from the Kailasanatha Temple.* Ellora, Maharashtra, India. 2nd half of 8th and early 9th century C.E.

It is a magic mountain with a court 276 feet long and 154 feet wide and a central tower reaching a height of 96 feet. The sheer physical challenge of carving this tremendous temple from the rock awes one. From the beginning of the cutting, the drop directly down to the court behind the temple is 120 feet. Though modeled after Kanchipuram as transmitted through Pattadakal, Ellora's Kailasanatha is on a larger scale, with more elaborately developed sculpture and architectural decoration. We see the same front screen and Nandi Shrine, but here the Nandi Shrine has been raised on a high base to a second story level and is connected by a bridge to the raised porch of the main temple. There is a tower over the main shrine, a subsidiary *chaitya* tower over the front porch, and the two side porches of the main building that are characteristic of this imported model. But in addition two tremendous stone columns, some sixty feet high, flank the entrance, with representations of jewels and other riches of this world. The plan (*fig. 275*) reveals the layout more clearly than any view, with the screen, the Nandi Shrine, the two towers, the porches, three in all, the gath-

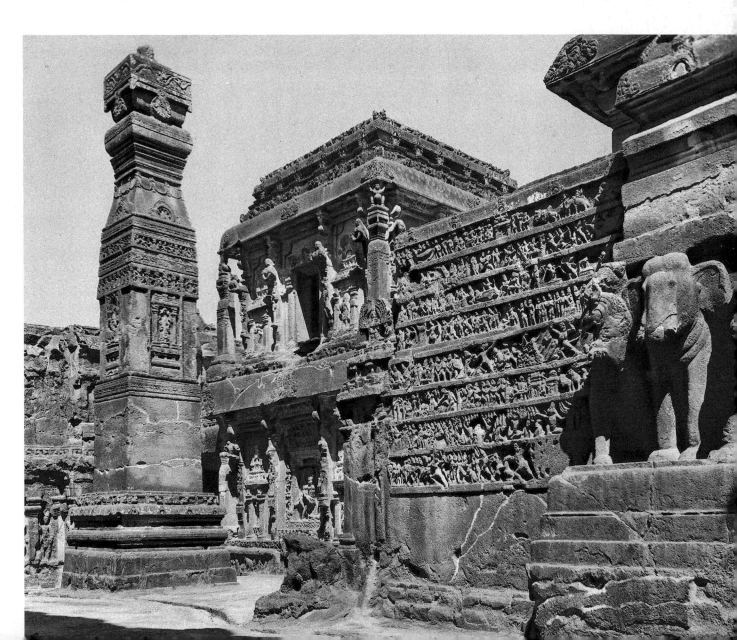

277. *Base of fighting animals, from the Kailasanatha Temple.* Ellora, Maharashtra, India. C. 2nd half of 8th century C.E.

ering place with its columned hall, the shrine proper, and the five subsidiary shrines on a second story terrace outside the main shrine, dedicated to various deities associated with Shiva. As if this were not enough, around the sides of this tremendous sculpture are carved subsidiary shrines in the vertical sides of the pit: the Shrine of Ablutions, or Shrine of the Three Rivers, with representations of the three great rivers Ganges, Yamuna (Jumna), and Sarasvati; a long series of sculptures at the rear; a second story temple carved in the rock, with a set of reliefs relating to Shiva; a series of reliefs of the avatars of Vishnu and aspects of Shiva on the ground floor, surrounding the sides and completely enclosing the back end; and a two story complex on the right, once connected by a bridge to the porch, with representations of the Great Goddess (Devi) and the Seven Mothers. Numerous smaller shrines complete the ensemble. Although one can understand why Goetz believes that it was not all built in a short time, it does represent the achievement of a single architectural conception.

The Kailasanatha is a massive work of sculpture. On entering, after passing through the main gateway, one is struck by the contrast of the brilliant sunlight of the Deccan Plateau, streaming into parts of the court, and the

deep blue shadows cast by the high surrounding mountainside. The wildly moving sculptural representations, the angels flying on the walls of the temple, the representations of Shiva, produce so overwhelming an effect that one feels feverish, as if overcome by wildly exalted feelings. It is one of the most extraordinary sensations to be experienced in looking at Oriental works of art.

The temple has only recently been adequately published, but there is still no publication that reveals its tremendous wealth of material. Figure 276 shows the relationship of the Nandi Shrine to the temple proper. The Nandi porch and shrine are on the second level, just to the right of the column. Eight registers of friezes, illustrating scenes from the *Ramayana,* connect the flat-roofed Nandi Shrine in the center to the main shrine at the extreme right in figure 276. Several characteristics are revealed by this illustration. The base is now enlarged to a full story in height. Indeed, if one removed the lower base, one would have the earlier Pattadakal forms preserved intact. As the base has become gigantic, so the elephants and lions of the base have become life-sized or larger (*fig. 277*). Standard photographs of the base of the Kailasanatha usually show the elephants standing rigidly stiff, acting as a support for the great mass of the structure

278. *Flying Devata.* Kailasanatha Temple, Ellora, Maharashtra, India. 2nd half of 8th century C.E.

279. *Shrine of the Three Rivers, also called Shrine of Ablutions.* Kailasanatha Temple, Ellora, Maharashtra, India. 2nd half of 8th century C.E.

above; but this is the most atypical part of the whole base. The typical part is in the shadows where the figures of life-sized elephants and larger-than-life lions are moving and rearing and tearing at each other. The very base seems to move and tremble, and the whole structure appears on the verge of cataclysmic collapse. The standard representation of the base is of course the best-preserved part, which happens to be neat, tidy, and stolid. But it gives one no idea of the rest of the base, which depicts movement as violent as an earthquake in progress.

Perhaps somewhat later in date, in accordance with Goetz's suggestion, are the narrative reliefs of the *Ramayana* on the side wall below the porch of the main shrine. These are almost a scroll-painting in format, presenting a continuous narrrative in horizontal registers reading from left to right and top to bottom. But the individual scenes do not have the character, movement, and life of the sculptures on the main structure. We can see the ultimate development of sculptural movement in the flying angels on the walls of the temple (*fig. 278*). These seem to soar off the walls and are completely nonarchitectural in character, almost denying the nature of the material, the substance and stillness of the architecture.

The original appearance of the building is difficult to determine. It may have been painted, over a covering layer of stucco. We know that it was painted before the Islamic invasions of the early fourteenth century, for Islamic sources called it Rang Mahal, the Painted Palace. There are remnants of a white gesso used to cover the volcanic rock; and on some of the angels, if one looks carefully with binoculars, one can see several older layers of gesso, which suggests that the figures may have been not only carved but modeled. The finishing touches in eyes, nose, mouth, and other details were achieved in gesso and by means of the fingers or other pushing instruments that modeled the soft material before it hardened. This fits the hypothesis that plastic materials influenced all Indian sculpture, but especially medieval sculpture. Plastic techniques also influenced Pallava sculptures, particularly those on constructed temples. For example, the Kailasanatha of Kanchipuram has remnants of what appears to be an old gesso covering, polychromed.

The Shrine of Ablutions, at the left as one faces the main gate, has three niches with sculptures of the three river goddesses Ganga, Yamuna, and Sarasvati—the three great sacred rivers (*fig. 279*). In my own hierarchy of

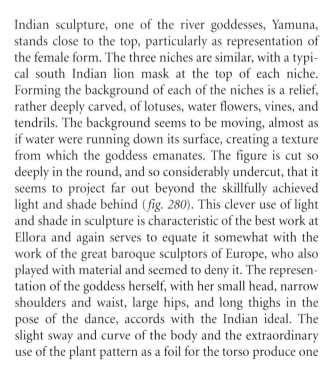

280. *Yamuna, from the Shrine of the Three Rivers (Shrine of Ablutions).* H. approx. 6' (1.83 m). Kailasanatha Temple, Ellora, Maharashtra, India. 2nd half of 8th century C.E.

281. *Shiva and Parvati on Kailasa.* H. approx. 12' (3.7 m). Kailasanatha Temple, Ellora, Maharashtra, India. 2nd half of 8th century C.E.

Indian sculpture, one of the river goddesses, Yamuna, stands close to the top, particularly as representation of the female form. The three niches are similar, with a typical south Indian lion mask at the top of each niche. Forming the background of each of the niches is a relief, rather deeply carved, of lotuses, water flowers, vines, and tendrils. The background seems to be moving, almost as if water were running down its surface, creating a texture from which the goddess emanates. The figure is cut so deeply in the round, and so considerably undercut, that it seems to project far out beyond the skillfully achieved light and shade behind (*fig. 280*). This clever use of light and shade in sculpture is characteristic of the best work at Ellora and again serves to equate it somewhat with the work of the great baroque sculptors of Europe, who also played with material and seemed to deny it. The representation of the goddess herself, with her small head, narrow shoulders and waist, large hips, and long thighs in the pose of the dance, accords with the Indian ideal. The slight sway and curve of the body and the extraordinary use of the plant pattern as a foil for the torso produce one

of the loveliest figures in all of Indian sculpture.

But the most famous of the sculptures at Ellora is the representation of Shiva and Parvati on Mt. Kailasa, with Ravana below shaking the foundations of the sacred mountain (*fig. 281*). The legend must be retold briefly to clarify the action. It is said that Ravana, a giant demon-king, wished to destroy the power of Shiva but was imprisoned within the mountain. Grasping it with his numerous arms, he began to shake it, so that all the gods felt certain the world would be destroyed. But Shiva, simply with the pressure of his toe, held the mountain in place. Eventually Ravana became a devotee of Shiva, and was thereupon released. The subject is a demonstration of the power of Shiva, and one with great representational possibilities. In contrast to the relatively static composition in the Dhumar Lena, the representation at the Kailasanatha is one of the most remarkable compositions in stone in the whole history of art. We are shown Ravana, a powerful, massive figure, with numerous heads treated as a huge block on top of great square shoulders and numerous arms placed in so deep a recess that the

282. *Painting on porch, from the Kailasanatha Temple.* Ellora, Maharashtra, India. Late 8th or early 9th century C.E.

figure seems actually to move and tremble. The arms seem to move in the play of light and shadow behind. Above, in a more evenly lit area, is the representation of the god Shiva with his consort Parvati, accompanied by his usual dwarf attendants. Farther above are the inhabitants of heaven, the gods and spirits who have come to witness this great event. In addition to the pictorial handling of light and shade, there are other devices more characteristic of painting than of sculpture: for example, the representation of rocks, mountains, and clouds by means of a linear pattern cut into the stone. The whole composition, partly as a heritage of the Gupta style and partly because it is a sculpture carved in a niche, is organized as an almost geometric grid or checkerboard, balancing a projecting mass against a receding void in a positive-negative pattern. Other shapes tie the whole action together and allow the frenzied movement to occur without completely destroying the enclosure. The niche is some eight or nine feet deep.

The composition creates depth not only by its use of light and shade, but also sculpturally and representationally. See, for example, the frightened maiden, alarmed by the shaking of the mountain, who runs off toward the back of the cave and seems to be dissolving into it. Notice, too, the pose of Parvati, whose knees are at the front of the composition, but who reclines back behind the god, clinging to him in fear. The figures of the two guardians at the sides show some trace of Pallava influence, as does the main figure of Shiva himself. The whole representation is

a perfect blending of sculptural and pictorial quality in a unity not merely aesthetic but psychological, expressed by the involvement of all the figures in an almost human way with the great activity that is taking place below. The result is a stupendous, large-scale composition, unique in Indian art and worthy of any great tradition at its peak.

We have mentioned that the Kailasanatha was called the Painted Palace. One illustration will show a bit of the remaining evidence. The underside of the roof of the porch still bears remnants of mural painting (*fig. 282*). There are three layers of painting, of three different ages, the earliest apparently being slightly obscure figures in reddish brown, perhaps executed soon after the temple was built, late in the eighth century. Over this were placed figures of animals and cloud forms, and over those are other figures in a later, almost folk-art, manner.

The last related monument we shall consider is the cave-*mandapa* of Elephanta, on the island of that name in the harbor outside Bombay. It may originally have been called Puri and was an ancient capital, conquered by the Chalukyas and Rashtrakutas in turn. The date of the sculptures at Elephanta is a much argued question: H. K. Sastri says seventh century, Coomaraswamy says eighth century. Current opinion favors a date as early as the second half of the sixth century. It is an excavated shrine, similar to some we have seen at Ellora; and aside from having two main axes instead of the usual one, it is not exceptional architecturally. The general view of the entrance and of part of the sculpture gives some idea of

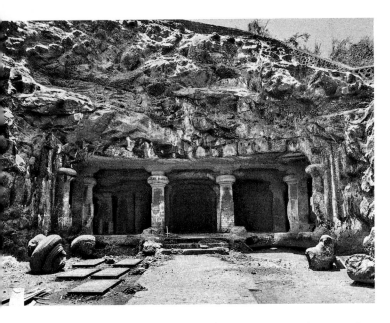

283. *Cave-temple at Elephanta, Maharashtra, India.* General view. C. 600 C.E.

The shrine is dedicated to Shiva and contains representations of his principal aspects. The sculptures at Elephanta are characteristically niche sculptures, predominantly square-framed, and reveal rather elaborate figural compositions. These usually involve a large-scale image of Shiva, sometimes supplemented with a fairly large-scale image of his consort, with numerous smaller representations of other deities. The result is a manifold focus often lacking in other medieval sculptures. These huge and dominating figures, coupled with the complex representational elements behind, produce an exuberant yet compact effect. Visually heightening this effect is the stone at Elephanta, which is not coarse volcanic stuff, nor a rather light and delicate-seeming fine-grained cream sandstone, but a rich, chocolate brown, fine grained sandstone. This material can be cut with great precision and detail, but when viewed as a whole it enhances the profuse yet concentrated effect created by the organization of the sculptures. Together, the conception and the material in which it was executed attain an extraordinary unity. Compared with the same subject at Rameshvara (*see fig. 271*), the Shiva Nataraja at Elephanta shows more movement and more distortion of the figure (*fig. 284*). The gentle S-sway of Rameshvara is changed here to a very definite and supple turn of the body in a full S; were the legs intact, we should undoubtedly find that one leg was raised quite high and that the dance was far more vigorous. The facial types at Elephanta, in contrast to those at Ellora and elsewhere, have a certain early, almost

its present condition (*fig. 283*). When the Portuguese occupied this area, it seems that the commander of the military garrison stationed on the island amused himself by holding artillery practice down the aisles of the *mandapa*; thus nearly all of the sculptures are thoroughly smashed from the waist down. The figures are colossal, between eight and ten feet in height, and are of the greatest interest. They represent one of the most notable expressions of early northern medieval style.

284. *Shiva Nataraja (Lord of the Dance).* H. approx. 10' (3.04 m). Elephanta, Maharashtra, India. C. 600 C.E.

285. *Shiva Maheshvara.* H. 10' 10" (3.3 m). Elephanta, Maharashtra, India. 7th century C.E.

Gupta quality about them. Their eyes are usually downcast and the mouths full, and they seem much more serene than the frenzied and dynamic examples from central India. The modeling is soft and supple, and the rhythmical treatment is comparable to that seen before in Andhra and Gupta sculpture.

The most famous of the sculptures of Elephanta, and justly so, is considered to be the principal image at the site, even though it occupies, in relation to the usual central axis, a secondary position (*fig. 285*). It is quite clearly the main image of the cave, being much larger in scale and cut in much deeper relief than any of the other representations. It is no taller than the others, but shows only the shoulders and heads of Shiva rather than the whole figure. Being but a part of a suggested monumental whole, it dominates the interior. Its niche is the only one, other than the *lingam* shrine or cell, that is flanked by

very large figures of guardians. The image represents Shiva in his threefold aspect as Mahesha. On the left is Aghora, the Wrathful One, with moustaches and bulging, frowning brows, holding a cobra in his hand. In the center is Tatpurusha, beneficent and serene in aspect. At the right is Uma Devi, Uma the Blissful One, Shiva's consort, with feminine earrings and the full "bee-stung" lower lip of poetic description. Her large lower lip and sharp, thin nose represent the very height of elegance and femininity. Visually these three different aspects are combined into one unified form by the massive base of the shoulders and by the pattern of the jewelry in the headdress. Psychological unity is achieved by the restraint with which the essential quality of each aspect is expressed, so that the three heads are consonant elements of a single being. This is in keeping with the controlled character of the sculpture at Elephanta.

10

Later Medieval Hindu Art

The northern medieval style of architecture, called Nagara by the Indians, as distinguished from the south Indian style, is found at its most characteristic in that region of India ranging from Bengal and Orissa in the northeast through north central India, past the region of Delhi and on into the northwest area, including the Gujarat peninsula. Various stones are found in these areas. There is the chlorite of Orissa, a brown-purple stone, becoming pockmarked when exposed to the weather but retaining, when protected, a very highly polished, smooth surface. There is the cream-to-tan sandstone of the north central provinces, particularly the region of Bundelkhand in northern Madhya Pradesh, perhaps the greatest center of the northern style. This sandstone is very similar to that of the Gupta images at Sarnath. And then there is the white marble-like stone of the Gujarat area. These stones of the north contrast rather sharply with the material available in the central and southern areas, especially the granite of Mahamallapuram in the far south and the volcanic rock of Ellora in the Deccan. We must bear in mind the influence of materials on styles of art, particularly in relation to sculpture. It is manifestly difficult to carve detail in a stone full of holes. It is equally difficult to achieve broad pictorial effects in stone, which seems to invite the carver to dwell on detail and smooth finish when working with sandstone, for example. So perhaps some of the characteristics noted in the sculpture of Ellora and Mahamallapuram, and those which we will see in the sculpture of the northern regions, derive from the reaction of the artist to the material in which he works. These northern materials, which seem more refined than those of the southern and central areas, produced sculpture rich in detail; at the same time the temple structures retain the characteristics of sculpture rather than of architecture.

CHARACTERISTICS OF THE NORTHERN STYLE

Let us first look at one of the Hindu temples at Khajuraho in north central India, for an introduction to the form of the northern temple (*fig. 286*). It is made of the warm cream sandstone of the region and dates from about 950 to 1050 C.E. There are no distinctive sectarian styles at Khajuraho; that is, we cannot differentiate a Jain style from a Hindu one. The northern style appears more organic than that of the south, emphasizing verticality and suppressing horizontality. Further, the architectural character resulting from the vestigial wall and enclosure that decorates towers of the southern style is absent; instead a series of small towers, repeated one against the other, build a form that ultimately becomes the large

286. (right) *Kandarya Mahadeva Temple.* Khajuraho, Madhya Pradesh, India. C. 1000 C.E.

287. (below center) *Bhubaneshwar, Orissa, India.* General view. 8th–13th century C.E.

288. (bottom) *Parashurameshvara Temple.* Bhubaneshwar, Orissa, India. C. 700 C.E.

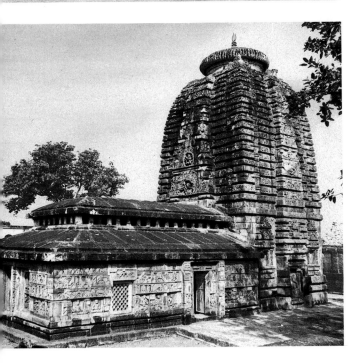

tower. There are quarter-towers, half-towers, and then, finally, the full tower, each part leading to the other like an organic vegetable growth rising from the earth. The crown on each of these little towers and on the large, bulbous, mushroom-like tower is more organic than the capstone used in the southern style. The extremely high base again emphasizes the verticality of the whole; and the *mandapa* (pillared porch and congregation area), which in the southern style was clearly separated from the tower over the shrine, is integrated with the tower and appears to lead up into its heights. In northern structures *mandapa* and tower are stylistically more unified and organic than in southern ones. If it is true that Hindu architecture is primarily not architecture at all, but sculpture, then its most typical expression is the northern style.

Bhubaneshwar

For the northern style the two main type-sites are Khajuraho and Bhubaneshwar. We shall consider the latter first, since it has temples of somewhat earlier date than those of Khajuraho. Bhubaneshwar is located in Orissa, the state immediately south of Bengal in northeast India. A general view of the site shows the great tank, or pool, with trees surrounding it, and the numerous towers of temples and shrines in the area (*fig. 287*). These are but a small part of the number of temples visible from vantage points near Bhubaneshwar. The effect at a distance is surprising, resembling mushroom-like growths sprouting over the countryside. The earliest of the complete temples at Bhubaneshwar is Parashurameshvara, of about 700 C.E. (*fig. 288*). It shows a primitive stage in the northern

289. *Mukteshvara Temple.* Bhubaneshwar, Orissa, India.
 C. 950 C.E.

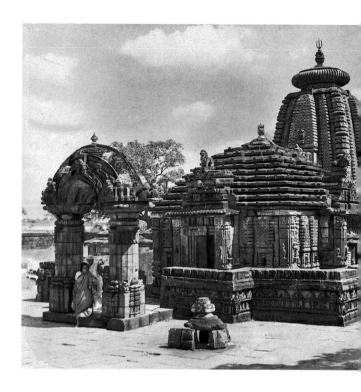

medieval style, for here the separation of the porch, or *mandapa,* from the tower is clearly marked; the former is a horizontal slab structure, whereas the tower is a primarily vertical structure over the shrine. There is no transition from the *mandapa* to the *shikhara* (tower). The *shikhara* on this early temple at Bhubaneshwar is still composed of strongly horizontal layers, and appears rectangular in plan, like a primitive cell-shrine. But the incrustation of the surfaces with numerous small carvings tends to break down its architectural character and to convert it into a work of sculpture.

These tendencies, seen here in embryo, are carried further in the later temples of Bhubaneshwar. One of the most fascinating of these is the Mukteshvara Temple, built about 950 C.E.; it is the jewel of all temples in the northern style (*fig. 289*). The Mukteshvara is very small—the tower is certainly no more than thirty to thirty-five feet in height—but it is complete with its own tank, entrance gate, and low railing around the whole enclosure. What distinguishes the Mukteshvara from all other temples of this group is its rich sculptural adornment, approaching a form of incrustation, as if stone jewelry had been hung on the surface of the tower. A type of ornament based on the old *chaitya* arch motif appears with the Mukteshvara Temple (*fig. 290*). The parabolic ceiling or roof line of a *chaitya* hall is playfully repeated, with numerous variations in the direction and thickness of the lines outlining the miniature arches. This ribbon-like ornament, which certainly begins to appear by the ninth century and becomes characteristic for the Nagara style, looks almost as if it had been squeezed out of a tube. Here we see one of its richest manifestations. The prevailing horizontality of the Parashurameshvara tower is modified here by vertical bands of ribbons cutting across the layers. Emphatic verticality, the characteristic trait of the Nagara style, is seen to be fully developed by the time of this little temple.

On the Mukteshvara the ornamental figure sculpture is somehow architectural in character. This is particularly true of the caryatids—potbellied dwarfs in square frames who support the weight above them. The projections made by their elbows, knees, stomachs, and heads form an abstract pattern of bulbous protrusions against the shadow of the undercut background. Another characteristic ornament of the northern style is the *kala* mask, also called "mask of glory" (*kirttimukha*), a mask of a devouring leonine monster. It is often used as a main motif on each side of the tower as well as over the false doors from which images of the gods seem to emanate from the shrine within.

290. *Chaitya arch ornament, from the Mukteshvara Temple.*
 Detail of fig. 289

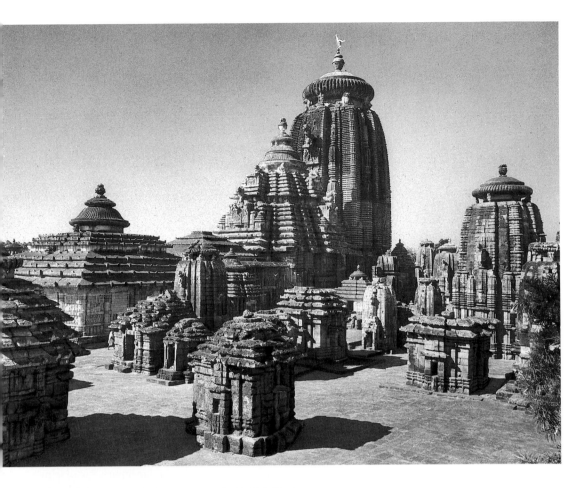

291. *Lingaraja Temple.* Bhubaneshwar, Orissa, India. C. 1050 C.E.

The temples at Bhubaneshwar are made of chlorite, which deteriorates somewhat under the influence of weather. But it is capable of being worked in great detail, as can be seen on the well-preserved side of the building. Chlorite is extremely rich in color, ranging from orange through red to purple. In the brilliant sunlight of northern India it produces a mottled, even fungus-like effect.

The largest temple at Bhubaneshwar is the Lingaraja, dedicated to Shiva and probably built about 1050 C.E. (*fig. 291*). Here is the style at—or perhaps just past—its peak. All the verticality of the little towers at the sides and of the small shrines surrounding the temple culminates in the main tower. The crowning stone, a giant mushroom-like shape, is of tremendous size and seems almost to overweigh the tower. The sculpture on the Lingaraja is less dominant, so that the towers seem slightly impoverished in their ornament, although the lower part of the *mandapa* and parts of the tower have much sculptural decoration. The side view of the Lingaraja is a classic picture of the developed northern style of Orissa.

The sculpture associated with these later temples at Bhubaneshwar is overwhelming in quantity and often of very high quality. Figure 292 shows a sculpture on the

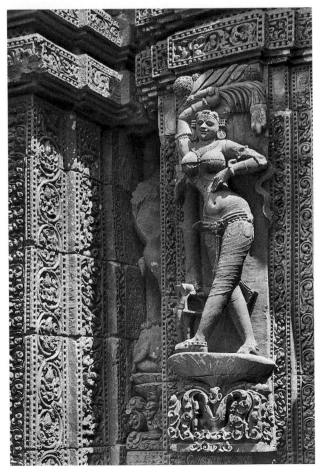

292. *Woman embracing a tree.* Stone; h. approx. 60" (152.4 cm). Rajarani Temple, Bhubaneshwar, Orissa, India. C. 1000 C.E.

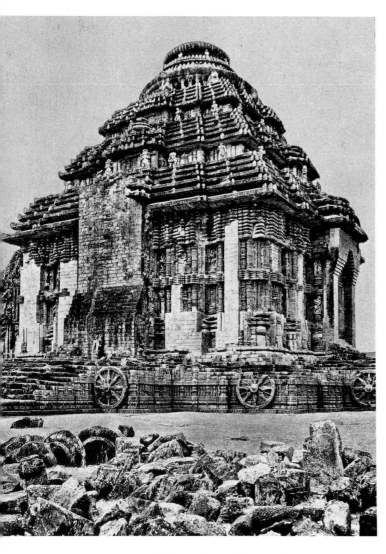

293. *Surya Deul (the Black Pagoda)*. Konarak, Orissa, India.
C. 1240 C.E.

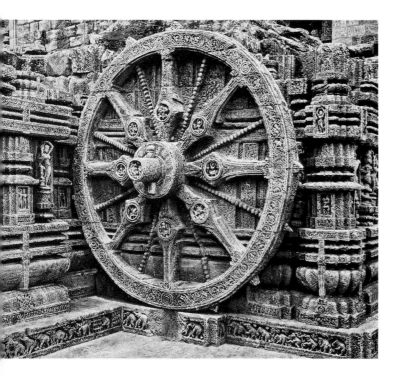

294. *Great Wheel, from the Surya Deul*. Diam. approx. 12'
(3.7 m). Detail of fig. 293

temple popularly called Rajarani, built about 1000 C.E., and situated on the outskirts of Bhubaneshwar. In addition to the decorative carvings of vine-scrolls and lotus-scrolls, lion monsters and masks of glory, the Rajarani Temple affords some of the best medieval depictions of the traditional female fertility deity. The woman embracing a tree, a motif going back as far as Bharhut (*see pp. 88–89 and fig. 115*), appears in many variations, both on a large scale and in the small secondary sculptures around the niches (*fig. 292*). Poses tend to continue the classic Gupta tradition. A certain restraint is manifest throughout the sculpture at Bhubaneshwar. Despite an occasional pronounced twist of the hips and torso, the figures are well contained within the pillar boundaries. The forms are ample and round, again maintaining the tradition of Gupta sculpture. We do not find the long, sinuous shapes common in north central India.

Konarak

The most famous, or notorious, of the temples of Orissa, depending upon the frame of reference, is the so-called Black Pagoda of Konarak, a temple past the prime of the northern style and dating from about 1240 C.E. (*fig. 293*). It was called the Black Pagoda because from the sea it appeared as a dark mass, a useful landmark for mariners coasting up the Indian Ocean to make a landfall near Calcutta. It is dedicated to Surya, the sun god, and is properly called the Surya Deul (Surya Shrine). What is left is a magnificent ruin. One sees only the *mandapa,* for the tower collapsed and is now no more than piles of fragmented sculpture and rock. Judging from the *mandapa,* the temple was originally the largest of its type built in the north. Being dedicated to Surya, the Black Pagoda—and especially the *mandapa*—was conceived of as a chariot. Its wheels are carved in the stone at the base of the temple. Stone musicians play on the roof while colossal stone horses, still extant, draw the heavenly chariot. The temple was constructed of chlorite, and the salt air and sea wind have badly eroded it on the two sides exposed to the sea, so that much of the sculpture is gone.

The Surya Deul is "notorious" because it is adorned with perhaps the most explicit erotic sculptures ever made. Certain writers try one's credulity by saying that such sculptures connote solely the union of the soul with God. Let us hope that the sculptural adornment of this temple is dedicated to concepts of both physical and mystical union. One of the great wheels supporting the *mandapa* reveals the same style of vine-and-tendril carving seen in the Mukteshvara, and so characteristic of ornament in Orissa (*fig. 294*). The wheel is further adorned on the spokes and rim with figures in cartouches—single figures of celestial deities, motifs of the woman under a tree, and embracing couples (*mithuna*). The large sculptures are like those on the Rajarani, voluptuous and full-

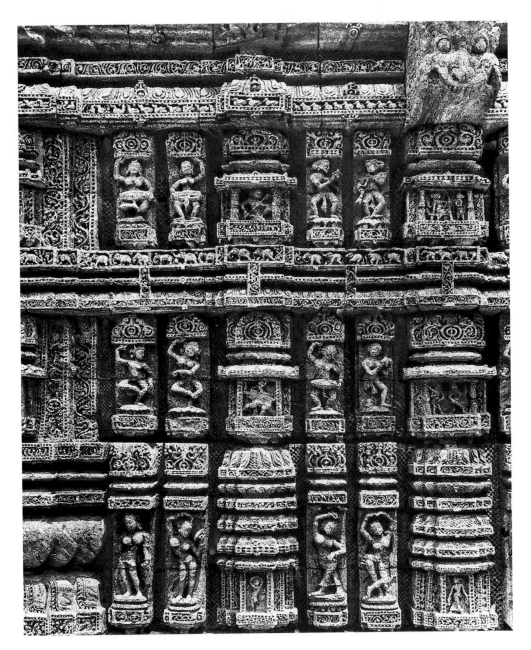

295. *Perforated screen with celestial beauties and mithuna.* Stone. Surya Deul, Konarak, Orissa, India. C. 1240 C.E.

bodied, not linear in their emphasis and not exaggerated in movement. The sculpture still retains a certain Gupta restraint, perhaps due to the influence of Buddhist art of the Pala and Sena dynasties in Bengal, where the Gupta style was preserved well into the eleventh and twelfth centuries. Another detail on the main *mandapa* at Konarak shows a late decorative note developed to an extremely high degree (*fig. 295*). This is a pattern of perforations used to create texture behind the images and floral ornament. It suggests so intense a desire to negate any architectural character and to create an embroidered or encrusted effect that hardly a square inch of surface is left uncarved. The tendencies under strict control at the Mukteshvara have here run riot.

Khajuraho

The second type-site for the northern style is Khajuraho. A side view of the Kandarya Mahadeva Temple (*see fig. 286*) shows the elaboration and development of this regional version of Nagara style. Three porches, each one increasing slightly in height, lead up to the great tower; the base is extremely high; and the miniature towers building up to the central tower are particularly numerous.

The temple sculptures at Khajuraho are quite different in style and character from those of Orissa, although the motifs are often the same. They seem more varied, and the general impression is of a richer sculptural style. The detail gives some idea of the variety: single figures of

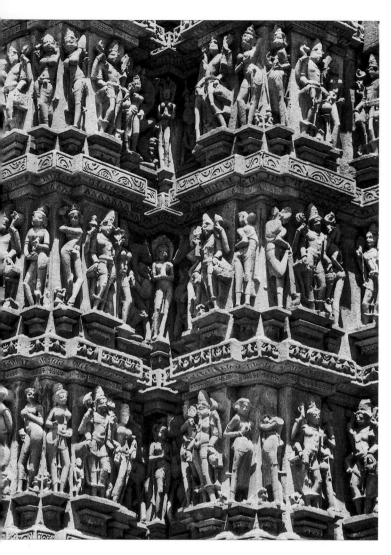

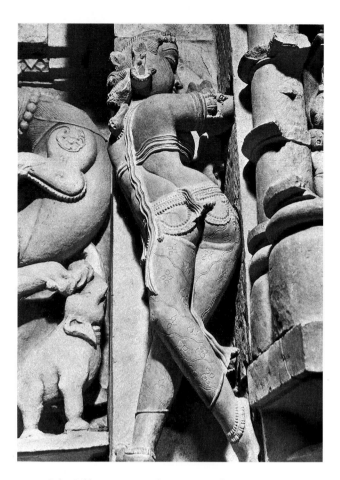

296. *Celestial deities.* Stone. Kandarya Mahadeva Temple, Khajuraho, Madhya Pradesh, India. C. 1000 C.E.

297. *Celestial beauty.* Stone; h. approx. 48" (121.9 cm). Parshvanatha Temple, Khajuraho, Madhya Pradesh, India. C. 1000 C.E.

celestial beauties (*sarasundari*), lions, amorous couples, and single images of deities (*fig. 296*). There is a marked development of the ribbon ornament we saw in Orissa. The Khajuraho variation is particularly arresting in its pictorial, or light and shadow, style. Tendril scrolls or arabesques are cut sharply and deeply into the flat surface of the sandstone, and the raking light makes a sharp contrast of light and dark, without variation or gradation or modeling around a shape. The result is like a drawing in black on white. This type of ornament is used to great effect throughout the structure and helps to maintain, on some areas, a flat architectural surface contrasting with the extreme development of the sculptured human forms on the rest of the building.

At Khajuraho the sculptured figures are tall and slim, and some have much elongated legs. The effects are linear, the poses exaggerated. A culmination of this tendency is to be found in one exquisite figure, perhaps the most interesting architectural sculpture at Khajuraho (*fig. 297*). It is a celestial beauty, occupying a corner position transitional from one main wall face to another. She inhabits a space that could have been very simply filled. The classic Gupta

solution would have been a figure standing there and looking out, but this was too straightforward for the complex and extraordinarily inventive minds working on this temple. They placed the figure in the space with one foot flat against one plane, the other foot on a different plane, the buttocks parallel to the spectator, the waist turned, and the shoulders on a plane perpendicular to the plane of the second foot; finally, the head faces the corner of the niche, with the arm making a connection from the body to the niche. The figure is spirally twisted so that it relates to all the real and implied faces of the space. Nevertheless the posture seems easy and natural, for the artist was master of linear effects. The emphasis is on the long, easily flowing line that repeats, with variations, the swelling curve of the hip. Scarf and breastband seem to ripple lightly over the torso. The drapery clings to the body, and only the borders of the sari are used as proper subjects for the sculptor. Such consistent and subtle linearity is the most characteristic feature of the sculptures at Khajuraho.

A third variant of the northern medieval style in this region is found at Mount Abu in western Rajasthan, where there is a group of marble temples dedicated to the

298. *Jain temples.* Mount Abu, Rajasthan, India. General view. Late medieval period

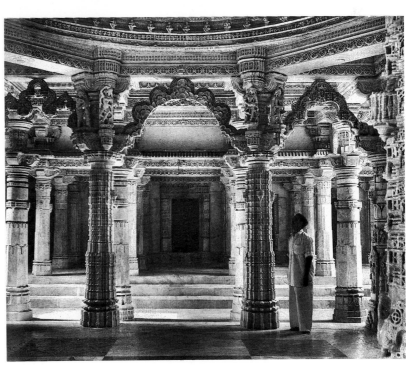

299. *Mandapa (pillared hall) of Dilvara Shrine.* Mount Abu, Rajasthan, India. 13th century C.E.

Jain faith (*fig. 298*). Because they are Jain temples, and separated geographically from the great region of northern medieval sculpture, they show a curious mixture of two styles. One, the northern medieval style, is confined to the secondary images of celestial dancers and musicians and so on, and is seen to better advantage at Khajuraho. The other, most prominent in the main images but tingeing the secondary images as well, is an ascetic and antisensuous style iconographically expressive of Jain religious ideals. If we examine a main image of a Tirthankara, or Finder of the Ford, we notice a smooth and geometric, almost tubular, treatment. In many images the style can be disturbingly geometrical and anti-human, reflecting a faith rigid in its ethics and more extreme in its passivity than Buddhism.

But in Jaina secondary images—the dancers, for example—some of the medieval style remains. The paramount impression made by this latter variant of northern medieval style is one of overelaboration of an embroidery-like ornament (*fig. 299*). In one of the great ceilings over the porches, or *mandapas*, the repetition of the dancing celestial beauties has become mechanical,

300. *Ceiling frieze of dancers, from Tejahpala's temple to Neminatha.* 1232 C.E. White marble. Mount Abu, Rajasthan, India

301. *Star Temple.* 1268 C.E. Mysore, Karnataka, India. General view

despite minor variations (*fig. 300*). The whole effect is now one of intricacy, with an accompanying loss of spirit and movement, and a tendency toward the coarseness commonly found in the sculpture of north India after the fifteenth century. Thenceforth the only vitality is to be found in folk sculptures, not in the works of the professional artisan.

There are other variants of the medieval style: the wood architecture of Kashmir, and the oddly similar wood architecture of the Malabar coast in the southwest. A peculiar style called Vesara (meaning "hybrid") is to be found in the region of Mysore, in low, flat temples built on a star-shaped plan (*fig. 301*). Their squat, truncated appearance is modified on closer examination by profuse sculptural decoration. The high bases seem encrusted with varied friezes of animals in apparently endless procession (*fig. 302*). Even the images of deities in their niches are blanketed with heavy and ornate decoration, largely representing festoons of jewelry. What could have been excessive profusion is redeemed by the sensitive and precise cutting of detail as well as by the ever-present living breath of the medieval style in stone.

302. *Animal base and figures.* Hoyshaleshvara Temple, Mysore, Karnataka, India. 13th century C.E.

SOUTHERN STYLE IN THE LATER MEDIEVAL PERIOD

We now turn to the south, principally to the region of the former Pallava kingdom. Here, distance and the political strength of the later south Indian kingdoms enabled the native tradition largely to resist the influence of Muslim arts of the foreign conquerors in north India. Here, too, in later medieval times were preserved many Hindu crafts, especially textiles and jewelry, and the arts of the dance.

During the early Chola dynasty the Pallava style was gradually transformed, becoming increasingly elegant. The Nageshvarashvami Temple (c. 910 C.E.) at Kumbakonam, a relatively modest single shrine with four-columned hall (*mandapa*), displays exterior niche sculptures of striking beauty and grace (*fig. 303*). Their slender proportions and clear articulation are achieved with seeming ease in the granite common to this region. Under Rajaraja I (r. 985–1014 C.E.) and his son Rajendra I (r. 1014–1042 C.E.) Chola suzerainty reached its zenith, expanding to Sri Lanka and to parts of Burma, Malaya, and Indonesia. At home this power was manifested in one

303. *Female figure.* Stone; h. 51" (130.8 cm). Nageshvarashvami Temple, Kumbakonam, Tamil Nadu, India. C. 910 C.E.

of history's great building projects—Rajaraja's Brihadeshvara (Temple of the Great Lord, i.e., Shiva). This was also called Rajarajeshvara, after its patron, and was consecrated in his capital city of Thanjavur (Tanjore) in about 1010 C.E. (*fig. 304*). This extraordinary monument was a combined fort and temple, with elaborate battlements and a surrounding moat. Thanjavur represents the final development of the earlier southern style, before the decadence of later times. A general view of the Brihadeshvara, with the separate Nandi porch in the foreground, reveals that although the tower has developed into a very high struc-

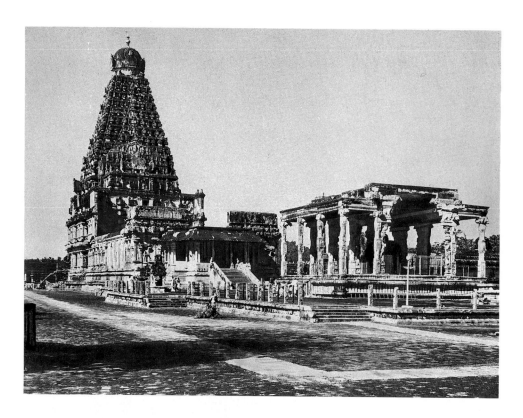

304. *Brihadeshvara Temple.*
Consecrated c. 1010 C.E.
Thanjavur, Tamil Nadu,
India. General view

305. *Niche sculpture.* Stone; h. approx. 7' (2.1 m).
Brihadeshvara Temple, Thanjavur, Tamil Nadu,
India. C. 1010 C.E.

ture, its general effect is still angular (*fig. 304*). A closer view would reveal the horizontal stages of the stepped tower characteristic of the southern style. The temple is over 180 feet high; the capstone is over 20 feet in diameter and weighs approximately 80 tons. It was raised to position by means of a ramp two miles long, and is one of the most extraordinary and, in its implications, frightening feats of engineering in India. The sculptures on the temples of Thanjavur, and in south India generally, do not have the exuberance exhibited by those of the north (*see figs. 296, 297*). They are usually single figures in niches, and for a very good reason (*fig. 305*). By the tenth century technical dominance in the field of sculpture had passed from stone workers to workers in metal, and the single figure now came into its own, taking on, even in other mediums, the character of sculpture in metal. The forms in the illustration imitate copper images.

It was not known until a few years ago that the Great Temple at Thanjavur also contained important Chola paintings. Inside the walls of the tower around the shrine is a narrow, rough corridor, and on its walls are frescoes, illustrated here in a detail. Though the paintings can be seen only by Hindus, since the temple is still in worship, photographs show that the art of painting was flourishing in the Chola period and that motifs of the dance were still favored (*fig. 306*).

The post-Chola development of south Indian architecture can be briefly summarized by two illustrations. One demonstrates the almost perverse enlargement of the towers over the various entrance gates, with the outermost towers being the highest, so that the periphery of the temple precinct comes to dwarf the shrine itself

306. *Dancing apsaras.* Fresco. Chamber 7 of inner ambulatory of sanctuary, Brihadeshvara Temple, Thanjavur, Tamil Nadu, India. C. 1010 C.E.

307. *Arunachaleshvara Temple.* Tiruvannamalai, Tamil Nadu, India. C. 12th century C.E.

(*fig. 307*). A typical example of this trait from the fourteenth or fifteenth century provides an exciting panorama of great towers rising up out of the hot and steaming plain—impressive until one realizes that the towers are simply gate-towers and that the temple proper, somewhere in the interior, is the architecturally insignificant center of a series of concentric walls whose towers become smaller as the walls approach the temple. Most of the activity of the town is contained in shops and bazaars within the various temple walls. Along with this tendency toward giantism in the towers, one finds a proliferation of sculpture over all their surfaces, sculpture of such extremely poor quality that we need not examine it. The only sculptural achievement of any interest is the development of large columns or piers comprising rearing animals—horses, lions, or elephants—their forefeet usually supported by smaller animals or attendants (*fig. 308*). A whole facade of such columns produces an unstable but imposing effect, until one examines the sculpture in detail. Then one sees the beginnings of a rather crude naturalism, of a petrified anatomical interest, of a frozen, hard, and gross expression in the faces, and of a marked impoverishment in the representation of ornament and

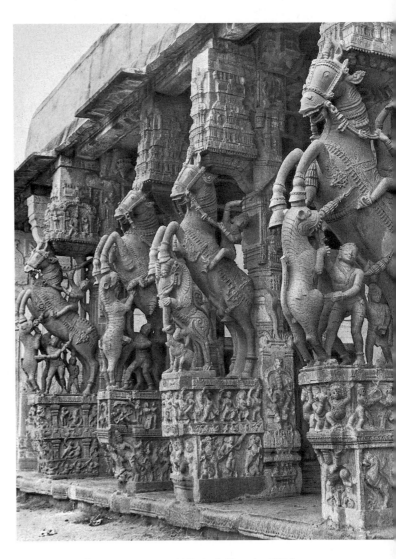

308. *Horse columns.* H. approx. 12' (3.7 m). Temple of Vishnu, Shrirangam, Tamil Nadu, India. Vijayanagar period, 16th century C.E.

309. *Shiva* (from double image with Uma). Copper; h. 41" (104.1 cm). Excavated at Tiruvenkadu, near Thanjavur, Tamil Nadu, India. Chola period, reign of Rajaraja I (985–1014 C.E.). Thanjavur Art Gallery

310. *Ardhanarishvara trident*. Bronze; h. 15" (38.1 cm). South India. Chola period, 11th–12th century C.E. Cleveland Museum of Art

movement. They are more like theatrical settings than great works of sculpture. Sometimes, in the subsidiary reliefs around the bases, or in narrative friezes of the *Ramayana* or other epics, there is still some descriptive or narrative power. But in general stone sculpture in the south after the Chola period is aesthetically unrewarding.

Southern Metalwork

Of interest from this time forward are the images in copper, sometimes in brass, among which are some of the greatest metal sculptures in the world. They were meant to be used as aids to worship, and range in size from almost life-sized images kept in *puja* (worship) in temples, and consequently often well preserved, to tiny images meant to be carried on one's person or worshiped in personal shrines. Most were cast by hereditary guilds of craftsmen, using the lost-wax process. Some of the images were taken periodically from their niches or places of worship in the temples and carried in processions. On these occasions they were dressed in rich silks and cloths which hid all but the face. Sculpturally these bronzes, as we shall call them, are the most significant objects of later south Indian art. If early stone work in the Pallava period influenced metal, it is certainly true that, from the Chola period on, metal influences stone. Various subjects are represented, but the motif is usually a single figure.

In nearly all of the well-known image types the handling of the material, especially in the taut profiles and complicated turns of the limbs, seems particularly dictated by the requirements of metal. This lithe image of Shiva, though relaxed in pose, has something of the spring and tension of metal in contrast to the more static character of stone (*fig. 309*). Its proportions are derived from Pallava sculpture, but its implied movement and conscious grace are contributions of the early Chola period.

Many of the images are badly worn at the face, because the rite of *puja*, or worship, involves not only prostrating oneself before the image but also the ritual touching of it. Through the holes in the bases passed a

311. *Krishna Dancing on the Serpent Kaliya.* Bronze; h. 34¹/₂"
(87.6 cm). Tamil Nadu, India. Early 11th century C.E. Asia
Society, New York. Mr. and Mrs. John D. Rockefeller 3rd
Collection

made, such as the *Marriage of Shiva and Parvati* in the
Thanjavur Art Gallery. In this group the image of Shiva
(*fig. 309*) appears with his right arm around his consort
Uma (or Parvati) and his left hand resting on his vehicle,
the bull Nandi. A smaller-scale echo of such a grouping is
to be found on the small trident of Shiva, bearing a repre-
sentation of Shiva Ardhanarishvara (*fig. 310*). This won-
derful combination of male and female expresses a
peculiarly Indian version of the hermaphrodite. The
litheness of the pose, the gentle bend and reverse bends of
the body, all show the Chola tradition of bronze casting at
its best. Not all the images were beautiful or handsome;
some represent ascetic devotees of Shiva (*cpl. 17, p. 208*).
These are shown as emaciated hags, with pendulous
breasts, ribs starting out of the body, and awesomely hid-
eous faces with fangs. But this image, from the Nelson-
Atkins Museum of Art in Kansas City, is wholly impressive
for its sculptural quality. The alertness of the carriage, the
still wonderful property of expansion, the physical well-
being despite the figure's emaciation, seem to shine forth
as from all great Indian sculptures.

One of the most entrancing of these conceptions, a
subject particularly appealing to Westerners, is the youth
Krishna dancing on the serpent Kaliya (*fig. 311*). As the
Krishna legend tells it, the serpent Kaliya came to dwell in
the river Yamuna (Jumna), causing the creatures living
along the river gradually to sicken from his seeping
venom. Learning of this, the boy Krishna leaped upon the
serpent and danced him into exhausted submission, then
spared his life but banished him from the river to the
ocean whence he had come. In its larger meaning the
image represents the triumph of Krishna-Vishnu over
Time-Eternity. Krishna is shown as a young boy, with one
leg raised as he dances on the serpent's hood. No subject
illustrates more clearly the importance of the dance for
these representational concepts, and none seems so singu-
larly appropriate to the medium of bronze. The weight
resting completely upon one leg, the thrust of the hip and
the bend of the left arm, all combine to make a metal
image worthy of comparison with the great bronzes of the
Italian Renaissance.

rod that was fastened to the wooden base upon which the
image was placed when in worship.

We have mentioned the influence of the dance
before; here it is dominant. The poses of these figures,
their attitudes and gestures, are all derived from the art of
the dance. Something of the quality of movement, of
rhythm, and of the physical expansiveness of these images
is to be found in the great dancers and dancing traditions
of south India.

Single figures or sets of two appear most often in
metalwork, though multifigure groups were occasionally

MUGHAL PAINTING

The last, most extensive, and most enduring of the
Muslim conquests in India became the Mughal Empire
(1526–1756 C.E.). Muslim incursions had begun in the
early eighth century, with the Arab occupation of Sind
(present-day southern Pakistan). Mahmud of Ghazni
annexed the Punjab in 1001 C.E., and from there raided all
across northern India (*see p. 101*). The later sultanates on
India's northern border espoused conquest rather than
plunder: northern India was occupied (if not precisely

subjugated) in the first decade of the thirteenth century; the Hindu kingdoms of the Deccan fell early in the fourteenth century; by 1330 C.E. the Muslim domain extended from Kashmir to Madurai in Tamil Nadu. Muslim rule, however, was neither centralized nor uncontested. It was divided among many competing Muslim sultanates. It was also challenged by the rising power of the Hindu Rajput rulers in present-day western Rajasthan and by the Hindu kingdom of Vijayanagar in the south (*see p. 190*).

Though the Mughal dynasts extended their territory and consolidated their rule more effectively than any of their predecessors, their empire was in decline by the end of the seventeenth century. Only the reign of Akbar (1556–1605 C.E.) combined political and administrative greatness with the artistic brilliance for which the Mughal period is renowned.

India's Mughal school of painting owed its existence to the munificent patronage of three emperors who were signally devoted to art. The development of the school, the direction it followed, the subjects it undertook, and the character it achieved were directly influenced by the personalities of these remarkable men: Akbar, his son Jahangir (r. 1605–1627), and Jahangir's son Shah Jahan (r. 1628–1658).

The Mughals came from Ferghana. The founder of the dynasty, Babur, who sought new lands to settle in and so moved to the conquest of India, was descended from Tamerlane and from Genghis Khan. Babur was familiar with the refinements of Persian art; later, his son Humayun, driven from India by a minor aspirant to the throne, sought refuge in the Persian court of Shah Tahmasp, where miniature painting flourished. Wanting court painters of his own, he brought two Persian artists, Abd as-Samad and Mir Sayyid Ali; to his subsequent refuge in Kabul, where his young son Akbar studied drawing and painting with them. When Humayun returned in triumph to Delhi in 1554, the two Persians came with him. After his father's death Akbar increased the number of court painters; the majority of them, however, were not Persians but Hindus. Akbar preferred their talents; his biographer reports his remark that "the Hindus did not paint their subjects on the page of the imagination,"[9] that is, their paintings were close to nature. This judgment is confirmed by Taranatha, the Tibetan historian who wrote in 1608 that Indian painters showed close adherence to natural appearances.

The *Hamza Nama* (or *Dastan-i Amir Hamza*) is a Persian tale conflating the marvelous exploits of the emir Hamza, who was the prophet Muhammad's uncle, with those of a later namesake. An illustrated version of this was the major manuscript produced early in the reign of Akbar. Executed on fine muslin on a scale significantly larger than that of any other extant manuscript, the "miniatures" of the *Hamza Nama* (*cpl. 18, p. 209*) are documents of the amalgamation of Persian and Indian idioms into a unified Mughal style. They are also works of art of the most bold and energetic character. The hot colors, strident juxtapositions of colors and shapes, and absorption in relatively realistic narrative detail make these pages the fount of later Mughal painting. Akbar's direct participation in the orientation of the work is documented by his friend and scribe, Abu'l-Fazl. A manuscript of the *Tuti Nama* (Tales of a Parrot), more recently discovered and much smaller, must have been begun slightly earlier than the *Hamza Nama,* about 1560. Its numerous miniatures reveal the participation of various native Indian workshops and the emergence of certain individual masters who later achieved considerable fame—Basawan (*fig. 312*), Daswanth, La'l, and others. The *Tuti Nama* shares with the *Hamza Nama* both the excellences and the defects of a new school building on the various manners available to the supreme ruler of a strong new dynasty.

Artists of the Mughal school drew their earliest inspiration from the actual presence of Persian artists; they had access also to the imperial library with its numerous albums full of Persian drawings and paintings. We can see minor Persian influences in the painting of a ceremonial gathering to witness the meeting of Jahangir and Prince Parviz (*fig. 313*). The Persian manner tended to flatness, a fondness for surface pattern, extreme elegance in line and decorative detail, and some freedom from symmetry in composition. Our illustration shows this Persian influence in the border of the painting with its Persian script, in the flat design of the textile in which the emperor is dressed, in the carpet, and in the Persian formula of the cypresses and the flowering trees beyond the wall. Distinctly not Persian is the formal balance of the picture, the absence of elegance in the figures standing in stolid array, the very realistic portraiture. The Indian feeling is also revealed in the mountain cluster at the top and in the flowers in the foreground, transforming them from flat patterns to warm and visually realistic areas.

Akbar was one of the world's great rulers and of a rare and remarkable character. Brought up a Muslim, in his role as emperor of India, which he took with profound seriousness, he sought to bring his Hindu and Muslim subjects together. To this end, he married a Hindu princess. His dream was the creation of a philosophy that would reconcile Muslim, Hindu, and Christian thought. But "divine worship in monarchs," he said, "consists in their justice and good administration."[10] He welcomed Jesuit priests, and on his walls and in his library were European paintings: Christian subjects, Dutch landscapes, and Flemish work. Mughal artists were quick to seize on the new aspects of these foreign pictures and to introduce landscape vistas, European perspective, and atmospheric effects—mist, twilight, or night light—into their pictures.

His artists were called upon to record history and legend in pictures full of action and figures. *Akbar Viewing a*

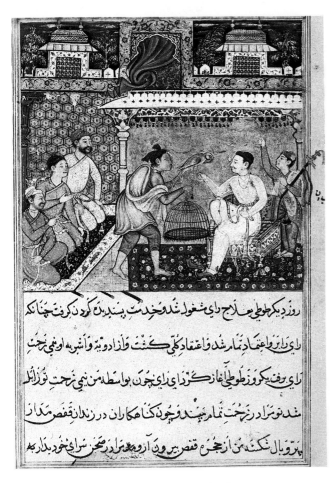

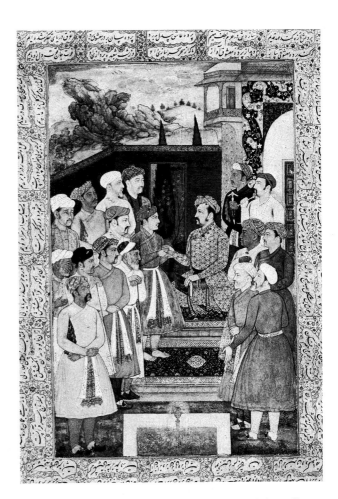

312. *Tuti Nama (Tales of a Parrot)*. Tale 5f. 36 v. By Basawan. Miniature; color, ink, and gold on paper; h. 7 7/8" (20 cm). India. Mughal, c. 1560 C.E. Cleveland Museum of Art

313. *The Emperor Jahangir Receiving Prince Parviz in Audience, from the Minto Album*. Attrib. Manohar. Miniature; color on paper; h. 15" (38.1 cm). India. Mughal, Jahangir period, 1610–1614 C.E. Victoria and Albert Museum, London

Wild Elephant Captured near Malwa, from the *Akbar Nama*, a history of the emperor, is an admirable example of the work of his school (*fig. 314*). In the elegant horse with its intricately patterned saddle cloth and in the curious rocks and shrubs are many echoes of the Persian style, but the elephants are not decorative—their form and action are masterfully depicted. Careful modeling brings out their massive bodies, and their expressions show close observation of individual creatures. These qualities are not Persian but Indian. The picture was painted by two artists, La'l and Sanwlah. Such collaboration was not unusual with Mughal artists, each man taking the subject best suited to his talents. Jahangir later boasted that he could recognize the brush of each of his artists, however small his part of the whole work.

The emperor was extremely interested in the work of his artists and provided the best possible materials. Fine papers were imported or made, delicate brushes and expensive pigments were sought—lampblack, ground lapis lazuli, gold leaf, and powdered gold among them. The resulting excellence of craftsmanship and delicate perfection of textures and atmospheric effects were admired by the Rajput princes often present in the palace. It be-

came the fashion among them, as it was the custom of the Mughals, especially in Jahangir's reign, to bring a train of painters along on their travels.

Akbar's attitude toward painting, frowned on by orthodox Muslims, throws light on the devoted absorption of the Mughal painter in the essentials of his subject. "It always seems to me," he said, "that a painter has very special means of recognizing God, for when he draws a living thing, and contemplates the thing in detail, he is driven to thinking of God, Who creates the life which he cannot give *his* work, and learns to understand God better."[11]

The influence of this attitude, which induced the artist to render with utmost care and skill the outward appearance of the subject, is most clearly seen in the paintings executed during Jahangir's reign. He had a great reverence for his father, Akbar, and a passion for life; people, birds, animals, and flowers absorbed his attention. He demanded that his artists follow him everywhere to record the amazing wonders that met his eyes. No perfunctory stylized record satisfied him. As can be seen in our illustration of the zebra, the gentle eye, the position of the ears, the delicate hair of the mane and forelock, and

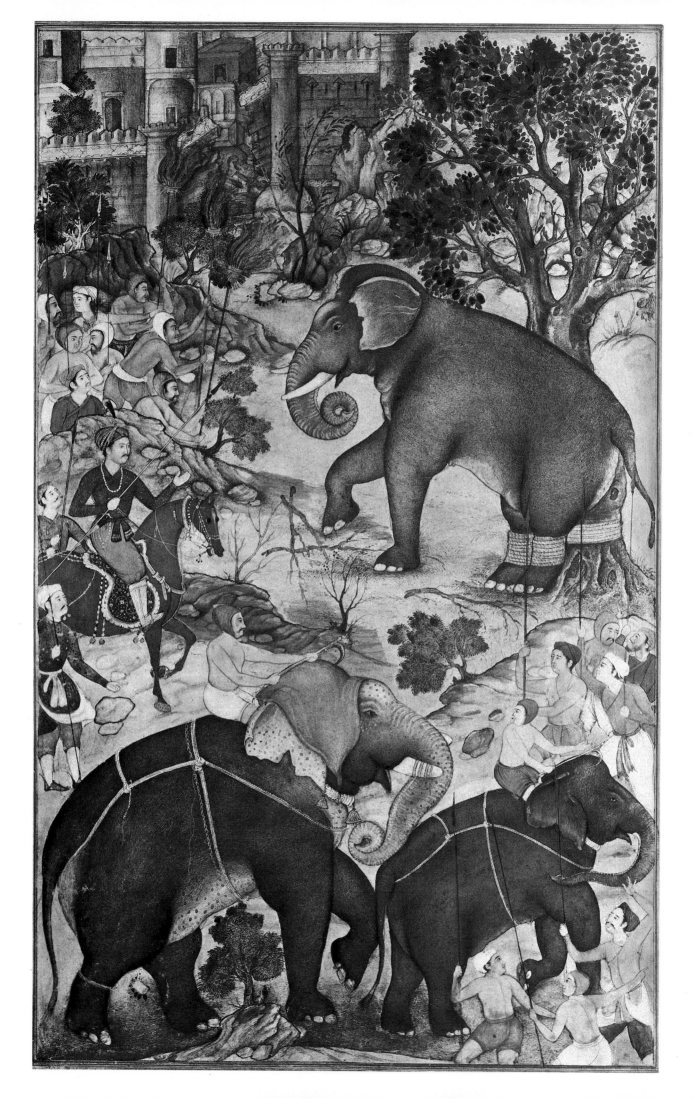

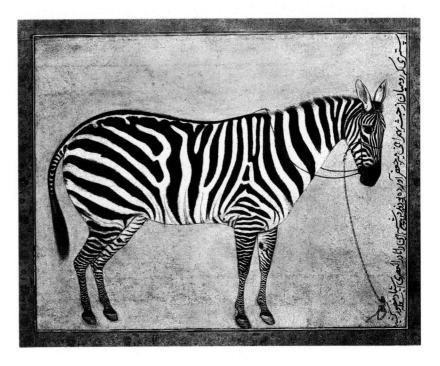

314. (opposite) *Akbar Viewing a Wild Elephant Captured near Malwa in 1564, from the Akbar Nama.* By La'l and Sanwlah. Miniature; ink and color on paper; h. 15" (38.1 cm). India. Mughal, Akbar period, c. 1600 C.E. Victoria and Albert Museum, London

315. (right) *Zebra, from the Minto Album.* By Mansur. Mughal, 16th year of reign of Jahangir, 1621 C.E. Miniature; ink and color on paper; h. 7¹/4" (18.4 cm). India. Victoria and Albert Museum, London

316. *The Dying Inayat Khan.* Drawing; ink on vellum; w. 5¹/4" (13.3 cm). India. Mughal, school of Jahangir, early 17th century C.E. Museum of Fine Arts, Boston

the dark, soft muzzle are all carefully recorded (*fig. 315*). Jahangir was not his father's equal in wisdom, but he inherited his father's dream of bringing together the contributions of many lands, a dream somewhat naively illustrated in the marvelous painting that shows Jahangir seated on a jeweled hourglass throne surrounded by a magnificent halo of sun and moon and receiving under his imperial aegis a Muslim divine, a Muslim prince, a European delegate, and an artist (*cpl. 19, p. 210*). The hourglass throne sits on a Renaissance carpet, and scattered about the composition are the figures of small cherubs, copied from European paintings.

The art of portraiture was one of the great contributions of the Mughal school to Indian painting, and the revelation of character in individual faces can be seen in figure 313, *Jahangir Receiving Prince Parviz,* surrounded by the members of his court. Each face has been thoughtfully studied and reveals the person, aged and wise or aged and sterile, youthful and worried or unaware, mid-dle-aged and strong or merely stolid. One of the masterpieces of Jahangir's reign has a curious history and reveals much of the emperor's personality. It portrays the dying Inayat Khan (*fig. 316*). Jahangir describes the occasion of its making in his diary:

On this day news came of the death of Inayat K[han]. . . . He was one of my intimate attendants. As he was addicted to opium, and when he had the chance, to drinking as well, by degrees he became maddened with wine. . . . By my order Hakim Rukna applied remedies, but whatever methods were resorted to gave no profit. . . . At last he became dropsical, and exceedingly low and weak. Some days before this he had petitioned that he might go to Agra. I ordered him to come into my presence and obtain leave. They put him into a palanquin and brought him. He appeared so low and weak that I was astonished. "He was skin

drawn over bones." Or rather his bones, too, had dissolved. . . . As it was a very extraordinary case I directed the painters to take his portrait. Next day he travelled the road of non-existence.[12]

Jahangir's artist drew the dying man with an awesome compassion, directly and without flourish. His frail body propped against massive, rounded bolsters, Inayat Khan looks at death with quiet acceptance.

During the reign of Jahangir's son, Shah Jahan, the painting of the Mughal school grew in elegance of texture and color. Portraits, durbars, and other subjects were painted so delicately that a hazy bloom seems to lie over the surface of forms. Some aspects of European painting appealed to the Indian artist, and these became assimilated into a thoroughly integrated style. During the reign of Aurangzeb (r. 1658–1707 C.E.), the last powerful prince of the dynasty, painting languished, for this emperor was a fanatical Muslim who discouraged figural art. A few portraits and battle scenes remain as a record of his day. Artists from the imperial household sought patrons elsewhere.

Related Mughal or Islamic schools of painting developed in outlying semi-independent principalities. Each of these schools developed a distinctive artistic personality, though the favored format in all of them was miniature painting in illustration of manuscripts. One of the most creative of these schools originated at Bijapur in the western Deccan. There, especially in the reign of Ibrahim Adil Shah II (r. 1580–1626 C.E.), a monumental yet patterned way of seeing the ruler produced some of the masterpieces of Islamic art in India. The shah's portrait (*cpl. 20, p. 211*), in the British Museum, is a piercing depiction of royal presence and intensity, with more of the pure and rich color of Persian painting than is usually to be found in Mughal work.

RAJPUT PAINTING

The Mughal style was primarily realistic, and its natural outlet was portraiture and narrative. But some of the most famous Mughal manuscripts, especially the *Tuti Nama*, on which Indian artists apparently worked, reveal a blending of two styles. The conceptual, abstract approach of the Jain tradition was wedded to the Mughal observation of nature to produce a fused style, which we can call Rajput. This style lay at hand and ready for a sympathetic subject matter, which was found in the literature of a later revival of Hinduism in northern India.

Perhaps the stiffest resistance to the Mughal conquerors came from the small independent Rajput kingdoms in the area of present-day Rajasthan in northwest India. Rulers and subjects alike belonged to patrilineal tribal clans, some Hindu, some Muslim, apparently descended from intermarriage between indigenous inhabitants and invading Iranian and Central Asian tribes of the first millennium C.E. Inability to maintain an alliance doomed the Rajputs' efforts to remain independent. Akbar's policy of conquest followed by conciliation subdued most of the Rajput kingdoms, and the last of them fell during the reign of Jahangir. The ruling houses, however, were not destroyed, but continued to maintain their courts in return for submission and revenues paid to the Mughal emperors.

Rajput painting is the last expression of the northern medieval tradition. With this subject, the question of decadent or retarded art forms in India immediately arises, for Rajput painting is in some ways a folk art or at least a semi-folk art, and it may well be this quality which has made it less appreciated in the West than it deserves. But there are signs that this attitude is changing, and numerous books on Rajput painting have appeared in recent years. The Rajput style is found in miniature painting, with subject matter ranging from the abstract and intellectual to the extremely concrete and emotional. The size may be partially due to the influence of the miniatures produced by Persian artists or artists under Persian influence at the Delhi Sultanate and later at the Mughal court. Although the art of miniature painting had been practiced in India before the coming of Islam, it is likely that Rajput painting owes at least its format to the influence of Persian and Mughal painting. To this influence also may be attributed the heightened color, so characteristic of Rajput painting, which in many cases outdoes that of the paintings from which it is derived. Color is one of the most creative aspects of the Rajput style, often used much more arbitrarily than in Mughal art, and in a manner quite akin to that of creative modern painting.

These small Rajput paintings, usually meant to be kept in albums and seen in sequence, are a product of a cultural atmosphere that included independent city-states, a regional point of view as opposed to the national or imperial one of the Mughal court, and the very important matter of patronage, for the miniature painter could not survive without the patronage of wealthy or royal personages. Strong Mughal influence notwithstanding, there is a basic difference between Mughal and Rajput painting. The former, for all its detail and marvelously taut and powerful drawing, is still naturalistic in its approach. It tends to be realistic, to attempt the appearances of nature, particularly in human and animal portraiture. On the other hand, most Rajput paintings are conceptual; the artist was mainly concerned with the idea, whether religious or poetical, behind the picture, and used color and shape to express the mood or atmosphere of the idea, its *rasa,* or flavor.

The origins of the Rajput style are twofold. We have already mentioned the underlying influence of Indo-Persian painters, who in turn were greatly influenced by

Persian miniaturists. The second influence is one out of Indian medieval tradition, and from a very particular and specialized part of that tradition—the Jain and Hindu manuscripts made in the Gujarat regions of western India for wealthy monasteries and merchants of the region. These manuscripts are painted on paper, with the text dominating a small illustration on each page (*fig. 317*). They employ certain mannerisms characteristic of medieval Hindu fresco paintings, such as can be seen in the surviving murals on the ceiling of the Kailasanatha at Ellora (*see fig. 282*). Persian influences are found mainly in certain textile designs and sprays of flowers; but no Persian would ever have painted a miniature like figure 317, whose style partakes largely of the geometricizing, antihumanist approach seen in Jain sculpture in the Gujarat. Here is one of the most abstract, most conceptual forms of painting that the world has ever seen. Color is used in simple, flat areas. Figures are arbitrarily conventionalized; the eye, for example, in a three-quarter view of the face, projects conspicuously, as it does in the frescoes at Ellora. This approach is not confined to the handling of figures, for architectural details and interior furnishings, trees and sky, all have their lively, stylized formulae, so constantly repeated that they often become monotonous. The patterning of the textile designs and the use of gold are also part of a seemingly desperate effort by the painter to reduce the visible world to a small conceptual framework that can be comprehended as one comprehends the script next to the picture.

Though some see in Rajput painting only a decadent and degenerate form of Mughal painting, a little illuminated manuscript showing two dancers has enough of the elements of the Gujarati manuscript style—particularly the use of the projecting profile eye—to prove at least the partial development of Rajput painting out of that tradition (*fig. 318*). Color, however, is less abstract, more deco-

317. (above) *One leaf from a Kalpa Sutra manuscript.* Color and gold on paper; l. 10¼" (26 cm). India. Western Indian school, 16th century C.E. Cleveland Museum of Art

318. *Poems of Spring, from the Vasanta Vilasa.* Color on roll of cotton cloth. Western India. Gujarati-Rajput, mid-16th century C.E. Freer Gallery of Art, Smithsonian Institution, Washington, D.C.

rative, and we have the use, as W. G. Archer says, of passionate reds and verdant greens to produce a new style that is primarily lyrical rather than intellectual, one that appeals to the emotions rather than to the mind. The future of the Rajput style was not to be in the western region, but in north central India, at first in Rajasthan, the same region that produced the Nagara style of Indian architecture and sculpture. Later the style would flower in the foothills of the Himalayas. The first phase of the Rajput style is primitive, derived from the fusion of the Gujarati and Delhi elements, and occurs in a few rare manuscripts of the sixteenth and early seventeenth centuries. One manuscript in particular is of the highest importance; it contains a painting representing the Month of Rains, with a cloudy sky and rain falling against a blue ground (*fig. 319*). In it the abstract patterning, the eye convention, and something of the color of the Gujarati manuscripts is fused with a new, fresh complexity of composition. It is this fusion which becomes the Rajput style. Niches containing vases are still used as patterns; the figure is confined to profile or the full front view; but the new style is now capable of expressing an intensity of passion, particularly through color. Such emotive intensity parallels that revival of personal devotion typical of the Krishna cult in the later medieval period. There are almost no traces of Mughal influence except in architectural motifs—and Mughal domestic architecture dominated north India. Representations of a cupola here, or of niches with pointed arches there, are derived from the familiar Mughal architecture rather than from Mughal painting.

Rajput painting differentiates into three major geographic areas and schools. The earliest to develop is that of Rajasthan and Malwa (in Madhya Pradesh), occupying the area corresponding roughly to the region north and west of Delhi as far as the foothills of the Hindu Kush. As early as the sixteenth century a "primitive" Rajput style emerged there, out of which developed the style of the seventeenth and eighteenth centuries, when the school was most active. The second school of Rajput painting was active in central India, the region of the Deccan plateau, from the late sixteenth century on, heavily influenced by Mughal style. The third is the Pahari school of the Punjab hill states; it included such states as Basohli, Jammu, Guler, Garhwal, and Kangra, and was particularly active in the eighteenth and early nineteenth centuries. The Pahari school produced the most charming and lyrical of the Rajput paintings, as the Rajasthani school provided the most powerful and most daring.

The schools are unified to a certain extent by their subject matter and symbolism. Principal subjects evoke seasonal songs called *raga*s (musical modes), and illustrate epics and other literature concerned primarily with Krishna and also with Shiva. We find, particularly in the Rajasthani school, close correspondence between given musical modes and their literary and pictorial interpreta-

319. *Month of Rains.* Color on paper; h. 9" (22.9 cm). Western India. Mid-16th century C.E. Central Museum, Lahore

tions. Such correspondence could only occur where there was an accepted tradition of interpretation: where a given color, certain birds and flowers, suggested particular moods or situations; where a representation of the month of August brought to mind the musical phrase appropriate and traditional for that month. Within the Rajput tradition music, literature, and painting achieved a unique unity, even beyond that attained by the baroque painters under the motto *Ut Pictura Poesis*. A pictorial representation of a musical mode has many levels of reference all merged in one vision: a specific musical theme, a particular hour of the day, day of the month, and month of the year, as well as a familiar romantic situation between the protagonists, usually Radha and Krishna. Coomaraswamy's description makes clear this interweaving of elements within a *raga* or *ragini*:

A favorite theme of Rajasthani painters is a set of illustrations to a *Ragamala*, or "Garland of Ragas," poems describing the thirty-six musical modes [six

320. *Adhira Nayaka.* Color on paper; h. 10" (25.4 cm). Mewar (present-day Udaipur), Rajasthan, India. Early 17th century C.E. Cleveland Museum of Art

ragas and thirty *raginis*]. The *Raga* [male] or *Ragini* [female] consists of a selection of from five to seven notes or rather intervals, distributed over the scale from C to C, the entire gamut of twenty-two notes being never employed in a single composition. . . . The *Raga* or *Ragini* is further defined by characteristic progressions, and a leading note to which the song constantly returns, but on which it does not necessarily end. . . . What is most important to observe is that the mode is known as clearly by the mood it expresses and evokes as by the technical musical definition. . . . The moods expressed . . . are connected with phases of love as classified by Hindu rhetoricians, and are appropriate to particular seasons or elements . . . and all are definitely associated with particular hours of day or night, when alone they may be appropriately sung. . . . *Ragamala* paintings represent situations in human experience having the same emotional content as that which forms the burden of the mode illustrated. In other words, the burden of the music, the flavor of the poem, and the theme of the picture are identical.[13]

The *nayikabheda,* a typology of romantic heroes and heroines, generally eight of them, was also a favorite subject of the Rajasthani school (*fig. 320*). It treats of roman-

tic love, that is, love at first sight, usually extramarital, and based upon a physical attraction that is not distinguished from a spiritual one. Such a concept of love, similar to the medieval European "courtly love," seems characteristic of a well-guarded social order in which marriages are arranged. *Abhisarika Nayika* is "she who goes to seek her beloved," heedless of perils and tribulations:

> Serpents twine about her ankles, snakes are trampled under foot, divers ghosts she sees on every hand,
> She takes no keep for pelting rain, nor hosts of locusts screaming midst the roaring of the storm,
> She does not heed her jewels falling, nor her torn dress, the thorns that pierce her breast delay her not,—
> The goblin-wives are asking her: "Whence have you learnt this yoga? How marvellous this trysting, O Abhisarika!"[14]

It is significant that in an early picture the representation of this *nayika* is not literal but general (*cpl. 21, p. 212*). In later depictions of this heroine the representation becomes literal: we see the serpents, the rain, and the jewels falling.

The *nayikas* and traditional religious subjects, representations of Shiva, of Durga, and of Vishnu, are characteristic of Basohli, the earliest of the hill schools; representations of the narrative stories of the Krishna cult seem most characteristic of the later hill schools. Portraits and court groups occur in all schools, usually where Mughal influence is heaviest and especially in the late eighteenth and the nineteenth century.

Priority for the development of a recognizable Rajput "primitive" style must be assigned to southern Rajasthan and to Malwa, geographically a part of central India but a close neighbor to Rajasthan. Pages from a few series are known, all in a similar style dated as early as 1540 by Gray and Archer, who attribute them to Mandu in southwestern Madhya Pradesh (*cpl. 22, p. 213*). Some Persian elements are discernible in the ornament, but the colors and figural representations are clearly derived from the west Indian manuscript tradition and perhaps in part from an almost lost mural tradition of the medieval period.

This new manner appears to have spread to the north, and by 1630 there is a broadly homogeneous style ranging from Malwa to Udaipur (formerly Mewar) in Rajasthan with, of course, local variations and flavors. The famous series of paintings in the collection of the pioneer scholar Ananda Coomaraswamy, with their distinctive dark blue backgrounds, is a particularly bold and daring rendering of the Malwa style. *Abhisarika Nayika* here represents both a musical mode (*Madhu Madhavi Ragini*) and a heroine who goes in the night to meet her

321. *Kakubha Ragini.* Color on paper; h. 10½" (26.7 cm). Bundi, Rajasthan, India. C. 1680 C.E. George P. Bickford collection, Cleveland

322. *Maharajah Umed Singh of Kotah Shooting Tigers.* Color on paper; h. 13" (33 cm), w. 15¾" (40 cm). Kotah, Rajasthan, India. C. 1790 C.E. Victoria and Albert Museum, London

lover (*see cpl. 21, p. 212*). She comes through the black night with peacocks screaming about her, as rain clouds form and lightning flashes, but the representation is not frightening. The situation is rendered "conventionally"; nevertheless, the use of color, shapes, and patterns of shape and color is hardly stereotyped. It is extremely daring and bold, and recalls Egyptian painting as much as it seems to anticipate some of the experiments of modern painting, particularly by artists such as Matisse. In this manuscript of about 1630 we have an early statement of the classic Rajasthani style, after the assimilation of the varied elements contributing to it.

The development of Rajasthani painting in the eighteenth century, under the influence of Mughal painting, is toward greater finish and perfection of detail, but it still maintains the brilliant and arbitrary use of color that is the hallmark of Rajasthan. These qualities are clearly present in the Bikaner and Jaipur pages. The schools of Bundi (*fig. 321*) and its derivative, Kotah (*fig. 322*), continue the bolder traditions of Rajasthan into the late eighteenth and early nineteenth centuries.

The third major school, that of the Punjab hills, is quantitatively probably the most important. Many of its works equal the Rajasthani school in quality, but are quite different in kind. The Punjabi painters emphasize linear drawing and, with the exception of the Basohli school, a lyrical, gentle style. The Basohli is the earliest of the hill schools and makes the transition from the Rajasthani style to the developed hill style. Basohli miniatures have something of the rich color and daring juxtapositions found in Rajasthani painting, along with a quality peculiar to the early Basohli school and its derivatives, Kulu and Nurpur, which does not appear in other, later, paintings of the hill states (*fig. 323*). This unique quality is an extreme warmth of palette, making some of the "hottest" paintings ever created. Mustard yellows, burnt oranges, deep reds, and torrid greens are pulled together in a unity as hot as Indian curry. The rigidly posed figures recall Rajasthani miniatures.

A very fine Basohli page of about 1690 shows a category of subject matter in which the Basohli school excelled: the representation of deities in almost iconic form (*cpl. 23, p. 214*). The manner recalls earlier traditions, in which Shiva, Vishnu, Brahma, and others were represented as rigid figures in a balanced composition. Here we have a representation of Shiva and Parvati, emphasizing Shiva as the slayer of the elephant-demon. They float in the sky on the elephant's hide, against stormy, curling clouds above a warm, if rather sparse, Basohli landscape.

But the characteristic work of the hill states is to be found in paintings produced first in Guler and later, when the style expanded, in all the hill states (*figs. 324–26; cpls. 24, 25, pp. 215, 216*). It is a gracious and poetic style, influenced somewhat by later Basohli but far more by

323. *Radha and Krishna.* Illustration of the *Rasamanjari* of Bhanudatta. Color, gold, silver, and beetle wing on paper; h. 9¹/8" (23.2 cm). Punjab hills, India. Basohli school, c. 1600–1670 C.E. Cleveland Museum of Art

324. *The Road to Krishna.* By the "Garhwal Master." Color on paper; h. 8" (20.3 cm). Guler, Himachal Pradesh, Punjab hills, India. C. 1785 C.E. Victoria and Albert Museum, London

Mughal painting. Its technique is more complex and tighter than that of Basohli. The miniature technique of the Mughal school, with its use of polished white grounds, under-drawing, over-drawing, and then an application of rich, jewel-like color, was carried on by the hill painters; but at the same time some of the flat mural color of the Rajasthani school was also preserved. Subject matter is usually drawn from either the poetic revival of the Krishna cycle, with its pastoral symbolism and erotic overtones, or from the heroic epics of the past, the *Mahabharata* and the *Ramayana* (*cpl. 24, p. 215*). The illustrations of musical modes almost disappear, though the heroines, the *nayikas*, continue, and also some of the traditional religious subjects. But in general the characteristic hill school subject matter is either from the *Krishna Lila* or from the two great Hindu epics.

An album page by the "Garhwal Master," as W. G. Archer calls him, presents the characteristic elements of the developed later Punjab hill style (*fig. 324*). Its emphasis on decorative pattern is achieved by repetitions of line and shape. An attempt is made, perhaps under Western influence, at landscape vistas with architectural views and perspective in depth. A more realistic and observant delineation of the figure is achieved, in an attempt to denote age and social position. All this is combined with enough decorative character to distinguish the style very sharply from that of the Mughal school.

Guler produced works that combine the very best qualities of the Rajasthani and Mughal schools. Another page displays rich colors in fascinating combination—the blue Krishna against pearly white accompanied by pale mustard yellow. The pure linear drawing of the figure,

325. *Durga Slaying Mahisha.* Color on paper; w. 10¾" (27.3 cm). Kangra, Himachal Pradesh, Punjab hills, India. C. 1830 C.E. Cleveland Museum of Art

326. *Kali Attacking Nisumbha.* Color on paper; h. 8⅝" (22 cm), w. 13" (33 cm). Possibly Guler, Himachal Pradesh, Punjab hills, India. Pahari school, c. 1740 C.E. Cleveland Museum of Art

profile, and drapery is a hallmark of the later hill schools (*cpl. 25, p. 216*). Perspective is introduced unobtrusively in the little porch leading off the main room, which actually serves as a point of focus, heightening the interest in the main figure of Krishna gazing into the distance and yearning for his beloved Radha. The knowing glances of the attendant girls are subtly depicted, and the whole picture shows the hand of one of the great masters of the school.

The later schools of the Punjab hills, particularly in rather large pages, are preoccupied with the Hindu epics. Here realism is combined with something of a fairy-tale quality in works of the greatest interest. Another Guler page is one of the masterpieces of the hill states and a rare representation of a traditional subject. It is the same subject seen in pages of Bundi and Kulu origin: Durga slaying the bull-demon Mahisha (*fig. 325*). The demon is a realistic bull, not a man issuing from a bull as in the earlier pages. Durga, on her chariot pulled by two lions, attended by her child-warriors, is drawn in a beautiful fine-line style. The landscape, used to reinforce the meaning of the composition, is divided into two parts: Over the evil bull is a rather barren and distant expanse with a storm; over the

forces of good, a lush view with a clear blue sky. At the same time the fairy-tale, never-never-land atmosphere of later Rajput painting permeates the picture. The imminent death of the bull seems forgotten; the lions are almost playful; and the goddess herself, even in this vengeful aspect, appears as a delicately beautiful young woman.

The extremes within the Pahari school can be demonstrated by comparing this lyrical work with the grotesque representation and composition of *Kali Attacking Nisumbha* (*fig. 326*). In place of the idyllic-looking encounter of the *Durga* picture, *Kali* presents a brutal and expressionistic rendering of a savage contest between equally bizarre principals. Since both paintings are the work of the Pahari school, and both take as their theme the combat between good and evil, their disparate renderings must reflect the individual preferences of the artists and/or patrons. In Indian painting such variety had little time to live.

Rajput painting deteriorated sadly by the middle of the nineteenth century, although some artists produced reasonably good pages up to 1900.

11

The Medieval Art of Southeast Asia and Indonesia

CAMBODIAN ART

Popular interest in Cambodian art stems largely from a sentimental fondness for the "smile of Angkor." Nearly all tourists to Southeast Asia made a point of the pilgrimage to Angkor Vat, there to be properly impressed with the size of the vast stone structure in the midst of the jungle. But sentimental appreciation is a most limited approach to the unique Cambodian style. Whereas India produced great sculpture in an organic tradition, one emphasizing movement and sensuousness, Cambodian art moves us by a peculiar combination of sensuality allied to a strong architectonic character, almost as if the sensuous elements of Indian sculpture had been merged with the formal characteristics of Egyptian sculpture.

Cambodia comprises a relatively small area in Southeast Asia. Its earliest artistic manifestations were influenced from the north, whence came certain techniques from south China. Among the artifacts left to us from this very early period are some intricately cast bronze drums and a few rudimentary animal sculptures in stone. But sea contacts with India became important beginning about the third century C.E., and as so often happens when a relatively low culture comes in contact with the high culture of a fully developed and expanding state such as India, the impact was sudden, dramatic, and overwhelming. Shortly after the fourth century C.E. manifestations of this Indian influence begin to appear in the regions of present-day Thailand and Cambodia. Indian influence not only affected sculpture and architecture but the organization of the higher levels of society as well. Its impact was relatively slight on the lower levels of society, where even today we can find traces of pre-Hindu culture. Buddhism and Hinduism were both imported into Cambodia at this time, with Hinduism by all odds the strongest and largely dominant influence, despite the evidence of numerous Buddhist monuments.

The Indianized kingdom of Fu Nan occupied southern Cambodia around the Mekong River delta and stretched west along the coast of Thailand into present-day Burma. About the year 539 C.E. Fu Nan was absorbed by Chen La, its neighbor along the northern Mekong in present-day Laos. The last capital of the united kingdom, Sambor Prei Kouk, is also the site of Hindu temples which are its finest surviving monuments. Mahayana Buddhism appears to have spread rapidly among the people during the seventh century, with royal acquiescence if not encouragement. The rulers, however, remained Hindu. Even among Buddhist images the most characteristic

is the bodhisattva Lokeshvara, Lord of the Worlds, with whom rulers might usefully claim spiritual identity.

In the latter part of the eighth century Chen La–Fu Nan disintegrated, and contact with India was broken. Unity was restored with the establishment of the Khmer empire by Jayavarman II, who came to Cambodia from the court of Shrivijaya (*see p. 142*). Very likely it was Shailendra notions of transcendent kingship that developed during Jayavarman's reign into the Cambodian concept of the *devaraja*, or god-king, in whom temporal and spiritual authority were fused. Jayavarman II, who ruled till 850 C.E., identified himself with Shiva. Either Jayavarman II or his immediate descendants created the concept of the temple-mountain, the temple or temple complex standing on a natural or constructed elevation, in which the divinity of the king might be said to dwell and which eventually became his mortuary shrine. Each ruler built his own temple-mountain, each of which seems intended to surpass its predecessors in size and splendor. The monuments of Cambodian art, sculptural and architectural, can be considered the embodiments and the continuations after death of the king and of his world. Although shrines might be built by private persons, the temple-mountain was the exclusive prerogative of the king.

Indravarman (r. 877–889 C.E.), who further extended Khmer boundaries, founded Angkor (along with the superb irrigation complex that made the city possible), and his son and successor moved the capital there some time before 900 C.E. After a brief remove to Koh Ker the capital returned to Angkor in 952, and remained there through several usurpations until the end of the Khmer empire. Suryavarman II (r. 1113–1150), who identified with Vishnu rather than Shiva, was nephew and successor of one such usurper. He built Angkor Vat as his temple-mountain several miles south of Angkor proper, a distance that preserved it when the Chams sacked and burned Angkor in 1177 C.E.

Suryavarman II's son, Jayavarman VII, drove out the Chams in 1181 and went on to annex Champa, along with much of Malaya, Thailand, and Laos, bringing the empire to its greatest extent. The Khmer were by then predominantly Mahayana Buddhists, and Jayavarman VII adopted Buddhism, identifying himself with Lokeshvara as predecessors had identified with Shiva and Vishnu. He was an indefatigable builder, who in the first two decades of the thirteenth century created the city of Angkor Thom, centered on his temple-mountain, the Bayon.

After about the middle of the thirteenth century Angkor began to decline. The all-conquering Mongols were appeased with tribute. Recurrent Thai invasions shrank the boundaries of the empire and by the mid-fifteenth century forced the court to retreat to the lower Mekong. The concept of the *devaraja* disappeared. Theravada Buddhism replaced Mahayana, and remains the prevailing religion to this day.

327. *Shrine.* Sambor Prei Kouk, Cambodia. Early 7th century C.E.

The common origin of the early styles in the region of Cambodia and Thailand is the Gupta style, originating in the third and fourth centuries C.E. in India and thence exported to Thailand, Burma, and Indonesia. But although the point of origin was the same, stylistic development in these countries took different paths. Thai and Cambodian art, somewhat difficult to differentiate in their earliest manifestations, later become more and more divergent, more individual, and more easily distinguishable. Successive waves of Indian influence can be detected, some of them from Bengal and some from the Pallava empire in southeastern India. Cambodian art ended in the fifteenth century, when Thai military power destroyed Angkor, after which the Cambodian style persisted only as a native folk art.

At Sambor Prei Kouk is a small group of shrines of the sixth or seventh century C.E., antedating the cult of the *devaraja* (*fig. 327*). Their interest lies in their Indian origins and in their physical insignificance compared with the later, magnificent monuments of the cult of the *devaraja*. Each shrine is fundamentally a single cell, like the Durga Rath at Mahamallapuram, its entrance flanked by niches containing images of the deity worshiped inside. Under

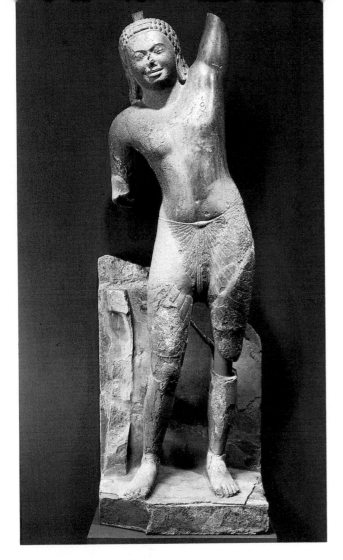

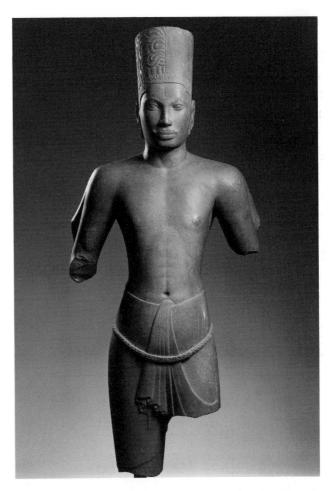

328. *Krishna Govardhana.* Gray limestone; h. 8' (2.4 m). Phnom Da, Cambodia. Early Khmer, 1st half of 6th century C.E. Cleveland Museum of Art

329. *Harihara.* Stone; h. 45½" (115.5 cm). Prasat Andet style, Cambodia. Pre-Angkor period, c. 675 C.E. Kimbell Art Museum, Fort Worth

the stone dressing the basic structure is brick; this too marks it as primitive, for the later development and glory of Cambodian architecture is embodied in stone.

The sculpture of the sixth to the ninth century C.E., which we call early Khmer, is of greater artistic interest than the architecture. Although the new sculptural style was derived from the Gupta manner of India, it seems to have acquired from the beginning a monumental and architectonic character radically different from its Gupta antecedents. The earliest sculptures are of one type, with the S-curve (*tribhanga*) of the body, magnificent squared shoulders, a large chest, and a delineation of the torso that is completely unknown in most Indian sculpture.

Many of these early sculptures apparently come from southern Cambodia, from such sites as Phnom Da and Angkor Borei. Stylistically related stone images of the same or slightly earlier date have been discovered directly across the gulf in peninsular Thailand, and both these and the Cambodian sculptures have antecedents in south India and Sri Lanka. Many of the images, from both sides of the gulf, represent Hindu deities heroic in size, monumental in bearing, majestically at ease. One of the most extraordinary of these productions is the *Krishna Govar-*

dhana (*fig. 328*), a work that ranks high in a world hierarchy of sculpture. The god is shown holding aloft the mountain as shelter for his devotees. The fusion of stress and superhuman ease is a complex problem not often assayed in early Cambodian art, and the solution here serves to raise the work above more iconic sculptures found in the same area.

The earliest purely Khmer sculptures, properly enough, still retain a certain sensuousness derived from the Gupta style. Later sculptures, of the seventh and eighth centuries C.E., have a far more powerful and architectonic character, exemplified in two very similar images of the deity Harihara. One, from Prasat Andet in the north, east of the lake Tonle Sap, is now in the Musée Guimet in Paris; the other, dated to circa 675 C.E., is in the Kimbell Art Museum (*fig. 329*). In both images the cylindrical crown, intense expression, heavy moustache, and powerful, athletic body are expressive of the transcendent authority of the subject—the great gods Shiva and Vishnu united in the single compound image Harihara. Unobtrusive linear incisions and precisely geometricized hanging folds suggest the draped loincloth (*dhoti*), and this careful understatement does much to emphasize

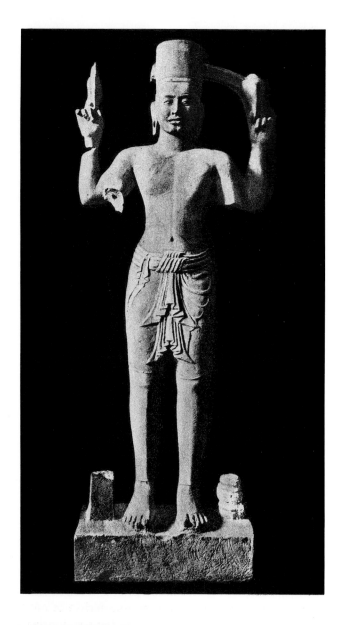

330. *Vishnu.* Sandstone; h. approx. 60" (152.4 cm).
Phnom Koulen, Cambodia. Koulen period, 1st half
of 9th century C.E.

the firm, architectonic character of the body. Like its counterpart in the Musée Guimet, the whole figure must originally have been backed by a stone *mandorla*, which was both an iconographic requirement and a practical means of supporting the mass of stone above the slender, fragile ankles.

In the royal temple-mountains, the mountain (or constructed elevation), which symbolizes the axis of the universe, must be incorporated in the temple itself, becoming an integral part of its architectural organization. The beginnings of this development consist in a simple cell-shrine of the type found at Sambor Prei Kouk, located on top of a natural holy eminence. This is the form of the first temple-mountain, established by Jayavarman II on Phnom Koulen (the Hill of Koulen) at the beginning of the ninth century as the earliest site of the cult of the *devaraja*. From this very simple beginning, a shrine on a natural elevation, the great complex stone architectural monuments of Angkor Vat and the Bayon in the region of Angkor were to develop.

The Koulen site is also important because it produced a sculptural style that marks the transition from the early Khmer to developed Angkor styles. This relatively complete image of Vishnu from Koulen (part of the body halo is missing) shows the god holding the disk, or wheel (*chakra*), as his principal attribute (*fig. 330*). Though the image retains something of the architectonic character of early Khmer sculptures, the lower limbs have begun to be modified. From the hips down, and particu-

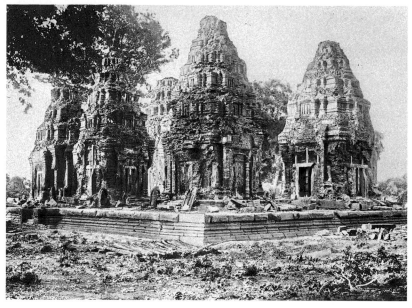

331. *Preah Ko.* Roluos, Cambodia. 879 C.E.

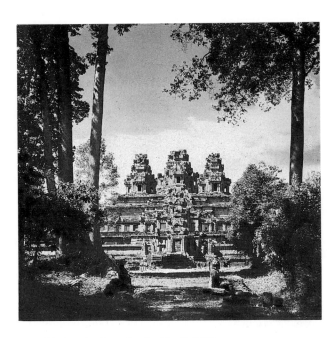

332. *Ta Keo.* Angkor, Cambodia. C. 1000 C.E.

Cambodian art is generally divided into three periods: early Khmer, also known as Pre-Angkor, from the sixth to the late ninth century C.E.; the First Angkor style, from the late ninth to the beginning of the eleventh century; and the Second style of Angkor, from the beginning of the eleventh to the beginning of the thirteenth. The First style of Angkor introduces increasing architectural complexity. In the development that leads to Angkor Vat, two significant steps are represented by the temple complexes of Preah Ko, dated to 879 C.E. (*fig. 331*), and Ta Keo, dated to about 1000 C.E. (*fig. 332*). Preah Ko is of mixed construction, brick and stone, and is more complex and developed than Sambor Prei Kouk. Its six shrines, though single cells, are now grouped on a common pedestal. The architects have abandoned the concept of a shrine standing on a natural mountain and have begun building a microcosm that symbolizes the mountain. But the combination of the two is not yet organic. Ta Keo, on the other hand, offers a full statement of the essentials of the great Cambodian architectural style: a central shrine flanked by four subsidiary shrines, each shrine surmounted by a tower. All this is made of stone and placed on a five-stepped pyramid of stone which represents the mountain. The beginnings of galleries encircle this structure. In the background near the palms, at the outer wall of the lowest level of the pyramid, there is a series of columns indicating a gallery around the whole structure. These essentials—towers of stone on a raised pyramid with surrounding galleries—are the basic elements of almost all later Cambodian architecture.

The development seen in architecture is paralleled in architectural ornament. We illustrate a sequence of three lintels in stone that span the time traveled so far. Figure 333 is early Khmer, figure 334 is a transitional example, corresponding to the style of Koulen. Figure 335 is from Banteay Shrei, a temple complex founded in 967 C.E., twelve miles north of Angkor, by a Brahmin aristocrat who served as royal tutor. Looking at the first, one can see that it is related in general format to the south Indian

larly from the knees down, the modeling seems much less sensitive than on the early Khmer pieces. As in much of later Cambodian sculpture, artistry seems to end at the waistline; the legs become rigid and inanimate, almost like tubes, while the upper part of the body retains the earlier sensitivity and finesse and the head begins to show, particularly in the modeling of the lips, something of that sensuous and romantic quality which has so endeared Cambodian sculpture to the modern world. The mysterious smile of Angkor is beginning to play about the corners of the mouth. The drapery, too, is developed into a larger and more important part of the composition, a decorative motif in its own right. Its folds are emphasized in relatively high relief, not simply incised on the surface of the sculpture. This tendency toward a decorative handling of drapery and accessories is characteristic of later Cambodian sculpture.

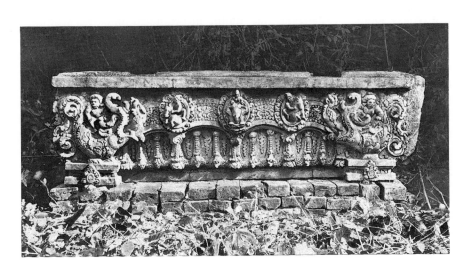

333. *Lintel, from Sambor Prei Kouk.* Sandstone. Cambodia. Early 7th century C.E. Musée Guimet, Paris

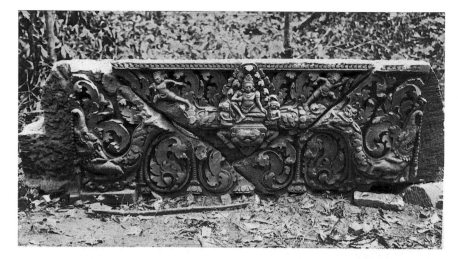

334. *Lintel, from Phnom Koulen.*
Sandstone. Cambodia.
Early 9th century C.E. Musée
Guimet, Paris

335. *Lintel, from Banteay Shrei.*
Sandstone. Cambodia.
10th century C.E. Musée
Guimet, Paris

architectural style. The little roundels correspond to the windows at Mahamallapuram (*see figs. 258, 259*). The *makaras* (dragon-fish) at either end are a typical south Indian and Sinhalese motif, as are the hanging jeweled garlands. Note, too, how the whole design is held in bounds by a heavy border above and below, and that this border is repeated within the sculptural decoration, allowing the lintel to retain its architectural character. Compared with what is to come, the carving is not insistent and does not yet dominate the shape of the lintel. The second lintel (*fig. 334*) is sculpturally much more elaborate. The carving breaches the architectural boundaries of the lintel and so breaks up its surface that the design tends to become an overall pattern. The third illustration (*fig. 335*) pictures a lintel of the First style of Angkor, and gives some idea of the beginnings of the last style in Cambodian architectural sculpture. Architectural

structure is now at a minimum; it is reduced to a small beaded border, and the form of the arch has become a hanging vine motif, incorporated into the sculptural foliage dominating the whole composition. Peering into this deeply cut vegetative ornament, one can make out *makaras*, lions, and small figures. But these figures are so intertwined with the foliage that the whole effect becomes jungle-like. This type of architectural ornament—showing a profusion of vegetable motifs, an abhorrence of empty space, and a desire to cover every possible area with as much carving as possible—is characteristic of the developed Cambodian style.

One monument provides us with a classic example of relief sculpture in the early First style of Angkor. Banteay Shrei is dated to 967 C.E., based on the incontrovertible evidence of inscriptions. The whole question of the dating of Cambodian sculpture and architecture is

336. *Side sanctuary, Banteay Shrei*. Cambodia. General view.
2nd half of 10th century C.E.

337. *Tympanum relief, Banteay Shrei*. Sandstone. Cambodia.
2nd half of 10th century C.E.

one of the most fascinating bypaths in art history. Before 1929 an apparently satisfactory system of dating had been proposed by French scholars. Then Philippe Stern published a small book called *Le Bayon d'Angkor et l'évolution de l'art Khmer*, completely reversing the accepted chronology and proving conclusively that monuments previously assigned to the thirteenth century were really of the ninth, and that monuments which had been considered ninth and tenth were of the thirteenth century. This was one of the most striking reversals in the dating of an important body of material ever published, as if European art historians had suddenly discovered that they had been transposing the dates of Romanesque Conques and Gothic Amiens.

Banteay Shrei is the key monument in this sequence (*fig. 336*). It is a jewel of a shrine complex, with important lintels showing scenes from the *Ramayana*. Note the character of the upper architectural ornament, a botanic

maze surrounding the arches. The arches themselves have taken on an undulating, almost snakelike, movement in keeping with the spirit of the carving. Inside these sinuously profiled arches the scenes are formally, almost symmetrically arranged, as on the tympanum, which shows a central figure, flanking figures in reversed poses, and finally figures balancing the lower part of the composition on each side (*fig. 337*). This carefully balanced, rather static composition is characteristic of the single-scene reliefs of the First Angkor style. Above the central figures are two flying angels. Compared with the similarly placed flying angels on the walls of the Kailasanatha of Ellora, with their boundless energy and their striking effect of movement, these Cambodian angels are frozen to the wall; they do not move, much less fly. They are stone embodiments of the relatively static tendencies of Cambodian figure sculpture.

The sculpture in the round is of even greater interest.

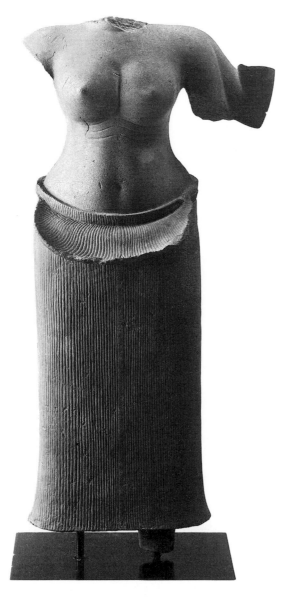

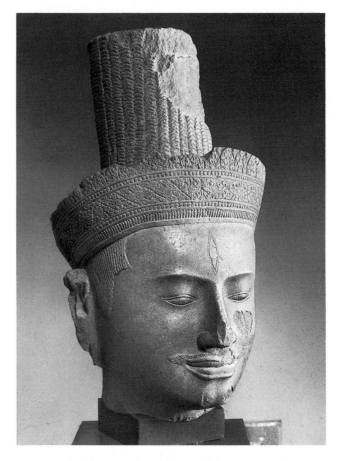

338. *Torso of female deity.* Stone; h. 35" (88.9 cm). Cambodia.
10th century C.E. Cleveland Museum of Art

339. *Head of Shiva.* Sandstone; h. 16¹/₂" (41.9 cm). Style
of Koh Ker, Cambodia. 2nd quarter of 10th century C.E.
Cleveland Museum of Art

Two basic manners are associated with the First Angkor
style, one with the monument at Koh Ker, and one with
the royal temple-mountain in Angkor called the Ba-
phuon. The Koh Ker style can be fairly seen in a relatively
complete and characteristic female image (*fig. 338*). The
drapery has increased in extent and depth of modeling to
become a strong architectural and decorative part of the
composition of the figure. The female torso in figure 338
is a standard example of Koh Ker style, but the head of
Shiva in figure 339 is at the very summit of Cambodian
sculpture and shows the style of Koh Ker at its most su-
perb. The head is carved as an architectural unit; the skin
of the stone is preserved, except for the high relief of nose

and lips. Everything else is kept on the surface or breaks
the surface as little as possible, so that when the piece is
viewed in flat, frontal lighting almost all of the ornament
and the cutting disappears. But in sharply raking light
we can see a fine and subtle pattern, built not only in the
ornament of the headdress but also in the treatment of
the hair and moustache, the incising of the lines for the
eyes, and the double outlining of the mouth. All this is
rendered with extreme delicacy, hardly breaking the skin
of the stone, and producing an effect simultaneously ar-
chitectonic and sensuous. This combination of two seem-
ingly incompatible ideals makes Cambodian sculpture a
unique expression, the best of it equal to the greatest

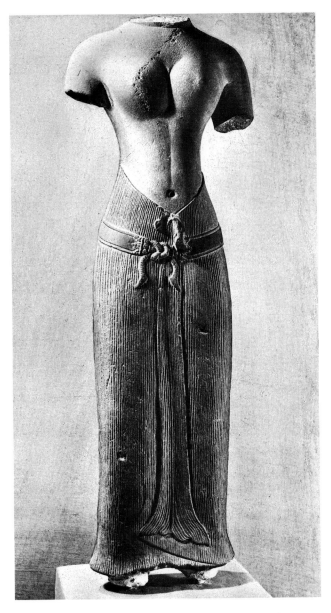

340. *Female torso.* Sandstone; h. approx. 48" (121.9 cm).
The Baphuon, Angkor, Cambodia. Mid-11th century C.E.
National Museum, Saigon (Ho Chi Minh City)

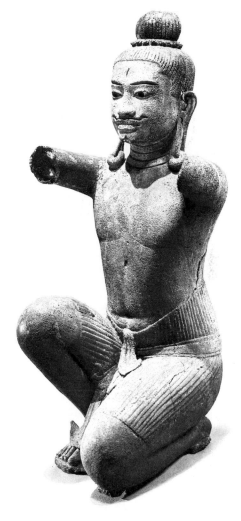

341. *Kneeling male figure.* Bronze; h. 17" (43.2 cm). Cambodia.
C. 1010–1080 C.E. Cleveland Museum of Art

sculpture in the world.

The later manner of the First Angkor style is that of the Baphuon, illustrated here by a typical female torso with a long skirt (*fig. 340*). The drapery now is not modeled in such high relief as at Koh Ker; the girdle is suppressed and tends to cling closer to the body. The whole figure still retains a strong architectonic character, strengthened here by the columnar appearance created by the ribbed ankle-length skirt.

In addition to the stone images, numerous smaller images were made in bronze during the First and Second Angkor periods. Most of these are ex-votos—small private altars or images—principally Hindu and most often

associated with Vishnu, though Buddhist images are often found (*fig. 341*).

The Second Angkor style, considered by many the classic Khmer style, is exemplified in the two most famous monuments of Cambodian art, Angkor Vat and the Bayon, the two great temple complexes respectively outside and inside the walls of the ancient capital at Angkor. It is possible to write the history of Cambodian art after the early Khmer period by reference to Angkor alone. It was the capital, and in and around it are most of the architectural and sculptural monuments built by each god-king to symbolize his merit and his divine authority. Angkor Vat was built by Suryavarman II, who

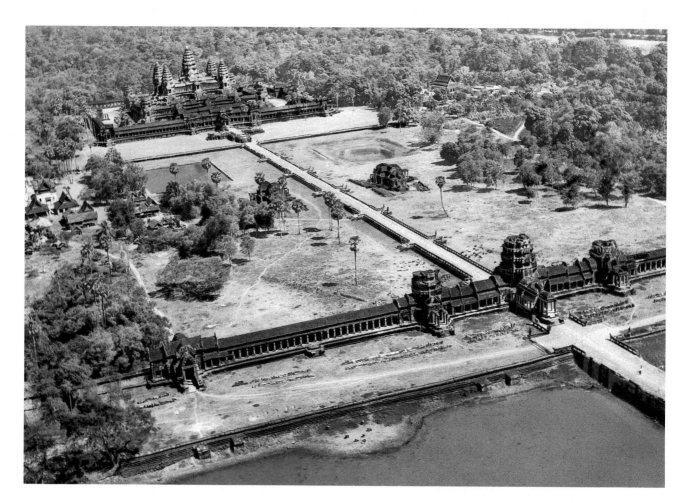

342. *Angkor Vat, Cambodia.* Aerial view. 1st half of 12th century C.E.

reigned from about 1113 to 1150 C.E. The aerial view of this great monument reveals that it is largely an elaboration and enlargement of the architectural model set by Ta Keo (*fig. 342*). At both monuments the main pyramid is surmounted by a central tower and towers at the four corners, but the elaboration of the galleries is carried much further at Angkor Vat and the size of the ensemble is enormously increased. The outermost enclosure, which encompasses the moat, measures nearly a mile by about three-quarters of a mile. The aerial view shows the one moat still in existence, with two water tanks beyond it in the best south Indian tradition, but it gives no idea of the splendor or magnificence of the ensemble as it was in the twelfth century. For that we must examine a ground plan (*fig. 343*), which gives some idea of the tremendous size of the complex, with its great surrounding moat, the causeway over the moat leading to the exterior gallery wall, and the multiplication of these gallery walls, particularly along the main approach to the central shrine, all on a scale unknown before in Cambodia. The gallery roofs are corbeled; the arch was not used. Corbeling requires a high roof line, so there is a considerable expanse of roof and all of the side corridors and galleries are rather tall. A corbeled vault leads up to the main shrine, which is enclosed by a great tower.

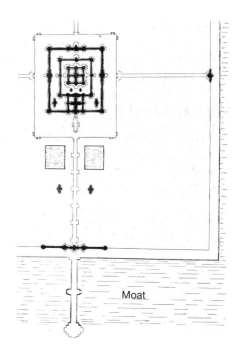

Moat

343. *Plan of Angkor Vat, Cambodia*

344. *Celestial dancers.* Sandstone. Angkor Vat, Cambodia. 1st half of 12th century C.E.

345. *Army on the march.* Sandstone. Angkor Vat, Cambodia.
1st half of 12th century C.E.

Angkor Vat was dedicated to the god Vishnu, and most of the sculptures represent the various avatars of Vishnu. Before turning to the principal Vaishnavite relief, let us examine a characteristic grouping of architectural sculpture at Angkor Vat. The exterior walls of many of the galleries are decorated above the plinths with figures of dancing celestial beauties, the same motifs seen in India, but treated here in a peculiarly Cambodian way (*fig. 344*). After construction of the temple they were carved into the sandstone of a relatively plain wall, so that they appear more related to the architecture than do the high reliefs and undercut relief carvings of the later Indian medieval school. The development of the drapery, the starched, band-shaped, heavy belts, and the complexity of the high headdresses show a decorative emphasis quite different from that of India. Each face wears the smile of Angkor, some to the point of caricature.

The interior walls of the galleries are carved in exceedingly low relief, almost as if painted in stone. Their subject matter is tales of Vishnu in his various incarnations. One relief reveals an army on the march, a scene from the *Ramayana*, in which the Cambodians have depicted their own soldiers as the forces ranged under Ravana and Rama (*fig. 345*). Note the *horror vacui;* every

inch of the stone is carved with either jungle foliage or figures. Note, too, the rather awkward movement of the figures and their lack of narrative value. All the figures and their accoutrements are shown clearly and in detail, a great boon to the sociologist, anthropologist, and historian of costume, but they are static and decorative, a pattern rather than a depiction of action. In a combat scene (*fig. 346*) certain figures are livelier and their postures more active, but the emphasis is still upon drapery patterns and static poses, as in figure 345. The warriors appear frozen in the postures of a ritual dance. There are no more complicated representations of numerous figures in all of Oriental art than in these relief sculptures at Angkor Vat. Compared with the great variety of the low reliefs at Angkor Vat, those simple little bands of figures in the reliefs of the *Ramayana* at Ellora (*cf. fig. 276*) seem the work of elementary and rather backward artists.

One of the most famous scenes at Angkor Vat illustrates the story of the Churning of the Sea of Milk (*fig. 347*). This story exists in several variants, but all of these are centered on Vishnu in his tortoise avatar. In one version the gods and demons (*asuras*) made a truce in order

346. *Detail of a combat.* Sandstone. Angkor Vat, Cambodia. 1st half of 12th century C.E.

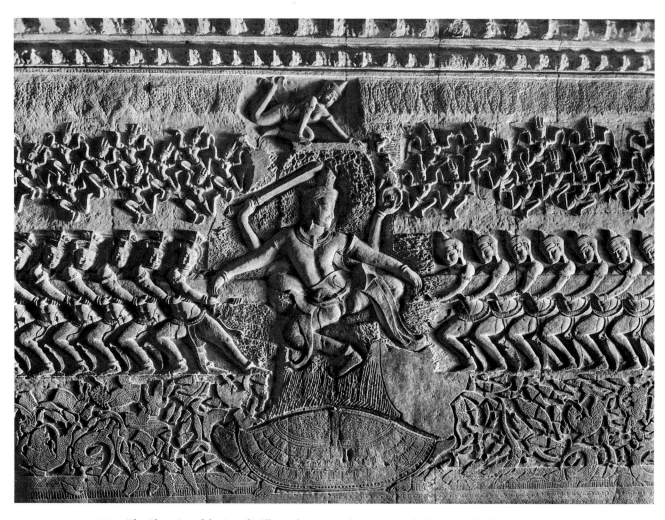

347. *The Churning of the Sea of Milk.* Sandstone. Angkor Vat, Cambodia. 1st half of 12th century C.E.

348. *The Bayon.* Angkor Thom, Cambodia. General view. Late 12th–early 13th century C.E.

to recover various treasures, including the Dew of Immortality (*amrita*), from the Sea of Milk. This they did by churning the Sea, using the World-Mountain as the dasher with the serpent-king Vasuki wound around it as the churning cord. As the Mountain began to sink in the Sea, Vishnu, assuming his avatar (a saving manifestation) of the tortoise, placed himself beneath it and supported it. The Sea gave forth various delights, ending with the Dew, which Vishnu then obtained for the gods alone by assuming the form of a desirable woman, Mohini, who seduced the *asura*s into abandoning the elixir. The gods then succeeded in defeating the demons, and thus Vishnu reconstituted the balance of good and evil.

349. *Bridge balustrade representing the Churning of the Sea of Milk.* The Bayon, Angkor Thom, Cambodia. Early 13th century C.E.

In the relief Vishnu appears twice, once as deity guiding the operation, bearing his attributes of mace and discus, and once, below, in his tortoise avatar. The relief is so low that, like the *rilievo schiacciato* of Italian Renaissance sculpture, it is a painting in stone; unlike the Italian relief, it is not flowing and naturalistic, but formal and hieratic, with an especially effective use of silhouetted forms against textured grounds. Because of their rhythmical repetition, these reliefs resemble an exotic, noble, and measured ritual dance, not unlike those traditionally performed by the court dancers of Cambodia.

The end of the Second Angkor style is to be found at Angkor Thom, in the great stone mass of the Bayon built at its center by Jayavarman VII, who reigned from about 1181 C.E. until about 1218 (*fig. 348*). The last of the great temple-mountains, the Bayon, is also the first to have

been erected as a Buddhist monument, dedicated to the bodhisattva Lokeshvara, a manifestation of the most popular of all Buddhist deities, the bodhisattva Avalokiteshvara. At the same time the Bayon includes representations of Hindu gods. It appears neither Buddhist nor Hindu, but a syncretic Cambodian monument truly expressive of the character of Jayavarman VII, the god-king, the *devaraja*. One enters the Bayon over a bridge (now spanning only dry land) whose balustrade illustrates a Hindu myth: Giant figures of gods and demons are holding a long serpent, enacting the Churning of the Sea of Milk (*fig. 349*). The Bayon itself is a forest of towers of the most curious appearance: Carved on all the towers are gigantic faces of the deity Lokeshvara or, more probably, of Jayavarman himself (*fig. 350*). From Angkor, the symbolic center, he surveys the four directions, a multiplied image of the vis-

350. *Detail of central towers of the Bayon.* Angkor Thom, Cambodia. Late 12th–early 13th century C.E.

age of the god-king looking out from the great central mass of towers over the kingdom of Cambodia. The architectural character of the building has begun to be lost; instead we are confronted with something that is, at least in theory, more like Hindu architecture—a work of sculpture rather than of construction. A closer look at some of the towers shows how completely sculptural rather than architectural they are. The sculptural style has also changed; the smile of Angkor has broadened, the lips are thicker and the nose flatter. The modeling of the face, too, shows less emphasis upon linear incision and more on sensuous and rounded shapes. These are the most characteristic elements of the last style of Angkor.

THE ART OF CHAMPA

The kingdom of Champa, which existed in the south of Vietnam from about the third century C.E. to 1471, de-

pended for a large part of its income on piracy and was one of Cambodia's principal military and political rivals. Its history was one of constant warfare and frequent subjugation—by the Annamese, the Chinese, the Mongol conquerors of China, the Javanese, and the Khmer. Reduced to vassalage and then annexed by the Khmer in 1145 C.E., the Chams seized their revenge in 1177, when they captured Angkor and sacked it. It was a short-lived triumph; Jayavarman VII built the Bayon to celebrate his defeat of the Chams in 1181, and to replace shrines destroyed by them.

Cham architecture generally parallels Cambodian in its appearance and stylistic evolution but tends to be higher, more massive, and simpler in plan. The principal difference is in material: The Cambodians (from about the ninth century) built in stone, the Chams in brick.

The evolution of Cham art can be traced best through its stone architectural decoration rather than through the monuments themselves, which changed rela-

351. *Seated Shiva.* Brown sandstone; h. 34" (86.4 cm). Dong-duong, Vietnam (Champa). 9th century C.E. Cleveland Museum of Art

352. *Celestial dancer.* Sandstone; h. approx. 36" (91.4 cm). Mi Son, Vietnam (Champa). 10th century C.E. Museum at Da Nang, Vietnam

tively little in plan and conception. A chronological sequence of styles was established, as it was for Cambodia, by the French scholars of L'Ecole française de l'Extrême Orient. Unfortunately, though we know the sequence of styles, we do not know their absolute dates. The sequence comprises five in all: first, an early style; second, the style of Hoa Lai: third, and most important, the style of Dong-duong; fourth, Mi Son; and fifth, Binh Dinh, a style that corresponds typologically to the development of a folk style in Cambodia.

In sculpture the most important style by all odds is that of Dong-duong. It is a mixed native Cham and Javanese style, and (in contrast to Khmer art) its most characteristic products are images, not of Vishnu, but of the god Shiva. The seated image of Shiva in the Cleveland Museum is the only complete Cham image in the United States, and one of a very few outside of Champa proper (*fig. 351*). Dong-duong art, as revealed in this image, is highly individual and quite different from that of Champa's nearest neighbor, Cambodia. The blocklike character,

based upon the original cube of stone, is paramount. Nearly all of the Dong-duong sculptures, whether standing or seated, are represented upon a heavy plinth; this plinth is in fact the lower part of the stone block from which the sculpture was made, and it determines the positions of the arms and legs. Equally characteristic of Cham art and, again, very different from Cambodian, is a certain broad, even coarse treatment of shape, which makes the male faces almost animal-like. Architectural strength is combined with physical coarseness, and the result is a powerful style but one less well known and represented by fewer examples than the art of Cambodia. The style of Mi Son is also of great interest, and it produced some ravishing figures of celestial dancers, derived from Gupta and Pallava sculpture (*fig. 352*). In the Binh Dinh style we find a final development along the lines of folk art, with an emphasis on grotesque dragons and other monsters, rendered with an abundance of decorative detail. The type is familiar from the present-day folk arts of Southeast Asia.

Medieval Art of Southeast Asia and Indonesia　　277

We have already considered perhaps the greatest monument of Javanese art, the Great Stupa of Borobudur. This Buddhist monument is so justly famous that it dominates the artistic map of Java. But we must remember that Javanese art began under Hindu influence, and despite the dominance of Buddhism in the eighth and the first half of the ninth century, a resurgent Hinduism prevailed until the triumph of the Muslims in the late fifteenth century. From about 750 to 850 C.E. the Shrivijaya kingdom, ruled by the Shailendra dynasty from the capital on Sumatra, was at its apex.

Though Buddhism was then dominant, numerous Hindu shrines, based upon single-celled south Indian prototypes, were built in the early eighth century on the Dieng Plateau of central Java. They are relatively well preserved, and two sites are of particular importance. One of them is Chandi (temple or shrine) Puntadeva (*fig. 353*). The Shailendra patrons adopted the high base of the Pallava style (seen, for example, at Kanchipuram, and much elaborated at Ellora), with projections containing niches added all over the face of the building, even more than in the usual south Indian style. There is also a playful use of curves over the main door and on the balustrades up the steps to the main shrine, and a further playfulness in the handling of detail, elements we will find recurring in Javanese architecture.

The second shrine, Chandi Bima, is unexceptional except for its tower (*fig. 354*), which is carved with large *chaitya* hall openings enclosing relief heads derived from motifs found at Mahamallapuram and elsewhere in south India. But fundamentally Chandi Bima is still a simple cell, with one entrance from the front through a small porch to the shrine proper. Most of the Dieng Plateau shrines are dedicated to Vishnu or Shiva—more often the latter.

After the period of Buddhist dominance there followed a distinct Hindu revival under the Javanese rulers of 850 to 930 C.E. This Hindu revival produced the principal monument of Hindu art on Java, the great temple complex called Loro Jonggrang, at Prambanam on the Dieng Plateau. Like the monuments of Cambodia, it is a shrine on a high constructed terrace symbolizing a mountain (*fig. 355*). The principal temple is dedicated to Shiva and the two smaller temples flanking it to Brahma and Vishnu. Thanks to restoration, the appearance of the Shiva temple is no longer problematical; one can see that it is a shrine placed upon a high-terraced pedestal. Reliefs encircle the terraces, usually composed of groups of three figures set in niches. The sculptures on the Prambanam (as Loro Jonggrang is often called) deal not only with Shiva but also with such Vaishnavite epics as the *Ramayana*. They show a continuation of the Shrivijaya style of Borobudur, but with certain distinctive new elements indicating the future direction of Javanese sculpture. The

principal figure of Shita as she is being carried off by Ravana, for example, is represented in the classic Shrivijaya style, in turn derived from the Indian Gupta style (*fig. 356*). The attendant servant girl, on the other hand, is represented quite differently. Here we see an exaggeration of hairdress, of ears, of protruding eyes, of sharp and

353. (opposite above) *Chandi Puntadeva.*
Dieng Plateau, Java. 1st half of 8th
century C.E.

354. (opposite below) *Chandi Bima.*
Dieng Plateau, Java. 1st half of
8th century C.E.

355. (right) *Chandi Loro Jonggrang.*
Prambanam, Java. C. 856 C.E.

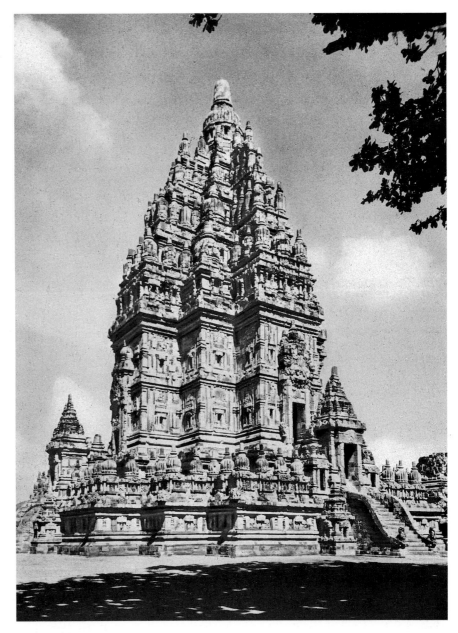

356. *Scene from the Ramayana.* Relief;
lava stone; h. approx. 24" (61 cm).
Chandi Loro Jonggrang,
Prambanam, Java. C. 856 C.E.

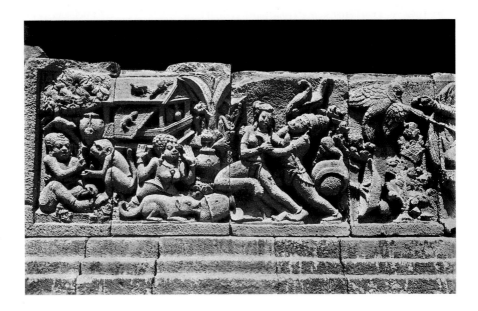

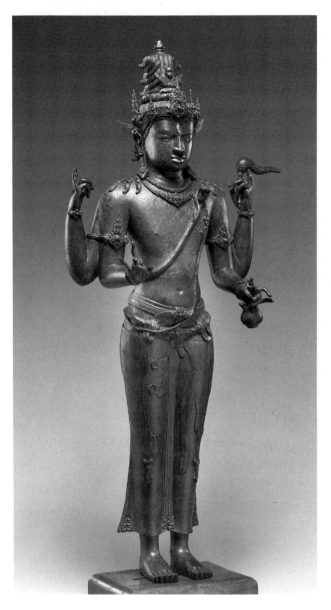

357. *Shiva Mahadeva.* Bronze inlaid with gold and silver; h. 42³/₈" (107.5 cm). Tegal, north central Java. 9th century C.E. National Museum, Djakarta

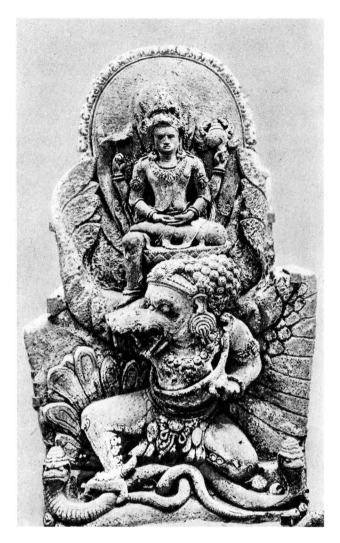

358. *Erlanga (?) as Vishnu.* Reddish tufa; h. 6'3" (1.9 m). Belahan, Java. C. 1042 C.E. Municipal Museum, Mojokerto, Java

rather prominent teeth, along with an odd physique that includes a square and angular shoulder line, large, pendulous breasts, and peculiarly large extremities. This tendency to caricature becomes the principal characteristic of the later Javanese style known so well to the West through the Javanese shadow puppets. The rest of the sculptural relief at Prambanam shows the elaboration of this most interesting and rich narrative style, involving the representation in stone of architecture and plants against the relatively plain landscape background developed earlier at Borobudur.

Javanese metalwork has always been outstanding. Artists in metal developed a distinctive technology and style, rich, detailed, and beautifully finished, accomplished in a variety of alloys as well as in gold and silver. Their mastery appears in bronze bells for both Hindu and Buddhist rituals, in palanquin and barge fittings, in small icons for private devotions, in larger three-dimensional temple mandalas, and in religious images of considerable size. Details of ornament show beaded motifs in profusion, while draperies, hands, and bodies seem fluid and sensuous.

Almost no large images have survived; demonstrating the great loss this has been to Javanese art is a Shiva Mahadeva (Shiva as the Great God; *fig. 357*), found by accident in 1933 on the northern coast of central Java. Inlaid with silver and gold for eyes and lips, respectively, this comparatively sizable image is an epitome of the par-

359. *Goa Gadjah (Elephant's Cave).* Bedulu, Bali. 11th century C.E.(?)

ticular contributions of the Javanese bronze sculptor. Crown, jewelry, and girdle display fine beaded decorative details, while the undulating modeling of legs and torso attest the artist's command of metallic surfaces. The stern visage and erect posture are appropriate to Shiva as a supreme Hindu god and quite in contrast to the usually benign and contemplative demeanor of Javanese Buddhist images.

The period of Hindu revival is followed by one described by Dutch scholars as the "intermediate period," when the capital was in east Java, not on the plateau. The reign of Erlanga (1010–1042 C.E.) is especially important, marked by the rise of a national literary language called *Kawi,* and of the theater and shadow plays, among other arts. One of the most interesting productions of the whole reign is an image of Vishnu, carved about 1042 in the characteristic volcanic stone of the island (*fig. 358*). The individualized, rather pinched face, possibly a portrait of the god-king Erlanga, is curiously combined with the classic Gupta type of the body of Vishnu. Below, a huge Garuda, vehicle of Vishnu, tramples upon a snake.

Embodied in Garuda and dominating the sculpture are elements that the Javanese particularly liked—exaggerated movements and grotesque animal and human forms. One of the most striking examples of this "grotesquerie" is the eleventh(?) century Goa Gadjah—Elephant's Cave—at Bedulu on Bali, where a colossal mask, part *kirttimukha,* part witch, seems to emerge from a natural mountain thickly ornamented with carvings in the living rock (*fig. 359*).

The last phase of Javanese art, before the coming of the Muslims and their final triumph in 1478 C.E., is called the East Javanese period, encompassing the full development of the native, or *wayang,* style, the well-known style of the shadow theater. A typical monument of the late period is Chandi Djabung, a circular brick temple built before 1359 (*fig. 360*). Here we see the most characteristic element of the later architectural style: the great monster masks (*kala* or *kirttimukha*) over the entrances. These "masks of glory," which on Hindu temples in India and even on earlier Javanese temples are subordinated to the architecture, increase in size until they seem almost to

360. *Chandi Djabung.* Java.
Mid-14th century C.E.

361. *Kala head.* Lava stone;
h. 45" (114.3 cm).
Chandi Djago, Java.
C. 1268 C.E.

362. *Ramayana scene, from Chandi Panataran.* Stone relief; h. 27¹/₂" (69.9 cm). Java. Early 14th century C.E.

overpower the rest of the structure. The single mask from Chandi Djago probably dates from the later thirteenth century (*fig. 361*).

Brick was also used for smaller, clustered shrines, as at Chandi Panataran, an informally planned temple complex built in the fourteenth and fifteenth centuries. The sculptures of the main temple, which depict scenes from the *Ramayana* and the *Krishnayana,* are of particular interest because they offer the first full statement of the *wayang* style, which was to last until modern times (*fig. 362*). The *wayang* mode dispensed with the plasticity and roundness inherited from the Pallava and Gupta styles. Instead, the relief was flattened by deep but unmodulated cutting, which produced an effect of silhouette against a dark background. The grotesque profiles and physical conformations so depicted were flat sculptures resembling shadow puppets. But some fragmentary earthenware figurines from Trawulan, capital of the Majapahit dynasty of eastern Java (1293 C.E.–end of fourteenth century), treat such attractive subjects as princesses or celestial beauties with a subtlety and graciousness that rival the finest achievements of the Gupta sculptors of India (*fig. 363*).

363. *Head of a figurine.* Earthenware; h. 3¹/₄" (8.3 cm). Trawulan, Java. 15th century C.E. Trawulan Museum

Medieval Art of Southeast Asia and Indonesia **283**

364. *Relief landscape.* Stone;
h. 19⅝" (49.8 cm). Old
Mosque, Mantjingan,
Java. 1559 C.E.

The *wayang* style continued in outlying areas beyond the reach of the Muslim rulers, particularly in Bali. Even some of the old mosques, including one dated to 1559 C.E., were decorated with nonfigural reliefs in a rich *wayang* manner, mostly devoted to pictorial treatment of the lush tropical landscape (*fig. 364*).

PART FOUR

*Chinese,
Korean, and
Japanese
National
Styles and
Their
Interplay*

12

The Rise of the Arts of Painting and Ceramics in China

We must recapitulate certain elements of Chinese art in order to reestablish our position in time and space. Even during the Buddhist ascendancy—in the period of the great cave sculptures and religious paintings—native Chinese forms and styles continued. In the collapse of the Han dynasty the educated governing class fled south in great numbers, there to establish itself in many of the short-lived dynasties that succeeded one another at Nanjing, afterward collectively termed the Six Dynasties. Here, in contrast to the foreign-ruled and predominantly Buddhist north, Confucianism persisted, albeit in a decline related to the political fragmentation and weakness of the Six Dynasties. Daoism too, though much diminished after the end of Han, continued to imitate and compete with Buddhism. The high Daoist tradition, represented by the philosophy and metaphysics of the *Dao De Jing,* continued to influence painting; the lesser, popular Daoist tradition of magic and alchemy was expressed in the iconography of certain ceramic figures as well as in the literature of the time. It is not surprising that the first great advances in the scholarly arts—calligraphy and non-Buddhist painting—took place in the south, where the Confucian tradition endured most strongly.

Sculpture

The continuity of native traditions is notable in the subsidiary sculpted figures of Buddhist stelae and in cave-temples. Here the Zhou and Han spirit persists in the conformation and vigorous linear handling of the various dragons, lions, chimeras, and fabulous birds. In the Buddhist cave site of Xiangtangshan were found grinning chimeras, originally caryatids beneath pillars flanking a niche containing a Buddhist image (*fig. 365*). One of these squatting figures, with square mouth, buck teeth, and great potbelly, forepaws planted on haunches, shows a degree of vigor and humor characteristic of the great Chinese animal sculpture of much earlier times. But there are monuments unrelated to Buddhism that possess these qualities in an even more pure and undiluted form. A whole series of great chimeras of the third and fourth centuries (early Six Dynasties period) exists, many from the Liang dynasty tombs near Nanjing, showing the vigorous, almost magical, qualities of Chinese animal sculpture (*fig. 366*). Such powerful figures flanked the "Spirit Paths" (*shen dao*) leading to the tumulus-tombs of rulers, princes, and high nobles, serving as honor guards for the funeral cortege and as protectors of the site.

367. *Tomb figurine: horse.* Earthenware; l. 8³/4" (22.3 cm).
China. Northern Wei dynasty. Cleveland Museum of Art

We find the same preservation of Han tradition in the numerous tomb figurines of the period. These are mostly of gray earthenware, unpainted or painted with slip colors, usually red, green, or yellow. They include chimeras like the stone figure from Xiangtangshan, dogs, lions, camels, and, above all, horses; and these horse figurines of the Six Dynasties period are among the most admirable Chinese animal sculptures (*fig. 367*). Many of the saddle skirts bear elaborate molded designs, linear and completely Chinese.

365. *Squatting caryatid monster.* Stone; h. 29¹/2" (74.9 cm).
Xiangtangshan, Hebei-Henan, China. Six Dynasties period, late 6th century C.E. Cleveland Museum of Art

366. *Chimera.* Dated to 518 C.E. Stone; h. 9'6" (2.95 m). Tomb of Xiao Xiu, Nanjing, Jiangsu, China. Six Dynasties period

Painting

But the most important medium for the development of native style was painting, and from the Six Dynasties period come the earliest known great Chinese masters and also the first treatises on painting and calligraphy. Xie He's (c. 500–c. 535 C.E.) *Six Canons of Painting* is the earliest of these, a text of fundamental importance in any study of Chinese painting theory. The six canons have been translated many times, but their interpretation has been open to some doubt until William Acker, in *Some T'ang and Pre-T'ang Texts on Chinese Painting,* and Alexander C. Soper, in "The First Two Laws of Hsieh Ho" (*Far Eastern Quarterly* 8), threw real light on their meaning by reference to their origin in music and calligraphy theory.

The six canons are: first and most important, *animation through spirit consonance,* qualified in Soper's translation by the phrase *sympathetic responsiveness of the vital spirit;* second, *structural method in the use of the brush;* third, *fidelity to the object in portraying forms;* fourth, *conformity to kind in applying colors;* fifth, *proper planning in the placing of elements;* sixth, *transmission of experience of the past in making copies.*

It can be seen that these canons represent general principles. Various interpretations are possible, and the first canon in particular allows great subjective latitude. Animation through spirit consonance is interpreted as a kind of resonance or rhythm in the painting, an expression of the artist's heavenly inspiration. The painting must have what the Chinese call *qi yun,* the spirit or breath of life. This criterion is thoroughly meaningful, because aesthetic quality is in the last analysis a matter of this intangible spirit or breath which the great work of art displays and which the great artist can impart. In technique and composition, for example, the works of Gerard Dou resemble Rembrandt's, but few would hold that Dou was as great a painter as Rembrandt. *Qi yun,* the life spirit, is the quality that differentiates genius from competence. Acker relates the meaning of this canon to a complex of Confucian and Daoist ideas, such as the Confucian term *li,* which is the inherent structure or principle of things, and the concept of cosmic rhythm in the *Dao De Jing.* Other commentators have suggested that this canon owes much to early writings on music and to the concept of responsive vibrations of bells and stringed instruments.

The second canon, structural method in the use of the brush, is almost equal in importance to the first, because Chinese paintings are produced with the brush— the instrument used for writing. Because the written word is not only a vehicle of culture but itself a prized element of culture, and because Chinese characters are almost wholly abstract, calligraphy was considered a more creative art even than painting. Consequently paintings were judged on the character of individual brush strokes, on the strength or weakness of a given line, or on the handling of a particular brush motif or technique. Embodied in this canon we have perhaps the most trying and difficult concept, the one that produces the greatest gulf between East and West in the judgment of Chinese painting. The Chinese judge a painting—its quality and authenticity—solely by the character of its brushwork, whereas the Westerner begins with composition, color, and texture, all qualities relatively unimportant to the Chinese. If we think of structural method in the use of the brush as being rather like the European concept of touch—of the difference between the "brush writing" of Rembrandt and Fabritius, of Seurat and Signac—then we may perhaps be able to comprehend something of the qualities that the Chinese are looking for in brushwork. Earlier critical writings on calligraphy contributed to Xie He's formulation of this canon.

The third canon, fidelity to the object in portraying forms, implies a certain degree of naturalism; when portraying a horse one is governed by the conformation of a horse. The fourth canon, conformity to kind in applying colors, applies most particularly to the use of colors in the decorative sense. It does not, according to Acker, imply that brown horses must be painted brown, but allows a certain leeway within a degree of naturalism. The fourth canon seems, therefore, related to the third. The fifth canon, proper planning in the placing of elements, involves the Western concept of composition but also, to a certain extent, qualities inherent in the first canon: The composition, the placing of elements in the picture, should correspond to principle and thus, in some degree, to natural law.

The importance of the sixth canon, transmission of past experience, lies in its expression of the consistent Chinese persuasion that what has gone before is more important than what is to come. Copying was the discipline by which the painter, through studying the brush of his predecessors, learned to control his own. Such copying was not necessarily a method of deception, but rather a way of study, of allowing one's brush to retrace the inspired hand and arm movements of great masters.

In contrast to the generalized and theoretical prescriptions of the *Six Canons of Painting* is the practical and specific approach of an earlier Six Dynasties text, Gu Kaizhi's (c. 344–c. 406 C.E.) *How To Paint Cloud Terrace Mountain* (translated by Sakanishi Shio in a little volume called *The Spirit of the Brush*). How does Gu Kaizhi say he paints? How does one paint Cloud Terrace Mountain? He says that he would place a figure at such-and-such a point, that he would paint this rock large and that one small, that he would use green here and blue there; in short, he tells you literally how he would paint Cloud Terrace Mountain. In Xie He we hear the critic speaking; in Gu Kaizhi, the artist. With only the six canons of Xie He, we might well hesitate to judge Chinese paintings. But Gu Kaizhi is stating directly and literally what he wishes to do.

368. *Instructress Writing Down Her Admonitions for the Benefit of Two Young Ladies, last scene from Admonitions of the Instructress to the Ladies of the Palace.* Attrib. Gu Kaizhi (c. 344–c. 406 C.E.). Handscroll; ink and color on silk; h. 9³/4" (24.8 cm), l. 11'6" (3.5 m). China. Six Dynasties period. British Museum, London

He is writing a painter's recipe, and his text allows us, with some modification of approach and a certain amount of training, to look at a Chinese painting and see almost as much, if somewhat differently, as a discerning Chinese viewer.

Little remains of painting from the Six Dynasties period, and much of that little is either tomb murals by provincial artisan-painters or copies of paintings incised on stone or on other hard materials. Paintings of the first rank in their original formats are pitifully few. The ravages of war in the Six Dynasties period made contemporary Chinese paintings rare even for collectors of the succeeding Tang dynasty. And by the Song dynasty even the collection formed in the late eleventh and early twelfth centuries by that most ardent and puissant connoisseur, the emperor Hui Zong, was amazingly weak in works of the early Chinese painters. Consequently we are skeptical of any painting purporting to be an original work by one of the great early masters. We have, however, a few exceedingly good copies in the style of these early masters, and one painting that seems to breathe the very spirit and style of Gu Kaizhi, to whom it is attributed. Master Gu was attached to the Eastern Jin court at Nanjing in southern China, where traditional Chinese styles and the Confucian theory of art were maintained during a period of Buddhist influence. Gu Kaizhi's subject is the *Admonitions of the Instructress to the Ladies of the Palace,* and its format is a handscroll painted on silk with ink and some color, mostly red with a little blue. Iconographically the picture is thoroughly Confucian. As the title suggests, it is a series of illustrations accompanying the text of a didactic poem of the third century C.E., setting forth rules of moral behavior proper to court ladies of the early Six Dynasties period. The very word

"admonitions" implies Confucian rectitude. At the end of the scroll (which, incidentally, is thoroughly and insensitively plastered with seals of the eighteenth century Qianlong emperor), the moral tone is confirmed by the figure of the instructress, holding a scroll of paper on which she writes, while the court ladies, who are presumably to follow her precepts, stand or kneel respectfully before her (*fig. 368*).

The painting shows impressive linear mastery, particularly in the handling of the drapery, where the effect is one of swirling and fluttering movement. The representational aspect of the picture is extremely archaic. These people look like the tomb figurines of the early Six Dynasties period. Their headgear is appropriate to the fourth century, and their voluminous garments, rather square skulls, slightly pointed chins and noses, and sloping shoulders are completely of the period. All this can be copied, but if this scroll is a copy, it is indeed an extraordinary one. Close examination of the scroll reveals a technique quite unlike the method a copyist would employ. A free preliminary drawing in pale red establishes the positions of the figures, general location of the draperies, and details of character in the faces. These indications in red are then painted over, again freely, with a black ink that dominates the red line and produces the final impression. Such a technique is a very early one. We find it, for example, on Han or early Six Dynasties tomb tiles and in the earliest Buddhist paintings of the Tang dynasty, and would presumably find it in the portable Buddhist paintings of the Six Dynasties period, if any had survived. The device implies that the artist wished to experiment with the location of the various figures and therefore did a preliminary drawing in red to establish the general layout and composition; once this satisfied him, it became the

369. *Paragons of filial piety and female virtue.* Dated to 484 C.E. One panel of a lacquer-painted wooden screen; h. of each scene approx. 7 7/8" (20 cm). Tomb of Sima Jinlong, Datong, Shanxi, China. Northern Wei dynasty. Shanxi Provincial Museum, Datong

basis of the final picture. A copyist, having the figures already disposed on the original painting, would need no preliminary drawing. We may very well have here an original masterpiece of the period and a fine touchstone for the purportedly early works that follow. None of them approaches the *Admonitions* in style or spirit; other paintings supposedly antedating the Tang dynasty are only mediocre copies of lost originals. The lacquer paintings on wooden panels discovered in 1965 at Datong, Shanxi,

in the tomb of Sima Jinlong (dated to 484 C.E.) provide stylistic confirmation of an early date for the *Admonitions* scroll (*fig. 369*). Moreover the lacquer paintings, like the scroll, illustrate Confucian values, taking their subjects from hortatory texts on filial piety and female virtue.[15]

The quality of an original can be seen in other details of the scroll. The famous scene in which the emperor talks with one of the ladies of the court has a marvelous archaic quality in its general disposition (*fig. 370*). We see a curious inverted perspective consistently followed in the upper part of the scene; the throne or dais on which the bed is placed is archaic in form, with cusped cutouts in the base in the style of Six Dynasties gilt bronzes. The shading of the draperies suspended from the canopy over the bed is schematic and arbitrary and quite unlike conventions of the Tang dynasty or later. The disposition of the figures is fairly sophisticated and the relation of the figures to their immediate surrounding is sure and convincing. The setting itself is placed in abstract space, with no indication of a room or of other furnishings around the dais. Merely the essentials for the story are stated and this, though an advance over the kind of stage we have seen in certain Han dynasty compositions, is still a long way from the developed environment for figures in Tang and Five Dynasties paintings such as *The Night Revels of Han Xizai* (*see fig. 457*).

The *Admonitions* scroll is extraordinary also in having one of the earliest representations of landscape in Chinese painting. Perhaps one of the reasons why critics are so suspicious, or rather unkind, is that the scroll offers so much. It is not just a figure painting but a complete and remarkably developed world of its own: didactically, in its moral exposition; representationally, in depicting figures in motion and from various angles; aesthetically, in its organization of line and color. To have, in addition, a landscape is almost too much. The landscape is present, however, for moral and didactic purposes. The legend preceding it reads, "He who aims too high shall be brought low," and as illustration an archer takes aim at one of the *feng-huang* or pheasants aspiring to the top of the peak (*fig. 371*). Like the "stage properties" in the other scenes (for example, the bed in scene five), the mountain is shown in isolation. It does not rise from a plain, nor is it part of a range of hills, since these are not necessary to the narrative. It is also worthy of note that it is not only an accessory landscape, but a symbolic one as well, for carefully balanced on either side of the mountain are a sun and moon, borne aloft on little cloud motifs that recall those of late Zhou and Han inlaid bronzes (*see fig. 91*). These celestial symbols are unsophisticated in comparison with the naturalistic details of the mountain proper. Indeed, they recall the celestial symbols on the painted banner of the Marquise of Dai (*see fig. 77*). Within the actual outline of the mountain is a highly developed landscape, with indications of space on plateau-like ledges, of different

370. *Bed scene, fifth scene from Admonitions of the Instructress to the Ladies of the Palace*

371. (below) *Landscape with hunter, third scene from Admonitions of the Instructress to the Ladies of the Palace*

types of trees, of rock inclines along the slope, and at the lower left a plateau with a plain above leading to a forest just over the brow. One critic finds in this animated passage proof of a later date, but the amazing development of landscape in the Han earthenware vases and hill censers makes it not at all impossible to believe that an accomplished southern master of the fourth century could achieve what we see in this scroll.

Throughout the scroll the brush line defining the images is not calligraphic. It is more like a pen line, uniformly thick, even wirelike, acting as a defining boundary around figure, drapery, or object. More flexible brushwork renders the text preceding each scene. Though there is a relationship between calligraphy and painting, it has been overestimated, especially by Chinese scholars. Early landscapes and figures reveal a use of line closer in many ways to *quattrocento* drawing than to the flexible brushwork in Song and later Chinese painting. It is not always essential to be a master of Chinese calligraphy to judge the quality of the brushwork in these early pictures.

A second handscroll associated with the name of Gu Kaizhi, now in the Freer Gallery in Washington, is *The Nymph of the Luo River*, painted on silk with ink and slight color and generally accepted as a copy of the late Tang or early Song dynasty (*fig. 372*). Other versions are in the former palace collections in Taibei and Beijing and in the Liaoning Provincial Museum in Shenyang. The Freer scroll is certainly based on an original by Gu Kaizhi, as literary records confirm that he painted a scroll of this title, and elements of the figure style, notably the draperies of the nymph floating above the stream, remind us of the *Admonitions of the Instructress*. But the drawing of the nymph's face is precisely what we would find in paintings of the early Song dynasty. The original must have been an apt illustration of the third century poem of the same name:

"I have heard of the Nymph of the River [Luo],
 whose name is Mi-fei.
Perhaps that is whom Your Honour sees.

太白星禊祭用黃食用瓜肉不殺牲火

鎮星禊改用煙霧宮祭用黍麻油蔬食飲水幣用鐵戒在香爐鎮故禊菜用鐵戒食飲水幣用星是御史空水土事企祠辰暚水濁懞

But what of her form? For I truly wish to know."
I replied: "She moves with the lightness of wild geese in flight;
With the sinuous grace of soaring dragons at play.
Her radiance outshines the autumn chrysanthemums;
Her luxuriance is richer than the spring pines.
She floats as do wafting clouds to conceal the moon;
She flutters as do gusting winds to eddy snow.
From afar she gleams like the sun rising from dawn mists;
At closer range she is luminous like lotus rising from clear waves.
Her height and girth fit exactly in proportion;
Her shoulders are sculptured forms, and her waist pliant as a bundle of silk.
Her slender neck and tapered nape reveal a glowing surface,
Without application of scent or fragrant powders;
Her hair coils in cumulus clouds and her brows curve in silken threads;
 Her cinnebar [sic] lips gleam without, with snowy teeth pure within;
 Her bright eyes glance charmingly, and dimples decorate her cheeks.
 Her deportment is superb and her attitude tranquil;
 Her manner is gentle and elegant, and her speech bewitching;
 Her unusual dress is that of another world and her form worthy of depiction.
Wrapped in brilliant gauzes, she is adorned with earrings of rich jade,
And hair ornaments of gold and feathers; her body glistens with strings of pearls.
She treads upon 'far-roaming' patterned slippers, trailing a skirt of misty silk;
She skims among fragrant growths of delicate orchids and wafts by the mountain slopes."[16]

374. *Sarcophagus illustrating tales of filial piety.* Engraved stone (detail of reverse print of rubbing); l. 7'4" (2.23 m). China. Six Dynasties period, c. 6th century C.E. Nelson-Atkins Museum of Art, Kansas City

The scroll reveals an elaborate fairyland landscape in miniature, with curious shifts in scale, but of a type, particularly in the overlapping mountain ranges of the background, probably not realized in Gu Kaizhi's day. Furthermore, the history of the painting cannot be traced much before the twelfth century, which would tend to confirm it as a Song copy of a much earlier painting. It is as interesting for its general composition and landscape as for its narrative subject, suggesting that to the artist the picture was the important thing.

Many other painters from the Six Dynasties period are known, but this is not a list of the names of Chinese artists, and we can study only those masters whose originals, or reasonably good copies therefrom, are extant. And so we are forced to jump some two or three centuries from Gu Kaizhi to a great artist of the later Six Dynasties period, Zhang Sengyou, active under the Liang dynasty (502–557 C.E.), whose capital was also at Nanjing. The handscroll of *The Five Planets and Twenty-eight Celestial Constellations,* now in the Abe Collection in the Osaka Municipal Museum, illustrates the style of this master (*fig. 373*). It is not, however, an original but a copy, probably of the Song dynasty. The detail illustrated shows, especially in the line drawing, a stroke excellent as a boundary but lacking the life, or *qi yun*, to be found in the *Admonitions of the Instructress* by Gu Kaizhi. Nevertheless, it is so far superior to other copies of similar early paintings that it deserves our attention. Its subject is astronomical-astrological, showing various human- or animal-headed figures that symbolize in Chinese lore the five planets and the twenty-eight celestial mansions of star forms. Each figure is represented singly against a plain background of silk, together with an attribute where this is necessary to identify the subject. If the figure must stand on a mountaintop, this is indicated as an adjunct to the figure, not as a true landscape setting. In contrast to the earlier style of Gu Kaizhi, with its flutter of draperies and movement of figures, it is more statically and more

monumentally conceived, an approach characteristic of late Six Dynasties paintings. The change in effect is comparable to that between the lively Northern Wei sculptures and the later, more massive ones of the Northern Qi and Sui dynasties. It reflects a change in emphasis, from linear movement to more plastic, static forms. The use of color in *The Five Planets* is in sharp contrast to the simple, almost monochrome palette of the *Admonitions.* Here are rainbow hues; the line tends to disappear among the varied colors and only comes to the fore on the whites, or in the hands or faces of figures. The calligraphy is interesting and much more formal than on the *Admonitions* scroll, employing Small Seal script, which was in common use before and during the Han dynasty. Such archaism is characteristic of the growing sophistication of China at this time.

One of the most important evidences for the development of setting in Chinese painting in this period is found on a stone sarcophagus in the Nelson-Atkins Museum in Kansas City. Its designs, lightly incised into dark gray stone, represent Confucian examples of filial piety (*fig. 374*). The monument is at once a sort of museum of archaisms, an adventuresome precursor of the future, and an enthusiastic fulfillment of the project at hand. Artisans who executed tomb sculpture picked their motifs from many sources. The cloud patterns here, used also by Gu Kaizhi, date from the late Zhou period; angular, prismatic rocks, the little knolls in the foreground, and even trees are elaborated treatments of forms seen in Han compositions. Some figures, like the one on the right with flying draperies, recall the lithe creatures in Gu Kaizhi's painting and in early Buddhist frescoes; others are stocky peasants, like certain tomb figurines of the late Six Dynasties period. But in the handling of space the craftsman followed now lost contemporary paintings, and records for us experiments definitely in advance of the picturesquely rendered old-fashioned forms. In contrast to Gu Kaizhi's primitive background details or Zhang

375. *Tomb figurine: woman.* Painted earthenware; h. 10¼"
(26 cm). China. Six Dynasties period. Royal Ontario
Museum, Toronto

376. *Tomb figurine: western Asian warrior.* Gray earthenware
with polychrome pigment; h. 12¼" (31 cm). China.
Northern Wei dynasty, 1st quarter of sixth century C.E.
Nelson-Atkins Museum of Art, Kansas City

Sengyou's virtual omission of background for his celestial subject matter, the Kansas City sarcophagus shows real ingenuity in the treatment of space, affording a limited but still convincing background for numerous groups of figures related to one another in action and motivation. The settings are a series of shallow cells enclosed by planes of rocks. In the foreground a kind of *repoussoir* keeps the spectator a certain distance from the scenes beyond—like the window ledge of fifteenth century Venetian portraits. The relations between near and fairly near are established, but there is little indication of deep space. Here, then, is one step forward in the achievement of subtlety and complexity in representations of pictorial space.

Compared with Gu Kaizhi's work, the Kansas City relief is much more competent; beside landscapes of the early Song it appears hopelessly naive. Painters of the Tang dynasty who worked to create truly spatial scenes filled with life and atmosphere were hard indeed on the efforts of their predecessors. Tang critics derided the mountains in Six Dynasties pictures as resembling the teeth of a lady's comb. Each generation thinks it has

achieved a sense of reality in painting, and each succeeding generation finds its predecessors' accomplishments amusing and inadequate.

Ceramics

The ceramic arts flourished in the late Six Dynasties period. Burial pottery continued in use, usually of gray clay, sometimes painted with slip but rarely, if ever, glazed. Tomb figurines are of two basic types: One consists of highly sophisticated and elegant figures of native civil and military officials, court ladies, and various retainers of the aristocracy, reflecting the art of men like Gu Kaizhi (*fig. 375*); the second, comprising principally guardian figures based on Buddhist iconography and derived from the Central Asian and Gandharan tradition, is ferocious and grotesque, reflecting the Chinese conception of these quasi-warrior figures as well as of demons and mythical animals (*fig. 376*).

Ceramics for daily use experienced a remarkable development. The southern green-glazed stonewares, pro-

377. *Urn of the soul (hun ping).* Dated to 260 C.E. Yue ware; h. 18" (45.7 cm), diam. at foot 6" (15.2 cm). China. Six Dynasties period. Palace Museum, Beijing

378. *Vase.* Stoneware; h. 16¼" (41.3 cm). China. Tang dynasty. Nelson-Atkins Museum of Art, Kansas City

duced since the late Zhou period, underwent further improvement in the area around modern Shanghai (southernmost Jiangsu and, principally, northern Zhejiang). The principal kilns of the area all produced pale gray-bodied stonewares with glazes ranging from gray-green to olive-green, retrospectively called Yue ware after an early name of the Zhejiang area. These wares are certainly descended from Han glazed stonewares and are furthermore direct ancestors of the celadon tradition of the Song dynasty. They were made in a great variety of shapes: pots, bowls, vases, dishes, and cups. Figure 377 is a *hun ping* (urn of the soul), dated to 260 C.E. on the (memorial?) tablet borne by the tortoise modeled in full round on the shoulder of the vessel. Inscribed on the tablet along with the date are wishes for "wealth, happiness, high rank, many descendants, and a long life—for thousands of years without end." All manner of land and water creatures in lively motion, also modeled in full round, share the shoulder of the vessel with the tortoise. Above the shoulder the vessel takes the form of a multistoried building, perhaps a storehouse, with two watch-

towers flanking its entrance, which is further guarded by three alert watchdogs. Along the opposite wall stand human figures, rather large in scale. Spaced around the outside of the urn at its very rim are four globular jars, which are nearly invisible under the multitude of birds clustering about them. The exuberant profusion of ornament—perhaps a kind of sympathetic magic—clearly expresses the wish for plenty in the inscription. Comparison with other *hun ping* strongly suggests that the urn's missing lid would have been shaped like a roof with upturned eaves.

On many pieces a technically advanced treatment of the gray-green glaze produced regularly spaced brown spots on the surface, called the buckwheat pattern by the Chinese. Buckwheat-patterned Yue ware is very much sought after both in China and Japan, and is the ancestor of the spotted celadon produced in the Yuan dynasty. The export of Yue ware marked the beginning of a long ceramic relationship between the Near East and East Asia. Yue vessels have been found as far away as Fostat in Egypt, Samarra in Iraq, Brahmanabad in India, and Nara in Japan. They must have seemed ultimately refined and luxurious compared with the crude earthenwares then produced in the Near East or with the even cruder material then made in Europe.

In the north, rather late in the Six Dynasties period, a white stoneware was produced that was the precursor of the white porcelain of Tang and Song, especially the famous Ding ware (*fig. 378*). This new development

apparently resulted from the discovery of suitable white porcelain clays in the north, principally in the region of Zhili (the area around present-day Beijing). These white stonewares, such as the magnificent vase in the Nelson-Atkins Museum, are distinguished by robust and simple shapes, a creamy white glaze, and an almost white body. Like the southern Yue wares of the same period, the shapes are extremely sculptural, with clear articulations between neck, lip, and body. As we begin to know more about Chinese ceramics—and this means adding to a still rather insubstantial foundation—developments in the Six Dynasties period become more and more important. Western appreciation of Chinese ceramics began at the end of the nineteenth century, with the porcelains of the Qing dynasty. In the 1920s we discovered classic Song wares, and in the 1930s we collected early Ming porcelains and began to appreciate Tang stonewares. Now we have discovered that many pieces thought to be Tang are really of the Six Dynasties period. As more excavations produce more material the picture will surely change again.

TANG

In considering the development of Tang painting, sculpture, and decorative arts, we must recall what was said of the Tang dynasty (618–907 C.E.) in our survey of Buddhist art of that period. Tang China was for most of its 289 years the best-governed polity in the world, the largest in extent and population, the strongest, and certainly the richest. Its brilliant high culture was the envy and model of all its neighbors. At its greatest extent, in the early eighth century, the empire stretched from the Caspian Sea to the China Sea and from Korea to Annam, and trade flourished, especially with the Middle East. Those catalysts of the social organism—printing, literacy, and the civil service examination system—progressed greatly toward that central and interrelated position they later occupied in Chinese civilization. The first task of the new dynasty was to replace the political volatility and dispersal of powers characteristic of the Six Dynasties period with order under centralized control, and this was accomplished within the first years of the regime. These conditions in combination produced an especially rich environment for the rapid development of literature and the arts. Tang China was cosmopolitan and tolerant, open to new ideas and eager for contacts with the outside world. It welcomed the seven religions of the then known world: Buddhists, Hindus, Muslims, Christians, Zoroastrians, Manichaeans, and Jews were free to observe their rites, even to establish communities in the capital, Chang'an. Tang civilization was an extraordinary achievement, even if it declined after the first century and a half of the dynasty.

Painting

In the arts the Tang style, as seen in Buddhist sculpture, mirrored the power and vigor of the empire. Sculpture was amply proportioned and fully three-dimensional. The same confident amplitude is found in painting, already discernible in the monumental tendencies of Zhang Sengyou. More than this, the self-confident and receptive spirit of this time permitted the artist to observe the world with fewer strictures of custom and tradition. The resulting realism in painting and sculpture is marked, most particularly in artists' preparatory sketches, which were generally translated into more idealized forms for the finished works. Much attention must have been given to the problems of painting, since the considerable literature on the subject uses specific terms and accurately analyzes Chinese style as well as exotic ones, particularly the Indian shading techniques transmitted through Central Asia.

It is possible that highly calligraphic painting styles, including the extreme forms of "splashed ink," began at this time, but probably not under Chan Buddhist influence, even though Chan figured in the religious life of the dynasty.

Tang affords us original paintings, or almost contemporary copies of them, in greater numbers than before. Recent discoveries include wall paintings from early Tang princely tombs, including hunting scenes in elementary landscape settings not unlike those in Buddhist works (*see fig. 241; cpl. 16, p. 207*), elaborate formal architectural settings, and sophisticated figural compositions of court ladies and attendants (*fig. 379*). The accomplished placement of these figures, and their subtle delineation in firm and even lines, confirm the meager evidence of portable works on silk and paper that Tang figure painting was highly developed at an early stage. All these works, however, reveal a noticeable lack of interest in placement of the figures in an environment beyond the shallow space they occupy.

One of the greatest masterpieces of all Chinese figure painting is the *Scroll of the Emperors*, almost certainly painted by Yan Liben (d. 673 C.E.) in the early decades of the Tang dynasty (*fig. 380*). Yan was an official and administrator of the highest rank as well as an extremely important court artist, providing designs for architecture, sculpture, and wall paintings—in short, fulfilling all the Chinese requirements of an artist-hero. The *Scroll of the Emperors* is the one remaining work that can in any way be considered his. It represents thirteen emperors with their attendants. The first part of the scroll, the part that would necessarily have been rather badly damaged by frequent unrolling, is a copy substituted for the original first six groups, but the latter part of the scroll contains seven groups of the highest excellence. Their brushwork, particularly the firm, even line, their composition, and the poise of their figures are worthy of a great master. Format, com-

379. *Female attendants.* Dated to 706 C.E. Wall painting from the tomb of Princess Yongtai; l. 14'5" (4.32 m). Qian Xian, Shaanxi, China. Tang dynasty

380. *Emperor Wen Di of the Chen dynasty, from the Scroll of the Emperors.* Attrib. Yan Liben (d. 673 C.E.). Section of the hand-scroll; ink and color on silk; h. 20⅛" (51.1 cm), l. approx. 18' (5.4 m). China. Tang dynasty. Museum of Fine Arts, Boston

positional methods, colors, and the history of the scroll, which from the evidence of collectors' seals goes back at least to the twelfth century, all combine to confirm the authenticity of the work. In the firm use of line, separated groupings of unified subjects, and alertness of secondary figures the work displays a relationship to what has gone before, particularly to Gu Kaizhi and Zhang Sengyou. At the same time it evinces a completely new spirit in painting. The figures are larger, ample and serene, and though the delineation of the faces still relies principally on line, it creates a suggestion of mass and volume quite different

from the more linear style of the Six Dynasties period. The modeling of the draperies, quixotic and decorative in the *Admonitions of the Instructress,* is here done more systematically, using shaded red, which undoubtedly reveals the influence of Central Asian and even Indian painting. The setting is still abstract, with the figures shown in relationship only to their immediate environment, the dais on which the emperor sits. The expanding perspective of the dais is precisely opposite to that used in most Western painting, but this expansion is handled much more convincingly than in the painting by Gu Kaizhi. The emperor

381. *Tang Tai Zong's horse Saluzi, with General Qiu Xinggong removing an arrow from his chest.* Designed by Yan Liben (d. 673 C.E.). Stone; h. 68" (172.7 cm). Emperor's tomb (Zhao Ling), Liquan Xian, Shaanxi, China. Tang dynasty, 636–649 C.E. University Museum, University of Pennsylvania, Philadelphia

382. (opposite) *Eighty-seven Immortals.* 14th century(?) copy after Wu Zongyuan (d. 1050 C.E.). Detail of the handscroll; ink and color on silk; h. approx. 16" (40.6 cm), l. approx. 20' (6 m). China. C. C. Wang collection, New York

of figure 380 is Chen Wen Di; he is shown at ease, quietly sitting instead of standing in a dominating pose. His summer garments of soft materials contribute to the image of an effete rather than a dynamic person. This characterization is part of the trend toward individual realistic portraiture in the Tang dynasty. The conventions for drawing an ear or a mouth—and they are conventions—are based on actual appearance to a much greater degree than in paintings of earlier periods.

The *Scroll of the Emperors* follows the same simple color scheme used by Gu Kaizhi, which seems especially appropriate to its exalted and didactic subject matter: the characters of emperors of the past providing Confucian moral lessons for the present. The simple sobriety of the colors, predominantly red, creamy white, and black, with occasional traces of blue or pale green, produces an effect of great austerity. "Strong" emperors are portrayed standing, their figures occupying the full height of the silk. Large scale, sober color, and powerful but simple linear drawing combine to create a coherent, harmonious, and monumental effect, making this scroll one of the greatest and most important of extant Chinese paintings. Yan was also commissioned to design sculpture, and his remarkable combination of realism and monumentality is to be seen in the six life-sized stone reliefs of favorite horses of the Tang emperor Tai Zong. Two of these are now at the University Museum in Philadelphia (*fig. 381*); the other four remain in Xi'an, not far from the imperial tomb site for which they were carved.

Yan Liben dominates Chinese art of the seventh century, but the greatest name of the Tang dynasty, if not the greatest name in Chinese painting, is that of the eighth century master Wu Daozi (act. 720–760). Wu Daozi was extolled even in his day, praised as the greatest of all figure painters and the epitome of the divine artist—and yet we have nothing by or even remotely close to his hand. We know that he was primarily a figure painter, that Daoist and Buddhist subjects were his specialty, and that he was able to create a look of unusual power and movement, stress and strain, in figures and compositions. Of Wu Daozi it is told that when he finished his last wall painting, he opened the door to one of the painted grottoes, walked in, and disappeared. Such myths about great Chinese painters have become clichés, but this one actually suggests something of the magical impact of Wu's paintings. He is said to have introduced one of the most unrealistic elements of Chinese painting, although one of its greatest glories—developed calligraphic brushwork. To him is ascribed the honor of creating the line of varying thickness to express the movement and power of the brush as well as to model drapery. The copy (fourteenth century?) after one of his followers, Wu Zongyuan, probably gives a fair indication of his style (*fig. 382*). There is, however, in the Shoso-in at Nara, a contemporary painted banner representing a bodhisattva, the work of some fairly accomplished but unimportant painter, possibly an artisan employed by the emperor Shomu or by Todai-ji (*fig. 383*). Painted with a brush on hemp, using a thick-and-thin line for depicting swirling drapery, it shows considerable vigor, and is our most spontaneous example of what may have been the art of Wu Daozi.

One of the few documented originals by a known artist of the Tang dynasty is by the hand of the minor master Li Zhen (*fig. 384*). A restored set of the *Seven Patriarchs of the Shingon Sect of Buddhism* is kept at To-ji, outside Kyoto. Five of the seven are Chinese originals; two are Japanese additions to the set. The *Patriarchs* of To-ji, one in decent condition, are, by temple records, the evidence of the inscriptions, and the quality of the painting itself, originals painted by Li Zhen and exported to Japan in the ninth century. Li Zhen was active about 800 C.E., and these pictures are recorded in Japan from that time.

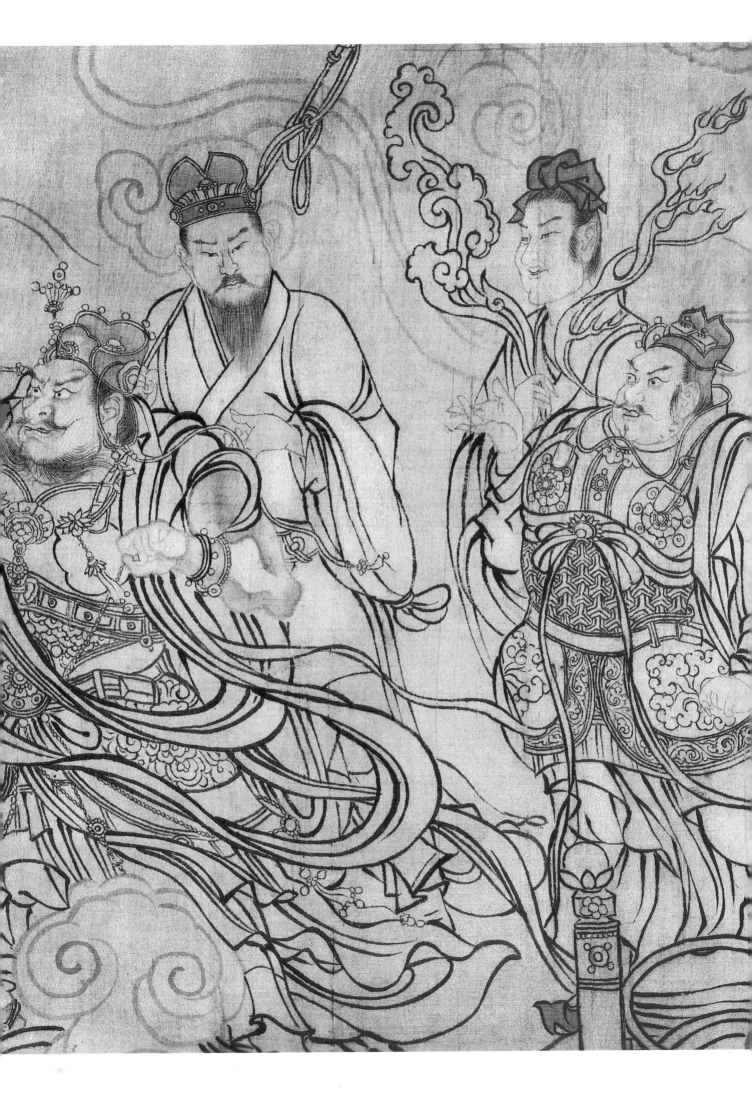

383. *Bodhisattva.* Detail from a painted banner; ink on hemp cloth; h. 52³/8" (133 cm). Japan. Nara period, mid-8th century C.E. Shoso-in, Todai-ji, Nara

384. *The Patriarch Amoghavajra.* By Li Zhen (act. c. 780–804 C.E.). Hanging scroll; ink and color on silk; h. 6'11" (2.11 m). China. Tang dynasty. To-ji, Kyoto

The portrait of the patriarch Amoghavajra shows him seated on a dais, like some of the emperors in the painting by Yan Liben. His slippers are under the dais, and he sits with his drapery falling about him, his hands in a ritual pose of adoration characteristic of the Shingon sect. Despite damage to the silk, details indicate a strangely powerful realism. If this is the work of a minor master, then what must the great paintings by Wu Daozi have been? The head, the ear, and the contour of the skull, which in later Chinese painting is represented as a very smooth arch, all have a sharply individual character, as do the eye, eyebrow, eye socket, and the unusually shaped nose. Such a search for individual traits was prompted by the artist's need to present Amoghavajra as he really looked, or at least was imagined to look, in the hope that these depicted traits, real or imagined, might reveal the nature of a truly holy man. Li Zhen's portraits are on silk in hanging scroll format of considerable size. Formally and symmetrically flanking Amoghavajra is his name, written in Chinese on the left and on the right in the Sanskrit *siddham* letters, whose spiritual significance transforms the portrait into something of a magical mandala, a diagram of the type particularly associated with Esoteric Buddhism.

From this purposeful realism to the grotesque and to caricature is but a step. Indeed, in both Oriental and Western art there is a close connection between a concentration on individual character and a corresponding interest in caricature and satire. In the later Tang dynasty, representations of the Eighteen Luohan (S: arhats, or enlightened beings) became the vehicles for extreme exercises in realism and the grotesque. Guan-Xiu, who lived from 832 to 912, through the very end of the Tang dynasty and into the period of interdynastic strife called the Five Dynasties, painted famous representations of such grotesque *luohan* (*fig. 385*). Unfortunately it is arguable whether the paintings attributed to him are original. The best examples are certainly those kept in the Imperial Collection in Tokyo. Guan-Xiu depicted grotesque exteriors to emphasize the holiness within. There is no easy path to Enlightenment. The Way, which is torturous, terrifying, and exhausting, needs must leave its marks on those who have followed it to its end. The old gnarled tree is somehow a more rewarding object of contemplation than the young sapling. And so the more gnarled and grotesque the figure, the more eccentric the glance, the heavier the beard and hornier the feet, the more noble is the character. It is not ugliness that we are being shown, but the outward aspect of supreme spiritual effort. The works of Guan-Xiu, as we know them from the paintings in the Imperial Collection, show a traditional thin, wirelike line, used, like Li Zhen's, in the service of his version of realism. Evidently the use of the calligraphic line, in the tradition of Wu Daozi, represents a separate strain, one persisting in later Chinese painting as well as

385. *Luohan.* By Guan-Xiu (832–912 C.E.). Hanging scroll; ink and color on silk; h. 50" (127 cm). China. Five Dynasties period. Tokyo National Museum

in the frescoes of the late Tang and the Song dynasties.

In contrast to these powerful painters of primarily masculine figures is the artist Zhou Fang (act. c. 780–c. 810 C.E.), who was most famous for his depictions of women. The picture that perhaps best expresses his style is one of court ladies wearing flowers in their hair (*cpl. 26, p. 329*). It is a handscroll on silk, with the remains of quite brilliant color, ranging from yellow, red, and orange to lapis blue, malachite green, and the usual black ink. To be fashionable, representations of court ladies and children had to be colorful. Also a la mode are the buxom figures

of the court ladies. Whereas Gu Kaizhi in the fourth century had painted "morsels of jade" and "swaying willows" with "petal faces" and "waists like bundles of silk," and the early Tang ladies in the tomb of Princess Yongtai (*see fig. 379*), though less ethereal, are almost equally delicate, the artist of *Court Ladies Wearing Flowers* depicts moon faces and plump bodies. Clearly the ideal of feminine beauty had changed. Perhaps these women express the pride and pleasure people took in ease and luxurious abundance during the waning years of the Tang dynasty. Tomb figurines of ladies of the late Tang and Southern Tang (937–975 C.E.) have the same ample proportions.

In most of the works we have seen so far, setting is minimal. Even the elaborately detailed *mise-en-scène* of the Nelson-Atkins sarcophagus is more than Zhou Fang provides for his palace ladies. The abstract background is characteristic of Chinese figure painting up to this time. Very rarely until the Song dynasty does one see a setting that relates every part of the composition either to an interior room or to infinite space. This problem seems to have been left to the landscape painter for solution. Figure painters concentrated on their subjects and on delineating a relatively shallow stage for them to function in.

There is also in this picture a subtle relationship between the figures and the surface spaces that contributes an almost musical quality to the composition. The gaps between the figures are most sensitively and exactingly varied in size and shape, and the figures themselves manipulated with studied care in relation to the picture plane and to each other, creating an almost musical rhythm. The spectator is not invited into the picture by glance or gesture but observes from a respectful distance.

Zhou Fang established the formula for the representation of aristocratic Chinese femininity, and his works were copied and used as models by all the great painters of women in the Song, Yuan, and Ming dynasties. Later artists sometimes changed the physical proportions in accordance with the taste of the time, but the general type of composition, subject matter, palette, drawing, and relationship between figures were largely established by Zhou Fang.

In addition to artists who confined themselves to figure painting, there were specialists in even more restricted fields. Thus for the first time we encounter painters whose primary subject was horses, or still lifes. Horses were as popular in art as in life, being equally necessary to Tang military strength and to the aristocratic recreations of polo and hunting. The greatest painter of horses, never surpassed in Chinese esteem, was Han Gan. Perhaps the finest painting attributed to him is one in the National Palace Museum in Taibei (*fig. 386*). It shows two horses, with a Central Asian groom riding one and leading the other, a combination often repeated in later painting. The realism of detail is notable, as is the now customary abstract setting.

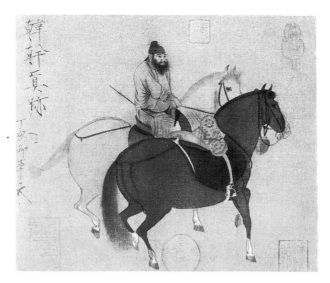

386. *Two Horses and Groom.* Attrib. Han Gan (act. 742–756 C.E.). Album leaf; ink and slight color on silk; h. 10⅞" (27.6 cm). China. Tang dynasty. National Palace Museum, Taibei

Another specialty, especially meaningful for the future, was the painting of "fur and feathers," a genre to which the Tang interest in reality was most appropriate. The most famous specialist of the day, Huang Quan (903–968 C.E.), reached maturity after the dissolution of Tang. The greater part of his career he spent at a short-lived but cultivated successor court in Chengdu, Sichuan, ending his days as an honored painter at the court of the conquering Song dynasty. A master of careful observation and accurate depiction, he also succeeded in capturing the life spirit (*qi yun*) of his subjects (*fig. 387*). His study sheet of birds, insects, and two wayward tortoises, now mounted as a handscroll, rivals similar studies by Dürer. Evidently this painting provided models for at least one of his painter-sons, being inscribed at the lower left, "Given to son Jubao to learn from."

One of China's most significant contributions to the art of the world is landscape painting, which developed rapidly in the Tang dynasty and reached fruition by the early Song dynasty. Few can deny the unique character of Chinese landscape painting. Though the first heights of this great tradition were not attained until the tenth century, certainly the preparation was made during the Tang dynasty. We have already seen tentative approaches to landscape in tomb tiles and inlaid bronzes; summary landscape adorns Buddhist painting as a setting for the protagonists of the faith; it occurs as an accessory to narrative in Gu Kaizhi's *Nymph of the Luo River.* But the beginnings of landscape for its own sake are to be found in paintings recording great historic events. They go back at least to the seventh century in the work of Li Sixun (651–718 C.E.), the greatest master of the "blue-and-green" narrative style, who was particularly famous for his use of color and gold to outline rocks, architecture, and decorative elements. His son and artistic successor was Li Zhaodao (act. c. 670–c. 730 C.E.). Both are known to us today only through literary references and copies such as the painting called *Emperor Ming Huang's Flight to Shu,* conventionally attributed to Li Zhaodao, in the collection of the National Palace Museum, Taibei. But the best extant example of Tang landscape is the *Traveling in Spring* in Beijing, attributed to Zhan Ziqian of the Sui dynasty but clearly representing the style and perhaps the period of the first half of the Tang dynasty (*cpl. 27, p. 329*). Though a small handscroll, it creates a convincing impression of deep space seen from an elevated viewpoint. This was accomplished by placing some mountains in echelon from right to left, by overlapping others from front to back, by extending the estuary from a low plane upward into the distance, and by making the figures diminutive in scale. Together these compositional techniques are far more effective than the simple and more naive landscape designs at Dunhuang (*see fig. 241*). Still, the decorative use of green and blue, the insufficiently differentiated trees, the persisting depiction of distant foliage only along the contours of hills and mountains, and the regular, repetitive, unvaried shapes of those mountains all combine to suggest a garden—a miniature landscape—rather than the grand and compelling visions of nature

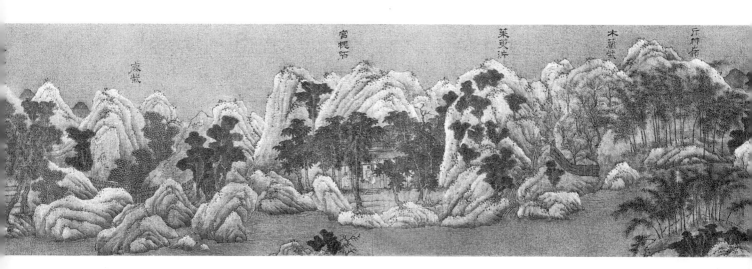

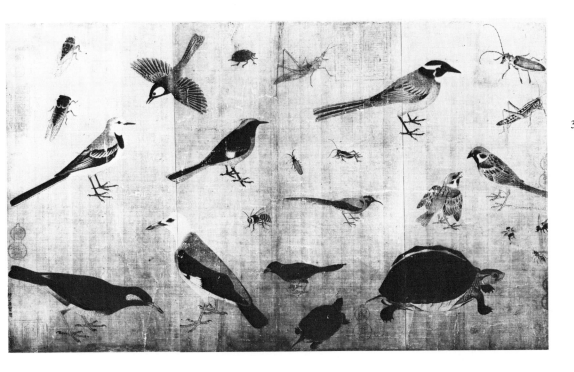

387. *Birds, Insects, and Tortoises.* By Huang Quan (903–968 C.E.). Study sheet mounted as a handscroll; ink and color on silk; h. 16¼" (41.3 cm), l. 27½" (69.9 cm). China. Five Dynasties period. Palace Museum, Beijing

painted in the tenth and eleventh centuries. The blue-and-green manner became associated with Tang and its court, providing archaizing painters of the Ming and Qing dynasties with a suitably archaic and elevated style for depicting subjects of legend or of early history.

The master most closely associated with the beginnings of pure landscape painting is the artist-scholar Wang Wei (699–759 C.E.); he was reputed not only one of the greatest of landscape painters, but the pioneer of monochrome landscape painting. That any one artist alone originated the ink landscape we can well doubt; it was, however, in his time that some kind of landscape rendered predominantly in ink developed. In many of the great paintings of the tenth century faint washes or even some bright and opaque color was used. But it was certainly Wang, judging from the evidence of remaining stone engravings, who "invented" landscape per se, and that further inventions are attributed to him is understandable. The scroll painting of his country estate, called Wangchuan Villa, is the first true Chinese landscape. The few figures are incidental; the landscape itself is the subject of the picture. *Wangchuan Villa* is known to us in a variety of copies, all remote from the original but some less so than others. Key among these is an engraving on stone, made in 1617 after a late tenth century painting claimed to be a faithful copy of Wang's original. There is also a handscroll, perhaps of the fifteenth or sixteenth century, painted, appropriately for its time, in color on silk (*fig. 388*). Between this handscroll and the stone engraving there is significant resemblance. If the engraving is in fact a fair reflection of the eighth century original, then the handscroll may suggest something of the

388. *Wangchuan Villa.* 15th or 16th century(?) copy after Wang Wei (699–759 C.E.). Section of the handscroll; ink and color on silk; h. 11¾" (29.9 cm), l. 15'9" (4.8 m). China. Ming dynasty. Seattle Art Museum

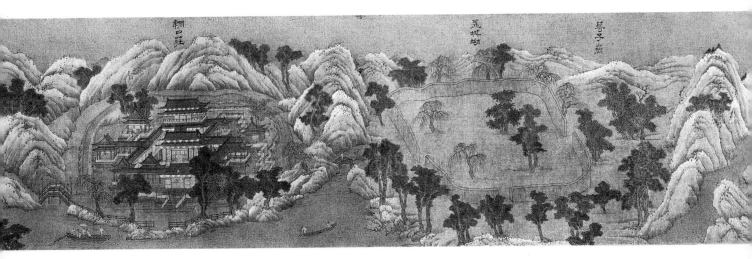

389. *Snow Landscape.* By Wang Wei (699–759 C.E.). Album leaf; ink and white pigment on silk; h. approx. 18" (45.7 cm). China. Tang dynasty. Formerly Manchu Household Collection

390. *Kichijoten.* Color on hemp; h. 20⅞" (53 cm). Japan. Nara period, 8th century C.E. Yakushi-ji, Nara

contribution of Wang Wei. Certainly it offers true landscape: a scene on an estate, a group of buildings, a few peasants working, a fishing boat on a stream. Instead of narrative we have a topographical treatment of nature. Each section is named for the part of the estate it represents, almost as if a surveyor making the rounds of the estate had produced a pictorial map for both identification and delectation.

Interestingly, this painting, which after all is based upon an eighth century "invention," still betrays uncertainty in the development of locations in the landscape. There is little indication of anything beyond the mountains, almost as if the landscape were tilted toward the spectator, who is presented with a segment instead of the whole. Then there is the most difficult problem of all landscape painting—creation of a convincing space between foreground and distance—which the artist has evaded by putting water there. This is a well-known escape device for primitive painters, indicating a still archaic state of development. The rest of the scroll is similarly archaic, with each section tilted as if it were a map and made into a space cell by the simple device of encircling mountains or rocks.

No ink monochrome landscapes of Tang date, or even copies of such, are now known, though there was undoubtedly some monochrome figure painting. But a small group of monochrome landscape paintings, one of

them excavated from a tomb of the early tenth century, indicates that the attribution of this genre to Wang Wei and to the eighth century may not be wrong. The best of these is a small album leaf on silk (*fig. 389*), formerly in the Manchu Household Collection, attributed to Wang Wei in an early twelfth century inscription written by the emperor Hui Zong. The subject is a winter landscape, a theme it shares with some others in this group. The artist used opaque white pigments on the silk, producing a reverse monochrome painting; the toned silk provides the darks and the white opaque paint builds the highlights. The simple and archaic modeling of rock forms is beautiful and unusual, as is the "primitive" architecture. The intimate quality of this album leaf is reminiscent of the *Wangchuan Villa* scroll, as is the solution of the middle ground problem by means of an expanse of water.

A few paintings of importance, preserved in Japan, shed additional light on some of the Chinese paintings we have just seen. A small painting kept at Yakushi-ji depicts

391. *Lady under a tree.* Detail of screen panel; ink and color on paper; h. 49¹/₂" (125.7 cm). Japan. Nara period, 1st quarter of 8th century C.E. Shoso-in, Todai-ji, Nara

392. *Landscape with musicians riding an elephant.* Painted leather plectrum guard of five-stringed *biwa*; h. 20³/₈" (51.8 cm). Nara period, 8th century C.E. Shoso-in, Todai-ji, Nara

the female deity of abundance, Kichijoten, derived from the Indian Lakshmi (*fig. 390*). Although the subject is nominally Buddhist, the manner of representation and the style are purely derived from Tang courtly representations of beauties, such as those by Zhou Fang (*see cpl. 26, p. 329*). Indeed, so well documented and preserved is the Kichijoten that she serves as a standard by which to judge the various Chinese paintings that claim her age and style. The plump physical proportions we have seen before, but the lovely linear rhythm of the windblown draperies, the delicate and variegated color in the textile patterns, and the conscious grace of the hands raise this painting far above all surviving Chinese figure paintings of the mid-Tang period except for the *Court Ladies Wearing Flowers in Their Hair*. The graceful geometry of the facial features, notably the eyebrows and the small cupid's-bow mouth, are closely related to the high style of Tang art in the eighth century, whether in paintings, sculptures, or the more lowly grave figurines.

A set of screen panels kept in the Shoso-in, representing court ladies beneath flowering trees, is purely decorative and secular in nature (*fig. 391*). Time and wear now reveal these paintings without their original sumptuous over-decoration of applied feathers in iridescent hues. The figure illustrated is in the style of Tang painting we associate with Zhou Fang. Probably such talented and famous artists worked on decorative panels of this sort in addition to the more usual formats of handscroll or hanging scroll. The linear basis of this figure style is evident, for the loss of decorative color does little to diminish the sophisticated effect of the whole. The line varies with the subject matter: Rock and tree are drawn with a varying, almost calligraphic line, the figure with a more measured, wirelike line.

Landscape painting is even to be found on some of the useful objects preserved in Japan. On the plectrum guard of one of the *biwa* (lutes) in the Shoso-in is painted a fanciful landscape, with musicians riding an elephant in the foreground and a flock of geese flying toward us through a pass in the distant mountains (*fig. 392*). The

393. *Rhyton in shape of an ibex head.* Onyx(?) or agate(?) with gold; l. 6" (15.5 cm). Hejia Cun, Xi'an, Shaanxi, China. Tang dynasty, probably before 756 C.E. Shaanxi Provincial Museum, Xi'an

394. *Ewer with decoration of performing horse.* Silver with repoussé gilt decoration; h. 5³/4" (14.5 cm). Hejia Cun, Xi'an, Shaanxi, China. Tang dynasty, probably before 756 C.E.

fairy-tale appearance of these mountains, with their repetitive, undulating outlines of receding ridges, recalls the courtly style of Li Sixun. The vertical format is one of the few remaining evidences for the landscape hanging scrolls of the Tang period, and the division of the space between near mountains on the left and a distant vista on the right is a rather advanced compositional device. Despite the charming miniature style, however, the actual definition of space and of the objects within that space is still highly schematic and little advanced beyond such late Six Dynasties works as the Nelson-Atkins Museum's sarcophagus. It is noteworthy that the musicians are Central Asian types, for nearly all of the arts of the Tang and Nara periods, especially the utilitarian arts, show much influence from Central Asia and even Sasanian Persia and Mesopotamia.

Decorative Arts

The worldly magnificence of Tang civilization naturally called into being large-scale manufacture of luxurious decorative arts, more varied and opulent than any since the late Zhou period. On the mainland, unfortunately,

only those objects that survived burial (as tomb furnishings or for safekeeping) are left, notably numerous splendid ceramics in both earthenware and stoneware, as well as a few objects in more precious materials—gold, silver, gemstones, even, occasionally, jade. The rhyton in the shape of an ibex head with a golden muzzle (*fig. 393*) is the only example of this shape in semiprecious stone to have been found in China. In style as well as in subject it evokes the art of late Sasanian Iran or of Sogdiana, the northeasternmost province of the Sasanian empire, but it may well have been made in Tang China, where all things Central Asian were the height of fashion.

Even more remarkable is the silver ewer with a gilt repoussé depiction of a performing horse (*fig. 394*). In shape the vessel echoes the leather flasks carried by the Turkic peoples of Central Asia; in technique it reflects the silverworking traditions of Sasanian Iran; but the curious subject illustrates an actual entertainment at the Tang court of Emperor Xuan Zong (Ming Huang; r. 712–756 C.E.). While gracefully maintaining a pose most unnatural to horses, the horse is holding between his teeth a footed wine cup. Tang texts record horses from the emperor's vast stables who were trained to dance while holding—

395. *Tomb figurine: harpist.* Earthenware; h. 12⁵/₈" (32.1 cm). China. Tang dynasty. Cleveland Museum of Art

and occasionally drinking from—cups of wine. This vessel, like the rhyton, was part of a hoard of precious objects found where a Tang palace had once stood, in Hejia Cun, a suburb of Xi'an.

Tang burial figurines have become especially well known in the West. These amazingly realistic and animated figures, intended to be seen only at funerals and then buried—forever, it was hoped—provide a kaleidoscope of the Tang world. All levels of society are represented, as are many of the beasts known to the artists of the time. The Han tradition of architectural models, however, had largely died out, perhaps because their static shapes held little interest for the dynamic vision of the Tang sculptor. The figurines of horses and camels, some almost three feet high, are perhaps the most interesting of all. A proud and vigorous example of Tang funerary ceramic art is the group excavated in 1957 from the tomb of Xianyu Tinghui in Nanhe Cun, Xi'an (*cpl. 28, p. 330*). A small troupe of foreign musicians sharing a single mount is a common conceit in Tang art, and may reflect a commonplace of Tang life. The musicians here, aboard a camel, recall the ones on elephant-back painted on the plectrum guard of the *biwa* in the Shoso-in (*see fig. 392*). The Shoso-in *biwa,*

in turn, closely resembles the one being played by the bearded Central Asian musician seated on the camel.

The successful firing of such large ceramic objects was in itself a tremendous accomplishment; yet so skilled were the artisans that literally hundreds of thousands of the figurines were made in varying quality for the different levels of society. The rarest of these ceramic sculptures, and often the finest, are not glazed but painted with colored pigments over colored slips covering the clay, which ranges in hue from white through buff to terracotta red.

Few Buddhist subjects save for guardian kings—and these might be Daoist or Confucian as well—are to be found among the tomb figurines. The greater number are of secular subjects—lady musicians, exotic court dancers, humorously portrayed foreigners, hunters, and many other categories are known in countless examples, some of them apparently made from the same or similar molds and differing only in hand-finished details (*fig. 395*). The overall appearance of a complete set of tomb furnishings can be gauged from well-preserved excavated groups now in the Royal Ontario Museum (*fig. 396*). Whole cavalcades of horses and camels with Central Asian grooms, whole troupes of dancers and musicians, battalions of cavalry or infantry were the usual accoutrements of the tomb of a wealthy official. Their magical purpose was still to accompany the deceased, and perhaps their extreme sophistication and realism made them seem even more suitable to this purpose than the earlier, more stylized figurines.

Such lead-glazed earthenwares do not represent, however, the most advanced sector of the Tang ceramic industry. Stoneware continued to develop, and true porcelains, in the modern Western definition, were created at this time. The Chinese term porcelain all ceramics whose glaze has been inseparably bonded to the body by high-temperature firing. Western connoisseurs require that the body fabric be white and translucent as well. Song celadons, for example, are porcelain to the Chinese, but rank only as porcelaneous stoneware in the Western hierarchy—in ascending order of firing temperature—of earthenware, stoneware, porcelaneous stoneware, and porcelain.

The Yue celadon wares of the south flourished and were exported far and wide. Their decorative freedom, greater than in earlier ceramics, reflects the cosmopolitanism and wide-ranging interests of Tang society. Molded, incised, and gilded designs of flowers and figures were the order of the day, but few complete examples have survived, though the skillful designs are well known from shards found at the kiln sites in northern Zhejiang.

By the end of the dynasty the north was producing a pure white porcelain known as Xing ware, usually in simply shaped bowls and dishes. More elaborate Xing vases are extremely rare, the most extraordinary being the well-known ewer formerly in the Eumorfopoulos

396. *Tomb figurines with stone mortuary tablet.* Glazed earthenware. China. Tang dynasty. Royal Ontario Museum, Toronto

collection and now in the British Museum (*fig. 397*). This robust vase with its bird's-head lip and floral arabesques on the body seems an epitome of the vigorous, worldly, and technically gifted Tang tradition. Tang celadons and white porcelains were to be the foundations of the numerous and more subtle porcelain traditions of the following period.

Among the thousands of Chinese jades preserved today, we are only now beginning to recognize some Tang examples. But from the number reasonably determined to be of Tang date, it is clear that jade was one of the mediums in which artists of the period tried to express their accepted vision. This most precious and intractable material was, however, the least amenable to Tang ideals of realism and movement. Consequently, however lovely they may be in themselves, the few remaining jades seem the least Tang-like of the decorative arts.

Fortunately there is also another source for our knowledge of Tang decorative art—Japan, which we have seen to be still a cultural and religious satellite of China during the Nara period. Almost miraculous circumstances contributed to the preservation, in the region of Nara, of decorative arts as well as Buddhist sculpture and painting. Horyu-ji and Todai-ji, the homes of so much of the best sculpture in Tang style,

also preserved some examples of the useful and secular arts. But the greatest repository of all is surely the Shoso-in in the precincts of Todai-ji, a treasury of court furnishings and accoutrements donated by the empress Komyo in memory and for the salvation of her husband, the emperor Shomu, in 756 C.E. This treasure is almost completely preserved to the present day in its original storehouse of cypress logs (*fig. 398*).

The more than six thousand objects in this remarkable assemblage, ranging from herbs and weapons to carpets, games, and musical instruments, do not all date from the empress's original donation, but almost all of them entered the Shoso-in during the eighth century. Many are as if made yesterday, for the log construction "breathes" with the seasonal changes in humidity, swelling to keep out the damp and contracting to allow the dry air of late summer and fall to circulate freely and air the three interior storerooms. Here, ranged row on row in chests and cases, are the imperial accoutrements of the Nara court. Even this array, as impressive in quality as in size, must have been but a fraction of what the Chinese emperor could command at Chang'an. Some of the objects in the Shoso-in are undoubtedly of non-Japanese origin, being gifts from abroad or the usual imperial accumulation of rare and exotic luxury items.

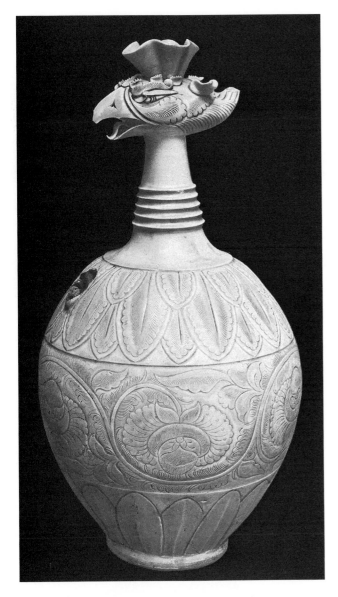

397. *Ewer.* Xing porcelain; h. 15³/₈" (39.1 cm). China. Tang dynasty. British Museum, London

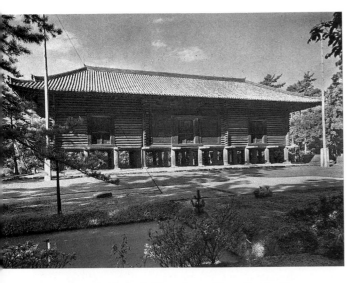

398. *Shoso-in.* Todai-ji, Nara, Japan. Front facade. Nara period, 756 C.E.

399. *Hunt in a landscape.* Detail of screen panel; batik-dyed silk; h. 64¼" (163.2 cm). Nara period, 8th century C.E. Shoso-in, Todai-ji, Nara

400. *Arm rest.* Wood covered with brocade; design: *feng-huang* in floral roundels; h. 7⁷/₈" (20 cm). Nara period, 8th century C.E. Shoso-in, Todai-ji, Nara

The textiles are particularly varied and numerous, and this is to be expected, for the East Asian silk industries were renowned. Indeed, the trade routes to the West were called the Silk Roads. Many of the silks are printed, some by stencil-dyeing, the more abstract patterns by tie-dyeing or by various resist methods. The most sumptuous of the dyed fabrics were made by a wax-resist technique resembling Southeast Asian batik dyeing. The designs on all the fabrics use typical international Tang motifs—the hunt in a landscape with the horses and animals at the Scythian flying gallop (*fig. 399*), or plump court ladies playing musical instruments beneath large-leafed trees.

Among the silks with woven patterns are: gauzes with varied and fine abstract patterns; rich brocades with repeat patterns of figural designs in roundels, the roundels enclosed in vine arabesques linked by semiabstract floral units; and twills of the same designs but usually with a more thoroughly Middle Eastern flavor. These last are closely related to, even copied from, Sasanian twills with their pearl-bordered roundels enclosing heraldic figure groups. Some of the textiles are fragments; others are incorporated in objects such as pillows, arm rests (*fig. 400*), shoes, mirror-box linings, costumes, fold-

401. *Eight-lobed mirror with design of flowers and birds.* Specular bronze coated with lacquer inlaid with gold and silver foil (*heidatsu*); diam. 11¼" (28.6 cm). Nara period, 8th century C.E. Shoso-in, Todai-ji, Nara

ing screens, and banners. Carpets are plentiful in the Shoso-in, made by the Central Asian technique of pressed hair, with inlaid repeat designs of large floral units.

The many metal objects too reveal the international civilization of the time. Some vessels in bronze or gilt bronze are purely Chinese in shape and decoration; others are direct copies of Sasanian silver and gold objects, like the many found in south Russia and now in the Hermitage in St. Petersburg. There are numerous unusually large mirrors whose backs of specular bronze may be plain, or covered with silver or gold, or with lacquer inlaid with precious metal, gemstones, and mother-of-pearl (*fig. 401*). All are decorated with Chinese or Middle Eastern designs of the same type as those on the textiles. Repoussé dishes and flasks are also to be found.

The most extraordinary of the Chinese metal objects are the large silver bowls in Buddhist alms bowl shape with engraved designs of hunting scenes. Smaller ones are known from excavations in China, but the great size and accomplished technique of the Shoso-in bowls place them at the head of their class (*fig. 402*). The landscape setting with its miniature mountains, scattered floral-and-foliage ground, and decorative character provides a tapestry-like background for spirited vignettes of hunters and prey at the flying gallop. One detail might almost be a literal copy of the Sasanian royal hunt motif as found on incised or relief-molded Persian dishes (*fig. 403*). The rider has passed the prey and turns in the saddle to shoot his arrow back over the hindquarters of his galloping horse at the charging, bristling boar. The motif is surely Sasanian, but the apparent speed of the moving figures is achieved by imposing the linear devices peculiar to Chinese painting upon the derived silhouettes.

Ivory, too, is a favorite material, almost completely destroyed on the mainland but preserved in the Nara treasure hoard. Along with plain pieces there are measuring rules whose units of measure are marked off with carved and color-stained designs (*fig. 404*). These were presentation pieces, offered to the sovereign annually on the second day of the second lunar month. Their patterns, smaller and more formal than those on metalwork, alternate birds and animals with flowers or floral medallions. All the motifs belong to the same international decorative vocabulary already noted in textiles and metalwork. Ivory was also used, along with precious colored woods, for marquetry work, particularly in the gaming boards and tables of the court. One *go* table in almost unbelievably splendid condition has side panels amounting to framed pictures, with genre scenes of foreshortened camels and attendants as well as the more usual galloping creatures

402. *Jar engraved with hunting scene.* Silver; h. 19⅝" (49.9 cm). Nara period, 8th century C.E. Shoso-in, Todai-ji, Nara

403. *Hunter and boar.* Detail of fig. 402

404. (above) *Foot rule with design of animals, birds, and flowers* (left, reverse; right, obverse). Carved and stained ivory; l. 11⅝" (29.5 cm). Nara period. Shoso-in, Todai-ji, Nara

405. (above right) *Go gaming table. Shitan* wood inlaid with marquetry, ivory, and deer horn; 19" (48.7 cm) square. Nara period. Shoso-in, Todai-ji, Nara

406. (below) *Decorated kin.* Lacquered wood inlaid with gold and silver foil (*heidatsu*); l. 45" (114.3 cm). Nara period. Shoso-in, Todai-ji, Nara

(*fig. 405*). If these lively scenes are the work of skilled artisans, what must the greatest paintings of the Tang court have been?

Lacquer and lacquered wood were an East Asian medium since the late Zhou period, and it is not surprising that they compose some of the most beautiful objects in the Shoso-in. Vessels, mirrors, and other objects were decorated with designs painted, incised, or inlaid in lacquer, but the most conspicuous and complex example of lacquer work is the seven-stringed zither called the *kin,* decorated in the *heidatsu* technique (*figs. 406, 407*). Sheets of silver and gold foil were cut into delicate floral and figural designs and imbedded in a carefully lacquered wood ground. The whole surface was then covered with additional coats of lacquer. When these had hardened, they were polished down until the precious metals reemerged, flush with the surface of the lacquer ground. The result is one of the most refined and beautiful utilitarian objects in all the world. Flower, wave, and cloud patterns compose an overall background, against which figures of musicians and birds and animals (both natural and mythical) are placed at regular, widely spaced intervals over the surface of the instrument. A square at the head is treated as a framed picture, enclosing a carefully balanced composition of three musicians playing and drinking on a flower-and-bird-carpeted ground beneath a flowering tree flanked by bamboo. Above, in the rhythmically cloud-decked sky, two Immortals riding *feng-huang* on waves of clouds complete the subtly symmetrical arrangement. Enormous technical virtuosity was required by the *heidatsu* technique, for many of the intricately

407. *Decorated kin*. Detail of fig. 406

408. *Musician riding a camel through an exotic landscape. Biwa* plectrum guard; tortoiseshell inlaid with mother-of-pearl; h. 12" (30.5 cm). Nara period. Shoso-in, Todai-ji, Nara

detailed trees are cut in one piece from single sheets of gold or silver foil. The delicate rhythms of the designs, combined with the soft sheen of silver and gold, make a visual counterpart to the limpid and gentle sounds produced by the *kin*.

Experimentation with exotic materials was the order of the day. One *biwa*, again from among the marvelous group of musical instruments, will serve to demonstrate this facet of Tang genius (*fig. 408*). The body combines red sandalwood for the back and neck and *sawaguri* (literally, "marsh chestnut") for the front. A sheet of tortoise-shell forms the plectrum guard, which is inlaid in mother-of-pearl with a musician on camelback playing a *biwa* in a landscape sparely indicated by a centered plantain tree and a few rocks and flowers. Incised details on the mother-of-pearl lend the scene movement and a degree of realism. Precisely spaced around the plectrum guard are thirteen small rosettes composed of mother-of-pearl, tortoiseshell, and agate. On the backboard of the instrument a florid design of cloud-scrolls, flowers, and birds holding scrolling ribbons in their beaks has been executed with utmost complexity: incised mother-of-pearl inlaid over gold and pigments and overlaid with bits of amber. In China we know of such tours de force only through representations in painting or from a few battered and eroded mother-of-pearl fragments.

409. *Gigaku mask.* Lacquered wood; h. approx. 11¾" (29.9 cm). Nara period. Shoso-in, Todai-ji, Nara

410. *Shallow dish.* Polychrome-glazed earthenware. China. Tang dynasty. Private collection, Tokyo

Realism, exoticism, and, by extension, caricature were characteristic interests of the artists of the Tang dynasty and the related Nara period in Japan. Various details and secondary images in the Buddhist sculpture of the period demonstrate this. But the most direct and specialized expression of this interest is found in quantities of wooden and lacquer masks preserved at Horyu-ji, Todai-ji, and the Shoso-in (*fig. 409*). These *gigaku* masks were used for dance interludes in Buddhist festivals, but their intent and derivation were more profane than holy. Unlike the small and subtle *no* masks of later times, whose message was for the few, the *gigaku* masks had to project character and emotion over considerable distance to large numbers; hence their larger-than-life size and their often very exaggerated conformation. Most writers agree that the masks as well as the dances for which they were designed have a Central Asian origin. But this tradition may refer largely to the racial types, represented with characteristic Tang curiosity and exaggeration. The realistic effect of these heads was much enhanced by the use of actual hair on the skulls and for moustaches, and sometimes in the ears or nostrils. All were painted in the desired flesh tone, and where hair was not used, a painted subterfuge was substituted. The facial expressions run from rage to hilarious laughter, from low cunning to benign wisdom.

Two important Tang materials, ceramics and jade, are little or poorly represented in the Shoso-in, and for these we must study the fortunately numerous materials from Chinese excavations and collections. The few ceramics in the Shoso-in are glazed earthenware, similar to more highly refined and skillfully made examples discovered in China. Such lead-glazed earthenwares, in the form of animal and human figurines or of useful vessels such as ewers, jars, plates, and cups, were predominantly used as burial furniture (*fig. 410*). Their bright splashed coloration of amber, green, yellow, or, more rarely, blue is quite unlike the subtle monochromes of the succeeding Song dynasty, and is interpreted by many as a reflection of western Asian tastes. Still, such a palette corresponds well with the rich coloration of Tang figure painting and polychromed sculpture. Taste, like all other aspects of Tang civilization, was robust and vigorous, and was expressed by bold use of color in the arts.

13

The Beginnings of Developed Japanese Art Styles

Japanese art of the Tempyo period truly mirrored the great Chinese imperial style of the Tang dynasty. But changing conditions and mood were both signified and advanced by the removal of the court to Heian-kyo (modern Kyoto), and in this changed environment styles in art began likewise to change. In the Heian period (794–1185 C.E.) a native Japanese spirit emerges, one in many respects quite different from the Chinese style from which it was ultimately derived—the first original contribution of the Japanese to the art of the post–Bronze Age of East Asia. This did not, of course, happen overnight; the Early Heian, or Jogan, period (794–897 C.E.) was the time of transition. Early Heian emperors still ruled, though progressively less effectively, and the style of the Early Heian period displays qualities of power and strength. But as real power slipped into the grasping hands of the Fujiwara clan, leaving reigning but impotent emperors surrounded by a largely ceremonial court, style in the Late Heian, or Fujiwara, period (897–1185 C.E.) became primarily delicate, fine, decorative, and highly aesthetic.

A singularly new kind of Buddhism took powerful hold in Japan during the Jogan period, having swept out of northern India, Nepal, and Tibet and established itself in China. This was Esoteric Buddhism, called *Mikkyo* in Japan, and principally embodied in the Shingon and Tendai sects, both brought to Japan in the first decade of the ninth century by Japanese monks of extraordinary charismatic force who had studied in China. Esoteric Buddhism emphasizes secrecy and mystery. Secret images were kept from the eyes of the laity in special tabernacles, to be revealed rarely or not at all. It includes an enormous and complex pantheon of deities and their multiple manifestations, whose interrelationships are precisely detailed in schematic diagrams called mandalas. And it stresses religious exaltation and magical numbers, incantations, gestures, and equipment. The iconography of Esoteric Buddhism is forbiddingly complicated, but fortunately some of the flavor of Esoteric faith is found in the style of buildings, images, and paintings produced under its influence.

EARLY HEIAN ARCHITECTURE

The temple complex of Muro-ji, outstanding for its sculpture, its painting, and especially its architecture, can be described as the type-site for the Jogan period (*fig. 411*). Here stand the only two remaining structures of that time. Muro-ji, a late Nara temple converted to Shingon

411. *Muro-ji.* Nara Prefecture, Japan. General view

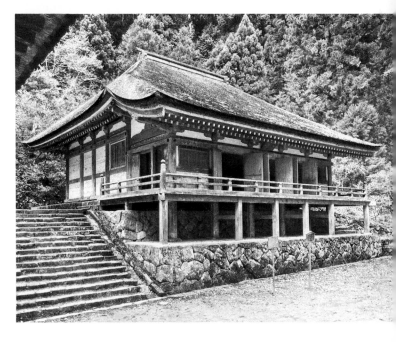

412. (below) *Kondo of Muro-ji.* Nara Prefecture, Japan. Early Heian period, early 9th century C.E.

use, is in a relatively remote area, some forty miles from Nara and twenty to thirty miles from Ise, among high, heavily forested mountains principally covered with cryptomeria, great cedar-like trees reaching heights of over a hundred feet. That other Jogan architectural monuments had similar settings we know from literary sources and archaeological remains. In the Asuka and Nara periods temples had been located on open plains, accessible to clergy and laymen alike, but the new sects wanted sites far from worldly distractions and corruptions, and Jogan temples were secluded in the mountains, among some of the most magnificent scenery in the world. The setting of Muro-ji, with a forested mountain behind it and a small village at its foot, is unforgettable.

A second characteristic of the Jogan temple complex, again in contrast to the Nara temples, is its deliberately asymmetrical plan, forced upon the architect by the lay of the land. The irregular ground plan manifests tendencies that develop into the strongest characteristics of Japanese architecture in native style: asymmetry, irregular ground plan, and a close relationship to the natural site. This relationship, first seen in pre-Buddhist Shinto shrines such as Ise and Izumo, recurs in the architecture of the Jogan period. Other evidence for the development of a native style in architecture can be seen in the shingle roof of the *kondo* of Muro-ji (*fig. 412*) and in the thatch roof of another partially restored structure. Tile roofs and stone platforms were predominant in periods when Chinese influence prevailed. At Muro-ji are shingle or thatch roofs

and wood supports. Japanese shingles are made of very thin sheets of cryptomeria bark, thickly layered to produce a carpet of wood.

Buildings in the Jogan period, as exemplified at Muro-ji, are smaller and more intimate than before. The *kondo*, nestling among the trees on a small platform, seems a part of the forest. The small, shingle-roofed, five-storied pagoda, or *goju no to*, seems almost a toy com-

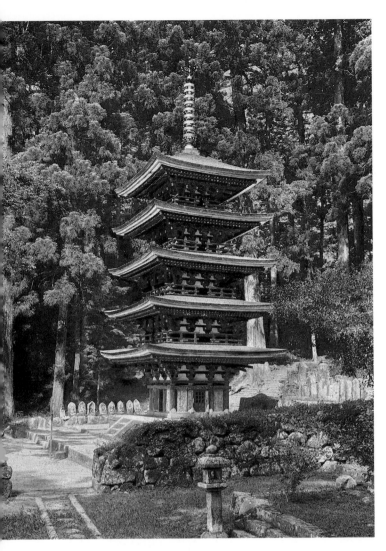

413. *Five-storied pagoda (goju no to) of Muro-ji.* Wood, plaster, bronze, and cedar shingle; h. 53' (16.15 m). Nara Prefecture, Japan. Early Heian period, early 9th century C.E.

pared with the great pagodas of earlier periods (*fig. 413*). With the gentle decrease in the size of the roofs and the small base on the stone platform, the proportions of this lovely structure create an intimacy and refinement quite different from the massive scale and impressive style of the buildings of the Nara period.

At the Nara temple of Toshodai-ji a porch was added to the *kondo*, so that for the first time laymen, although separated from the clergy in the worship area, might be protected from the weather. This division becomes standard in the Jogan period: The icon hall (*kondo*) continues to be used by the clergy, and the *raido*, a separate covered hall for the laity, appears. The first version of the *raido*, which we know only from literary sources, is at once interesting and rather naive. It took the form of a slightly smaller building in front of the icon hall, where laymen could hear the ritual proceedings in the hall. Then a covered passage was added to connect the *raido* and the icon hall. The next logical development was to place *kondo* and *raido* side by side under a double gable. From this to numerous variations, such as the gabled roof with a

closed porch, making the *raido* an integral part of the icon hall, was but a step, but such variations never got beyond the simple separation of one room from another to preserve the secrecy of esoteric rituals.

EARLY HEIAN SCULPTURE

Jogan sculptures have survived in greater number than Jogan buildings—some fifty or sixty, which is few enough, but still more than two. Indeed, works of sculpture are the most numerous monuments of the period. Jogan sculpture presents one of the truly remarkable sculptural styles in the world, and also one of the most difficult, confronting modern art historians with the familiar problem of unintelligibility in relation to art. Art that is difficult tends to be either ignored or disliked; but the twentieth century has redis-covered various styles—European, African, and Pre-Columbian—that were once considered forbidding or even ugly but are now looked upon as aesthetically interesting, indeed, aesthetically great. To enjoy sculpture of the Jogan period, we must bear in mind that it is a hieratic art, produced in the service of a faith and strictly regulated by that faith. It is physically forbidding, and its image types do not accord with present-day ideals of beauty. At the same time they are awesome, perhaps the most awesome icons created in East Asia, just as the Byzantine icons may well be the most awesome created in Europe. Although Jogan sculpture is representational and primarily concerned with rendering an image, the style in which these austere types are presented to us is almost geometrical.

Let us look at an extreme example of Jogan style. The small seated image of a Buddha, Shaka (S: Shakyamuni) or Miroku (S: Maitreya), perhaps sixteen inches high, is carved from a solid block of cypress wood (*fig. 414*). The deity is presented as fleshy, with a heavy body, almost feminine chest, large round face, wide lips and nose, and elongated eyes; the whole effect is massive or, in critical eyes, merely fat. But if we can suspend for the moment our dislike of fat, we begin to notice that the figure's very simple contours convey a monumentality that belies its small size. We note also that the rhythmical repetition of the drapery ridges adds to the solemn deliberation of the image. More than anything else, it is the play of sharply cut details against tautly modeled contours that gives the image its quality of tremendous power under transcendent control. The hands are exaggeratedly large, as befits a figure of weighty and forbidding aspect. From the side, where its corpulence is less apparent, the figure is immediately more attractive, and this in itself is a degree of proof that current notions of physical beauty oftentimes condition our aesthetic reaction. From the side, the fatness is seen only in the double chin, and we can concentrate more upon the deep but not undercut modeling,

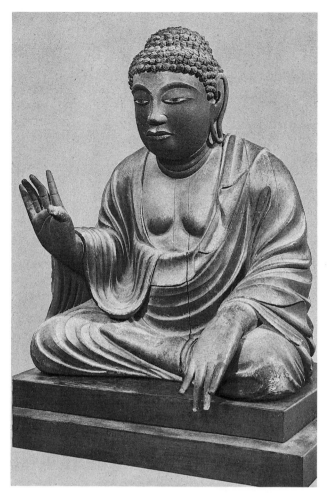

414. *Shaka (Shakyamuni) or Miroku (Maitreya) Buddha.*
Wood; h. 15 3/8" (39 cm). Todai-ji, Nara, Japan. Early
Heian period, 9th century C.E.

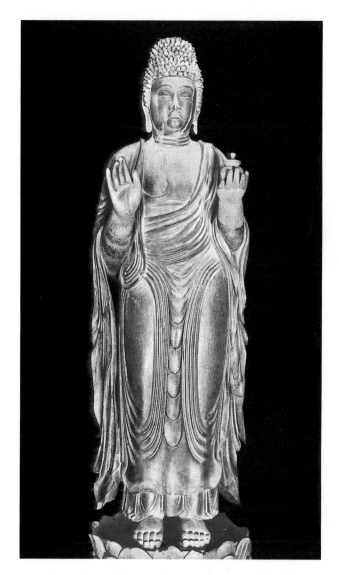

415. *Yakushi.* Wood; h. 66 5/8" (169.2 cm). Jingo-ji, Kyoto,
Japan. Early Heian period, early 9th century C.E.

which describes the simple, rhythmic flow of the drapery
without obliterating the character of the block of wood.
We are also aware of certain forms, such as the ear, which
have been simplified to an almost geometric formula of
great abstract beauty.

We have begun with perhaps the most difficult of all
Jogan images, simply to indicate the problems involved.
Now let us look at some of the more famous images,
which show the style fully, sometimes even ingratiatingly.
The classic Jogan image of the Healing Buddha, Yakushi,
is kept at Jingo-ji in the mountains west of Kyoto (*fig.
415*). Both hands and forearms are modern restorations,
and these disturbingly puffy and formless attachments
make one realize that the Jogan style consists not in mere
fleshiness or mass, but in what is achieved within those
conventions assumed by the sculptor.

As with most Jogan sculpture, at least the head and
torso of this image have been carved from a single block
of wood, a technique called *ichiboku-zukuri,* answering to
the desire for a columnar and massive icon. From the
Fujiwara period images tended to be assembled from
many separate pieces of wood. These blocks were first
hollowed and rough-hewn, then glued or pegged together,
the finishing details carved, and paint or ornament

applied. This technique, called *yosegi-zukuri,* allowed
greater undercutting and ease of pose and prevented
warping and checking. One can almost guarantee that any
genuine Jogan sculpture has a large split because the sur-
face of the wood dried and contracted sooner than the
interior. The Yakushi of Jingo-ji shows the Jogan style at its
most hieratic and formal. The Buddha stands erect, evenly
balanced on both feet in a perfectly symmetrical pose, fac-
ing the worshiper with no sway, no bending of the head, a
pose as rigid and formal as that of the most formal
Byzantine icon. The expression of the face is forbidding;
Jogan figures rarely seem gracious or approachable. But
though they lack affability, they are not less compassionate
and beautiful for that. Indicating the breast of the image
by symmetrical arcs, and disposing the skirt of the robe so
that its folds border a large smooth area on the front of
each thigh, are both devices that call attention to the geo-
metric and columnar quality of the figure and to its origin
in a block of wood. The drapery is in a sense forced to the
edges of the pillar-like legs, producing a pattern that, like
the figure itself, is symmetrical, balanced, and formal.

Beginnings of Developed Japanese Art Styles **317**

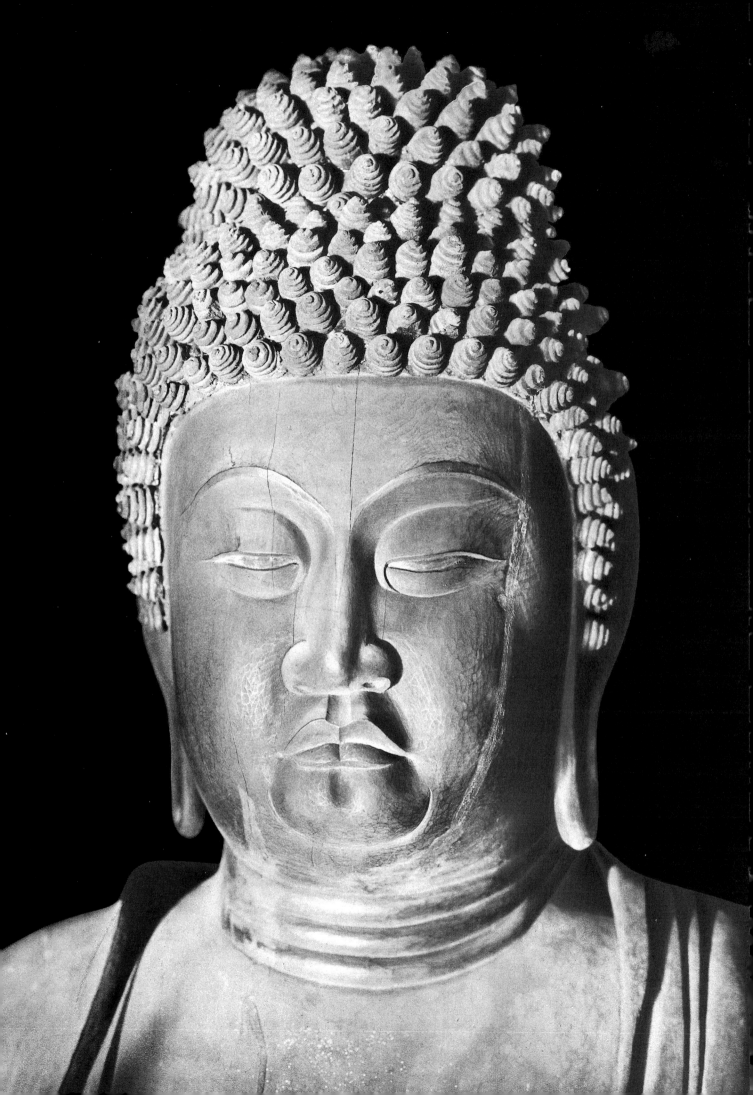

416. (opposite) *Head of Yakushi.* Detail of fig. 415

417. *Priest Roben* (689–773 C.E.). Colored wood; h. 36"
(91.4 cm). Kaisan-do (founder's hall) of Todai-ji, Nara,
Japan. Heian period, datable before 1019 C.E.

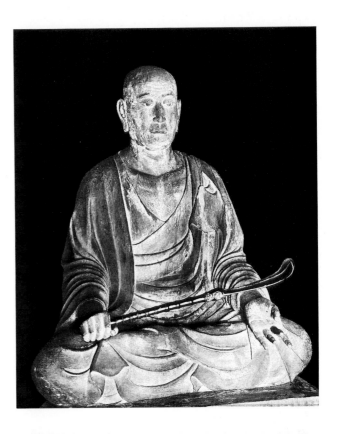

The head of the Yakushi reveals certain other features
characteristic of Jogan sculpture (*fig. 416*). Most impor-
tant among these is a keen sense, not only of the material,
but of the tool used to work it. In contrast to much sculp-
ture of earlier and later periods, there was no attempt to
smooth over the cuts of the knife. This does not mean
that the work was crude, though some provincial Jogan
pieces were. It does mean that the knife was used
extremely skillfully to produce very small but discernible
finishing cuts, which show on the now darkly polished
wood like the facets of a cut diamond. Observe the treat-
ment of the Mongoloid fold of the eye; notice the similar
delicacy in the treatment of the nostrils and mouth. The
edges are sharp, and again the knife was the final finishing
tool. Few sculptural styles display such a proper and con-
vincing union of technique, tool, and material as that of
the Jogan period. The detail of the head shows particular-
ly well the stern, almost scowling, expression characteris-
tic of these Jogan images.

Even portrait sculpture, rare in the Jogan period, has a
massiveness and purposely somber facial expression char-
acteristic of the style and contrasting with the more sym-
pathetic portrait sculptures of the Nara period (*see fig.
237*). The portrait of the priest Roben at Todai-ji, Nara,
traditionally dated to 1019 C.E. but preserving many ele-
ments of Jogan style, is unusual in being extensively poly-
chromed over gesso (*fig. 417*). In most Jogan sculpture
plain wood forms the principal surface. Color is most
sparingly used, and applied transparently over the wood.

The characteristic drapery of Jogan period images,
called *hompa shiki* (rolling wave pattern), is composed of
high, rounded ridges alternating with lower angular ones.
Its derivation is reasonably clear, originating in the sculp-
tural style previously seen in Tang images at Longmen
and Tianlong Shan (*see figs. 227, 221*) and in the colossal
image of the Buddha at Bamiyan in Afghanistan. This
towering image (*see fig. 191*) was a focus of attention for
all pilgrims traveling the Central Asian pilgrimage routes
to Bamiyan and thence to India. A number of works in
this style were carried back by pilgrims to China, Korea,
and Japan, and so became prototypes for particular
sacred images. The peculiar "string-drapery" pattern of
the Bamiyan Buddha, in turn derived from the Kushan
art of India, was the dominant stylistic motif in these
"souvenirs." This motif was then modified in various
sculptures of bronze and wood to produce a style first
perfected, in the transitional period from Nara to Jogan,
in a series of sculptures kept at Toshodai-ji in Nara. Of
these the torso, figure 418, is perhaps the most beautiful

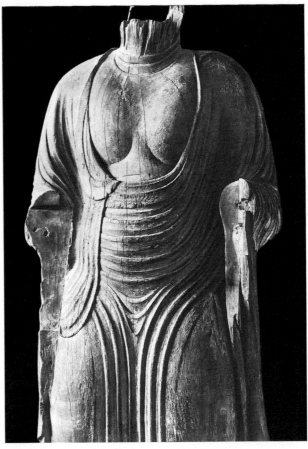

418. *Torso of a Buddha.* Wood; h. 69¼" (175.9 cm). Toshodai-ji,
Nara, Japan. Early Heian period

Beginnings of Developed Japanese Art Styles **319**

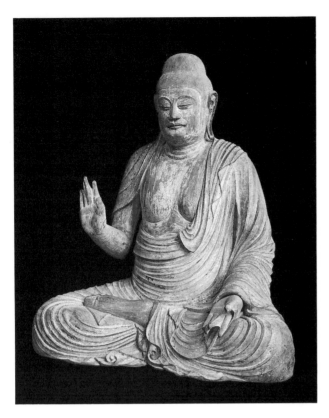

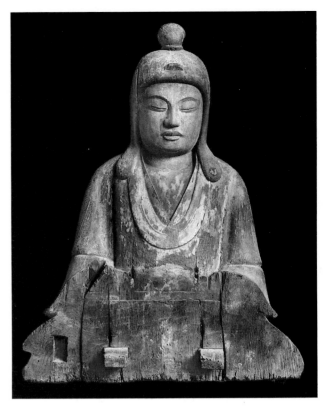

419. *Seated Shaka.* Wood; h. 41" (104.1 cm). Muro-ji, Nara Prefecture, Japan. Early Heian period

420. *Female Shinto image.* Wood; h. approx. 39¼" (99.7 cm). Koryu-ji, Kyoto, Japan. Early Heian period

and famous example, much admired by Japanese and foreigners alike for its purity of form. It shows an intermediate stage in the development of the *hompa shiki* drapery motif from the Bamiyan image: The drapery folds at the elbow are not stringlike but triangular or wavelike. We should note the close resemblance between this figure and the Jingo-ji Yakushi (*fig. 415*), in the modeling of the torso as well as the draperies. A classic example of *hompa shiki* drapery is to be found on the Shaka at Muro-ji, a figure which originally had some color applied on a white gesso ground and is otherwise in almost perfect condition (*fig. 419*). The folds of the robe are everywhere composed of large, rounded waves alternating with shallower waves with pointed profile. This rolling rhythm of alternate small and large ridges is subtly varied in places and is produced wholly with the knife.

Sculptured Shinto icons began to appear in the late eighth century and increased in number during the ninth, clearly in emulation of Buddhist usage. Some are embodied in forms borrowed directly from Buddhist iconography—Hachiman as a monk, or various guardian deities closely resembling the fierce gods of Esoteric Buddhism. Others wear the characteristic features and dress of contemporary aristocrats. Typically, they represent the gods of Japan's creation legends, or deified clan ancestors, or animistic deities associated with the forests, fields, and waterfalls, although few of the images bear specifically identifying attributes. Considered material embodiments

of the native gods, these images are held especially sacred and usually occupy the innermost sanctuaries of their respective shrines. A female Shinto image from Koryu-ji in Kyoto shows a simple variation of the *hompa* pattern on the drapery folds and is related to the seated Buddha images by her blocklike massiveness and by her somewhat severe, or at least inward expression (*fig. 420*). The headdress is aesthetically interesting and also exemplifies the standard upper-class female headdress of the period. It is certainly no coincidence that massive headdresses and heavy draperies were characteristic costumes of a period that produced sculptures with similar qualities, and it would be an interesting exercise to correlate sculptural styles with contemporary dress.

For contrast to this somewhat provincial Shinto goddess, let us look at one of the more suave and aristocratic productions of the Jogan period (*cpl. 29, p. 331*). Its quality and fine state of preservation make it one of the two or three most important Jogan sculptures. The base, the figure, and the body halo (*mandorla*) are all original and of the period, as is the polychromy. The six-armed Nyoirin Kannon is seated on a lotus pedestal in the traditional posture of "royal ease." Two hands hold the wish-granting jewel (*nyoi*) and the Wheel of the Buddhist Law (*rin*) from which the icon type derives its name; two more hold a Buddhist rosary and a lotus, the flower symbolizing purity of soul amid worldly corruption. Of the remaining two hands, one touches the cheek in a pensive gesture, the

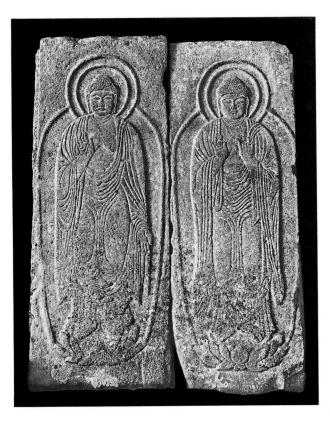

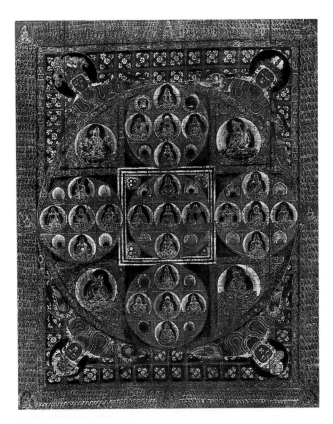

421. *Shaka and Miroku.* Stone relief; h. 9'6" (2.9 m). Kanaya Miroku-dani, Nara, Japan. Early Heian period

422. *Kongo-kai mandala* (detail of central section called the Joshin-kai). Gold on purple silk; h. of whole 13' (3.97 m). Kojima-dera, Kyoto, Japan. Late Heian period

other rests palm down on the pedestal, the touch alluding to Kannon's paradise. Each hand holds the power to save all sentient beings in one of the Six Realms of Existence. Of all the Jogan figures we have seen, this one has the roundest face, but any associations between roundness and geniality are contradicted by the unsmiling mouth and the inward gaze of the elongated eyes. As in most Jogan images, a majestic aloofness predominates, reflecting, together with the involved symbolism of gestures and attributes, the emphasis on mystery and complexity that characterizes Esoteric Buddhism.

All these figures have been in wood, the natural Japanese sculpture medium. Yet, significantly enough, the one period from which some important figures in stone exist is the Jogan, when Japanese sculptural style achieved its most compact and massive qualities and when the carving was largely limited to the surfaces of the material. In two reliefs of Buddhas, a Shaka and a Miroku, characteristic *hompa shiki* drapery style is translated into low relief of a somewhat provincial rendering by comparison with the great works in wood (*fig. 421*).

EARLY HEIAN PAINTING

Paintings of the Jogan period are extremely rare, but those few we have are of great interest. One type, the

mandala, derived by the Esoteric sects from China, came into being at this time and continued to be made almost to modern times. Now, a mandala is simply a diagram, a graphic representation of the cosmos or of the relationships among various deities. As an object of meditation, however, a mandala is an instrument to bring about psychic union between the devotee and the Supreme Buddha, Mahavairochana (J: Dainichi Nyorai). Two mandalas are particularly important for the Esoteric Buddhist sects of the period. The Garbha-dhatu (J: Taizo-kai) is the "womb circle," containing some 407 deities in twelve sections, explaining principles and causes. The Vajra-dhatu (J: Kongo-kai; *fig. 422*) is the "diamond circle," with some 1,314 deities in nine sections, expounding reason and effect. Naturally the Supreme Buddha, Dainichi Nyorai, is at the core of each mandala, or diagram explaining the complex Shingon hierarchy. Each of the myriad deities is an emanation from, and acting for, Dainichi Nyorai. The mandalas combine representation (of the Buddhas and bodhisattvas) with extreme symbolism (attributes of deities and Sanskrit letters and "germ syllables" imbued with magical powers). The images are arranged according to a rational and cosmologically significant scheme of interrelationships. Thus the mandalas are nearly always laid out geometrically, on a grid pattern or in a circle or a combination of the two. Borobudur, the great monument in Java, is a mandala in stone (*see fig.*

423. *Taizo-kai mandala* (detail). Gold on purple silk; h. of whole approx. 13' (3.97 m). Jingo-ji, Kyoto, Japan. Early Heian period

424. *Attendants of Fudo.* Detail of cpl. 30

183); the Kongo-kai is a painted one. In figure 422 the central square contains the five most important deities, with Dainichi in the center. The Buddhas of the Four Directions are the central figures in each of the four large circles, and the deities of the Four Elements occupy the four smaller circles. The geometric and primarily intellectual placement gains aesthetic appeal from its subtly abstract arrangement and its gold and dark blue coloring. Indeed, the Kojima-dera mandalas are eleventh century versions, with variations, of a much earlier and finer, if sadly damaged, pair preserved at Jingo-ji in Kyoto. If one looks at details of these older paintings, one sees some remnants of Nara period style, a certain grace in rendering figures recalling the frescoes of Horyu-ji or the painted banner in the Shoso-in. The small details of the mandala show that the style is really a continuation of the linear style of the Tang dynasty (*fig. 423*). Here a bodhisattva attended by two angel-musicians is doing a dance like those seen in the foregrounds of representations of the Western Paradise at Dunhuang in northwest China (*see fig. 238*).

The great contributions of the Jogan period in painting are not to be found, however, in the restricted art of mandalas but in the representational pictures that correspond to the sculptures, particularly in those icons representing the terrible aspects of deities. These manifestations are epitomized by the famous *Red Fudo* of Koyasan, a representation of an Esoteric deity dubbed the Immovable, a terror to evildoers (*cpl. 30, p. 332*). Adamant upon his rock, Fudo sits attended by his usual two youthful acolytes, glaring out past the worshiper. The composition, filling the frame from the very bottom at the attendants' feet to the top, where the red flames reach even beyond the edge, produces a massive effect controlled by the figures, especially Fudo, whose red color dominates the whole conception. The expression of the deity, with one fang up and the other down, and rolling, glaring eyes, combines with the *vajra*-handled sword, a materialized thunderbolt with a dragon coiled about its sharpened blade, to produce a convincing pictorial realization of the awesome and the terrible. Fudo's two boy attendants, one a proper-looking youth, the other with fangs, glaring eyes, and unkempt hair, conform to the Jogan physical type (*fig. 424*). The style of the representation—the drapery with its reversed shading of the *hompa shiki* folds, the heavy line creating simple, geometric forms, not graceful and elegant as in the Nara period, but massive and almost deliberately simple and rude—invests this image, overall, with tremendous awesomeness.

One of the most arresting examples of Jogan pictorial style, despite its bad condition, is a depiction of a lesser deity of Esoteric Buddhism, Suiten (*fig. 425*). Suiten is a "borrowed" deity, having originated in Hinduism as

425. *Suiten.* Color on silk; h. 63" (160 cm). Saidai-ji, Nara, Japan. Early Heian period

Varuna, lord of the waters. These squared, thrown-back shoulders and the massive chest proclaim strength. Unlike the bird or animal vehicles of earlier and later periods, which may be rather small, even playful, Suiten's giant turtle vehicle has a dragon-like head as awe-inspiring and massively convincing as the image it bears. Big, sweeping curves form the turtle's neck, the dragon crown, the halo, and the roll of the drapery over the shoulders, recalling the stately rhythms of a *hompa* drapery pattern. The repetition of these curves is one means whereby the artist creates monumentality.

EARLY HEIAN DECORATIVE ART

Numerous ritual tools of Esoteric Buddhism—bells, *vajra* (thunderbolts), ritual daggers, and other implements—were used in connection with the intricate hand motions, rhythms, and sequences that were part of worship (*fig. 426*). These reflect the Jogan ethos in metalwork, and are continued in later periods.

Apart from literary sources, we have only a single gold lacquer sutra box (*kyobako*) from which to infer the appearance of Jogan secular art (*see fig. 445*). The decoration of the sutra box is Buddhist in subject: Embedded in a rock in the middle of the sea is the dragon-wreathed, *vajra*-hilted sword that symbolizes Fudo, the Immovable. Fudo's two young acolytes (*see cpl. 30, p. 332*) flank the sword. The design is in gold and silver on a brown lacquer

426. *Vajra-handled bell.* Gilt bronze; h. 6¼" (15.9 cm). Japan. Early Heian period. Y. Yasuda collection, Japan

ground, with falling lotus petals as a decorative accent in the background on either side of the sword with its flaming dragon. Here is a primarily religious subject with decorative overtones. It indicates the beginnings of a decorative style of great importance for the later development of Japanese art.

THE LATE HEIAN PERIOD

In the Late Heian period art becomes more refined, decorative, and aristocratic. It is all too easy, but not necessarily correct, to assume the influence on Fujiwara art of political events and changing social structure. But social and artistic similarities do not necessarily guarantee causal relationship or even chronological sequence. All we can say is that in the ethos of the Fujiwara period there seems to be a definite correlation between the type of society then developing and the new tendencies of Japanese art. The power of the emperor was usurped by the aristocratic Fujiwara clan at Kyoto, but this did not

lead, as it might have in Europe or even in China, to the founding of a new dynasty. The emperor and the emperor's lineage were maintained with full honors and, in theory, full sovereignty. In practice power was wielded—i.e., Japan was governed—by the dominant clan, which was at first the Fujiwara; and this was the beginning of a system of government that continued in Japan without much change or interruption to the present day. Once real power no longer inhered in imperial lineage but was available to whatever clan could grasp and hold it, the stage was set for palace struggles and intrigue and internecine war on a grand scale, this in contrast to the relative tranquillity and centralized power of the preceding periods. There were now in effect two courts at Kyoto, and the imperial one, shorn of political power and administrative responsibility, was left with considerable leisure for the appreciation and practice of the arts.

In this period court life became exquisitely refined. It is a period of great poets, and of the earliest Japanese novel, *The Tale of Genji*, by Lady Murasaki. This new ethos, highly aesthetic, self-conscious, almost overly subtle, is reflected in the painting and sculpture of the period, particularly in that associated with the court, for in the religious centers, despite new influences, the Early Heian tradition was still strongly maintained. We will first consider traditional religious art and its gradual changes, finding in those changes some hint of aesthetic attitudes that were to reach their clearest and most unalloyed expression in the secular art associated with the court. The conservatism of a period is almost as historically instructive as its innovation. We can tell a great deal about any period by asking what kind of art continued from the previous period and what kinds of modifications were introduced.

427. *Dai-itoku Myo-o.* Ink, color, and gold leaf on silk; h. 6'2⁷/₈" (1.9 m). Japan. Mid-Heian period. Museum of Fine Arts, Boston

LATE HEIAN RELIGIOUS ART

In the Fujiwara period the painting of Buddhist icons, as one might expect, continued in the earlier style, particularly in representations of the terrible aspects of deity, such as Dai-itoku Myo-o (*fig. 427*). Dai-itoku Myo-o was one of the five Wisdom Kings (*myo-o*), fearsome Esoteric deities introduced into Japan by the Shingon and Tendai sects and worshiped as manifestations of the Supreme Buddha's holy wrath against ignorance and illusion. Dai-itoku is portrayed by the early Fujiwara artist much as he had been during the Jogan period: a large-scale figure filling the entire silk to the edges of the frame; ample extremities; large planar structures boldly and vigorously patterned. Only in certain minor details, notably in the more elegant geometry of the knees, legs, and body structure, is there any sign that this icon was painted over a century after the Jogan period.

Iconic art is traditionally conservative, because the

magic that (in the minds of most believers) resides in the image may not work if the image is not accurate (i.e., like earlier, proven images). Something like the same belief attaches to representations of founders of the various Buddhist sects. The simple monumental style, based upon Tang Chinese painting and continued in the one or two remaining fragments of the Jogan period, is maintained in the Late Heian period. The portrait of Jion Daishi, patriarch of the Hosso sect, carries on the Tang figure painting tradition in its fine, even, linear drawing and in its nearly empty background, the only indication of actual setting being the dais, a water vessel to the left, and a little table holding scrolls and brushes to the right (*fig. 428*). But in the original color, especially the varicolored rectangles on which the calligraphy appears, one senses the difference between the austerity of a Jogan portrait and the relaxation of that austerity in this portrait of the Fujiwara period.

If the icons and single figures tend to be conservative, certain other paintings associated with Buddhism show

428. *Portrait of Jion Daishi.* Color on silk; h. 63" (160 cm). Yakushi-ji, Nara, Japan. Late Heian period, 11th century C.E.

429. *Mourners, from the Parinirvana.* Detail of cpl. 31

significant modification. One of the most important Buddhist paintings in Japan or, indeed, in East Asia is the great representation of the *Parinirvana of the Buddha,* a very large hanging scroll at Koyasan (*cpl. 31, p. 333*). The painting is beautifully preserved, and presents a veritable kaleidoscope of soft greenish yellows, pale oranges, greens, blues, mild reds, and numerous touches of gold. The effect is not unlike that of a complex Italian altarpiece of the fourteenth century. The *Parinirvana* is dated to 1086 C.E., and incorporates both Jogan survivals and important changes of the Fujiwara period. The Buddha, represented completely in gold, lies on a dais, with his head resting on a lotus pillow. About the dais are the many bodhisattvas, disciples, and followers of the Buddha who have come to mourn the great event, even including some grieving animals at the edges of the composition. The setting is a placid landscape of a decorative Tang dynasty type, with flowering trees reaching to the sky where the Buddha's mother, Queen Maya, appears to witness the "final extinction" of her son, the fulfilled Buddha. The composition also follows Tang style by occupying a completely defined, stagelike space. The foreground area leads up to the dais, which is slightly tilted toward the viewer. Four trees, slightly off center at each of the axes of the dais, further define the space. Foliage and

clouds finish the picture surface and also create a convincing spatial setting, modified and made more flat and decorative by the way in which the color is applied.

The representation of the figures is extraordinary, particularly in its hierarchical revelation of psychological states. As a mark of reverence the Buddha is shown in gold, as are the bodhisattvas, while the lesser members of the Buddhist hierarchy, the disciples and, of course, the animals, are shown in color only. The psychological states correspond to this order. The Buddha and the bodhisattvas are impassive, their eyes closed or almost closed, wearing the traditional masklike, slightly smiling countenance of beatific deity. The disciples, on the other hand, mourn, pray, weep, or even cry out, looking to the sky, their faces contorted by grief (*fig. 429*), resembling grotesque Tang representations of founders or patriarchs. Even the figures of the Guardian Kings of the Four Directions show realistically observed emotion. One, at the lower left, shields his eyes with a hand covered by his sleeve, a usually fierce and overpowering figure here reduced to sadness and tears. The guardian on the right is in the same state, his teeth bared in a mask of sorrow. The animals, the lowest of the hierarchies presented, are even more violently affected. At the lower right a lion, presumably the vehicle of the bodhisattva Manjushri,

rolls on his back with his legs in the air in paroxysms of grief. The combination of space, color, and pattern with a unified psychological progression from sublime calm to extreme emotionalism produces a masterpiece of Buddhist painting.

There is another work comparable to the *Parinirvana*, not only in subject matter but in quality—a most unusual representation of the resurrected Buddha preaching to his mother, Queen Maya, who is just to the left of the dais (*fig. 430*). This hanging scroll might almost be by an artist trained in the studio that produced the *Parinirvana*. Here the Buddha's aureole, or halo, is dotted with representations of other Buddhas. The landscape setting with its Tang type trees recalls the slightly earlier work, as does the differentiation of types, from the Buddha and bodhisattvas to disciples and commoners who have fallen to their knees in adoration of the event. It is important to recognize that both of these paintings are not only icons but also decorative and rich color orchestrations. This in itself marks a distinct change from painting of the Jogan period, which tended to simpler color arrangements. Common to the two Fujiwara paintings, then, are the traditional Tang style settings and a new interest in psychological characterization and in the decorative use of color. These two modes, the decorative and the realistic, emerging clearly and in native form, constitute a dualism that remains one of the outstanding characteristics of Japanese art.

In sculpture, too, similar changes are evident. Many sculptures of the earlier part of the Fujiwara period are, in essence, continuations of Jogan style; but by the middle of the period, and certainly at the end, even the principal—hence most conservative—icons have changed radically in sculptural style. The Supreme Buddha, the primordial form of Dainichi Nyorai, from whom all creation emanates, is Ichiji Kinrin. His image, kept in a secret tabernacle at Chuson-ji, a temple near Sendai in northern Japan, is a telling example of this change in sculpture (*fig. 431*). Polychromy completely covers the wood, with elaborate cut-gold (*kirikane*) patterns on the draperies. Modeled not in the round but in half-round relief, the icon shows a softness quite unlike the powerful forms of earlier periods. The face is no longer stern and austere but aristocratic, almost effeminate, with small, rosebud mouth, high-arching brows, and very narrow, short, sharp nose, not unlike that to be seen shortly in the *Genji* scrolls.

But the work that summarizes fully developed Fujiwara tendencies in sculpture is a famous representation of the goddess Kichijoten (*cpl. 32, p. 334*). The figure, from Joruri-ji, is one of the most beautifully preserved sculptures of the period. Executed in richly polychromed wood, it makes a gay, almost gaudy, first impression. In contrast to the relatively simple female forms of the Nara and Early Heian periods, the Kichijoten of Joruri-ji has the same kind of feminine elegance to be seen in the Ichiji Kinrin; but here it seems somehow more appropriate and

more related to the structure beneath, producing a unified and coherent work of art. One can see remnants of older traditions in the underlying structure of the figure, notably the wide, falling sleeves with the hollow recesses, simply carved so as to preserve the essentially trunklike character of the body. All the complicated drapery and the jewelry hanging from the neck and waist and ornamenting the hair is executed in carved and painted wood. Thus a simple basic structure is overlaid by elegant and aristocratic detail expressive of the new Fujiwara interest in decorative style. In the Nara period such detail would have been simply painted on; by Fujiwara times it has acquired complex sculptural form.

A new subject appears in Late Heian religious art, associated with the emergent sect of Jodo (Pure Land) Buddhism. This sect is primarily devoted to the worship of Amida (S: Amitabha), Buddha of the Pure Land, also called the Western Paradise. We have seen Amida represented in Tang art in a formal, Chinese style Paradise (*see fig. 238*). In the seventh century the Pure Land sect took great hold in China, and Japanese monks returning from study there brought with them an increasing emphasis on Amida worship. By the tenth century Amidism, or Jodo, was attracting significant numbers of adherents, though it had not yet emerged as a distinct sect in Japan. In contrast to the secret, awesome, and complicated practices of Shingon, Jodo was simple and comforting. One needed only to adore Amida to be saved. The Western Paradise was painted as a bounteous land of celestial sights and sounds, where jewels and flowers bloomed on every tree. The cult appealed tremendously to both aristocracy and commoners—to the aristocracy, because its approach to faith was relatively worldly and sensuous and its Western Paradise resembled a particularly refined Heian court; to the common people, because salvation by faith is an accessible and consoling doctrine, certainly in comparison with Esoteric teachings.

A favorite theme of the new sect was the *raigo*, or "welcoming approach" of Amida Buddha. It is a subject that first appeared in Japanese art about 1053 C.E., on the doors of the Phoenix Hall. Very likely the *raigo*, which represents one of the most lyrical visions of deity achieved by any faith, is a Japanese invention. The essence of the *raigo*, in sharp contrast to the forbidding nature and sequestration of the Esoteric icon, is the Buddha coming to the believer. Amida is not merely approachable; he descends to receive and escort the soul of the dying believer into his Western Paradise. Now, this is psychologically an extraordinary change and is accompanied by a very interesting pictorial development, from an iconic representation of the coming of the Buddha to an asymmetrical composition, realistic in detail—a gracious and personal depiction of his descent.

Earlier *raigo* are oriented toward the spectator, as if he were the dying person, as in the great *raigo* triptych at

430. (left) *Shaka Emerging from the Golden Coffin.* Hanging scroll; color on silk; h. 63" (160 cm). Choho-ji, Kyoto, Japan. Late Heian period, late 11th century C.E.

431. (below) *Ichiji Kinrin.* Painted wood; h. 29⅞" (76 cm). Chuson-ji, Hiraizumi, Iwate Prefecture, Japan. Late Heian period

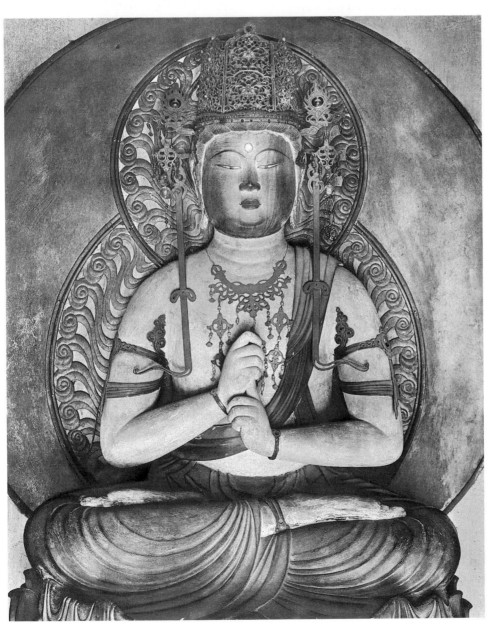

432. (above) *Amida raigo triptych*. Color on silk; h. 6'11" (2.1 m). Japan. Late Heian period, late 11th century C.E. Koyasan Museum, Wakayama

433. *Amida Kochoho*. Dated to 1146 C.E. Drawing; ink on paper. Japan. Late Heian period. Ishikawa Prefectural Art Museum, Kyushu

Koyasan (*fig. 432*). Here the large figure of Amida, accompanied by a retinue of angels, bodhisattvas, and monks borne on clouds, faces and moves toward the spectator. Their motion is indicated by the perspective of the clouds as they rise and recede to the left and top of the central panel. The vision hovers above a landscape clear at the lower left but barely visible at the right. But the landscape is a small and unobtrusive part of the picture, so that the whole effect is a rather more iconic than realistic presentation of an imagined scene. Details of the figures reveal, just as in the *Parinirvana* at Koyasan, a marked development of decorative detail, color, and realism. The celestial musicians are particularly interesting. They are shown in poses observed from nature, dancing or playing their instruments, and puffing out their cheeks as they blow into more difficult wind instruments.

Usually one can find the more advanced pictorial tendencies at a given time in secondary parts of pictures. In Italian painting, for example, new developments appear first on the predella panels or in secondary figures. In these the artist seems to feel freer to invent and improvise, whereas the central figures must remain true to their iconic types. So it is here. The observation of nature and the development of new decorative patterns and color chords are recorded in the heavenly musicians surrounding the Buddha rather than in the Buddha himself.

The development of realism in the *raigo* is perhaps best seen in a small and wickedly humorous sketch, but recently discovered and now in a private collection (*fig. 433*). It is a monochrome satirical representation of Amida Kochoho (Amida Who Summons to a Higher Plane) pulling an unwilling soul toward him by a string

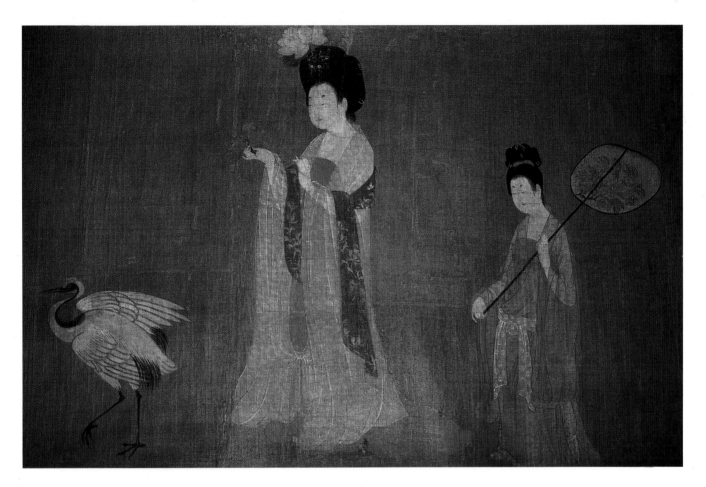

Colorplate 26. *Court Ladies Wearing Flowers in Their Hair.* Attrib. Zhou Fang (act. c. 780–c. 810 C.E.). Handscroll; ink and color on silk; h. 18" (45.8 cm), l. 5'8" (1.8 m). China. Tang dynasty. Liaoning Provincial Museum, Shenyang

Colorplate 27. *Traveling in Spring.* Attrib. Zhan Ziqian (act. late 6th century C.E.). Handscroll; ink and color on silk; h. 16⁷/₈" (43 cm), l. 31⁵/₈" (80.5 cm). China. Style of 1st half of Tang dynasty. Palace Museum, Beijing

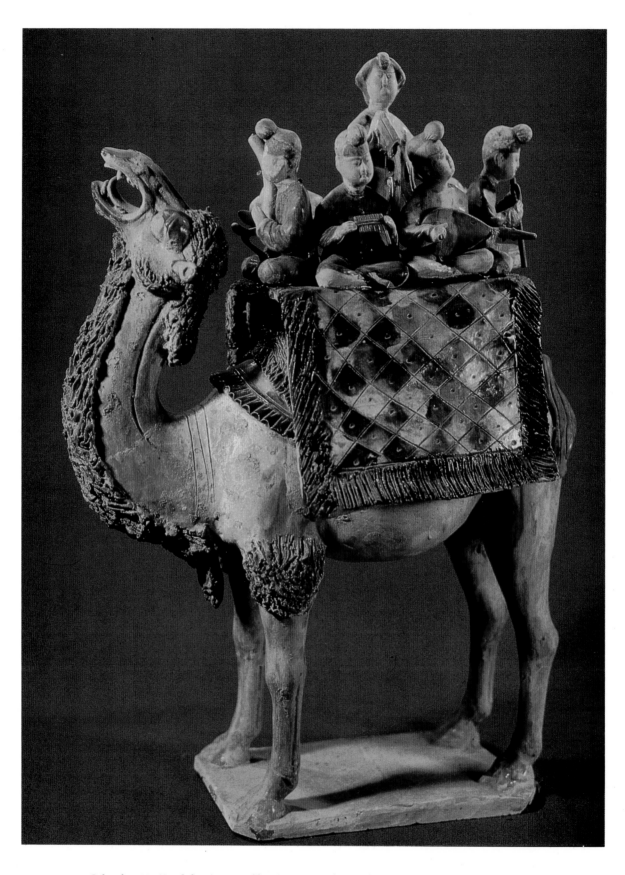

Colorplate 28. *Tomb figurine: camel bearing troupe of Central Asian musicians.* Three-color glazed earthenware; h. 23" (58.4 cm). Tomb of Xianyu Tinghui, Nanhe Cun, Xi'an, Shaanxi, China. Tang dynasty, 1st half of 8th century C.E.. Museum of Chinese History, Beijing

Colorplate 29. (opposite) *Nyoirin Kannon.* Colored wood; h. 43" (109.2 cm). Kanshin-ji, Osaka, Japan. Early Heian period, early 9th century C.E.

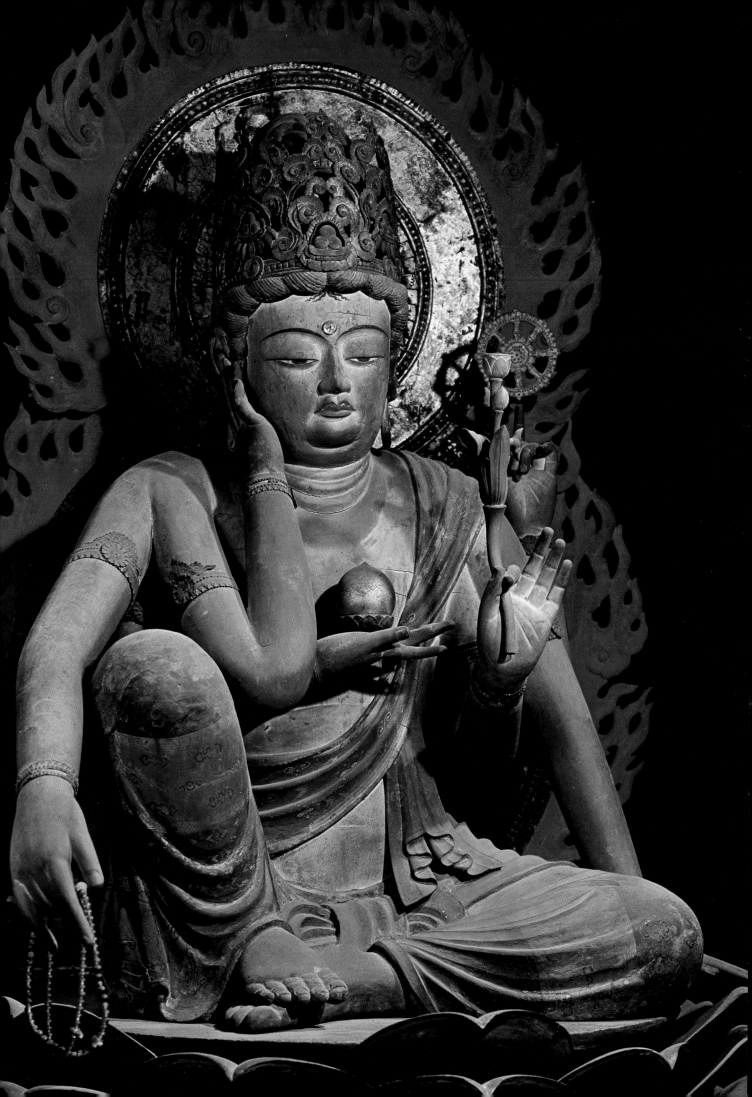

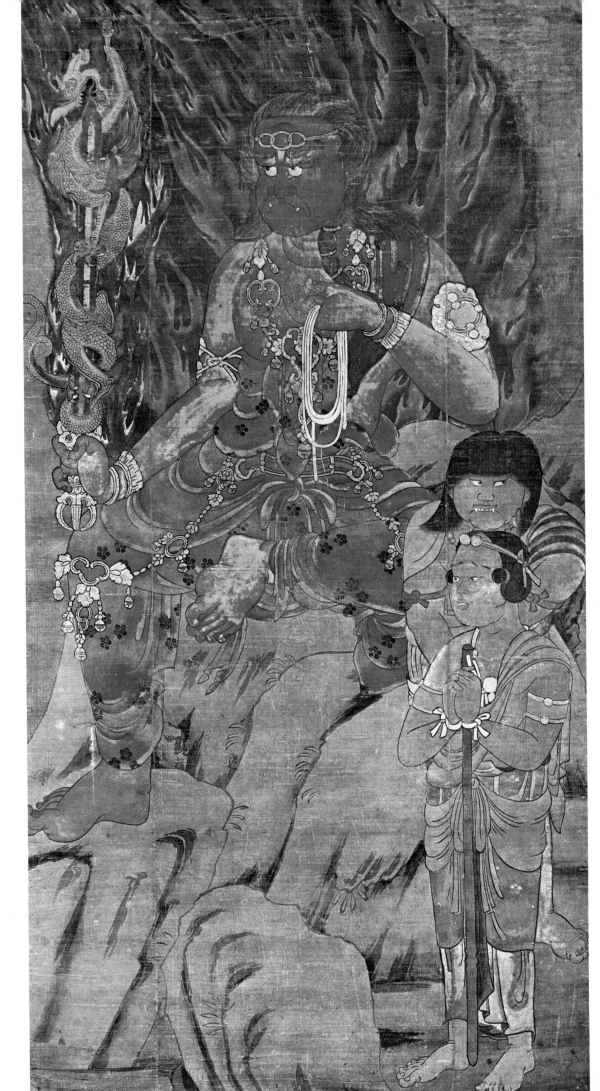

Colorplate 30.
Red Fudo Myo-o.
Color on silk;
h. 61¹/₂" (156.2 cm).
Myo-o-in, Koyasan,
Wakayama
Prefecture,
Japan. Early Heian
period

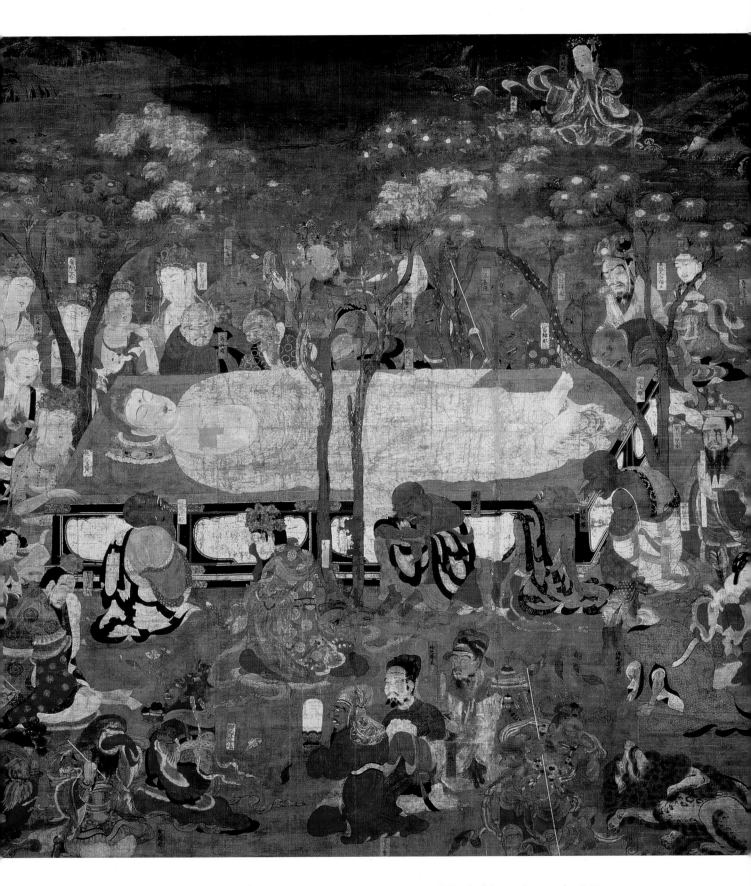

Colorplate 31. *The Parinirvana of the Buddha.* Dated to 1086 C.E. Color on silk; h. 8'10" (2.69 m). Kongobu-ji, Koyasan, Wakayama Prefecture, Japan. Late Heian period

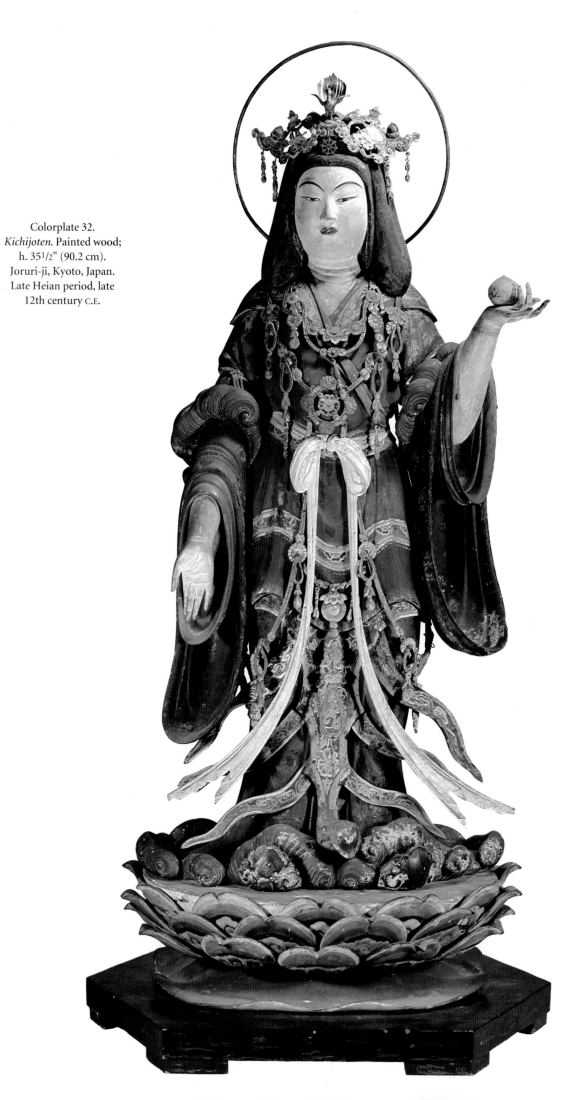

Colorplate 32.
Kichijoten. Painted wood;
h. 35¹/₂" (90.2 cm).
Joruri-ji, Kyoto, Japan.
Late Heian period, late
12th century C.E.

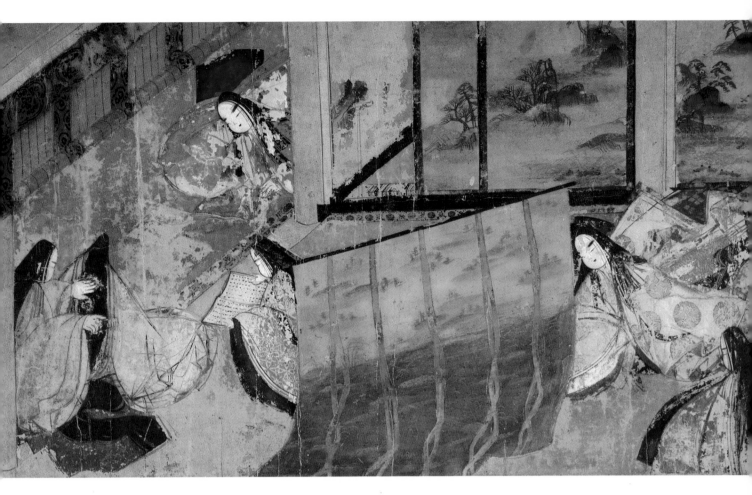

Colorplate 33. *First illustration to the "Azumaya" chapter of The Tale of Genji.* Handscroll; ink and color on paper; h. 8¹/₂" (21.6 cm).
Japan. Late Heian period, 12th century C.E. Tokugawa Art Museum, Nagoya

Colorplate 34. *Heads of nobleman and lady.* Details of a mural; ink and color on wood; approx. two-thirds life size.
Aegaki Shrine, Shimane Prefecture, Japan. Late Heian period, 10th century C.E.

Colorplate 36. *Ladies Preparing Newly Woven Silk.* Attrib. Emperor Hui Zong of Northern Song (r. 1101–1126 C.E.), but probably
by court academician, after a lost painting by Zhang Xuan (act. 713–741 C.E.). Section of the handscroll; ink, color, and gold on silk;
h. 14¹/2" (36.8 cm), l. 57¹/4" (145.4 cm). China. Northern Song dynasty. Museum of Fine Arts, Boston

Colorplate 37. (above right) *Covered jar.* Jun porcelaneous stoneware; h. 3³/4" (9.5 cm). (above left) *Bulb planter.* Jun porcelaneous stoneware, diam. 9¹/4" (23.5 cm). (right) *Dish.* Ru porcelaneous stoneware; diam. 5" (12.7 cm). All: China. Northern Song dynasty. Cleveland Museum of Art

Colorplate 38. (left) *Covered vase.* Longquan Celadon porcelaneous stoneware; h. (with lid) 9⁷/₈" (25.2 cm). China. Southern Song dynasty, 12th–13th century C.E. Percival David Foundation of Chinese Art, London. (below) *Incense burner in form of archaic gui.* Longquan Celadon porcelaneous stoneware; h. 3³/₄" (9.5 cm), diam. (incl. handles) 7¹/₄" (18.4 cm). China. Southern Song dynasty, 12th–13th century C.E. Percival David Foundation of Chinese Art, London

Colorplate 39. (left) *"Gall-bladder" shape vase.* H. 5¹/8" (13 cm). (right) *Gui incense burner.* W. 6¹/8" (15.6 cm). Both: Guan porcelaneous stoneware. China. Song dynasty. Cleveland Museum of Art

Colorplate 40. *Dainichi Nyorai.* Color on silk; h. 37" (94 cm). Daigo-ji, Kyoto, Japan. Kamakura period, 13th century C.E.

Colorplate 41. *No mask: Ko-omote.* Painted wood; h. approx. 10" (25.4 cm). Japan. Muromachi period, 15th century C.E. Kongo Family collection, Tokyo

Colorplate 42. *Burning of the Sanjo Palace.* Section of the handscroll *Heiji Monogatari Emaki*; ink and color on paper; h. 16³/4" (41.3 cm), l. 22'11" (7 m). Japan. Kamakura period, late 13th century C.E. Museum of Fine Arts, Boston

Colorplate 43. *Fresh-water jar for tea ceremony.* Shino stoneware; h. 7¹/4" (18.4 cm). Japan.
Momoyama period, 16th century c.e. Cleveland Museum of Art

434. (left) *Ho-o-do
(Phoenix Hall)
of Byodo-in.*
Uji, Kyoto Pre-
fecture, Japan.
General view.
Late Heian period,
11th century C.E.

435. *Plan of Phoenix
Hall of Byodo-in.*
Uji, Kyoto Pre-
fecture, Japan.
Late Heian period,
11th century C.E.

around the neck. The sketch is dated to 1146 C.E., close to the end of the Fujiwara period, but is executed in conservative style, using a thin, wirelike line. Apparently realism and even satire were sometimes allowed in the sacred precincts of the icon.

For a sculptural rendering of Amida enthroned in his Western Paradise we turn to the Phoenix Hall, a remarkable intermingling of the secular-aristocratic and religious arts of the Fujiwara period (*fig. 434*). Because its plan and appearance suggest a great bird in flight, it is called the Ho-o-do, or Phoenix Hall (*fig. 435*). The Ho-o-do stands beside the Uji River, entirely surrounded by a pond, and its lovely reflection in the water is unforgettable. It is part of the temple complex of the Byodo-in, originally a country villa of the Fujiwara family, and many elements of its design derive from secular palace pavilions. There is a central hall with three large doors, a covered porch, and a covered runway leading out from each side to covered tower pavilions. All of this is raised rather high above the ground on posts, except for the central hall, which sits on a stone platform. Certain Chinese elements—the tile roofs and the stone platform—have reasserted themselves here. Indeed, the whole arrangement recalls very much the kind of Chinese architecture portrayed in representations of the Western Paradise at Dunhuang. The Ho-o-do is a conscious imitation of Amida's Western Paradise as described in scripture and depicted in painting, and hence embodies a current belief in sympathetic magic. Despite Chinese influence, and in contrast to the severe strength of Jogan architecture, this Fujiwara building is decorative, light, and aristocratic in appearance, a mirror of the essential stylistic qualities found in the painting and sculpture of the period.

The interior of the doors to the hall were originally richly painted with nine separate *raigo* scenes, and much of that polychromy still remains. The architectural form of the temple interior is transformed and to a certain extent negated by the rich decorative quality of the ornament (*fig. 436*). Not only are parts of the interior painted with representations of lotus, falling lotus petals, and other flowers, but there are mother-of-pearl inlays on the central dais and in some of the columns. All of this combines to produce the same kind of complex, encrusted effect that we saw in the sculpture of Kichijoten at Joruriji (*see cpl. 32, p. 334*).

Against the background of the painted *raigo* scenes the interior of the central hall houses a sculptured portrayal of Amida enthroned in his Western Paradise. The image is seated on a richly carved lotus throne, in the pos-

436. *Interior of Ho-o-do (Phoenix Hall) of Byodo-in.* Uji, Kyoto Prefecture, Japan. Late Heian period, 11th century C.E.

ture and gesture of "ecstatic concentration," backed by a *mandorla* (flame-shaped radiance) of carved and gilded wood on which are many angel-musicians in high relief (*fig. 437*). The ensemble is the most famous work of Jocho, the leading sculptor of his day, and was dedicated in 1053 C.E. The Buddha is more elegant than earlier seated figures, appearing lighter in weight, with a distinctly aristocratic turn of lip and eyebrow. Around the dais, fastened by hooks to the upper walls, are sculptured representations of the bodhisattvas and angel-musicians who inhabit the Western Paradise. Standing just inside the icon hall and looking directly to the altar, one sees in sculpture the same stylistic traits found in the painted *raigo* triptych of Koyasan. The little music-playing angels, seen close up, show that same observation of natural movement displayed in the Koyasan picture, as well as playfulness, an elegance, and a charm that are extremely courtly (*fig. 438*). With its original color and inlays and the complete ensemble of figures, this image hall must have been one of the most lyrical sculptural expressions of religious art ever seen in East Asia.

Phoenix Hall is a rather large building. The same aristocratic elegance was attempted on a smaller scale in the far northeast corner of Honshu, at Hiraizumi, near Sendai, where a powerful northern branch of the Fujiwara clan undertook to create a capital resembling Kyoto and its environs. The Amida hall of Chuson-ji, called the Konjiki-do, is the only surviving structure of this enterprise. Inside, it resembles fine cabinetry more than it does

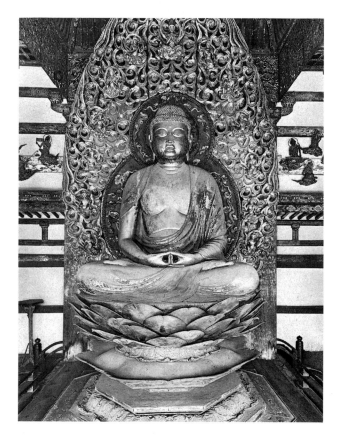

437. *Amida.* By Jocho (d. 1057 C.E.). Dated to 1053 C.E. Gilded wood; h. 9'4" (2.84 m). Ho-o-do (Phoenix Hall) of Byodo-in, Uji, Kyoto Prefecture, Japan. Late Heian period

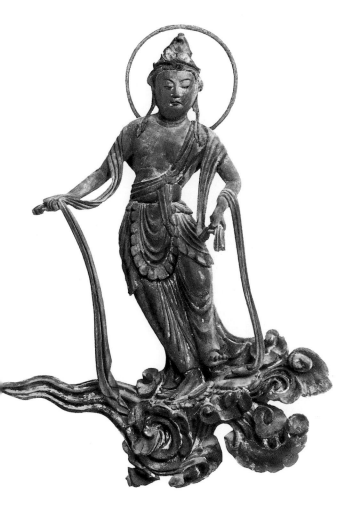

438. *Angel, from wall of Ho-o-do (Phoenix Hall).* Wood, originally gilded; h. approx. 28³/8" (72 cm). Byodo-in, Uji, Kyoto Prefecture, Japan. Late Heian period, 11th century C.E.

439. *Interior of Konjiki-do of Chuson-ji.* Hiraizumi, Iwate Prefecture, Japan. Late Heian period, 12th century C.E.

architecture, being lavish with gilded metal and mother-of-pearl inlay on lacquered wood (*fig. 439*). Even the exterior retains traces of decoration in gold leaf on lacquer.

LATE HEIAN SECULAR ART

We must begin the study of secular art of the Fujiwara period with a religious work that is also one of two remaining examples of the style of secular and aristocratic court painting in the period. Scrolls of the Lotus Sutra, the *Hokke Kyo,* were offered by the Taira family in the twelfth century to the Shinto shrine at Itsukushima, south of Hiroshima, as an act of piety and devotion. There they are kept in a box adorned on the outside with traditional Nara style dragons in gilt bronze on a ground of dark brown lacquer (*fig. 440*). This conservative housing would not lead one to expect anything so radically new as the twenty-nine scrolls inside. The text sections are simply written, in columns of gold and silver characters, as one would expect; but the endpapers—the first eight or ten inches of each scroll—are decorated with scenes of

440. *Box for sutra offered by the Taira clan.* Dark brown lacquer with gilt bronze fittings; l. 13³/8" (34 cm). Itsukushima Shrine, Hiroshima, Japan. Late Heian period, 12th century C.E.

441. *Prayer offering, from sutra offered by the Taira clan.* Scroll; ink and color on paper; h. 10¹/₂" (26.7 cm). Itsukushima Shrine, Hiroshima, Japan. Late Heian period, c. 1164 C.E.

442. *Landscape scene, from sutra offered by the Taira clan.* Scroll; ink and color on paper; h. 10¹/₂" (26.7 cm). Itsukushima Shrine, Hiroshima, Japan. Late Heian period, c. 1164 C.E.

ostensibly religious subject matter (*fig. 441*). An aerial view of a house with the roof removed (a pictorial convention allowing the viewer to look inside) shows a monk sitting next to a woman, with a court noble behind them at his writing desk holding a scroll; golden rays come from the left, the direction of the Western Paradise of Amida Buddha. The priest in the middle ground, hidden in part behind the rolling hill, is praying, with his head turned toward the rays. Along with the Japanese and Sanskrit written characters incorporated into the rock structure of the garden outside the house, the rays signify that this is a religious scene. But what is shown and the style in which it is shown make this picture one of the first examples of a characteristically Japanese secular style that reaches its greatest heights in the *Genji* scrolls to be considered shortly. In color these sutra endpapers are brilliant, with purples, reds, oranges, deep blues, yellows, and ink, and with a copious use of sprinkled gold as well. In the left foreground, for example, in the pond outside the garden, large squares of cut gold are apparently floating in the water, and little strawlike sticks of cut gold are clustered on its surface. All are part of the decorative cut-gold patterning that we have seen to be characteristic of religious paintings also. But the decorative intention did not preclude painstaking observation of reality: the bundled-stick hedge in the middle ground; the long bamboo runner with the water coming out and pouring into the pond; and the house itself. The representation of all these details shows a peculiarly Japanese quality, particularly the aerial view of the house with the roof removed. This representational device, so arbitrary and extreme as to be untypical of China, was used by the Japanese with great abandon.

The landscapes in the Itsukushima sutras are derived from Tang type landscapes but have become distinctively Japanese (*fig. 442*). The first appearance of the type in Japanese art can be seen in the distant mountains on the painted plectrum guard of the eighth century *biwa* in the Shoso-in (*see fig. 392*). Three centuries later a mature and coherent form of the same vision is used to render Japanese earthly locales in the nine *raigo* paintings on the walls and doors of the Phoenix Hall of Byodo-in. The term that the Japanese use again and again to describe this landscape seems most appropriate to the style representing it here: lovely. Hills and rocks have a gentle, rolling rhythm; trees branch gracefully. All elements of the picture are treated in subtly decorative fashion. This lyrical style, called *yamato-e*, meaning Japanese picture, is particularly important in the twelfth and the very beginning of the thirteenth century. It is a late Fujiwara style, secular and decorative; the realistic or even satirical style that is more characteristic of the thirteenth century will be considered when we approach the Kamakura period.

The greatest monument of *yamato-e* is the group of illustrations of *The Tale of Genji*, usually attributed to the painter Takayoshi (act. early twelfth century C.E.) and now distributed between the Tokugawa Art Museum at Nagoya and the Gotoh Museum in Tokyo (*fig. 443*). These are the remnants of a series of handscrolls, cut into small panels and now kept flat to avoid the wear incurred by the constant rolling and unrolling necessary to view scrolls. Their narrative scheme of organization is fairly primitive: Each picture follows the block of text it illustrates in strict alternation. In marked contrast with later, more complexly organized narrative scrolls, these are individual, sepa-

443. *First and second illustrations to the "Suzumushi" chapter of The Tale of Genji.* Handscroll; ink and color on paper; h. 8¹/₂"
(21.6 cm). Japan. Late Heian period, 12th century C.E. Gotoh Museum, Tokyo

rate pictures, enclosed as if framed between blocks of text. The text pages are almost as decorative as the illustrations, being unevenly and asymmetrically sprinkled with cut gold in a way that seems typically Japanese.

But the pictures especially command our attention and repay study. They illustrate *The Tale of Genji* (*Genji Monogatari*), a novel by Lady Murasaki, justifiably famous in English-speaking lands through translations by Arthur Waley and Edward Seidensticker. Its story is simple in outline and complicated in detail and is principally concerned with the doings and intrigues and amorous affairs of the high aristocracy at Kyoto, especially the aristocracy of the emperor's court. The narrative proceeds in leisurely fashion, creating characters of great psychological complexity and an atmosphere redolent of the peculiarly exquisite sensibility and hyperaestheticism of the Heian court. One passage may give some idea of the flavor and style of the literary work that Takayoshi illustrated:

On a morning of heavy mists, insistently roused by the lady, who was determined that he be on his way, Genji emerged yawning and sighing and looking very sleepy. Chujo, one of her women, raised a

shutter and pulled a curtain aside as if urging her lady to come forward and see him off. The lady lifted her head from her pillow. He was an incomparably handsome figure as he paused to admire the profusion of flowers below the veranda. Chujo followed him down a gallery. In an aster robe that matched the season pleasantly and a gossamer train worn with clean elegance, she was a pretty, graceful woman. Glancing back, he asked her to sit with him for a time at the corner railing. The ceremonious precision of the seated figure and the hair flowing over her robes were very fine.

He took her hand.

"Though loath to be taxed with seeking fresher blooms,
I feel impelled to pluck this morning glory.

Why should it be?"

She answered with practiced alacrity, making it seem that she was speaking not for herself but for her lady:

*"In haste to plunge into the morning mists,
You seem to have no heart for the blossoms
here."*

A pretty little page boy, especially decked out
for the occasion, it would seem, walked out among
the flowers. His trousers wet with dew, he broke off
a morning glory for Genji. He made a picture that
called out to be painted.[17]

Now, we can see from this that a great deal is going
on, but veiled in images of color, of costume, of rooms
and screens, of hurrying figures, of draperies fluttering—
in short, in all of the things so represented in the scroll by
the artist Takayoshi that the pictures delight the eye at the
same time that their narrative content is minimized (*cpl.
33, p. 335*). The colors of the scroll, applied rather thickly
over a preparatory ink drawing on the paper, range from
pale mauve to deep browns, purples, oranges, and greens,
the whole effect being distinctly aristocratic and decora-
tive. The artist uses the screens, walls, and sliding panels
of the Japanese aristocratic house of the Fujiwara period
as a means of breaking up the composition and of indi-
cating mood. Alexander Soper noted a correlation be-
tween the mood represented in each scene and the angle
of the principal lines of the composition: The higher the
degree of the angle, the more agitated is the scene repre-
sented. Such an interpretation may well be true, since
yamato-e is a calculatedly decorative style, an art of care-
ful placement and juxtapositions of color and texture.
Placement in particular is almost everything, along with
the interrelationships of elaborate patterns of angle and
line, of triangle and square, and of the large overall pat-
terns on the costumes (*fig. 443*).

In the paintings the figures are shown only as heads
and hands emerging from great masses of enveloping
drapery. The women especially, with their fashionably
high eyebrows painted on white-powdered faces and their
rivers of loose jet-black hair, seem to be little heads set on
top of voluminous elaborately pleated and starched cos-
tumes. With care one can follow the narrative content, but
this is subtly restrained—cloaked or hidden by the overall
decorative emphasis on color and arrangement. Colorplate
33 (*p. 335*) shows a group of ladies and their maids. Naka
no Kimi is having her hair combed after washing. Her
half-sister, Ukifune, facing her, looks at picture-scrolls
while a maid reads from the accompanying text. The pic-
ture contains no suggestion of Ukifune's tension and dis-
may over her attempted seduction only a few hours before.

Several scenes are arbitrarily cut off at the top by
clouds, a device used by the Japanese scroll painter and
screen painter in all subsequent periods to enhance the
aesthetic development of his composition. Certainly, if one
is to pick any one example of painting as the beginning of
what we call here the Japanese decorative style, then the

Genji scrolls are that beginning. There are related works in
other collections, but those are somewhat later and the
Genji scrolls are by all odds the most precious of all.

This singular, subtle, and consciously aesthetic style
finds clear parallels in the cursive calligraphy used to write
the Japanese *kana* syllabary (*see texts in fig. 443*) and in
the imagistic, ambiguous, and allusive poetry then being
written in *kana*. Writers of the Fujiwara period refer to
this style in all three mediums as "feminine." The calligra-
phy appears so by virtue of its emphasis on grace and del-
icacy. With regard to poetry, "feminine" meant in general
that poets of the period took as their subject private emo-
tions rather than public concerns and that their approach
was intuitive rather than intellectual. More particularly,
"feminine" referred to an amazing constellation of women
writers—all members of the aristocracy—whose intro-
spective works reflected their secluded, constricted, and
consequently introverted lives. Pictures of the *Genji
Monogatari* type, imbued with the same qualities as the
poetry and the calligraphy, were therefore called *onna-e*
(women's pictures). This aptly describes the courtly and
feminine ambience of the paintings, their air of "deco-
rous elegance"; it does not mean that all or even most of
the painters were women.

In contrast to *onna-e* was the term *otoko-e* (men's pic-
tures), used for pictures of public occurrences, freely
brushed, pragmatic or even satirical in tone. These works
became common toward the end of the Fujiwara period
and extremely numerous during the following Kamakura
period, when the military class and its government (*baku-
fu*) replaced the civilian nobility and the emperor as the
locus of power, and the warrior ethos began to rival the
courtly as the dominant tone of society.

The above definitions of *onna-e* and *otoko-e* and the
distinction between them (which we owe to Okudaira
Hideo) permit a clear differentiation of the two late
Fujiwara approaches to narrative handscroll painting
(*emaki*).[18] *Otoko-e* will be considered shortly.

Historical accidents of preservation and destruction
can distort our understanding of even important and
well-known achievements. The greatness of the *onna-e*
style in the *Genji* scrolls is abundantly clear, but the care-
ful stylization and abstraction renders the faces virtually
expressionless and indistinguishable. Did Heian painters
lack ability or inclination to realize the novel's sensitive
and detailed descriptions of the beautiful, complex people
who inhabited the "world of the Shining Prince"? On the
wooden walls of the ruined tenth century(?) Shinto shrine
of Aegaki, near Izumo, are two little-noted fragments of a
painted mural (*cpl. 34, p. 335*). They provide astonishing
affirmation of the ability of Heian painters to produce
psychologically revealing and moving portraits. Sketchy
under-drawing contributes to the fleeting poses and
moods caught in the finished works. These are no expres-
sionless masks, and they add new dimensions to our

444. *Landscape screen.* Two panels from a six-fold screen; color on silk; h. 57³/4" (146.7 cm). To-ji, Kyoto, Japan. Late Heian period

445. *Box for Buddhist sutra.* Lacquered wood with gold and silver decoration; l. 12¹/4" (31.1 cm). Taima-dera, Nara, Japan. Mid-Heian period

446. *Garment chest with plover and iris design.* Lacquered wood with gold, silver, and mother-of-pearl decoration; h. 11⁵/8" (29.5 cm). Kongobu-ji, Koyasan, Wakayama Prefecture, Japan. Late Heian period

understanding of *onna-e.*

The refinements of court life and the rise of *yamato-e* reflected a growing interest in landscape, as seen in two panels of a famous six-fold screen at To-ji, in Kyoto, reproduced in figure 444. Here a highly colored and decorative style of landscape painting is used on an object whose purpose is primarily decorative—a folding screen. The figures are freely rendered variations on Tang style male figures, and certain realistic tendencies relate them to developments in the narrative scrolls of the late twelfth and the thirteenth century. But one's attention is drawn particularly to the landscape, the gently rolling hills, the flowering trees with rhythmically profiled trunks, and the use of the fence to add an architectural structure comparable to that found in the *Genji* scrolls.

The useful arts, too, show the same development from a religious art with decorative overtones to an almost purely secular one in a decorative style. On the mid-Heian period sutra box (*fig. 445*) we have a primari-

ly religious subject somewhat decoratively presented. But on later Fujiwara boxes the decoration has become largely secular with strong literary overtones; the clothes chest in figure 446 bears a design of irises by a stream with plover

447. *Toilet box with design of cart wheels in water.* Mother-of-pearl and gold on lacquered wood; l. 12¹/₈" (30.8 cm). Horyu-ji, Nara Prefecture, Japan. Late Heian period. Tokyo National Museum

flying overhead. The plover are made of mother-of-pearl, the iris and the stream banks are gold and silver, against a dark brownish black lacquer ground. The whole effect is decorative in the best sense of the word. Such subject matter was mainly derived from poetry of the early Fujiwara period, in which place, episode, and feeling (usually of love or longing) are mutual resonances of a single theme. In the design on the clothes chest we find two poetic images that have been indelible since first they were coined. Irises are virtually synonymous with the courtier-poet Ariwara no Narihira (825–880 C.E.), author of the *Ise Monogatari;* "river plovers crying in the waning night" have signified piercing longing since Otomo no Yakamochi (716–785 C.E.) wrote the line.

A lacquer toilet box has a pattern of cart wheels half submerged in water, a standard allusion to the ox-drawn carriages of the Heian nobility, here interpreted as a bold, asymmetrical decorative design: The wheels, most carefully grouped and angled to create variations on a theme, are united by the wave pattern of the water (*fig. 447*). The wheels are in mother-of-pearl and gold on a dark ground, and the silver handles of the box repeat the wheel pattern. For the first time in the Japanese utilitarian arts we have an original style, purely decorative in intention and secular in subject matter. The decorative style is the most important artistic contribution of the Fujiwara period, and one that was to have great influence on later Japanese art.

While this courtly, decorative style was flourishing, the new *otoko-e* approach, vigorous, direct, and realistic, was being manifested in masterful handscrolls, unified in

style but varying in subject, all reflecting an age of radical change, deep uncertainty, and religious pessimism. Behind the aesthetic and decorative courtly style lay a keen delight in the world's beauty, twinned with an equally poignant sense of that beauty's fragility and evanescence—a fusion of joy and misgiving often expressed by writers of the Fujiwara period, who termed it *mono no aware* (the pity of things). Even halcyon times provide sensitive observers with ample grounds for such feelings, and Japanese society in the second half of the twelfth century was in turmoil and disarray. Violence was tearing the hitherto pacific fabric of Heian aristocratic life: The warrior clans were progressively annexing the privileges of the courtly aristocracy even as they squared off against each other in increasingly destructive and bloody conflicts, culminating in the Gempei War of 1180–1185 C.E. and the extermination of the once mighty Taira clan. Events of the time abundantly confirmed the prevalent belief that the Buddhist era of *mappo* was at hand, the "end of the Law," a time of pervading evil and depravity when Enlightenment was beyond human reach. (Similar apprehension in similarly dark times tormented the millenarians of Christian Europe as the year 1000 C.E. approached.)

Only Amidism held out hope, offering salvation into the Western Paradise through faith in Amida, and the chief text of Amidism, Priest Genshin's *Ojo Yoshu* [Essentials of Salvation, 984–985 C.E.], stressed the ugliness and pain of the Six Realms of Existence even as it prescribed the path of deliverance. Genshin's depictions of

448. *Rabbit diving.* Attrib. Toba Sojo (1053–1140 C.E.). Section of the handscroll *Choju Jimbutsu Giga*; ink on paper; h. 12¹/₂"
(31.8 cm), l. 37' (11.28 m). Kozan-ji, Kyoto, Japan. Late 12th century C.E.

449. *Monkeys worshiping a frog.* Attrib. Toba Sojo (1053–1140 C.E.). Section of the handscroll *Choju Jimbutsu Giga*; ink on paper;
h. 12¹/₂" (31.8 cm), l. 37' (11.28 m). Kozan-ji, Kyoto, Japan. Late 12th century C.E.

Hell surpass those in James Joyce's *Portrait of the Artist as a Young Man*. His graphic descriptions were exploited by the professional painters beginning to develop the observant and pragmatic *otoko-e* manner in narrative handscrolls (*emaki*) both matter-of-fact and satirical.

The famous ink monochrome handscrolls *Choju Jimbutsu Giga* (*Caricatures of Animals and People*), traditionally attributed to Toba Sojo, are ascribed by most scholars to two different hands and dated to the end of the twelfth century (rolls 1, 2; *figs. 448, 449*) and the second quarter of the thirteenth (rolls 3, 4). The depictions of deities as frogs, priests as monkeys, and nobles as rabbits, all behaving more or less discreditably, are certainly based upon wry observation in the service of astringent judgment. We

see in these drawings a practice basic to the *otoko-e* style: pragmatically observed forms deliberately distorted by way of acerbic comment. Scenes range from amusing to sacrilegious, from rabbits diving into the water holding their noses to a large frog sitting as a Buddha in meditation against a plantain leaf *mandorla*, receiving the adoration of chanting monkey priests (*fig. 449*). Other scrolls illustrate absurd wrestling matches, contests between corpulent and emaciated yokels, and farting contests. One scroll is devoted to vigorous line representations of domestic animals, notably of two bulls battling head on.

A second "religious" genre in this late Fujiwara group of *otoko-e* comprises representations of the Buddhist Realms of Existence. Among these paintings the most

450. *Starving ghosts.* Section of the handscroll *Gaki Zoshi;* ink and color on paper; h. 10³/₄" (27.3 cm), l. 17'8" (5.38 m). Japan. Late Heian period, late 12th century C.E. Tokyo National Museum

famous is the *Gaki Zoshi* (*The Scroll of Starving Ghosts,* Kuwamoto version, now in the Tokyo National Museum; *fig. 450*). The starving ghosts inhabit a space between Hell and the Realm of Humans, among whom they can mingle invisibly. For their misspent lives they suffer unappeasable hunger and thirst, which drives them to seek their food in graveyards and their water at holy wells, from which they cannot drink. These gruesome and pitiful specters and their abhorrent food, cautionary devices originating in Buddhist scripture, are given shape by the artist, based on close observation of poor starving wretches, corpses, and skeletons. Even apart from the charnel house, everyday life offered scenes sufficiently repellent or brutal to serve as effective vehicles for Buddhist comment on the "dusty world."

In the *Gaki Zoshi* scroll, though observation of the poses and movements of individual figures is close and keen, as in the reaching gesture of the ghost at upper left, the landscape setting is still archaic. The small hummocks with their miniature trees are not much advanced beyond the settings seen in the *Kako Genzai E-inga Kyo* (*see cpl. 16, p. 207*), some five centuries earlier. Convincing renderings of nature as a believable setting for figures in action will be achieved within the next fifty years, during the early Kamakura period.

Another scroll, now in dispersed segments, apparently represents the afflictions of the Realm of Humans, and

has been titled *Yamai no Soshi* (*Scroll of Diseases*). In the section illustrated (*fig. 451*), an obese woman is ridiculed by village loafers while in the background a mother suckles her baby. Characteristically, no sympathy is shown for the victim, which may accurately reflect the growing secularization and harshness of life as power migrated from the court nobles and learned monks to the rude provincial warriors.

A corollary of this concern for realism is the interest in caricature—faces distorted by emotion, pain, or disease are mockingly depicted, as in the *Scroll of Diseases.* The painters of these works are cruder and more pragmatic souls than those of earlier times. Even in earlier centuries, however, a similar low tradition existed. It has come to light in the scribbling or sketches discovered on the bases of statues, and in the remarkable caricatures and obscene drawings on the ceiling boards of the *kondo* at Horyu-ji (*fig. 452*), dating from the early eighth century C.E. These doodles, perpetrated by artists whose lofty commission was murals of Buddhist Paradise scenes on the walls of the *kondo,* attest a covert interest in reality, peculiarity, and caricature. It remained for artists of the decades before and after 1200 to express this interest fully and freely in a major format, the narrative handscroll.

The early thirteenth century *Jigoku-zoshi* (*Scroll of Hells*), representing the nine levels of Hell, combines realistic depiction with the grotesque. No description of the

451. *The Fat Lady Mocked.* Section of the handscroll *Yamai no Soshi*; ink and color on paper; h. 9⁷⁄₈" (25.1 cm). Japan. Late 12th century C.E. Fukuoka Municipal Art Museum

452. *Caricatures.* Ceiling of the *kondo* of Horyu-ji, Nara Prefecture, Japan. Late Nara period, 8th century C.E.

453. (right) *Hell scene.* Section from the handscroll *Jigoku-zoshi*; ink and color on paper; h. 10³⁄₄" (27.3 cm). Japan. Kamakura period, c. 1200 C.E. Seattle Art Museum

artist's narrative achievement could better the inscription preceding the scene illustrated here (*fig. 453*).

Within the Tetsueisen there is a place called the Shrieking Sound Hell. The inmates of this place are those who in the past accepted Buddhism and became monks. But failing to conduct themselves properly and having no kindness in their hearts, they beat and tortured beasts. Many monks for such cause arrive at the Western Gate of Hell where the horse-headed demons with iron rods in their hands bash the heads of the monks, whereupon the monks flee shrieking through the gate into Hell. There inside is a great fire raging fiercely, creating smoke and flames, and thus the bodies of the sinners become raw from burns and their agony is unbearable.

In drawing the figures of these monks, the artist has deliberately used a series of rather short strokes, producing figures pathetic in their naked plight. The strokes used to form the horse-headed demons are rich, full, "nail-head" types, producing powerful figures, almost like batters on a demonic baseball team, wielding their iron bats with obvious pleasure. The rendering of fire is perhaps as effective as any painted representation in East Asian or any other art. This quality owes as much to direct observation of burning buildings during the Gempei War (1180–1185) as to the traditional depiction of the flaming

454. *The Flying Storehouse.* Section of the handscroll *Shigisan Engi Emaki*; ink and slight color on paper; h. 12¹/2" (31.8 cm), l. 116'8" (35.6 m). Chogosonshi-ji, Nara, Japan. Late 12th century C.E.

*mandorla*s of Fudo and other Buddhist deities. The sense of impermanence and the revulsion against both the sins and their ghastly punishments must have been familiar to those who lived during the forty years of chaos just beginning to subside in the early thirteenth century.

Artistically more important than these Buddhist visions are *emaki* illustrating legendary or historical narratives. Most of these avoid the old limiting format of pictures alternating with sections of text, dispensing with text or concentrating it at the beginning or end of the scrolls in order to permit more extended pictorial development. Imagine a handscroll more than forty feet long, unrolling from right to left and filled with hundreds of men, women, children, animals, demons, storms, quiet landscapes, great fires—all the elements of divine and human drama, and since visually presented, cinematic in scope. The stories unfold simultaneously through space and time. The characters enter on stage from the left and pursue their quiet or turbulent ways. Rest spaces are provided by landscapes or blank spaces, while structure and setting for the story are provided by architectural elements. These are usually depicted in conceptual fashion, rising sharply across the paper in isometric perspective, limiting and defining the stage upon which the characters perform. The very method is exciting, but never before or since the late twelfth or thirteenth century has the method been employed with such enormous vigor and technical dexterity. The forms are usually brushed directly, without underpainting, and the line is marvelously varied, bending to the grace of reeds or knotting to the muscles of warriors or demons. Line, and shape defined by line, convey the essentials. Color tends to be supplementary, applied surely but freely in transparent washes.

Narratives were available in abundance. Each temple or shrine had its legend, now capable of being put into vivid and understandable visual form. Viewers often got to see these handscrolls accompanied by recitations of the narrative by itinerant performers or monks of the temple to which the scroll belonged (*etoki hoshi*, "picture-telling monks"). The narrative *emaki* was nearly universal in its appeal, comprehensible to priest and layman, warrior and merchant. Repeated rolling and unrolling of the paintings over decades and centuries made damage and destruction inevitable, hence the extreme rarity of pre-fourteenth century *emaki*. Perhaps a few more than one hundred survive, plus a few fragments.

Along with the much damaged *Kokawa-dera Engi Emaki*, the *Shigisan Engi Emaki* (*fig. 454*), which relates the miraculous origins of Mt. Shigi Temple, is the earliest extant *emaki* of a temple foundation legend. It begins, on the first of three rolls, with the story of Priest Myoren and his miraculous golden bowl, in which he customarily received food alms from a rich farmer. Came a time when the offering was denied. The bowl flew under the farmer's granary and transported it by air to Myoren's retreat at Mt. Shigi, in western Nara Prefecture. Well-fed women of the household are seen dashing out the gate in amazed dismay at the liberation of the storehouse. In the center the farmer is mounting his horse to pursue his granary, while at left lower servants gesticulate and grimace in wild surprise and the household priest frantically rubs his prayer beads in a vain effort to immobilize the magic bowl. Subsequent scenes show the granary flying over the mountains, watched by curious deer, and finally setting down at Myoren's abode, where the building becomes his warehouse. The bales of rice within are then restored by the same magic to the repentant farmer, while the granary remains as the storehouse for Chogosonshi-ji, the temple on Mt. Shigi, which to this day owns the *emaki*.

One of the few remaining early *emaki* represents

455. *Ban Dainagon Ekotoba.* Section of the 2nd handscroll; ink and color on paper; h. 12¼" (31 cm), total l. (of 3 scrolls) 85'4" (26 m). Japan. Late 12th century C.E. Tokyo National Museum

456. (below) *Ban Dainagon Ekotoba.* Section of the 1st handscroll; ink and color on paper; h. 12¼" (31 cm), total l. (of 3 scrolls) 85'4" (26 m). Japan. Late 12th century C.E. Tokyo National Museum

another narrative category, the history of military and political events. Artists used the historical feuds and intrigues of noble families freely as subject matter, and the story of the unscrupulous minister Ban Dainagon is a complex one, worthy of the best artistic talents of the day. The key episode in the *Ban Dainagon Ekotoba* (*Illustrated History of Ban Dainagon's Conspiracy*), the event on which the plot turns, is a children's scuffle in the street (*fig. 455*), a scene of farcical low life amid intrigue in high places. The scheming minister (*dainagon*) Tomo Ban no Yoshio in 866 C.E. set fire to the Oten Mon, a gate of the imperial palace in Kyoto, in order to blame the arson on his rival, Minister of the Left Minamoto no Makoto. The first roll (*fig. 456*) depicts conspiratorial conversations and then the conflagration, watched by spectators from all ranks of society. The great fire and surging crowd movements are masterfully composed and rendered with artistic genius. It is no coincidence that Akira Kurosawa's movies of fire and battle, *Throne of Blood* or *Ran,* were made by a modern genius keenly aware of the great *emaki* tradition. The complex spacing of the figures in the *Ban Dainagon* scroll is achieved by turning people in various poses and by grouping some in semicircles and others in thrusting diagonals. Equally cinematic, but composed around individual figures rather than crowds, is the section of the second roll leading up to the revelation of the plot (*fig. 455*). At upper left a brutish father runs to separate two fighting urchins, one his son. At lower left the same father, holding his miserable but triumphant son with one hand, gives a mighty kick to the boy's opponent in the spotted coat, sending him flying. Onlookers observe the fracas coolly. But the irate father is Ban Dainagon's treasurer, and the father of the boy he kicked, a butler in the city guard, audibly theatens the treasurer with disclosure concerning the burning of the Oten Gate. Summoned to court, he reveals evidence pointing to Ban Dainagon's guilt. The Minamoto minister is freed and Ban Dainagon convicted and exiled.

One should particularly note the keen observation and spontaneous drawing in the movements of the father running from the house and of the boy propelled through the air, and in the expressions of the bystanders. Little sympathy is to be seen in *otoko-e,* and certainly none of the nuanced tender sadness of the *onna-e.* In their places are the realistic assessment and speedy action essential to warriors. The age of the military clans has arrived—and with a very high artistic accomplishment.

14

Chinese Art of the Song Dynasty and Korean Ceramics of Koryo

Song China presents a picture of towering attainments in intellectual, artistic, and material culture, achieved under conditions of recurrent political crisis and chronic military weakness punctuated by devastating military defeats. Northern and Southern Song are retroactive political designations, the first signifying the period 960–1126 C.E., when the Song dynasty ruled most of northern as well as southern China from its capital at Kaifeng (Henan), the second embracing the period 1127–1279, during which the dynasty re-established itself at Hangzhou (Zhejiang) and ruled only as far north as the Huai River.

The most striking characteristic of Song is its accessibility: Song life seems considerably more familiar, more contemporary, than medieval Europe, to say nothing of Tang China. Most historical change is infinitely gradual, and many of the values and patterns of culture that characterize the Song dynasty were present in embryo during the late Tang. Still, life in Song China was most unlike life under the Tang.

Song China bears the stamp of its founding emperor, a thoughtful, historically minded general who profoundly distrusted militarism. He perceived that Tang had died of its conquests, dismembered by hereditary army commanders turned warlords. Though aggressive steppe neighbors posed a recurring and ultimately fatal problem, the chief concern of Song governments remained consistently civilian: to achieve an efficient and benevolent administration and a stable, productive economy. The military profession was held in low esteem; no Song ruler was ever styled "Martial Emperor."

The land-rich Tang grandees had destroyed each other fighting for the throne. With imperial encouragement, their place was taken by a more modestly landed gentry, well-to-do but not individually powerful, and with a sense of corporate identity based on their function and status as a governing elite. Office was no longer the prerogative of powerful clans; rather, influence and prestige were the perquisites of office. The civil service examinations, tentatively begun four centuries before, were regularized and expanded, and promotions were based on examination standing, tenure, and merit.

Since learning now opened the high road to success, schools proliferated—public, private, or religious. Like their objectives, their curricula were similar: Confucian ethics, history as a source of exemplary or cautionary precedents, and literature. Woodblock printing made an increasing variety of books more widely available. The nature of the curriculum tended to produce a large number of administrators who were also distinguished schol-

ars and men of letters.

Artistic and intellectual output increased vastly. Few governments in history have attracted so many first-rank artists and thinkers who were also capable administrators. It is one measure of Song civility that, despite often severe political factionalism, no heads rolled; political rivals even exchanged visits to talk philosophy and literature.

Education for the civil service was entirely secular. Buddhism was still practiced, but it no longer monopolized the creative energies of the intelligentsia. Furthermore, Song is marked by distaste for many aspects of the Tang (and even the Han) ethos, and Song thinkers turned back to the Confucian classics, attempting to purge them of Han and Tang accretions. The resulting Neo-Confucianism (as it is now called) was most concerned with good government and the hierarchical but benevolent ordering of society. Yet it was also heavily tinctured by Buddhist ideals of compassion and kinship with all sentient beings and by the Buddhist/Daoist concept that the moral order was implicit in the natural order and that the two are mutually interactive. Song governments are notable in Chinese dynastic history for a concept of services to the governed: public works, famine relief and loans to needy farmers, government-sponsored handbooks and encyclopedias on every subject from history to farming and pharmacology.

In theory almost any man could sit for the civil service examinations, and in fact history records many poor, bright boys who rose to high office via educations financed by their village neighbors or a benevolent sponsor. But the main means of access to education was wealth gotten in commerce. A quiet but effective technological revolution was transforming China's medieval economy into an integrated market system, creating a thriving middle class of bankers, brokers, wholesalers, managers, clerks, and carriers. Though shrunken in extent, the empire was richer than ever before, even after the loss of all of northern China to the Tartar Jin dinasty in 1127. Tradesmen were legally barred from government service, and trade was déclassé, but it paid for the country estate that conferred respectability and for the leisure and education that transformed one's grandsons into scholar-officials. Power was concentrated in the scholar-official class, but access to this class was open if not always easy, making Song the most egalitarian of all periods in China's dynastic history.

Trade and towns were mutually stimulating. Urban life was no longer confined to half a dozen administrative centers floating remotely above a parochial and illiterate countryside. Now commerce linked hundreds of commercial and craft towns, and business needs induced even shopkeepers into a semblance of literacy, which was the first step on the way to gentility.

In the arts as well Song differed profoundly from Tang. Simplicity and restraint replaced magnificence as key aesthetic values.

PAINTING

Strangely enough, conditions of political and military decline and contraction during the Song dynasty proved particularly appropriate for the development of painting and ceramics. For parallels, one can think of Florence in the *quattrocento,* already declining from its great period of commercial enterprise in the fourteenth century; one can think of Holland in its golden age of art in the early seventeenth century, its economic ascendancy already beginning to wane with the waxing of English sea power; the glories of eighteenth century Venice were products of a refined but decaying social order; conditions in France during the Impressionist and Post-Impressionist periods come to mind as well. Two things are certain: that one of the reasons for a great artistic development is patronage, which implies leisure, and that in the Song dynasty there was abundant patronage and abundant leisure. The result was a unique intellectual and artistic flowering: a period of philosophic creativity, reformulation, and synthesis embodied in Neo-Confucianism and a period of artistic glory in which painting and ceramics reached perhaps unequaled heights. The Song dynasty produced the first really important academy of painting in East Asia. Other academies were to follow, but the one formed by the painter-emperor Hui Zong was their prototype.

The late Five Dynasties period and the beginning of Northern Song, the century between about 920 and 1020 C.E., was crucial in the development of the great tradition of Chinese landscape painting. During this time the experiments and tentative innovations of late Tang were transformed as if by a catalytic agent into a mature and unified art. Visually the new landscape art offered a realism based on patient observation and conveyed through disciplined and creative brushwork. Intellectually and morally it answered to the resurgent Confucianism of the time, which considered the natural world to be a metaphor for a moral and metaphysical order. Beginning in the tenth century, most Chinese paintings of nature were interpreted in three ways: as more or less objective depictions of their subjects, as more or less subjective expressions of the painter's character and feeling, and as more or less explicit philosophical statements.

Problems of Painting Scholarship

Problems in the study of Song painting are many. We now have a great many paintings claimed to be of the Song period, and undoubtedly many, though fewer, paintings that actually are of the Song period. In distinguishing the true from the false claimants, we have been hampered by misconceptions, false starts, and unscientific attitudes. Compared with the number of surviving Ming and Qing paintings, Song paintings are few.

Surviving Song literature on painting records many

works no longer extant. At the same time a surfeit of copies—varying greatly in quality and in likeness to the originals—have been invested with the names of these lost originals. The correlation of literary sources with rational judgment, a critical and analytical approach to the examination of the paintings, and a stylistic analysis of their aesthetic form can bring some order to this chaotic field and allow a reasonable determination of what probably is Song and what probably is not.

We must distinguish first between contemporary and later source material. Song dynasty sources—lists of paintings and descriptions of styles—are most useful. But the later the sources of information, the less reliable they usually are. Nothing more quixotic can be imagined than the usual opinion of a seventeenth or eighteenth century Chinese scholar-critic examining a purportedly early painting.

The kernel of the problem is the question of authenticity. It is misleading to discuss the stylistic qualities of painting in the thirteenth century while looking at a seventeenth century copy of a fifteenth century copy of a thirteenth century painting; and this is all too often done. The problem is complicated further by the tradition, embodied in Xie He's sixth canon, of copying the paintings of the past as training in brush discipline and composition. This tradition of copying produced a great many good copies of now lost earlier paintings. Still, a judicious use of literary sources, scientific analysis of pigment, silk, and seals, and a careful study of the style of Song painting can help us to identify originals. What are the pictorial assumptions of the Song painter? What does he see, in common with others of his time, that a painter of the sixteenth century does not see? What does the sixteenth century copyist assume that the Song master would never have incorporated in his work? Comparison of unimpeachable Song originals with their copies is most useful in answering these questions, and even partial answers can help separate sheep from goats and identify probable Song originals.

Painting Formats

The major formats of Chinese painting were by this time firmly established. Painting of large mural decorations continued, and the three portable formats—the hanging scroll, handscroll, and single sheet—were in full use. These latter three are of primary importance in both the professional and literary painting traditions. The hanging scroll is a painting surface of paper or silk, mounted with paper backing and cloth facing, stored in rolled-up form, and exhibited unrolled and suspended from a peg or portable stick some seven to nine feet above the ground. The hanging scroll is therefore usually vertical in format, although some approach a horizontal arrangement.

Unlike hanging scrolls, handscrolls are horizontal in their long dimension, which can measure from about one foot to about forty. The painting surface is likewise paper or silk, and the exterior binding is usually a rich brocade. Like hanging scrolls, handscrolls are also rolled up for storage. For viewing, they are unrolled from right to left, revealing first a brocade border, then the painting, usually preceded by its title, and finally a number of *di ba*, which we would call colophons. These occur mostly in the handscroll format, and are written either by an owner of the painting or by a person invited to comment on the painting or to improvise on its theme or mood at some auspicious time. Some sets of colophons number over thirty, often on a painting a foot or two in length.

The single sheet format, also on paper or silk and always small, has two subtypes: the square or round album leaf and the oblate circular fan shape.

The hanging scroll and the single sheet are framed in a border (sometimes in multiple borders) of silk. They correspond in general format to Western painting. The handscroll is not used in the West. In addition to these, the traditional types of religious wall painting on wood, plaster, or other permanent material continue and ultimately decline.

Painting Theory

Guo Ruoxu, writing about 1070 C.E. in his *Experiences in Painting*, very specifically notes the dichotomy between figure painting and landscape:

> If one is speaking of Buddhist and Taoist (Daoist) subjects, secular figures, gentlewomen, or cattle and horses, then the modern does not come up to the ancient. If one is speaking of landscapes, woods and rocks, flowers and bamboo, or birds and fishes, then the ancient does not come up to the modern.[19]

Guo is simply recognizing a transparent fact. Tang figure painting, at the hands of Yan Liben, Wu Daozi, and Zhou Fang, was unsurpassed. Further, the tradition of emulating and learning by copying kept the great models of the past visible and vital. Thus a mid-Song copy of *The Night Revels of Han Xizai* (*fig. 457*), by Gu Hongzhong of the Five Dynasties period, preserves the scale of Tang figure style while providing a more realistic and complex interior setting than is characteristic in Tang works. The original scroll was famous in its day, commissioned by the emperor of Southern Tang to document charges of licentious behavior against a high official at court. By present-day standards the "orgy" depicted seems quite decorous, the lasciviousness polished and subtle. Pictorially the essence of the scroll lies in the placing of Tang style figures within the appreciably more realistic environment characteristic of the tenth and eleventh centuries. Few other

457. *The Night Revels of Han Xizai*. Attrib. Gu Hongzhong (act. 943–960 C.E.), but probably a mid-Song dynasty copy. Handscroll; ink and color on silk; h. 11¼" (28.6 cm), l. 11'1/8" (3.4 m). China. Palace Museum, Beijing

paintings of the Five Dynasties and Song periods possess the sophisticated secularism of *The Night Revels*.

As we have seen, by the end of the Tang dynasty landscape has become a subject in its own right, and under the influence of such men as Wang Wei the first full attempts at landscape art occur, exemplified by the lost Wangchuan Villa scroll (*see fig. 388*). After that, in the tenth and eleventh centuries, development is rapid. To the Chinese, landscape was not merely a pretty picture or a recorded scene; it held major philosophical implications. The developing Neo-Confucianism of the Song dynasty, a selectively syncretic reformulation of earlier Confucianism, Daoism, and Buddhism, contained an all-embracing philosophy of nature amenable to a school of landscape painting. Confucius in his *Analects* regards nature with a somewhat human bias: "Wise men find pleasure in water, the virtuous find pleasure in mountains"—with the emphasis on the wise and the virtuous men rather than on water and mountains. But the later (probably Han) *Zhong Yong* [*The Conduct of Life*] states a position greatly to our purpose: "Nature is vast and deep, high, intelligent, infinite, and eternal." This attributes to nature an order or principle (*li*), which is the inherent congruence of each natural thing with what Neo-Confucianism calls the Supreme Ultimate and Daoism calls the Way. The changing, variegated, visible landscape has become a map of the one, unchangeable moral and metaphysical heart of things, and therefore a fit subject for understanding. Painting a landscape, as well as observing one either real or painted, becomes an act of spiritual knowing and regeneration. The great early tenth century landscape painter Jing Hao writes about the appearance of trees with reference to *li* and morality:

Every tree grows according to its natural disposition. Pine trees may grow bent and crooked, but by nature they are never too crooked; they are upright from the beginning. Even as saplings, their soul is

not lowly but their form is noble and solitary; indeed, the pine trees of the forest are like the moral character of virtuous men, which is like the breeze.

Certainly Song artists were interested in the appearance of nature. For this we have both literary evidence—descriptions of Chinese artists sketching from nature—and the evidence of the paintings themselves, where we find the most beautiful representations of and conventions for natural forms. Additionally, they were interested in the rational and ethical correspondences of nature. Rationality, the manifestation of *li*, is of utmost importance in Northern Song (960–1127 C.E.) painting; with few exceptions, its absence strongly suggests a painting of later date. Next in importance is faithfulness to nature, achieved through brush conventions, and by the early Song dynasty such conventions, satisfactory both as calligraphy and as symbols for natural form, were being developed for the representation of rocks, foliage, bark, water, and so on. The *cun*, or contour strokes by which rocks and mountains were defined and modeled, developed during this early period, as well as many other conventions that later became standard.

Song Landscape Styles

Before we study the landscapes, let us briefly outline a framework that may be useful for the study of Song painting. It is only a convention, but only by such a convention are we able to discern some pattern in a chaotic mass of material. This schema has real relation to the actual development of the painting of the period, insofar as we are able to determine it. It divides Song painting into five major categories, to be considered in part progressive. The first is the earliest, and represents the persistence of an archaic manner; the last is the final development of the Southern Song period (1127–1279 C.E.), although it may have had a few precursors. A

painter may work in one, two, or even three modes, but in general works in two that are adjacent in point of development.

The first, or courtly mode, usually in color, is the continuation of the Tang tradition of narrative and courtly art. The second is a monumental mode, primarily of the Northern Song period, and comprising the great early school of landscape painting. The word "monumental" is especially descriptive of these paintings. The third, or literal mode, particularly associated with the Northern Song Academy of the emperor Hui Zong (r. 1101–1126 C.E.), is transitional between the two earlier modes and the later ones of the Southern Song period. The fourth, or lyric mode, classic for the Southern Song period, abstracts and develops certain elements of the monumental and literal styles to create evocative landscapes that appear lyrical and allusive rather than explicitly descriptive. The fifth and last, the spontaneous mode, which develops logically out of the fourth, is an extreme and radical expression of certain brushwork tendencies within the lyric mode. Orthodox critics of late Ming and early Qing spurned the Southern Song style and its "expressionist" offshoot, to the impoverishment of the later Chinese painting tradition. The Japanese, however, particularly fifteenth and sixteenth century artists affiliated with Zen monasteries, approved and adopted these styles. As a result, many extraordinary Song works have been preserved in Japan.

The Courtly Mode

The first, or courtly mode is seen perhaps at its most creative in a handscroll by Zhao Boju, the most famous Song practitioner of this Tang-influenced style (*cpl. 35, p. 336*). The picture is painted in rather bright malachite green and azurite blue, an homage to the archaic proto-landscape tradition of the Sui and Tang dynasties. The delineation, however, shows an artist fully aware of the revolutionary developments in landscape painting of the tenth and eleventh centuries. His painting fuses the courtly and aristocratic garden-landscape of bygone times with latter-day realism and depiction of space. At a time when the Jin "barbarians" ruled northern China and exacted tribute from the Southern Song court, the "blue-and-green" manner of the triumphant Sui and Tang came again into vogue, presumably because it evoked past glories as talisman against a dubious present. Other artists offered more literal renditions of the archaic manner in copies and adaptations of older works. It was Zhao's accomplishment to harmonize two fashionable manners, the archaistic and the up-to-date.

458. *A Noble Scholar.* Attrib. Wei Xian (act. 937–975 C.E.).
Hanging scroll mounted as a handscroll; ink and slight color on silk; h. 53" (134.6 cm), w. 20¾" (52.7 cm). China.
Five Dynasties period. Palace Museum, Beijing

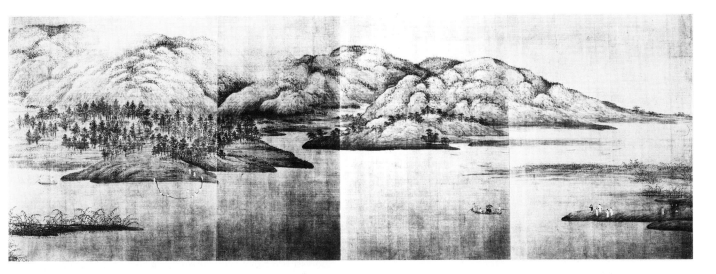

459. *Scenes along the Xiao and Xiang Rivers.* Attrib. Dong Yuan (act. late 10th century C.E.). Handscroll; ink and slight color on silk; h. 19 5/8" (49.8 cm), l. 55 5/8" (141.3 cm). China. Five Dynasties period. Palace Museum, Beijing

The composition is crowded and full, with sustained attention to detail. One of the commonest clichés of Western writers on Chinese painting, and one harder to kill than any other, is the characterization of all Chinese painting as a great expanse of empty silk or paper with just a few brush strokes in the corner. Rhapsodies on the contrast of nothingness with something, and myriad other philosophical inferences, follow in the turbulent wake of this misapprehension. Nothing could be less descriptive of the majority of fine Chinese paintings of all periods. Complexity figures at least as largely as the convention just described. The use of large blank spaces is characteristic of one period, Southern Song; it certainly does not represent Chinese painting as a whole. A composition such as this in the traditional blue-and-green style—complex, rich, varied, and detailed—is much more typically Chinese. Other conservative and traditional painters, too numerous to name, worked in this style. Zhao Boju is the most famous for such paintings in this dynasty.

The Monumental Mode

The second category, and perhaps the most important, is one associated with monumental effects in nature. It certainly begins in the Five Dynasties period, between the fall of Tang and the founding of Song in 960 C.E. Its first painter, legendary to us, is Jing Hao, whose remarks on the nature of trees were quoted above. Unfortunately we have no works that can be considered his. In the Palace Museum in Beijing, however, is an impressive hanging scroll attributed to Wei Xian (*fig. 458*). Its tall, stiffly contoured, vertical mountains remotely recall the comblike mountains of Tang and earlier paintings, but the landscape that forms its subject differs radically from the decorated and incidental landscapes of the Tang dynasty. The title, *A Noble Scholar,* may imply human activity, but the subject of the picture, dominating the composition, is the landscape. In general, the monumental mode seems best accomplished in the hanging scroll. Its verticality allows the development of height particularly appropriate to the rational and monumental aims of the painters who produced some of the greatest masterpieces of Chinese painting.

The second master, Dong Yuan, is famous for his representations of the Nanjing area which was his native soil. We have several paintings that may well be early and close to his manner. One of them is a large handscroll in the Palace Museum, Beijing (*fig. 459*). Tiny human figures add touches of color, but their activities are completely dominated by the landscape. In contrast with the verticality of figure 458, implicit in the hanging scroll format, Dong Yuan's work was most famous for its development of far space and rolling, resonant mountain shapes. He paints the geography of southeastern China rather than the dry and barren landscape of the north. Nevertheless the deep space, the long vista with the water zigzagging back into the distance between overlapping projecting peninsulas, the palpable yet atmospheric land, are quite in the monumental mode. Some difficulties with space organization remain. The planes of the different water areas are not consistent: Foreground, middle ground, and background seem to follow three different plans. This division of the space and the surface organization into self-contained and separate parts is rather characteristic of the new landscape mode. An inner rhythm dominates the whole composition, artfully created by rhythmical repetition in the points of land, in the forms of trees, and particularly in the folds of mountains.

In this painting we can also see an increase of realism in landscape. We look out over the mountains in the painting from a high viewpoint, across an expanse of water and low-lying land. Such a view the Chinese call "level distance." Added to this realism in the general

appearance of things is a growing realism in the handling of details—the differentiation of greater numbers and varieties of trees, and the representation of different types of marsh grasses and other foliage. There is also greater differentiation in the conventional *cun,* those brush strokes that form the different kinds of wrinkles and so describe types of rock and mountain: soft, hard, crystalline, and others.

Ju-Ran, another great tenth century master, was famous for towering mountain compositions. In the Cleveland Museum of Art is a hanging scroll by him showing a landscape with high mountains (*fig. 460*). In this picture there occurs one device that is used again and again in the early vertical formats, that is, the division of the picture into two fundamental units: a foreground unit, which includes everything usually considered foreground and near middle ground; and a background unit, separated from the foreground by a gap where the far middle ground would have been, had it been represented. The foreground is conceived as nearby, and the eye of the spectator travels over the near detail, taking in the sure brushwork in the foliage and the architecture. But then comes a subtle break between the foreground and the area behind, which is treated as if it were a backdrop suspended and fitted into a slot behind the foreground. This device adds to the towering quality of the mountains rising precipitously behind the foreground unit. The large, wet brush spots provide almost musical accents and may well be the first appearance of this technique, so important in the unique style of Mi Fu, an artist of the late eleventh century C.E. Figure 460 was painted by Ju-Ran in the north, on a visit to the capital, but the moist and vaporous rendering is in the artist's characteristic style, associated with south China and with his countryman Dong Yuan.

We must never forget, despite these aesthetic devices, despite some conventions in the representation of space, such as the tilting of the foreground and the flattening of the background, that one of the things uppermost in the Chinese landscape painter's mind at this time was the question of representation and especially of achieving a believable path through the painting. The Chinese write constantly about landscape painting that it shows country good to walk in; we read in the colophons that one travels through the painting, that here we see so and so, and there is such and such, over there a wine shop, and that we ford a stream and reach a certain place. We must remember that the hanging scroll, though rather like a framed picture, does have a path that one follows through space and time. This path for the viewer becomes notably

460. *Buddhist Monastery in Stream and Mountain Landscape.* By Ju-Ran (act. c. 960–980 C.E.). Hanging scroll; ink on silk; h. 6'1" (1.85 m). China. Northern Song dynasty. Cleveland Museum of Art

461. *Travelers amid Mountains and Streams.* By Fan Kuan (act. c. 990–1030 C.E.). Hanging scroll; ink on silk; h. 6'9¼" (2 m). China. Northern Song dynasty. National Palace Museum, Taibei

important in the handscroll. One of the tests of authenticity for a Song painting is the believability of the landscape as a place to walk in. One must not climb a rock and find nothing behind it; one does not arrive at a wine shop and find its welcoming banner missing. The Song painter is intensely interested in logical detail. Each part is a separate part, but each part fits into the whole and the whole is the sum of the parts with nothing left over.

Perhaps the greatest single example of this monumental approach is the hanging scroll on silk in the National Palace Museum, attributed to the tenth century master Fan Kuan (act. c. 990–1030 C.E.; *fig. 461*). All that has been said about figure 460 certainly applies to this painting. Here rocks in the foreground create a visual bar-

rier so that the spectator's eye is not pulled suddenly into the landscape. Tremendous complexity marks the forest on the cliff, with its small temples nestled among the trees. Sharp brushwork clearly differentiates all the various deciduous and coniferous tree forms. The rocks are typical Fan Kuan rocks, slightly more crystalline than, for example, the smoothly rounded rocks of Dong Yuan or the peculiar "alum lump" rocks characteristic of Ju-Ran. The backdrop is a magnificent towering peak topped with patches of low bush. A single cascade of water falls at the right of the picture, balanced by the cleft in the small mountain at the left. It is one of the simplest compositions of Chinese landscape painting, and it is overpowering. The immensity and the manifest greatness of nature are rationally expressed here, without resort to clichés of empty space. The vastness of nature is observed and realized in complex detail and careful organization. In this respect it bears comparison with any of the great landscapes of Western art.

We are fortunate in having available for comparison both a copy and the presumed original of this painting. Remember several things about the Fan Kuan: the natural appearance of the slope; the sharp differentiation of little things, such as the clear silhouette against a light background of the mule team and caravan going down to the ford; the sharp definition of the waterfall against the background by light and dark patttern; and the separation of the background massif from the foreground forest and ford. With these in mind, let us turn to a copy probably made in the seventeenth century, a copy that the Qianlong emperor and his curators accepted as the original Fan Kuan (*fig. 462*); although they owned the other painting, they evidently did not consider it authentic. There is great satisfaction in this, for it tends to confirm that the usual Chinese critic of the seventeenth or eighteenth century, being unscientific and subjective, could not help preferring the work closer to his own way of thinking over that of the Northern Song painter. Notice how much nearer everything seems; the spectator is physically and psychologically more involved in this landscape than in the other, which appears to be more remote. Note how the waterfall has lost contrast and become hardly noticeable. The lines of the mountain bases are pulled down and involved with the foreground. Visually, the copy is more textured, more unified, and less realistic than the work of the Northern Song period. It can be shown to be seventeenth century by comparison with dated seventeenth century pictures, which used the same textural and visual devices. The authentic work, on the other hand, emphasizes rationality, separation of parts, and realism. Comparisons like this improve our ability to distinguish original from copy.

Another great figure in the development of the monumental landscape style was Li Cheng (919?–967? C.E.), forerunner of Guo Xi. He was most famous for his repre-

462. *Travelers amid Mountains and Streams.* Copy of Fan Kuan scroll. Hanging scroll; ink on silk; h. approx. 24" (61 cm). China. Late Ming or early Qing dynasty. National Palace Museum, Taibei

463. *A Solitary Temple amid Clearing Peaks.* Attrib. Li Cheng (919?–967? C.E.). Hanging scroll; ink and slight color on silk; h. 3'8" (1.1 m). China. Five Dynasties period–Northern Song dynasty. Nelson-Atkins Museum of Art, Kansas City

sentations of gnarled, twisted trees and of distant vistas of the barren north. A hanging scroll in the Nelson-Atkins Museum depicts his style and is one of the two most aesthetically rewarding pictures to which his name is attached (*fig. 463*). The treatment of the mountains and trees is complex, but each individual tree and bush partakes of that twisted and gnarled character traditionally associated with the artist. The architecture is rational and clear and demonstrates the logic we should expect from an early Song landscapist. It is interesting that this painting and figure 460, attributed to Ju-Ran—one northern, the other southern—were both in the Northern Song

Imperial Bureau Collection (*Chong Wen Yuan*).

Li Cheng's unmistakable style was carried on by his most famous follower, Guo Xi, one of the greatest of Northern Song landscape painters (c. 1020–c. 1090 C.E.). In *Early Spring*, the most important picture attributed to Guo, one can see the derivation of some elements of the style from a painter such as Li Cheng: the gnarled trees, the topography of the dry and barren northern country (*fig. 464*). But Guo Xi informed his work with a distinctive rhythmical quality and complexity that were the envy of his contemporaries. He was acclaimed the very greatest artist of his day and a rival of the giants of the past, and

464. *Early Spring.* By Guo Xi (c. 1020–c. 1090 C.E.). Dated to 1072 C.E. Hanging scroll; ink and slight color on silk; h. 62¼" (158.1 cm). China. Northern Song dynasty. National Palace Museum, Taibei

this for a Chinese is the highest possible praise. One is conscious of a strongly rational construction in *Early Spring,* despite the baroque impression created by the abnormalities of tree formations and twisted rocks. The picture is organized on a grid, with forms growing out from either side of a vertical midline in a regular and rhythmical order. Again we see that separation of near and far which appears almost a rule in these early paintings. The dividing line runs from the valley up and around the near hill and then on through and past the distant mountain range on the far right. The separation leaves an apparently empty area between the end of the nearest peak and the lowest point of the beginning of the highest peak. The explanation can be found in nature: The Chinese painter had looked at the mist swirling about the mountains and used it in his painting. In the monumental mode of Northern Song mist became a device to mask the problem of relating near, middle, and far ground. The full solution, without the aid of mist, was

found probably in the fourteenth century and from that time was handled with great skill by the Chinese painter. So from the standpoint of the conquest of visual space, the monumental mode is, in a sense, archaic. It is of interest that the paintings we consider to be of the Northern Song period usually allow the silk to represent mist, in contrast with later paintings, in which there is a tendency to make the mist appear palpable. The treatment of mist by the Northern Song painter is more abstract. On the other hand, there is much of convincing reality in the Guo Xi, notably in the vista up the valley to the left, depicting the almost tundra-like country of north China, reaching past dry washes of loess soil to the distant mountain ranges. No representational elements have been lost; the differentiation of pine and of gnarled and twisted deciduous trees is clear; the architecture is believable and strongly drawn. Another of the hallmarks of Northern Song landscape painting is its rational handling of architecture, from the standpoint both of construction and of placement in space. This is a radically different picture from the relatively simple composition of Fan Kuan, but both are encompassed within the monumental mode.

The Northern Song landscapists also produced superb handscrolls, adapting the towering mountain subject to the horizontal format in "level distance" pictures. One of the most dramatic and original of these handscrolls is *Fishing in a Mountain Stream* (*fig. 465*), by Xu Daoning (c. 970–c. 1052 C.E.). Continuing the tradition of Li Cheng, its drama lies in the saturated-ink brushwork used to render the bare, spiky trees, and in the contrast between these and the paler expanses of a chill and barren northern landscape. Whereas paintings of the Li Cheng tradition locate intensity and grandeur in awesome massifs, here they are to be found in the swooping parabolic curves of the mountainsides. The originality of the painting consists in suggesting towering monumentality by cutting off the tops of the peaks, thereby implying heights beyond the upper border of the scroll. This serious and somber work is perhaps the finest surviving landscape handscroll of the Northern Song period. Its brushwork unites calligraphic integrity with descriptive realism.

With the end of the eleventh and the beginning of the twelfth century a new intimacy enters the painters' approach to nature. We find this particularly in the work associated with one artist, Zhao Lingrang, where near views and relatively low and close horizons replace the monumental format (*fig. 466*). These small, charming, and intimate views of idyllic, nearby, and understandable nature seem part of a new ethos, centered in the Academy of the emperor Hui Zong, who favored a realistic and literal mode. In a sense, Zhao Lingrang's low horizon and near view partake of the literal mode of the Academy, since they tend to produce a more visually realistic depiction of nature than the great, noble, and remote compositions of the preceding two centuries. Figure 466 is one of

465. *Fishing in a Mountain Stream.* By Xu Daoning (c. 970–c. 1052 C.E.). Handscroll; ink and slight color on silk; h. 19¼" (48.9 cm), l. 6'10½" (2.1 m). China. Northern Song dynasty. Nelson-Atkins Museum of Art, Kansas City

two or three leaves probably by or close to Zhao Lingrang. He was an admired master, much copied in later days.

At this point it seems appropriate to show the handscroll *Streams and Mountains without End,* painted about 1100 C.E., because it is a somewhat eclectic picture, recapitulating much previous development (*fig. 467*). It begins with a small, low, intimate landscape in the then up-to-date and fashionable style of Zhao Lingrang, goes on to a mountain-encircled space recalling *Wangchuan Villa,* then proceeds to a style of painting rather like Dong Yuan's, rolling and resonant in its form, followed by a crystalline style based upon another Northern Song mas-

ter, Yan Wengui (967–1044 C.E.). It then moves to a climactic mountain unit painted very much in the towering style of Fan Kuan, and finally ends with a forest and distant mountain area, perhaps close in style to Guo Xi.

The painting is also of great interest because of its format and its organization within that format. The handscroll, being unrolled from right to left, not only allows development of pictorial structure between the beginning and end of the painting but also demands organization in time and space. In a way it is the ancestor of the motion picture; one can vary the frame by rolling either end, or both, thus creating innumerable small pic-

tive aesthetic judgment. Furthermore, to the later Chinese painting tradition, the Southern Song styles were unorthodox.

A vertical composition in traditional hanging scroll format recalls something of the monumental style, but with a telling difference (*fig 478*). Two fragile pine trees with fantastically elongated and twisted branches, which would in the earlier style have been a detail of the composition, here project dramatically into space, their prominence exemplifying the painter's new approach. More characteristic of Ma's developed style is the spring landscape of ducks and bamboo beside a stream (*fig. 479*). Chinese writers called him "one-corner Ma," and with reason. Regarding this painting one can speak of the asymmetric balance, or rather tensions, of space against form, mystery against sharp explicitness. Here, too, are the projecting branches and other elements so important in the Zhe school painting of the early Ming dynasty, and to the Japanese painters of the fifteenth century.

For various reasons, this mode has been unjustly disparaged in favor of the *wen ren* styles of late Ming and Qing. First, its enormous popularity in Japan gave rise to so many Japanese copies and even forgeries that the great majority of paintings in this mode are not Song at all, if indeed they are Chinese. Second, the style is much appreciated in Japan, making it incumbent upon the Chinese to dislike it. Third, it was much appreciated many years ago, therefore modern critics must not like it. Nevertheless, lyric paintings of Song China deserve admiration and repay study. Ma Yuan is the most romantic and exaggerated practitioner of the asymmetrical composition that is the hallmark of the school; and he, his father, his son, and his nephew, forming the Ma school, all painted very much in the same style and with the same results. The collective contribution of the Ma school equals that of any other mode of Song painting, before or after.

The second great master of the lyric style is Xia Gui, active in the first quarter of the thirteenth century, with two distinct styles associated with his name. One of these appears in a fragment of a longer scroll, *Twelve Views from a Thatched Hut,* of which only four views now remain (*fig. 480*). This handscroll is in a way much more

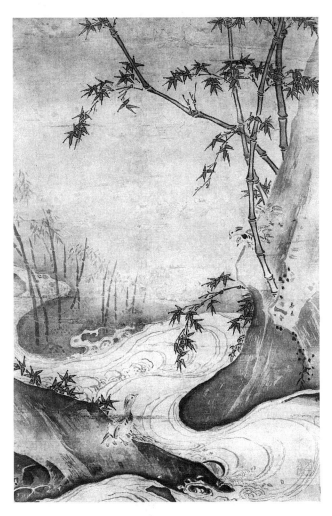

479. *Bamboo and Ducks by a Rushing Stream.* By Ma Yuan (act. c. 1190–c. 1225 C.E.). Hanging scroll; ink and slight color on silk; h. 24" (61 cm), w. 14¹/2" (36.8 cm). China. Southern Song dynasty. Cleveland Museum of Art

480. (below) *Flying Geese over Distant Mountains; Returning to the Village in Mist from the Ferry; The Clear and Sonorous Air of the Fisherman's Flute; and Boats Moored at Night in a Misty Bay; from Twelve Views from a Thatched Hut.* By Xia Gui (c. 1180–1230 C.E.). Section of a handscroll; ink on silk; h. 11" (27.9 cm), l. 7'7¹/4" (2.3 m). China. Southern Song dynasty. Nelson-Atkins Museum of Art, Kansas City

481. *Clear and Distant Views of Streams and Hills.* By Xia Gui (c. 1180–1230 C.E.). Handscroll; ink on silk; h. 18¹/₄" (46.4 cm), l. 32'6" (9.9 m). China. Southern Song dynasty. National Palace Museum, Taibei

sophisticated than any handscroll of the Northern Song period. At the same time it is simpler, with much less control and complexity in organization. The brushwork is completely in ink; there is no color. Forms are much simplified: Tree trunks are indicated by heavy, thick outlines that seem also to model them in the round; rocks and mountainsides are treated as planes indicated by washes, with no great use of *cun*. Types of foliage and textures of tree bark are relatively undifferentiated, the emphasis being upon silhouette and the projection of shapes into areas of blank silk. Distant objects are misty and simplified to an almost abstract, hazy ink pattern, a technique of some significance in the later development of a spontaneous approach to landscape. Like Ma Yuan's *Landscape in Rain* (*fig. 478*), the *Twelve Views from a Thatched Hut* reveals why the "one-corner" epithet was given to the Ma-Xia school. It also demonstrates that in the hands of a master the convention produces a result as satisfying aesthetically as any of the more complex and rational products of the Northern Song period. Brusque and rapid representation of forms against water only vaguely indicated with a few ripples displays this suggestive and asymmetric style at its most developed and sophisticated best. Xia Gui is also famous for another manner more directly based on Northern Song style and very much respected and admired in China. This is best seen in a long handscroll, *Clear and Distant Views of Streams and Hills,* kept in the National Palace Museum (*fig. 481*). It combines sharp and crystalline brushwork in its representations of mountains and rocks with the same silhouette treatment of tree foliage to be seen in the *Twelve Views from a Thatched Hut.* The *Clear and Distant Views* scroll, some thirty-three feet in length, shows an amazingly complex development through time, in the finest handscroll tradition. This picture and others like it were of great importance in the development of early Ming painting. They also influenced such Japanese painters as Sesshu (*see figs. 561–63*).

The Spontaneous Mode

The spontaneous mode, last of the five categories to develop, is twofold in origin. Its abbreviated techniques were derived from ink painting of bamboo and kindred subjects. As early as the tenth century these themes had been a preoccupation of the scholar-painter (*wen ren*) and calligrapher wishing to transfuse the discipline of writing into pictorial form. Out of the lyric mode came the gradual dissolution of pictorial form and the preference for rapid, calligraphic brushwork, pure monochrome ink, and the close-up detail. In figure 482, attributed to the first great master of bamboo painting in Chinese history, Wen Tong (1019–1079 C.E.), brush discipline is evident in the control of each leaf stroke, and compositional mastery in the great S-curve of the main stalk and the disposition of the almost moving sprays and stems that branch from it. Later, a shift in emphasis put this same technique and style more to the purpose of expressing the artist than depicting the subject.

To the influence of calligraphic discipline and of the lyric mode was added the emphasis of Daoism and Chan (J: Zen) Buddhism on intuitive response to nature. Toward the end of the Song dynasty all of these coalesced to produce what we have called a spontaneous mode. Chan provided much of the subject matter, just as its monasteries provided many of the retreats for these painters. The prime factor, however, was the gradual shift of the lyric mode toward highly specialized, intuitive, and personal expression. One cannot discount the influence of an early and still little understood attitude of scholar-amateurs to ink painting.

Chan Buddhism was also concerned with individual character. Figure 483 shows the careful, detailed style, derived from Tang portraiture and decorative painting, used by a Southern Song painter to reveal the saintly individuality of Priest Bu-Kong. After all, the original Chinese Chan patriarchs lived during the Tang dynasty, the greatest period of figure painting, making the conservative

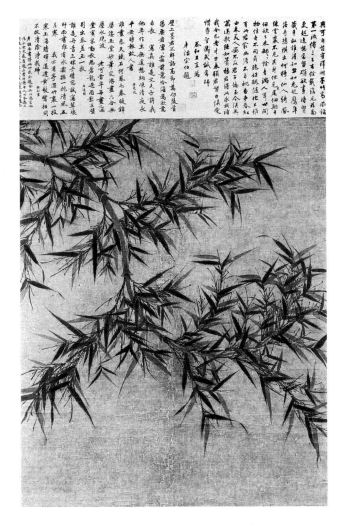

482. *Bamboo.* By Wen Tong (1019–1079 C.E.). Hanging scroll; ink on silk; h. 52" (132.1 cm). China. Northern Song dynasty. National Palace Museum, Taibei

483. (right) *Priest Bu-Kong.* Traditionally attrib. Zhang Sigong (act. Northern Song dynasty). Hanging scroll; ink and color on silk; h. 45" (114.3 cm). China. Southern Song dynasty. Kozan-ji, Kyoto

Tang style seem appropriate for patriarch portraits. Such portraits were also a part of other traditions—Daoist sages, powerful rulers, noble officials were depicted in similar styles but with different iconographies. The wildly different spontaneous manner was used for metaphoric subjects—landscape, still life, visual *koan*; and it was used by Daoist, Confucian, and Chan artists alike. The large number of extant Chan portraits is undoubtedly due to the Chan teachers' custom of providing pupils with a "diploma portrait" at the time of their parting.

The monk Mu Qi, better known in China as Fa-Chang, was one of the two greatest exponents of the spontaneous mode. His triptych in the Zen monastery of Daitoku-ji in Kyoto, painted in ink and very slight color on silk, is executed with such rapidity and abbreviaton of brushwork and such boldness of composition that the result is, in effect, a new manner (*fig. 484*). The pine branches and monkeys, as well as the bamboo grove

behind the crane, reveal extreme spontaneity in brush handling; the crane and white-robed Guanyin are more carefully painted. The overall misty tone is still related to the works of the Ma-Xia school.

Mu Qi's consummate expression of this new style is the famous *Six Persimmons,* kept at the same monastery in Kyoto (*fig. 485*). Painted in cool, blue-black ink on paper, the *Six Persimmons* has been aptly described by Arthur Waley as "passion . . . congealed into a stupendous calm."[21]

The painting communicates many of the qualities that we associate with Chan Buddhism: It is intuitive, brusque, enigmatic. But one cannot help noting as well the tremendous skill of hand and brush that painted these persimmons. Their subtlety of modeling is remarkable. The darkest one, painted as an oblate circle, seems the heaviest as well. The long, flowing, thick-and-thin brush stroke that models the lightest of the persimmons makes

484. (above) *Triptych:* (left) *Crane in a Bamboo Grove;* (center) *White-Robed Guanyin;* (right) *Monkey with Her Baby on a Pine Branch.* By Mu Qi (Fa-Chang; c. early 13th century–after 1279 C.E.). Hanging scrolls; ink and slight color on silk; h. 70" (177.8 cm). China. Southern Song dynasty. Daitoku-ji, Kyoto

485. *Six Persimmons.* By Mu Qi (Fa-Chang; c. early 13th century–after 1279 C.E.). Ink on paper; w. 14¼" (36.2 cm). China. Southern Song dynasty. Daitoku-ji, Kyoto

it seem to float in contrast to the heavy, dark one. Note the subtle placement of these "inanimate" objects: The two at the left overlap slightly, the heavy one in the center has a wide and a narrow margin, the two at the right overlap greatly, the single fruit below the others stands separate from all of them. All of these subtleties and refinements, including the treatment of the stems and leaves as if they were Chinese characters, reveal brush control at its very highest level. The range from sharpness to vagueness, from pitch darkness to extreme lightness, encompasses extremes greater even than in the lyric mode. It recalls the short riddles or paradoxes, the *gong an* (J: *koan*) of Chan Buddhism:

"Who is he who has no companion among the ten thousand things of the world?" "When you

486. *Shakyamuni Leaving His Mountain Retreat.* By Liang Kai (3rd quarter of 12th century–probably after 1246 C.E.). Hanging scroll; ink and slight color on silk; h. 46½" (118.1 cm). China. Southern Song dynasty. Tokyo National Museum

487. *Hui-Neng, the Sixth Chan Patriarch, Chopping Bamboo at the Moment of Enlightenment.* By Liang Kai (3rd quarter of 12th century–probably after 1246 C.E.). Hanging scroll; ink on paper; h. 29¼" (74.3 cm). China. Southern Song dynasty. Tokyo National Museum

swallow up in one draught all the water in the [Xi River], I will tell you." Another is: "Who is the Buddha?" and the answer, "Three *jin* of flax." Still another example: "What is the meaning of the First Patriarch's visit to China?" with the answer, "The cypress tree in the front courtyard."²²

We know only two great masters of this extreme manner—Mu Qi and Liang Kai, who, although never a monk, resigned from the Southern Song Painting Academy and frequented Chan temples. Not surprisingly, he is famous for Buddhist subjects. His extant works show considerable stylistic range. The famous *Shakyamuni Leaving His Mountain Retreat* combines elements of Tang Central Asian figure style with the lyric landscape mode and shows Liang as a disciplined painter, original but still

within the Academy tradition in which he began (*fig. 486*). One of the great expressions of the spontaneous mode is his *Hui-Neng, the Sixth Chan Patriarch, Chopping Bamboo at the Moment of Enlightenment,* which unites Shakespeare's conviction that much can be learned from a seeming fool with the Chan esteem for roughness and spontaneity and meaningful illogicality (*fig. 487*). The technique is matched to each part of the subject and ranges from the most precise use of calligraphic brushwork to indicate the joints and movement of fingers, through long curves indicating the roundness of the arms, to the almost scrubby use of a tremendous ropelike brush for the texture of the tree bark. At the left is the artist's signature, not the neat, carefully written signature of a Li Tang or a Li Anzhong, but a bold, almost illegible, powerfully conceived insignia.

雨
艳
雲
暗
歓
長
沙
隱
三
残
虹
常
吹
霞
最
好
市
撟
歿
柳
升
酒
旗
推
臭
多
思
家
山
市
晴
嵐

488. *Mountain Village in Clearing Mist.* By Yu-Jian (act. mid-13th century C.E.). Section of a handscroll; ink on paper; h. 117/8" (30.3 cm), l. 327/8" (83.3 cm). China. Southern Song dynasty. Idemitsu Museum of Arts, Tokyo

Liang Kai and Mu Qi are the greatest masters of this spontaneous mode. Their few extant paintings survive for the most part in Japan; very few Song works in this style remain in China. Thus the "splashed ink" works of the Buddhist monk Yu-Jian (act. mid-thirteenth century C.E.; *fig. 488*), though acceptable in thirteenth century south China, are known to us only because they were treasured and therefore preserved in Zen circles in Japan. His *Mountain Village in Clearing Mist* is one of three surviving segments, all in Japan, of a handscroll of the *Eight Views of the Xiao and Xiang Rivers.* If it seems to us an intuitive, almost abstract masterpiece, we owe our appreciation to the hindsight made possible by Modernism, especially Expressionism and its later manifestations. For the logical development of this style in China, we must wait for the works of the seventeenth century individualists.

ARCHITECTURE

Architecture during Song continued to develop post-and-lintel buildings with hipped and gabled roofs, following precedents revealed in Tang murals and in the building models and wall engravings found in Han tombs. Perhaps the Song architects' most signal contribution was to perfect the bracket-supported roof with eaves turned up at the corners, which has given Chinese architecture its characteristic profile ever since. An architects' manual entitled *Building Standards* (*Ying Zao Fa Shi*), prepared at imperial request during the last decades of the eleventh century, notes that builders before Song were "not so good at turning up the eaves." In the library of the Lower Huayan Si in Datong, Shanxi, the sutra cabinets are carved to represent a pair of two-story pavilions joined at their second stories by an arched bridge bearing its own miniature pavilion. An inscription on these cabinets records their completion

in 1038 C.E. Together with the buildings of the Upper and Lower Huayan Si, they offer some notion of Song architecture of the mid-eleventh century.

SCULPTURE

Icons created for new Buddhist establishments give ample evidence of sculptural creativity during Song. Most of the extant examples come from north China, the southern temples having suffered greater losses from wars and insurrections even into modern times. Buddhist temples multiplied in the north under "barbarian" as well as Song patronage. The Khitan rulers of Manchuria, Mongolia, and northeast China (Liao dynasty, 947–1125 C.E.), the Jürchen (Jin dynasty, 1122–1234 C.E.) who extinguished Liao and Northern Song, and even the Mongols (Yuan dynasty, 1271–1368 C.E.) understood well how Buddhism could serve the purposes of dynastic control. Precedents for identifying the emperors with the Buddha dated from the Six Dynasties period; the faith created common bonds of culture as well as religion between the Chinese and their alien rulers; and patronage of Buddhism cloaked the foreign emperor in Chinese precedent and lent him a suitable aura of benevolence.

These dual, or "Sino-barbarian," dynasties became major patrons of Buddhism. Sculptures produced under their auspices from the tenth through the fourteenth centuries show basically a revival of Tang styles with certain new qualities superimposed.

Of all the deities Guanyin (S: Avalokiteshvara, the Compassionate Bodhisattva) was the most popular, particularly in the newer embodiments based on the Lotus and Flower Garland sutras. Most widely venerated of these was Guanyin of the Southern Seas, savior from shipwreck (both literal and spiritual). This deity resided on

490. *Seated Potalaka Guanyin.* Painted wood; h. 7'11" (2.4 m). Shanxi Province, China. Liao dynasty, 11th–12th century C.E. Nelson-Atkins Museum of Art, Kansas City

489. *Eleven-headed Guanyin.* Wood with traces of color and cut-gold leaf; h. 7'2" (2.2 m). China. Song dynasty, 12th century C.E. Cleveland Museum of Art

Mt. Potalaka (C: Putuo Shan, Radiant Mountain), which the Chinese popular imagination had, perhaps as early as the eighth century, located in the South China Seas. Over time this Guanyin incorporated major elements from Chinese folk culture, including a growing feminization of the image type and its increasing association with aid in conception and childbirth. The monumental twelfth century standing image in the Cleveland Museum (*fig. 489*) shows the traditional masculinity, albeit somewhat softened, of the Tang image type. But in the Nelson-Atkins Museum, seated in the posture of royal ease on a simulated outcropping of craggy, perforated rock, is the remarkable image of a Potalaka Guanyin whose soft skin and

contours, charm of bearing, and beguiling smile create an aura of femininity (*fig. 490*). During the Song dynasty the Potalaka Guanyin became a special patron of women and the object of a separate cult, in which Potalaka was identified with an island off the coast of Zhejiang near Ningbo.

Both of these sculptures, especially the beautifully polychromed and well-preserved seated figure, have been aptly compared by Laurence Sickman with baroque sculpture in Central Europe, a comparison enhanced by their sharply undercut, swirling draperies. Although much of later Chinese Buddhist sculpture is mediocre, virtuoso carving distinguishes these and similar Buddhist icons of the Northern Song, Jin, and Yuan dynasties as singular and inventive creations.

Numerous images of this type exist, in China and elsewhere. They bear witness to major patronage by the northern dynasties which stimulated a well-organized industry for the production not only of Buddhist sculptures but of Buddhist paintings in scroll and fresco formats. Few wall paintings of Song times have survived. Those that have, along with the more numerous works of Yuan and early Ming, exemplify the Tang tradition in decline, unleavened by the inventiveness shown by contemporary sculptors.

CERAMICS

Chinese ceramics of the Song dynasty are probably the classic expression of ceramic art not only in China but in all the world. By classic we mean that Song ceramics achieved an unsurpassed integration of shape, glaze, and decoration, and Song potters acquired a superlative command of potting and firing techniques and glaze making. The result was a series of flawless wares that remain the admiration as well as the despair of the modern potter. The shapes of Song dynasty wares are mostly extremely simple. They tend to be subtle and suavely flowing, in contrast to the robustly swelling, sharply angled forms of the Tang dynasty and earlier. In a Tang vessel, neck, body, and foot are clearly differentiated, but in many Song wares the parts are so smoothly and fluently connected that it is hard to know where the neck commences, the body leaves off, or the foot begins. The glazes of Song ceramics are mostly monochromatic, with rather soft, mat surfaces that appear an integral part of the ceramic form, and with a depth and texture wondrously inviting to the touch. They were created, not by scientific experimentation in the modern sense, but by a skillful and knowledgeable trial-and-error pragmatism. The fortunate inconsistencies and imperfections of technique served to preclude the hard, bright uniformity so characteristic of later Chinese glazes. Shape is the dominant aesthetic element of Song vessels. Except on one type of ware, ornament, where used at all, is spare, chaste, and restrained. The glaze, applied over the carved or incised or molded decoration, serves to mask and subdue it even further. Usually this minimal ornamentation is floral, though figures are known, and always it is composed to enhance the form of the pot.

There are important general distinctions between northern and southern wares, though recent and continuing excavations on the mainland have indicated that these are not absolute or ironclad. Nevertheless, wares from the north are predominantly white or creamy white both in body and in glaze. White stoneware was pervasive in the north, used by peasant and rich man alike, with certain special wares made for a limited aristocratic consumption. In the south the ubiquitous ware was gray-bodied and glazed either pale blue-white or, more often, green ranging from olive to blue-green. The pervasive northern white wares, except for some Ding types, were not fired at a high enough temperature to qualify as porcelain, but most of the celadons, the predominant ware of the south, are porcelain in the Chinese sense. Some of these geographically based distinctions may be attributable to topography and natural resources. Even by Song times the mostly flat north was largely deforested, and local coal was fast becoming the major fuel. The south, by contrast, is hilly or mountainous, and even today is partly forested. The beehive kiln imposed by the flat terrain of the north could not often, in its Song stage, reach temperatures high enough to create porcelain. Moreover, coal burns at a lower temperature than wood. But the southern hills lent themselves to dragon kilns, which stretched up the hillsides with their vents at the highest point; in these, the natural draft together with wood fuel created temperatures high enough to make porcelain production simple—often, indeed, inevitable. These geographical distinctions do not apply to imperial wares. The court, whether at Kaifeng in the north or at Hangzhou in the south, commanded sufficient wealth and sufficiently advanced techniques to obtain whatever wares it wished. Thus one can find green wares and black wares in the north, and as many white wares were produced in the south, especially during the Southern Song dynasty. But in general, the distinctions between northern and southern ceramics are valid and help to simplify a complicated picture.

We will consider first the classic northern wares, then those of the south. Both northern and southern wares were made at the same time, but the most refined and aristocratic wares, made for court use, were produced in the north at the end of the Northern Song dynasty and in the south during the Southern Song dynasty.

Cizhou Ware

The everday, common ware of the north is a slip-decorated stoneware called Cizhou, after one of the principal kiln-site towns. A better term would be Cizhou type or, more accurate still, northern slip-decorated stoneware, for the varieties of this ware are extremely numerous, and the quality runs from rough and crude to highly refined. The essential elements of the Cizhou type are a stoneware body, usually creamy in color, covered with a white slip that was sometimes left plain and sometimes used as the ground for further colored or carved and colored decoration. Figure 491 shows a vase intended to hold plum blossoms (*mei ping*, plum vase). Its rich, slightly creamy white color is produced by the slip over the buff body, which is just visible at the base of the pot. A variation of this undecorated monochrome ware is not white but black or brown—the color created by a thick glaze applied directly to the buff body without the use of slip. This type is also found throughout north China and is sometimes called Henan ware.

The simplest type of decoration on the white ground is painted. Such decoration was executed in dark brown or black slip, the blacker the color, the more desirable to Chinese taste. Cizhou being a utility ware, shape and decoration often tended to be rough and robust. Judged by the imperial standards of the Song and later dynasties, it was not part of the classic tradition. Cizhou pillows were made in great abundance, many decorated with naturalistic and freely painted designs (*fig. 492*). The bird on a branch looking at an insect gives us a very good idea of

491. *Mei ping vase.* Cizhou stoneware; h. approx. 18" (45.7 cm). China. Song dynasty. Formerly C. T. Loo collection, New York

492 (center) *Pillow.* Cizhou stoneware; l. approx. 12" (30.5 cm). China. Song dynasty. Saint Louis Art Museum

the freedom with which the artist used his brush and of the influence that must have filtered down to him from contemporary painters. At the same time, the vigorous, rather offhand brushwork and composition are characteristic of folk art.

Another type of Cizhou decoration is achieved by incising or carving or by a combination of these. Figure 493 shows a Cizhou teapot or winepot with a floral design created by carving away the thick white slip down to the buff body in the background areas. The whole is then covered with a transparent glaze. The result is a two-color design with a powerful sculptural quality somewhat related to designs on Tang and early Song silver work. Much of the best Cizhou ware appears at the beginning of the Song dynasty and shows the influence of Tang metalwork and of Tang shapes. This pot, with its sharp differentiation of neck, body, and high foot, has inherited its general form from Tang. A variation on the carving method in figure 493 is to be found in a *mei ping* whose decoration was created by covering the vessel with blackish brown slip, then carving this slip away from the background areas and filling in the cut-away areas with a white slip (*fig. 494*). Here the design is the standard peony motif used so often on the best Cizhou wares, displaying that rich contrast of blackish brown and creamy white which is one of the most characteristic and decorative effects of the ware.

An even more complex feat of incising and inlaying creates the design on a large vase considered by many to be one of the greatest Cizhou vases in the world (*fig. 495*). Its shape continues the style of the Tang dynasty, with sharply differentiated spreading lip, long neck, prominent shoulders, and sharply cut high foot. Its combination of incising and inlaying is among the rarest of the techniques found in Cizhou ware, and one that seems characteristic of a site in Henan Province called by various names, but perhaps most commonly Jiaozuo. Here a combination of brown slips and needle-point incision inlaid with white slip produces a type of decoration clearly under the influence of metalwork, particularly of incised silver. The bold strength of Cizhou shape and decoration is especially marked in this piece.

Toward the end of Song and continuing well into the Yuan dynasty, colored enamels come into use for the decoration of Cizhou wares, replacing plain black or blackish brown slip. A series of wares, some dated, ranging from

493 *Winepot or teapot.* Cizhou stoneware with carved decoration; h. 6⅞" (17.5 cm). China. Song dynasty. Cleveland Museum of Art

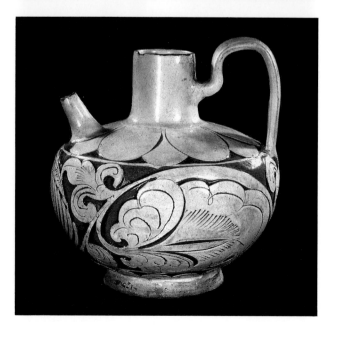

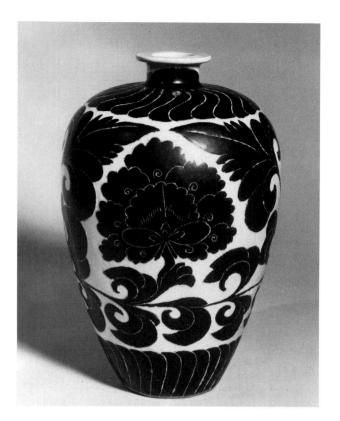

494. *Mei ping vase.* Cizhou stoneware with carved decoration; h. 12½" (31.8 cm). China. Northern Song or Jin dynasty. Asia Society, New York. Mr. and Mrs. John D. Rockefeller 3rd Collection

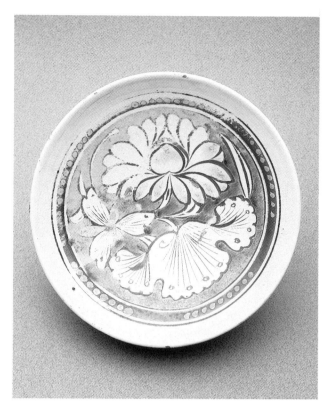

496. *Shallow bowl with lotus pattern.* Cizhou stoneware with decoration in red, yellow, and green overglaze painted enamel; diam. 6⅛" (15.6 cm). China. Jin dynasty, 13th century C.E. Art Institute of Chicago

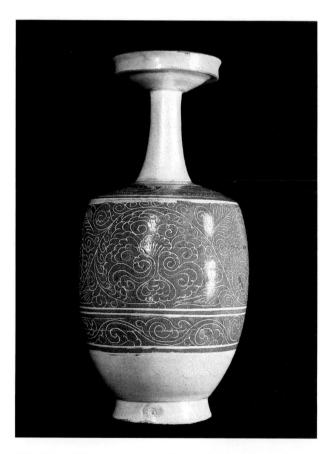

495. *Vase.* Cizhou stoneware with incised decoration; h. 16¼" (41.3 cm). China. Song dynasty. Cleveland Museum of Art

1204 C.E. until well into the Yuan dynasty, bears designs painted over the white slip and transparent glaze in red, yellow, and green enamels (*fig. 496*). These appear to have been made under Mongol or Tartar influence and, though they form but a small part of Song dynasty Cizhou ware, are of great importance as the origin of the enamel-decorated porcelains that took pride of place in the Ming and Qing periods. The enamel decoration represents a Chinese allowance for what might be considered Jürchen or Mongol taste: rich color and a rather gay and eye-filling effect quite unlike that desired by the Song court. It should be said in conclusion that Cizhou ware has been made from early Song times until the present day, and many of the pieces that were formerly considered to be of Song or Yuan date are now known as Ming or even Qing.

Ding Ware

Of the porcelains made in the north the most important was the ware called Ding, after the type-site near Dingzhou in Hebei Province in northeast China. Shards of the ware have been found in various parts of north China, and though production appears to have centered around Dingzhou, the ware may also have been made at kilns some distance from that site. In contrast to Cizhou ware it is, by Chinese definition, porcelain: a ware in which glaze coalesces with the body, and which, when struck with a hard instrument, produces a clear, resonant tone.

497. *Bowl.* Ding porcelain with incised design of ducks swimming amid waves and water reeds; diam. 7⁷/₈" (20 cm). China. Song dynasty. Museum of Fine Arts, Boston

499. *Bowl.* Ding porcelain with gold and lacquer decoration; diam. 6⁷/₈" (17.5 cm). China. Song dynasty. Tokyo National Museum

498. *Bowl.* Ding porcelain with molded design of scrolling peonies; diam. 10¹/₈" (25.7 cm). China. Song dynasty. Cleveland Museum of Art

Not all of it fulfills the traditional Western definition of porcelain, which requires translucency. But obviously almost anything can be made translucent if sliced thin enough; it is also possible to make a true industrial porcelain of the highest known vitreous substance, but too thick to be translucent. The Chinese test of resonance for porcelain is inconclusive only in that certain low-fired earthenwares containing a high proportion of chalk can also be resonant. In general, resonance is as good an indication as any that a piece sufficiently high-fired to fuse glaze with body is indeed porcelain. Ding ware, then, is porcelain. Its creamy white body is covered with a transparent, almost colorless glaze that occasionally runs down toward the foot, forming thick straw-colored drops called tearstains by Chinese connoisseurs (*fig. 497*). Bowls or dishes are the standard shapes, though some vases are known. The bowl illustrated is the finest known example of the common Ding decorative motif of ducks swimming amid water reeds and waves. The design is incised in the white paste of the porcelain, the waves indicated by comb marks. Delicacy and refinement combined with simplicity of shape make Ding wares particularly attractive to the modern Western connoisseur. Vessels are relatively thin-bodied and were usually fired upside down, which necessitated leaving the rim unglazed. After firing, the raw rims would be bound with a narrow strip of metal, usually copper, rarely silver, and even more rarely gold. Designs were molded as well as incised (*fig. 498*). The peony, as on Cizhou ware, was a favorite decorative motif.

In addition to the incised and molded white porcelains, Ding potters produced a rare brown- or black-glazed ware, called black or purple Ding by the Chinese (*fig. 499*). This was simply the usual white porcelain body covered with an iron-oxide glaze that ranged from cinnamon brown to a deep and lustrous black. These thin and resonant wares, of which a very few are decorated with painted or gold-stenciled designs applied with lacquer, are among the rarest of all Song ceramics. One other type of Ding ware, seen in a few vases and pillows, is decorated in iron oxide under the transparent glaze, usually with pe-

500. (left) *Truncated bottle vase.*
Ding porcelain with iron-
oxide design of peonies; h. 7¹/2"
(19.1 cm). China. Song dynasty.
Seikado Library, Tokyo

501. (below left) *Dish.* Northern
Celadon porcelaneous stone-
ware with carved design
of lotus and water lilies; diam.
7¹/4" (18.4 cm). China. Song
dynasty. Cleveland Museum
of Art

502. (below right) *Pillow.* North-
ern Celadon porcelaneous
stoneware with molded design
of *feng-huang*, peonies,
and flower-scrolls; l. 9¹/4"
(23.5 cm). China. Song dynasty.
Seikado Library, Tokyo

ony scrolls clearly related to Cizhou decor. In figure 500 we see a truncated bottle-vase from the Seikado Library, perhaps the most beautiful specimen of this technique known. It is differentiated from its Cizhou counterparts by its thinness, hardness, and resonance.

Northern Celadon

Cizhou and Ding wares form the largest proportion of northern ceramics, but there are also important colored wares. Northern Celadon, also called Yaozhou ware after a major kiln site northeast of Xi'an, is a gray-bodied porcelaneous stoneware, usually with a rather brilliant sea green or olive green glaze over designs that are bold and vigorous rather than delicate. These may be incised or

carved or, more rarely, molded or applied. It appears to have been made in the north in emulation of the southern Yue wares of the Tang and early Song dynasties, and to have used at first decorative motifs derived from contemporary Cizhou and Ding wares, especially the peony, or, as in figure 501, the water lily and lotus decoration most characteristic of Northern Celadon. Japanese attempts to identify it as Ru ware have proved abortive, and the best name for this ware, apparently not described in the ancient Chinese texts, is Northern Celadon, though the term Yaozhou ware is gaining favor. An extraordinary specimen is the porcelain pillow in the Seikado Library, decorated on the sides with peonies and on the top with peony scrolls surrounding a *feng-huang* in flight, recalling the decoration on southern Yue wares (*fig. 502*).

503. *Winepot.* Yaozhou porcelaneous stoneware; h. 7³/₈"
(18.7 cm). China. Northern Song dynasty. Cleveland
Museum of Art

A ewer earlier described as Dong ware, a ceramic
supposedly made for imperial use, seems most likely to be
a very early type of Yaozhou ware (*fig. 503*). Its shape and
decoration recall Tang silver; its color and leonine spout
echo the Yue ware of southern kilns.

Jun Ware

A second northern colored ware, related to Northern
Celadon, is called Jun ware. Although named for kilns in
the area once called Junzhou (present-day Yu Xian) in
Henan Province, it appears, like most Song ceramic types,
to have been made over a long period in various kilns
scattered over a considerable area. Jun ware has the same
gray to gray-tan stoneware body as Northern Celadon,
and although its glazes, predominantly blues, purples,
and mauves, look radically different from Northern
Celadon greens, chemical analysis reveals that they are
very close indeed. Both were fired in a reducing kiln, i.e.,
a kiln atmosphere of reduced oxygen, achieved by
decreasing the flow of air into the kiln. The difference
seems to have been produced by the addition of phospho-
rus from plant ash to the Jun ware glaze, and by extremely
slow cooling of the kiln. If the ware cooled too fast,
its desired glaze characteristics—soft, milky, opaque—
turned to glassy hardness. Jun ware was extremely popu-
lar with Western collectors after the initial discovery of
Song dynasty wares, from about 1910 to 1930, in part

because its brilliant color made it easier to appreciate for
lovers of Qing porcelains, especially the powder blues,
"ox-bloods," and "peach-blooms." In recent years Jun has
experienced something of an eclipse, but the vessels in
true ceramic shapes—those that do not imitate metal
prototypes—are now returning to favor. The covered jar
illlustrated (*cpl. 37, p. 338, top*) is one of the rare vessels
whose cover has been preserved. It illustrates the desider-
ata of the Jun glaze: opacity, milky texture, and color
ranging from soft powdery blue to deep purple, with
occasional flushes or splashes of mauve and, more rarely,
green, created by adding a bit of copper oxide to the glaze
and brushing or splashing it onto the vessel body. Other
Jun vessels show a brilliant, glassy glaze in brighter hues
of reddish and purplish as well as powdery blue, and
many of their shapes reflect metal prototypes. Though
Ming or even early Qing dates have been ascribed to cer-
tain of these, evidence from kiln sites has proved them to
be Song pieces. Many have a number between one and
ten incised on the bottom; these were apparently used as
flower containers (*cpl. 37, p. 338, center*). The illustration
shows a bulb planter in a typical combination of liver red
and blue. Its foliate rim and three scroll legs recall silver
shapes of the late Tang and early Song dynasties.

Ru: Imperial Ware of Northern Song

Chinese sources of the opening decades of the twelfth
century mention a Ru ware made exclusively for imperial
use; they also refer to "a new ware," resembling Korean
celadon, made in Ruzhou (present-day Linru Xian,
Henan Province). Kiln sites in Linru Xian, however, have
so far yielded only Yaozhou type wares, while remains of
Ru ware have been found only in Baofeng Xian, immedi-
ately to the south, where recent excavations have finally
discovered the Ru ware kilns. The new ware was probably
originated by potters familiar with the Jun and Northern
Celadon traditions. Some two decades of production
ended with the destruction of Northern Song in 1127 C.E.,
making Ru ware the rarest of all imperial wares. Although
undoubtedly some Ding and Jun wares were made for
imperial use and hence could be called Official (Guan),
the first eclectic ware—combining elements of Jun and
Northern Celadon—made for imperial use was Ru ware.
A testing disk now in the Percival David Foundation in
London bears an incised date equivalent to 1107 C.E. for
its first firing. One of the few known Ru pieces in the
United States is in the Cleveland Museum of Art (*cpl. 37,
p. 338, bottom*). It appears to be based upon the Jun style.
Its color is a unique and indefinable hue of soft, almost
robin's-egg blue. The shapes of the known Ru vessels are
very simple but refined, reflecting certain elements of
Tang shape, particularly in the concave roll of the foot.
But the most characteristic trait of Ru vessels is a very fine
and regular flaky crackle, peculiar to all examples of the

ware. Taken together, these traits create one of the most subtle wares ever produced under imperial patronage, and powerfully appealing to the senses of touch and sight. The one little black spot is identified in Chinese sources of the fourteenth century as one of the slight imperfections characteristic of genuine Ru ware, which even by the fifteenth century was being forged for the Chinese connoisseur. Even present-day auction prices pale beside the prices paid for Ru ware by Ming and Qing collectors; it was valued only somewhat less than fine jade.

Other imperial (Guan) wares, probably made at special kilns in the northern capital, are almost impossible to differentiate from imperial wares produced in the south after the capital was moved. The pieces we have chosen to discuss below as examples of southern Guan ware form a homogeneous group, although some of them may in fact have been made in the north before the fall of Northern Song. When the capital fell, the potters went with the fleeing court. We know, for example, that Ding potters reestablished themselves at Jizhou in Jiangxi Province, and there continued to produce wares almost indistinguishable from those they had made in the north. The court, however, was now located in the great center of green ware production, with the result that the greatest of the Guan wares were produced by the Southern Celadon potters.

Longquan Celadon Ware

The pervasive ware of the south is Longquan Celadon, after the many kiln sites in Longquan Xian in southern Zhejiang Province. Its ancestor was Yue wares made continuously in northern Zhejiang from the early Six Dynasties period, and the most highly prized of wares during the Tang dynasty. The finest of early Song Yue pieces is a bowl with carved dragon decoration in the Metropolitan Museum of Art (*fig. 504*). The gray-green glaze is a little thin and watery, showing some of the imperfections in the body. Nevertheless, the piece is dexterous and powerful. By the tenth century Yue ware was surrendering its primacy in the south to the products of the Longquan kilns, and with the arrival of the court at Hangzhou, and the changing taste of the Song dynasty, we witness the rapid development of Longquan and the waning of the Yue kilns.

Late Song Longquan Celadons and Guan wares must be understood and appreciated as responding to the characteristic taste of the court and the scholar-gentry, for whom jade was the most precious of all materials. At the heart of the great development of ceramics in south China during the Song dynasty is the desire to produce a ware resembling jade. In producing wares that evoked the unctuous look and feel of jade and its wonderful depth and range of colors, from rich greens through grays, browns, and brown-greens, the Yue kilns failed, and the Longquan kilns succeeded.

504. *Bowl.* Yue porcelaneous stoneware with carved dragon design; diam. 10⁵/8" (27 cm). China. Song dynasty. Metropolitan Museum of Art, New York

The typical Longquan ware can be seen in the pieces shown in colorplate 38 (*see p. 339*). It has a white to whitish gray porcelaneous stoneware body that burns to a sugary brown or even a reddish brown where exposed to the flame of the kiln. Its glaze color is a blue-green of great depth, and the thickness of the glaze covers any imperfections in the body. Longquan glazes are characteristically viscous and thick, with many tiny bubbles beneath the surfaces, and range in color from this blue-green to sea green, olive green, and a powder blue much like Jun blue. They produce a material that does indeed rival jade in appearance. It is from such Longquan wares that the great Guan wares developed.

The covered vase (*cpl. 38, p. 339, top*) offers a superb example of the classic sea green Longquan glaze, thick and filled with minute bubbles, giving an effect of semi-translucency and great depth. Characteristically, the glaze does not quite cover the foot rim, where the exposed body has burned a rich reddish tan in the kiln. Rounded horizontal ribs encircle the shoulder, suggesting the bodies of the two molded dragons applied as decoration. More slender vertical ribbing runs from the shoulder to the foot. A bird perched on the center of the lid serves as handle. The decoration is subtle and does not compete with the shape of the vessel. Such vases, which may derive their shape from earlier funerary urns, were by Song times luxury items for secular use.

505. *Vase in shape of cong.* Longquan Celadon porcelaneous stoneware; h. 7³/4" (19.7 cm). China. Song dynasty. Tokyo National Museum

506. *Kinuta vase.* Longquan Celadon porcelaneous stoneware; h. 10¹/8" (25.7 cm). China. Song dynasty. Freer Gallery of Art, Smithsonian Institution, Washington, D.C.

Rarer than the sea green glaze, and particularly unctuous, is the soft blue cloaking the archaistic *gui*-shaped incense burner (*cpl. 38, p. 339, bottom*). Enhancing the note of archaism are the two "bowstrings" encircling the body (a common decoration on ancient bronze *gui*). The handles vaguely recall the fish-shaped handles found on other Longquan shapes, especially the mallet-shaped (J: *kinuta*) vases so highly prized in Japan. A variety of archaistic, Bronze Age shapes was developed especially for the antiquarian taste of the court (*fig. 505*), with color and luminosity to rival jade.

All of these pieces are devoid of crackle, as the perfect Longquan pot usually is. Certain celadons, however, show an apparently accidental crackle, and experiments of the Longquan potters in the purposeful use of crackle were certainly the origin of the characteristic controlled crackle of Guan wares. The Longquan crackle can be seen in a Freer Gallery *kinuta* vase (*fig. 506*). The name, descriptive of shape, came to be applied to the blue-green color seen here, which the Japanese prize as the finest of all celadon hues. The fish handles are especially well modeled, and their size is beautifully proportioned to the neck and body of the vase. The square vase illustrated in figure 505, from the Tokyo National Museum, shows an apparently purposeful crackle, yet the glaze and the body seem to be of typical Longquan manufacture. It is a moot question whether this is a crackled Longquan vase or one of the early crackled Guan pieces derived from celadon. The shape again reveals the antiquarian interests of the court. It is a *cong*, the symbol of heaven and earth joined, often found among jades of the late Neolithic and early Bronze Ages.

Guan Ware

The technical and aesthetic culmination of the Song celadon tradition is found in the Guan wares made for the Imperial Household. The tradition of a special imperial ware goes back at least to the Ru ware produced for the northern court in the early twelfth century. Imperial taste combined antiquarianism with subtle sensuality, and imperial resources made almost anything possible. Guan ware is an even more exquisite simulation of jade than Longquan ware. Like jade, its high-fired celadon glaze varies in hue, from off-white to pale gray-buff and soft blues of a grayish or greenish tone. The wide, dark-stained crackle may have been developed to simulate the fissures and earth stains of jade. In contrast to Ru imperial ware, Guan bodies are dark, which tempers and softens the brilliance of the glaze, making it "lustrous as jade." Thinning the body and thickening the glaze heightened the new effect. Guan ware became a glaze suspended on the frail framework of the body.

Some idea of the rarity and desirability of such wares may be had from a tale told in later times:

507. *Bottle vase.* Guan porcelaneous stoneware; h. 6⅝"
(16.8 cm). China. Southern Song dynasty. Percival David
Foundation of Chinese Art, London

508. *Teabowl.* Jian porcelaneous stoneware; h. 2¾" (7 cm).
China. Song dynasty. Cleveland Museum of Art

Ts'ao Ch'iung of the Chia district of Hsiu, a man of
substance and a connoisseur, got hold of a censer
two inches and more in height and broad in pro-
portion; the cover consisting of a beautifully carved
piece of jade representing a vulture seizing a wild
swan—a really lovely piece.

News of it trickled through to the ears of the
local Governor Mo, a eunuch, who jailed Ch'iung
and demanded it by way of ransom; and Ch'iung's
son had no option but to hand it over. Later a cer-
tain powerful person in charge of the Board of Rites
seized it from Mo.

In the time of Cheng Te thieves stole it and sold
it in Wu-hsia where Chang Hsin-fu of Tienshan in
Shanghai acquired it for two hundred ounces of
gold. Chang took it home and resold it to an expert;
and the palace never recovered it. That was a gen-
uine old Ko piece.[23]

Two types of Guan ware are now clearly distinguish-
able. Type A (*fig. 507*) is possibly northern but definitely
more opaque in glaze and wider in crackle than type B.
Most of the shapes in this A type are simple and pure
ceramic types, notably the "gall-bladder" vase (*cpl. 39, p.
340, left*). The B type, including those wares ascribed to
the Phoenix Hill kiln within the palace grounds in
Hangzhou, is bluer in glaze color with a more grainy body
and often a smaller crackle pattern. It occurs both in
purely ceramic shapes and in archaistic imitations of
ancient bronzes, notably the incense burner in shape of an
archaic *gui* (*cpl. 39, p. 340, right*). Of a third Guan type,
the "Suburban Altar" wares from Hangzhou, part may
have been for court use, but most were probably made for
general use or as souvenirs for Altar pilgrims.

Readers may find occasional references to Ge (elder
brother) ware. This seems to be a term of later invention
and not applicable to true Song imperial wares.

Temmoku Wares

A quite different ware of humble origin was equally spe-
cialized and functionally successful. Jian ware, named for
the province of its manufacture, Fujian, is a heavy, dark
brown- and purple-bodied ceramic with a thick iron-
brown glaze. It was made only in teabowls, but these
achieved a functional truth equaled only by modern insu-
lation porcelains (*fig. 508*). The tea cult, sometimes asso-
ciated with Chan Buddhism in China, may well have been
the spur to the special development of Jian ware. Like the
spontaneous ink-painting style associated with many
Chan monk-painters, Jian ware was seemingly rough and
direct, but with subtle refinements. Tea should be hot; the
cupped hands holding the bowl should be no more than
pleasantly warm. Tea is green and needs, especially for
the residue, a dark brown background for full aesthetic
appreciation. The base of the bowl should feel quietly
rough to the palm of the hand; the lip of the bowl should
be shaped to prevent unseemly dripping. All of these
requirements were perfectly met by the Jian teabowl. Its
success led to imitation, both near at hand in the Jizhou
wares of Jiangxi (sometimes called Kian wares, after Ji'an,

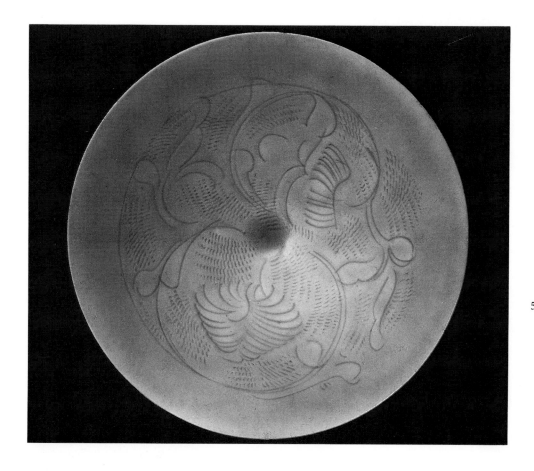

509. *Bowl.* Yingqing porcelaneous stoneware with incised floral scroll; diam. 5³/4" (14.6 cm). China. Song dynasty. Victoria and Albert Museum, London

the older name of the site) with their "tortoiseshell" exteriors, and in Henan Province in the north, where the white body of the teabowl was camouflaged to counterfeit Jian by the application of a dark brown or purple slip over the foot, where the dark glaze did not reach.

All these wares—Jian, Jizhou, and Henan—were termed Temmoku by the Japanese, after the Japanese pronunciation of Tianmu, a mountain in northern Zhejiang Province. Tradition has it that this was the site of a Buddhist temple often visited by Japanese monks, who discovered the bowls there and introduced them to Japan. Temmoku was much admired by Japanese tea masters of the Muromachi and later periods. The Seto kilns near Nagoya made excellent imitations for the Muromachi (*see pp. 445–48*) tea masters, the only difference being in the characteristic gray body of the Japanese bowls.

Yingqing Ware

Unloved in its own day—we have no contemporary Chinese name for the ware—the pale blue-white Yingqing ware (also called Qingbai), made in Jiangxi Province near the sites of the later imperial kilns of Jingdezhen, was of the utmost importance for the future of Chinese porcelain. Although its extreme thinness and the frail, sugary texture of its cream white body would seem to disqualify it as a traveler, Yingqing ware was a staple export. Shards and complete pieces were and are found in Korea, Japan, the Philippines, Indonesia, Southeast Asia, India, the Middle East, eastern Africa, and Egypt. The delicately incised floral and figural designs on Yingqing made for Chinese use recall those of Ding ware, but the paper-thin walls of these household vessels lend added delicacy to Yingqing decoration (*fig. 509*). Yingqing evolved into the Yuan dynasty imperial ware called Shufu, after the characters often found on the interior surfaces of the vessels. Shufu ware shows a whiter and heavier body, a thicker and more opaque pale blue-green glaze, and molded designs on the inside. With a clearer glaze and decoration in underglaze cobalt blue, Yingqing became the Blue-and-White of the Ming dynasty. All of its better-esteemed contemporaries—Ding, Ru, Jun, Longquan, Guan—were continued and imitated in declining quality. Ironically, it is from the two poor relations among Song ceramics that the porcelains of the Ming and Qing dynasties evolved, taking their painted and enameled decoration from Cizhou ware and their fragile, pure white body fabric from Yingqing.

KORYO

In Korea the Unified Silla kingdom had begun to disintegrate in the mid-ninth century C.E. By 936 the peninsula was reunited under a new dynasty and a new name, Koryo. Compared with contemporary China, Koryo was economically backward and rigidly aristocratic; Chinese observers noted the immense disparity between opulence at court (present-day Kaesong) and miserable poverty

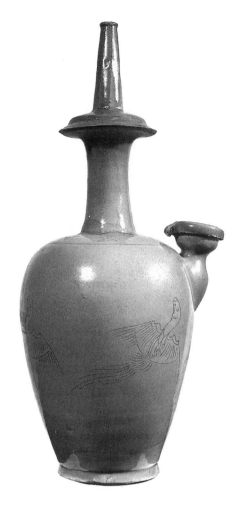

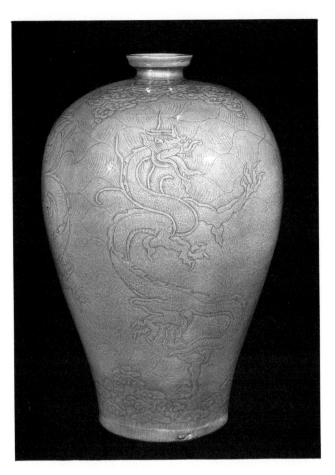

510. *Kundika (Buddhist holy-water ewer)*. Korean Celadon porcelaneous stoneware with incised design of birds; h. 14¼" (36.2 cm). Korea. Koryo period, 11th century C.E. Cleveland Museum of Art

511. *Maebyong vase*. Korean Celadon porcelaneous stoneware with incised design of dragons amid clouds; h. 13⅞" (35.2 cm). Korea. Koryo period. Museum of Fine Arts, Boston

elsewhere. In its political and cultural forms, however, Koryo modeled itself upon China: Kaesong was laid out like Tang dynasty Chang'an; a Chinese style bureaucracy administered the state; beginning in 958, would-be administrators sat for Chinese style civil service examinations whose content and viewpoint were strongly Confucian (though in fact the candidates were all aristocrats); Koryo's kings adopted posthumous titles like those of Chinese emperors (e.g., Korean T'aejo was Chinese Tai Zu); society was organized in kinship groups; from the court to the peasantry all classes were fervently Buddhist, and Buddhist monasteries were centers of art and scholarship; Buddhist painting and landscape painting followed Song styles, though little has survived; in celadon wares ceramics reached new heights of excellence.

Koryo endured repeated usurpations of the throne and (like Song China) attacks by the Liao and Jin states. Mongol assaults beginning in 1231 C.E. turned Koryo into a puppet state, which could not long survive the end of Mongol dominion in China. In 1392 General Yi Song-gye usurped the throne and gave his state the name bestowed by the Ming emperor of China: Choson.

Korean Celadons of the Koryo Dynasty

By the Koryo period the ceramic art of Korea was already well developed. Stoneware vessels and figures, unglazed or with ash-induced glazes, characterized the preceding Unified Silla period (*see fig. 96*), and such wares continued to be made, though in different shapes during Koryo. The ceramic masterpieces of the Koryo period, however, are celadon wares rivaling those of China. Indeed, the Chinese envoy Xu Jing in 1123 described a Korean celadon incense burner as follows:

A lion emits incense and is likewise "kingfisher colored"; the beast crouches on top supported by a lotus. This is the most distiguished of all their wares; the other resembles the old [*bi se*] of [Yuezhou] and the new kilns of [Ruzhou].[24]

Taiping Laoren (the studio name of another Song commentator) called Korean secret-color (*bi se*) ware "precious," and "first beneath Heaven."

Chinese use of the term *bi se* to describe Korean celadons is significant. *Bi se* ware was another name for

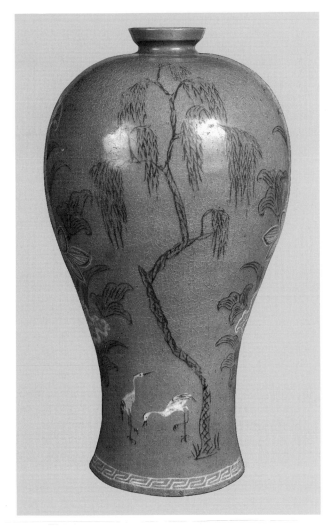

512. *Maebyong vase.* Korean Celadon porcelaneous stoneware with inlaid design of birds and trees; h. 13¹/2" (34.3 cm). Korea. Koryo period, late 11th–early 12th century C.E. Ashmolean Museum, Oxford. G. M. Gompertz Collection, England

Yue ware (*see fig. 504*), and there is little doubt that the initial impetus for Koryo celadons came from the Yue wares of northern Zhejiang, which were losing favor in China to the newer Northern Celadon and Longquan wares. Possibly Yue ware potters as well as their wares went from China to Korea and imparted their techniques and styles to Korean potters. The incised parrot decor of the early Koryo *kundika* (*fig. 510*) occurs often on Yue wares, and the superb dragon on the Koryo *maebyong* (*fig. 511*) is closely related to the dragon on the Yue bowl in figure 504.

The location of the vast majority of Koryo celadon kilns supports the conjecture that they were in contact with Yue potters and their wares. The Korean kilns are concentrated in Cholla Province, the southern tip of the peninsula and the part of the realm closest by sea to the port of Ningbo in northern Zhejiang, not far from the principal Yue ware kilns.

Most of the earlier Koryo celadons are plain or bear

513. *Covered ewer in shape of bamboo shoot.* Korean Celadon porcelaneous stoneware with incised decoration; h. 9¹/4" (23.5 cm). Korea. Koryo period, c. 1100 C.E. Museum of Oriental Ceramics, Osaka

incised or carved decoration under the glaze. After about the mid-twelfth century this Chinese style decor gave way to a mode of decoration invented in Korea: underglaze incised designs inlaid with black or white slip (*fig. 512*), an idea perhaps prompted by Cizhou decorative techniques (*see fig. 495*).

Some Korean shapes—such as plum vases (C: *mei ping*; K: *maebyong*)—are indentical to or closely derived from the Chinese; others are entirely original and inventive. The superb "bamboo shoot" ewer (*fig. 513*) is a shape unknown in China or medieval Japan. Decorated celadon-glazed architectural tiles were also made, to be used for the walls, floors, and roofs of extravagant aristocratic dwellings.

In the late twelfth and thirteenth century Korean celadons seem to have deteriorated, but the few surviving *maebyong* with white slip designs over black slip backgrounds are remarkably innovative (*fig. 514*).

The finest celadons are most distinctive. Their green glaze is rather thin but over the light gray body shows a very wet green to blue-green color of great apparent depth and translucency. Though smooth and glassy, the surface is never mechanical. Indeed, one of the most distinctive features of these wares is their informality. Some accidents of making and firing are cheerfully accepted, as if the potter welcomes signs of the making. In this regard Koryo celadons are quite different from the antique perfection of much Song production. Koryo celadons also make frequent use of pictorial decoration, which is

514. *Maebyong vase.* Black stoneware with incised floral scroll; h. 13¹/₂" (34.3 cm). Korea. Koryo period. Freer Gallery of Art, Smithsonian Institution, Washington, D.C.

515. *Ewer.* Korean Celadon porcelaneous stoneware with inlaid design of boys amid vine-scrolls; h. 7⁵/₈" (19.2 cm). Korea. Koryo period. Museum of Oriental Ceramics, Osaka

almost never found on Chinese Song celadons or imperial wares. The willow landscape of figure 512 and the boys amid flower-scrolls of figure 515 are unthinkable on a mainland celadon. These cheerful and nonchalant wares are among the greatest of East Asia's contributions to world ceramic history.

15

Japanese Art of the Kamakura Period

etween 1156 and 1185 C.E. Japan was convulsed with strife as the two major warrior clans, Taira and Minamoto, struggled for supremacy. A Taira triumph in 1160 brought only two decades of relative quiet. The civilian court aristocracy, including the once all-powerful Fujiwara clan, were apprehensive onlookers at this contest, retaining of their former power only a social ascendancy acknowledged even by the warriors. Even monastic communities became embroiled in the general disorders, sending frightening, if ill-trained, mobs of monks and lay adherents with fire and sword against each other or the court. A spirit of apocalypse was abroad, expressed in the Buddhist term *mappo*, "the end of the Law," a time of evil so great as to preclude Enlightenment. This dark mood is not surprising, since famines, plagues, and great fires accompanied war through the capital and the Home Provinces. Peace returned with the total defeat of all enemies of Minamoto no Yoritomo.

Minamoto triumph confirmed the advent of seven centuries of feudalism in Japan. The "onset" of Japanese feudalism in 1185 was neither sudden nor uniform. The courtly aristocrats and Buddhist temples of Heian Japan were absentee landlords of the provincial estates which provided their incomes. Absentee owners require resident managers, and these, mostly drawn from the provincial aristocracy, began to treat their posts as hereditary and to usurp their trusts. At the same time the central government, deprived of funds and manpower by both capital and provincial lords, began to abandon control of the provinces. By the ninth century estate managers were arming their retainers in order to police and protect the domains they administered. They were also banding together for mutual support, often under the leadership of one or another cadet branch of the capital houses (such as the Taira and Minamoto clans), who formed the major provincial aristocracy and offered protection in return for allegiance. As their power increased, provincial aristocrats encroached further on the economic privileges of the courtly aristocracy and on the governing authority of the central administration. No principle was at issue between the two clans, only a grimly rapacious winner-take-all intention toward the wealth and power passing from the civilian aristocracy into their hands.

This is the essence of feudalism, in Japan as in Europe: Economic and political power, as well as social eminence, are united in the holders of military power; military power is based on land tenure granted in return for allegiance, a reciprocity which forms the sinews of society; between the armed and mounted knights and the

516. *Priest Chogen.* Wood; h. 32¼" (82 cm). Shunjo-do of Todai-ji, Nara, Japan. Kamakura period

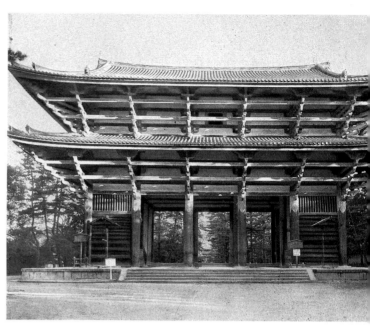

517. *Great South Gate of Todai-ji.* Nara, Japan. Dated to 1199 C.E.

rest of society the disparity in power is vast; physical courage and loyalty to overlords and comrades-in-arms are pre-eminent social values. In certain respects Japanese feudalism differs from European: The imperial institution and its civil administration, however weakened, were never eliminated or wholly shorn of prestige; learning and the arts did not suffer but were preserved by the courtly aristocracy and the Buddhist church and were increasingly cultivated by the warriors.

In 1192 the emperor granted Yoritomo the title of shogun, giving Yoritomo, his allies, and his retainers official status as the military arm (*bakufu,* or "tent government") of the imperial court. When the Minamoto line failed in 1219, the Hojo clan assumed power as shogunal regents. From 1185 to 1333 C.E. *bakufu* headquarters were in Kamakura (south of present-day Tokyo), whence the period derives its name.

THE NARA REVIVAL

The Taira-Minamoto conflict, called the Gempei War (1180–1185 C.E.), ended in the rout and virtual annihilation of the once paramount Taira clan. Even the Buddhist establishment had become enmeshed in the deadly rivalry, and in the twelfth month of 1180 a Taira cavalry squadron set fire to the great Nara temples Kofuku-ji and Todai-ji (*see fig. 224*), whose monks were perceived as Minamoto sympathizers. Todai-ji's Shoso-in treasure house and Sangatsu-do, with its Nara period sculptures, fortunately

escaped destruction, but Kofuku-ji was leveled and many of its artistic treasures destroyed. This act of combined sacrilege and barbarity, which epitomizes the viciousness of the war, greatly discredited the Taira and provided Minamoto no Yoritomo (1147–1199 C.E.; *see fig. 532*), leader of the rude, provincial "eastern warriors," with an opportunity to improve his public image. Within a month, almost before the ashes had cooled and well before the Minamoto triumph, Yoritomo called for the restoration of the temples. Kofuku-ji being the Fujiwara clan temple, the court and the Fujiwara clan depleted their resources in its rebuilding. For the rebuilding of Todai-ji Yoritomo immediately authorized public fund-raising, and in 1185, newly victorious and de facto ruler of Japan from his home base at Kamakura, he contributed materially. Most likely this act helped legitimate his unprecedented regime, smoothing his progress from imperially proclaimed rebel in 1180 to imperially designated shogun (*Sei-i Tai Shogun,* "Barbarian-Subduing Generalissimo") in 1192.

Architecture

To raise the funds and supervise the reconstruction of Todai-ji, a remarkable Buddhist priest, Shunjobo Chogen (1121–1206 C.E.; *fig. 516*), was appointed. Chogen had visited China at least once (he claimed three visits), and from southeast coastal China he introduced a Southern Song architecture, misleadingly dubbed "Indian style" (*tenjiku yo*) by the Japanese. The Great Buddha Hall (Daibutsu-den) was rebuilt in this style, and also the

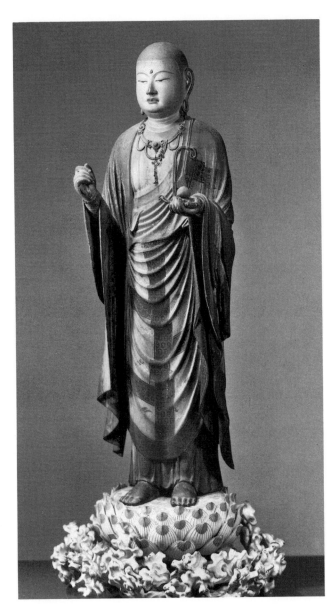

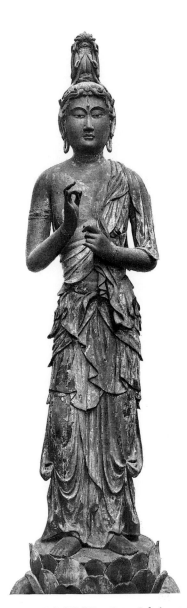

518. *Jizo Bosatsu.* By Kaikei (act. 1185–1223 C.E.). Dated between 1203 and c. 1210 C.E. Painted wood with cut-gold leaf; h. 35³/8" (89.8 cm). Kokei-do of Todai-ji, Nara, Japan. Kamakura period

519. *Sho Kannon.* By Jokei II (Higo Betto Jokei; act. 1224–1256 C.E.). Dated to 1226 C.E. Wood; h. 68¹/2" (174 cm). Kurama-dera, Kyoto, Japan. Kamakura period

Great South Gate (Nandai Mon; *fig. 517*), which was completed in 1199 C.E.

The gate structure is logical and simple, straightforward and heavy rather than aristocratic and elegant. Its pillars are over sixty feet high; those of Chogen's Great Buddha Hall (burned again during civil war in 1567) were over ninety feet. Each is a single huge timber, and these were transported over sea and land, with awesome labor, from present-day Yamaguchi Prefecture in far western Honshu. The eaves extend more than sixteen feet, supported on enormous nine-tier bracket sets whose simple one-sided projection, together with the lateral run of the purlins, produces an almost crude effect, far from the refined Heian style and expressing something of the ungloved power and pragmatism of the new military rulers. Despite its structural and visual strength, *tenjiku yo* was shortlived.

Sculpture

We know that Chogen employed Chinese artisans, among them the shipwright and bronze founder Chen Heqing and his assistants, who came from the Ningbo area and would have been acquainted with the new architectural style. They were engaged specifically to recast the bronze head of the Great Buddha (*Daibutsu*). The two stone lions now at the back of the Great South Gate were also carved by Song Chinese artisans; these, originally made in 1196 for the Inner Gate (Chu Mon), show a rather blocky handling of the traditional Chinese guardian lion type, little related to the more supple and dramatic Japanese renditions of the motif. Although Song influences may be found in some Kamakura sculptures (*figs. 518, 519*), early Kamakura sculptural style is primarily a reinterpretation of Nara period sculptural style (which shows strong Tang

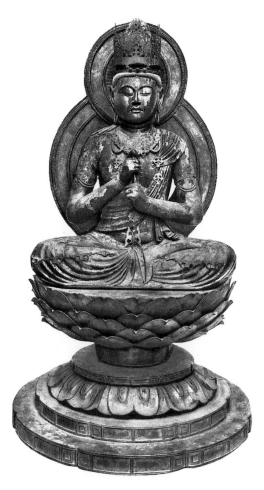

520. *Dainichi Nyorai.* By Unkei (d. 1223 C.E.). Dated to 1175 C.E. Lacquered wood; h. 39¹/4" (99.7 cm). Enjo-ji, Nara, Japan. Late Fujiwara period

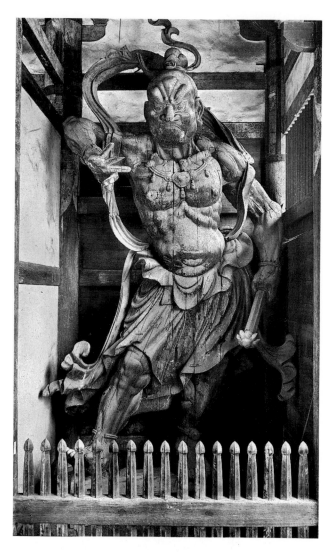

521. *Kongo Rikishi (Guardian).* Dated to 1203 C.E. By Unkei (d. 1223 C.E.), Tankei (1173–1256 C.E.), and Jokaku (act. 12th–13th century C.E.). Wood; h. 27'6" (8.42 m). Great South Gate of Todai-ji, Nara, Japan. Kamakura period

influence) by the creative sculptors of the Kei school. Like Kaikei's *Jizo,* the *Sho Kannon* of Jokei II displays some Song influence, primarily in its drapery and hair style, but its quality of "loveliness" is distinctively Japanese. Of the Kei sculptors, Unkei (d. 1223 C.E.) and Kaikei (act. 1185–1223 C.E.) were the most gifted.

The Kei artists claimed stylistic descent from the great Jocho, sculptor of the Byodo-in's *Amida* ensemble of 1053 C.E. (*see fig. 437*). Late in the eleventh century a disciple of Jocho left Kyoto and established himself in Nara, and competition between the monk-sculptors (*busshi*) of the two cities became keen. With the close of the Gempei War in 1185, sculptors were in demand both in the imperial capital, Kyoto, and in Minamoto headquarters in Kamakura, now become the new military capital. While his father, Kokei (act. 1175–1200 C.E.), and colleague Kaikei remained in Nara working on Kofuku-ji, Unkei went east to Kamakura, there to execute numerous commissions for Minamoto and allied lords and to establish his reputation as a master sculptor with a new and powerful style. In the *Dainichi Nyorai* carved a decade earlier for the Nara temple of Enjo-ji (*fig. 520*), he had imbued a traditional Late Heian style rendering with robustly erect posture, taut

contours and silhouette, and a vivid expression enhanced by inlaid painted crystal eyes.

Chogen, when he took charge of the restoration of Todai-ji, knew the Kei school sculptors and trusted them to create the necessary quality and quantity of icons. By the early 1190s Unkei was at Todai-ji, working with the other Kei sculptors under Chogen's supervision. Of the many images on which they collaborated, only the pair of heroic-sized *Guardian Kings* (*Nio, Shukongojin,* or *Kongo Rikishi*) that stand facing each other in the bays of the Great South Gate survive (*fig. 521*). Despite their great height, the complexity of their joined woodblock construction (*yosegi-zukuri*), and the intricacy of their swirling draperies and scarves, both images were completed in about two months—attesting the high priority ascribed to this work. Unkei and Kaikei were chiefly responsible for the open-mouthed figure, while Unkei's son and brother, Tankei and Jokaku, were the principal sculptors of the

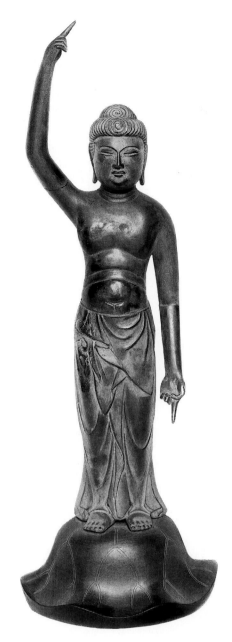

522. *Youthful Shaka (Shakyamuni).* Gilt bronze; h. approx. 12"
(30.5 cm). Kofuku-ji, Nara, Japan. Kamakura period, 13th
century C.E.

guardian with mouth grimly shut (*fig. 521*).

The two *Nio* clearly reveal the influence of the
famous Nara period *Shukongojin,* the clay guardian fig-
ure now housed in the Sangatsu-do (*see cpl. 13, p. 204*).
Conscious revival of Nara period style, occurring in tan-
dem with the restoration of the ruined temples, is a sig-
nificant element in early Kamakura sculpture. The
bronze *Youthful Shaka* in Kofuku-ji (*fig. 522*), for exam-
ple, shows a Nara period image type almost never seen in
Heian period images, albeit softened in the manner of
Kaikei's mature work (*see fig. 518*).

The famous *Daibutsu* of Kamakura (*fig. 523*) did not
replace an icon destroyed by war but was cast in emula-
tion of the Nara *Daibutsu* at Todai-ji. Its monumentality
demonstrates the power of its patrons. Its style reflects the

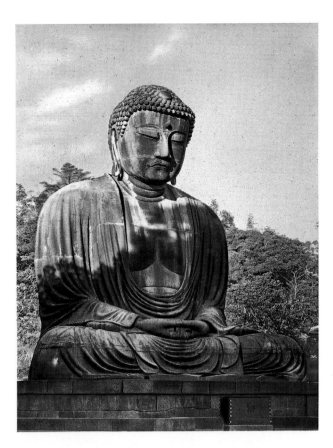

523. *Great Amida Buddha (Daibutsu).* Bronze; h. 37'4"
(11.4 m). Kotoku-in, Kamakura, Japan. Kamakura period,
1253 C.E.

realist emphasis of the Nara revival as expressed not by
Unkei but by Kaikei, whose images are characterized by a
more "idealized realism" that emanates sweetness, benig-
nity, and grace rather than strength.

Nara sculpture, closely and sympathetically studied,
may have provided the initial impetus for the Unkei style.
But the full fruition of that style, requiring brilliant tech-
nical virtuosity, merged newly realistic form with an
astonishing suggestion of natural, even abandoned,
movement. Comparing the *Twelve Generals of Yakushi* at
Muro-ji (*fig. 524*) with the monumental, impassive Jogan
images behind them points up the volatile swirls of drap-
ery and exaggerated facial expressions of the generals. At
the same time wood had become the most popular sculp-
ture medium. Wooden images in the developed Kama-
kura style—whether of violently agitated guardian (*see fig.
521*) or still, contemplative priest (*see fig. 516*)—tend to
show the volume of the wood penetrated by space. The
tree trunk is no longer sacrosanct; its shape no longer
imposes a quality of stillness on the image. Instead it is
deeply carved and pierced, creating a vigorous articula-
tion that expresses the propensity to action and violence
in the new military society. Jokei's *Kongo Rikishi* (*figs. 525,
526*) displays keen interest in the convincing depiction of
the half-nude body in a posture of potential or arrested
violent action. Although the anatomy is based on obser-

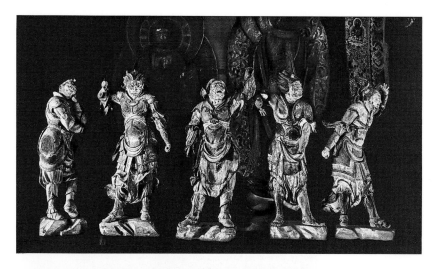

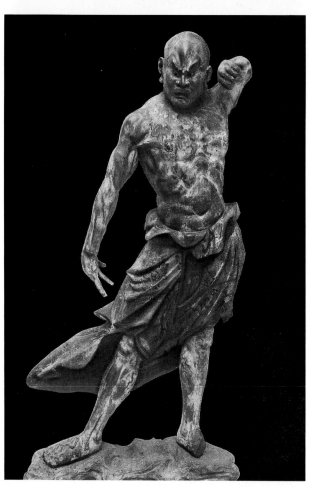

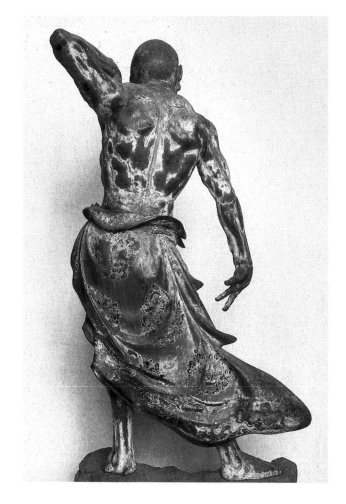

524. (left) *Five of the Twelve Generals of Yakushi.* Wood; h. approx. 48" (121 cm). Muro-ji, Nara Prefecture, Japan. Kamakura period, 13th century C.E.

525. (below left) *Kongo Rikishi (Guardian).* Attrib. Jokei I (Dai Busshi Jokei; act. 1184–1212 C.E.). Painted wood; h. 64" (162.6 cm). Kofuku-ji, Nara, Japan. Kamakura period, c. 1210 C.E.

526. (below right) *Kongo Rikishi.* Back view of fig. 525

vation and appears plausible, it is inaccurate in Western Renaissance terms, and it contains an element of exaggeration, even caricature, characteristic of Kamakura and later realist efforts.

A new device to enhance sculptural realism, invented by the Japanese probably in the first half of the twelfth century, is called *gyokugan*. These are quartz crystal inserts, painted with the pupil and iris of the eye, then inserted from the back into the carved eye orbits of hollow joined woodblock images. At the corners of the eyes the crystal may be touched with red, green, or blue, and

the iris is sometimes ringed with cut-gold leaf (*kirikane*). To simulate the whites of the eyes, the crystal is backed with cotton (more rarely, paper), held in place by a splint of wood fastened with bamboo nails or lacquer paste. The earliest extant dated images to employ this technique are the Amida triad at Chogaku-ji, Tenri City, dated to 1151 C.E. Unkei's *Dainichi* (*see fig. 520*) and his *Seshin* and *Muchaku* of 1208–1212 C.E. (*figs. 527, 528*), Jokei's *Kongo Rikishi* (*see figs. 525, 526*), Koben's *Lamp Bearers* of 1215 C.E. (*fig. 529*), and almost all subsequent Kamakura sculpture make good use of this Japanese invention. *Gyokugan*

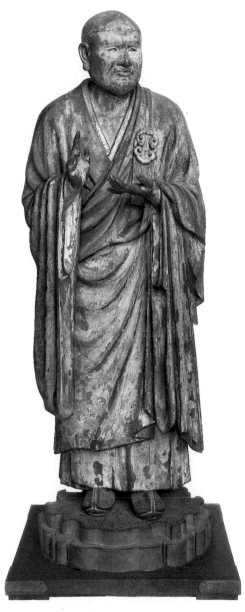

527. *Priest Seshin.* By Unkei (d. 1223 C.E.). Dated to 1212 C.E. Painted wood; h. 6'2¾" (1.88 m). Hokuen-do of Kofuku-ji, Nara, Japan. Kamakura period

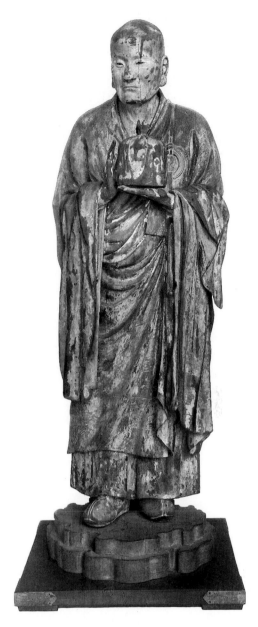

528. *Priest Muchaku.* By Unkei (d. 1223 C.E.). Dated to 1212 C.E. Painted wood; h. 6'2¾" (1.88 m). Hokuen-do of Kofuku-ji, Nara, Japan. Kamakura period

serves not only to enhance the animation of the images but also to epitomize the Kamakura period artists' primary interest in realism and the sharp difference this created between their work and that of their predecessors. By contrast with Unkei's monumental standing images of Seshin and Muchaku, with their strongly individualized faces and firmly carved robes, even the Nara period dry lacquer figures of the Buddha's Ten Disciples (also at Kofuku-ji) seem dessicated.

The Kei school artists' zest for innovation is nowhere more amusingly seen than in Koben's two diminutive demon *Lamp Bearers* (*see fig. 529*). In addition to the enlivening features generally characteristic of Kamakura sculpture, the companion to the *Lamp Bearer* shown here has jagged eyebrows of cut sheet copper, an invention

worthy of any modern artist. At midcentury the realist impulse shows no signs of flagging: In the terrifying *Bato Kannon* (Horse-headed Kannon) of 1241 at Joruri-ji (*fig. 530*) powerful realism verges on the grotesque.

The Kamakura artists' enthusiasm for direct observation and recording of reality was particularly applicable to portraiture. In pose the sculptured portrait of Priest Chogen (*see fig. 516*) hardly differs from the late eighth century image of Priest Ganjin (*see fig. 237*), but its penetrating revelation of character through relentless realism of detail is specific to the Kamakura period. Sunken cheeks, puffy eyes, and gaunt neck testify to the ravages of age, but the tight-clamped lips, the deep furrows between nose and mouth, the forward thrust of the head, and the large, still powerful hands all convey tenacity and experi-

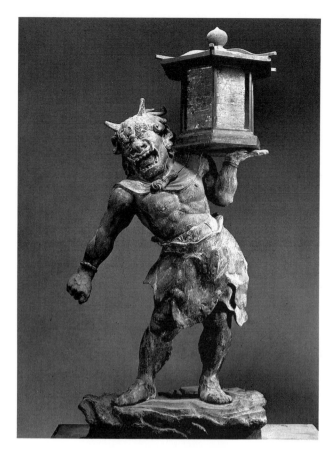

529. *Lamp bearer* (one of two). By Koben (act. late 12th–early 13th century C.E.). Dated to 1215 C.E. Painted wood; h. 30 5/8" (77.8 cm). Kofuku-ji, Nara, Japan. Kamakura period

ence worthy of Chogen's recorded accomplishments.

Secular portraiture, though rare, was also a fitting vehicle for the new realism. Uesugi Shigefusa (*fig. 531*), who came to Kamakura in 1252, was a trusted adviser to the *bakufu*. He is portrayed by a local sculptor wearing the formal costume of a Kamakura warrior-aristocrat, with the differing textures of his skin, cloak and trousers, and court hat carefully contrasted. His face is highly individualized—stern and impassive but of a sculptural fullness congruent with the bulky clothing. This realism of feature and expression was made possible (as Langdon Warner pointed out) by a new refinement of wood-carving technique: the head is not only carved separately from the body but is split vertically before carving (*warihagi*) into two unequal pieces, the larger for the back of the head, the smaller for the "mask" of the face. The "mask" could be held in the hand and chiselled or shaved from any angle, like the masks worn in the ritual dance-dramas performed in temples and at the imperial court (*see fig. 540*).

Painting

Painted portraits also reveal the new realism, though to a lesser degree due to the strong hold of the past on court artists accustomed to the *onna-e* mode of painting. At Jingo-ji in Kyoto are three portraits of outstanding historical and aesthetic importance, traditionally but loosely

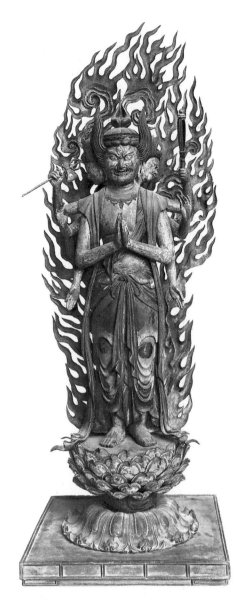

530. *Bato Kannon (Horse-headed Kannon)*. Dated to 1241 C.E. Wood; h. 41 3/4" (106.3 cm). Joruri-ji, Nara, Japan. Kamakura period

associated with the famous court master Fujiwara no Takanobu (1142–1205 C.E.). One subject is Yoritomo himself (*fig. 532*), formally dressed as a Heian courtier rather than a Kamakura warrior-aristocrat. The opaque black and color of the opulently detailed costume and the strong geometric pattern that it creates recall the world of *onna-e*. But the *onna-e* face, plump, scant of feature, undifferentiated, and expressionless, is here replaced by a hard, calculating, ruthless visage, unmistakable and unforgettable. The other portraits of the set depict Taira no Shigemori and Fujiwara no Mitsuyoshi, suggesting that these scrolls were perhaps intended to record the protagonists of the Taira-Minamoto struggle. Retired Emperor Go-Shirakawa, likewise a participant in the intrigues of those times, is shown in monastic garb (*fig. 533*) in a painting trimmed at the sides but close in height to the three at Jingo-ji. His portrait, however, derives not from the *onna-e* tradition but from the Buddhist patriarch portraits of the Early Heian period (*see fig. 428*).

531. (right) *Uesugi Shigefusa.* Wood; h. 26⅞" (68.2 cm). Meigetsu-in, Kamakura, Japan. Kamakura period

532. (below left) *Minamoto no Yoritomo.* Attrib. Fujiwara Takanobu (1142–1205 C.E.). Hanging scroll; ink and color on silk; h. 54⅞" (139.4 cm). Jingo-ji, Kyoto, Japan. Kamakura period

533. (below right) *Retired Emperor Go-Shirakawa.* Hanging scroll; ink and color on silk; h. 52" (132.1 cm). Myoho-in, Kyoto, Japan. Kamakura period, c. 1200 C.E.

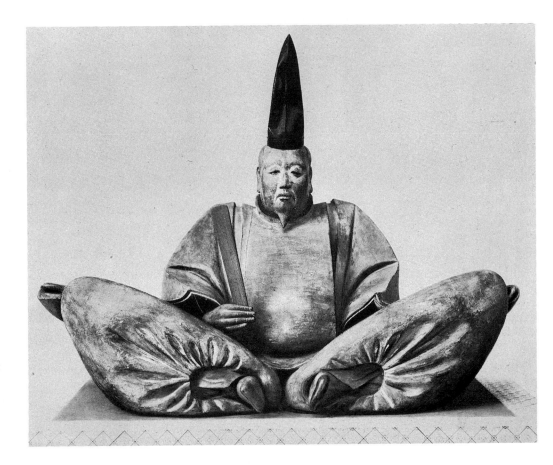

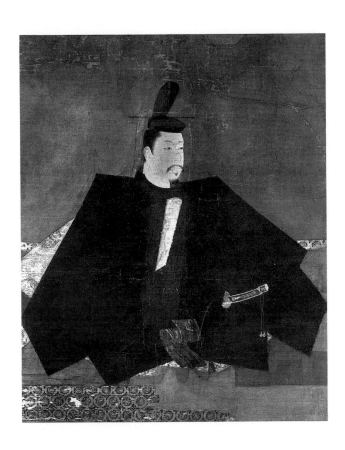

534. *Illustrated Sutra of Cause and Effect (Kako Genzai E-inga Kyo).* By Keinin. Dated to 1254 C.E. Section of the handscroll; ink on paper; h. 11" (27.9 cm), l. 37¼" (94.6 cm). Japan. Kamakura period. Nezu Museum of Art, Tokyo

535. *Swift raigo.* Gold and color on silk; h. 57" (144.8 cm). Chion-in, Kyoto, Japan. Kamakura period, early 13th century C.E.

Only the realism still perceptible in the damaged face and the screen painting behind the emperor, showing a composition of birds, flowers, and rocks, signal a late twelfth or early thirteenth century date—the screen by its indebtedness to Song Chinese "fur and feathers" painting, and the features by their coolly observed particularity.

Buddhist painting likewise reflects the "Nara revival," showing in some works greatly increased movement of the figures and the brush. The Sutra of Cause and Effect (J: *Kako Genzai Inga Kyo*), which recounts the life of the historical Buddha, was intensely popular during the Nara period and was often reproduced in illustrated handscrolls with pictures above following the text below—a format unique to this scripture in Japan. Beginning in the ninth

century Esoteric and Pure Land Buddhism displaced the worship of Shaka, and the *Inga Kyo* fell into disuse. Shaka worship revived during the Kamakura period, generating new illustrated handscrolls of the sutra. Some of these are virtual copies of the eighth century version now in Daigo-ji (*see cpl. 16, p. 207*); others show a rollicking, youthful fluency (*fig. 534*), much like the narrative scrolls of Late Heian and early Kamakura (*see figs. 454–56*).

Conservative Kamakura artists continued the idioms of Late Heian, but with some tempering. Esoteric Buddhist icons continued to be made, superbly for the imperial capital and only somewhat less so for the provinces. The splendidly preserved *Dainichi Nyorai* (*cpl. 40, p. 341*) in Daigo-ji is somewhat firmer and more

536. *Hondo of Kanshin-ji.* Osaka Prefecture, Japan. Kamakura period, 14th century C.E.

dynamic in configuration and pose than its Late Heian predecessors, and the pattern in its drapery is rendered for the most part in paint rather than in the cut-gold leaf (*kirikane*) customary in earlier times.

Until the rise of Amidism (Jodo, or Pure Land school) Japanese Buddhism was primarily a religion of the aristocracy and the intelligentsia. Amidism first emerged in the tenth century not as a separate sect but as a shift of emphasis within Tendai Buddhism, a shift away from Tendai's extensive pantheon, complex metaphysics, and elaborate rituals toward a focused belief in the saving power of Amida and in the Pure Land as a life-after-death paradise awaiting anyone who repeatedly and with perfect faith invoked Amida's divine compassion. Such a consoling doctrine was within the comprehension of the simplest layman, and it was energetically propagated among the common people by a series of charismatic evangelists whose preaching encouraged emotionally fervent and often communal expressions of devotion to Amida. The times were increasingly propitious to such a teaching, particularly as civil disorder, bloodshed, and corruption escalated during the twelfth century, generating profound and pervasive anxiety. By 1175 C.E. Jodo had emerged as a distinct sect with a powerful appeal among all classes.

To reach unsophisticated viewers, Amidist art had to be intellectually unassuming and emotionally compelling. The unique icon of Amidism is the *raigo*, Amida's "welcoming approach" to escort the soul of the dying believer to the Pure Land. *Raigo* images first appear during the Late Heian period, with the deities generally depicted frontally, seated in majesty. Their essential quality of accessibility is heightened by realistic and vivid depiction, which probably explains the appearance of the *Yamagoshi Amida,* the "mountain-crossing Amida," who appears, accompanied by the bodhisattvas Kannon and Seishi, over lovingly detailed mountain landscapes.

But the most vividly immediate *raigo* type is the *haya raigo,* or "swift *raigo*": Amida, accompanied by a heavenly retinue (often twenty-five in number, following Priest Genshin's description in the *Ojo Yoshu*), borne to earth on a trail of clouds. The earlier *raigo,* frontally and rather symmetrically posed, are iconic, but these increasingly give way to *scenes* in which the divinities descend toward the dying person along the diagonal, the speed of their passage indicated by swirling clouds, their proximity to earth suggested by the flowering landscape over which they pass (*fig. 535*). At lower right is the house of the dying person, with a monk in attendance reading aloud from the sutra scrolls ranged on the table before him. The vision is conceived from the point of view of a spectator. Even frontally posed swift *raigo* might offer a sense of connection: As at Konkaikomyo-ji in Kyoto, real silk threads would be run from the hands of the Amida image to those of the devotee, who could thereby be pulled up to the Western Paradise.

TRADITIONAL ARTS

Traditional Architecture

Traditional architecture—i.e., neither the "Indian" style associated with the rebuilt Todai-ji (*see fig. 517*) nor the Chinese Chan style that begins to appear in the late thirteenth century (*see fig. 573*)—becomes increasingly patterned and decorative. The main hall (*hondo*) of Kanshin-ji (*fig. 536*), dating from the very end of the Kamakura period (1334–1335 C.E.), best exemplifies that nonfunctional multiplication of interpillar bracketing which eventually trivialized the simple and monumental temple architecture of early Japan.

Traditional Painting

Onna-e painting and *maki-e* lacquerware continued to reflect the activities and ambience of courtly life in its golden age, and to illustrate tales popular with courtly audiences, though patronage had diminished since the Heian period. Exceedingly popular were imaginary portraits of the Thirty-six Immortal Poets (*Sanjurokkasen-e*), a canonical list of master poets compiled early in the eleventh century. Poetry was a vital element of Heian period courtly life and poetic ability was virtually indispensable to a court career. "Portraits" of the thirty-six, generally accompanied by one or more of their verses, offer a felicitous mingling of highly stylized visual art with equally stylized poetry (*fig. 537*). Probably these began to appear during the twelfth century (the earliest on record dates from 1170 C.E.), and the popularity of the genre peaked during the Kamakura period. These Kamakura period Immortal Poet portraits (*kasen-e*) are redolent of nostalgia: The courtier-poets in their stiffly starched robes, the court poetesses almost invisible beneath layered silks and streaming cataracts of raven hair, all hark back to the exquisite, ceremonious world of Prince Genji. Even Yoritomo's portrait (*see fig. 532*) cloaks his body in courtly formality and visual stylization, though unable to formalize the cruel reality of his visage.

537. *Portrait of the poetess Saigu no Nyogo Yoshiko, from a set of Thirty-six Immortal Poets.* Attrib. Fujiwara Nobuzane (1176–c. 1265 C.E.). Originally a section of a handscroll; ink and color on paper; h. 11" (27.9 cm). Japan. Kamakura period. Freer Gallery of Art, Smithsonian Institution, Washington, D.C.

Landscape continued to be depicted in the *yamato-e* manner, whose origin in the Late Heian period is exemplified by the painted doors of the Byodo-in's Phoenix Hall and by the six-fold screen at To-ji (*see fig. 444*). Such pictorial celebrations of the "loveliness" of Japan's rolling, flowering countryside are particularly apt in depictions of the shrines and rituals of Shinto, whose essence is reverence toward the numinous forces (*kami*) dwelling in illustrious persons and striking natural entities—trees, rocks, waterfalls, valleys, groves, mountains. Since the spiritual power of the *kami* devolved on the emperors, Shinto icons were a close concern of the imperial court, and naturally they reflect the artistic mediums and styles favored in courtly circles.

Buddhist influence on Shinto gave rise to image-icons—sculptures and paintings of personified *kami* (*see fig. 420*) and deified rulers and culture heroes. But beginning in the Kamakura period, paintings of shrine environs become the most common Shinto icons. Buddhist influence is apparent in these landscape-icons as well. De facto accommodation between Shinto and Buddhism was underway during the Nara period, when Buddhist temples were erected by permission of the local *kami.* By the eleventh century most Buddhist temples had a tutelary Shinto shrine on their premises, and Shinto *kami* were being identified as local manifestations of the universal divinities of Tendai and Shingon Buddhism. This systematic syncretism is termed *honji suijaku* (original ground, manifest trace) in Buddhist doctrine and *Ryobu Shinto* (two sides) in Shinto. Shrine priests, patrons, and pilgrims commissioned "map-views" of the sacred precincts, many showing Buddhist deities in small scale as if floating above the site. These strange yet moving combinations of flowering landscape, native Shinto architecture, and miniature haloed Buddhist images are at once a mandala of the Buddhist-Shinto relationship and a portrait of the shrine.

Even more complex than most such works is the *Kumano Mandala* (*fig. 538*), which depicts the three relat-ed Shinto shrines of the Kumano region, at the southeastern tip of the Kii peninsula (Wakayama and southern Nara prefectures). In this schematic rendering we see at the top Kumano Nachi Shrine, comprising the sacred Nachi waterfall and its adjacent Hiryu Gongen Shrine compound; in the center is the Hayatama Shrine, called the New Shrine (Shingu), located at the mouth of the Kumano River (in Nara Prefecture); at the bottom is the Nimasu Shrine, called the Original Shrine (Hongu), in the mountains on the upper reaches of the Kumano River (in Wakayama Prefecture). The three similar, isometrically projected shrine complexes are set in a *yamato-e* spring landscape of blue and green, with flowering trees below and cypress-clad mountains above. Traversing the picture from bottom to top simulates the actual pilgrimage route of devotees coming overland from Kyoto: from the Hongu high in the mountains to the Shingu at the coast and finally to Nachi, not far from the Shingu. (Artistic license has set Nachi rather than the Hongu among the high peaks.) Passing the first gate into the Hongu, one sees a vision of Blue Fudo; beyond the *torii* (sacred gate) leading to Kumano Nachi Shrine is an apparition of the wonder-working mountain priest En no Gyoja (d. 701 C.E.?) with his two small supernatural attendants. At far upper right is Nachi Waterfall, some 430 feet high, its adopted Buddhist deity at its base. In its complexity and intuitive balance between Shinto and Buddhism, architecture and landscape, real and unreal, the *Kumano Mandala* resembles numerous other shrine-mandalas of the Kamakura period.

Probably the most extraordinary of these landscape-mandalas is *Nachi Waterfall* (*fig. 539*), which is sometimes mistaken for a "pure" landscape. At the very bottom of the scroll, which may have been somewhat cut down, close observation reveals the red-brown roof of the shrine of Hiryu Gongen, the *kami* of Nachi Falls. The waterfall dominates the picture surface, falling onto great rocks among giant cryptomeria. At top right a large golden sun disk disappears into a rock-bordered pool. This wonder-

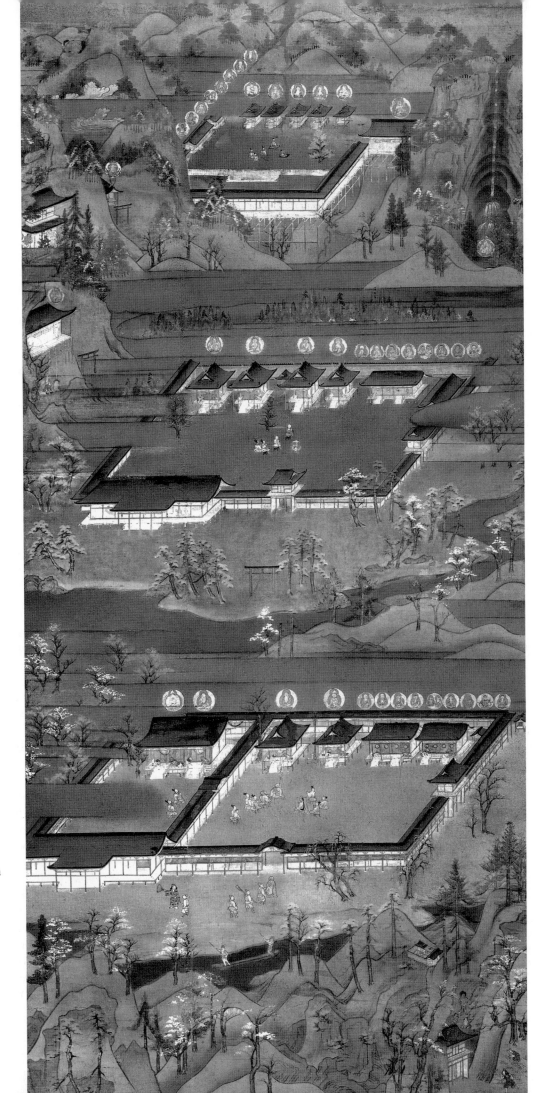

538. *Kumano Mandala.*
Hanging scroll;
color on silk;
h. 52³/4" (134 cm).
Japan. Kamakura
period, c. 1300 C.E.
Cleveland Museum
of Art

539. *Nachi Waterfall.* Hanging scroll; ink and color on silk; h. 63" (160 cm). Japan. Late Kamakura period. Nezu Art Museum, Tokyo

ful fusion of decorative design with closely observed cliffs, rocks, and trees is suffused with mystery and sanctity. The awesomeness of the place suggests the immanence of the *kami* with a power seldom matched in East Asian art.

Masks

Formalization extended to other mediums, with varied effects. Masked dance forms entered Japan from the continent during the sixth century C.E., and came to function simultaneously as religious and secular ritual and as entertainment. *Bugaku,* which has survived to the present, reached its peak during the Heian period, adorning almost all the secular and religious occasions of court life and being performed by aristocratic amateurs as well as by highly regarded professionals. Though each dance (and its mask type, which is specific to that dance) is named for a tale or legend, *bugaku* dances are abstract rather than narrative. With the shrinkage of courtly patronage during the Kamakura period, some *bugaku* performers left Kyoto for provincial temples and shrines, and provincial variations on the old courtly forms emerged, influenced by and influencing local folkish performance arts such as the comic and popular *dengaku* and *sarugaku.* During the fourteenth century *sarugaku,* which had absorbed certain aspects of *dengaku,* evolved into *no,* the stylized, formalized dance-drama associated with Zen Buddhism and the "new style" of Chinese monochrome ink painting (*see chap. 16*). Though mood or "flavor" is the most significant aspect of *no,* each play also contains an element of narrative.

Highly regarded sculptors (*busshi*) of Buddhist icons also made *bugaku* masks, as we know from signed masks appearing about the end of the twelfth century. In order to command attention from a distance and to signify the dance being performed, *bugaku* masks are broad and exaggerated of feature and often elaborate of construction, with separately attached chin, nose, eyes, and hair that move with the movement of the dancer. *No* masks are equally but quite differently stylized. Each mask is specific not to a particular play but to a particular type of character, and its purpose is to reveal, to an audience at close range, extremely subtle nuances of character and shifts of emotion. *No* masks are smaller than *bugaku* masks and more delicately carved, without moving parts, and the carvers tended to be hereditary specialists. The difference between the magical masks of early Kamakura *bugaku* (*fig. 540*) and the subtle, hyperaesthetic masks of the later *no* drama (*see cpl. 41, p. 342*) is apparent.

Arms and Armor

As one might expect, the arts associated with military prowess reached unsurpassed technological and aesthetic

540. *Bugaku mask.* Painted wood; h. approx. 12" (30.5 cm).
Kasuga Shrine, Nara, Japan. Kamakura period

541. *Sword Blade.* Signed: Yamato no Kuni Hosho Goro
Sadamune (act. 1318–1335 C.E.). Japan. Kamakura period.
Metropolitan Museum of Art, New York

542. *Grand armor (oyoroi).* Iron, leather, lacquer, textile, gilt
bronze; h. (excluding helmet) approx. 27¹/₂" (70 cm).
Japan. Kamakura period, late 13th–early 14th century C.E.
Kushibiki Hachiman-gu, Aomori Prefecture

heights during the Kamakura period. Of particular
importance were arms and armor and illustrated hand-
scrolls recording major military events.

Among warriors the matchless Japanese swords
(*Nippon to*) became quasi-sacred, imbued with vital spir-
it, and swordsmiths when practicing their art were
thought to be possessed by a divine Shinto spirit. The
making of a blade was as much ritual as craft. Sword-
smiths, like Shinto priests, wore white for their work and
underwent preliminary rituals of purification and cleans-
ing. The finest swords are laminates of softer, low-carbon
steel with harder, high-carbon steel; in lesser blades iron
replaces the low-carbon steel. Bars of the two metals were
welded together, then repeatedly folded over and ham-

mered out to their original length. Following this forging
process, the blades were tempered by repeated heating
and cooling. Finally they were polished by a master pol-
isher. The nearly superhuman complexities of this long
process—making a single blade might require eight
months—were mastered empirically, by concentrated
observation. In its fusion of tensile strength, keen edge,
and functional beauty no sword of any place or time
excels Japanese blades made at the end of Heian and the
first half of Kamakura (*fig. 541*). Numbers of these blades
exist, and their variations attest numerous distinct pro-
vincial traditions and, by extension, the rise of Japanese
feudalism. Homma Junji identifies sixteen provincial
types and subdivides those of Kyoto, Bizen, and Yama-
shiro still further into schools.

Armor too was much prized, as in late Gothic Eu-
rope. Like Late Heian armor, that of early Kamakura was
meant for mounted bowmen and continued the same
style, but on a heavier and grander scale and with the typ-
ical antler-like helmet ornaments greatly enlarged (*fig.
542*). Kamakura period grand armor (*oyoroi*) is especially

543. *Illustrated History of the Mongol Invasions (Moko Shurai Ekotoba).* Section of the handscroll; ink and color on paper; h. 15¹/₂" (39.4 cm), l. approx. 78' (24 m). Japan. Kamakura period, late 13th century C.E. Imperial Household Collection, Tokyo

544. (below) *Fudo Myo-o.* By Shinkai (act. 1278–1287 C.E.). Dated to 1282 C.E. Hanging scroll; ink on paper; h. 46" (116.8 cm). Daigo-ji, Kyoto, Japan. Kamakura period

rich in its decoration of gilt bronze, patterned leather, and figured textiles. But beneath the splendor is an efficient protective combination of iron, steel, leather, and lacquer.

War Tales

Of the surviving handscrolls illustrating tales of battle (*gunkimono*), the most accomplished are the three remaining scrolls of the *Heiji Monogatari Emaki* (*Illustrated Tale of Events of the Heiji Era*). These represent incidents of 1159–1160 C.E., the opening round of the Taira-Minamoto conflict: the burning of the Sanjo Palace in 1159 C.E., in the Museum of Fine Arts, Boston (*cpl. 42, p. 343*); the death of Fujiwara Shinzei, in the Seikado Library, Tokyo; and the escape of Emperor Nijo from the Minamoto forces, in the Tokyo National Museum. Dating from the late thirteenth century, the scrolls picture the brutal might of the warriors and attest the skill of the painters commissioned to represent them in action. The masterful depiction of raging fire, turbulent crowds, and powerful chargers reveals the strong tradition inherited from such late Fujiwara period handscrolls as *Ban Dainagon* (*see figs. 455, 456*), though the *Heiji* figures are more stereotyped than those in the earlier scroll.

This marvelous *emaki* tradition was available for recording Japan's historic defeat of the Mongol invasions of 1274 and 1281 C.E. In 1266, not yet fully master of China and Korea, Kubilai Khan sent ambassadors to Japan demanding fealty. These envoys were sent packing by the Kamakura regent, Hojo Tokimune. In 1274 a Mongol army, carried by a fleet of conquered Chinese and Koreans, landed at Hakata (present-day Fukuoka) in Kyushu, but were quickly driven off by *bakufu* vassals aided by a timely storm. Renewed Mongol demands were answered by summary execution of the Mongol envoys in 1275. A second and vast expeditionary force landed in Kyushu in 1281, but was stalemated by a well-prepared Japanese defense. After two months of fierce fighting a "Divine Typhoon" (*kami-kaze*) wrecked the Mongol fleet and doomed the invasion.

Moko Shurai Ekotoba (*Illustrated History of the Mongol Invasions; fig. 543*) is the sole surviving *emaki* to record these momentous events. It was commissioned by a Japanese officer, Takezaki Suenaga, in support of his claims to recompense for gallant action in the two invasions. The multitude of such claims, added to the cost of

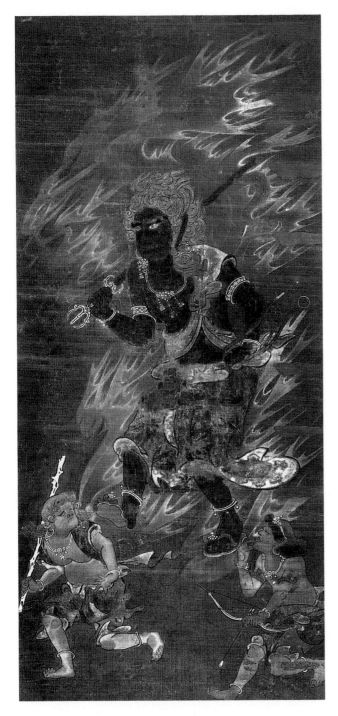

545. *Running Fudo Myo-o.* Hanging scroll; ink and color on silk; h. 50¾" (128.9 cm). Japan. Kamakura period, c. 1280 C.E. Heisando collection, Tokyo

the fighting, contributed materially to the undoing of the Kamakura *bakufu.*

Despite its title, the scroll shows only Takezaki's part in the fighting. Even so, it reveals some of the invasions' effects on the Japanese military. In the detail illustrated, a heavy-armed mounted Japanese bowman confronts lightly armed Mongol archers on foot. The fighting efficiency of the latter was instrumental in converting the samurai from mounted bowmen to foot soldiers whose principal

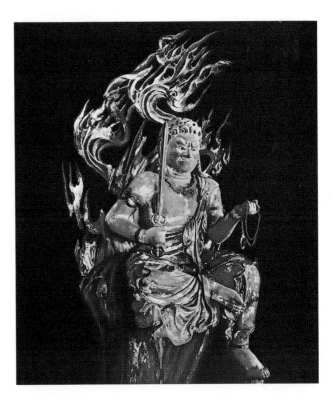

546. *Fudo Myo-o.* Dated to 1373 C.E. Wood; h. 34" (86.5 cm). Sangatsu-do of Todai-ji, Nara, Japan. Nambokucho period

weapon was the long sword. A similar shift can be seen in late medieval Europe, from heavy-armed mounted knights to more maneuverable infantry.

Perhaps the most telling artistic evidence for the dominance of the Japanese military at the time of the Mongol threat is a transformation of Fudo, "the Immovable," into a strenuous defender of the islands and the Buddhist faith. Shinkai's ink sketch for an image, dated to 1282 C.E. (*fig. 544*), stands on a sea-girt rock, glowering in the direction of the Mongol threat. In the remarkable *Running Fudo* (*fig. 545*) the deity rushes diagonally through the picture space with his acolytes, his sword at the ready over his shoulder. Only a potential cataclysm could have so revolutionized the traditional concept. Fudo's pose here supports the tradition that this was the image to which Emperor Kameyama prayed for deliverance from the Mongols. A *Fudo* in Todai-ji's Sangatsu-do (*fig. 546*), dated to 1373 C.E., is shown seated, and presents a comparatively benign, even playful, aspect by comparison with the furious, warlike icons of a century earlier.

Buddhist Narrative Handscrolls

As the thirteenth century moved to its close, the new forms of Buddhism generated innovations in the arts. In paintings with Buddhist contexts landscape becomes ever more prominent, a development we have already seen in Shinto shrine-mandalas. In the *Saigyo Monogatari Ekotoba*

547. *Illustrated Biography of the Monk Saigyo (Saigyo Monogatari Ekotoba).* Section of the 2nd hand-scroll; ink on paper; h. 12" (30.3 cm), l. approx. 38' (11.58 m). Japan. Kamakura period, 13th century C.E. Manno Hiroaki collection, Osaka

548. (below) *Illustrated Biography of the Holy Man Ippen (Ippen Shonin Gyojo Eden).* By Priest En'i. Dated by inscription to 1299 C.E. Section of the handscroll; ink and color on silk; h. 15" (38.1 cm), l. approx. 32' (9.8 m). Kangiko-ji, Kyoto, Japan. Kamakura period

(*Illustrated Biography of the Monk Saigyo; fig. 547*) the changing landscape is not background but foreground, fully equal in visual importance to the experiences of the wandering poet-priest-recluse Saigyo (1118–1190 C.E.) and also fully expressive of the emotional resonances of Saigyo's superb poetry. In similar fashion the *Ippen Shonin Gyojo Eden* (sometimes called *Ippen Hijiri-e; Illustrated Biography of the Holy Man Ippen; fig. 548*), painted in twelve scrolls by En'i in 1299 C.E., records the life of the Jodo priest Ippen (1239–1289 C.E.), founder of the Ji (Timely) sect of Amidism. The charismatic mendicant Ippen roamed Japan from 1251 till his death, preaching salvation through repeated invocations of Amida accompanied by ecstatic dancing (*odori nembutsu*). Ippen's wide-ranging mission has afforded the artist all of Japan as his

subject, and the scrolls abound in views of recognizable sites, including the earliest dated representations of Mt. Fuji and Enoshima. A careful and subtle spaciousness in the landscapes strongly evokes the painting of Southern Song China. The scrolls are also painted on silk, the preferred ground of Southern Song painters, rather than on paper, which was more customary in Japan.

Even Hell receives more landscape than was its portion in earlier times. The *Kasuga Gongen Reigenki-e* (*Illustrated Tales of the Kasuga Gongen Miracles*) was painted by Takashina Takakane, chief painter to the court, and dedicated to Kasuga Shrine in 1309 C.E. by Saionji Kinhira (1264–1315 C.E.), Minister of the Left. Its Hell scene (*fig. 549*) shows demons far more patterned and decorative but far less frightening than those of *Jigoku*

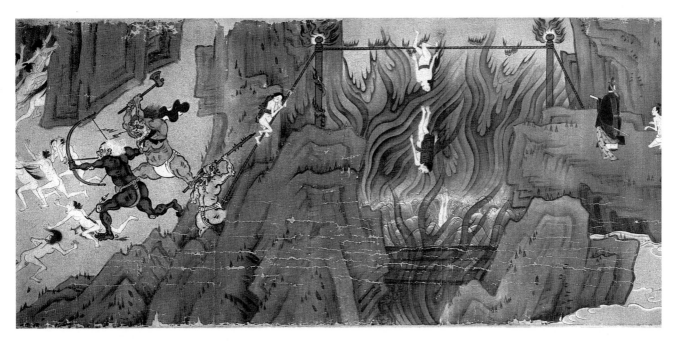

549. *Hell scene.* By Takashina Takakane (act. 1309–1390 C.E.). Dated to 1309 C.E. Section of the handscroll *Kasuga Gongen Reigenki-e*; color on silk; h. 16" (40.6 cm). Japan. Late Kamakura period. Imperial Household Collection, Tokyo

Zoshi (*see fig. 453*), in a rocky landscape with modeling and dotting (C: *cun*) in a Song manner.

Zen Influences in Art

In 894 C.E. the Japanese court had broken off official relations with China, and during much of the Late Heian period contact between the two countries was minimal. By the middle of the twelfth century, however, gifts and letters were being exchanged unofficially between the Heian and Song courts, and commerce was becoming increasingly lively. In addition to goods, the trading vessels carried Buddhist priests, senior Chinese monks invited to teach in Japan and Japanese monks (e.g., Chogen) bound for study in China. Both visiting Chinese and returning Japanese monks were valued in Japan for the secular arts and letters as well as the religious doctrine that they brought with them.

The most influential of the new modes in painting is associated with Zen (C: Chan) Buddhism. Priest Myoe (1173–1232 C.E.), Kegon abbot of Kozan-ji in the northwest outskirts of Kyoto, was deeply interested in Zen and a great patron of the arts. In the early part of the thirteenth century he collected and commissioned sketches of Chinese Chan icons by Japanese painters. The *White-Robed Kannon* (*Byaku-e Kannon; fig. 550*) is one of five such sketches from Kozan-ji. It is the earliest extant Japanese depiction of this quintessential Zen icon (*see also fig. 484*), the first of a flood of such images beginning

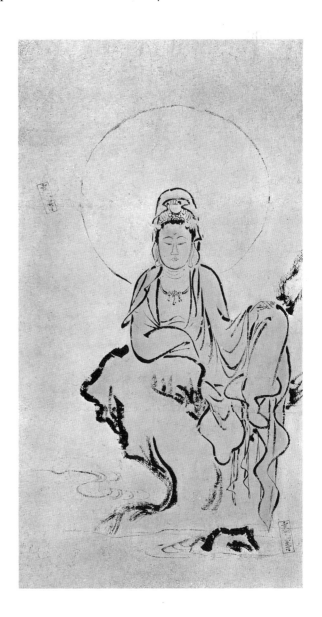

550. *White Robed Kannon (Byaku-e Kannon).* Hanging scroll; ink on paper; h. 36" (91.4 cm). Kozan-ji, Kyoto, Japan. Late Kamakura period. Cleveland Museum of Art

about 1300 C.E. Chinese Chan priest portraits, notably that of Priest Bu-Kong (*see fig. 483*), also came to Kozan-ji. These in turn inspired thousands of painted Japanese Zen priest portraits (*see fig. 553*) as well as many extraordinary sculptural examples. The latter are rare in China.

Later Song painting and Chan Buddhism exerted a critical influence in late Kamakura Japan and over the next four centuries. The native Japanese love for what is spontaneous and irregular, their passion for simplicity, their highly personal views of nature and the world, and their predilection for intuition and feeling over logic and ideas, all made them ready vessels for receiving the rich Chan heritage from China. In addition, the dominant warrior class prized self-discipline, self-abnegation, concentration, and directness of perception and action, and decried complex scholasticism and ritual. Chan answered to or could be reconciled with these values and, as Zen, it quickly became the principal religion of the warrior class. Many of the warriors were simultaneously practitioners of Zen and devotees of Amida, and Amidism continued strong among commoners and courtly aristocrats. Con-

temporary monochrome ink paintings imported from Korea and China offered a new imagery and stylistic austerity that were particularly appealing to the warriors. The refinement of the *no* drama, of late Kamakura architecture, and of the tea ceremony (*cha no yu*) reflects Zen teaching. Later Zen would be modified in spirit, the intuition elaborated into sophisticated and subtle forms, the simplicity formalized and "aestheticized" into often superb rituals. Still later, the complicated means to achieve simplicity often attained greater importance than simplicity itself; thus the later *no* and *cha no yu* became aesthetic ceremonies of great complexity. The humble Jian teabowls imported from Song China (*see fig. 508*) and the Seto ware copies of these were exalted into prestigious works of art, and later Japanese tea ceramics became the self-conscious creations of numerous honored tea masters, with a slackening of integrity as the centuries passed. All this and much more in the arts of Japan resulted from the fusion of Chinese and Japanese, Chan and Zen, Song and Kamakura, priest and warrior, achieved during the thirteenth century.

16

Japanese Art of the Muromachi Period

The Japanese period known as Muromachi or Ashikaga (1392–1573 C.E.)—Muromachi after the quarter in Kyoto housing the shogun's palace, Ashikaga after the family name of the ruling shoguns—is one of failure of central authority, disastrous political confusion, and continual fierce warfare among the feudal barons hungry for power and domains. The split between the court and the warriors, between the prestige of the emperor and the power of the shogun, was becoming thoroughly institutionalized, at the same time that the authority of both was being superseded by relationships of pure military vassalage. The Ashikaga family and their chief advisers exercised an uneasy, brief, and limited dominion that imposed relative peace for about three generations; thereafter for about a century and a half all supremacy failed, war convulsed the country, and the house laws of the feudatories were the only law in Japan.

By removing the shogunate from Kamakura to Kyoto, seat of the imperial court, the Ashikaga shoguns promoted, in this age of political fragmentation, a process of cultural synthesis between rude, provincial, military society and elegant, metropolitan, civilian society. In Kyoto the increasingly powerless shoguns could devote lives largely emptied of political responsibility to the cultivation of refinement and the arts, and upstart captains eager for social acceptability could seek lessons in taste and deportment from impoverished court nobles.

During this violent, bloody age, trade and the arts—as in China during the similarly anarchic Warring States period—flourished. The paradox is more seeming than real. Fighting was vicious, but farming, the chief wealth of the country, was not much disturbed. Warlords needed arms for their troops, furnishings for their households, luxuries to signify and celebrate their triumphs. The "sudden lords" (contemporary term for men of humble origin aggrandized by the fortunes of war) needed fine things to remove the stigma of boorishness. And the Buddhist sects continued rich and strong enough to serve as havens for apolitical artists and aesthetes. Finally, the very absence of central authority both permitted and demanded the emergence of a strong mercantile class to furnish the necessities of the military arrivistes.

Among the "new men" the old *yamato-e* and *emaki* styles fell into disfavor. After five hundred years of slight and rare contact, Japan turned its eyes again to China.

From China at the very end of the twelfth century had come Zen (C: Chan) Buddhism, eliciting from the Kamakura warriors a vigorously enthusiastic response. Zen doctrine was simply stated, brief, and direct; to pragmatic and doubtless laconic military men its appeal is

551. (left) *Table top.* Lacquered wood with design in gold and silver; l. 23" (54.2 cm). Japan Muromachi period. Cleveland Museum of Art

552. (below) *Visiting the Stables.* One of a pair of six-fold screens; ink and color on paper; h. 57¼" (145.7 cm), l. 11'5¾" (3.49 m). Japan. Muromachi period. Cleveland Museum of Art

553. (opposite) *Posthumous Portrait of Enni Ben'en (Shoichi Kokushi).* By Mincho (also called Kichizan Mincho or Cho Densu; 1352–1431 C.E.). Hanging scroll; ink and color on silk; h. 8'4½" (2.55 m). Tofuku-ji, Kyoto, Japan. Muromachi period

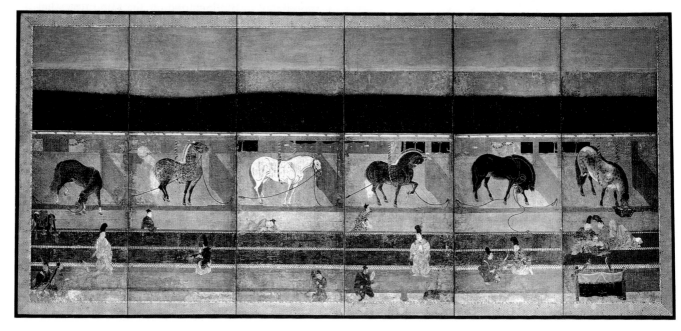

obvious. Zen practice dispensed with image worship and ceremonial sutra reading in favor of meditation under the tutelage of an already enlightened master; to feudal warriors and their overlords the master-disciple relationship must have seemed natural and congenial. By the Muromachi period Zen dominated intellectual as well as religious life. In its company came the art and literature of the Song renaissance and its continuation by conservative masters during the Yuan and early Ming dynasties. So overwhelming was the Japanese response to these that interest in native Japanese subject matter and style withered. Chinese models and Zen masters influenced virtually every aspect of life among the new rulers and high intellectuals. The ideal for the Japanese scholar of the Muromachi period was China: Chinese style painting and most particularly monochrome landscape, Chinese ceramics, Chinese poetry and philosophy. To say that Zen influenced all of these is not, of course, to imply exclusive Zen parentage. But Muromachi art expresses the Zen

apprehension of the spiritual identity of all created things and the Zen appreciation of direct, intuitive perception, and it shares the Zen aesthetic standards of subtlety, allusiveness, and restraint.

Conservative Style

We have mentioned the importance of first looking at the traditional or conservative side of a period. In the applied arts and in some paintings the decorative *yamato-e* style of the Fujiwara period was continued, largely by artists of the Tosa school. Lacquer in particular was made for the court in Fujiwara style, and surviving pieces in this most fragile medium are of great value today. The top of a small lacquer table illustrates a style of decoration almost identical with that on twelfth century lacquer clothes boxes (*fig. 551*). Only in the summary application of the silver spit of land at the left directly over the gold grasses

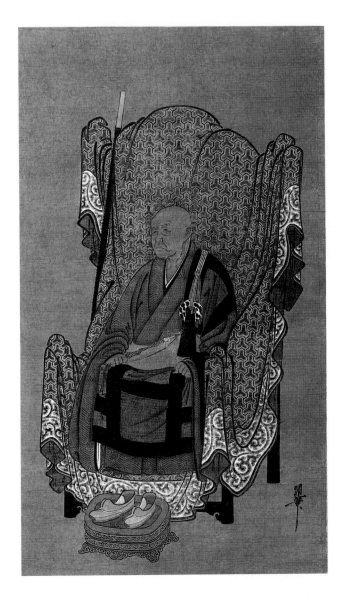

and tree trunks is there any indication of a slightly different attitude. This rather brusque and arbitrary quality is found often in the paintings and especially in the tea ceremony works of this period.

Paintings of the Tosa school perpetuated the Fujiwara and Kamakura narrative handscrolls in various sizes and proportions and in a rather cautious style, to which vigorous "folkish" narratives form an exception. In the now revived form of the folding screen Tosa painters produced some of the most important conservative works of the fifteenth and sixteenth centuries. A particularly attractive subject, known in several examples, shows warriors, gentlemen, and priests occupying their leisure before a stable of horses so finely bred, so well groomed and cared for that they require halters around their bellies to prevent them from lying down (*fig. 552*). The main elements of this style are derived from the *emaki* mode of the Kamakura period. The simple, repetitive arrangement is intended decoratively, a precursor of the full-fledged decorative style of the Momoyama period.

Portraiture was also continued, particularly remembrance portraits of Zen masters (*fig. 553*). These might be painted from life and given by a master as mementos to departing disciples, or, like figure 553, they might be imaginary commemorative portrayals of eminent deceased monks. Both types are subsumed under the term *chinso*. Enni Ben'en (posthumous honorific: Shoichi Kokushi; 1202–1280 C.E.) was founding abbot of Tofuku-ji. His portrait by the artist Mincho, also known as Cho Densu (1352–1431 C.E.), perpetuates unaltered the portrait style of Southern Song and Kamakura (*cf. figs. 483, 533*). Though it adds nothing new to previous Chinese or Japanese painting, it is an excellent traditional portrait. The forthrightly rendered face may or may not be accurate as to feature, but it conveys the essential qualities of the enlightened Zen master. Figure 553 also exemplifies the combination of Japanese decorative and realistic styles that emerged in the Kamakura period: The patterning of the abbot's throne is as marked as the character of his face.

One unusual aspect of the traditional art of the Muromachi period is illustrated by a pair of six-fold screens called *Spring Landscape in Sunlight, Winter Landscape by Moonlight* (*fig. 554*). Their style is a wild, rough continuation, bordering on folk art, of the decorative *yamato-e* treatment of the rolling, gentle hills of Japan and of pine trees, water, rocks, and waves. The sprinkling of gold leaf in the upper left of the *Sunlight* screen and of some silver around the sun and moon recalls the use of this technique in the *Genji* scrolls, but these screens are lively and vigorous rather than elegant and aristocratic in the Fujiwara manner. Other works of this rare type presumably were painted in some quantity in the Muromachi period and were of considerable importance for the development of a later decorative style. But the syncopated rhythms of the *Sunlight* and *Moonlight* screens survive as virtually unique indications of new directions.

THE CHINESE MONOCHROME STYLE

The mainstream of the "new" Japanese painting in the Muromachi period comprises monochrome painting in Chinese style of Chinese subjects. It was almost a point of honor to ignore the Japanese landscape, though there were notable exceptions. Monochrome painting was associated with Zen, and many of the greatest practitioners of the Muromachi monochrome style were painter-monks. The new mode first reached Japan in the Kamakura period, as revealed by certain extant sketches and a few finished paintings imported from China. The *White-Robed Kannon*, from Kozan-ji in Kyoto, is one of these: a Zen subject in the new Chinese monochrome technique (*see fig. 550*). The subject, seated upon a rock amid the waters, now seems more female than male. The calligraphic brush strokes forming the rock; the flowing waterfall of drapery; the Chinese style of the face, with straight nose,

554. *Spring Landscape in Sunlight, Winter Landscape by Moonlight.* Pair of six-fold screens; ink, color, gold, silver, and gesso on paper; h. 57⁷/₈" (147 cm), l. 10'4¹/₂" (3.14 m) each. Kongo-ji, Osaka Prefecture, Japan. Muromachi period

small eyes, and a withdrawn expression rather than the animation usually found in Japanese representations—all these derive from such Chinese works as those of Mu Qi. Nevertheless, minor details of brushwork, notably the hints of "nail-head" brush stroke technique in the foreground rock, indicate this to be a work by a Japanese painter, schooled in native style, making an early attempt at the new Chinese monochrome style. The Muromachi monochrome school developed from such beginnings.

Mincho, in addition to portraits in traditional style, also painted landscapes in monochrome. Of these presumably numerous works, only one is left: a landscape in the Konchi-in in Kyoto depicting a thatch-roofed cottage in a grove of trees overhanging a stream; in the distance are "ax-cut" mountains, executed in broad strokes with the side of the brush (*fig. 555*). Knowing that this painting is Japanese, one can then "see" differences from Chinese style, but one's overwhelming spontaneous impression is that the painting is completely and utterly Chinese; so extensively and thoroughly did the Japanese priest painter appropriate the Chinese Ma-Xia style of the Song and Yuan periods and use it to develop the Muromachi monochrome school. These artists believed so completely and fervently in Song culture and style that their re-creations of the lyric style of the Southern Song dynasty equal the Chinese prototypes. No Chinese critic or sinologue would ever allow such a statement to go unchallenged, but then—there are the paintings! The little painting by Mincho stands at the threshold of this fruitful development.

Another artist of great importance is Josetsu, active about 1400 C.E., of whose work we have left only one widely accepted painting, *Catching a Catfish with a Gourd* (*fig. 556*). The subject, a man trying to catch a catfish with a gourd, illustrates the Zen aphorism "The heart cannot be grasped." Josetsu's fisherman stands on the

shore of a little stream opposite a clump of bamboo, holding his gourd, while from the stream a catfish observes the absurd and futile figure. In the distance is the bare outline of a mountain, and above the painting are thirty-one poems by Zen priests, one of whom notes in his preface that this picture was painted as a screen for the shogun about 1413. Most likely "the shogun" was Ashikaga Yoshimochi, fourth of his line (r. 1394–1423 C.E.) and a fervent disciple of Zen. His commission to Josetsu for a "small single-leaf screen in the *new style* [italics added]" must surely have alluded to the new and growing shogunal collection of late Song and early Yuan works. Shogunal approbation of this new taste is both clear and significant for the future.

Catching a Catfish symbolizes the extent to which the Japanese absorbed and were absorbed by the new Zen ideal. Though it came from China, it became, literally and figuratively, their faith. An idea penetratingly understood and passionately adhered to is, in a sense, thereby re-created, and something of that reinvented quality is at the heart of the Muromachi monochrome school and informs the whole ethos of the period.

Josetsu was, according to tradition—and there seems no reason to dispute it—the real founder of the Muromachi monochrome school. His pupil was Tensho Shubun and Shubun's was Sesshu, and from this line came most of the significant developments in monochrome ink style. Shubun, active in the first half of the fifteenth century, is perhaps its greatest master, but he is for us a shadowy figure. We know that he was a priest, that he not only painted for the shogun but was a painter of sculpture as well, that he visited Korea circa 1423–1424 and presumably was familiar with the Ma-Xia style of Korean painting of the time. He was primarily a painter of screens and large hanging scrolls, though a few small hanging scrolls are attributed to him. Skeptics tell us that not a single

extant work may be surely attributed to Shubun. Still, a small but important group of screen paintings, some with the seal of Shubun, are traditionally ascribed to him. They are painted in a synthesis of the Northern Song and Jin monumental style with the Ma-Xia style of asymmetry and abbreviation, both as mediated through Korean brush style. In power and richness they seem, if anything, superior to earlier and later works. One of them is the screen *Winter and Spring Landscape,* illustrated in figure 557. The subject should be read from right to left, as if the screen were a handscroll. Winter with its soft snow and cold mist grips the landscape of the first four panels. The selfsame atmosphere is rendered by two famous haiku (poems of seventeen Japanese syllables) by Zen monks:

> Under the winter moon,
> The river wind
> Sharpens the rocks.
>
> Chora: IV, 213

> I walk over it alone,
> In the cold moonlight:
> The sound of the bridge.
>
> Taigi: IV, 205

The last two panels convey a softer message; a slight warmth in the tones of the ink changes the chilly steam of winter to the soft breath of spring:

> Peace and quiet:
> Leaning on a stick,
> Roaming round the garden.
>
> Shiki: II, 43

> Suddenly thinking of it,
> I went out and was sweeping the garden:
> A spring evening,
>
> Tairo: II, 54[25]

555. *Hermitage by the Mountain Brook.* Attrib. Mincho (also called Kichizan Mincho or Cho Densu; 1352–1431 C.E.). Dated to 1413 C.E. Hanging scroll; ink on paper; w. 13¼" (33.7 cm). Konchi-in, Kyoto, Japan. Muromachi period

556. *Catching a Catfish with a Gourd.* By Josetsu (act. c. 1400 C.E.). Hanging scroll; ink and slight color on paper; h. 32¾" (83.2 cm). Taizo-in of Myoshin-ji, Kyoto, Japan. Early Muromachi period, c. 1413 C.E.

Shubun's style had a sound foundation. As painter to the shogun he undoubtedly had access to Yoshimitsu's great collection of Chinese Southern Song paintings. The brush style of Ma Yuan is evident in the "ax-cut" strokes defining the rocks; Xia Gui's manner is to be seen in the trees; and the general disposition of the trees against the nearby towering, truncated mountains markedly resembles the two famous hanging scrolls, mistakenly attributed to Li Tang, once in Yoshimitsu's collection and now kept at Daitoku-ji in Kyoto. But the artist has not merely borrowed; he absorbs the essence of the Chinese masters and makes their techniques and thoughts his own. It now appears certain that Shubun borrowed much from Korean monochrome paintings as well as Chinese. Some knowledge of northern Chinese styles was transmitted through Korean artists such as Yi Sumun (J: Ri Shubun), and some through collections of Chinese works which Shubun would have had opportunity to see in the Korean capital (present-day Kyongju) in 1423–1424.

Yi Sumun (act. first half of 15th century C.E.) was in Japan in 1424, the year in which Tensho Shubun's embassy returned from Korea, so the two painters can reasonably be assumed to have met and may even have traveled together. A pair of landscape screens bearing Yi's seals (*fig. 558*) combines northern Chinese style (and its continuation under the Jin) in the rather dry and barren landscape, Southern Song style in the forms of the trees and the use of plateaus and spits of land to suggest recession in space, and Korean traits of strong, repetitive brushwork and marked tonal contrast.

557. *Winter and Spring Landscape.* Attrib. Tensho (also called Ekkei) Shubun (act. 1st half of 15th century C.E.). Six-fold screen; ink and slight color on paper; l. 12' (3.65 m). Kyoto, Japan. Muromachi period. Cleveland Museum of Art

558. *Landscapes of the Four Seasons.* By Yi Sumun (J: Ri Shubun; act. 1st half of 15th century C.E.). Pair of six-fold screens; ink and slight color on paper; h. 36¹/2" (92.7 cm), l. 11'5¹/4" (3.49 m), each. Japan. Muromachi period. Cleveland Museum of Art

Tensho Shubun added a breadth of scale in part inherent in the large, decorative expanse of the folding screen. Though Northern Song masters sometimes created grouped hanging scrolls of landscapes, in China the folding screen was never more than decorative. It remained for the Japanese genius to make decoration and profundity congruent. Shubun was able to do this by avoiding the extremes of stylized composition and brushwork to which so many later Japanese monochrome painters became addicted. His ink varies from the lightest tones to the darkest; his brush can be soft or harsh at will. Complexity and simplicity are fused by an almost magical

ability to convince without display. The *Winter and Spring Landscape* screen is a product of this mature style, an embodiment of intellect and emotion in perfect harmony.

Shubun by no means confined himself to large pictures, screens, or wall paintings, although his strong brushwork and ability to unify intricate compositions in a simple overall pattern were particularly suited to such forms. Of the hanging scrolls that bear hopeful attributions to Shubun, very few are generally accepted as his, but in our judgment a few are close to his style. One of them, *Color of Stream and Hue of Mountain,* is illustrated in figure 559. Here, as in the screen paintings, is the satisfactory unity and complexity underlying simplicity. The painting owes a great deal to the Song artist Xia Gui, particularly in the clump of reaching pine trees and the structure of the rocks in the foreground, and yet it exceeds any of the Southern Song masters in the extreme use of vertical composition. The elements of the landscape seem more arbitrarily and decoratively disposed than such elements in the works of Southern Song painters. The brushwork is suave, and the "ax-cut" strokes used in the foreground rock are related to similar strokes in the screen paintings. In overall effect the brushwork is spidery, and the short vertical and horizontal strokes depicting trees along the silhouette of the mountain greatly resemble Korean monochrome conventions of the early Choson period. The architecture is convincing, a characteristic of work attributed to Shubun.

In marked contrast to the works of Shubun are the characteristic paintings of his student Sesshu (1420–1506 C.E.). Among Sesshu's masterpieces is *Eka Showing His Severed Arm to Daruma* (*fig. 560*), dated to 1496 C.E., recalling one of the epochal events in the early transmission of Chan/Zen. Daruma (S: Bodhidharma), the Indian monk who came to China about 520 C.E. and became the First Patriarch of Chan, is seated facing the cave wall on Mt. Song, rapt in his nine-years meditation. Behind Daruma the Chinese Hui-Ke (J: Eka) is proffering the arm he has just cut off in proof of his invincible determination to become Daruma's disciple. Sesshu has delineated these superhuman figures in large scale, using markedly broad, flat brush strokes of pale color to silhouette their largely undetailed robes. By contrast, the grotesque, menacing rock walls of the cave are sharply outlined and contoured with staccato strokes of dark ink. Sesshu's almost geometric brush strokes are deliberately dramatic, and the monumentally powerful image they create is utterly different from the subtle and lyrical art of Shubun. This painting expresses not only the essence of

559. *Color of Stream and Hue of Mountain.* Attrib. Tensho (also called Ekkei) Shubun (act. 1st half of 15th century C.E.). Dated to 1445 C.E. Hanging scroll; ink and slight color on paper; h. 42⅝" (108.2 cm). Japan. Muromachi period. Fujiwara Yuzo collection, Tokyo

Colorplate 44. *Lion Grove Garden (Shizi Lin)*. Suzhou, Jiangsu, China. View west to Heart of the Lake Pavilion. Yuan dynasty, 1342 C.E., with later additions

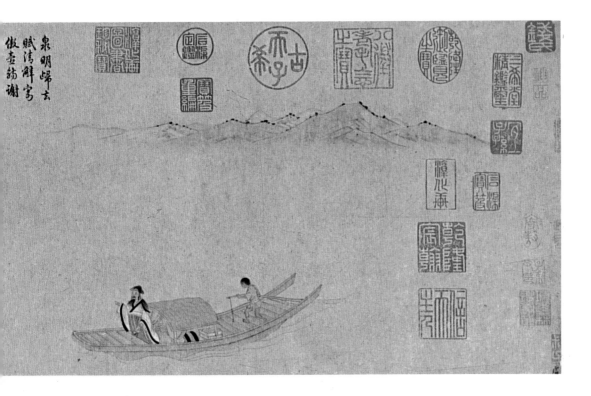

Colorplate 45.
Home Again.
By Qian Xuan
(c. 1235–after
1301 C.E.).
Handscroll; ink
and color
on paper; l. 42"
(106.7 cm).
China. Yuan
dynasty.
Metropolitan
Museum of Art,
New York

Colorplate 46. (far left) *Stem cup.*
Porcelain with decoration in underglaze
cobalt blue and overglaze iron red enamel;
h. 3¹/₂" (8.9 cm). China. Ming dynasty, mark
and reign of Xuande (1425–1435 C.E.).
(center) *Wine cup.* Porcelain with Doucai
decoration in underglaze cobalt blue and
overglaze red and green enamels; h. 1⁷/₈"
(4.8 cm). China. Ming dynasty, mark and
reign of Chenghua (1464–1487 C.E.).
(near left) *Covered jar.* Porcelain with Wucai
decoration of underglaze cobalt blue and
overglaze red, green, yellow, and brown
enamels; h. 4" (10.2 cm).
China. Ming dynasty, mark and reign of
Wanli (1572–1620 C.E.).
All: Cleveland Museum of Art

Colorplate 47. (left) *Plate.* Yellow-enameled porcelain; diam. 8³/₈" (21.3 cm). China. Ming dynasty, mark and reign of Chenghua (1464–1487 C.E.). (right) *Plate.* Porcelain with copper red glaze, diam. 5¹/₄" (13.3 cm). China. Ming dynasty, mark and reign of Xuande (1425–1435 C.E.). Both: Cleveland Museum of Art

Colorplate 48. *Ke si*. Silk and gold tapestry; l. 6'6" (1.98 m). China. Ming dynasty. Cleveland Museum of Art

Colorplate 49. *Golden Valley Garden.* By Qiu Ying (act. c. 1522–1552 C.E.). Hanging scroll; ink and color on silk; h. 7'4¼" (2.2 m), w. 51¼" (130 cm). China. Ming dynasty. Chion-in, Kyoto

Colorplate 50. *Lotus*. By Chen Shun (1483–1544 C.E.). Handscroll; ink and color on paper; h. 12" (30.5 cm), l. 19'1" (5.8 m). China. Ming dynasty. Nelson-Atkins Museum of Art, Kansas City

Colorplate 51. *Lady Xuanwen Giving Instruction in the Classics.* By Chen Hongshou (1598–1652 C.E.). Dated to 1638 C.E. Hanging scroll; ink and color on silk; h. 68³/₈" (173.7 cm), w. 21⁵/₈" (55.6 cm). China. Ming dynasty. Cleveland Museum of Art

560. *Eka Showing His Severed Arm to Daruma.* By Sesshu Toyo (1420–1506 C.E.). Dated to 1496 C.E. Hanging scroll; ink and color on paper; h. 78 3/4" (200 cm). Japan. Muromachi period. Sainen-ji, Aichi Prefecture

its awesome subject but the formidable character of the artist. Even the inscription is aggressive: "This was painted at age seventy-seven by Sesshu, holder of the chief seat at Tiantong, Siming"[26] (i.e., "at the Jingde Si on Mt. Tiantong, near Siming [present-day Ningbo], in China[!], I was honored as chief monk").

Sesshu's work can be divided roughly into two styles, *shin* and *so: shin* defined by sharp, angular, and relatively complex brushwork; *so* a soft, wet, explosive, and ultra-simplified style, also called by the Japanese *hatsuboku*, or "splashed ink." Sesshu has customarily been ranked higher than Shubun, and the number of his known works, compared with the number plausibly associated with his master, is considerable. Some thirty-five works can, with some degree of certainty, be attributed to Sesshu. Most famous of all is the so-called *Long Landscape Scroll*, a handscroll of some fifty-two feet, belonging to the Mori daimyo family for many generations. It is the most developed of all his works and represents a series of "Chinese" scenes. The scene showing the pagoda tower, flanked on the right by pine trees reaching into space from a craggy outcropping and on the left by a pine-topped terrace extending into the background, is a typical section of the scroll (*fig. 561*). The pine trees recall Shubun's, though they are perhaps less

561. *Long Landscape Scroll.* By Sesshu Toyo (1420–1506 C.E.). Dated to 1486. Section of the handscroll; ink and slight color on paper; h. 15 3/4" (40 cm), l. approx. 52' (15.85 m). Japan. Muromachi period. Mori Art Museum, Yamaguchi

562. *Long Landscape Scroll.* By Sesshu Toyo
(1420–1506 C.E.). Section of the handscroll
(see fig. 561)

563. *Ama no Hashidate.* By Sesshu Toyo (1420–1506 C.E.). Hanging scroll; ink and slight color on paper; l. 66³/4" (169.5 cm).
Japan. Muromachi period. Kyoto National Museum

soft and a little more mannered in their handling. Indeed, each detail of this scroll sounds overtones that recall other painters, both Chinese and Japanese, and in this sense it is an eclectic work. We know that Sesshu studied Southern Song masters—Li Tang, Ma Yuan, Xia Gui, and others (see figs. 473, 478, 481). Small album leaves, signed by Sesshu with his notation that they are in the style of these masters, still exist. He had also traveled in China in 1468–1469 as part of a trading and diplomatic mission that landed in Ningbo, Fujian Province, and moved slowly north to Beijing. He mentions seeing the work of some of the important Ming painters of the fifteenth century academic school, among them Li Zai. In his opinion the Ming painters did not equal the finest of the Japanese masters, notably his own teacher, Shubun. Certainly the basic elements of the early Muromachi monochrome style are derived more from Southern Song painting than they are from Ming. At the same time details in Sesshu's works remind us of certain Ming painters of the fifteenth century. In figure 561 the general handling of the pine trees on the right and the rather exaggerated near-and-far treatment in the right corner recall the work of masters of the Zhe school such as Dai Jin, and the terrace on the left, reaching into the distance, is a favorite device of fifteenth century Chinese painters.

A close detail of one of the river and forest scenes with figures will best illustrate those qualities which raise Sesshu to the pinnacle he occupies in Japanese art history: the strength of his brushwork, the brilliance of his handling of ink on paper (fig. 562). A passage such as the one in the center, with an old man followed by a boy attendant amid sharp rocks and rippling water, is not as naturally rendered as in the work of Shubun. Still, it seems remarkably expressive of the Japanese feudal ethos and of those Zen Buddhist qualities that appealed to the martial spirit: Direct and intuitive understanding has been translated into pictorial style by direct and immediate brushwork. Certain decorative qualities are to be discerned here that are quite different from those of Chinese painting, whether Song, Yuan, or Ming. Forms are more arbitrarily placed; transitions from near to far are abrupt; the texture patterns on the rocks, the patterns of foliage, and the shapes of branches are more exaggerated. Such conscious emphasis is not Chinese and points the way to the growing decorative tendencies of the late fifteenth and the sixteenth century, ultimately to reach their fullest expression in the Japanese decorative style of the seventeenth and eighteenth centuries. One can readily see whence the Kano masters, those rather academic followers of the monochrome school, received the elements of their style and how in overemphasizing decorative qualities they underestimated the primacy of brushwork and the directness of Sesshu's style.

Sesshu painted, as did most of his colleagues, the Chinese landscape in the Chinese style. Nevertheless, there are certain rare works by Muromachi masters in which monochrome ink is used to represent Japanese scenery. By far the most important of these is *Ama no Hashidate* by Sesshu (*fig. 563*). Along the coast of the Japan Sea northwest of Kyoto a sandy spit of land reaches across the mouth of the bay. Ranks of pine trees march along the peninsula to the very end of the point. The scene is represented again and again in later Japanese art and is one of the great pilgrimage sites for travelers, Japanese or foreign. Sesshu represents it in the cold blue ink typical of his later work, with just touches of pale orange-red giving some warmth to a few temple structures. Here the painter has somewhat modified his style. These Japanese hills are undulating, not as angular or steep as the imagined Chinese mountains. Their "loveliness" recalls the landscapes of the Fujiwara and Kamakura periods. If the dominant elements of the style are Chinese, their modification by Sesshu's unusually rigorous realism here produces one of the most interesting of Sesshu's landscapes in the *shin* style.

Ama no Hashidate was not the only outlying site visited by Sesshu, one of the most peripatetic of Japanese masters. Perhaps in part because of the Onin War that devastated Kyoto and its environs from 1467 to 1477, Sesshu traveled widely in Honshu and Kyushu and maintained a studio in Kyushu and one in Yamaguchi Perfecture. His wanderlust may also have been spurred by his willful and independent nature, which brooked little restraint or influence and felt undervalued in Kyoto.

Sesshu also painted a few paired six-fold screens. One of the finest, *Flowers and Birds,* illustrates the decorative development of monochrome painting at this time (*fig. 564*). Slight touches of red and green, while decorative, also contribute to the lifelike quality of the birds and foliage. But certainly the placement of the elements of the composition—pine branch, pine trunk, reeds, rocks, flowers, and the cranes—is extremely arbitrary, almost as if the artist had selected these motifs and then disposed them on the surface of the screen for maximum decorative effect. It is not yet an extreme decorative style, but motifs derived from China are here adapted to a different and Japanese taste.

The *so,* or *hatsuboku* (splashed ink), style, also used by Sesshu, is rightly considered the most extreme form of Chinese monochrome painting, and is often associated with Chan Buddhism in China and Zen in Japan. *Hatsuboku* was practiced in China, notably by Yu-Jian of late Southern Song (*see fig. 488*), but not often and to no great acclaim. Most Chinese *hatsuboku* paintings ended in Japan, brought by Zen monks returning from study in China.

In a few landscapes painted at the end of his life, Sesshu made extreme use of this style. The most famous and often reproduced example is the one painted in 1495 C.E. for Josui Soen, his disciple, and now in the Tokyo

564. *Flowers and Birds.* By Sesshu Toyo (1420–1506 C.E.). Pair of six-fold screens; ink and slight color on paper; h. 70 1/2" (179 cm), l. 12' (3.65 m). Japan. Muromachi period. Kosaka Zentaro collection, Tokyo

National Museum (*fig. 565*). Its sharpness and dramatic tonal contrasts belie the artist's inscription, ". . . my eyes are misty and my spirit exhausted. . . ," and bear out the verse inscribed by the monk Ryuto:

Within the wayside village a wine flag flutters in the wind.
A man grasps his oars in the calligraphic boat.
This brushwork from the height of intoxication is endlessly inspiring;
The southern mountain is veiled with mist in the evening dusk.[27]

Another hanging scroll, softer and simpler, by Sesshu's pupil Shugetsu Tokan, is illustrated in figure 566. The style of both is of such simplicity and subtlety that

although it is possible to analyze it, to demonstrate that the variation of wash is delicately controlled, that the tones are minutely calculated so that each wash occupies the imaginary space provided for it, that a foreground rock does come forward, that a distant building and its surrounding shrubbery recede, still, ultimate knowledge of the picture remains beyond our grasp. In contrast to much later works in the splashed ink style, these have a wide range of tone. But the fundamental touchstone of this style is its immediate and convincing impact. If the painting is sensed in the Zen way, visually and intuitively, one is emptied and only calm remains. Such works are the silent dialogue between a great artist and the materials—brush, ink, and paper—that he knew best and on their own terms.

A contemporary but somewhat separate line of devel-

565. *Hatsuboku Landscape for Soen.* By Sesshu Toyo
(1420–1506 C.E.). Dated to 1495 C.E. Section of a hanging
scroll; ink on two joined sheets of paper; h. 58¹/₄"
(148 cm), w. 12⁷/₈" (32.7 cm). Japan. Muromachi period.
Tokyo National Museum

566. *Hatsuboku Landscape.* By Shugetsu Tokan (1440?–
1529 C.E.). Hanging scroll; ink on paper; h. 23¹/₂" (59.6 cm).
Japan. Muromachi period. Cleveland Museum of Art

opment was established by the three generations of Kyoto
painters and connoisseurs known as the Three Ami—
Noami (1397–1471 C.E.), Geiami (1431–1485 C.E.), and
Soami (d. 1525 C.E.), who signified their devotion to
Amida by incorporating -*ami* into their given names. All
three served as aesthetic advisers (*doboshu*) to the Ashi-
kaga shoguns Yoshimasa (1436–1490 C.E.) and Yoshihisa
(1465–1489 C.E.), and as curators of the shoguns' Chinese
art collections. Their few surviving paintings usually show
a softer touch than Sesshu's, with brush strokes less
assertive and more pictorial and much use of ink wash.
The manner recalls Mu Qi, Yu-Jian, and the Ma-Xia

school of Southern Song, all of whose paintings the Ami
would have had opportunity to study in the shogunal col-
lections. Geiami's *Viewing a Waterfall* (*fig. 567*), while
uncharacteristically sharp and angular, clearly reveals its
Southern Song antecedents in the textures of the rocks
and trees and in the close-up intimacy of the composi-
tion. But where the Chinese artists would have left evoca-
tive open space, Geiami floats pale, ethereal clouds,
characteristic of the Ami style. One of the great examples
of this softer style of painting is the sliding-screen panels
(*fusuma*) in the Daisen-in of Daitoku-ji in Kyoto, painted
by Geiami's son Soami.

567. *Viewing a Waterfall*. By Geiami (1431–1485 C.E.). Dated to 1480 C.E. Hanging scroll; ink and color on paper; h. 41³/₄" (106 cm). Japan. Muromachi period. Nezu Art Museum, Tokyo

568. *Spring Landscape*. By Kenko Shokei (Kei Shoki; act. c. 1478–1506 C.E.). Hanging scroll; ink and slight color on paper; h. 20¹/₈" (51.1 cm). Japan. Muromachi period. Nezu Art Museum, Tokyo

Viewing a Waterfall was Geiami's parting gift and "certificate of achievement" to his student Kenko Shokei (also called Kei Shoki; act. c. 1478–1506 C.E.), painter-monk of Kencho-ji in Kamakura, who studied with Geiami in Kyoto between 1478 and 1480, then returned to Kamakura. *Viewing a Waterfall* is an important source of the Kamakura school of monochrome ink painting.

Shokei's paintings emphasize the uncharacteristically sharp brushwork of his teacher's gift-picture. In this respect they approach Sesshu's manner, but with an elegant subtlety in place of Sesshu's willful brusqueness. Shokei's masterpiece, *Spring Landscape*, represents a grotesque hollowed-out cliff with a small hut between its jaws, while beyond is a simplified view of mountain ranges and pines (*fig. 568*). Here is even more arbitrary brushwork and composition than that of Sesshu. The rhythms of the rocks, the twisting branches of the pine trees, and the gradations of the washes seem more calculated, even if brilliantly handled.

569. *Dragon and Tiger.* By Sesson Shukei (c. 1504–c. 1589 C.E.). Pair of six-fold screens; ink on paper; l. 11'1½" (3.39 m) each. Japan. Muromachi period. Cleveland Museum of Art

The ranking artist of the first half of the sixteenth century, almost equal in esteem to Shubun and Sesshu, is Sesson Shukei. He avoided Kyoto, metropolitan center of Zen culture, and though he traveled to Kamakura, he never settled there. But the works of Sesshu and of Song and Yuan masters were available to him for study in the collections of the daimyo of northeastern Honshu. His considerable body of work shows a distinctive style that emphasizes the decorative possibilities of rhythmic and graceful brush movements rather than the placement of elements within the composition. In the pair of screens in the Cleveland Museum of Art we have a particularly dra-

matic example of Sesson's characteristic highly volatile composition, with rapid and distinctive brushwork in the wind-tossed bamboo and in the outlines of the reaching waves (*fig. 569*). Sesson's most famous picture is a tiny rectangle, perhaps twelve inches wide. Past a point of land with a swaybacked hut and a wind-blown tree one looks out to a strong sea and a small boat running landward before the wind (*fig. 570*). In the waves in the right foreground, in the type of brush stroke used to represent the windblown tree or the curve and bend of the bamboo above the hut, one senses an elegant and refined decorative quality within a masterful *shin* style. The combination

570. *Wind and Waves.* By Sesson Shukei (c. 1504–c. 1589 C.E.).
Hanging scroll; ink and slight color on paper; 8³/4"
(22.2 cm). Japan. Muromachi period. Nomura Art
Museum, Kyoto

is so simple and arbitrary that, in order to sustain it, each
brush stroke must be flawless. Even in passages close to
the *so* style, the same elegance and decorative quality
inform each individual brush stroke. No one could mis-
take his work for Sesshu's. The effect is perhaps more cal-
culated and less immediate, but it is certainly much more
"stylish," with a light and witty quality quite lacking in the
paintings of the fifteenth century. Shubun, Sesshu, Shokei,
Soami, and Sesson are the leading masters of Japanese
painting in the fifteenth and early sixteenth centuries.

THE KANO SCHOOL

The founding and early development of the Kano school
are artistically significant; its later manifestations seem
conservative and a matter of national historical interest.
The school is traditionally derived from Kano Masanobu
(1434–1530 C.E.), represented here by one important
masterpiece, a painting of the Chinese scholar Zhou
Maoshu, seated in his boat under an overhanging willow
tree, admiring lotuses (*fig. 571*). In general it recalls the
richness and breadth of Shubun but with some decorative
qualities more suggestive of Shokei or Sesson. It is not a
standardized or academic work, though the Kano school
did ultimately standardize the monochrome style. The
school became in a very real sense an academy, with a
founder and an elaborate genealogy of acknowledged

571. *Zhou Maoshu Admiring Lotus Flowers.* By Kano Masanobu
(1434–1530 C.E.). Hanging scroll; ink and slight color
on paper; h. 36" (91.4 cm). Japan. Muromachi period.
Nakamura collection, Japan

572. *Summer, from Flowers and Birds of the Four Seasons.* By Kano Motonobu (1476–1559 C.E.). Two of eight sliding screens, now mounted as hanging scrolls; ink and color on paper; h. 70¹/₈" (178 cm). Japan. Muromachi period, c. 1510 C.E. Daisen-in, Daitoku-ji, Kyoto

masters. Kano masters also undertook art criticism and the authentication of paintings, both of the Kano school and of Chinese and Muromachi monochrome types.

More than any other painter, Kano Motonobu (1476–1559 C.E.), Masanobu's son, crystallized a Kano style. Motonobu's most famous works are at the Daisen-in of Daitoku-ji in Kyoto, in the form of quite large hanging scrolls originally used as sliding screens, or *fusuma* (*fig. 572*). Plants and birds of the four seasons, decoratively treated, was already a popular subject, as attested by such works as the flower-and-bird (*kacho*) folding screens attributed to Sesshu (*see fig. 564*). But Motonobu's attack on realism is infinitely more daring, creating a boldly arbitrary decorative scheme that carries over a great distance. The marked S curve of the pine trunk crossing the sharply unreal, "frozen" waterfall, is a remarkable invention, which would be further developed in the great castle decorations of the Momoyama period. Motonobu was but thirty-three when he received this commission. Together with his marriage to the daughter of Tosa Mitsunobu (act. c. 1469–c. 1521 C.E.), head of the paint-

ing atelier of the imperial court, these paintings sealed his position among major patrons of the day—the Imperial Household, the shogunal government, the daimyo, and the important Zen temples. Their patronage continued until modern times and was the prime agent of the Kano atelier's continuing dominance, even after its eighteenth century decline into skillful conservatism.

ARCHITECTURE AND LANDSCAPE ARCHITECTURE

Architecture in the Muromachi period shows the growing influence of certain Chinese temple styles rapidly merged with earlier Japanese traditions into a simple, light, and serene style. Its best qualities are seen in aristocratic pavilions and in teahouses. Temple buildings become overelaborate, particularly in their bracketing, and also develop a tendency toward minutely detailed surface embellishment approaching cabinetwork. The most famous temple structure in the *kara yo,* or Chinese Zen style, is the relic hall (*shari-den*) of Engaku-ji in Kamakura, dating from

573. *Shari-den (relic hall) of Engaku-ji.* Kamakura, Japan. Late Kamakura period, c. 1282 C.E.

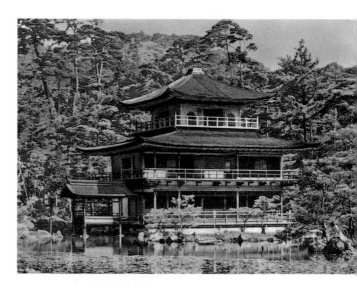

574. *Kinkaku (Golden Pavilion) of Rokuon-ji.* Kyoto, Japan. Muromachi period, 1397 C.E.

about 1282 C.E. (*fig. 573*). Its heavily thatched double roof is a later addition; the original roof was of tile and much lower in profile. The brackets under the eaves have increased in number and intricacy past the point of function. Fine, delicate window and door openings and latticework are distinctively Chinese, quite different from the strong architectural treatment, whether simple or complex, of earlier Japanese styles.

The most successful and interesting buildings of the Muromachi period are those associated with leisure and pleasure—with the contemplation of the moon, the landscape, or the garden, and with the tea ceremony. The most famous of these, tragically destroyed in 1950 by a crazed Japanese monk, was Kinkaku (Golden Pavilion), the private chapel of the shogun Yoshimitsu's Kitayama Villa in Kyoto (*fig. 574*). After Yoshimitsu's death in 1408 C.E. the Kitayama Villa was converted into a Buddhist temple, formally named Rokuon-ji but popularly called Kinkaku-ji, Temple of the Golden Pavilion. It has lately been rebuilt according to the original plan, but of course with new materials. The illustration shows the original structure, set on a manmade platform jutting out into a pond and surrounded by pines and deciduous trees carefully planted in "natural" profusion to show seasonal changes in foliage to best advantage. The pond has small rock islands, artificially created to appear spontaneous and natural. It could be a scene from a Southern Song painting, but was most likely inspired by the "Western Paradise gardens," such as the one at Phoenix Hall of the Byodo-in, in Uji (*see fig. 434*). Elaborate bracketing is not used in this "secular" style structure, whose lower two stories were intended for Amidist worship, while the top floor was a Zen meditation hall. Tile roof and round columns, typical of Chinese style, are avoided. The roof is of native shingle and the whole is constructed of squared

timbers with plain surfaces of largely natural wood, though the roof line, most of the exterior, and parts of the interior were actually covered with gold leaf; hence the name Golden Pavilion. The posts along the exterior corridors of the simple three-story post-and-lintel structure are placed with deliberate asymmetry. The whole is consciously nonchalant, carefully calculated to appear both opulent and spontaneous. Kinkaku-ji can serve as an architectural metaphor for the commingling of Amidism and Zen, of courtly and warrior taste, which occurred during the Muromachi period.

About a century later, in emulation of Kinkaku-ji, Yoshimasa, the eighth Ashikaga shogun, built Higashiyama Villa, later converted into Jisho-ji. Its Kannon chapel is popularly called Ginkaku (Silver Pavilion), though the intended silver leaf was never in fact applied (*fig. 575*), and from this the complex derives its popular name—Ginkaku-ji, Temple of the Silver Pavilion. Ginkaku-ji is almost a small version of Kinkaku-ji, with two stories instead of three. Nearby on the same estate, in a garden designed by the painter Soami, is the Togu-do, a small four-room building that served Yoshimasa as Amida chapel, study for copying the sutras, and teahouse (*chashitsu*, the first such structure in the modern sense of the term). In the chapel a portrait sculpture of Yoshimasa has replaced the original sculpted Amida trinity. The essential elements of the teahouse, already present in the nature-viewing pavilions, have here become far smaller, humbler, and simpler.

It is no coincidence that the Ashikaga shoguns, especially Yoshimitsu (1358–1408 C.E.) and Yoshimasa (1436–1490 C.E.), formed fine collections of Chinese paintings and art objects (J: *karamono*, "Chinese things"). Figures 474 and 486 entered Japan as Ashikaga acquisitions. The "Three Ami" served the shogunate as connoisseurs and

575. *Ginkaku (Silver Pavilion) of Jisho-ji.* Kyoto, Japan. Muromachi period, c. 1483 C.E.

curators of the collections, and as advisers on the appropriate settings, modes of display, and uses for *karamono.* They also functioned as impresarios of all the arts in the "new style," including *no* drama and gatherings at which Chinese poetry was composed.

The tea pavilion, based on a combination of Chinese pavilions seen in paintings and actual farmhouses seen in Japan, is an unpretentious structure whose subtlety and refined detail were calculated to appeal to the complex tastes and motivations of the cultured samurai. Stone platforms, characteristic of Chinese style, were replaced by pilings or wooden posts under the floor structure, almost as in Fujiwara secular architecture. This native Japanese style, modified by the simplicity of contemporary Chinese taste, was placed at the service of Zen and of its accompaniment, the tea ceremony.

An integral part of the teahouse was its surrounding garden, which could be of various types. A large garden, such as the one around the Golden Pavilion, was like a beautiful glen or clearing in the woods, though meant to evoke Buddhist paradises. Sand gardens were also made, some large, as at Higashiyama, where the dry sand was conceived as water, the rocks as islands, and the larger trees and shrubs as distant mountain ranges or other land forms in the midst of the water. Significantly, many of these gardens were designed by the most famous painters of their day, including Soami and Sesshu. In a curious inversion particularly characteristic of the subtlety and complexity of Japanese taste, the garden was conceived of very much as if it were a painting. Out of the raw material of nature, the landscape painter made gardens to look like paintings. No convolution could be more suited to the Japanese taste. The sand gardens are intended only for contemplation—landscape paintings in the round, so to speak, to be viewed from all sides but not entered.

Strolling would destroy the fragile raked patterns. In contrast with these arrangements of sand and rock are the moss gardens, landscapes created not of white and black, as in ink painting, but of tones of green. The effect is richer, more sensuous, perhaps related to the old native tradition of landscape painting and to the Japanese garden of the Fujiwara period.

Perhaps the most interesting of all is the tiny garden, representing in microcosm the vastness of nature with nature's own materials. The most famous of these, and by all odds the most beautiful, is the Daisen-in garden in Kyoto, whose design is attributed to Soami (*fig. 576*). This small garden, constructed of rocks, sand, and shrubs—the sand intended as water, the rock slabs as a bridge from one spit of land to another, and the carefully selected rocks of the background serving as a mountain range—is, in an area of ninety-two square yards, one of the greatest of all the gardens in Japan. It is meant to be seen from the two adjacent porches of the abbot's house and from its approach, where it is possible to sit in the changing light of day or evening and contemplate a landscape as rich and complex as a painting by Shubun or Sesshu.

Even more famous, certainly more commented on, is the raked white gravel garden of Ryoan-ji (*fig. 577*), the Kyoto Zen temple where fifteen rocks artfully placed evoke a broad vista within an actual enclosure of 260 square yards. Small patches of moss promote the suggestion of landscape. Austerity may be the keynote of Ryoan-ji's "dry landscape," but conscious rationality is present as well, in the careful patterning of the raked white gravel and in the spacing of the weighty, dark, enigmatic rocks. By contrast, the smaller garden of the Daisen-in of Daitoku-ji seems more intuitive and spontaneous, somewhat like a *hatsuboku* ink painting. Though many Japanese gardens are designed to be walked in, these two

576. (opposite) *Garden of the Daisen-in of Daitoku-ji.* Attrib. Soami (d. 1525 C.E.). Kyoto, Japan. Muromachi period

577. (right) *"Dry Landscape" garden of Ryoan-ji.* Kyoto, Japan. Muromachi period

great gardens of the Muromachi period are as clearly meant for contemplation as the hanging scrolls placed in the *tokonoma* of the teahouse.

TEA CEREMONY

The tea ceremony (*cha no yu*) was a significant byproduct of the same Muromachi culture that produced the related arts of monochrome landscape painting and garden design. But it is debatable whether the cult of tea is a proper subject for inclusion with the visual arts. Like the dance, the tea ceremony is a series of actions involving the use of works of art—gardens, teahouses, iron kettles, bowls, dishes, hanging scrolls, and others. Beginning as an informal and uncodified meeting of congenial spirits—*cha no yu* means simply "hot water for tea"—it became a rigid cult of taste, as ritualistically and artificially dedicated to simplicity as a Byzantine coronation was dedicated to mystic splendor. The actual event in both cases became something less than met the eye.

Tea was first imported from China by the ninth century, enjoyed a brief vogue before falling out of favor, and was reintroduced in the context of Zen monastic life by the monk Myoan Eisai on his return from China in 1191 C.E. Its use in Japan for more than refreshment probably derives from the ceremonious tea drinking of Tang and Song literati and Chan monks. On such occasions the color and savor of the tea were discussed and judged, along with the appreciation or even creation of poems and works of art. In Chan monasteries tea was used as medicine, as a stimulant, and as a pleasant interlude in knotty discussion or deep meditation. We have seen that a kiln complex in China's Fujian Province specialized in producing Jian ware solely in the form of bowls especially designed for the drinking of tea. The combination of Zen tea and Temmoku teabowl was certainly established in Japan at the beginning of the Muromachi period. It seems equally certain that the tight codification of the tea ceremony did not begin until the end of that period, at the same time that the art of monochrome painting began to suffer from the comparable formalism of the later Kano school of painting.

The traditional founder of the ceremony was the Zen priest Murata Shuko (c. 1422–1502 C.E.), who reputedly designed the first tea ceremony and the first teahouse (Yoshimasa's Togu-do), with the aid of the painter and connoisseur Noami. His patron was the shogun Yoshimasa, whom we have already noted as a great aesthete and collector. But the most famous and revered name in tea is Sen no Rikyu (1521–1591 C.E.), tea master to both Nobunaga and Hideyoshi, the two successive warlord-unifiers of Japan, who ended his life by suicide at Hideyoshi's order. From Rikyu comes the first codification of tea practice, and from his time the various hereditary lines of tea masters (*chajin*). His four requirements for the ceremony—harmony, respect, purity, and tranquillity—are understandable defenses for the conservative and cultivated few against the robust, gorgeous, and sometimes gaudy tendencies of the new dominant classes of the seventeenth century. Two all-important tea ceremony qualities, *sabi* (the beauty of worn and rustic

578. (left) *Tai-an teahouse* (interior). Attrib. Sen no Rikyu (1521–1591 C.E.). Myoki-an, Kyoto Prefecture, Japan. Early Momoyama period, 1582 C.E.(?)

579. (below left) *Tai-an teahouse* (exterior). Attrib. Sen no Rikyu (1521–1591 C.E.). Myoki-an, Kyoto Prefecture, Japan. Early Momoyama period, 1582 C.E.(?)

informal garden, stopping en route by a stone water basin to perform what amounts to a ritual purification of hands and mouth in the old Shinto tradition. When they arrive at the house, a small and calculatedly rustic structure designed with only the interior in mind, they enter through an almost square entrance so small that they must bend low and literally crawl into the tea room, presumably shedding their status as they do so. In the soft light within they admire in turn the hanging scroll—either a painting or calligraphy—and the vase with a flower arrangement. These occupy the *tokonoma*, a niche specifically designed for their display. The guests then seat themselves on mats in a row, the place of honor—for rank has reappeared—being before the *tokonoma*. After they have disposed themselves, the host appears and wordlessly proceeds to serve powdered green tea to each guest in turn, preparing each bowl separately in a graceful, elaborate, and precise ritual involving an iron water kettle, bamboo water dipper, stoneware vessel for cold water, teabowls, powdered green tea from a lacquer or ceramic caddy, bamboo scoop for the tea, bamboo whisk for mixing the tea and water, incense from a lacquer or ceramic box, and a tidily folded, unfolded, and refolded silk napkin. Today the ritual even prescribes the number of sips required to drink the tea (three and one half), the *chajin*'s manner of turning the bowl on presentation, and the recipient's manner of turning it before and after imbibing. After drinking, the utensils used are laid out for inspection and admiration. The guests depart as silently as they came, but not before noting carefully the small interior with its clean and asymmetrical arrangement of windows, posts, and mats, all made of the humblest materials. Conscious rusticity combined with an almost Mondrian-like purity is the aesthetic end in view (*figs. 578, 579*).

things) and *wabi* (cultivated poverty), can also be best understood against such a historical background.

Reduced to essentials, the activities of the tea ceremony participants can be simply described. The guests, usually five in number, approach the teahouse through an

580. *Teabowl named Shibata Ido.* Stoneware; diam. 5⅝"
(14.3 cm). Korea. Late 15th–early 16th century C.E. Nezu
Art Museum, Tokyo

582. *Bowl.* Seto stoneware with leaf design. Japan. Muromachi
period. Private collection, Japan

581. *Jar.* Yellow-glazed Seto stoneware with *tomo-e* design;
h. 8⅝" (21.9 cm). Japan. Late Kamakura period, 14th
century C.E. Umezawa Memorial Museum, Tokyo

Inside and out, Tai-an teahouse at the Myoki-an,
Kyoto Prefecture, illustrates almost perfectly the required
balance between geometry and rusticity. The informally
placed stepping-stones and the bamboo secondary struc-
ture, derived from farmhouse architecture, are played off
against the severe verticals and horizontals of the various
posts and lintels. In the interior this contrast is replicated
by the variety of natural textures—smooth wood, cherry
bark, and straw-supplemented clay for the walls—set

against the rectilinear patterns of the four and one-half
tatami, the *shoji* (paper windows), and the ceiling. Tai-an
is thought to have been designed by Sen no Rikyu in
1582, just after the end of the Muromachi period.

What had begun in the fifteenth century as an infor-
mal gathering has become an exercise in studied noncha-
lance with overtones of repression and symbolic poverty.
One says "symbolic" because the prices of tea ceremony
objects often reach fantastic heights, depending not so
much on their intrinsic aesthetic worth as on their history
and association with distinguished tea masters of the past.
One small implement may sell for more than half a mil-
lion dollars.

The recent fossilization of *cha no yu* is mirrored in
the extreme self-consciousness of the nineteenth and
twentieth century objects used in the ceremony. A tea-
bowl made on the wheel may be purposely bashed into
asymmetry in emulation of the artless asymmetry of the
beautiful Korean Ido bowls produced for peasant use
during the late sixteenth and the seventeenth century
(*fig. 580*). The tea wares produced in Japan in the late six-
teenth and seventeenth centuries, largely in the neigh-
borhood of Nagoya at the Seto kiln complexes, have
abundant natural charm. Beginning with olive- or brown-
glazed stonewares of the late Kamakura period, the Seto
potters developed a varied repertory of wares for everyday
as well as tea ceremony use (*fig. 581*). Bowls imitating
Chinese Jian ware are the first evidence of a specialized
tea production, and these rather simple wares are fol-
lowed by more accomplished and artful ones. Yellow Seto,
with its freely incised floral and vegetable designs height-
ened by splashes of soft green, is one of the rarest and
most attractive of these later efforts (*fig. 582*). Shino
wares, produced at the Mino kiln complex some fifteen
miles north of Seto, in Gifu Prefecture, use an opaque,

583. *Storage jar.* Shigaraki stoneware; h. 16¹/₂" (41.9 cm). Japan. Muromachi period, 14th–15th century C.E. Cleveland Museum of Art

584. *Kettle.* Iron; h. 7¹/₈" (18 cm). Japan. Muromachi period. Cleveland Museum of Art

thick, and bubbly white glaze, transparent where it runs thin, enlivened by hastily but delicately drawn black or dark brown floral or abstract designs. Orange-brown streaks occur where the iron oxide of the painted decoration bleeds into the glaze during firing, and these random patches of color are considered to enhance the beauty of the ware. Production consists mostly of teabowls and cold water vessels (*cpl. 43, p. 344*). Oribe ware is characterized by boldly asymmetric shapes in teapots, bowls, plates,

and serving utensils. Its equally novel and asymmetric designs are executed in iron brown pigment or white slip, and the glazes are mostly pale buff or bright green and blue. Kilns in other regions, notably those that followed a medieval folk tradition, continued to produce their monochrome brown, olive, and unglazed biscuit wares, but in shapes appropriate to the tea ceremony. The best known of these are the so-called Six Old Kilns: Bizen (Okayama Prefecture), Shigaraki (Shiga Prefecture) (*fig. 583*), Iga (Mie Prefecture), Tamba (Hyogo Prefecture), Tokoname (Aichi Prefecture), and Seto (Gifu Prefecture).

The great artistic contribution of the early tea ceremony consists in these ceramics, so different in appearance from the subtle perfection of the Chinese wares. These Japanese stonewares are justly admired by contemporary Western potters for their rugged simplicity, their daring asymmetric shapes, and designs paralleling the developments of seventeenth century decorative painting and expressing the qualities implied by the words *wabi* and *sabi*. The same may be said of the iron kettles, made primarily at Ashiya in Fukuoka Prefecture, Kyushu (*fig. 584*). Teahouse architecture reflects on a small scale that peculiarly Japanese originality expressed more completely in religious and domestic architecture. Although the tea ceremony is of interest as an exercise in taste and a symbol of later Japanese aestheticism, it also seems an appropriate subject for cultural history and anthropology as well as for the history of art. The many other manifestations of art in the Muromachi, Momoyama, and Tokugawa periods should place it in proper perspective as an expression of elite conservatism as well as an effective instrument for aesthetic education.

CHINESE AND JAPANESE ART: THE NATURE OF THE DIFFERENCES

A recurring problem in East Asian art is to discover the similarities, differences, and relationships between Chinese and Japanese works. Defining the differences is difficult indeed for such a period as the sixth through ninth century C.E., when Japan adopted Buddhism and with it the Tang Chinese International style (*see chap. 7*). Since the Japanese of the Asuka and Nara periods adopted the Chinese style virtually in toto and intact, such works as the *Hokke Mandala* (*see cpl. 14, p. 205*) still escape final classification as Chinese or Japanese.

The questions become more productive applied to the art of the Muromachi period. Muromachi styles in architecture, sculpture, painting, and ceramics are clearly derived from near-contemporary China but are given final shape by a people with some six hundred years of sophisticated, complex, urban artistic production behind them. The differences now are not so difficult to identify and define in a way that can be helpful in understanding

the originality of Japanese art even at a time of deep Chinese influence.

If we compare two hanging-scroll landscapes, one by Ma Yuan (*fig. 478*) and one by Tensho Shubun (*fig. 559*), the Chinese work seems more solid, closer to nature in its representation, more rational in its careful location of receding planes and specific treatment of foliage. Shubun's painting, a nostalgic view of a China he has never seen, appears more casual and improvisatory, suggestive rather than explicit.

Both masters are making *pictures,* to which Chinese critics of later times denied the name of "art." That term they reserved for scholars' painting (*wen ren hua*), which emphasizes rationality and calligraphic rectitude of brushwork as metaphors of the ideal order of the cosmos and the elevated character of the artist. Because Chinese theorists of late Ming and after disparaged representation and decried visual loveliness, whereas the Japanese cherished both, the Chinese did not collect Japanese paintings, but the Japanese avidly collected Chinese paintings of the Ma-Xia school and its Ming academic derivations.

Xia Gui's long handscroll (*fig. 481*) is a particularly telling foil to Sesshu's (*fig. 561*). One of the most manifest differences between them lies in the extremes of tone and brush stroke practiced by the Japanese artist in contrast to the "blander," more even approach (suggestive of the Confucian "Middle Path") of the late Southern Song master.

This same restraint characterizes Lin Liang's *Peacocks* of about 1500 C.E. (*see fig. 634*), decoratively intended but avoiding bold asymmetry or representational distortion. Kano Motonobu's *Flowers and Birds of the Four Seasons* (*fig. 572*) reveals no such inhibitions. Motonobu manipulates his pine into an extravagant reflex curve, carves his waterfall of ice, and produces a work of decorative bravura. These characteristically Japanese qualities—decorativeness and exaggeration—seem merely vulgar to Chinese mainstream critics.

The differing criteria of the two nations are even more obvious in ceramics. The Chinese require symmetry and an approach to technological perfection. By Chinese imperial and aristocratic standards Jian ware teabowls (*fig. 508*) are crude. Hence their appeal to the Japanese, who prize the spontaneity, roughness, and asymmetry of folk wares (*fig. 583*), and who find perfection in such seemingly artless, casually made vessels as the Shino water jar for the tea ceremony (*cpl. 43, p. 344*).

In gardens too the contrasts reflect the differing assumptions of the two nations. Chinese gardens are mostly designed to be walked through (*cpl. 44, p. 425*), reflecting the Chinese view of nature as a process revealing fundamental principle (*li*). The grotesquely twisted trees and weathered rocks so prominent in Chinese gardens recall the Confucian respect for longevity and for human character formed by service and adversity. The Daisen-in and Ryoan-ji gardens (*figs. 576, 577*) are visual set pieces, meant not for strolling but for viewing from without; they are paintings in which nature itself is the brush and ink, intuitive images designed for pictorial contemplation. Native Chinese and Japanese landscape painting styles, and writings about landscape painting, express the same difference: Chinese landscape paintings are settings through which the viewer may journey in spirit, whereas landscapes in native Japanese style hold the viewer outside the picture plane, looking in.

The differences between Chinese and Japanese art can be summarized, perhaps too simply but usefully, in pairs of categorical opposites: rich/poor, imperial/feudal, gentry/folk, mastery of medium/submission to medium, smooth/rough, balance/asymmetry, ideal/real, word/image, reason/intuition, mean/extremes. Despite exceptions, these polarities supply for most Chinese and Japanese art a framework that allows us to distinguish and to celebrate their crucial differences.

17

Later Chinese Art: The Yuan, Ming, and Qing Dynasties

THE YUAN DYNASTY

In their progress from nomad horde to Yuan dynasty (1271–1368 C.E.) the Mongols were materially aided by Chinese foreign policy. This policy of "using barbarians to fight barbarians" had in the early twelfth century rid the Chinese of their old enemies the Liao, but the price they paid to their erstwhile allies, the Jin, was all of northern China. A short century later the Southern Song government embraced an identical opportunity with far worse results. The Mongols, with Song help, annihilated the Jin, laying north China waste in the process, and went on to the destruction of Southern Song as well, becoming the first "conquest dynasty" to master all of China. Kubilai Khan (Great Khan 1260, Emperor of China 1280–1295 C.E.), unquestionably the most perspicacious of the Yuan rulers of China, made conscientious efforts to be simultaneously Mongol khan and Chinese emperor. Long before 1279 he enjoyed the counsels and services of numerous defected Chinese scholar-officials. Probably on their advice, measures were undertaken to restore China's war-ravaged economy, to carry out the imperial rituals and ceremonies of China's three religions, and to patronize traditional Chinese arts. To preserve Mongol preponderance in government, however, the civil service examinations were abolished. Marco Polo, in the service of Kubilai Khan, was overwhelmed with admiration for Yuan China.

But to many Chinese scholar-officials the *Pax Mongolica* and its enhancement of trade, and the rude creative vigor of Mongol tastes, counted as less than nothing against the brutality of the conquest, the repugnant and unassimilable foreignness of Mongol culture, and the rapid descent into incompetence and corruption of an administration mostly foreign-staffed and ill adapted to Chinese governance. Considerations of personal and, even more, of family advancement dictated service to the new regime. Confucian precepts of political loyalty, reinforced by deep distaste for the Yuan, demanded retirement from the "dusty world" into private life and political noncooperation.

Ceramics

Fourteenth century achievements in the ceramic tradition are of the utmost importance for the future development of porcelain. Traditional ceramics, on the whole, declined in quality, due in part to a relative decrease in court patronage for fine wares. The Cizhou tradition of decorated slip ware, made for high and lower classes alike,

585. *Jar.* Cizhou stoneware; h. 11" (27.9 cm). China. Yuan dynasty. Cleveland Museum of Art

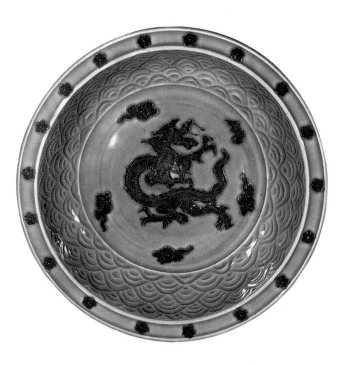

586. *Basin.* Longquan Celadon porcelaneous stoneware; diam. 17" (43.2 cm). China. Yuan dynasty. Cleveland Museum of Art

587. *Bowl.* Shufu porcelain; h. 3¹/₂" (8.9 cm). China. Yuan dynasty. Cleveland Museum of Art

continued in the Yuan dynasty, using the traditional techniques, perhaps with less refinement and with greater emphasis on painting than on the more complicated and expensive techniques of incising and inlaying. Painted jars are rather bolder in their decoration and tend toward a more pictorial treatment of the design. A frame is placed about the picture, as the dragon on the jar in figure 585 illustrates. The borders, which in Song dynasty wares tended to be integrated into the main design, are in Yuan wares also framed, like applied strips of continuous decoration that are often cut off at top and bottom. Nevertheless, the robustness of Yuan period draftsmanship, combined with the usually vigorous qualities of northern slip-decorated stoneware, maintained the traditions of this ware.

The same was not altogether true of other classic wares of the Song dynasty. Jun ware tended to become somewhat simpler and cruder in its techniques and coloring. Ding ware declined in importance. Longquan and other celadons produced in the south continued rather high in quality, particularly in vessels displaying a new decorative technique: On the flat surface of the glazed but unfired dish, stamp-molded decorations of unglazed clay would be applied; on firing, these would bond to the celadon glaze and turn a handsomely contrasting terracotta color, like the dragon, cloud-scrolls, and border florets of figure 586. This is a move away from the monochrome glazes over slight relief patterns or none, characteristic of Southern Song wares, and toward the designs in highly contrasting colors characteristic of later Chinese porcelains.

Chinese porcelains from the Yuan dynasty until modern times have developed out of a combination of two ceramic traditions. One is Yingqing ware, the pale blue or sky blue porcelaneous stoneware made principally in Jiangxi Province; the other is a robust form of decoration in underglaze blue. An obvious offshoot of Yingqing wares is the Yuan court ware called by the euphonious name Shufu (*fig. 587*). Its body material resembles Yingqing, but is more refined and homogeneous, whiter, thicker, and stronger. The glaze is pale blue-green, thicker and more opaque than Yingqing glazes, and the bond between glaze and body is more cohesive. The result is a ware with a slightly thick, milky

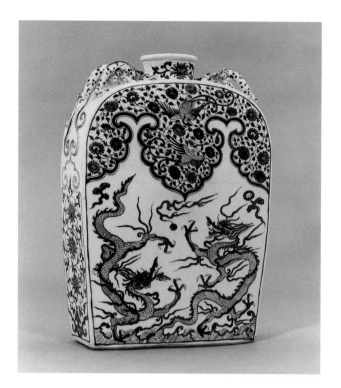

588. *Flask.* Porcelain with decoration in underglaze cobalt blue; h. 15³/₈" (38.9 cm). China. Yuan dynasty, c. 1350 C.E. Idemitsu Museum of Arts, Tokyo

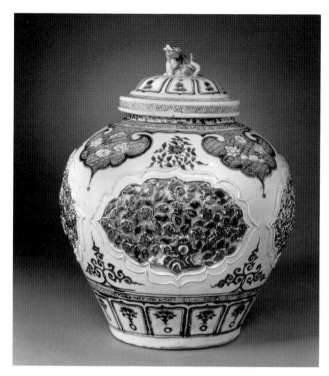

589. *Guan covered jar.* White porcelain with decoration in underglaze blue and red, openwork, and pearl beading; h. 16⁵/₈" (42.2 cm). Excavated Baoding, Hebei, China. Yuan dynasty. Palace Museum, Beijing

quality in the glaze and a pleasing heft when lifted. It combines the strength of the celadons with a color very close to that of Yingqing wares. Now this Shufu ware had a relatively short production span, but decoration added to it in underglaze blue began the great Chinese tradition of Blue-and-White. The earliest vestige of cobalt blue-and-white dates from Tang, but its continuous development began only in the fourteenth century.

In all Blue-and-White wares the body fabric is a fine white porcelain related to Shufu. On pieces of Yuan date the transparent glaze is slightly green-tinged over the underglaze cobalt decoration on the white body. The forms are mostly traditional ones, including jar shapes found also in Cizhou ware (*figs. 585, 589*), large dishes, elaborate "temple vases" like the famous dated examples in the Percival David Foundation in London (dated to 1351 C.E.), small stem cups, and *mei ping* vases. They combine the strength to be found in folk wares with a rich decoration that would have been considered barbarous in the Southern Song period but evidently satisfied the new Mongol ruling class.

In addition, we find in the Yuan Blue-and-White repertory some utterly un-Chinese shapes. One such is the flask in the Idemitsu Museum (*fig. 588*), a piece remarkable for its opulent decoration, brilliant color, and combination of foreign shape with Chinese decorative motifs. Above a narrow band of waves drawn in typical Yuan fashion are two dragons pursuing a flaming pearl. Mantling the shoulder of the vessel are two *feng-huang* against a peony-scroll background that forms the lobed

and pointed lappet silhouette called a "cloud collar." In the postures of each pair—one rising, the other descending—the *feng-huang* and dragons subtly echo one another. All these motifs are purely Chinese, but the penchant for containing decoration within strongly marked outlines is new in the Yuan dynasty. The decoration, somewhat pictorial on this flask, is even more so on many plates and jars.

In the large covered Guan jar (*fig. 589*) we see yet another innovation of the Yuan potters, decoration in underglaze copper red. The jar was excavated near one of the walls of Beijing, site of Khanbaliq, the Mongols' "great capital" (C: Dadu). In the pierced (*ajouré*) design of chrysanthemums underglaze copper red colors the blossoms, cobalt blue the leaves. The "pearl beading" that borders the chrysanthemum cartouches was often used by Yuan potters in conjunction with openwork floral motifs; it also appears frequently on the Yingqing wares from which Blue-and-White was derived. As on the flask (*fig. 588*), most of the decorative motifs on the jar are firmly outlined, with cloud-collar lappets (here enclosing designs of lotus ponds) again mantling the shoulder of the vessel. Copper-oxide red easily turns gray or brown at high firing temperatures, and its use was but fitfully mastered. Its decorative appeal remained strong, however, and its vagaries were overcome by seventeenth century potters. The techniques and the decoration of these two vessels are revolutionary, and they establish a new direction for Ming and Qing porcelain.

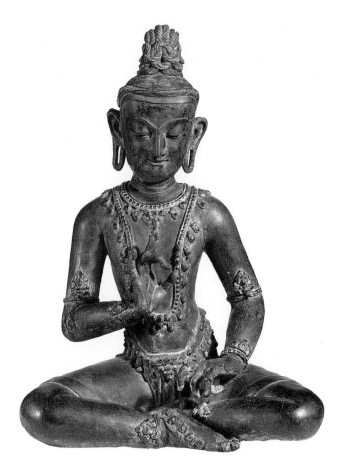

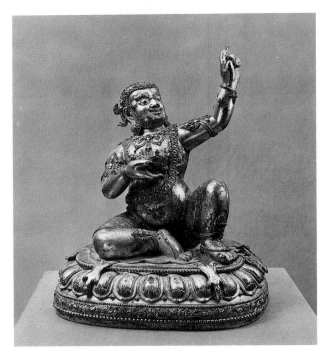

591. *Mahasiddha Virupa.* Gilt bronze; h. 17" (43.2 cm). China. Ming dynasty, mark and reign of Yongle (1403–1424 C.E.). Cleveland Museum of Art

590. *Bodhisattva.* Dry lacquer; h. 22⁷/₈" (58.1 cm). China. Nepalese style. Yuan dynasty. Freer Gallery of Art, Smithsonian Institution, Washington, D.C.

Sculpture

Sculpture continued under imperial patronage. Secular sculpture comprised mostly large-scale relief decorations for walls and gates, and Buddhist sculpture revived under the impetus of the new Tantric, or Esoteric, sects, whose complicated forms derived ultimately from Nepal and Tibet. The Mongols and the Central Asians who flocked after them into China were strong adherents of these sects, and many sculptures of the time show Himalayan influence or handiwork.

In 1263 there arrived at the court of Kubilai Khan, not yet master of all China, a famous young Nepalese artist, Aniko (1244–1306 C.E.), master of painting, sculpture, metalwork, and textiles. Aniko rose rapidly in Kubilai's esteem, and from 1273, as Director-General for the Management of Artisans, he and his Nepalese or Chinese assistants produced a quantity of work in the Lamaist and Esoteric Buddhist modes. One of the most notable and rare examples of this influence on Chinese art is the sculpture of a bodhisattva in the Freer Gallery (*fig. 590*). Using the difficult native Chinese dry lacquer technique (*see figs. 235, 237*), the sculptor created a work in almost pure Nepalese style; only the eyes and mouth of the deity show traces of Chinese proportions. By the mid-

fourteenth century and after, Chinese artists and methods were once again dominant (*fig. 591*), and their influence is found throughout Tibet and Central Asia. The most formidable monument of later Yuan sculpture is the Juyong Guan (1342–1345 C.E.), the great free-standing ceremonial gate that marks the road from Inner Mongolia to Beijing (*fig. 592*). It is constructed of the white marble characteristic of the Zhili region (the environs of Beijing), in the form of a vaulted passageway. On its walls are reliefs of the four Guardian Kings of the Four Directions attended by assorted demons. They are carved in a revival of the powerful Tang style associated with the legendary Wu Daozi. The precision and accuracy of detail in the depiction of armor and musical instruments make this ensemble a valuable source of information on the dating of many objects of decorative art. Mandalas are carved on the ceiling, and parallel translations of a *dharani* (charm or incantation) in six languages (Chinese, Sanskrit, Mongolian, Tibetan, Uighur, and Tangut) are incorporated into the sculptural program. These monumental and vigorous low reliefs are major accomplishments of Chinese sculpture, insufficiently appreciated.

Another complex of Lamaist images can be found on the west side of West Lake in Hangzhou, at the cave-temple of Feilaifeng Si, near the Lingyin Si. Here again Nepalese, Tibetan, and Chinese styles as well as imagery are mingled.

Apart from these two complexes, Yuan sculpture consists largely of traditional Buddhist non-Esoteric subjects, executed in wood in variations of Song and Jin styles.

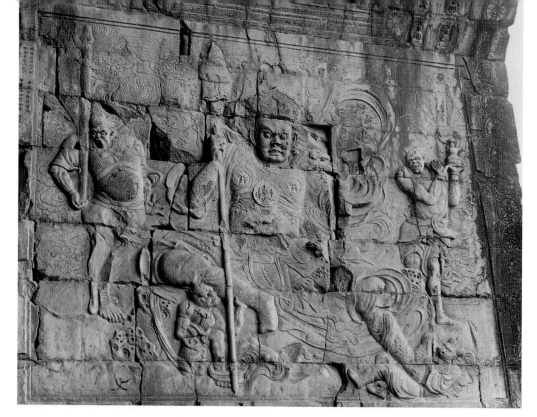

592. *Vaishravana, Guardian King of the North.* Dated to 1342–1345 C.E. Relief sculpture on interior wall of Juyong Guan; h. approx. 51" (129.5 cm). Hebei Province, north of Beijing, China. Yuan dynasty

593. *Letter to a friend named Jingdao.* By Huang Tingjian (1045–1107 C.E.). Handscroll in regular script; ink on paper. China. Northern Song dynasty. National Palace Museum, Taibei

594. *Poems in cursive script.* By Zhu Yunming (1460–1526 C.E.). Handscroll in wild cursive script; ink on paper; h. 9⅝" (24.4 cm), l. 21'5¼" (6.6 m). China. Ming dynasty. Palace Museum, Beijing

Calligraphy

Calligraphy has been esteemed by the Chinese throughout their history as an art intimately associated with poetry and belles lettres and profoundly revealing of the calligrapher. Since the same instruments (brush and ink on bamboo, silk, or paper) are used to produce both writing and painting, the exceedingly close relationship between the two arts has been recognized from early times. In the Chinese hierarchy of the arts calligraphy slightly outranks painting, if only because it is the instrument of the word and because it preceded pictorial art.

The flexibility of the brush, the varieties of ink, and the exacting discipline of mind-hand coordination produce unimaginable calligraphic virtuosities. These range in style from the solid rationality of Huang Tingjian's letter to his friend (*fig. 593*), written in lucid, formal "regular mode" (*kai shu*), to the headlong impetuosity of the "wild cursive mode" (*kuang cao shu*) employed by the most famous of all Ming dynasty calligraphers, Zhu Yunming, for a group of poems (*fig. 594*). Between and even beyond these apparent extremes are a host of other variations, as can be seen by studying the inscriptions on various works reproduced in this book. In both calligraphy and painting various orthodoxies begin to emerge during the Yuan dynasty, becoming increasingly retrospective, exclusive, and class-related during Ming. At this point in our survey it is well for us to remember the enormous variety that actually existed in the arts of the brush during Yuan.

Painting

Chinese creativity in the Yuan period flowed mostly into painting, and the innovations of this time dominated the work of all later artists. Those scholar-officials who withdrew from public life under the Mongols included many creative painters; those who took service at court tended to be more academic and conservative. As we have said, it is usually rewarding to study first in the painting of any period its traditional or conservative aspects, which reveal by contrast what constitutes the originality of its progressive works. The tradition of the Song dynasty was by no means dead, and it was continued with some degree of quality and force by numerous painters of the day. The Southern Song tradition of Ma Yuan and Xia Gui, the tradition of "one-corner" or asymmetrical composition, was continued by masters such as Sun Junze, whose works are almost indistinguishable from those of his predecessors (*fig. 595*). His paintings enjoyed extraordinary popularity when they reached Japan in the fourteenth century, but were somewhat eclipsed in the fifteenth century, when the Japanese discovered the great Southern Song masters Ma Yuan and Xia Gui.

Religious painting endured, including brightly colored

595. *Landscape.* By Sun Junze (act. beginning of 14th century C.E.). Hanging scroll; color on silk; h. 56⅛" (142.6 cm). China. Yuan dynasty. Seikado Library, Tokyo

works in Tang and Song style that preserved, with some weakening of draftsmanship and composition, the ideas of the great early Daoist and Buddhist paintings. Many of these are in the form of wall paintings, such as those of the "Yongle Palace," originally a Daoist temple in Shanxi where extensive mural decoration was completed in 1325

596. *Li Tieguai, Daoist Immortal.* By Yan Hui (act. c. 1270–1320 C.E.). Hanging scroll; ink and color on silk; h. 63¾" (161.9 cm). China. Yuan dynasty. Chion-in, Kyoto

C.E. The entire temple is now preserved in Ruicheng, some twelve miles east of the original site in Yongle.

Another and more original form of religious painting, though still not part of the creative mainstream, is best exemplified in the works attributed to the painter Yan Hui. Typically, they are found in Japan, where the Southern Song tradition has been prized, and are relatively rare in China, where it has been coolly regarded. Yan Hui painted Buddhist priests or disciples and Daoist sages, emphasizing their strange, gnarled, and rude aspects. *Li Tieguai, Daoist Immortal* gives some idea of Yan Hui's characteristic style (*fig. 596*). The large scale and massiveness of the figure recall the Tang tradition of

597. *Shi De* (one of two paintings of Han Shan and Shi De). By Yintuoluo (Indra [?]; act. 2nd half of 13th century C.E.). Hanging scroll; ink on paper; h. approx. 36" (91.4 cm). China. Yuan dynasty. Maeyama collection, Tokyo

598. *Two Doves on a Branch of a Blooming Pear Tree.* By Qian Xuan (c. 1235–after 1301 C.E.). Handscroll; ink and color on paper; h. 12" (30.5 cm), l. 38¹/₂" (97.8 cm). China. Yuan dynasty. Cincinnati Art Museum

Yan Liben, but that tradition is combined with something of the mysterious and romantic qualities of Southern Song, particularly in the distant rocks and water and in the rough and rapid treatment of the rock on which Li sits. Yan's own genius, particularly inclined to the grotesque, is to be found in the modeling of the figure itself, the sad eyes and projecting profile, the grotesquely twisted fingers and toes. Also repaying study is Yan's method, almost Western in effect, of modeling in light and shade. The solidity imparted to his figures is unusual in Chinese art, for no one developed this innovation. There were also Buddhist paintings of the new Himalayan Lamaist iconography; some of these even show the stylistic influence of Nepalese painting.

A third type of Buddhist painting, representing a continuation of Song tradition, is found in the works of monk-artists such as Yintuoluo (S: Indra?), a Chan monk of Indian extraction who was abbot of a temple in Kaifeng in the 1340s. His art, unknown in China, is found only in Japan (*fig. 597*). Yintuoluo's work is derived from the Chan-inspired tradition of Mu Qi and Liang Kai. The emphasis upon rapid and spontaneous use of ink, which reaches a culmination in Japan in the splashed ink style (C: *po mo*; J: *hatsuboku*), is evident in the picture of one of a pair of Buddhist eccentrics, where the wet, dark washes of the edges of the garment are contrasted with the gray but sharply drawn strokes representing head and fingers, strongly recalling the style of Liang Kai. Numerous painters besides Yintuoluo worked in the Chan tradition. And since many Chan monks fled from the Mongols to Japan, it is only natural that their works should be found there in considerable quantity when even their names were lost to Chinese tradition.

Another aspect of traditionalism is found in paintings that cannot be classified as religious or official but are in a sense derived from other great Song traditions. Foremost among the artists in this vein, and oftentimes grouped with painters of the Song dynasty, was Qian Xuan, born in 1235, and particularly famous for flower-and-bird painting. Qian Xuan was a traditionalist in the Confucian sense. His figure paintings illustrate Confucian virtues, and his stylistic traditionalism consists of a con-

scious archaism to be found in parts of the paintings attributed to him. Such a painting is *Home Again,* based on a prose-poem by Tao Yuanming (365–427 C.E.) and embodying both traditional and new ideals (*cpl. 45, pp. 426–27*). The scholar-official returns from distasteful government employment to his rustic home in the country. The blue-green-gold courtly style, common in Tang and early Song, is seen here in the touches of green, gold, and blue in the foreground rocks and especially in the far distant mountains to the right. The peculiar and exaggerated perspective of the old earthen wall at the far left makes it seem tilted, like the work of a Six Dynasties painter rather than a great master of the late thirteenth century. The figures too, where they are not damaged or retouched, seem deliberately stiff and archaic. On the other hand, the fluent handling of the dead branches of the tree and the carefully realistic willow tree are very much up-to-date and in the accomplished still-life manner that was Qian Xuan's specialty. This picture is one of several short handscrolls that Qian based upon the life of the great poet and scholar Tao Yuanming, all of which share this combination of realism and archaism.

But Qian Xuan is most famous as a "fur and feathers" painter, and his paintings in this genre have something of the archaic manner seen in the handscrolls with landscape and figures. The doves on a pear-tree branch, illustrated in figure 598, are executed in this formal manner. The soft browns and the careful treatment of beak and eye recall the technique in the Northern Song academic painting of the *Parakeet* (*see fig. 471*). It is precisely the spirit one would expect from the traditionalist Qian Xuan, and the charm of these rather still silhouettes seems consistent with other paintings attributed to him. The bark of the pear branch is shaded at the outer edge, giving a semblance of volume, and painted with a blotting technique that uses a dry brush to absorb the ink and color on the branches, producing a crystalline pattern that simulates the texture of the rough bark in a mixed realistic and stylized way. The flowers and leaves, on the other hand, are painted with softness and delicate precision. These are almost surely characteristic works by Qian Xuan, judging from the discovery, in the tomb of a Ming prince (d. 1389

599. *Sheep and Goat.* By Zhao Mengfu (1254–1322 C.E.). Handscroll; ink on paper; l. 19" (48.3 cm). China. Yuan dynasty. Freer Gallery of Art, Smithsonian Institution, Washington, D.C.

C.E.), of a monochrome handscroll depicting lotus, signed by the master. His work proclaims him an arch-disciple of the Song tradition rather than a forward-looking Yuan artist, despite later attempts to claim him for the literati (*wen ren*) tradition.

The second master often called a traditionalist is Zhao Mengfu (1254–1322 C.E.), so described because he gave up his loyalist reclusion and rose high in the ranks of the Yuan government. Despite this collaboration with the barbarian, he was ranked by later Chinese scholars and critics as one of the greatest of painters and calligraphers—ample proof of his abilities. Unfortunately his name has become a byword for one subject: horses. Every Oriental horse painting from the year of Zhao's birth to the present day, with few exceptions, has been attributed to—indeed, inscribed by—this master. If, however, one studies the works reasonably attributed to him, a personality and a style emerge considerably at variance with the hackneyed view of Zhao Mengfu as a realistic horse painter. The Freer Gallery possesses a very short handscroll from the former Imperial Collection, the *Sheep and Goat,* with calligraphy by Zhao at the left in his characteristic rational yet pleasingly cursive style (*fig. 599*). This painting may well serve as a standard for judging other animal paintings attributed to him. The contrast between the sheep and the goat is made preternaturally sharp. The sheep is globular, graceless, motionless, all dappled wool and stupid expresssion. But the goat is all definition, grace, and suggested movement, with emphasis on the delicate sharp hoofs, the firm spine, and the linear rhythm of the beautifully delineated long coat. The two are rendered with a minimum of line and effort, and the effect is convincing.

If this painting represents Zhao Mengfu's conserva-

600. *Bamboo, Tree, and Rock.* By Zhao Mengfu (1254–1322 C.E.). Hanging scroll; ink on silk; h. 39 1/8" (99.4 cm). China. Yuan dynasty. National Palace Museum, Taibei

601. *Autumn Colors on the Qiao and Hua Mountains.* By Zhao Mengfu (1254–1322 C.E.). Dated to 1296 C.E. Handscroll; ink and color on paper; h. 11¼" (28.6 cm), l. 36¾" (93.3 cm). China. Yuan dynasty. National Palace Museum, Taibei

tive style, there are other pictures, particularly those of bamboo and of landscape, that reveal a more original intent. The painting on silk of a dead tree with rock and bamboo at its base, in the National Palace Museum, is one of the finest examples of Zhao's originality (*fig. 600*). The rock is outlined with rapid strokes of a dry brush. The bamboo leaves are not painted in the careful traditional style, but rapidly, using a wet, heavily charged brush in an attempt to catch the warm, humid limpness of the plant. The tree is a tour de force, created with a large brush that outlined only in part the exterior edge of the trunk, leaving a rough texture of ink scraped over the silk to simulate bark and provide modeling in light and shade. This brush stroke, called "flying white" (*fei bai*) by the Chinese, is particularly associated with Zhao Mengfu. It requires extraordinary control of the brush and a sure sense of when to press and when to lift so as to produce the white areas in the center while the exterior edges of the brush produce the ink modeling. This brush discipline created bamboo-and-rock pictures that influenced painters of the fourteenth century and of the mid-Ming period as well.

Zhao's historical importance rests on at least two handscrolls in which he invented the appearances of the *wen ren,* or scholarly, style: the *Autumn Colors on the Qiao and Hua Mountains* of 1296 C.E. (*fig. 601*), and *Water Village* (*fig. 602*), recently published from the Beijing Palace Museum and dated to 1302 C.E. These are the first of the seemingly artless works whose heavy reliance on open paper and superb brushwork are the invention of Yuan artists and the hallmark of the *wen ren* style. Zhao's artlessness is obviously deliberate, as we can see by comparing *Autumn Colors* with the preceding two works. His aim seems to be to produce a work with only the barest pictorial existence, with the emphasis transferred to the writing of the brush. Obviously such a specialized manner appealed only to those "in" on the method—the *wen ren* themselves. Zhao's innovation was not to bear its full fruit until about 1350, in the work of

the Four Great Masters.

Zhao Mengfu's son, Zhao Yong (1289–c. 1362 C.E.), is far more conservative than his father, less brilliant in brushwork but rather more solid in his approach to nature's shapes. Even more specialized than Qian Xuan or Zhao Mengfu is the archaistic painter Ren Renfa. His *Horses and Grooms* (*fig. 603*) harks back stylistically to the Tang horse painters, whose high quality of line and color it perpetuates most remarkably.

A group of important painters in the Yuan dynasty seems to have worked in both traditional and progressive styles, as Zhao Mengfu did. We will consider only two, the first being Cao Zhibo, who produced several pictures now in the National Palace Museum. One is *Old Trees,* dated to 1329 C.E., recalling the works of Li Cheng and Guo Xi, with its subject matter of gnarled trees as symbols of Confucian integrity (*fig. 604*). But in the paintings attributed to the older masters forms are sharp and precise throughout. In *Old Trees,* by contrast, the foreground is sharp but the background fades out, an effect realized by a shift of light and shade that tends to make the painting visual and pictorial, something seen rather than something conceived solely in the mind and translated into brush terms. The shadowy pine in the middle ground behind the two sharply delineated foreground pines is a device developed in the Yuan dynasty and characteristic of many landscapes of that time. Still, such a picture, despite new tendencies, is fundamentally traditional. A characteristic *wen ren* rendering of a similar subject, painted some thirty years later by Ni Zan, shows how rapidly the *wen ren* style took hold and how consistent a manner it was, considering the short time of its development (*fig. 605*). Cao seems far closer to the remote past of Northern Song than to the slightly younger artists of the near future.

The second painter who illustrates this combination of conservatism and progressivism is the painter Li Kan. Li Kan too paints old pine trees, in rather a stronger and

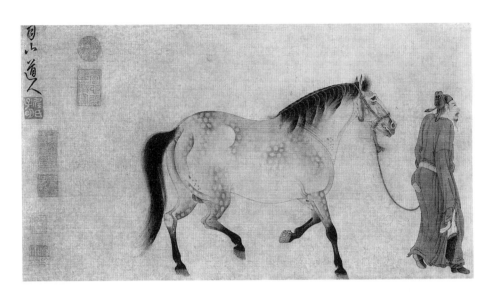

602. *Water Village.* By Zhao Mengfu (1254–1322 C.E.). Dated to 1302 C.E. Handscroll; ink on paper; h. 9⁷/8" (24.9 cm), l. 47³/8" (120.5 cm). China. Yuan dynasty. Palace Museum, Beijing

603. *Horses and Grooms.* By Ren Renfa (1255–1328 C.E.). Detail of the handscroll; ink and color on silk; h. 11³/8" (28.9 cm), l. 53¹/8" (134.9 cm). China. Yuan dynasty. Cleveland Museum of Art

more traditional style than that seen in the picture by Cao Zhibo. But in Li's painting of *Bamboo* a new style can be seen (*fig. 606*). The Chinese critic-scholar especially admires the strength of the brushwork and the accuracy of the brush in depicting bamboo leaves. No artist of the Song dynasty or earlier would have dared to emphasize so much the diffferent tones of the leaves and to omit almost completely the actual stalks of the bamboo, an unusual effect which seems to have reached its height in this work.

In Li Kan's progressive pictures a great amount of white paper shows. This implied purity is most important and leads us to the Four Great Masters of the Yuan period, whose close connection with the traditionalists is demonstrated in one beautiful picture in the National Palace Museum in Taibei, a collaborative work of two men (*fig. 607*). The bamboo is painted by the great bamboo painter Gu An, the rock by one of the Four Great Masters, Ni Zan. In the delicate refinement of that rock with its barely sketched outline, in the emphasis upon a maximum of untouched paper and a minimum of ink, we have some of the qualities associated with Ni Zan and with at least two of the other three masters.

The Four Great Masters of the Yuan dynasty—Huang Gongwang, Wu Zhen, Ni Zan, and Wang Meng—are traditionally looked upon as founders of the new school of literati painting. Unlike Zhao Mengfu, they refused service under the new dynasty. They emphasized what might be described as an art-for-art's-sake attitude, a growing development and codification of calligraphic technique, and the importance of purity and cleanliness in mood. Works on silk by these men are almost unknown—an indication of the importance they attached to the calligraphic touch of the brush on paper and to the sharpness and precision with which the paper received ink. Their subject is almost always landscape, that visible key to the invisible reality. They did not paint horses or still lifes or mundane things. It is also of some significance that they knew each other and restricted their acquaintanceship to like-minded *wen ren*. Such in-group exclusiveness was not full-blown till the end of Ming, but its implications were present from the beginning.

The canonical grouping of the Four Great Masters, the definition of *wen ren* painting, and its elevation to preeminence in the history of Chinese painting constituted a revolution in aesthetic theory. This revolution was largely brought about by the eminent Ming scholar-official, critic,

604. (left) *Old Trees.* By Cao Zhibo (1272–1355 C.E.). Dated to 1329 C.E. Hanging scroll; ink on silk; h. 52" (132.1 cm). China. Yuan dynasty. National Palace Museum, Taibei

605. (above) *Bamboo, Rock, and Tall Tree.* By Ni Zan (1301–1374 C.E.). Hanging scroll; ink on paper; h. 26¹/₂" (67.3 cm). China. Yuan dynasty. Cleveland Museum of Art

606. *Bamboo.* By Li Kan (1245–1320 C.E.). Dated to 1308 C.E. Section of the handscroll; ink on paper; h. 14⁷/₈" (37.8 cm), l. 7'8⁵/₈" (2.4 m). China. Yuan dynasty. Nelson-Atkins Museum of Art, Kansas City

607. (right) *Bamboos, Rocks, and Old Tree.* By Gu An (c. 1295–c. 1370 C.E.) and Ni Zan (1301–1374 C.E.). Hanging scroll; ink on paper; h. 36³/₄" (93.3 cm). China. Yuan dynasty. National Palace Museum, Taibei

608. (below) *Dwelling in the Fuchun Mountains.* By Huang Gongwang (1269–1354 C.E.). Dated to 1347–1350 C.E. Section of the handscroll; ink on paper; h. 12⁷/₈" (32.7 cm), l. 20'11" (5.59 m). China. Yuan dynasty. National Palace Museum, Taibei

and painter-calligrapher Dong Qichang (1555–1636 C.E.) and by members of his circle, who projected into the past ideas and attitudes of the early seventeenth century. They correctly observed that a great change had occurred in painting about 1350 C.E. (the date of completion of Huang Gongwang's *Dwelling in the Fuchun Mountains, fig. 608*), and that certain masters had accomplished that change. By 1600 they had established the Four Great Masters as eminences of the *wen ren* tradition.

Since Chinese reverence for tradition made forebears essential, Qian Xuan and Zhao Mengfu were so nominated, despite their mixed conservative-progressive output and even despite Confucian disapproval of Zhao's service to the Yuan government. The Northern Song circle of the painter-critic Mi Fu (*see fig. 468*), the poet-painter Su Shi (1036–1101 C.E.), and the calligrapher-scholar Huang Tingjian (1045–1107 C.E.; *see fig. 593*) supplied the literary sophistication, calligraphic accomplishment, and philosophical attitudes required by Dong Qichang's formulation. As remote ancestors of the *wen ren* tradition, Wang Wei and the southerners Dong Yuan and Ju-Ran (*see figs. 389, 459, 460*) were anointed.

Wen ren theory transformed the very definition of a painting from a *picture*, a visually convincing representation of a subject, to a vehicle of intellectual or emotional self-expression for the artist and an object of aesthetic contemplation for the viewer. It followed from this that the noblest minds would be also the best painters (and the only true connoisseurs), and this claim, which had been enunciated as early as the eleventh century, was duly stressed by *wen ren* theorists. Shared mediums and techniques had always linked painting with calligraphy; since calligraphy had long been interpreted as a manifestation of the writer's character, calligraphic brushwork was adopted as the appropriate mode for *wen ren* painting.

Since technical skill and polish are not innate, and have nothing to do with nobility of character, they were despised as marks of the artisan-painter, whose output was considered to be inevitably abased by his lesser virtue and corrupted by the demands of patrons or the marketplace. Amateurism—or at least the appearance of amateurism—was an absolute prerequisite of *wen ren* painting. In proof of amateurism and as a sign of gentlemanly reserve, brushwork was to be deliberately "bland," unassertive, even awkward.

Suitable subject matter was also redefined by the *wen ren* theorists. Largely disqualified were figure painting, genre and still life, narrative painting (even didactic narrative), and anything suggestive of violence or even great animation. The most valid subject was landscape—usually not particularized depictions of specific places but generalized, idealized, or literary notations of landscape compositions.

Such ideas were present in embryo during and even before the Yuan dynasty. Under Mongol rule especially Chinese literati were impelled to find some way of expressing their feelings in pictorial form, since "to serve or not to serve?" and "to live near the court or far away?" were burning moral questions and dangerously consequential decisions. Certainly the Four Great Masters and like-minded Yuan artists evince, in both their works and their words, distaste for professionalism, material profit, and representational accuracy. But though Dong Qichang found the building blocks of his *wen ren* theory in intellectual developments of the fourteenth century and earlier, his prescriptive formulation would have been quite foreign to the Yuan masters. Chinese painting from 1350 until 1600 reveals a variety of attitudes and outputs and a division by no means strict between *wen ren* and professional painters.

Huang Gongwang (1269–1354 C.E.), the oldest of the Four Great Masters, is known through very few works indeed. A long handscroll on paper, painted between 1347 and 1350 and representing the Fuchun Mountains, is one of a very few works of major importance possibly from his hand (*fig. 608*). He was influenced by the monumental style of Northern Song, but instead of the close Northern Song composition in which mountains could be seen in their fullness and to their heights, the Yuan master arbitrarily used the mountains as a means of orchestrating the length of the handscroll, cutting off the tops at will, extending the *repoussoirs* and points of land beyond the lower limits of the handscroll. Note the use of the paper and ink, particularly the closely grouped sharp strokes, which replace the older practice of dispersing the ink throughout the surface of the paper with rhythmically recurring emphases. One can say of this, as of most late *wen ren* works, that it is written, not painted. The style can be complex, as in the heavy mountain scene illustrated, or simple, as in another section of the same scroll, where the dry, almost barren topography supports only a small clump of trees at the center, revealing the close connection between the art of Huang Gongwang and that of Ni Zan. Huang's works seem more complicated and cerebral than those of his two colleagues to be considered next.

In place of rationality and complexity Wu Zhen (1280–1354 C.E.) offers intuitional simplicity, conveyed in coldly brilliant ink. His brusque shorthand, epitomized by the Chinese as the "single-stroke" style, combines rapid certainty with calculated but bold compositions and deliberately rough representations. The handscroll *Poetic Feeling in a Thatched Pavilion*, dated to 1347, embodies these qualities in a nostalgic reverie of scholarly delights, which would have been hackneyed but for the artist-individualist's deliberate obliteration of sentimentality (*fig. 609*). Until one realizes that the content of the scroll is primarily bold brushwork, supported by a daring use of open paper and sharp tonal contrasts, *Poetic Feeling* is incomprehensible. Perhaps the qualities that distinguish Wu from the other three masters grew out of his love of

609. *Poetic Feeling in a Thatched Pavilion.* By Wu Zhen (1280–1354 C.E.). Dated to 1347 C.E. Handscroll; ink on paper; h. 9³/₈" (23.8 cm), l. 39¹/₈" (99.4 cm). China. Yuan dynasty, Cleveland Museum of Art

painting bamboo, which requires ultimate discipline of brushwork and effectiveness of each single stroke. But Wu's brushwork never degenerates into mere formula. The early Chinese scholar-painter might force man and man-made things into set forms, but never landscape, the prime subject of his art. This was inviolate until the sixteenth century innovator Dong Qichang succeeded in transforming landscape into pure painting.

The *Poetic Feeling* scroll is entirely given over to the original brusque, sharp, single-stroke style associated with Wu Zhen's name, but other pictures, particularly in the National Palace Museum—notably a hanging scroll with twin pine trees by a ferry crossing—indicate his sources for that style (*fig. 610*). Like so many of the creative Yuan masters, he looked back to the monumental landscape style of Northern Song and especially to the powerful brushwork of Ju-Ran. And it was brushwork rather than monumentality that ultimately became Wu Zhen's main preoccupation. This scroll might almost be taken for a Ju-Ran, were it not that the tilted mountain creates a tension more characteristic of a later period than the tenth century. The sharp break between the foreground and the distant mountains on the far right, linked by that wide, bare expanse of water, is most typical of Yuan masters. In detail the brushwork is summary, sharp, and bold—an end in itself. Still, these essays by Wu Zhen in Northern Song style are so effective that some have been taken for Song originals, and certain paintings in the National Palace Museum, hopefully attributed to Ju-Ran or Dong Yuan, are probably by Wu Zhen. Wu Zhen's art is "rough," in the very best sense of that word. It is a sturdy, forthright style, not necessarily pleasing at first sight, largely dependent upon the strength and simplicity of its brushwork. Consequently, he is enormously admired by the Chinese

610. *Lone Fisherman on a River in Autumn (after Ju-Ran).* By Wu Zhen (1280–1354 C.E.). Hanging scroll; ink on paper; h. 74³/₈" (188.9 cm). China. Yuan dynasty. National Palace Museum, Taibei

and rather more difficult for the Western critic and connoisseur to approach.

The third of the Four Great Masters of the Yuan dynasty, Ni Zan (1301–1374 C.E.), is the most famous of them all, not only for his painting, which certainly excites our admiration and interest, but also for his legendary character. To the Chinese he was the scholar-painter par excellence, and no praise was higher than to compare a painting to the work of Master Ni. Son of a wealthy family, he began painting relatively late and always described himself as an amateur. His inscriptions record a certain nonchalance, a certain contempt for the ordinary workaday world that greatly appealed to the later Chinese scholar-critic. With the biographical clichés stripped away—the scholar-painter-amateur background, the eccentricity, the snobbism—Ni's paintings alone qualify him as one of the Four Great Masters of Yuan. In contrast with Wu Zhen and Huang Gongwang, Ni Zan's forte is neither strength of brushwork nor intellectual consistency; he is pre-eminently a poet in paint, and his style is delicate. His brush strokes are specialized: long, thin lines to define rocks or mountains, short, delicate dashes for bamboo or leaves or the shrubbery on distant mountains. His compositions are characteristically simple, usually a dominant rock, a few trees, a few sprigs of bamboo, sometimes a pavilion, often a distant mountain, never a human being. Their effect is greatly dependent upon sensitive placement and upon that tension, characteristic of the period, between foreground and background widely separated by water. The *Rongxi Studio*, its empty pavilion perhaps symbolizing the artist's disdain for humanity, is pure Ni Zan (*fig. 611*). As Chinese painting texts repeat, great painters used their ink sparingly, as if it were gold, and Ni Zan is most sparing in his use of ink. In paintings such as this the blank paper dominates, with brush strokes scattered on its surface like notes of quiet music. Ni Zan invented a characteristic brush stroke much imitated in later times—a crystalline stroke that begins fluently and then angles sharply. Such strokes are used repeatedly in the rocks and mountains, sometimes one on top of the other to produce *cun*, or wrinkles, and effects of light and shade. Ni Zan has been extravagantly admired and much imitated, making his works perhaps the most difficult to authenticate in all of Chinese painting.

Some three and one-half centuries later the great individualist painter Yuan-Ji (often called Dao-Ji) characterized Ni Zan's art: "The painting by Master Ni are like waves on the sandy beach, or streams between the stones which roll and flow and issue by their own force. Their air of supreme refinement and purity is so cold that it overawes men. Painters of later times have imitated only the dry and desolate or the thinnest parts, and consequently their copies have no far-reaching spirit."[28]

Although the tall, vertical landcape with the sharp separation of near and far is characteristic, Ni is equally

611. *The Rongxi Studio.* By Ni Zan (1301–1374 C.E.). Dated to 1372 C.E. Hanging scroll; ink on paper; h. 29⅜" (74.6 cm). China. Yuan dynasty. National Palace Museum, Taibei

famous for another type of composition, which largely omits the elements of landscape and contains only the bare essentials: a rock, a tree, and bamboo. Several of these exist, including one in Cleveland (*see fig. 605*). Here the brush strokes are crystalline and the dots are sparingly used. The same kind of dot indicates a lichen on a rock or a leaf on a tree. The bamboo is less readily recognizable than in versions by the great Song master Wen Tong, or by Li Kan or Wu Zhen, nor does it have that systematic organization or strength of brush stroke supposedly essential in all bamboo painting. Ni Zan, speaking of one bamboo painting, explains what he sought: "[Chang] I-chung always likes my painted bamboo. I do bamboo merely to sketch the exceptional exhilaration in my breast, that's all. Then, how can I judge whether it is like something or not,

612. *Lion Grove in Suzhou.* By Ni Zan (1301–1374 C.E.), possibly in collaboration with Zhao Yuan (act. c. 1370 C.E.). Short handscroll; ink on paper. China. Yuan dynasty. Location unknown

whether its leaves are luxuriant or sparse, its branches slanting or straight? Often when I have daubed and smeared a while, others seeing this take it to be hemp or rushes. Since I also cannot bring myself to argue that it is bamboo, then what of the onlookers? I simply don't know what sort of thing I-chung is seeing."[29] And by that last sentence he means that he really doesn't care, an attitude shared by contemporary painters in the West. Ni Zan stands among the first conscious rebels against tradition.

The *Lion Grove in Suzhou* (*fig. 612*), painted toward the end of his life, reveals an unusual aspect of his art. This famous garden (*see cpl. 44, p. 425*) featured curious and fantastic rock formations suggesting lions and lions' heads. Using his typical brushwork, the artist has created a composition with hardly a focal point or pattern; rather it is a collection of individual elements placed on the paper with relatively equal emphasis. Here his limitations in comparison with the other three of the Four Great Masters are revealed. Ni's compositions tend to be simple and stereotyped; everything depends on the mood and the sparse brushwork, in contrast with the boldness of Wu Zhen or the complexities of Huang Gongwang and Wang Meng. But however enjoyable the individual details of brushwork in the *Lion Grove,* one senses in its lack of focus a curious aloofness. At the left of the scroll are the famous rock formations behind a typical Ni Zan bamboo grove, more texture than bamboo. The architecture is summarily rendered and certainly repudiates the earlier pictorial idea of a believable, habitable building. Instead it is part of the new individualist trend, an abstract pattern of brush strokes intended to represent an aesthetic statement, not a gross material thing.

Its varied textures relate the *Lion Grove* scroll to the work of the last of the Four Great Masters, Wang Meng (1308–1385 C.E.). Wang was the youngest of the group

613. *Forest Grotto at Juqu.* By Wang Meng (1308–1385 C.E.). Hanging scroll; ink and color on paper; h. 27¼" (69.2 cm). China. Yuan dynasty. National Palace Museum, Taibei

and perhaps less famous in his time than Wu Zhen, Huang Gongwang, and Ni Zan. Nevertheless his style greatly influenced later Chinese painting, and in some ways he stands as the most original and creative artist of the four. Where Ni Zan was simple, noble, and elevated, Wang Meng is complex and almost coarse, with his hemplike, ropy brush strokes piled one on the other to produce masses of texture combined in dense and extremely involved overall patterns. Wang reminds us of something that much Chinese landscape painting and theory largely ignore—that nature can be restricted and unkempt as well as vast and ordered. By Yuan dynasty standards, it is a viewpoint of extreme heterodoxy. *Forest Grotto at Juqu* is the most complex and congested of his works, perhaps the most extreme example of his *horror vacui* (*fig. 613*). Nevertheless the closely woven brush strokes are not merely a surface pattern but have substance and do imply movement in restricted space. Textural analysis and variations are the staples of his style, which was somewhat tidied up in the numerous works "after Wang Meng" by later *wen ren* painters. These dynamic compositions by Wang Meng retain elements of monumentality. Their very complexity recalls details of Northern Song masters. One masterpiece by Wang Meng, *The Dwelling in the Qingbian Mountains*, dated to 1366, may with reason be considered the most monumental of all Yuan landscapes (*fig. 614*). The combination of rich brushwork, undulating contours, grand scale, and size is unforgettable—and so it proved for later Chinese painters fortunate enough to see it, such as Dong Qichang, who painted the same subject almost three hundred years later (*see fig. 648*). Wang Meng, then, is the last of the great fourteenth century masters, living into the Ming dynasty and becoming one of the recognized giants of the *wen ren* tradition.

A painting by a little-known master, Yao Tingmei, will serve to sum up the interests and contributions of the Yuan painters. It is a short handscroll formerly in the Imperial Collection, dated to 1360 and entitled *Leisure Enough to Spare* (*fig. 615*). *Leisure Enough to Spare* is on paper, the favorite ground of Yuan painters, and represents an oft-repeated subject: a hut, a scholar seated by a waterfall, an old gnarled pine tree, and distant mountains. There is nothing new in this, but the disposition of elements is important, and the brushwork more so. The twisted strokes in the rocks and trees, the crumbly textures of the rocks around the waterfall, the style of the architecture, the distant mountains, and the rhythmical swirling of the pine boughs as they reach out to repeat the rolling motif of the distant hills, all recall the style of Wang Meng. The painting is followed by colophons written by famous poets and calligraphers of the Yuan and Ming dynasties, all extolling the virtues of leisure, and particularly of scholars' leisure. In this it is characteristic of the Yuan period, when the gentleman-scholars attained

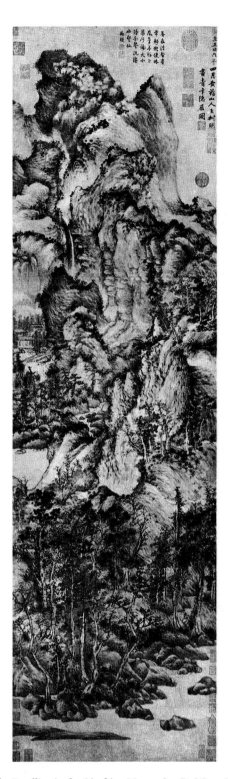

614. *The Dwelling in the Qingbian Mountains.* By Wang Meng (1308–1385 C.E.). Dated to 1366 C.E. Hanging scroll; ink on paper; h. 55 1/2" (141 cm). China. Yuan dynasty. Shanghai Museum

the pre-eminence they enjoyed till the mid-twentieth century. True painting was not a profession but a recreation of gentleman-scholars, intimately connected with poetry. Inscribed on almost all Yuan paintings, even hanging scrolls, are numerous poems, either encomiums of the painting or poetic analogues of the pictorial mood, but rarely the literal descriptions of the painting found on many works of the Song dynasty.

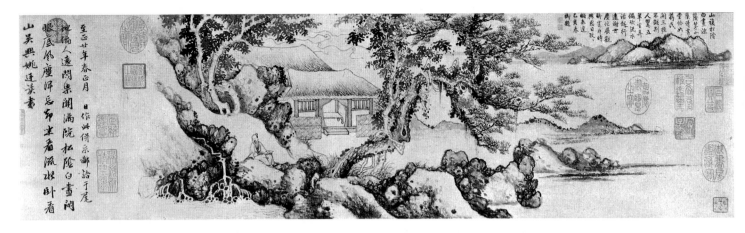

615. *Leisure Enough to Spare.* By Yao Tingmei. Dated to 1360 C.E. Handscroll; ink on paper; h. 9" (22.9 cm), l. 33" (83.8 cm). China. Yuan dynasty. Cleveland Museum of Art

THE MING DYNASTY

Beginning in the 1340s a succession of natural disasters exacerbated Mongol incompetence and disunity and Chinese antipathy to "barbarian" rule, touching off a series of rebellions that culminated in the founding of the Ming dynasty by the peasant-born Chinese Hongwu emperor. Accompanying this native resurgence was a wish to obliterate the Yuan experience and to turn back for inspiration past the defeated Song to the potent Tang dynasty. Revulsion against the Mongols may well be the root of the disdain (partly lofty, partly fearful) for all things foreign that characterizes the later empire.

Not innovation but idealization of past models marks the political and cultural institutions established during the Ming dynasty, and these institutions remained the pattern during the succeeding half millennium. At best this made for a stability which fostered prosperity; at worst it later became an intense and rigid conservatism which inhibited effective response to changing realities. In proportion to the population the governing bureaucracy was minuscule, and most of the functions of local government were carried out by local "gentry," i.e., landowners who were eligible by virtue of education for the civil service. These sponsored and supervised public works, local schools and temples, law enforcement, and emergency relief. They also constituted the intelligentsia, from whose ranks came the scholars, poets, and painters.

The founding Hongwu emperor (r. 1368–1398 C.E.) proved a ferocious and paranoid anti-intellectual whose purges decimated and depleted the literati class. His successors, fortunately, were less prone to murderous delusions. Though Ming courts were plagued more than most by cutthroat factionalism and intrigue, the arts flourished, mainly by virtue of strong imperial political and economic support in all fields. Imperial patronage was revived in painting. A great kiln complex was set up in Jiangxi Province at Jingdezhen, where all the imperial porcelains of the Ming and Qing periods were made. Lacquer, textiles, and all those industries that require stable conditions and dependable patronage proliferated and prospered.

Now, however, a real gulf appeared between art and handicraft, a split that had germinated in the attitudes of the Song scholar-painters. The scholar-painter differentiated between the work of the artist, in our sense of the word, and that of the artisan; and in the term artisan he included painters who worked in the Ma-Xia style of the Southern Song dynasty, and painters of religious pictures, and all those who were not amateur scholar-gentlemen but professionals who made their living by their art. Of course the term also included all sculptors and ceramic, lacquer, and textile workers.

Architecture and City Planning

Since the Ming dynasty was a period of strongly centralized administration and reasonable peace and prosperity, both reconstruction and new building were undertaken on a grand scale by the government. Much of present-day Beijing—the general layout of the city, the Temples of Heaven and Earth, and the palace—is Ming dynasty design, executed by the architects of the Yongle emperor (r. 1402–1424 C.E.)

The Ming architects whose work dominates the present Beijing scene made no fundamental changes in architectural construction. Earlier techniques were merely elaborated. Post-and-lintel construction, bracketing, tile roofing, stone platforms, the modular system of bays—all were retained in the Ming period.

The plan and organization of cities and of palace areas is one of the most significant manifestations of the Chinese mentality. A typical Chinese city or palace is oriented according to philosophical and cosmological concepts primarily rational in origin and geometrical in appearance. The aerial view of the Forbidden City in Beijing shows logical order and symmetrical arrangement

616. The Imperial City, Beijing, China, with the Forbidden City at center right. Aerial view, 1945

which, while characteristic of most great empires and pyramidal political structures, was developed with distinctive Chinese consistency and balance (*fig. 616*).

Since Ming and Qing times Beijing has been divided into a southern Outer City and a northern Inner City, approximately oblong and square, respectively. Enclosed by the Inner City is the rectilinear Imperial City. Within the Imperial City lies the walled enclosure, nearly square, of the Forbidden City. Its principal buildings and gates face south along the north-south axis. To either side are other buildings and gates fronting on the main axis, and yet others are disposed in walled compounds along the same north-south axis. The thickly clustered buildings east of this axis housed offices and departments of the imperial government, and their number and structural elaboration suggest the intricacy of the political organization.

The surrounding wall, so essential to a Chinese city, village, or town, temple, palace, or house, achieved not only protection but also privacy for the unit within, symbolizing that containment and strong in-group feeling characteristic of the Chinese family and of Chinese society in general.

One approaches the Imperial city from the south. The Gate of Heavenly Peace (Tian An Men) comprises five vaulted gateways topped by a pavilion with double eaves lines. This is the entrance to the Imperial City enclosed by the Inner City. A short distance beyond the Gate of Heavenly Peace is the similar Gate of Uprightness

(Duan Men), opening into a plain courtyard formerly flanked by the Altar of Soil and Grain and the Imperial Ancestral Temple. Proceeding north, one arrives at the U-shaped Meridian Gate (Wu Men), a massive structure housing government offices and topped by five symmetrically located second-story pavilions.

The Meridian Gate is the entrance to the Forbidden City and leads to a spacious courtyard crossed from east to west by a bow-shaped waterway spanned by five parallel arched marble bridges, symbolic of such auspicious fives as the five elements, the five virtues, and the five Confucian relationships. Beyond the bridges is the Gate of Supreme Harmony (Tai He Men), set high on a marble platform and flanked by subordinate buildings. North of the Tai He Men is an even larger courtyard, the precinct of the three primary ceremonial halls, whose importance is emphasized by the three-staged white marble terrace on which they stand. The largest is the Hall of Supreme Harmony (Tai He Dian), where ceremonies for the new year, the winter solstice, and the emperor's birthday were held (*fig. 617*). Directly behind stands the small square Hall of Central Harmony (Zhong He Dian), which served as a robing pavilion. Beyond is the Hall of Protecting Harmony (Bao He Dian), where the emperor met with the embassies of vassal states and with scholars whose successful examinations made them eligible for office. On either side of the surrounding court, which was walled in with galleries, were large pavilions used for libraries, temples, the government printing office, and halls for Confucian lectures and for sacrifices to ancient sages.

Behind the Hall of Protecting Harmony the Qian Qing Men (Gate of Celestial Purity) leads to the inner court, where the buildings, which repeat on a smaller scale the plan and shape of the three ceremonial halls, were devoted to less formal aspects of the emperor's life. In the Palace of Celestial Purity (Qian Qing Gong) he held audiences; imperial seals were kept in the square pavilion behind it, called the Hall of Mutual Ease (Jiao Tai Dian). The farther Palace of Earthly Tranquillity (Kun Ning Gong) was that of the empress. Beyond and surrounding this central core of palaces were walled-in compounds with gardens for royal residence, the emperor's ancestral hall, his library, offices, studies, a theater, Daoist, Lamaist, and Buddhist temples, treasure rooms, and a park.

So, through symmetry and balance, masses of buildings—relatively uniform in structure, shape, and color scheme—create a serene and magnificent pattern. Their ordering was related to their function, and the whole organization symbolized the underlying harmony of the universe which, in the age-old tradition, the emperor, Son of Heaven, maintained on earth.

Three basic building types, the hall (*dian*), the tower (*tai*), and the pavilion (*ting*), were unified by their common elements: tile roof, bracketing, stone platform, and modular bays constructed of wooden posts and lintels.

617. *Hall of Supreme Harmony (Tai He Dian).* Throne hall, as seen from the Gate of Supreme Harmony. Forbidden City, Beijing, China. Ming dynasty and after

The tile roofs of Ming buildings were highly decorative. Advanced glazing techniques permited mass production, and black-and-white photographs belie the colorful patchwork of city roofs—gray, blue, green, and, in Beijing, yellow for the imperial palaces. The effect is brilliant, not unlike the mosaic-covered domes of Persian mosques. Bracketing, too, was elaborate, with much polychrome painted decoration. In contrast to Japan, where monochromatic and subtle coloring was usually desired, the whole tendency of Chinese architecture was toward brilliance and vivid contrast.

In less official architecture, associated particularly with the residences of the aristocratic or well-to-do and even found in the Summer Palace outside Beijing, informality ruled, though the principles of balance and symmetry remained. Such buildings were less elaborate and their bracketing was simpler, tending to draw attention away from the building to its surroundings, as if the resident had consciously moved into a landscape to escape the "dusty world" of officialdom. Color, often shiny red or black, is almost always present on exteriors and interiors. Rooms are high and spacious, opening onto each other or onto the garden, somewhat like a maze. Lattice was developed in these less formal surroundings to an amazing degree of complexity and variation within the simple purpose of providing interesting grilled windows.

The garden too is a sort of labyrinth, a succession of walls and courtyards that wind away and double back, constrict and expand, offering a series of unexpected and contrasting prospects. Unlike the typical Japanese garden, which is meant to be contemplated as a single picture, the Chinese garden characteristically offers a series of compartments meant to be walked through and experienced in sequence (*fig. 618*). Unlike the restrained and natural-looking gardens of Japan, which emphasize the appear-ance of spontaneity and carefully suppress any evidence of human handiwork, the Chinese garden reflects the same interests and tastes as does painting—a fondness for old and interestingly shaped trees, sometimes of great size; flowers and living still lifes in beds or basins as if arranged from or for a painting; and above all strange and fantastic rocks that suggest mountains or fabulous beasts, such as the Lion Rocks of the garden in Suzhou made doubly famous by Ni Zan (*see fig. 612*). Pavements of cut stone, railings, and planted borders create formality reminiscent of European garden styles (*cpl. 44, p. 425*).

The Golden Valley Garden was a famous pleasance created for a shipping magnate of the third century C.E. In Qiu Ying's imaginary depiction of it (*see cpl. 49, p. 430*) we see wealth, complexity, and antiquity, the Ming criteria for a splendid garden. There are peacocks and peonies, joint emblems of wealth and beauty; old trees, both living and fashioned of coral in antique bronze vessels; brocade canopies over open pavilions; ancient fantastic rocks eroded and perforated into strange shapes by wind and water; and, though out of sight in the painting, there are surely walls all around, enclosing this vale of privileged sensibility.

The Chinese love for ancient rocks goes beyond passion to petromania. Some gardens seem crammed with grotesquely shaped, seemingly metamorphosed rocks, smaller versions of which adorn the gentleman's desk and tables. All reflect an obsession with the found (and often manipulated) object as miniature embodiment of primordial elements. Enclosing walls are (according to Nelson Wu) derived from Confucian concepts of ethics and society. The garden itself is simultaneously a place of recreation and seclusion from worldly concerns and a microcosm of nature—an allusion to the Daoist Isles of the Immortals or to the great ritual hunting parks of the

618. *Hall and garden of the Summer Palace.* Beijing, China. 17th–18th century C.E. and after

early emperors or to the "mountains and waters" (*shan shui*) that are the essential elements of landscape itself. As such, gardens are both secular retreats and manifestations of magic, metaphysics, and religion.

Ceramics

Centralization of power and money in the emperor and his court was a spur to the decorative arts. In old records the quantities of porcelains or lacquers ordered by the court for a given year are nothing short of astounding. Seventeen thousand first-class "round" pieces was a commonplace order for the imperial kiln, and this for only one year. Such figures suggest the extent of subsequent destruction: The wonder is not that we have so many Chinese porcelains but that we have so few.

In the private kilns Song traditions were maintained. The distinctions between northern and southern wares continued. Cizhou ware—northern slip-decorated stoneware—was still produced in quantity at the great beehive kilns, though the quality began to decline. In the south, in Zhejiang Province, celadon wares were made for domestic use as well as for export in great quantities. These Ming celadons are found throughout Indonesia, Southeast Asia, India, and Japan, wherever the Chinese export trade flourished. But these are fundamentally regressive wares, less fine than in earlier times. The creative wares were the imperial wares, made at Jingdezhen in Jiangxi Province.

We have seen that during the Yuan dynasty a new porcelain style evolved from the Yingqing tradition of the Song dynasty, beginning with the Shufu ware made for the Yuan court. Decoration in underglaze blue (reportedly occurring as early as Tang) proceeded in earnest from this time, and the technique was available at the beginning of the Ming dynasty for further advances and refinements. We will consider this florescence in a chronological sequence of basic types, beginning with monochrome white porcelain and white porcelain with decoration painted in underglaze blue.

619. *Vase.* Porcelain; h. 12⁵⁄₈" (32.1 cm). China. Ming dynasty, reign of Yongle (1402–1424 C.E.). Cleveland Museum of Art

The classic period for white porcelain was the Yongle reign (1402–1424 C.E.). Although Blue-and-White and monochrome colored wares were produced as well, it is usually accepted that the white porcelains of the reign are among the greatest ever made (*fig. 619*). The body of these porcelains is almost pure white with a slight grayish tinge and tends to burn slightly pink or yellow where the glaze stops. A transparent glaze enhances the brilliant whiteness of the body, and many vessels were further enriched by incised or molded decoration under the glaze, so subtle and so skillfully executed that much of it quali-

620. *Plate.* Porcelain with grape decoration in underglaze blue; diam. 17" (43.2 cm). China. Ming dynasty, reign of Xuande (1425–1435 C.E.). Cleveland Museum of Art

621. *Bowl.* Porcelain with decoration in underglaze blue and copper red; diam. 6 3/4" (17.1 cm). China. Ming dynasty, mark and reign of Xuande (1425–1435 C.E.). Percival David Foundation of Chinese Art, London

fies as *an hua*—secret or hidden decoration. Though some bowls were made by slip casting, most shapes were wheel-thrown, particularly the vases, so that their surfaces are slightly irregular. The relatively thick transparent glaze fortified the irregularity, producing an undulating surface with a texture that the Chinese liken to various citrus skins. These variations, lovingly described and catalogued by the Chinese collector, are in sharp contrast with the more perfect, glossy-smooth glazes standard in the best porcelains of the Qing dynasty.

The next step in the development of porcelains, effectively begun during the Yuan dynasty, was the addition of underglaze decoration. In the Ming dynasty such underglaze decoration in cobalt blue was applied in a variety of styles and with extraordinary color control. Although Blue-and-White porcelain was made during the Yongle reign, the Xuande reign (1425–1435 C.E.) is considered by many to be its classic period, in which decoration achieved a notable clarity of drawing and richness of color. This mastery is exemplified in the large plate with concentric designs of grapes, flowers, and waves (*fig. 620*). The variety of early Ming shapes is extraordinary, including dishes, vases, teabowls, wine cups, and utensils for Buddhist ceremonial offerings. The designs are typically in blue verging on blue-black, with a pleasing unevenness of shade contrasting with the more perfect but colder blues of later times. Despite their rich decoration the Xuande Blue-and-White porcelains convey an impression of austerity and simplicity.

Underglaze copper red is a far more difficult medium than cobalt blue, tending to turn faded brown or cold gray at the high kiln temperatures needed for porcelain. A few pieces of varying quality exist from the Xuande peri-

od. The dragon bowl in the Percival David Foundation shows one of the rare successful marriages of underglaze blue and under-glaze copper red (*fig. 621*).

Enamel color, later a most important decorative technique, was added to rare pieces of Xuande Blue-and-White. A singular specimen bears the six-character imperial mark, as did most of the porcelains made at the factory, inside the bowl of a stem cup decorated with a wave pattern in underglaze cobalt blue (*cpl. 46, p. 426, far left*). Sporting in the waves are mythical beasts rendered in overglaze red enamel. The addition of a second color enriches the effect. The transition from this relatively sparing use of enamels to the gay and brilliant multicolor enameled porcelains of the later Ming dynasty occurred in the Xuande reign (1425–1435 C.E.), if not earlier, but the polychrome-enameled wares were brought to perfection only during the Chenghua reign (1464–1487 C.E.) Chenghua enameled procelains are mostly of the type called Doucai, referring to decoration combining underglaze cobalt blue with overglaze enamels in some combination of red, yellow, green, and aubergine. As used in cabinet work, the term *dou cai* means "fitted," but it may also signify "contending," which makes it an apt descriptive for this color scheme of harmonious contrasts. Most Doucai pieces are small and delicate in shape, complementing their delicate color scheme. A Chenghua wine cup, once in the palace, was copied in the Zhengde reign (1505–1524 C.E.), suggesting that it was already a classic specimen. This small wine cup, only some two inches high, combines freedom of drawing and pure, clear enamel color with a glaze that was perhaps one of the finest technical achievements of the Chinese potter (*cpl. 46, p. 426, center*). The slightly greenish tinge of the glaze and the slightly yellowish burn of the thin glaze and body at the foot are firm indications of authenticity. Such wares were much copied from the next reign to modern times and are the rarest of all the enameled porcelains of China.

Five-color enamels (Wucai), which became the standard decorated ware, may also have originated in the

622. *Dice bowl*. Porcelain in curdled underglaze blue; diam. 9¹/₂"
(24.1 cm). China. Ming dynasty, mark and reign of Xuande
(1425–1435 C.E.). Percival David Foundation of Chinese Art,
London

Chenghua period but reached their apogee in the Jiajing
(1521–1566 C.E.) and Wanli (1572–1620 C.E.) reigns. They
are distinguished from Doucai wares not only by a wider
range of colors (often numbering more than five on a sin-
gle piece) but by darker, more saturated hues. To make
the small but brilliantly colored Wanli covered jar, parts of
the decoration were painted in underglaze blue onto the
white body and covered with transparent glaze. Over this
high-fired glaze the decoration was completed in red,
green, yellow, and brown enamels, and the whole refired
at a lower temperature (*cpl. 46, p. 427*). The complex pro-
cess required several firings, but the final result was a rich-
ly colored ware, admirably effective in narrative scenes
and freely painted floral designs, which became even
more refined and complex in the Qing dynasty.

The imperial kilns were set up for mass production or
at least for the division of labor. Certain workers collected
and refined the raw materials—clay and powdered
quartzite; one man made the pot; a second painted the
decoration; a third glazed it; yet others applied the enam-
els. The painting of a pot can be a rapid and even
mechanical business for a man who has done it his whole
life long, as did his father and grandfather before him,
and such hereditary specialization often obtained.

Simultaneous with the development of two-, three-,
and five-color porcelains arose monochrome porcelains of
more subtly brilliant aspect, using either colored glazes or
colored overglaze enamels. From the Xuande reign come
monochrome vessels with a copper red glaze, the so-called
sacrificial red (*cpl. 47, p. 428, right*). They are extremely
rare; genuine examples are to be counted, even from the
former Imperial Collection, on the fingers of two hands.
The red is usually a little mottled and is sometimes
described as "liver red." The feature that distinguishes this
early Ming copper red glaze from the rather more com-
mon and more famous *lang*, or "ox-blood" red, of the late
Ming and Qing dynasties is to be found where the red
meets the white of the body at foot and lip. In the earlier
"sacrificial red" vessels the transition is subtle and cloudy;

623. *Mei ping vase*. Fahua porcelain; h. 14³/₄" (37.5 cm).
China. Ming dynasty, late 15th century C.E. Cleveland
Museum of Art

in the later "ox-bloods" it is much sharper and clearer.

Predictably, monochrome blues were also made.
Uniform cobalt blue glazes were relatively common in
later reigns, but the "curdled" blue of the Xuande reign is
of great beauty and rarity (*fig. 622*). This curdled blue
embodies the same taste for forms grotesque, ancient,
and gnarled that led to the creation of Chinese rock gar-
dens. Bowls of the same shape occur often in underglaze
Blue-and-White and in plain white. This bowl has very
thick walls and appears to have been used as a dice bowl
for gaming.

The most famous monochrome ware of the Ming
dynasty is the overglaze yellow-enameled porcelain, most
often found in bowls and plates (*cpl. 47, p. 428, left*). The
classic period for resonant yellow is the reign that pro-
duced the great Doucai porcelains, Chenghua, though the
yellows of the following Hongzhi (1487–1505 C.E.) and
Jiajing (1521–1566 C.E.) reigns are also important.

Porcelains of great interest and importance were also
made outside the imperial kiln. Fahua decorated ware is
one of these, made by a process deliberately imitating
cloisonné enamel (*fig. 623*). The fired white porcelain
body was decorated with raised flowers or figures outlined
in threads of slip, and the areas inside the raised slip
boundaries were painted with various enamels. On this
lotus-decorated *mei ping* the lotus blossoms are reserved

624. *Octagonal jar.* Porcelain with overglaze enamels; h. 15"
(38.1 cm). China. Ming dynasty, early 16th century C.E.
Percival David Foundation of Chinese Art, London

625. *Guanyin.* Dehua porcelain (*blanc de Chine*); h. 17 3/4"
(45.1 cm). Fujian, China. Late Ming or early Qing dynasty,
c. 17th century C.E. Cleveland Museum of Art

in white and covered with transparent enamel, and the
balance of the design is pale yellow and pale blue enamel
against a background of dark blue glaze. The result seems
very much in keeping with the Blue-and-White tradition,
and in this vase has a restraint not always found in the
Fahua technique of later years.

Doucai and Wucai bowls and vases might be further
embellished with gilding. These were made for use in
China, but more especially for export to Japan. The vase
in the Percival David Foundation suggests their rich,
almost brocaded effect (*fig. 624*). Indeed, in Japan they
were called brocaded vessels (*kinrande*) and were very
much sought after for use in the tea ceremony. Later
Japanese imitations founded a new tradition of Japanese
porcelain in the seventeenth and eighteenth centuries.

The so-called *blanc de Chine,* a white porcelain more
properly called by its Chinese name, Dehua, was probably
inspired by the imperial porcelains of the Yongle period
(*fig. 625*). It was made in large quantities in Fujian
Province, near the seacoast, for sale in China and also for
export. The white porcelain of Fujian can often be distin-
guished from that of the imperial kiln by its creamier
color and glassier surface.

Textiles

During the Ming period the textile industry flourished.
The *ke si* silk tapestry technique was continued and was
often used to produce pictorial effects (*cpl. 48, p. 429*),
even to copy famous paintings. The results are never sim-
ple imitations but art works in their own right, with
unshaded but soft color schemes that enhance the
tapestry technique. Embroidery was put to the same uses
as *ke si,* and leading embroiderers—mostly women—
enjoyed considerable acclaim. The growing use of elabo-
rate costumes whose decoration designated the wearer's
social status or official rank provided an on-going market
(*fig. 626*). Few, if any, Ming robes have survived, but
many early Qing examples preserve their style. Like the *ke
si* workers, Yuan and Ming embroiderers proved capable
of ever more remarkable pictorial effects.

Lacquer

As early as the late Zhou period lacquer had been used for
painted designs of remarkable finesse and beauty. This art
attained what was probably its second peak in the Yuan
and Ming dynasties. The same imperial patronage respon-
sible for the great porcelains required carved cinnabar lac-
quer, painted lacquer, and incised or gilded lacquer of
high aesthetic quality. The early reigns of the Ming peri-
od, such as Yongle and Xuande, are well known for their
carved cinnabar lacquer. Probably the table in the Victoria
and Albert Museum dates from the Xuande reign (*figs.
627, 628*). The dragon is of the type found on underglaze

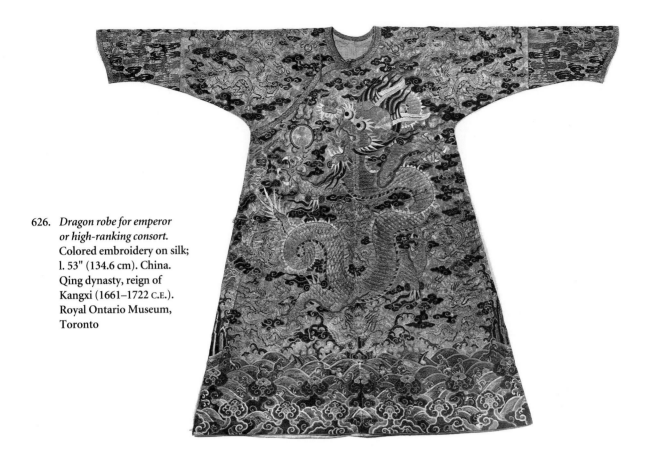

626. *Dragon robe for emperor or high-ranking consort.* Colored embroidery on silk; l. 53" (134.6 cm). China. Qing dynasty, reign of Kangxi (1661–1722 C.E.). Royal Ontario Museum, Toronto

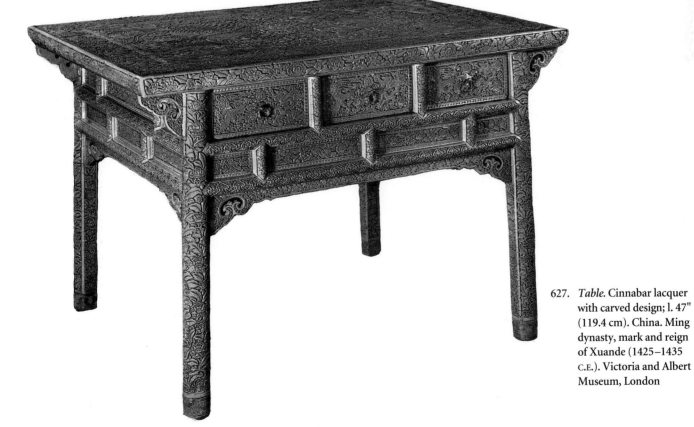

627. *Table.* Cinnabar lacquer with carved design; l. 47" (119.4 cm). China. Ming dynasty, mark and reign of Xuande (1425–1435 C.E.). Victoria and Albert Museum, London

628. *Table.* Detail of fig. 627

629. *Plate.* Carved lacquer with design of garden and terrace scene; diam. 13¹/₂" (34.3 cm). China. Ming dynasty, reign of Yongle (1402–1424 C.E.). Asia Society, New York. Mr. and Mrs. John D. Rockefeller 3rd Collection

Blue-and-White porcelains, but here the red color combined with richly sculptured low relief produces an effect quite different from the austerity of the Blue-and-Whites. In its aesthetic overtones this table is close to the crowded richness of *ke si,* embroidered textiles, and polychrome enameled porcelains. The lacquer is built up layer on layer before being carved. In the rare authentic examples from the early Ming period the carving has a vigorous and slightly rounded quality quite different from the later flat and decorative effects. In the early reigns the carved cinnabar technique was used principally for dragon, peony, and lotus decoration; pictorial effects, rare at first, later became increasingly popular. The plate in figure 629 derives its shape from porcelains; its decoration, showing a garden and terrace scene, is inspired by the work of academic court painters. Each pattern, whether of waves or clouds, is carved with refinement and delicacy and developed consistently, logically, and painstakingly, so that one texture complements another.

Probably early in the Chenghua reign (1464–1487 C.E.) the carved lacquer palette broadened to include black, dark brown, green, and yellow as well as cinnabar red. The colors were laid on in meticulously calculated order so that the carved scene would reveal the desired color at the desired depth of relief. Polychrome carved lacquers required even more superlative patience and more nearly magical skill than carved cinnabar wares. Painted lacquer, often in the form of trays and dishes, was generally for ordinary use. But the most complicated technique used by the imperial lacquer craftsmen required the incising of the lacquered object with a design, often of dragons, flowers, or *feng-huang,* the simple coloring of the incised design with a few colored lacquers, and finally the gilding of details to bring out linear elements of the design. This technique is seen at its best in the chest with drawers dating from the Xuande reign (*fig. 630*). A view of the whole chest reveals the richness of the design, which is related to the pictorial effects of later Ming porcelain and textiles. A detail (*fig. 631*) displays the meticulous refinement characteristic also of the carved lacquers of the middle Ming period.

Painting

If we consider the history of painting during the Ming dynasty solely as a chronological sequence, we do a stylistic injustice to the material. The very early years of the dynasty, from about 1368 to 1450 C.E., show a continuation of the styles already formulated by the conservative masters of the Yuan dynasty. The period from 1450 until the close of the dynasty in 1644 witnesses a steady stream of creative painting, almost all of it by members of the scholarly class which we have seen emerging as the dominant school of Chinese painting. The body of critical writing on painting is enormously enlarged during this centuries, contributed to by nearly all the scholars, scholar-painters, and scholar-critics. A great body of work surrounds the figure of the painter-critic Dong Qichang

630. *Chest.* Lacquer with incised and gilded design; w. 22³/8" (56.8 cm). China. Ming dynasty, reign of Xuande (1425–1435 C.E.). Victoria and Albert Museum, London

631. *Chest.* Detail of fig. 630

(1555–1636 C.E.), who with his immediate associates was principally responsible for the classification of all painters into the "northern" or "southern" school. Although the terms are arbitrary and misleading, the distinction they express is essential to any discussion of Chinese painting.

This distinction is neither geographic nor in any way associated with the Northern and Southern Song periods. It is a critical distinction, based on a tenuous analogy with the northern and southern schools of Chan Buddhism in the Tang dynasty. "Northern" implied, on the whole, reactionary and bad, "southern" implied progressive, good, and scholarly. The northern school was derogated by the literati as a professional artisan school, and to this limbo they relegated court painters, academicians, practitioners of all realistic, decorative, or romantic styles, including Ma Yuan and Xia Gui. The southern school they held to begin with Wang Wei of the Tang dynasty and to include subjective, expressive, calligraphic painting. The differentiation was beclouded, however, with moral considerations: Zhao Mengfu's art was impeccably southern, but his service to the Mongol government initially barred him from the southern category. Fundamentally the two cate-

632. *The Hermit Xu You Resting by a Stream.* By Dai Jin (1388–1462 C.E.). Hanging scroll; ink and slight color on silk; h. 54³/₈" (138 cm). China. Ming dynasty. Cleveland Museum of Art

gories reflect a qualitative and class distinction, and different critics have been known to assign the same painter to different schools. For us these distinctions are of secondary importance. The conservative Ming masters, whom we shall consider first, fell largely into the northern school, the more progressive *wen ren* painters into the southern school.

The early years of the Ming dynasty saw the continuation of numerous conservative tendencies already in evidence during the early Yuan period. For example, the "blue-and-green" Tang landscape style, exploited by Qian Xuan and Zhao Mengfu, was continued by some of the early Ming court painters. A second type of conservative painting of quality and interest is associated with the Zhe school, so called after Zhejiang Province, where many of

its practitioners lived. This school, banished by later Ming critics to the northern category, produced some of the most interesting paintings in the Ma-Xia tradition. Such masters as Dai Jin (1388–1462 C.E.), whose famous *Fishermen on the River* scroll is in the Freer Gallery in Washington, or Wu Wei (1459–1508 C.E.), with his rapidly brushed figures of sages and scholars, are typical Zhe school masters.

So significant is Dai Jin in the development of Ming painting that he is acclaimed the founder of the Zhe school, named for his native province of Zhejiang. His application to become a court painter to the Xuande emperor (r. 1425–1435 C.E.) had so misfired that Dai fled for his life to the protection of a princely patron in distant Yunnan; according to one (plausible) account, an envious senior colleague had convinced the emperor that Dai's paintings were seditious. With the Xuande emperor safely dead, Dai returned to Beijing to become the most famous and successful painter of his day. His painting of *The Hermit Xu You Resting by a Stream* (*fig. 632*) depicts a legendary Confucian worthy famous for his refusal of the throne and of high office. Xu is shown as a wandering recluse, resting beneath a Ma Yuan–type pine tree in a very strongly brushed vertical landscape. The interweaving of brush strokes and images produces powerful and decorative forms in a somewhat flattened space—particularly well suited to Confucian iconography meant to be seen at a distance in a somewhat formal setting.

A fine picture and a rare example of the work of Du Jin, another master of the Zhe school, is *The Poet Lin Bu Walking in the Moonlight* (*fig. 633*). It is a hanging scroll with slight color on paper, representing a famous Northern Song poet. He is walking between two rocks on a path by a stream; nearby a twisted tree thrusts one branch beneath the water's surface—a typical motif of early Ming painters. The style, based on that of the Ma-Xia school, is even freer, seeming halfway between the lyric and the spontaneous. The brushwork depicting the twigs and branches of the tree is of particular interest. So is the pictorial effect of the pale figure before the lightly washed rock, which creates a visual impression of moonlight that reinforces the unusual cast shadow.

Associated with these conservative painters are Lü Ji (c. 1440–c. 1505 C.E.), a fine painter of colored and decorative flower-and-bird works, and the great bird and bamboo artist Lin Liang, active until about 1490. One of his paintings represents two peacocks in a bamboo grove (*fig. 634*). In a picture of this type the Chinese approach the decorative style of the great Japanese painters of the Momoyama and Edo periods. But what distinguishes this painting from Japanese decorative style is precisely that sober and rational control of composition we feel to be Chinese, and especially that emphasis upon the integrity of every brush stroke which is at the heart of all Chinese painting. The Chinese painter will never, as the Japanese

633. *The Poet Lin Bu Walking in the Moonlight.* By Du Jin (act. before 1465–after 1509 C.E.). Hanging scroll; ink and slight color on paper; h. 61⅝" (156.5 cm). China. Ming dynasty. Cleveland Museum of Art

634. *Peacocks.* By Lin Liang (act. c. 1430–c. 1490 C.E.). Hanging scroll; ink on silk; h. 60½" (153.7 cm). China. Ming dynasty. Cleveland Museum of Art

painter occasionally may, sacrifice the ideal nature of the brush stroke to the decorative requirements of the painting by making a brush stroke that is primarily decorative in itself. Thus, if we examine the tail of the great cock, with the differentiation of tones in the eyes of the feathers, and the contrasts between the long, thin strokes of the tail feathers, the sharp, heavy strokes of the wing

feathers, and the shorter, fuzzier strokes of the hackle feathers, we see that the brushwork has maintained its inflexible integrity at the same time that it differentiates natural textures in the most subtle way. The contrasts, for example, between the softness of the feathers, the firmness of the body underneath, and the spiny, stiff legs and talons of the bird are remarkably well achieved. The bamboo is a classic example of fifteenth century bamboo painting, and again, every stroke reveals the sharpness and sure placement achieved by the great Yuan bamboo painters. Lin Liang's bamboo is rather delicate in the leaves but very firm in the construction of the main stalks of the plant. The rationality of the composition is evident, particularly in the use of thrusting diagonals and the balancing of the principal stalk of bamboo by the large area of rock at the lower right.

Yet another form of conservatism at the beginning of

635. *Streams and Mountains*. By Xu Ben (1335–1380 C.E.).
Hanging scroll; ink on paper; h. 26 3/4" (67.9 cm). China.
Ming dynasty. Mr. and Mrs. A. Dean Perry collection,
Cleveland

offended the paranoid Hongwu emperor and so died in prison, as did Wang Meng. Xu Ben arrived at a style of his own within Wang Meng's idiom. In the small *Streams and Mountains,* one of his few extant paintings, he, like Wang Meng, emphasized texture, covering the whole surface of the picture, except for a very small area of sky, with brush strokes that produce the foliage of trees and bushes and the folds of mountains (*fig. 635*). The composition is extremely complex, taking its compositional devices from the Northern Song period rather than from the forbidden masters of Southern Song, the Ma-Xia group, called "northern" school by the later critics. Xu Ben, of course, was an accepted member of the "southern" school, a major figure in the tradition of the late Yuan period. A close view of *Streams and Mountains* discloses again that Chinese integrity of brushwork which we have already analyzed in the quite different work by Lin Liang. In the clearly distinguished deciduous foliage conventions—triple-dotted foliage, straw stick foliage, and black dot foliage—each stroke, each dot, each movement of the brush that puts ink to paper can be looked at as an individual stroke and not found wanting. In this, perhaps, is one of the major distinctions not only between Chinese and Japanese painting, but also between Chinese and Western handling of the brush. In the West the usual intention until recently has been to obliterate the brush stroke in order to achieve the effect of reality in nature. In the Chinese scholarly "southern" tradition, on the contrary, the artist insisted primarily upon precision and integrity of brushwork, even at the expense of verisimilitude to nature.

Three painters stand between the northern and southern schools of the early Ming period. They have been called both northern and southern but should be associated with the conservative group. The first of these is Zhou Chen (d. c. 1536 C.E.), probably the master of the other two painters of this triad, Tang Yin (1470–1523 C.E.), and Qiu Ying (act. c. 1522–1552 C.E.). Zhou's landscapes owe much to Li Tang of the middle Song period. His carefully controlled brushwork can be found in numerous handscrolls and hanging scrolls, on both silk and paper, well composed and full of rich detail. In this he was probably surpassed by his two major followers, but one of his surviving works displays a singular facet of his artistic character—his interest, unusual for its day, in low life and the grotesque. In general, the subject matter appropriate for the later Chinese painter, and especially for the scholar-painter, was landscape. If he did paint figures, they would illustrate edifying tales of the past, scenes from famous poems, or members of his own class. He might occasionally turn out pseudopoetic representations of woodcutters or peasants, idealized images of Confucian rusticity. But Zhou Chen reveals in this one painting a realistic interest in the lower classes, whether sympathetic or critical. A handscroll made up of leaves from an album

the Ming dynasty consisted of a continuation of the creative styles of the Four Great Yuan Masters, the scholar-painters Huang Gongwang, Wu Zhen, Ni Zan, and Wang Meng. Xu Ben, who worked in this vein, is a transitional figure. He began painting at the end of the Yuan dynasty and became an official at the Ming court, where he

636. *Beggars and Street Characters.* By Zhou Chen (d. c. 1536 C.E.). Dated to 1516 C.E. Section of the handscroll; ink and light color on paper; h. 12¹/₂" (31.8 cm), l. 8'1/4" (2.4 m). China. Ming dynasty. Cleveland Museum of Art

and now divided between the Cleveland Museum and the Honolulu Academy, it is one of the most striking, touching, and powerful works by this very important artist (*fig. 636*). It is a representation of unfortunates, a series of single or paired figures executed in ink and color on paper: a gaunt and demented-looking woman with an infant at her shriveled breast; a poor beggar in tatters leading a dog. The other figures are crippled or diseased, and all are subjects unpleasant in themselves and outside the accepted range of subject matter. The artist's inscription can be plausibly construed as a comment on the famine and other social ills afflicting that time. Another of his pictures, in the Princeton University Art Museum, represents a cockfight with a group of peasants watching. Zhou Chen applies the brush discipline learned from his master with a rapid and free technique to these unusual subjects. The one precedent for this subject matter is the demons and damned souls appearing in the subsidiary parts of Buddhist icons representing scenes in hell.

Tang Yin also reaches back beyond the Zhe school to the great Song master Li Tang, whose work is transitional between the early monumental style of the Northern Song dynasty and the lyrical style of the Ma-Xia school. Tang Yin occupied a somewhat similar position in the late fifteenth century. His brushwork is rather conservative—a means of representing nature with relative realism as well as an expressive end in itself—and his compositions are sober. He characteristically builds up his rocks from the center to the surface, like an oyster producing a pearl, creating a shell-like form with a series of strokes of increasing circumference. His mostly tall, vertical compositions are monumental in the earlier tradition, but with overtones of poetic unity implying a mood quite different from the generalized and cool aloofness of the Northern Song

637. *Murmuring Pines in a Mountain Path.* By Tang Yin (1470–1523 C.E.). Hanging scroll; ink and slight color on silk; h. 77¹/₂" (196.9 cm). China. Ming dynasty. National Palace Museum, Taibei

painter. In a hanging scroll in the National Palace Museum, a monumental landscape format presents a summery and luxuriant scene with a marked counterpoint between the rich and soft textures of the foliage and the more austere and angular faces of rocks and mountains (*fig. 637*). One is always conscious of a vigorous and robust talent behind his brushwork. Most of Tang Yin's paintings, like those of the Song masters, are on silk, the characteristic medium of the conservative northern painters; the scholarly painters of the southern school tended to work on paper.

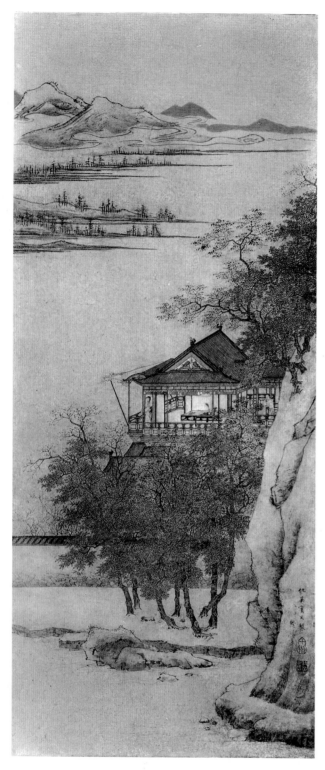

638. *Lady in a Pavilion Overlooking a Lake.* By Qiu Ying (act. c. 1522–c. 1552 C.E.). Hanging scroll; ink and color on paper; h. 35 1/8" (89.2 cm). China. Ming dynasty. Museum of Fine Arts, Boston

Qiu Ying is one of the most admired and forged of Chinese painters. He worked in a variety of styles with a sheer technical skill that commanded the nuances of Tang, Song, or Yuan styles at will. He was famous for his copies of pictures, some of them painted for such great

patrons as the noted sixteenth century collector Xiang Yuanbian. His technical brilliance in the execution of minuscule detail as well as his broad and abstract use of the brush earned the respect of critics who would otherwise have relegated his type and style to the northern school. In the West he is belied by an endless series of album leaves and scrolls representing aristocratic ladies in bright colors playing in the park or puttering in houses— pretty, decorative paintings in the worst sense of the words. Needless to say, these are nearly all forgeries produced by the artisans of Hangzhou and Suzhou, who have manufactured Qiu Yings ever since the inevitable demand began. From these poor counterfeits to Qiu Ying's finest works is a tremendous distance.

The *Golden Valley Garden,* one of a pair of garden views, shows his conservative style at its height (*see cpl. 49, p. 430*). Its subject is a party in the famously lavish garden of the third century merchant prince Shi Chong. To represent that choice and rare setting, those opulent costumes and accessories, Qiu uses opaque, jewel-like color and early figure and landscape styles (though later in date than the historical subject). Figured awnings cover the walkways, and beneath them the host stands to receive his guests, surrounded by peacocks and peonies (symbols of wealth), antique bronzes, rare fantastic rocks, ornamental trees and shrubs, and numerous servants. So perfect is the virtuoso handling of detail that even a magnifying glass reveals no hesitancies or missteps. The antiquarian accuracy of the garden containers Qiu gained in part from his friendship with famous collectors, such as the Suzhou pawnbroker and art collector Xiang Yuanbian (1525– 1590 C.E.). Some later scholar-critics denigrated Qiu's magical technique and thorough professionalism, but the work shows a creative fusion of the historical and artistic past with inimitable representational mastery.

Many of Qiu Ying's paintings, regardless of size, can be characterized as the works of a great miniaturist, in which the smallest brush, sensitively used, creates exquisitely refined detail. He also had strong antiquarian interests, and his friendship with collectors enabled him to study Song ceramics and bronzes of the Shang and Zhou dynasties. His pictures are full of archaistic details that are archaeologically accurate and interesting, and this too distinguishes his work from the later artisans' copies. One of the finest and most unusual pictures by Qiu Ying in this country is a hanging scroll on paper in the Museum of Fine Arts in Boston, showing a lady in a summer pavilion set among a grove of trees beside a large lake or river (*fig. 638*). Here Qiu Ying rivals the scholar-painter at his best. In its pure, serene air and in the distant view of mountains and spits of land the style of Ni Zan is apparent, but in the exquisitely fine detail of the scholar's table and female attendants we see the delicate miniature quality that is most characteristic of the style of Qiu Ying. His architecture is accurate and believable, the implements on

640. *Gardeners.* By Shen Zhou (1427–1509 C.E.). One of six album paintings mounted as a handscroll; ink and color on paper; h. 15³/4" (40 cm). China. Ming dynasty, c. 1490–1500 C.E. Nelson-Atkins Museum of Art, Kansas City

639. *Landscape in the Style of Ni Zan.* By Shen Zhou (1427–1509 C.E.). Dated to 1484 C.E. Hanging scroll; ink on paper; h. 54" (137.2 cm). China. Ming dynasty. Nelson-Atkins Museum of Art, Kansas City

the table in the scholar's study are correct in drawing, and yet the painting of the trees and their foliage, despite its lapidary precision, shows a freedom and spontaneity of brushwork that make him one of the great painters of the Ming dynasty.

The southern style of the early Ming period is wholly dominated by one great master and his immediate succes-sor, Shen Zhou (1427–1509 C.E.) and Wen Zhengming (1470–1559 C.E.). Shen Zhou was the founder and leading spirit of the Wu school, named for the district around Suzhou where its members lived. Wen Zhengming was his pupil. Between them, they set standards for scholarly painting that lasted until the end of the sixteenth century. Shen Zhou looked especially to the traditions of the Four Great Masters of the Yuan period. In works such as the hanging scroll dated to 1484 C.E., one cannot mistake the style of Ni Zan: the tall thin trees, the blank areas of paper, the dotted brushwork indicating lichens on the rocks, the open, spare style in the distant mountains (*fig. 639*). But in the hands of Shen Zhou, Ni's style becomes much stronger, bolder, and sturdier, revealing in this the pre-dilection that led Shen especially to the works of Wu Zhen. Wu was famous for a powerful, economical style, representing figures with just four or five telling brush strokes or a landscape with a few washed and a few sharp strokes. Shen Zhou's mastery of the style equaled Wu Zhen's, and to it he added in certain works a boldness of composition and touches of color that anticipate several of the seventeenth century individualists. His masterwork in this country is a group of five album paintings, mount-ed as a handscroll (*fig. 640*). One of the album leaves shows idealized peasants working in the fields beyond a wooden fence. The leaves and trunks of the trees, and more especially the outlines of the peasants' bodies, show the powerful, emphatic brush stroke derived from Wu Zhen. But the complex composition, with its zigzagging fence and its trees that fade to nothingness as they approach the alley at the central axis, is characteristic of Shen Zhou's advanced interests. The finest of the leaves in this scroll depicts a poet on a bluff overlooking a chasm,

641. *Poet on a Mountaintop.*
By Shen Zhou (1427–
1509 C.E.). One of six
album paintings
mounted as a hand-
scroll; ink and color on
paper; h. 15³/4" (40 cm).
China. Ming dynasty,
c. 1490–1500 C.E.
Nelson-Atkins Museum
of Art, Kansas City

in heavy and rich ink with slight color on paper (*fig. 641*).
It is a monumental composition. A great mountain with a
steeply tilted flat top thrusts into the center of the picture
space, and at the right is a temple in a fold of hills. The
artist's brush made rapid, thick strokes, the distant moun-
tains being represented by simple, even-toned washes,
rather abstract, even cold. In mood the picture combines
the coldness—in the best sense of the word—attributed
to Ni Zan with the strengh of Wu Zhen. Shen Zhou's
paintings are not "attractive"; he does not make pic-
turesque and charming compositions. He inherited the
revolution instituted by the Four Great Masters of Yuan
and consolidated it, producing an objective and complete
rendition of its aims.

The last leaf of the scroll under discussion is by Shen's
pupil, Wen Zhengming (*fig. 642*). Its inclusion in this
scroll illuminates the difference in temperament and style
between the two men. Wen's leaf, depicting a stormy
shore, with trees and a small boat being driven by the
wind and rain, shows the same disciplined brush as the
album pages by Shen Zhou: the same manner of outlining
tree trunks, the same manner of forming foliage and
rocks. But his painting is much more elegant, without that
brusque coldness found in Shen Zhou's work. The distant
waves are broken and curled, painted in a delicate, detailed
style almost like Qiu Ying's or the paintings of Southern
Song. In the trees and foliage the strokes are not quite as
wide, the dots not quite as fat as Shen Zhou's, while the

642. *Storm over the River.* By Wen
Zhengming (1470–1559 C.E.).
Dated to 1516 C.E. One of six
album paintings mounted
as a handscroll; ink and light
color on paper; h. 15¹/4"
(38.7 cm). China. Ming dynasty.
Nelson-Atkins Museum of
Art, Kansas City

643. *Old Trees by a Cold Waterfall.* By Wen Zhengming (1470–1559 C.E.). Dated to 1549 C.E. Hanging scroll; ink and color on silk; h. 6'4³/8" (1.94 m). China. Ming dynasty. National Palace Museum, Taibei

number of dots in the rocks is reduced so that their profile becomes more prominent. The effect is of a refined, aristocratic, and elegant rendition of Shen Zhou's style: in short, what we would expect in Wen Zhengming's early work.

But Wen's fully developed style, complex and gnarled, is completely his own, though much imitated in later times. Its most characteristic exemplars are works like the hanging scroll of a high waterfall amid grotesque cypress and cedar trees, in the National Palace Museum (*fig. 643*). Executed in ink and color on silk, it has overtones of Qiu Ying's detailed rendition, but the tightly knit and convoluted composition conveys a slightly inverted, even repressed, quality that seems characteristic of Wen Zhengming. The grotesqueness of Wen's trees and rocks and his interest in tortured and intertwined forms also appear in a more fluid work, *Old Pine Tree* (*fig. 644*), and in the small *Old Cypress and Rock* (*fig. 645*). The former is daring in its composition, with the partially seen pine tree moving in and out of the handscroll format to produce an expanding, larger-than-life effect. The resemblance to dragons is made explicit in the artist's own inscription on the painting and is part of the metamorphic character to be found in many of Wen's later works. *Old Cypress and Rock* is a perfect jewel, an epitome of Wen's brilliant brushwork and ability to convey the age and complexity of nature's elements. In this it embodies concepts analogous to those found in the Chinese garden (*see cpl. 44, p. 425*)—indeed, Wen Zhengming is reported to have contributed to the design of at least one famous Suzhou garden, that of the "Impractical Official."

Wen Zhengming painted in many different styles, but this seems to be his most characteristic and most creative manner. The ability of the Chinese painter, especially of the Ming and Qing painter, to adopt different styles did not proceed from lack of integrity but is, rather, comparable to a musician's infusing someone else's composition with his own technique and interpretation to create an individual performance. At its most creative, in the hands of such an artist as Wen Zhengming, the process is comparable to one composer's writing variations on another's theme, producing thereby a new seamless idiom.

Four of Wen Zhengming's family as well as other followers continued his middle period style with diminished scale in ever more complicated landscapes. Among his descendants the most notable painters are his nephew Wen Boren (1502–1575 C.E.) and his son Wen Jia (1501–1583 C.E.). Almost all of these later Wu school masters tended to exaggerate Wen Zhengming's propensity for crowded, finely detailed compositions, while lacking his gift for pictorial organization. The overembroidered landscapes that resulted from their aversion to empty space and bold brushwork were derided by Chinese critics as "like putting legs on a snake." A very few were able to create interesting scrolls in the Wu manner, notably Lu Zhi and Chen Shun.

644. *Old Pine Tree.* By Wen Zhengming (1470–1559 C.E.). Handscroll; ink on paper; h. 13³/4" (34.9 cm), l. 54" (137.2 cm). China. Ming dynasty. Cleveland Museum of Art

645. *Old Cypress and Rock.* By Wen Zhengming (1470–1559 C.E.). Dated to 1550 C.E. Handscroll; ink on paper; h. 10¹/4" (26 cm). China. Ming dynasty. Nelson-Atkins Museum of Art, Kansas City

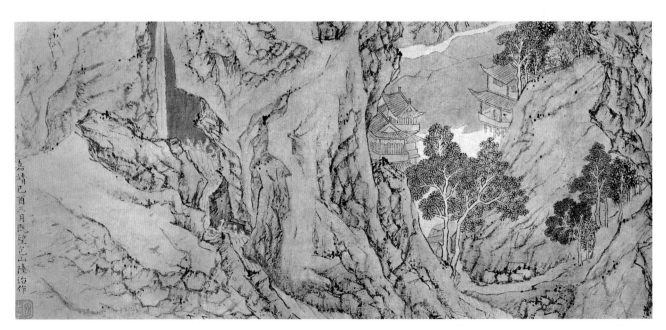

646. *The Field of Jade.* By Lu Zhi (1496–1576 C.E.). Handscroll; ink and color on paper; h. 9¹/2" (24.1 cm), l. 53⁷/8" (136.8 cm). China. Ming dynasty. Nelson-Atkins Museum of Art, Kansas City

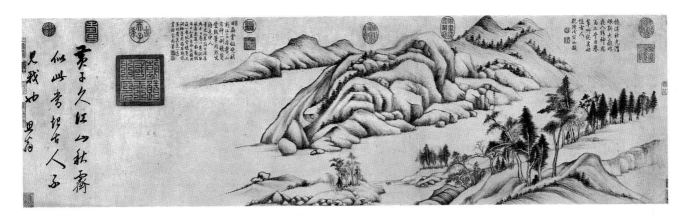

647. *Rivers and Mountains on a Clear Autumn Day.* By Dong Qichang (1555–1636 C.E.). Handscroll; ink on Korean paper; h. 15¹/8" (38.4 cm), l. 53³/8" (136.2 cm). China. Ming dynasty. Cleveland Museum of Art

Lu Zhi, in the handscroll *Field of Jade*, shows another variation on the manner inherited from Wen Zhengming (*fig. 646*). Rocks, trees, and landscape details fill the scroll from bottom to top and side to side; no horizon line, no sky mitigates the complexity of the composition. His brushwork is delicate and refined, but sharp and crystalline. To overall patterning and small scale Lu Zhi added a peculiar tartness of color, like lemon and lime.

Shen Zhou painted a few flower and foliage pictures, to which his bold brushwork was most appropriate. But the most interesting flower paintings in this manner are by the slightly later artist Chen Shun (1483–1544 C.E.), whose handscroll of lotus (*cpl. 50, p. 431*) combines soft and decorative color with vigorous "boneless" brushwork—that is, areas of ink and color applied without outlines. Still, the dominant mode of the first half of the sixteenth century was that of Wen Zhengming—detailed, complex, and dignified.

By the end of the sixteenth century the creative momentum of the Wu school was beginning to subside. New impetus was forthcoming in the theories and paintings of Dong Qichang (1555–1636 C.E.), who dramatically changed the course of Chinese landscape painting. His importance and the extent of his influence is comparable to Caravaggio's in European painting. The two men, incidentally, were active at about the same time.

Dong Qichang is the watershed figure of later Chinese painting. His influence on literature, criticism, calligraphy, and painting is paramount. In his writing he asserts the supremacy of the Northern Song and Yuan masters, and in his paintings he attempts to recapture the monumental strength of the former and the controlled calligraphy of the latter. No one could describe the later productions of the Wu school as universal, monumental, or markedly rational, and in opposing the direction of this scholar-painters' school Dong Qichang was simultaneously a supreme reactionary and a supreme revolutionist. His painting theory brought about a loss of the outward reality of nature but a significant aesthetic gain

consisting in a fiercely arbitrary reorganization of the elements of landscape painting into a monumental scheme (*fig. 647*). In his most typical pictures this aesthetic reformulation is manifested in striking distortions. Ground and water planes are slanted, raised, or lowered at will. Foliage areas are forced into unified planes regardless of depth, often with striking textural juxtapositions. No small details of form or texture are allowed to impede the artist's striving for a broad and universal expression of the traditional attitudes to nature (*fig. 648*). Malraux's subtle distinction between Chardin and Braque, "In Chardin the glow is on the peach; in Braque, the glow is on the picture," applies as well to the works of Dong. His pictures realize his theories incompletely and with difficulty by comparison with the works of such later giants as Zhu Da or even the more academic Wang Yuanqi, for theirs was a pictorial genius that accomplished what Dong Qichang proposed. Other later individualists, Gong Xian for example, pursued and enlarged upon specific elements in Dong's painting.

We must not assume, as this writer once did, that Dong Qichang's pictures look as they do because the theorist was an incompetent painter. Like the Post-Impressionists, the artist was desperately striving to reconstitute the powerful and virile forms rather than the surface likeness of the earlier painters. Dong Qichang had the last word: "Those who study the old masters and do not introduce some changes are as if closed in by a fence. If one imitates the models too closely one is often farther removed from them."[30]

Dong's high position in government and his influence as arbiter of taste and authenticity confirmed the lofty prestige of the scholar-painters' tradition identified by him and his colleagues with the "southern" school and the denigration of the "northern" tradition represented by the Zhe school. His own immediate following, including Chen Jiru (1558–1639 C.E.) and Mo Shilong (act. 1552–1587 C.E.), is usually described as the Songjiang school, after the town near Suzhou that was their center.

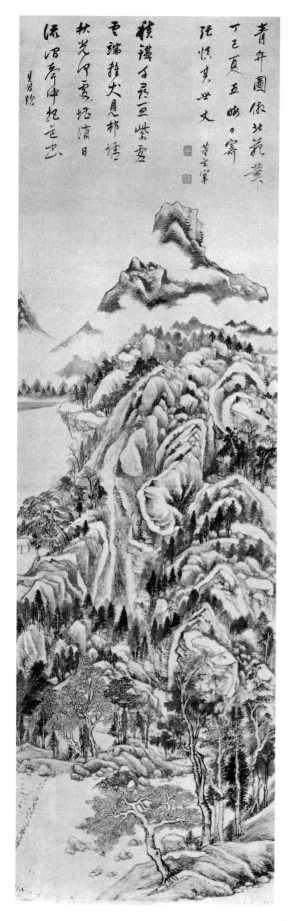

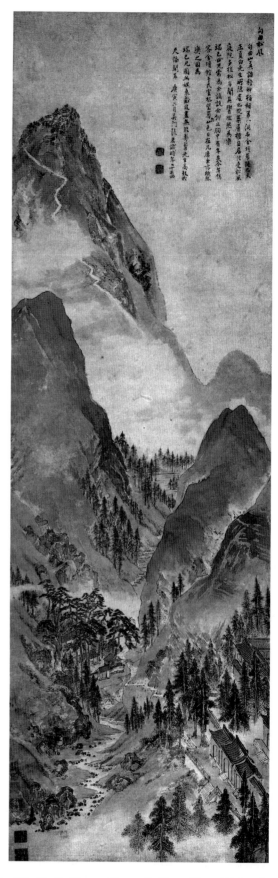

648. *The Qingbian Mountains.* By Dong Qichang (1555–1636 C.E.). Dated to 1617 C.E. Hanging scroll; ink on paper; h. 88³/8" (224.5 cm). China. Ming dynasty. Cleveland Museum of Art

649. *Wind in the Pines at Gouqu.* By Zhang Hong (1577–after 1652 C.E.). Dated to 1650 C.E. Hanging scroll; ink and color on paper; h. 58⁵/8" (148.9 cm), w. 18³/8" (46.6 cm). China. Qing dynasty. Museum of Fine Arts, Boston

650. *Scholars Gazing at a Waterfall.* By Sheng Maoye (act. 1594–1637 C.E.). Dated to 1630 C.E. Hanging scroll; ink and color on silk; h. 61⁷/₈" (157 cm), w. 39" (99 cm). China. Ming dynasty. Museum für Ostasiatische Kunst, Berlin

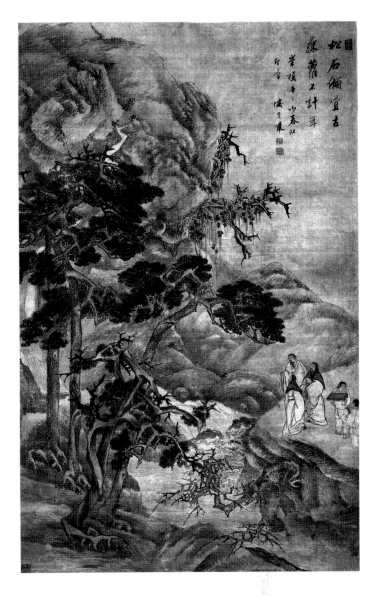

Dong influenced many other important painters who can only be described as seventeenth century individualists—a description that can be narrowed to these late Ming figures alone, or extended to all the distinctive personalities of the troubled later years of the century. But these later individualists, occupying the changed social and political matrix of the new and alien Qing dynasty (1644–1912 C.E.), will be considered subsequently, as a contrast with the almost neoclassic academicism that was the early Qing outgrowth of the Songjiang school. Their multiplicity and relatively recent discovery by Westerners preclude all but a summary presentation of the other Ming individualists. Zhang Hong (1577–after 1652 C.E.), though nominally a member of the Wu school and very little known until recent years, emerges as a most original artist and thinker—but along quite different lines from Dong Qichang. His paintings and inscriptions reveal a keen interest in reality and in the visual appearances of specific landscapes. His brushwork and application of color are fresh and almost "impressionistic"; Zhang is more concerned with conveying the impression of a place than with traditionally "correct" *wen ren* brush conventions. The monumental, expansive *Wind in the Pines at Gouqu* (near Nanjing) (*fig. 649*) is especially convincing as a particular locale depicted by an artist deeply familiar with the place.

Consider as well the fantastic boldness of Sheng Maoye's *Scholars Gazing at a Waterfall*, dated to 1630 C.E. (*fig. 650*). Sheng has taken a segment of a monumental landscape and magnified it, treated it with great bravura, producing a large-scale painting with an immediate rather than a cumulative effect. Though the figures are substantial and very well drawn, they are overborne by the grotesque and menacing old trees, whose stubby, crabbed limbs are depicted with deliberately heavy brush strokes. The painting fascinates precisely because of its wild, offbeat quality.

Another of these individualists was a direct pupil of Dong Qichang. We can see the art of Cheng Zhengkui in a

handscroll modeled stylistically after the Yuan master Huang Gongwang (*fig. 651*). The composition is in equal measure strong and willful, based on a jerky, erratic rhythm of near masses and sudden apertures into the far distance that is typical of the artist. In other scrolls he exploits this mode even further, with an even wetter brush and rapid, unshaded handling, using slight color. Cheng painted well over a hundred such imaginary landscapes, all with the identical title and similar inscriptions, and he numbered each one (though not, apparently, in order of execution).

Of course many in this period continued to practice a more conservative and detailed style, often combining

651. *Dream Journey among Rivers and Mountains.* By Cheng Zhengkui (1604–1676 C.E.). Dated to 1658 C.E. Section of the handscroll; ink and light color on paper; h. 10¹/₄" (26 cm), l. 11' 3¹/₂" (3.4 m). China. Qing dynasty. Cleveland Museum of Art

652. *The Five Hundred Arhats.* By Wu Bin (act. c. 1591–1626 C.E.). Section of the handscroll; ink and light color on paper; h. 13¹/4"
(33.7 cm), l. 76'11¹/4" (23.5 m). China. Ming dynasty. Cleveland Museum of Art

653. *Greeting the Spring.* By Wu Bin (act. c. 1591–1626 C.E.). Dated to 1600 C.E. Section of the handscroll; ink and color on paper;
h. 13³/4" (34.9 cm), l. 8'1/2" (2.5 m). China. Ming dynasty. Cleveland Museum of Art

it with the new directions indicated by Dong Qichang.
Wu Bin (act. c. 1591–1626 C.E.), who was also a master
of fine-line (*bai miao*) figure painting (*fig. 652*), has left
a number of finely executed colored landscapes whose
dynamic convolutions amaze the eye and express the
twisted and baroque aspects of nature. *Greeting the
Spring* nominally represents a spring fertility ritual of
ancient origin, along with its accompanying festivities
(*fig. 653*). Hundreds of figures throng the handscroll—
scholars traveling the mountains or groups of festive
townsmen. But the real subject of the picture is the land-
scape, ranging from calm waterways bordered by tran-
quil willows to high mountains darkly reaching beyond
the upper edges of the scroll. The color is structured
rather than decorative; it serves to accent the openings
into the far distance and the movements of the slate gray
hills. Idiosyncratic use of color becomes one of the
major contributions of the Qing individualists whom we
shall soon consider.

The last of these late Ming individualists to be con-

sidered is probably the most interesting and, in a perverse
way, the most innovative. Chen Hongshou (1598–1652
C.E.) was born into a moderately successful scholar-offi-
cial's family, but repeatedly failed the provincial examina-
tions which would have admitted him to that privileged
community. Though he had hoped for the life of a *wen
ren*, Chen was forced to settle for the livelihood and low
status of a professional artist. His *Essay on Painting* is one
of the few critical works to challenge Dong Qichang's
evaluation of Song and Yuan painting. Even more hetero-
dox, and more scandalous to the *wen ren* ideal, were the
woodblock prints he designed, some to decorate playing
cards, others to illustrate "novels" popular with both the
scholarly and merchant classes, such as *Shui Hu Zhuan*
[Story of the Water Marshes] and *Xi Xiang Ji* [Romance of
the West Chamber].

Chen studied early figure painting styles, becoming a
consummate master of the styles of the Six Dynasties
period. His quirky, idiosyncratic variations on these
archaic modes are remarkable in themselves and unique

in later Chinese painting. *Lady Xuanwen Giving Instruction in the Classics* (*cpl. 51, p. 432*), painted in 1638 to honor the sixtieth birthday of the artist's aunt, celebrates a learned and pious Confucian heroine of the Six Dynasties period. This work offers a grave and ordered homage to Confucian tradition. At the same time it reveals the antecedents and innovations of Chen's art: in the worshipful figures of the young officials we see Chen's mastery of early figure style, in the ritual vessels on the altar table his wonderful knowledge of antiquities, in the stylized clouds and carefully contrived land forms and trees his understanding of the painting styles of Tang and Northern Song.

His evaluation of his own accomplishments is as keenly perceptive as his critical sense: "To enliven the rigidity of Song with the charm of Tang, and apply the Yuan style within the Song rationality—this indeed will be the ultimate."[31]

THE CHOSON PERIOD IN KOREA

In 1392 C.E., in the wake of the retreating Mongols, General Yi Song-gye overthrew the moribund Koryo state and proclaimed his own dynasty with its capital at present-day Seoul. Korea entered at once into a tributary relationship with Ming China, and the closeness of this relationship is attested by the name Choson, chosen for the new state at Yi's request by the Ming emperor.

For the next five centuries cultural as well as political ties with China were closer than ever before. As in China, Neo-Confucianism in all its aspects was ascendant, supported by the state, and Buddhism was waning. Reflecting this development, the arts of the period are overwhelmingly secular, and as the call for religious art dwindled, painting and ceramics replaced sculpture as the predominant forms. Painting of the Choson period shows the influence of various Chinese traditions, beginning with those of Northern and Southern Song and continuing with the contemporary schools of the Ming and Qing times. In ceramics Blue-and-White and Red-and-White decorated wares echo Chinese trends, albeit with a distinctive difference.

The Japanese invasions of 1592 and 1597 ravaged Korea, but though government and the economy never completely recovered, scholarship and the arts showed resurgent creativity during the eighteenth century. Their flourishing continued to embody the influence of China as transformed by Korean sensibilities.

Korean Ceramics

Related to Ming porcelains as a country cousin to the urban sophisticate are the porcelains produced in the sixteenth and seventeenth centuries during the Choson period (*fig. 654*). These sometimes rough but original variations on Koryo and Ming themes greatly influenced Japanese stoneware and porcelain of the seventeenth and eighteenth centuries. In the 1580s the invading Japanese took some contemporary Korean "farm" wares home

654. *Jar.* Stoneware with iron-oxide decoration of tiger and heron; h. 11⅞" (30.1 cm). Korea. Choson period, 16th century C.E. Museum of Oriental Ceramics, Osaka

655. *Wine bottle.* Punch'ong stoneware; h. 10½" (26.7 cm). Korea. Choson period, 15th–16th century C.E. National Museum of Korea, Seoul

656. *Vase.* Porcelain with decoration in underglaze blue and copper red; h. 17¼" (43.8 cm). Korea. Choson period, 1599–1717 C.E. Private collection, Japan

with them. These vessels were called "Ido" bowls in Japan, where they became treasured accoutrements of the tea ceremony, endeared to tea-ceremony devotees by their qualities of devil-may-care informality derived from hasty and unconstrained technique.

Among the considerable variety of Korean ceramics three other types are worthy of mention. One is derived from the decorated celadons of the Koryo period, with white or gray slip beneath the now grayer green celadon glaze. Sometimes this slip is merely wiped onto a smooth surface, and the marks of the cloth or brush form the sole decoration apart from the glaze. In other vessels the slip is wiped over stamped, incised, or carved abstract, floral, or fish designs before the piece is glazed. The light-colored slip, pooling in the recesses of the design, forms a light-against-dark pattern (*fig. 655*). These vessels, called Punch'ong ware in Korea, are termed Mishima ware by Japanese collectors.

These stonewares are matched by heavy-bodied porcelains with decoration in underglaze cobalt blue or, more rarely, blue and copper red (*fig. 656*). Although these partly resemble fifteenth century Chinese imperial wares, the drawing of the subjects is particularly bold and free. The best of them, like this jar, are probably the products of royal patronage under King Songjong (r. 1469–1494 C.E.). Cobalt, imported from the Middle East, was prohibitively expensive in Korea, leading Songjong's predecessor to attempt to monopolize Blue-and-White wares for the use of the court, high-ranking military men, and a few royal favorites.

Plain white porcelains in distinctively Korean rounded shapes were luxury wares and also for ritual use. It is noteworthy that the Chinese court, with all the resources of Jingdezhen at its disposal, requested Korean white porcelains as gifts. These heavily potted monochromes evoke the prescriptive purity of the state-supported Confucian ideology. Such porcelains were little appreciated until the modern Japanese folk art (*mingei*) movement and allied Western aesthetic trends brought attention to them. Korea's resurgent economy and cultural awareness have greatly elevated their status in recent years.

THE QING DYNASTY

The second great alien dynasty to master all of China was the Qing (1644–1912 C.E.). Between Qing rule and that of the Mongols the differences could hardly have been greater. Despite military and political cataclysm, secular trends apparent in mid-Ming continued or even accelerated under Qing rule—increasing urbanization, the growth of commerce, the ever wider dissemination of learning.

As their name implies, the Manchus came from Manchuria. They were sufficiently independent of Chinese control to become a formidable military rival, sufficiently

657. *Mountain Village Embraced by the Summer.* By Wang
 Shimin (1592–1680 C.E.). Dated to 1659 C.E. Hanging scroll;
 ink on paper; h. 49¹/₂" (125.7 cm). China. Qing dynasty.
 Mr. and Mrs. A. Dean Perry collection, Cleveland

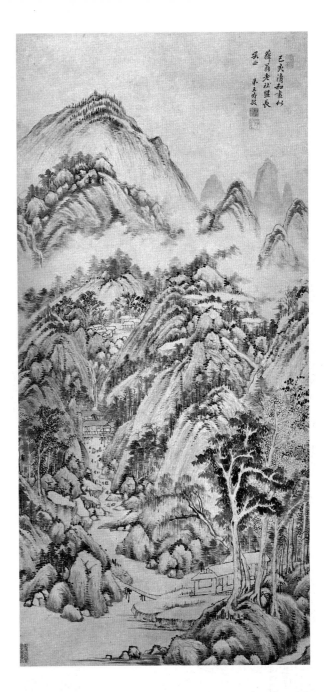

close to China to learn selectively from Chinese ideology
and institutions. Economic depression exacerbated by
government incompetence, corruption, and ferocious fac-
tionalism had led to the rebellion that toppled the Ming
dynasty. The Manchus, presenting themselves less as con-
querors than as liberators from chaos and oppression,
won China with relatively small popular opposition. So
successfully did their Qing dynasty woo the Chinese
scholar-gentry that Confucian odium against collabora-
tion with the new regime was relatively soon dissipated.
The Manchu conquest was the least traumatic of Chinese
dynastic transitions, and the first century and a half of
Manchu rule was the last golden age of imperial China.

At the same time, it must be noted that Ming loyal-
ism remained strong among the Chinese intelligentsia for
at least a generation after the conquest. Neo-Confucian
ethics forbade an official to serve two masters and glori-
fied those who followed their prince in death. But it was
also acceptable to signify such fidelity less fatally, by
adopting a new name and a radically different life style—
in other words, by abdicating one's normal social role—as
did many of the artists we are about to consider.

Even before moving to the conquest of China, the
Manchu rulers, aided by Chinese advisers, had adopted
Chinese administrative institutions and techniques. As
conquerors, they preserved the inherited Ming social
structure (while imposing themselves at its apex), and
diligently acquired Chinese culture, including the con-
cept of the Son of Heaven as exemplar and chief patron
of learning and the arts. Particularly with regard to art,
the Manchu rulers became more Chinese than the
Chinese, concentrating in the Imperial City of Beijing
the great Palace Collection—today divided between
the National Palace Museum in Taibei and the Palace
Museum in Beijing.

Painting

Dividing the history of Chinese art into dynastic periods
is sometimes sound, but between the Ming and Qing
dynasties the continuity in the arts is such that the first
part of the Qing dynasty, particularly the seventeenth cen-
tury, may be considered a continuation, in some ways a
culmination, of tendencies already present in the painting
and decorative arts of the later Ming dynasty. It was by no
means a period of decline in taste and standards, as undue
concentration on Chinese decorative and export porce-
lains might lead one to think.

The painting of the Qing dynasty comprises two
basic styles: the conservative, based upon the late Ming
scholars' painting stemming from the great innovator
Dong Qichang; and an original movement more thor-

oughly individualistic than any previous school. At the
beginning of the dynasty painting styles paralleled politi-
cal alignment. Qing adherents tended toward orthodoxy
in painting, Ming loyalists toward individualism. Such a
division into conservative and original streams deliber-
ately overlooks other and stagnant pools of Chinese
painting, which are truly declining phases of the earlier
styles of the Song, Yuan, and early Ming periods. We will
pass over these competent but usually uninspired
painters, though in their own fashion they too made a
contribution.

The conservative style of the Qing dynasty, based
upon the scholar-painter tradition of Dong Qichang and
his school, is epitomized in the works of the Four Wangs:
Wang Shimin (1592–1680 C.E.), Wang Jian (1598–1677
C.E.), Wang Hui (1632–1717 C.E.), and Wang Yuanqi
(1642–1715 C.E.). They are listed in order of birth date.
Wang Shimin, the oldest, was also the most traditional
(*fig. 657*). His style largely combines Yuan versions of

658. *Ten Thousand Miles of the Yangzi.* By Wang Hui (1632–1717 C.E.). Section of the handscroll; ink and slight color on paper; l. 53' (16.2 m). China. Qing dynasty. H. C. Weng collection, New Hampshire

Northern Song painting with the more monumental and arbitrary space and brushwork that were the original contribution of Wang Shimin's teacher, Dong Qichang, fifty or sixty years earlier. His compositions tend to be traditional and rather uninspired. They are always solid, massively built up, and usually of great complexity, with repetition of trees, rocks, and mountains in a basically similar set of rhythms. Wang Shimin's use of brushwork, and his patterning of it over the whole surface of the picture, are correct and consistent, recalling perhaps that rational master of the Yuan dynasty, Huang Gongwang. Probably Wang Shimin is more important for his antecedents and successors than in himself, as the pupil of Dong Qichang and the practical and spiritual master of the three other Wangs.

At least in his compositions, Wang Jian is the more original and interesting painter. The rolling rhythms that dominate his landscapes even more than Wang Shimin's are highly repetitive and relatively complex but also pleasant and elegant. Compared with Wang Shimin's more imposing and forbidding works, Wang Jian's seem lyrical, with something of that loveliness characteristic of the rolling landscapes of the early Japanese schools. One seldom finds, in the work of this artist, a monumental composition of imposing scale or powerful brushwork, but rather a consistent and elegant use of the brush in compositions dominated by gentle rhythms and sometimes highly decorative color (*cpl. 52, p. 513*).

Wang Hui, who belongs to the following generation, is probably the best known of the group. He was perhaps the most famous painter of his day in China, a prolific master whose genuine works exist in considerable quantity. Wang Hui's style, based primarily on gifted brushwork, is much more varied than that of the two older Wangs. From the first, like such geniuses as Dürer and Leonardo,

he seems to have been able to do whatever he willed with the brush. His long scrolls (some, like the one in the Weng collection, over fifty feet in length) show the most remarkable consistency of brushwork at the service of the most complex temporal and spatial organization to be found in Chinese painting (*fig. 658*). In 1691 Wang Hui was commissioned by the Kangxi emperor (r. 1661–1722 C.E.) to paint the Imperial Southern Tour, a seventy-one day royal progress through present-day Jiangsu and Zhejiang provinces. The resulting twelve handscrolls, each over twenty feet long, are the most complex and extensive pictorial record of their time. No painter of the Song dynasty or later produced works of greater competence. If at times they seem a little dry and less inspired than earlier works, it is only because Dong Qichang's revolution had, over about a century, become Wang Hui's orthodoxy. The followers of the bold innovator were a bit academic. Albums, handscrolls, or hanging scrolls executed as variations on the themes of earlier men certainly dominate the pictorial production of the conservative artists. Perhaps the main reason for the Western neglect, until recently, of the orthodox painters of the Qing dynasty has been their relative lack of originality in composition. But in Chinese eyes composition is a secondary point.

The last and youngest of the Wangs, and certainly the most original, was Wang Yuanqi, who also stands closer than the others to the individualist painters. His pictures testify to his understanding that the revolutionary essence of Dong Qichang did not consist in the lovely pictorial effects often achieved by Wang Jian and Wang Hui but in the arbitrary reorganization of the elements of nature in terms of brushwork and of an almost abstract pictorial structure. Consequently, when Wang Yuanqi paints a picture in the style of Ni Zan (*fig. 659*), it is in homage to Ni Zan's spirit only, to the coldness and serenity of

that Yuan master. The actual means by which this was achieved were much more under the creative influence of Dong Qichang. The enormous contrast in scale between the trees and the house, the distortion of the tree trunks and the heaviness of their foliage as a balance to the compactly constructed distant mountain-island—these are combined to make a picture that, while recalling Ni Zan, bespeaks only Wang Yuanqi. In this sense he is an individualist: His work is recognizable as his and his alone. His brushwork is bold, and particularly in the distant landscape he is inclined to arbitrary tilts and shifts of terrain, startling if one looks at the picture from a purely representational point of view, but remarkably effective in creating dynamic intensity. For this reason, his paintings have been compared with Cézanne's watercolors, and the comparison is just and illuminating. Seeing them side by side, one can perceive the relationship between their aims, although Cézanne had richer coloristic means at his disposal than those simple color schemes of tart orange, green, and blue available to the Chinese master.

Traditionally associated with the group of the Four Wangs, also known as the Loudong school, are some painters whose work is neither wholly orthodox nor completely individualist. Of these, two are especially worthy of note. One was Wu Li, the only prominent Chinese painter ever to become a Christian. He died a Jesuit priest, and consequently has been one of the few Chinese painters identified with the later orthodox school to be early and effectively studied and published in the West. Wu Li, like the four Wangs, uses the discoveries of Dong Qichang,

659. *Landscape in the Color Style of Ni Zan.* By Wang Yuanqi (1642–1715 C.E.). Dated to 1707 C.E. Hanging scroll; ink and light color on paper; h. 31⅝" (80.3 cm). China. Qing dynasty. Cleveland Museum of Art

陶淵明採菊東籬下悠然見南山宗人不三者多獨莫應物採菊露未晞莘頭見秋山真意知和畫三題古六和未陶情類先發更出新無為生脫脫雜手小重陽日暮

660. *The Continuing-and-Rejecting-the-Classical-Inheritance Landscape.* By Wu Li (1632–1718 C.E.). Hanging scroll; ink on paper; h. 25⁷/8" (65.5 cm). China. Qing dynasty. Palace Museum, Beijing

particularly in the construction of his monumental backgrounds and in the distortions of the distant mountains and their tops, to create tense and dense effects. The landscape in figure 660 offers a satisfying, honest adaptation of his immediate predecessors and a relaxed acceptance of more distant ones. It also reveals Wu's ability to construct a monumental composition; continuous overlaps in the foreground lead up to the markedly vertical mountain in the background, recalling, at least in spirit, some of the

compositions of the Northern Song period. In detail Wu's brushwork is less elegant than Wang Hui's but almost as precise, a little sharper and more angular, almost as if engraved with a burin. It is in general an orthodox work, related more closely to the painting of the Four Wangs than to any other antecedents. Its title, of course, expresses the time-honored ideal of Chinese painting: creative reinterpretation of hallowed traditions.

The second of the painters who was neither orthodox nor individualist is Yun Shouping (1633–1690 C.E.). Yun has been unjustly typed as a flower painter, for some of his landscapes are among the most beautiful, limpid, and delicate productions of later Chinese painting. But it is as a painter of flora that he is best known, and in the picture from the National Palace Museum we can see—even in a black-and-white reproduction—something of his distinctive wet style (*fig. 661*). The bamboo, even the tree trunk on the right, seem to be painted with a very wet brush that slithers over the surface of the paper, leaving not a blurred impression but a sharp one, in contrast with the medium-dry brushwork of Wu Li and Wang Hui. The wetly applied subtle tints create an effect perhaps best described as rather French and decorative. Many small albums by Yun combine landscapes and flower subjects. His landscape compositions, however, are similar to those of the four Wangs and Wu Li and are largely based on the late Ming painters; hence he is usually classified, not with the most original and creative of Qing painters, but with the more orthodox group.

The individualists are a different sort. Many were resentful of the new dynasty and felt, like the Yuan masters, a moral obligation to retire to the mountains or to Buddhist or Daoist retreats, there to practice their art and compose protests against the conquerors. One of them, Zhu Da, was of the Ming royal line, and hence had good reason to oppose the new dynasty. Others, like Kun-Can, were monks with a pronounced antipathy to the Chinese world of the seventeenth century. They are united by a revolutionary attitude within the limits of Chinese society and by their common interest in painting. Kun-Can, for example, on a well-known painting representing a monk meditating in a tree (*fig. 662*), a traditional subject with which the artist identified himself, wrote the following inscription: "The question is how to find peace in a world of suffering. You ask why I came hither; I cannot tell the reason. I am living high up in a tree and looking down. Here I can rest free from all trouble like a bird in its nest. People call me a dangerous man, but I answer: 'You are like devils.'"[32]

Or that surprisingly vocal artist Yuan-Ji writes: "I am what I am because I have an existence of my own. The beards and eyebrows of the ancients cannot grow on my face, nor can their lungs and bowels be placed in my body. I vent my own lungs and bowels and display my own beard and eyebrows. Though on occasion my painting

661. *Bamboo and Old Tree.* By Yun Shouping (1633–1690 C.E.). Hanging scroll; ink on paper; h. 40" (101.6 cm). China. Qing dynasty. National Palace Museum, Taibei

662. *Monk Meditating in a Tree.* By Kun-Can (Shiqi; 1612–1673 C.E.). Hanging scroll; ink on paper. China. Qing dynasty. Location unknown

may happen to resemble that of so-and-so, it is he who resembles me, and not I who willfully imitate his style. It is naturally so! When indeed have I ever studied past masters and not transformed them!"[33]

Such sentiments have been heard before, notably from certain Ming painters complacent about their versions of earlier artists' works, but never so vehemently expressed. If the individualists had been all talk, then there would be nothing to write about. But their paintings justify their pride and their revolutionary position in art history. Although aesthetic and, to some extent, social revolutionaries, they were not as isolated as one might think. Wang Hui, for example, who painted for the emperor and was considered the leading master of the orthodox school, called Yuan-Ji the finest painter south of the Yangzi. Their paintings were collected by many contemporary connoisseurs, and, unlike their early Ming counterparts, they died natural deaths. But it is also

663. *Landscape after Guo Zhongshu.* By Zhu Da (1626–1705 C.E.). Hanging scroll; ink on paper; h. 43¹/₄" (109.9 cm). China. Qing dynasty. Cleveland Museum of Art

true—and our good fortune—that imperial and orthodox collectors ignored their works, which are therefore better seen in Western museums and private collections than in China or Taiwan.

Zhu Da (1626–1705 C.E.) is known also by the sobriquet Bada Shanren. His work comprises at least two main

styles, the first heavily indebted to the principles of Dong Qichang. Whereas most other painters tended to adopt the more easily understandable aspects of Dong Qichang, Zhu Da derived his style out of the more radical of Dong's innovations. This style he tended to use most often in landscape, as in figure 663. According to Zhu Da's inscription, the painting is based upon a composition of the tenth century master Guo Zhongshu, but no one would ever mistake it for a tenth century painting, nor would one, without the inscription, realize the artist's reference, which probably applies to the twisting monumentality of the mountain. In boldness of brushwork and in his unique angling of the trees to support the almost jazzlike rhythm of the picture, Zhu Da surpasses even Dong Qichang. The construction of the picture by means of a series of tentative brush strokes searching for final forms rather than crystal clear and fully realized, is wholly characteristic of this style of Zhu Da. In these landscapes one senses the form emerging beneath the brush; one imagines the painter producing the picture. This is a direct contradiction of the oft-repeated old saw that all Chinese paintings were first conceived and then put down complete, perfect, and without correction from the image in the mind. Some were so painted, but certainly not most. Indeed, one can study the works of almost any painter and see where the artist corrected, changed, added, or in some way showed a method of thinking and working comparable to the methods characteristic of Western artists.

Zhu Da's other style, the one most characteristic of his art and most appealing to Western critics, is an extremely abbreviated one, brilliantly thought out and then set down, seemingly, with great rapidity and ease. We see it exemplified in the short handscroll *Fish and Rocks* (*fig. 664*). It begins with an overhanging rock and chrysanthemums, executed with a fairly dry brush in big swinging strokes, accompanied by a poem that refers to the overhang, the color of the chrysanthemums, and the clouds in the sky. This is followed with a wetter section, not quite so sharply painted as the preceding one, representing a fantastic rock and two small fish identified as carp in the inscription, and shifting the onlooker's point of view from the world above to the world below, from sky to water. The fish in particular are characteristic of Zhu Da's work, with their almost whimsical vitality, their eyes looking up to the rock and the sky above. The humorous sympathy characteristic of most of Zhu Da's bird, animal, and fish paintings is the most easily imitated facet of his art and consequently the most often forged. The scroll ends with a completely wet passage. One has passed from dry brushwork to increasingly wet brushwork, from very sharp forms to very soft and ill-defined forms, like those of the lotus in the water, where the fish can escape from the world. The third poem alludes to the lotus as a Buddhist symbol and a haven. The poetry of Zhu Da is as sharp and laconic as his painting. Poetry, cal-

664. *Fish and Rocks.* By Zhu Da (1626–1705 C.E.). Section of the handscroll; ink on paper; h. 11 1/2" (29.2 cm), l. 62" (157.5 cm). China. Qing dynasty. Cleveland Museum of Art

ligraphy, and painting are unified by succinctness and ambiguity of expression.

Another of the great individualists, the monk-painter Kun-Can (also called Shiqi), is a more complex painter than Zhu Da but more limited in his stylistic vocabulary. In interest and profundity he equals any other painter of his time. Figure 665, representing the Bao'en Temple, shows his style at its best. Next to Yuan-Ji he is the most effective colorist among the four individualists, and warm orange hues enhance the ropelike, close-knit texture produced by the complex interweaving of his brush strokes. His brushwork, brisk or rolling, creates a style more compact and graciously rhythmical than that of the Yuan painter Wang Meng. In contrast with Wang's direct and uncompromising brusqueness, Kun-Can displays a greater elegance, and something of this can be seen in the cloud forms, in the rocks and trees, and even in the convincing representation of thatch on the hut. Kun-Can's work is very much rarer than that of the other individualists, and the best of it is almost nonexistent in the West.

Yuan-Ji (whose name was formerly read as Dao-Ji; 1641–1707 C.E.) is, by general consensus, the most protean of these four individualists. (He is also called Shitao, and he and Kun-Can, whose other name is Shiqi, are often referred to as the "Two Stones," since the character *shi* in both names means "stone.") His use of color is innovative—richer, deeper, closer to the Western use of watercolor than to any Chinese painter of his own time or earlier (*cpl. 53, p. 514*). He is addicted to an extremely bold use of the brush for washes laid one next to the other, sometimes creating a rounded and solid effect not unlike that achieved in Western watercolor technique. He is also capable of work of the utmost refinement and detail. In the realm of composition he is also an innovator, for he creates in each picture a new, unique, and often intimate

665. *The Bao'en Si.* By Kun-Can (Shiqi; 1612–1673 C.E.). Dated to 1664 C.E. Hanging scroll; ink and color on paper; h. 52 1/2" (133.4 cm). China. Qing dynasty. Sen'oku Hakkokan (Sumitomo Collection Museum), Kyoto

丹井不知處藥竈尚生煙何季來石虎
臥聽鳴乾泉

荜蘂爐丹井後看鳴乾泉傍有山君去
石濤元濟苦瓜和尚

666. *One leaf from Eight Views of Huang Shan.* By Yuan-Ji (Shitao; 1641–1707 C.E.). Album leaf; ink and color on paper; w. 10⅝" (27 cm). China. Qing dynasty. Sen'oku Hakkokan (Sumitomo Collection Museum), Kyoto

667. (below) *A Thousand Peaks and Myriad Ravines.* By Gong Xian (c. 1619–1689 C.E.). Hanging scroll; ink on paper; h. 24⅜" (61.9 cm), l. 40⅛" (101.9 cm). China. Qing dynasty. Rietberg Museum, Zurich

world, reinventing, as he said, every composition in Chinese painting.

One leaf from the small album in the Sen'oku Hakkokan gives some idea of his detailed style, of the refinement of his brushwork and, at the same time, of the complete originality and daring of his composition (*fig. 666*). Two figures enter the scene from the lower right—an old, bearded sage and a boy—both mist-shrouded from the waist down. They stand under the grass-fringed overhang of a massive cliff whose base is also hidden by the mist, with a waterfall like parallel ribbons running over the rocks. In relation to the inscription incorporated

into the page, which reveals that this is a Daoist subject, the placement of these images is arbitrary, yet coherent and successful. The delicate, precise little strokes that make the leaves on the bushes at the left of the cliff contrast with the long, writhing strokes that form the layered rock formations of the cliff. In the movement of the hanging vines and grasses we sense a parody of the old man's beard and the boy's hair. All reveals a bold mind, oriented to visual perception. Like many of these painters, Yuan-Ji traveled a great deal and particularly delighted in the scenery of certain places, notably Huang Shan in Anhui Province, the Taihang Shan range in Shanxi, and the

668. *Pure Tones among Hills and Waters.* By Xiao Yuncong (1596–1673 C.E.). Dated to 1644 C.E. Section of the handscroll; ink and light color on paper; h. 12¹/8" (30.8 cm), l. 25'7³/4" (7.8 m). China. Qing dynasty. Cleveland Museum of Art

region of the Xiao and Xiang rivers in Hunan. Paintings that were in a sense reminiscences of travel form a special subgroup of Chinese painting in general and of Qing painting in particular. Each picture by Yuan-Ji, whether small album leaf or large hanging scroll, is a new adventure; in many ways he stands with Dong Qichang as the most individual and revolutionary figure of the sixteenth and seventeenth centuries.

The fourth of the great individualists is Gong Xian (c. 1619–1689 C.E.). Although the most limited in style, he is clearly the most forceful and dramatic in impact. His work has been described variously as gloomy and full of foreboding, almost funereal, a world populated by ghosts and wraiths, or the expression of a monumental, dramatic genius of somber and passionate temperament. Certainly his paintings are dramatic and somber: His characteristic format is the hanging scroll, painted in perhaps the richest blacks ever achieved in Chinese painting, shading to melancholy grays and contrasting with the sunless whites of cloud and mist and rock; and his landscapes, like those of Ni Zan, are unpeopled (*fig. 667*). Nature expresses all that he wishes to say; even the dwelling places and boats of men are presented in the thinnest and most abbreviated possible manner. He wrote a treatise on landscape painting containing the admonition that landscape must be simultaneously "convincing" and "startling," i.e., it must persuade the eye and stimulate the mind. In many of his paintings one clearly senses Western influences on the handling of light and shade. Gong Xian carried the exploration of the possibilities of light and shade as far as anyone in the history of Chinese painting.

The individualists of the seventeenth century number enough to make a crowd. Typical is a group associated with the province of Anhui in south China, whose Yellow Mountains (Huang Shan, beloved of Yuan-Ji) are a characteristic and famous geographic feature. Paintings of the Yellow Mountains are known from the Song dynasty on, and in these wild and fantastic ranges four early Qing painters found inspiration. Probably the senior member of this group was Xiao Yuncong (1596–1673 C.E.), important not only for his painting but for his book illustrations. Xiao designed many of the woodcuts illustrating

one of the most popular seventeenth century treatises on the technique of Chinese painting. The woodcuts from this book were collected in Japan as well as China and influenced numerous scholar-painters of both countries. Xiao is also important for his influence on slightly younger contemporaries from Anhui Province. His style is represented in a work called *Pure Tones among Hills and Waters*, dated to 1664, which shows his indebtedness to the great Yuan master Huang Gongwang (*fig. 668*). This long handscroll ends with a harbor amid clearing banks of mist, following a penultimate scene of a cave housing a lone monk and his attendant. A detail shows a typical unit of the composition, with numerous plateaus and a characteristic swinging rhythm based upon the careful juxtaposition of an arc and a countering angle. This slightly syncopated and oft-repeated rhythm constitutes Xiao's characteristic and individual flavor. His color scheme is also in part derived from Huang Gongwang. The use of slightly lavender blue and pink is similar to the palette reputedly used by Huang Gongwang, from whom only one work in color survives.

Xiao was slightly older than the second of the Anhui Masters, the monk-painter Hong-Ren (1610–1664 C.E.), who, judging from all the evidence, studied with him. Hong-Ren's style is utterly distinctive but just as clearly reveals its origin in the works of Ni Zan. Hong-Ren's style is even chillier and more abbreviated: spare, crystalline, wintry, and rendered especially fine by the extreme sensitivity of his brushwork. Judging from one or two pictures, he also learned much from Xiao Yuncong, as the rhythmical repetition in the big hanging scroll of figure 669 seems to suggest. Other paintings by Xiao, in turn, seem to show the influence of his pupil. Hong-Ren's style, limited and specialized as it is, shows how the style of one of the Four Great Masters of the Yuan period could still serve as original theme for a creative variation.

The third of the Anhui Masters, Zha Shibiao (1615–1698 C.E.), is a different personality. Zha seems more easygoing and extroverted, a painter with few problems or inhibitions who enjoys painting. His pictures look free and easy, as if they had been rapidly and joyously done, with no thought of profound philosophical implications. One of his album masterpieces, containing twelve

669. *The Coming of Autumn.* By Hong-Ren (1610–1664 C.E.).
Hanging scroll; ink on paper; h. 48" (121.9 cm). China. Qing
dynasty. Honolulu Academy of Arts

scenes, most of them in color, presents a favorite Qing theme, variations on the styles of earlier masters, but so radically rephrased that they become fresh and creative new works. One of these, most original in its coloring, is a representation of spring that owes nothing to the great masters of the past (*fig. 670*). Green and orange, enclosed by black ink, make the picture glow, and combined with gentle washes of blue in the grass and trees create a coloristic effect not unlike that of the great individualist Yuan-Ji. At this time color became a serious means of pictorial construction, and the seventeenth century individualists,

whether the four great masters or such secondary figures as the Anhui group, are particularly inventive in its use.

The last of the Anhui individualists, Mei Qing (1623–1697 C.E.), has perhaps the most individual style of the group and seems, like Zha Shibiao, to have been a rather blithe spirit. He goes to great lengths in distorting pictorial elements, whether they are mountains rendered in crumbly, scalloped strokes or trees and forests that look like enormously enlarged exotic and decorative flowers (*fig. 671*). Like Xiao Yuncong, Mei uses repetitive rhythms, but creates with them billowing, almost rococo effects.

The eighteenth century saw the continuation of the individualist tradition in the work of many painters. One of the most delightful of these is Hua Yan (1682–1756 C.E.), famous not only for his landscapes but for his paintings of animals and birds in a new, enlarged, and decorative style of his own, which secures him an honorable place in the history of bird and animal painting. One of his masterpieces is the landscape hanging scroll *Conversation in Autumn* (*fig. 672*), an illustration of a famous Song dynasty work of rhymed prose by Ouyang Xiu (1007–1072 C.E.). The author reflects on the curious autumnal softness of the rustle of leaves, the trickle of water. Hua Yan seems to have caught these qualities, in a work famous in China from the time it was painted. The almost impossibly tall mountain—not unlike those found in the work of the Anhui painter Mei Qing—seemingly stretches up to the sky, as if it were a plastic substance rather than a thing of rock and earth. The lower part of the picture combines the twisting rocks supporting the scholar's hut with a delicate treatment of the foliage of trees and bamboo. The leaves, spare and drifting as one would expect in the autumn, have a delicate, almost musical quality, suggesting at the same time the rhythm of a lilting tune and the look of its notes on paper.

Others of the individualists became monks, in the great Chinese priest-painter tradition. Two of these are Jin Nong (1687–1763 C.E.) and Luo Ping (1733–1799 C.E.), who were teacher and pupil and whose styles were often identical. Chinese tradition has it that Jin Nong was not much of a painter and that many of the pictures signed in his characteristic rather square calligraphy were actually painted by Luo Ping. The curious style of these two masters harks back to the metamorphic tradition of landscape painting—the visual pun—already seen in Ni Zan's *Lion Grove.* In Luo Ping's painting (*fig. 673*) a traditional Chan Buddhist subject is portrayed in a manner derived from late Northern Song masters strongly affiliated with Chan, such as Mu Qi and Liang Kai. The informal, happy compression of the work, however, is wholly in the manner of eighteenth century individualism. It was a famous work in its own time—a close copy was engraved on a stone stela in Suzhou in 1765.

Jin Nong and Luo Ping were perhaps the last significant individualists of the Qing dynasty. From about

670. *Spring, from Landscape Album in Various Styles.* By Zha Shibiao (1615–1698 C.E.). Dated to 1684 C.E. Album leaves; ink or ink and light color on paper; h. 11³/4" (29.8 cm), w. 15¹/2" (39.4 cm). China. Qing dynasty. Cleveland Museum of Art

671. (below) *One leaf from Landscapes after Various Styles of Old Masters.* By Mei Qing 1623–1697 C.E.). Dated to 1690 C.E. Album leaves; ink or ink and light color on paper; h. 11¹/4" (28.6 cm), w. 17³/8" (44.1 cm). China. Qing dynasty. Cleveland Museum of Art

1800 on painting in China became repetitive, although interesting work surfaced from time to time. Modern efforts in the traditional "individualist" style are being increasingly and favorably studied. But efforts to inject "people's realism" into modern painting have produced only dreary inanities comparable with Soviet and Nazi state-approved art.

Extremely competent and sometimes very gifted painters of flowers and birds, a genre much liked by the Qianlong emperor, are well represented in the National Palace Museum. Excellent landscapes in the orthodox tradition, deriving from the Four Wangs of the seventeenth century, were also being painted. But these add nothing to a general survey of the field. Still, one painter

672. *Conversation in Autumn.* By Hua Yan (1682–1756 C.E.). Dated to 1732 C.E. Hanging scroll; ink and light color on paper; h. 45³/8" (115.3 cm). China. Qing dynasty. Cleveland Museum of Art

673. *Han Shan and Shi De.* By Luo Ping (1733–1799 C.E.). Hanging scroll; ink and slight color on paper; h. 30⁷/8" (78.4 cm). China. Qing dynasty. Nelson-Atkins Museum of Art, Kansas City

should be mentioned as a symbol of Western influence in eighteenth century China, the Jesuit priest-painter Giuseppe Castiglione, called Lang Shi'ning by the Chinese. Castiglione, an emissary to the Chinese court, brought with him a fairly good Italian painting technique, learned in Genoa. Other artists and technicians came with him, but he became a special favorite of the court, painting many pictures for the emperors as well as influencing the decoration of porcelains. Some of his scrolls are in mixed Western-Chinese manner; a very few are thoroughly Chinese. The handscroll in the National Palace Museum, twenty or thirty feet long and representing a hundred horses, a subject that goes back to the Tang dynasty, characteristically combines Western realism in the shading and modeling of the horses with Chinese conventions in the painting of trees and mountains (*fig. 674*). The two manners have not, however, been successfully synthesized. Castiglione's works are competent, if curious and gaudy in color, but they cannot be taken as seriously as works

674. *One Hundred Horses at Pasture.* By Lang Shi'ning (Giuseppe Castiglione; Italian, act. in Beijing 1715–1766 C.E.). Section of the handscroll; ink and color on silk; h. 37¼" (94.6 cm), l. 25'5" (7.7 m). China. Qing dynasty. National Palace Museum, Taibei

wholly Chinese or wholly Italian in style. This mixture of two styles contrasts with European *chinoiserie,* in which European rococo style was brought to bear on Chinese subjects, with delightfully decorative results, particularly in porcelain and textiles.

China in the nineteenth century, suffering the massive convulsion of the Taiping Rebellion (1850–1865 C.E.) and the relentless military and political humiliation inflicted by Western nations, was not a fountainhead of great painting. But suffering and cataclysm still elicited estimable works in the two traditional modes of response—reclusive withdrawal or passionate reaction. Zhang Yin (1761–1829 C.E.) and Qian Du (1763–1844 C.E.) were fine masters of the first category, the former producing soundly and thoughtfully composed works of reduced monumentality, the latter creating contracted and hypersensitive versions of a more expansive past (*fig. 675*). Passionate response takes a new, even revolutionary, form in the works of Ren Xiong (1820–1857 C.E.), epitomized by his self-portrait with its brooding, troubled gaze

675. *Landscape Added to a Portrait of Xiangshan Seated While Watching Rising Clouds.* By Qian Du (1763–1844 C.E.). Dated to 1838 C.E. Hanging scroll; ink and color on paper; h. 67⅞" (172.5 cm), w. 21¼" (53.8 cm). China. Qing dynasty. Palace Museum, Beijing

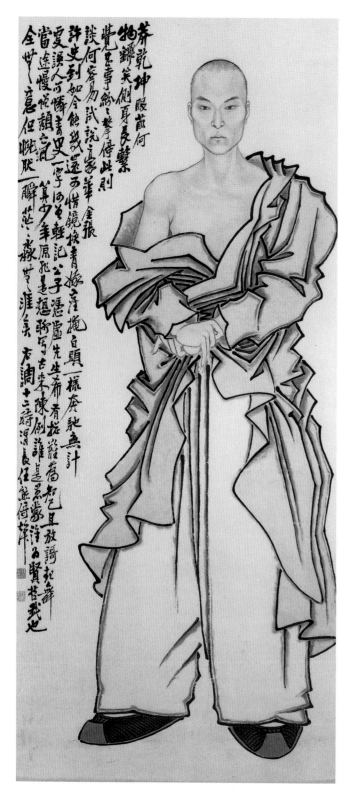

676. *Self-Portrait.* By Ren Xiong (1820–1857 C.E.). Hanging scroll; ink and color on paper; h. 69⁷/8" (177.5 cm). China. Qing dynasty. Palace Museum, Beijing

Ceramics

Only too recently it was fashionable to underrate Chinese porcelains of the seventeenth and eighteenth centuries. They were the first love of the great collectors of the early twentieth century, including J. P. Morgan, Benjamin Altman, and P. A. B. Widener. One remembers mirror-back museum cases in which six ox-blood vases became six hundred ox-blood vases, inducing surfeit and stupefaction. But it is unfair to condemn the late works on these grounds, for their technical refinement represents one high point of many in the Chinese ceramic tradition. No finer porcelains have been made before or since from the standpoint of materials and technique. The wares acquired by the great collectors of the early century usually matched French eighteenth century taste, like the rest of the decor in the great mansions where they were housed. The Chinese, and the Japanese as well, made porcelains expressly for eighteenth century French and English consumption. Black hawthorn vases, powder blue vases, jars with decoration in rose or green enamels, were desired by nearly all. Now they are the inamorata of Hong Kong and Taibei collectors. Another type of porcelain, relatively unknown in the West until recently—porcelain in Chinese taste—now commands the attention of museums and Western collectors.

A simplified account of the Qing porcelain tradition, based on appearance and technique, is necessary before we consider the precious porcelains made solely for the Chinese court. Monochromes continue to be made with ever increasing technical skill in the Qing dynasty. The basic technique of monochrome glaze color is to be seen in the ox-blood, or *lang*, wares, of which vases are the most common shape (*cpl. 54, p. 515, upper left*). The glaze color, called also by its French name, *sang de boeuf*, tends to be pale and slightly grayish at the lip of the vessel, becoming a progressively deeper coppery red with crimson or red-brown highlights, and it stops in a perfectly even line at the foot rim with no assistance other than the skill of the potter. Wares ground at the bottom in order to achieve the proper line are highly suspect as products of later, declining technology. The brilliance of this glowing red color makes it one of the most boldly dramatic glazes, in high contrast with another copper-oxide glaze of most delicate hue, appropriately known in the West as peachbloom and to the Chinese as apple or bean red. While in ox-blood porcelains the color appears to lie deep under a brilliant, transparent surface, peachbloom seems closer to the surface and mat in texture like the down of a peach—hence the appellation. Sometimes the rosy color is mottled with soft green, or is closer to ashes-of-roses than to peach color. Collectors delight in distinguishing nuances of color within each particular ware, sometimes creating extremes of minute classification. Where one separates ashes-of-roses from peachbloom is hardly a

and unflinching stance (*fig. 676*). In the context of Chinese painting Ren's bare chest is representationally aggressive and unusual, while the extraordinary agitation of his clothing is in striking and significant contrast to his motionless body.

677. *Vase.* Porcelain with *clair de lune* glaze; h. 6¼" (15.9 cm). China. Qing dynasty, reign of Kangxi (1661–1722 C.E.). Metropolitan Museum of Art, New York

weighty matter. Eight prescribed shapes of peachbloom porcelain were made for imperial contemplation, nearly all in the reign of the Kangxi emperor. One of the eight shapes is called the lotus-petal or, less properly, chrysanthemum vase, represented here by a perfect specimen (*cpl. 54, p. 515, upper right*). Another of the rare and treasured monochromes is the *clair de lune,* or moonlight glaze, its pale, shimmering cobalt blue suggesting the poetic name (*fig. 677*). Production of *clair de lune* porcelains—in a variety of shapes including those prescribed for peachbloom—was also largely limited to the Kangxi reign. The great monochromes come mostly from this early reign, the reigns of the Yongzheng and Qianlong emperors being richer in decorated porcelains.

Another group of monochromes, usually of Yongzheng or Qianlong date, used iron oxide to color the glaze. Of these the most famous is probably the tea-dust glaze, an opaque glaze of a greenish tea color with a slightly grainy texture (*cpl. 54, p. 515, bottom*). The shapes of the tea-dust wares are simple and oftentimes more agreeable to modern taste than the more elaborate monochrome and decorated porcelains. The famous apple green glaze was actually a green enamel applied over a stone-colored glaze, producing a rich lime green.

Underglaze Blue-and-White continued in wares of cold perfection made by the standard Ming technique. For a less cold and brilliant effect, potters of the Kangxi reign and after (according to Père d'Entrecolles, writing in 1722 from Jingdezhen) replaced the kaolin in the body fabric with "slippery stone" (C: *hua shi,* probably talc or steatite). This produced a creamy white, somewhat less homogeneous ware, known in the West as Chinese soft-paste porcelain (*fig. 678*). *Hua shi* might also be used, less expensively, as a slip over standard porcelains. The softness of this body and slip causes slight crazing in the covering glaze.

The greatest innovations in Qing porcelains are to be found in the enamel-decorated wares, whose French appellations—*famille verte, famille rose, famille noire*—are by now firmly ensconced in the language. Some use a limited palette—one color of enamel, plus black, in a taut but rich allover decoration of peonies against a green enamel ground. More colors and greater elaboration were a matter of technical refinement. *Famille verte* wares comprise large vases in green, rose, black, and brown enamels,

678. *Bottle vase.* Soft-paste porcelain with decoration in underglaze blue; h. 11¼" (28.6 cm). China. Qing dynasty, mark and reign of Yongzheng (1722–1735 C.E.). Cleveland Museum of Art

680. *Bottle vase. Famille rose* porcelain, *fa lang* (so-called *gu yue xuan*) style; h. 5¹/₄" (13.3 cm). China. Qing dynasty, mark and reign of Qianlong (1735–1795 C.E.). Percival David Foundation of Chinese Art, London

sometimes including underglaze or overglaze blue, with green predominating. The decorations are floral motifs or narrative scenes from famous tales or novels, with the designs vigorously and boldly drawn (*fig. 679*). The *famille verte* technique was also used in combination with the black-ground enamel technique, where a black enamel ground gave a dramatic and somber appearance to the colors, in contrast with the transparent, clean white tonality customary in most Chinese porcelains of Ming and Qing. Again one can note how much the combination accorded with French eighteenth century taste.

The *famille rose,* the rose family of porcelains, is more characteristic of the later Yongzheng and Qianlong reigns. These porcelains almost always show the white ground, with rose or yellow enamels predominating and green as a supporting note in foliage (*cpl. 55, p. 516, top*). The rose enamels were sometimes used on large vases and plates with decorations of peaches and peonies, birthday presentations to the emperor, but they were at their most refined on smaller porcelains. Some larger pieces were exported, and it was these that first entered the great American collections.

Not until the beginnings of Sir Percival David's collection in the late 1920s, and the London Exhibition of 1935, did the West realize that the *famille rose* technique had also been used for imperial porcelains of surpassing quality. These enameled wares are called by the Chinese "raised enamel" wares, or sometimes, after 1743 C.E., "foreign enamel" (*fa lang*) decoration. In the West they have been called *gu yue xuan* (moon pavilion ware), a misnomer derived from a group of late eighteenth and nineteenth century glass bottles made for private use, but we propose to return to the traditional Chinese appellations.

This new and creative style, perhaps revealing Western influence, appears at the very end of the Kangxi reign. It was based on the discovery that an opaque white lead-arsenate pigment could be mixed with colored enamels in varying proportions to produce opaque and delicately variegated tints and shades (called *fen cai,* "powdery colors"). In these tints artfully shaded designs were executed on brilliant rose or yellow grounds (*cpl. 55, p. 516, bottom*). Nearly all examples of raised enamel ware have the mark of the reign on the base, not in the usual underglaze blue, but in Song style characters of raised blue or, less often, rose enamel. The height of the technique was achieved in the Yongzheng reign and in the early years of the Qianlong reign, under Nian Xiyao and Tang Ying, successive directors of the imperial factory from 1726 to 1756. Works were produced such as the superb small vase in figure 680, which combines poetry in

681. *Bowl. Famille rose* porcelain, *fa lang* (so-called *gu yue xuan*) style, with prunus decoration; diam. 4¹/²" (11.4 cm). China. Qing dynasty, mark and reign of Yongzheng (1722–1735 C.E.). Percival David Foundation of Chinese Art, London

682. *Incense burner (koro).* Jade; h. 6" (15.2 cm). China. Qing dynasty, reign of Qianlong (1735–1795 C.E.). Cleveland Museum of Art

black enamel with floral decoration in *famille rose* enamels in a delicate and refined, lyrical, and beautifully unified expression of painting and ceramic art. One may prefer Song porcelains, Tang pottery, or Neolithic earthenware, but one cannot deny the superb quality of these porcelains made in small numbers for the court. The bowl in figure 681 shows the influence of sophisticated *wen ren* style painting in its use of monochrome black for a traditional prunus design on snow-white porcelain.

Other Decorative Arts

Other decorative arts are numerous, technically refined, and oftentimes interesting, even beautiful in an ornamental way. They display an unmatched technical virtuosity that often partakes more of patience than of inspiration: "My, what a lot of work went into that!" To which one adds, "To what end?" Still, the technical virtuosity that could produce a green jade dish so thin as to be translucent is to be admired and deserves mention in any history of Chinese decorative arts. The jewel jade incense burner in figure 682 (usually known in the West by its Japanese name, *koro*) bears a design worked in raised ridges, giving

an almost cloisonné effect to the surface. Such workmanship represents a dexterity commanded only by artisans to the court. Naturally such bibelots as this, pleasing to early twentieth century taste and admirable to anyone for their unearthly technique, were much copied and are made to the present day. The ability to distinguish between a fine piece from the eighteenth century and a mechanically made twentieth century object comes with repeated handling and looking; once acquired, it shows us that dentists' drills and machine tools are no substitute for endlessly patient hand abrasion.

The complex development of official costume and the ritual importance of different court ranks reached new heights under the Manchu emperors, resulting in magnificent robes of silk tapestry and embroidery, with the same rich, almost willfully bold and complicated decorative quality that is found in some of the porcelains and jades. From this to the repetitive inanities of the late Empire and the Republic was but a patient if agonized breath. Nothing, save for the work of a few individualists in painting and calligraphy, was worthy of the past; and China's present achievements are still in the process of assimilation and becoming.

18

Later Japanese Art: The Momoyama and Edo Periods

The endemic warfare that afflicted Japan throughout the sixteenth century changed in the course of that century from a process of fragmentation to one of consolidation as the weaker contenders for power were progressively eliminated. This continuous struggle, which terminated by 1615 in the supremacy of one clan, the Tokugawa, changed the entire composition of the ruling class. Of the nearly three hundred great families that had dominated Japan before 1500 C.E., extinction or obscurity overtook all but about a dozen, while new families rose from insignificance to supplant the rest. The history of Japan during this time can in effect be summarized in the achievements of three uneasy allies whose drive to power effected the reunification of the country: Oda Nobunaga, Toyotomi Hideyoshi, and Tokugawa Ieyasu.

The names conventionally attached to their time accurately reflect their roles as historical agents. The Momoyama period, generally dated from 1573 C.E., when Nobunaga deposed the last Ashikaga shogun, to 1615, when Tokugawa Ieyasu attained sole mastery of Japan, is named, retrospectively, for the hill on which stood Hideyoshi's lavish castle in the district of Fushimi south of Kyoto. When Tokugawa Ieyasu demolished the castle in 1622 C.E., the hill was planted to peach trees, hence the name Momoyama—Peach Hill. The early phase of the Momoyama period is sometimes called Azuchi, after Nobunaga's similarly splendid castle on the southern shore of Lake Biwa, begun in 1576, decorated by one of the foremost painters of the age, and burned to the ground a scant seven years later by the rebellious vassal who murdered Nobunaga. From Nobunaga's death in 1582 till his own in 1598 Hideyoshi ruled Japan. The Edo period is said to begin in 1615, when Ieyasu, predictably, exterminated Hideyoshi's favorite son and successor along with all his family; it is called the Edo period after the old name for Tokyo, the Tokugawa capital, and it endured till 1868, when internal and foreign pressures combined to force the abolition of the shogunate and the restoration of power to the emperor.

In fact Momoyama and Edo are a continuum, politically, socially, and artistically. They constitute a period of economic strength, feudal organization and military dictatorship, and—with the end of Hideyoshi's abortive invasion of Korea in 1598 and the expulsion of the last European traders and missionaries in 1638—nearly total isolation from the rest of the world.

Society under the *Pax Tokugawa* was strictly hierarchical, and change of class status was forbidden by law. Within each class, however, the economic and social

683. *Himeji Castle.* Hyogo Prefecture, Japan. Momoyama period, begun 1581 C.E.

range was enormous; the daimyo and the foot soldier were both samurai, the merchant prince and the urban laborer were both townsmen (*chonin*). Legally and socially, the samurai class formed the pinnacle of Edo period society and the townsmen its despised base. The old courtly aristocracy was constrained by its own traditions and by explicit shogunal regulation to the practice of arts and letters, and the cultivators of the land, though in theory ranked just below the samurai, were as much as possible kept poor and subservient. Chinese Neo-Confucianism offered philosophical justification for this system, and exalted the corollary virtues of duty, loyalty, and respect for superiors. Buddhism and Shinto did not die out, but the tone and content of life as well as art became predominantly secular.

Though the samurai retained their martial character (as symbolized by the right to wear two swords), the coming of peace changed their function from warfare to civil administration and their recompense from land held in fief to salary or annual stipend. Their new duties required some of them to be educated and concentrated them in the shogunal capital of Edo or in the castle-town capitals of the daimyo domains. They were the leaders of society, both creators and patrons of the arts, entertainment, and fashion. The existence of urban centers in each of the domains promoted stylistic variation in the arts and also increased total output. Samurai who failed to acquire a civilian function became a depressed class, "homeless samurai," harmless in times of prosperity but unruly and dangerous in times of depression or insurrection.

Kyoto continued as the preserve of the courtly nobility, who held to their traditional cultural pursuits—poetry and poetics, calligraphy, and painting—harking back in mood and subjects to the Heian period, the golden age of courtly culture.

Formation of a unified national economy and accelerating urbanization (despite the continuing official and philosophical denigration of commerce and "luxury") expanded and enriched the urban class. By the end of the seventeenth century the mercantile middle class rivaled the samurai in buying power if not prestige, and their patronage called forth a lively popular style that found its most distinctive visual expression in textiles, lacquerware, genre paintings, and *ukiyo-e*.

Robust and sumptuous tastes in this period of national inward-turning led to the creation of new native styles, based in part upon Late Heian and Kamakura revivals and in part upon the widespread strong impulse toward pleasure, entertainment, and decorative splendor.

ARCHITECTURE

The most highly visible and striking expression of the expansive, ambitious temper of the times was the castle. Earlier military architecture had been largely utilitarian—small-scale defensive fortresses separate from the living-quarters of the daimyo, or lord. But the Momoyama period saw the culmination of a trend, originating perhaps a century before, to combine keep and home into one massively fortified mansion, whose interior lavishness was designed to impress as much as its exterior strength was designed to protect. The walls of the compound, generally of earth faced with stone, encompassed all the buildings necessary to house the lord, his family, and his retainers; within, the multistoried principal building commanded a strategic view of the surrounding countryside. The great Togukawa castle at Nagoya was unfortunately destroyed during World War II, but Himeji on the Inland Sea (called Shirasagi, Castle of the White Herons, for its soaring white walls), begun by Hideyoshi in 1581 and enlarged to its present state by 1610, remains as an outstanding example of the best castle architecture of its time (*fig. 683*). The exterior of the main building, for a

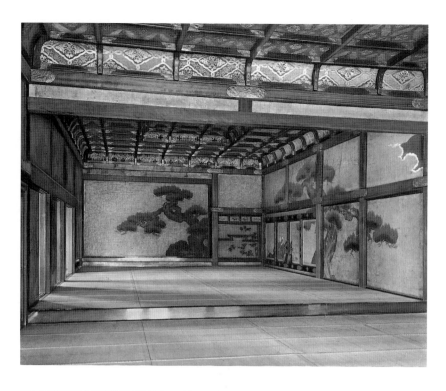

684. *Interior of highest reception and audience hall (Ni no Maru), Nijo Castle. Kyoto, Japan. Edo period, 1626 C.E.*

685. *Exterior of highest reception and audience hall (Ni no Maru), Nijo Castle. Kyoto, Japan. Edo period, 1626 C.E.*

third of its height, is a massive masonry construction, rising some fifty or sixty feet above the surface of a surrounding moat. This forbidding military aspect was newly required to withstand cannon, apparently first used in 1558 C.E. Above the masonry, however, tile roofs with upturned eaves (like those of Japanese temple architecture) top four soaring wooden stories, producing an almost pagoda-like effect and making Himeji at once watchtower, symbol of lordship, and spacious home. Within the walls, parks, gardens, and room interiors reflect not military but aesthetic and decorative requirements. The small exterior windows and the post-and-lintel construction characteristic of all East Asian architecture tended to make the great rooms rather dark, since light could enter only from the perimeter of the building; the far walls opposite the windows enjoyed a kind of perpetual glimmering twilight (*fig. 684*). This had considerable effect on the type and technique of decoration that

was to develop. One of the few remaining urban castles (*jo*) is Nijo, begun by Ieyasu in 1602 C.E. as his Kyoto headquarters. Its clean lines and dominating roof are softened by the surrounding trees and open space. Here again the building exteriors (*fig. 685*) give no hint of the palatial decoration to be found on the sliding and fixed panels of the interior walls. Even the gardens attached to aristocratic pavilions reflected something of the new sumptuousness of the age. The garden of the Sambo-in in Kyoto was designed for the great dictator Hideyoshi himself, and in contrast with the considerable restraint characteristic of gardens of the Muromachi period, such as the jewel-like garden of Daisen-in or the sand garden of Ginkaku-ji, the Sambo-in garden luxuriates in boldly shaped and landscaped artificial islands connected by subtly varied bridges (*cpl. 56, p. 517*). The Sambo-in building was brought in from the country by Hideyoshi, and illustrates a continuation of that taste for farm architecture which

Colorplate 52. *White Clouds over Xiao and Xiang (after Zhao Mengfu).*
By Wang Jian (1598–1677 C.E.). Dated to 1668 C.E. Hanging scroll; ink and color on
paper; h. 53¹/4" (135.3 cm). China. Qing dynasty. Freer Gallery of Art, Smithsonian
Institution, Washington, D.C.

泛柳縣弄色不管人
白頭一春雨露阻
遊袋梅花閣可清
明留老去無聊籍
波鷗汪子無端向栽
發長嘴吾將絕
覽閒澥之奧妙請
君置栽先向畫圖
看眼嚴正墼都一
非墨非煙聊寄傲
君家嚴親百什才一
言　奏對鷥風雷
天子非常賜顏色瀲
墾稱　青今南來多
女輩庚待者濟看君
作意爲龍其六益着
汪子牧庭之閒海莱星思
白學使潛清汕老人濟大
涤堂下

Colorplate 53. *Spring on the Min River.* By Yuan-Ji (formerly known as Dao-Ji; Shitao; 1642–1707 c.e.). Dated to 1697 c.e. Hanging scroll; ink and color on paper; h. 15³/8" (39.1 cm). China. Qing dynasty. Cleveland Museum of Art

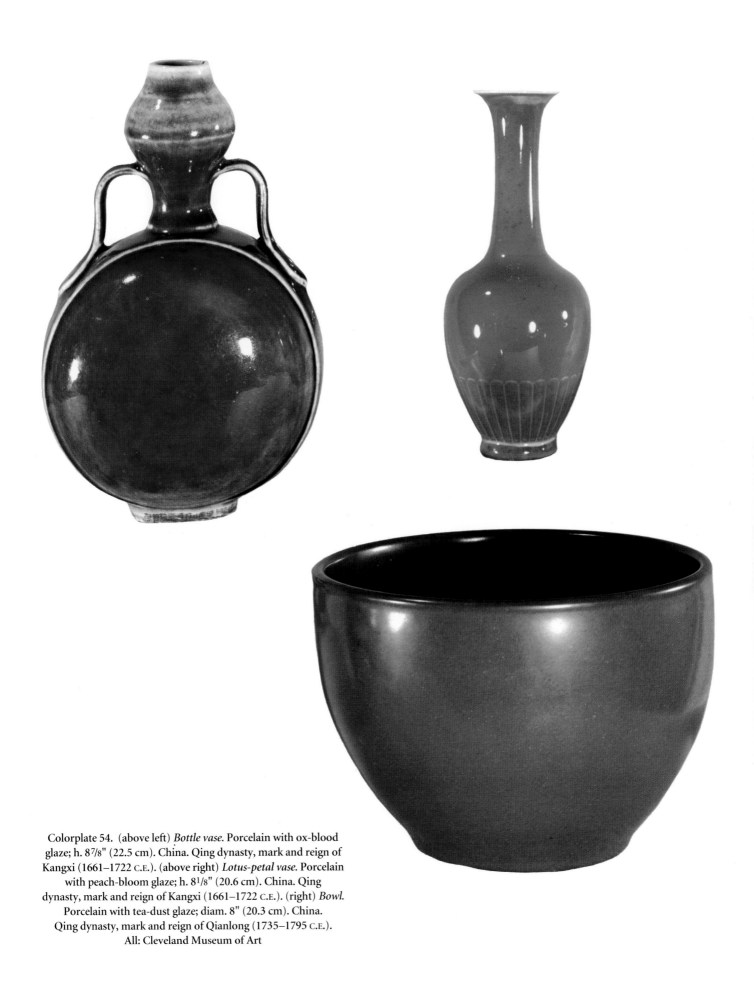

Colorplate 54. (above left) *Bottle vase*. Porcelain with ox-blood
glaze; h. 8⁷/₈" (22.5 cm). China. Qing dynasty, mark and reign of
Kangxi (1661–1722 C.E.). (above right) *Lotus-petal vase*. Porcelain
with peach-bloom glaze; h. 8¹/₈" (20.6 cm). China. Qing
dynasty, mark and reign of Kangxi (1661–1722 C.E.). (right) *Bowl*.
Porcelain with tea-dust glaze; diam. 8" (20.3 cm). China.
Qing dynasty, mark and reign of Qianlong (1735–1795 C.E.).
All: Cleveland Museum of Art

Colorplate 55. (above) *Bowl. Famille rose* porcelain; diam. 5¹/₂" (14 cm). China. Qing dynasty,
mark and reign of Yongzheng (1722–1735 C.E.). (below) *Bowl.* Porcelain, *fa lang* (so-called *gu yue xuan*) decoration
of raised enamel on yellow ground; diam. 4⁷/₈" (12.4 cm). China. Qing dynasty, mark and reign of Kangxi
(1661–1722 C.E.). Both: Cleveland Museum of Art

Colorplate 56. *Garden of the Sambo-in of Daigo-ji.* Kyoto, Japan. Momoyama period, completed 1615 C.E.

Colorplate 57. *Cypress Trees.* Attrib. Kano Eitoku (1543–1590 C.E.). Eight-fold screen; color, gold leaf, and ink on paper; h. 67" (170.2 cm). Japan. Momoyama period. Tokyo National Museum

Colorplate 58. *The Pass through the Mountains.* By Fukae Roshu (1699–1757 C.E.). Six-fold screen; ink, color, and gold leaf on paper; h. 60" (152.4 cm). Japan. Edo period. Cleveland Museum of Art

Colorplate 59. *Tigers and Bamboo.* By Kano Tan'yu (1602–1674 C.E.). Two panels of a sliding screen; ink, color, and gold leaf on paper; h. approx. 67" (170.2 cm). Nanzen-ji, Kyoto, Japan. Edo period

Colorplate 60. *White Prunus in the Spring.* By Ogata Korin (1658–1716 C.E.). One of a pair of two-fold screens; color and gold leaf on paper; h. 62" (157.5 cm). Japan. Edo period. MOA Museum of Art, Atami

Colorplate 61. *Irises.* By Ogata Korin (1658–1716 C.E.). Pair of six-fold screens; color and gold leaf on paper; h. 59" (150.9 cm), l. 11'1" (33.8 m) each. Japan. Edo period. Nezu Art Museum, Tokyo

Colorplate 62. *Golden Pheasants in Snow from the series The Colorful Realm of Living Beings (Doshoku Sai-e)*. By Ito Jakuchu (1716–1800 C.E.). Hanging scroll; ink and color on silk; h. 55⁷/8" (142 cm), w. 28³/4" (72.9 cm). Japan. Edo period, c. 1758–1770 C.E. Imperial Household Collection, Tokyo

Colorplate 63. *Women of Fashion at Leisure.* Pair of six-fold screens; color on gold paper; l. 12' (3.65 m). Japan. Edo period, 1st half of 17th century C.E. Yamato Bunkakan, Nara

Colorplate 64. *Summer Rain and Autumn Wind.* By Sakai Hoitsu (1761–1828 C.E.).
Pair of two-fold screens; color on silver paper; h. 65³/₈" (166 cm), w. 71⁷/₈" (183 cm). Japan.
Edo period. National Commission for Protection of Cultural Properties, Tokyo

Colorplate 65. *Jar.* By Nonomura Ninsei (d. c. 1685 C.E.). Stoneware with overglaze enamel decoration of poppies; h. 16³/₄" (42.5 cm). Japan. Edo period. Idemitsu Museum of Art, Tokyo

Colorplate 66. *Dish.* Ko Kutani (Old Kutani) porcelain with overglaze enamel decoration of Chinese *feng-huang*; diam. 13³/8" (34 cm). Japan. Edo period. Yamagami collection, Ibaragi Prefecture

686. *Detail of carved wooden transom (ramma) from Fushimi Castle, later moved to audience hall of Nishi Hongan-ji.* Kyoto, Japan. Momoyama period

687. (right) *Kara Mon (Chinese Gate; detail) of Nishi Hongan-ji.* Kyoto, Japan. Momoyama period

688. (below) *Yomei Mon (Yomei Gate) of Tosho-gu.* Nikko, Japan. Edo period, 17th century C.E.

we have seen to be one aspect of the cult developed around the tea ceremony. But the rich and brilliant colored panels inside this apparently rustic structure belie the exterior.

In mediums other than painting this rich tradition of interior decoration is perhaps best seen in the interior of the great audience hall of Nishi Hongan-ji, where open-work wooden panels are elaborately pierced and carved into images of waves, flowers, and animals (*fig. 686*). The same decorative emphasis can be seen on a larger scale in the ornately carved panels of the gate at Nishi Hongan-ji (*fig. 687*). Here the realistic tradition of wood sculpture so strongly developed in the Kamakura period was modified for decorative ends; the result, opulent and overwhelming in its complexity, balanced realistic detail with a decorative use of rhythmical repetition and bold color.

The comparatively restrained style of carved wood decoration characteristic of the Momoyama period becomes almost a jungle of profusion in the Edo period. The Japanese buildings best known to Western tourists, and the type-site for Edo period gorgeousness in architecture, are the lavish shrines built by the Tokugawa shoguns at famous Nikko. The elaborately painted and lacquered interiors certainly overwhelm the spectator, as does the Yomei Gate, with its white base and pillars, elaborately carved and colored reliefs of peonies on the side panels, and profusion of copiously colored and gilded bracketing on the upper part of the gate (*fig. 688*). Yet this extreme expression of the decorative style is perhaps the least of

689. *Masonry from Tosho-gu.* Nikko, Japan. Edo period, 17th century C.E.

690. *Katsura Detached Palace* (front view; right to left: Old, Middle, and New Shoin). Kyoto, Japan. Edo period, begun c. 1625 C.E.

the achievements of Japanese architecture. A real architectural contribution of this later military society is to be found, not in the overweening wooden decoration of the shrines, but in stonework such as that at Nikko (*fig. 689*). All of the great walks, stairs, and walls here are made of large blocks of granite, cut and fitted with the utmost precision, and so laid as to harmonize with the incredibly beautiful forest setting of great cryptomeria trees, some of them over a hundred feet high. The unornamented grandeur of this stonework seems the true measure of the men who by force and guile created the Momoyama and the early Edo periods.

691. *Hiun-kaku (Fleeting Cloud Pavilion) of Nishi Hongan-ji.* Kyoto, Japan. Momoyama or early Edo period

Notwithstanding the riotous extravagance of Nikko and the opulence of the castles, the already deeply rooted Japanese taste for simplicity in architecture was not displaced; rather, it was embraced even more avidly, not only by the aristocracy and the military but by the new, wealthy upper middle classes. The antithesis of Nikko is the calculated tea-ceremony taste embodied in the Katsura Detached Palace (Katsura Rikyu, begun 1625 C.E.). Built over two generations by Prince Hachijo Toshihito (1579–1629 C.E.) and his son Toshitada, Katsura, which still belongs to the Imperial Household, has become the most famous of all Japanese tea-taste villas. In the modern West admiration from faculty of the Bauhaus sealed its importance as an influence on the formation of the "International Style" of architecture. Katsura is almost certainly the purest and most ordered of tea type buildings and gardens. Its stone pathways and the oldest part of the main house, the Ko Shoin (*fig. 690*), are especially admired. Some, including this writer, find a degree of self-conscious, even coy, simplicity in this late manifestation of a tradition beginning in Heian palace style but thoroughly tempered by tea taste.

Small tea pavilions continued to be built by all who could afford them, and these carry on with more or less success the tea-ceremony architecture that had been established by the middle and late Muromachi period. At Nishi Hongan-ji in Kyoto Hideyoshi's tea pavilion was re-erected and called the Hiun-kaku (*fig. 691*), in the great tradition of such pleasure pavilions of the early Ashikaga shoguns as the Gold and Silver Pavilions in Kyoto. With its dark exterior woodwork, it seems even more asymmetrical and informal in general plan and arrangement than the earlier structures. Situated in a lush garden, perhaps even more decorative than that of the Sambo-in, the pavilion was a place where the new dictator and his military acquaintances could gather in an atmosphere suggestive of the Muromachi tea house. But inside the Hiun-kaku, though some rooms are decorated with monochrome paintings in the tea tradition, others boast colored *fusuma* in the sumptuous painting style developed in the Momoyama period.

692. *Bridge at Uji.* Pair of six-fold screens; color, gold, and silver on paper; h. 67¹/₂" (171.4 cm). Japan. Momoyama period. Nelson-Atkins Museum of Art, Kansas City

PAINTING

We shall consider Japanese painting of the Momoyama and Edo periods, not according to the detailed genealogies of painter families, but according to leading stylistic tendencies. As in any period, conservative styles persisted, but with few exceptions the numerous painters continuing in the Chinese-influenced style of the Muromachi period, particularly in the Kano school, contributed little that was new to Japanese painting. Among the creative trends we shall consider first the decorative style, perhaps Japan's most original and fruitful painting style. Second is a Chinese-influenced style, not based, like Muromachi monochrome painting and its Kano continuation, on Song and early Ming masters, but on the scholars' painting of the seventeenth and eighteenth centuries. This latter style, known in Japanese as *bunjinga* or *nanga* ("literati painting" or "southern painting," in Dong Qichang's terminology), boasted several artists of great importance and creative ability. The third trend is a naturalistic one, influenced in part by Western art and even more by a growing awareness of nature as seen, rather than as rendered in brush conventions. Finally the *ukiyo-e* tradition produced some very important paintings of mixed decorative and *ukiyo-e* subjects and styles in the seventeenth and eighteenth centuries and culminated in the great woodblock prints of the eighteenth and nineteenth centuries.

The native decorative style, which first appears in Fujiwara and Kamakura painting, revives in the sixteenth century and especially in the Momoyama period. In figure 692 a golden bridge gleaming in the moonlight crosses a willow-bordered stream. The motif is traditionally associated with the Uji River near the famous Phoenix Hall (Ho-o-do) of the Fujiwara period, but its rendition is almost totally Momoyama in style. The silver moon recalls Fujiwara painting; the juxtaposition of undulating trees against the geometrically arched bridge recalls certain Fujiwara or Kamakura lacquers. But the overall opulent splendor of the composition, the copious use of gold in the background, the large and bold rhythms of the willow-tree

trunks, the obvious delight in textures and rather crowded composition—these make a new and original statement, a Momoyama contribution, out of which most of the later decorative style develops. Earlier painting, whether iconic or Zen monochrome, had been primarily religious in tone and purpose; in Momoyama it tends increasingly to serve secular requirements. The new style employed many formats, including sliding panels, stationary wall paintings (*shohekiga*), single screens, folding screens, and decorative hanging scrolls. Gold leaf, because it reflects light, brightened the dark castle rooms; used as background, it also outlined painted forms dramatically. The new decorative art originated in the Chinese-influenced Kano school but soon advanced to extremes of pattern and color that belied the severe aims of the parent style.

This development can be traced from the first great master of the Momoyama period, Kano Eitoku (1543–1590 C.E.). As his name implies, he was in the main line of the Kano school, a grandson and pupil of Motonobu, with whom much of the impetus toward decoration had originated. But in the painting attributed to Eitoku on the two sliding panels from the Juko-in subtemple of Daitoku-ji, Kyoto, the ostensibly monochrome Kano style of representation of the blossoming tree, the birds, and the bamboo has been further developed as a decorative style, with greater complexity of composition, fewer areas of open space left untouched by the brush, and a faint gold wash applied to the background sky (*fig. 693*). From this decoratively inclined but still relatively severe style of painting to Eitoku's main contribution is a considerable step, but it was made in one lifetime. It can best be seen in an eight-fold screen in the Tokyo National Museum (*cpl. 57, pp. 518–19, top*). The large cypress tree is not an exercise in the use of ink, but a massive, even sculpturally modeled form produced in color. Rich browns and reds model the general shapes; ink supplies the bark texture. Malachite green silhouettes the lithe boughs as well as creating their leaves. Rocks are now colored and placed against azurite blue areas indicating water. The background as well as the swirling clouds is indicated in gold

693. *Plum Tree by Water.* Attrib. Kano Eitoku (1543–1590 C.E.). One of a pair of sliding screens; ink and slight color washes on paper; h. 69¹/8" (175.6 cm). Juko-in, Daitoku-ji, Kyoto, Japan. Momoyama period, begun 1566 C.E.

694. (below and opposite) *Pine Wood.* By Hasegawa Tohaku (1539–1610 C.E.). Pair of six-fold screens; ink on paper; h. 61" (155.7 cm). Japan. Late Muromachi or Momoyama period. Tokyo National Museum

leaf applied to the surface of the stretched paper. The result is very largely an art of silhouettes and of their careful placement against a background of gold. This ground, an abstract, unearthly realm in Byzantine art, becomes in the Momoyama decorative style a most palpable and solid ground of rich gold acting almost as a stage flat against which the clear silhouettes of natural forms stand out. Eitoku is still a shadowy figure and few works are surely by him, but tradition affirms and life span does not contradict his role as founder of the Momoyama decorative school. In 1576 Oda Nobunaga made him chief of the painters creating the lavish decorations of Azuchi Castle, an appointment that gave Eitoku unprecedented authority over many artists of different schools.

His rival was Hasegawa Tohaku (1539–1610 C.E.), whom we know to have disliked the Kano tradition. Like Eitoku, he painted in both monochrome and colored decorative style, but his monochrome paintings, such as the famous *Monkeys and Pines* in the Ryusen-an of Myoshin-

ji, Kyoto, derive directly from the art of Mu Qi, especially the famous triptych at Daitoku-ji (*see fig. 484*), rather than secondhand through the late Kano school. If this were the only monochrome work by Tohaku, we would recognize him as a brilliant practitioner of late Southern Song monochrome style. But Tohaku also painted one of the supreme masterpieces of monochrome ink painting, *Pine Wood,* illustrated in figure 694. This pair of screens, executed solely in monochrome ink on paper, reveals the true originality and daring of Tohaku and his generation. Taking what would have been a detail in an earlier composition, he enlarged the pine trees and simply isolated them on the screens, providing no background of mountains, no foreground of scholars or rocks, suggesting space by means of graded ink tones implying swirling mist around the pine trees. These are painted boldly and simply, with something of the dancing movement and rhythm of the trees in the screens by Tensho Shubun (*see fig. 557*). Though implying the influences of Mu Qi and

Shubun, the screens exist as an original creation, one expressing something of the grandeur and scale of the Momoyama effort, even in such a usually nondecorative medium as monochrome ink.

Tohaku also attempted the more typically decorative Momoyama style in the numerous sliding panels now preserved at the Chishaku-in, Kyoto (*fig. 695*). These sliding panels, like those of Eitoku, have gold-leaf backgrounds, and are painted in opaque mineral colors instead of monochrome ink. Indeed, there is little ink to be found in the originals except for occasional accents or underpainting guides to the application of color. The gold background has greatly increased in area and enhances the brilliance of the color and especially the importance of the profiles, which are not rendered in a single dark tone but vary from grays, pinks, and pale greens to the darkest azurite, malachite, and brown. The motifs of these screen paintings range from allover patterns of flowers and maple leaves to dominant, heavy tree trunks and boughs. The tree trunk reaching up and out of the panel at the top and then returning at the center demonstrates the decorative daring of the new approach, as do Tohaku's striking combinations of strong tree trunks with delicate foliage, blue water with green plants. Despite the decorative emphasis, it is a powerful painting.

The third of the great Momoyama decorators is Kano Sanraku (1559–1635 C.E.). Like the others, he created both monochrome and colored paintings, which can be

695. (left) *Maple Tree and Flowers.* Attrib. Hasegawa Tohaku (1539–1610 C.E.). Dated to 1592 C.E. Two panels of sliding screens; color and gold leaf on paper; h. 70" (172.5 cm), w. 54 1/2" (138.5 cm) each panel. Chishaku-in, Kyoto, Japan. Late Muromachi or Momoyama period

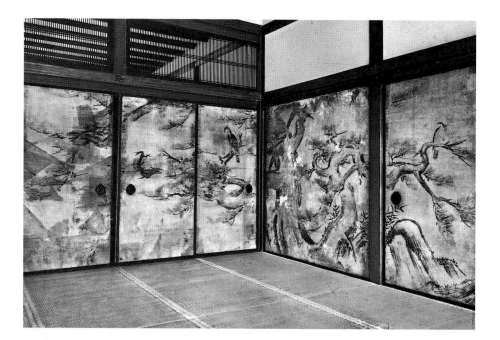

696. *Hawks and Pines.* By Kano Sanraku (1559–1635 C.E.). Sliding screens; ink on paper; h. approx. 70" (177.8 cm). Daikaku-ji, Kyoto, Japan. Momoyama or Edo period

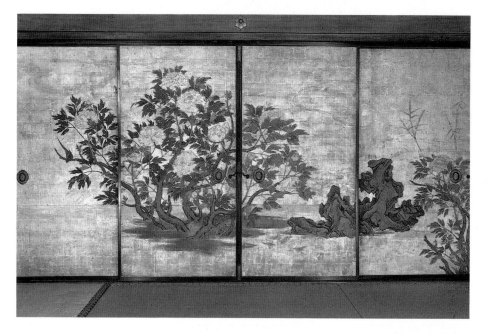

697. *Tree Peonies and Rocks.* By Kano Sanraku (1559– 1635 C.E.). Four panels of eight-panel sliding screen; color, ink, and gold leaf on paper; h. 6'3/4" (1.85 m). Daitoku-ji, Kyoto, Japan. Momoyama–Edo period

seen mainly at Daikaku-ji in Kyoto (*fig. 696*). There, in adjacent rooms, are superbly painted monochrome panels showing birds of prey on old pines and deciduous trees, and richly colored panels with gold backgrounds. The Daitoku-ji screens of Chinese peonies give some idea of the subtlety and restraint characteristic of Sanraku, in contrast with the bold and powerful styles of Eitoku and Tohaku (*fig. 697*). Some of Sanraku's panels seem to combine the type of composition usually found in monochrome painting with the new colored decorative style. The delicate and refined tree-peony branches are balanced by the powerful tree trunk and rocks, but even these are more stylized than the massive forms depicted by the two earlier painters. Sanraku seems to anticipate something of the mode to be developed by Sotatsu and Korin in the seventeenth century.

Other Kano painters, famed in their day for monochrome painting, worked in the new decorative style. The best achievements of an artist such as Kano Tan'yu (1602– 1674 C.E.), perhaps the most famous name in monochrome painting of the seventeenth century, are for the most part in the new color-and-gold medium. The screens at Nanzen-ji, picturing tigers and bamboo, the favorite samurai emblems of fierce strength and pliant endurance, utilize the gold ground to emphasize the silhouettes of the animals and complement their interior bulk (*cpl. 59, p. 520*). There is a trace in these panels of that sharpness of observation particularly important in works of the "realistic" school associated with the name of Okyo, though Tan'yu was a talented late representative of the Kano school. Tan'yu enjoyed the patronage of the shogunal house and the daimyo, of the emperor and the

698. *Thunder God.* By Tawaraya Sotatsu (act. late 16th–early 17th century C.E.). Section of a pair of two-fold screens; color, gold leaf, and ink on paper; h. 60" (152.4 cm). Kennin-ji, Kyoto, Japan. Edo period

courtly aristocracy, and of the major Buddhist temples, and his style is correspondingly varied. Furthermore, he was the director of a large atelier, and many of his designs were executed at least in part by other artists working to his specifications. In addition to fulfilling a huge number of painting commissions, he also served his patrons as a connoisseur of earlier ink paintings. His and his successors' sketch records of old works are invaluable visual sources for the history of Chinese and Japanese art.

The Momoyama painters and their followers in the Edo period quickly and definitively established a luxuriant, complex style difficult of further development. The statement was so complete and overwhelming—some four hundred-odd sliding panels were made for Nagoya Castle alone—that a new style became almost imperative. Changing tastes also dictated a different manner. The unabashed splendor of the Momoyama style, which might satisfy the first generation of the new ruling class, the old Kyoto aristocracy, and the wealthy and ambitious merchants and artisans (*chonin*), could not continue to please as their more refined descendants became increasingly aware of the contributions of older Japanese art.

The Momoyama period may be considered a brilliant prelude to the culmination of later Japanese decorative style in the school established by Tawaraya (or Nonomura) Sotatsu (act. late 16th–early 17th century C.E.). Some thirty years ago Sotatsu was merely a name to be mentioned in conjunction with Korin, but subsequent research and rediscovery of his paintings have led to his just evaluation as the most creative master of later decora-

tive style and the founder of the great Sotatsu-Korin school, also called the *rimpa* school. We know that in Kyoto Sotatsu opened and ran a shop specializing in painted fans, and that his *Pine Trees* on sliding screens in the Yogen-in represent a major commission which he received in 1621.

A major work by Sotatsu, such as the pair of two-fold screens representing the deities associated with thunder and wind, discloses a different decorative approach from that of such Momoyama painters as Eitoku, Tohaku, and Sanraku (*fig. 698*). In contrast with the overall patterning of these Momoyama painters, and their use of Chinese-derived motifs, Sotatsu's work seems more audacious and severe, with stronger emphasis upon asymmetry of composition and simplicity of silhouette and a greater variety in the handling of color and ink. In subject matter too it differs from paintings of the earlier generation, being derived from pre-Muromachi Japanese traditions, particularly from representations of deities, demons, and noble personages in scrolls of the Fujiwara and Kamakura periods. Tawaraya Sotatsu bypassed the Chinese style paintings of the Muromachi period to find other sources more deeply rooted in the Japanese tradition: the decorative style of the Fujiwara period, best seen in the *Genji* scrolls, and the narrative tradition of Kamakura handscroll painting with its emphasis upon action and caricature-like figures. He did not, however, rely completely upon early Japanese sources for his style but used also techniques of paint application developed in the Muromachi period. The bold brushwork of the clouds surrounding the wind

699. *Zen Priest Choka.* By Tawaraya Sotatsu (act. late 16th–early 17th century C.E.). Hanging scroll; ink on paper; h. 37³/4" (95.9 cm). Japan. Edo period. Cleveland Museum of Art

700. *Teabowl.* By Hon'ami Koetsu (1558–1637 C.E.). Raku stoneware, h. 3³/8" (8.7 cm). Japan. Momoyama–Edo period. Freer Gallery of Art, Smithsonian Institution, Washington, D.C.

hatsuboku tradition. This inspiration is clearly visible in one of Sotatsu's important monochrome paintings, a hanging scroll of paper representing the Zen priest Choka sitting in a tree (*fig. 699*). The subject is derived from Chinese paintings familiar to the Japanese from woodblock-print compendiums and was used by such literati painters as Kun-Can (*see fig. 662*). But Sotatsu transforms the original work, which shows the whole tree and clearly delineates the figure of the monk, into a daring asymmetrical composition. He leaves most of the tree outside the picture and deliberately de-emphasizes the monk by using pale ink lines, thus creating a decorative composition while adhering to the *hatsuboku* style. Of few pictures can it be more truly said that one praises what is not there.

Sotatsu's style of painting is not wholly tradition-directed. Sotatsu's wife may have been related to Hon'ami Koetsu, and it is certain that Koetsu had some influence on Sotatsu's new painting style. Koetsu was known as a tea master who also made teabowls, in the tradition of the tea masters of the late Muromachi and the Momoyama periods (*fig. 700*). This famous example displays a beautiful control of the slightly asymmetrical bowl shape and an especially interesting and subtle use of orange and moss green in the glaze. Koetsu's training as a tea master undoubtedly reinforced his inclinations to aesthetic severity and to the deliberate roughness associated with the cult of tea. He was also a very important calligrapher, not in the Chinese but in the Japanese semicursive (*gyosho*) style. He collaborated with Sotatsu on several scrolls of poems, writing the text over under-decoration by Sotatsu. On a long scroll bearing the signature of Koetsu and the seal of Sotatsu are herds of deer and poems from one of the great imperially commissioned poetry anthologies, the *New Anthology of Ancient and Modern Verse* (*Shin Kokinshu*, completed 1205 or 1206 C.E.; *fig. 701*). In this combination of freely executed semicursive calligraphy

god shows that Sotatsu had studied Sesshu's *hatsuboku* ink painting. The fading off of color boundaries, the blurred effect created when ink or dark color is added to still-wet lighter color and allowed to puddle (*tarashikomi*), are Sotatsu's inventions but certainly inspired by the

701. *Deer Scroll.* Painting by Tawaraya Sotatsu (act. late 16th–early 17th century C.E.); calligraphy by Hon'ami Koetsu (1558–1637 C.E.). Section of the handscroll; gold and silver pigment and ink on paper; h. 12¹/₂" (31.8 cm), l. 30'³/₄" (9.2 cm). Japan. Edo period. Seattle Art Museum

with informal gold and silver representations of deer we can see how Koetsu's tea inclinations and his accompanying asymmetry and slight roughness merged with Sotatsu's study of pre-Muromachi Japanese art. It was a fusion that transformed the Momoyama decorative style. The compositional device of allowing the herd of deer to run up and off the paper, with only the head and feet of one deer visible at the top of the scroll, is comparable with the barely visible tree in the monochrome representation of Priest Choka. This audacious combination of the handscroll format, the brilliant gold and silver of the Momoyama decorative style, and the asymmetry and roughness of tea-ceremony taste will rightly always be associated with Sotatsu's name.

Perhaps the most important of Sotatsu's screen paintings are the pair belonging to the Seikado Library, representing two episodes from *The Tale of Genji* (*fig. 702*). Though the episodes are well albeit subtly developed in the novel, their narrative or illustrative possibilities are played down by the artist. The representational elements of each scene are present—Genji, the curtained ox cart that was the vehicle of Heian nobility, the two retinues, and the boat in one scene and screened cart in the other that bear two of Genji's lovers. But these are not primarily narrative screens. The gold background, the brilliant use of green, blue, and brown, the lively silhouettes of the figures derived from Kamakura scroll painting, the construction of the landscape as a series of overlapping stage flats, probably under the influence of both Fujiwara lacquers and Kamakura handscrolls, are all elements derived from the past but fully assimilated and transformed into a new and original style. The placement of these silhouettes is crucial and has been exquisitely calculated, almost as if Sotatsu, like Matisse, had used a collage technique, moving cut-out figures against the gold background till the composition was perfect. The use of tilted perspective and of abstract water patterns at the top of the "Miotsuku-

shi" scene is also part of this silhouette style. We need not merely infer the influence of Fujiwara and Kamakura styles on Sotatsu, for we know that he was called upon to restore and redecorate some of the endpapers of the famous sutras at Itsukushima, which, you will remember, are key documents of the *yamato-e* style of the late Fujiwara period (*see pp. 347ff. and figs. 441, 442*). Also extant are free copies by Sotatsu after the mid-Kamakura scroll *The Fast Bulls.* His style reflects other sources as well, but Sotatsu's great contribution—unlike the merely eclectic Kano painters—was to fuse these influences into a new synthesis. The sense of humor apparent in his work seems in keeping with his Japanese artistic origins.

Of Sotatsu's contemporary followers—shadowy figures whose names are only now emerging—Fukae Roshu is one of the most significant. He seems to have absorbed the lessons of his master's new and radical approach. *The Pass through the Mountains,* a screen ostensibly illustrating a poem from the *Ise Monogatari,* is an example of Sotatsu's art carried to further extremes, particularly in the treatment of the landscape as a series of stage flats and in the unusual color harmonies of blue and rust red (*cpl. 58, pp. 518–19, bottom*).

Though Sotatsu undoubtedly influenced numerous painters, a direct line traditionally leads from him to Ogata Korin (1658–1716 C.E.) and thence to Sakai Hoitsu (1761–1828 C.E.), each the leading decorative master of his generation. So important is Korin that in Japan his name and Sotatsu's are often used jointly to designate the later decorative school of painting, now more often known as the *rimpa* school—an early Meiji period coinage combining the *-rin* of *Korin* with the *-pa* that means "school." We know more of Korin's life than we do of Sotatsu's. He was descended from Koetsu's sister and came not of the samurai class but of an upper-middle-class merchant family, and he exemplifies the relationship between the new style and the new society of the Edo period. He was officially

702. *Two scenes from The Tale of Genji:* (above) chapter 14, *Channel Buoys (Miotsukushi);* (opposite) chapter 16, *The Barrier Gate (Sekiya).* By Tawaraya Sotatsu (act. late 16th–early 17th century C.E.). Pair of six-fold screens; ink, color, and gold leaf on paper; h. 59½" (151.1 cm), l. 11'7½" (3.54 m). Japan. Edo period. Seikado Library, Tokyo

reprimanded by the court for an overconspicuous display of wealth when at a party he wrote poems on gold leaf and floated them down a stream in emulation of legendary poets' gatherings in Tang China. His works were collected, however, not only by the new wealthy merchant class but also by the aristocracy. Genroku is the era-name for the fifteen-year period, from 1688 to 1703 C.E., in which the Japanese townsmen came into their own, supplanting the samurai not in social status but in economic power, and giving rise to a distinctive culture. The Japanese decorative style, first appearing in Fujiwara and Kamakura art and suddenly revived during the Momoyama period, came to full flower during Genroku.

Korin's works are more carefully and less freely painted than Sotatsu's, with a greater emphasis upon precise outline and a relatively even application of color. Korin tempers Sotatsu's boldness to greater elegance and refinement, renders it more approachable; hence he was celebrated before the rediscovery and proper evaluation of Sotatsu. His two screens in the Tokyo National Museum, *White and Red Prunus in the Spring* (of which only the left-hand one is shown here), present an arresting contrast between Korin's native elegance, seen especially in the painting of the tree branches, and the daring inherited from Sotatsu, reflected in the strong shape and swirling surface of the stream (*cpl. 60, p. 521*). Korin's most famous paintings, and probably his masterpieces, are the pair of six-fold screens in the Nezu Art Museum in Tokyo, representing irises, a subject derived from the *Ise Monogatari* (*cpl. 61, p. 522*). It is characteristic of the Sotatsu-Korin school that its motifs can usually be traced to a literary source, although little if any effort is made to illustrate the scene literally; there is only an allusion to the setting or the accoutrements, or a suggested mood or flavor that can perhaps be sensed by the Japanese if not

by us. The irises angled across a gold ground in Korin's screens actually border an eight-branched stream crossed by eight bridges in an episode of the *Ise Monogatari*. But Korin has focused on the iris as his sole motif, enlarging them into a great decorative composition, with the malachite green spikes of the leaves dancing across the screen in counterpoint to the iris blossoms in two shades of azurite blue. The effect from a distance is that of a silhouette modified by inner resonances of color. As one approaches the screens, the color becomes ever more dominant until at last the vibration of the blue and green against the gold reaches its climax. The subject was painted again by Korin in a pair of screens in the Metropolitan Museum of Art, where the bridges mentioned in the *Ise Monogatari* are included. The iris screens of Korin, and those by his pupil Watanabe Shiko, are among the most musical of all decorative style paintings.

Korin, like his predecessor Koetsu, worked in lacquer and ceramics as well as paint, and one of the lacquer boxes attributed to him represents cranes on a dark, blackish brown ground (*fig. 703*). The same subject was used by Korin in a screen recorded by Sakai Hoitsu, perhaps the one now in the Freer Gallery. In this box the influence of the tea ceremony and of tea taste is more evident than in the screens. In addition to the gold defining some of the shapes, Korin composed the design not only of gold but of inlaid pewter and lead, whose different textures as well as colors lend variety, complexity, and a note of roughness, of that *shibui* (astringent) quality so important to the Japanese tea master. The shape of the box, with its slightly domed lid and rounded edges and corners, is in this tea taste. Another box attributed to Korin, in the Tokyo National Museum, depicts the iris and bridge pattern already seen in his screens.

Korin's brother, Kenzan (1663–1743 C.E.), executed

703. *Writing box with cranes.* Designed by Ogata Korin (1658–1716 C.E.). Black-lacquered wood with decoration of gold lacquer and pewter and lead inlay; l. 9¹/₈" (23.2 cm.). Japan. Edo period. Seattle Art Museum

few paintings, but his famous masterpiece, *Baskets of Flowers and Weeds,* beautifully exemplifies the combination of tea taste and decorative style (*fig. 704*). The artful positioning of the baskets, the overlap of the two at the top, the tilt of the one at the bottom, the different color notes of the flowers in the three containers, the combination of calligraphy and decorative motifs, and the stylized representation of the wickerwork are in keeping with the

704. *Baskets of Flowers and Weeds.* By Ogata Kenzan (1663–1743 C.E.). Hanging scroll; color on paper; h. 44" (111.8 cm). Japan. Edo period. Fukuoka Art Museum

705. *Teabowl with flowers.* By Ogata Kenzan (1663–1743 C.E.). Earthenware. Japan. Edo period. Yamato Bunkakan, Nara

flavor of the lacquer box by Korin or the joint works of Koetsu and Sotatsu. Kenzan also made ceramics, especially utensils for the tea ceremony—cake trays and teabowls. One of his teabowls fulfills the same intention as his hanging scroll of flowers and baskets (*fig. 705*). In a design of melon flowers on a black-glazed earthenware ground he combined large, forceful decorative sihouettes with the roughness and the "naturalness" of a utensil in tea taste. Kenzan's influence on later Japanese ceramics is enormous, and even today his artistic lineage is continued by the ninth artist to take the name Kenzan.

706. *Rapids in Summer and Autumn.* By Suzuki Kiitsu (1796–1858 C.E.). Pair of six-fold screens; ink, color, and gold on paper; h. 65¼" (165.8 cm), w. 11'10¾" (36.3 m). Japan. Edo period. Nezu Art Museum, Tokyo

707. *Hozu River.* By Maruyama Okyo (1733–1795 c.e.). Pair of four-fold screens; ink and color on paper; l. 15'8" (4.78 m). Japan. Edo period. Nishimura collection, Kyoto

The third great master of the *rimpa* school is Sakai Hoitsu (1761–1828 c.e.). That he was of the direct line is quite certain, for on the back of Korin's screens copying Sotatsu's depictions of the wind and thunder gods he painted wild flowers and vines by a river bank on a silver background (*cpl. 64, p. 526*). In this work Hoitsu carries even further Korin's tendencies toward elegance and a more flowing and refined composition than that used by Sotatsu. Here is something comparable to European rococo decoration—the emphasis on silhouette is gone. The stream is smaller now and swirls more gently and rhythmically, and the color scheme is subtle. Boldness and gorgeousness have been sacrificed to attain greater elegance and refinement on a small scale. Some realistic influence is to be seen in this as well, particularly in the depiction of the windblown vines at the left, from which an autumn-colored leaf or two swirls in the silvery air. Hoitsu's pupil Suzuki Kiitsu (1796–1858 c.e.) continued his master's developed *rimpa* style, cloaking an increasing realism within decorative intentions. Kiitsu's *Rapids in Summer and Autumn* (*fig. 706*) is dramatic, even melodramatic, in color but restrains the riotous effect with the firm verticals of the cryptomeria trees. His painting offers a striking combination of some of the main movements of the previous century, including naturalism, to which we now turn.

The second main current in later Japanese painting, usually described as realistic, is perhaps more accurately termed naturalistic. It is seen at its highest level in the work of Maruyama Okyo (1733–1795 c.e.). The pair of screens representing the Hozu River illustrates his strange amalgam of a stylized Muromachi monochrome manner with a degree of observation of nature that approaches Western objectivity (*fig. 707*). The topmost tree, with its slightly stunted trunk, is less an ideal tree than one observed from nature. The surfaces of the rocks are some-

where between the stylized *cun* of monochrome painting and the observed texture of volcanic rock. Even the rhythmical sweep of the water partakes of both stylization and naturalism. The general composition, however, is fairly arbitrary and almost decorative. Okyo's interest in realism is more clearly divulged in other works, and most explicitly in one scroll (*fig. 708*). These realistic studies in ink and color of leaves and insects show direct observation translated into brush strokes that follow observed forms rather than East Asian conventions. The difference between this true naturalism and the stylized or conventional naturalism of the decorative or Kano style painters becomes apparent if one contrasts the Okyo scroll with a similar scroll painted by Korin, in which brush conventions seem to dominate (*fig. 709*).

Such realism in pictorial form was derived in part from observation and in part from Western influence. The Portuguese missionaries and Dutch traders in southern Japan introduced a style of painting that impressed many Japanese painters, some of whom set about picturing Europeans in court costumes of the seventeenth and early eighteenth centuries, with backgrounds in a strange and naive, even comical, combination of Western and Japanese techniques (*fig. 710*). The same curious, unassimilated mixture of East and West has already been seen in China, in works by Castiglione (*see pp. 504–5 and fig. 674*).

Pictorial modeling in light and shade to develop the sculptural quality of figures impressed the Japanese, and numerous works in this genre were painted. It remained, however, for a painter of the Japanese scholarly tradition of the early nineteenth century, Watanabe Kazan (1793–1841 c.e.), to produce perhaps the most striking and original works under the influence of Western realism. Kazan, who painted in Chinese style as well, was able to absorb the mixed stylistic influences in the *namban* (Western

708. *Nature studies.* By Maruyama Okyo
(1733–1795 C.E.). One section of three
handscrolls; ink and color on paper;
h. 12³/₈" (31.4 cm). Japan. Edo period.
Nishimura collection, Kyoto

709. (right) *Birds.* By Ogata Korin (1658–
1716 C.E.). Detail of sketch sheets
mounted as a handscroll; ink and color
on paper; w. 24" (61 cm). Japan.
Edo period. Watanabe Zenjuro
collection, Tokyo

710. (below)*Westerners Playing Their Music.*
Pair of six-fold screens; ink and color on
paper. Japan. Edo period, c. 1610 C.E.
Eisei Bunko, Tokyo

六旬誕日寫傳神鷺
見著蒼頲一老人烏帽
戴來雖似貴綿裘著
得竟應真縈名文花
癭相頹游手墨池龜
有因無事散閒能到
七重逢垂白畫中身
戊戌九月六日
未莽自題

711. *Portrait of Ichikawa Beian.* By Watanabe Kazan (1793–1841 C.E.). Hanging scroll; ink and color on silk; h. 50⅞″ (129.5 cm). Japan. Edo period. Bunkacho collection, Tokyo

712. *Sketch for Portrait of Ichikawa Beian.* By Watanabe Kazan (1793–1841 C.E.). Hanging scroll; ink and color on paper; h. 15½″ (39.2 cm). Japan. Edo period. Bunkacho collection, Tokyo

subject) screens and to apply them with great virtuosity of the brush. The *Portrait of Beian,* which owes its realism to modeling in light and shade, seems a unified work combining Chinese, Japanese, and Western methods (*fig. 711*). We know that he prepared portraits very carefully from preliminary sketches, and in such a watercolor sketch for the *Portrait of Beian* realism and the influence of Western modeling are even more apparent than in the finished work (*fig. 712*). Also apparent is the extent to which Kazan modified these to harmonize with East Asian brush style. Kazan, an opponent of the shogunate

who was persecuted and driven to suicide, stands outside the mainstream of painting, but he can be considered a culminating master of the naturalistic style.

In the hands of certain individualists the monochrome style of Sesshu and Tohaku could still produce masterpieces. One such is *Shrike on a Dead Branch* (*fig. 713*), by the samurai-painter Miyamoto Niten (or Miyamoto Musashi; 1584–1645 C.E.). Much has been written comparing the "single" stroke of the branch with the cut of a sword, since Niten was a samurai, but a careful examination of the painting, even in reproduction, reveals that the branch is composed of not one but at least three strokes. This in no way impugns the quality of the picture but merely indicates the degree of thought and care behind its apparent swiftness of execution. The boldness of the bird's silhouette and the elegance of the composition, with the shrike at upper left balancing the branch and leaves at the lower right, suggest a more decorative intention than would be found in a similar Chinese painting. The arbitrary fading off of the second stem at the lower left as it moves to the upper right is certainly not a naturalistic device but a decorative one. Niten's known works are in monochrome and of remarkably consistent

714. *Fishing in Springtime.* By Ike no Taiga (1723–1776 C.E.). Hanging scroll; ink and color on silk; h. 48¹/₈" (122.2 cm). Japan. Edo period. Cleveland Museum of Art

713. *Shrike on a Dead Branch.* By Miyamoto Niten (Miyamoto Musashi; 1584–1645 C.E.). Hanging scroll; ink on paper; h. 59" (150 cm). Japan. Edo period. Formerly Nagao collection, Tokyo

quality, but this painting towers above his others. His style is that of a great and gifted individual remote from the blandness of the Chinese-influenced Kano school.

The third of the creative styles of later Japanese painting is called *bunjinga* (literati painting) or *nanga* (southern painting) by the Japanese. Among its numerous adherents are some of the most original and creative painters of the eighteenth and nineteenth centuries. The style is derived from Chinese literati painting (C: *wen ren hua*). The *nanga* painters saw imported Chinese paintings and studied *wen ren* theories. Without the seventeenth and early eighteenth century Qing individualists, the *nanga* style is most unlikely to have arisen. Nevertheless, the masters who created it, like the great Japanese ink painters of the early Muromachi period, took an effective Chinese style and transformed it into a new and creative

715. *Viewing Fine Scenery, from The Ten Conveniences and the Ten Pleasures of Country Life.* By Ike no Taiga (1723–1776 C.E.). Dated to 1771 C.E. Album leaves; ink and slight color on paper; h. 7" (17.8 cm). Japan. Edo period. Formerly Kawabata Yasunari collection, Kanagawa

716. *Enjoyment of Summer Scenery, from The Ten Conveniences and the Ten Pleasures of Country Life.* By Yosa Buson (1716–1783 C.E.). Dated to 1771 C.E. Album leaves; ink and slight color on paper; h. 7" (17.8 cm). Japan. Edo period. Formerly Kawabata Yasunari collection, Kanagawa

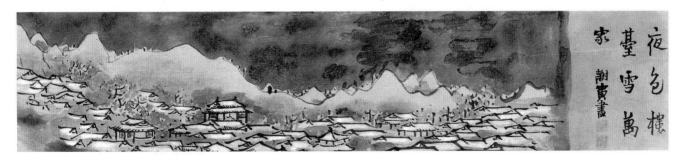

717. *Evening Snowfall.* By Yosa Buson (1716–1783 C.E.). Hanging scroll; ink on paper; l. 50 5/8" (128.6 cm). Japan. Edo period. Formerly Muto Kinta collection, Kobe

manner of such intense conviction that it transcends mere imitation. The *nanga* painters, like their early Muromachi ancestors, tended to exaggerate the elements of Chinese *wen ren* painting, not only in composition but in brushwork, and added to them a strong sense of humor.

Two names in particular are closely associated in the *nanga* school: Ike no Taiga (1723–1776 C.E.) and Yosa Buson (1716–1783 C.E.). Taiga is one of the wittiest and most daring of *nanga* painters. Most of his works in color have a summery, light, and cheerful tone (*fig. 714*). He emphasizes brush-dotted textures, and a rolling, rollicking rhythm runs through nearly all of his pictures, implying an extroverted good humor. In *The Ten Conveniences and the Ten Pleasures of Country Life,* an album painted jointly with Buson, Taiga's pages (the *Ten Conveniences*) seem creative, forthright, and humorous. Like the Chinese individualists of Anhui in the seventeenth century,

Taiga, in the picture of an old scholar on a grassy knoll looking at the mountains, seems to be making a visual pun: The scholar and the mountain resemble each other (*fig. 715*). The homely old scholar with his bulbous nose is a latter-day version of the *luohan* or arhat: an unprepossessing exterior concealing an enlightened heart. The soft ink tones and brilliant simplification of the figure are the work of a master of the brush whose ideal was naturalness, simplicity, artlessness. Buson is less humorous but just as gay, with a springlike, pleasant, even disposition that surfaces in his part of the album (the *Ten Pleasures*) (*fig. 716*). This quality relates him closely to the Chinese individualists. His most fascinating handscroll, a view of a village in the snow, seems to be a reinterpretation of Sesshu in *nanga* style (*fig. 717*). Even Sesshu would not have played with the ink tones in the sky so freely, even carelessly; and even Sesshu would have looked askance at

718. *Frozen Clouds Sieving Powdery Snow.* By Uragami Gyokudo (1745–1820 C.E.). Hanging scroll; ink and light color on paper; h. 52¼" (132.7 cm). Japan. Edo period. Formerly Kawabata Yasunari collection, Kanagawa

the rather humorous and lilting hit-or-miss treatment of the roof lines; but perhaps only Sesshu could also have created the effect of the dampness and weight of wet snow, achieved so playfully by Buson.

Another master of the *nanga* school, Uragami Gyokudo (1745–1820 C.E.), has recently grown to great esteem. In contrast to Taiga and Buson, he is dramatic and somber. His compositions, with their feathery, high mountains, their tilted, circular planes that seem to be floating in different layers of space, and their sudden movements in the midst of the rich ink, reveal an arbitrariness related to the equally arbitrary compositions of the decorative style, but handled in the witty and flexible medium of the scholar-painter. His generally acknowledged masterpiece is the great composition *Frozen Clouds Sieving Powdery Snow,* where the texture, weight, even the feel of the snow are produced in his unique style (*fig. 718*). The fluttering rhythms, the swinging arcs indicating rocks, mountains, and movements, are Gyokudo's handwriting.

In the Momoyama and Edo period artists whom we have been considering, it is apparent that individuality counts for at least as much as adherence to a school tradition. Perhaps it is only by contrast with this idiosyncratic creativity that the steady professionalism of the Kano painters seems so much less than inspiring. In the eighteenth and nineteenth century willful and daring individualism became for many artists a virtual imperative, giving rise to some wild and interesting paintings.

Nagasawa Rosetsu (1754–1799 C.E.) was a pupil and lifelong collaborator of Maruyama Okyo and thus nominally a member of the Maruyama-Shijo school. In 1786–1787 he and Okyo were in southern Wakayama Prefecture, collaborating on wall paintings and sliding screens (*fusuma*) and scrolls commissioned by local temples. Okyo's competition and tutelage seem to have been epochal in the development of Rosetsu's style: His works from that time on express unbridled bohemianism. Daring compositions in broad brushwork feature various animals, especially lions, whose nature evidently appealed to the wildness in the artist. For presentation to the ancient Shinto shrine of Itsukushima on the Inland Sea, Rosetsu painted a votive panel (*ema*) of *Yama-uba and Kintaro* (*fig. 719*), the legendary "mountain witch" and her adopted herculean child. Their grotesque appearance contrasts effectively with the quintessential humanity of their gestures—the maternal holding of the child's hand, the childlike tugging at the mother's sash. Visually there is a similar counterpoint—between the wild ink brushwork of the tattered parasol and vaporous background and the freely handled patterns of the witch's gown. Rosetsu's grotesquerie subtly evokes the dreadfulness of early depictions of Buddhist deities in their terrible aspects, such as the *Red Fudo* of colorplate 30 (*p. 332*). Yama-uba and Kintaro were a favorite subject of *ukiyo-e* artists and of the Edo theater.

By contrast with the boisterous and uninhibited Rosetsu, Ito Jakuchu (1716–1800 C.E.), son of a prosperous Kyoto merchant and inheritor of the family business, was decorous and restrained in his private life. In his painting, however, he was equally eccentric and uninhibited. In 1755, aged forty, he turned the business over to his brother in order to study painting with a teacher of the Kano school. At the same time he became friends with Taiten, the Zen monk who in 1772 became abbot of Shokoku-ji in Kyoto, where Tensho Shubun and Sesshu had begun their careers. Taiten introduced Jakuchu to the cultural and religious elites of Kyoto and enabled him to study Shokoku-ji's sizable collection of old Chinese, Korean, and Japanese paintings. Between about 1758 and 1770 Jakuchu created his masterpiece, the thirty large hanging scrolls of *The Colorful Realm of Living Beings* (*Doshoku Sai-e*), represented here by *Golden Pheasants in Snow* (*cpl. 62, p. 523*). These he presented to Shokoku-ji, along with a Shaka triad, as a votive offering and memorial to his brother. All but the Shaka triad were later given by the temple to the Imperial Household.

Jakuchu's study of Shokoku-ji's Korean icons informs his Shaka triad. He also studied the temple's collection of Ming dynasty professional and academic works, particularly the "fur and feathers" subjects. But his own renditions of animals and plants are true creative transformations: They look nothing like the Chinese paintings, nor do they resemble any works of his contemporaries. Some paintings in the set are more conventional than others, but the *Golden Pheasants* exemplifies his obsessive concern with textile-like patterning and his penchant for sudden weird aesthetic events like the hole through the snow-covered trunk at lower left or the snow-laden branches that trail like melting wax. The allover pattern of the pine needles provides a nervous, almost vibrating background. Jakuchu's monochrome ink paintings are if anything wilder, and certainly far more abbreviated, than the *Colorful Realm* scrolls.

Hakuin Ekaku (1685–1768 C.E.) is an equally individualistic and expressionist painter, but of the Rinzai Zen tradition. He became a Zen monk at fifteen, abbot of a small branch temple of Myoshin-ji at thirty-two, and received the honorary appointment of "chief monk" at Myoshin-ji at about age thirty-three. He traveled widely, preaching and founding temples as far afield as the Izu peninsula. His characteristic exaggerated Zen monochrome manner reflects his aim to spread Zen teachings among the common people. It features powerful, broad, wet brush strokes that vary in tone from jet black to very pale, and a limited subject matter depicted with almost cartoon-like simplicity, as in this rendition of the omnipresent Zen subject Daruma (*fig. 720*). Together with Sengai Gibon (1750–1837 C.E.), also a Zen priest-painter but less gifted artistically, Hakuin is considered the most representative of all later *zenga*. Both have been much

719. *Yama-uba and Kintaro.* By Nagasawa Rosetsu (1754–1799 C.E.). Presented to Itsukushima Shrine 1797 C.E. Framed panel; ink and color on silk; h. 61⁷/₈" (157.6 cm). Japan. Edo period. Itsukushima Shrine, Hiroshima Prefecture

copied and forged.

The fourth of these mainstreams of pictorial style is usually called *ukiyo-e*, pictures of the floating world, using "floating" in the Buddhist sense of transient or evanescent, the world of everyday life and especially of pleasure—theater, dancing, love, or festivals. The term *ukiyo-e* is particularly associated with the popular art of woodblock prints, but it really describes a style that begins with paintings of mixed heritage. The realistic, storytelling style of the *emaki* (narrative picture scrolls) that originated in the Kamakura period, the decorative style brought to its peak by Sotatsu and Korin during the Momoyama and Edo periods, the Chinese elements of Kano painting, and something of both native and foreign realism were combined and adapted to the new and, in

traditional eyes, vulgar demands of the merchant and plebeian classes of urban Japan after the seventeenth century. If even Hideyoshi delighted in gorgeous displays of "vulgar" art and decoration for the delight of the assembled masses on festival days, what was to prevent the adaptation of existing styles of painting to more popular consumption?

Genre subjects entered Japanese art before the mid-sixteenth century, appearing in all formats but most popular in large scale, on walls and sliding (*fusuma*) or folding (*byobu*) screens. They were painted by anonymous "town painters" (*machi eshi*), i.e., purveyors of art to the affluent middle class, not painters in service to the court or the shogunate. As in the West, the subject is everyday life, comprising occupations, recreations, customs and ceremonies, famous places. First to appear were *Views in and around Kyoto* (since medieval Kyoto was popularly called Raku, these paintings were called *Rakuchu Rakugai Zu*). The subject proved exceedingly popular, and was taken up by the most illustrious of the Kano school masters—by Motonobu (1530s), Eitoku (c. 1570), and Mitsunobu (1580s). In 1574 a pair of *Rakuchu Rakugai* screens by Eitoku made a suitably spendid gift from Oda Nobunaga to his formidable rival Uesugi Kenshin. The screens were by no means a monopoly of the town painters or the Kano school, however, but were produced by many ateliers in response to the great demand.

Such screens teem with festivals, processions, entertainments, and the activities of daily life, involving thousands of small-scale figures and hundreds of buildings. All are shown in great and reasonably accurate detail, so that many if not most of the activities and structures are recognizable even today, making the screens a gold mine for the social historian. The individual scenes are not continuous but are emphatically framed and often partially obscured by decorative bands of stylized gold leaf clouds. Scenes and figures appear as if transferred without enlargement from narrative handscrolls (*emaki*); their small scale in the large screen format renders their action and design illegible in book-sized reproduction, hence their absence here.

In the seventeenth century Edo came to rival and eventually surpass Kyoto as Japan's cultural center, and Edo sites and activities, sports (hunting, archery contests, horse races, etc.), Chinese edifying narratives or precepts, specific festivals, battle scenes, and representations of Westerners (*namban jin*, "Southern Barbarians," i.e., Europeans) entered the repertory of subjects. At the same time the artistic focus shifted from the panorama to its individual elements: The demand for larger-scale genre subjects was answered with spectacular figure screens of entertainments and beautiful women.

Some of the earliest *ukiyo-e* are scrolls and screen paintings loosely associated with an almost folk-hero artist, Iwasa Katsumochi, popularly known as Matabei

(1578–1650 C.E.). These actually do not share a distinctively similar artistic "handwriting," but they do share a delight in gorgeously dressed, portly, large-scale figures engaged in commonplace pleasures or tasks (*cpl. 63, pp. 524–25*). Often the figures are of low-class women, even prostitutes, dressed in everyday gay costume. Traces of other styles are readily visible; the subject matter may even be a plebeian version of the traditional Chinese-derived Kano "Four Accomplishments"—rendered in *ukiyo-e* as writing, music, dancing, and games. But the new interest in the floating world, in the latest hairdo and the most fashionable robe, dominates the screens. Their true subject is the pursuit of pleasure, whether visual, auditory, or tactile. Signed or not, and usually not, these screens are not the work of a mere artisan. The placement of the figures and their interrelations, psychological and aesthetic, show a calculation and subtlety worthy of the great decorative masters.

In addition to the painting traditions at hand, *ukiyo-e* artists exploited another, until then devalued, tradition—the woodblock print. The printing of books, even of single sheets, had been known in East Asia from the eighth century. But the technique had largely been used to produce cheap Buddhist icons or illustrated texts and many painting manuals and textbooks. Of the latter, the most famous are the Chinese *Mustard Seed Garden* and *Ten Bamboo Studio* manuals. Printing had yet to be fully exploited, both technically and aesthetically. Despite the fantastic ability of the block cutters to reproduce *paintings*, little had been done to produce *prints*, works of art in their own right with rules of form pertinent to the medium. The new interest in the urban everyday world and the new market among the moderately well-to-do and the not-so-fortunate motivated the swift development of numerous original *ukiyo-e* woodblock prints. These were designed for mass production, and answered with lightning rapidity to changing urban fads and fashions.

Perhaps millions of prints were produced in the two hundred years between 1658 C.E., the year of Hishikawa Moronobu's first recognized illustrated book, and the death of Ando Hiroshige in 1858, when the first great tradition of woodblock artistry ended. These were usually despised by the upper-class artists and their patrons, and considered expendable trifles by the classes that bought them. Thus Japan is relatively poor in fine old prints today. But in Europe, and by extension America, fine Japanese print collections are legion, largely because the prints won the enthusiastic approbation of the Post-Impressionists during the late nineteenth and early twentieth centuries. This patrimony has had one somewhat unfortunate result: Japanese art has often been judged by standards derived from the appreciation of woodblock prints, if indeed earlier Japanese art has been seen at all. Many viewers find in these prints a culmination of Japanese traditions—and certainly the sheets combine some elements of nearly all

earlier styles. To others they represent the last creative emergence of the great earlier traditions in a final popular expression before the sad decline of Japanese art in the late nineteenth and early twentieth centuries. This deterioration has only recently been arrested and turned by the rise of modern international art movements and by the shock effects of World War II.

Throughout its history the *ukiyo-e* woodblock print was the result of close collaboration among the artist-designer, the publisher, who often dictated or molded subject matter and style, the woodblock carver, and the printer. The complex and specialized development, both technical and aesthetic, of the Japanese woodblock print can be but barely summarized here. Hishikawa Moronobu (d. 1694 C.E.) is the first *ukiyo-e* print artist to have signed a number of his works, and is therefore considered the founder of the tradition. His *Street Scene* is set in the red-light district of Edo (Tokyo) and, while it is indebted to traditional book illustration, it recalls sections of the earlier narrative handscrolls (*fig. 721*). The artist's line, though based on brush drawing, is adapted to the cut of knife on wood. The print is in black and white, and until the invention of color printing, about 1741, what restricted color was used was applied by hand. Print makers of the early period are called Primitives.

The leading master of the transition from single-block black-and-white prints to the printed two-color designs, mostly in pink and green, was Okumura Masanobu (1686–1764 C.E.), who claimed credit as well for the invention of a new shape—the extremely long and narrow "pillar" print—and a new mode, the perspective print (*uki-e*). In contrast with the saturated hues of hand-applied colors, block printing permitted subtle, delicate, low-toned color combinations at the same time that the growing command of the artist produced more complex figure compositions. The *Parody on a Maple Viewing Party* (*fig. 722*) combines the Tosa version of the narrative scroll tradition with the decorative development already seen in the costumes of the *Women of Fashion at Leisure* (*see cpl. 63, pp. 524–25*). The *Maple Viewing Party* is an early example of an increasingly popular kind of print called *mitate-e*, at once charming and parodistic, in which various sacred cows—secondary Buddhist deities, Confucian exemplars of virtue, aristocratic court nobles, and heroic samurai—are portrayed as pretty young girls. There could be no clearer expression than these parodies of the lighthearted exuberance and irreverence of the Japanese townsmen newly come into their own. The three beauties in Masanobu's print are attired cap-a-pie as members of the imperial guards.

In 1765 the two-color print technique was expanded, and polychrome prints ("brocade pictures," *nishiki-e*) using numerous color blocks took the market by storm. Prints were evidently popular, for the new technique was far more expensive and time-consuming than the old.

The first artist to take full advantage of the new possibilities was Suzuki Harunobu (1725–1770 C.E.), whose lovely prints show the most refined and subtle taste achieved in the medium. Harunobu, like Sotatsu, knew the value of contrast between plain and complex areas, of purposeful juxtapositions such as flowering plant and beautiful woman, or of deliberate suppression. This last is particularly significant in the parodistic representation of the lion-vehicle of Monju (*fig. 723*). Not only is it aesthetically effective, but it serves to submerge the Buddhist content of the print into the image of a fashionable youth with elegantly elongated neck and almost unbelievably tiny hands and feet. Harunobu's style and mood were adapted by Kitagawa Utamaro (1753–1806 C.E.) with somewhat stronger draftsmanship and larger scale, his most remarkable works being the *Ten Types of Female Physiognomy* of 1794, whose tinted mica backgrounds add to their lively decorative effect (*fig. 724*).

For the incredibly brief span of ten months in 1794–1795 an artist-actor with noble connections, Toshusai Sharaku, poured out a spate of shockingly bold and harsh prints. Some 159 caricature-portraits of *kabuki* actors combine decorative power with the long-dormant satirical temper of Kamakura narrative scrolls (*fig. 725*). Further to heighten this aggressive, dramatic style, Sharaku often used dark mica backgrounds from which the silhouettes of the posturing actors seem to leap out at the viewer. We know that Sharaku's prints were not popular and, significantly, his output ceased abruptly. Such a frank record of the overacted, almost Grand Guignol realism of the *kabuki* theater may well have startled or even repelled the pleasure-loving public, more attuned to lovely women and conventionally attractive theatrical portraits. Perhaps, too, the actors represented took offense.

The heyday of the figure print ends with the eighteenth century. The most creative print makers of the first half of the following century, Katsushika Hokusai (1760–1849 C.E.) and Ando Hiroshige (1797–1858 C.E.), were primarily landscapists. Figures play a subdued if effective role in Hokusai's sturdy, energetic compositions, while in Hiroshige's prints they often become sticklike staffage to the serene and poetic beauty of his famous views. In the nineteenth century landscape series captured the public's fancy, and Hokusai exercised remarkable ingenuity in making his scenes transcend locality. The *Thirty-six Views of Mount Fuji* are universal landscapes, usually dramatic and capitalizing on unusual juxtapositions—Fuji and the fishermen dwarfed by the clawing wave (*fig. 726*) or Fuji enmeshed in a mackerel sky.

As the popular taste for figure prints became ever more garish, landscape became the only subject for the sensitive and original artist. Hiroshige put his technical virtuosity at the service of the "loveliness" of the Japanese landscape, which his prints render in velvety color and a naturalistic, even Western-influenced style. His land-

720. *Daruma*. By Hakuin Ekaku (1685–1768 C.E.). Hanging scroll; ink on paper; h. 51¹/8" (130 cm). Japan. Edo period. Empuku-ji, Kyoto

721. (above right) *Street Scene in the Yoshiwara*. By Hishikawa Moronobu (d. 1694 C.E.). Black-and-white woodblock print; h. 10¹/2" (26.7 cm), w. 16" (40.6 cm). Japan. Edo period. Metropolitan Museum of Art, New York

722. (right) *Parody on a Maple Viewing Party*. By Okumura Masanobu (1686–1764 C.E.). Dated to c. 1750 C.E. Two-color wood-block print; h. 16¹/2" (41.9 cm), w. 12" (30.5 cm). Japan. Edo period. Metropolitan Museum of Art, New York

723. *Youth Representing Monju, Bodhisattva of Wisdom, on His Lion.* By Suzuki Harunobu (1725–1770 C.E.). Full-color woodblock print; h. 11¹/₂" (29.2 cm). Japan. Edo period. Cleveland Museum of Art

724. *Beauty, from Ten Types of Female Physiognomy.* By Kitagawa Utamaro (1753–1806 C.E.). Full-color woodblock print; h. 15" (38.1 cm), w. 10" (25.4 cm). Japan. Edo period. Cleveland Museum of Art

scapes are nearly always idyllic yet particular, with a local flavor as well as recognizable landmarks (*fig. 727*). His numerous series of views, including the *Fifty-three Stages of the Tokaido,* the *Sixty-nine Stages of the Kisokaido,* and the *Hundred Views of Edo,* maintain interest from print to print because of their particularity, while the subjects of Hokusai's landscapes seem far less important than their willful inventiveness and daring organization. Both artists, especially Hiroshige, whose paintings are singularly dull and pretty, are much indebted to the amazing skill of the engravers and printers who produced the prints from their designs. Nearly all print designers produced paintings as well, often highly accomplished and beautiful but overshadowed (unjustly) by the popularity of the far more numerous prints. Traditional Japanese pictorial art ends in a consummate craft.

CERAMICS

The potter's art, which attained supreme excellence in East Asia, was an accurate reflection of artistic currents, both aristocratic and popular. The development of fine porcelain manufacture in seventeenth century Japan,

under the stimulus of both Chinese and Korean influence, provided a new medium for the Japanese potter and spurred a decorative development parallel to that seen in painting.

The Momoyama and early Edo periods saw a rising demand for tea-ceremony ceramics. Potters of the Mino kilns adjacent to Seto produced, for subtle and aristocratic taste, wares that maintained the desired noble, rough, and warm qualities, notably in Shino and Oribe types (*figs. 728, 729*), both named for famous tea masters. In the Fukuoka region of northern Kyushu the ceramic technology and styles of late sixteenth century Korean folk wares intersected with the aesthetics of the Japanese tea ceremony. High-fired stoneware in utilitarian shapes, sometimes clad in soft gray slip under transparent glaze, and often with spare, simple designs painted in iron oxide under the glaze, show the inspiration of Korean vessels and Korean potters brought to Japan by daimyo returning from Hideyoshi's Korean campaigns (*see p. 510*). From the nearby port through which much of the production was distributed, these wares acquired the name Karatsu; pieces with iron-oxide decoration are called E-garatsu (Painted

725. (opposite) *Otani Oniji III as Edohei.* By Toshusai Sharaku (act. 1794–1795 C.E., d. 1801 C.E.). Dated to 1794 C.E. Full-color woodblock print; h. 14³/₄" (37.5 cm). Japan. Edo period. Art Institute of Chicago

726. (right) *Mount Fuji Seen below a Wave at Kanagawa, from Thirty-six Views of Mount Fuji.* By Katsushika Hokusai (1760–1849 C.E.). Full-color woodblock print; w. 14³/₄" (37.5 cm). Japan. Edo period. Museum of Fine Arts, Boston

727. (below) *Rain Shower at Ohashi Bridge.* By Ando Hiroshige (1797–1858 C.E.). Full-color woodblock print; h. 13⁷/₈" (35.2 cm). Japan. Edo period. Cleveland Museum of Art

728. (right, center) *Flower basin.* Nezumi (mouse-gray) Shino stoneware; l. 9¹/₈" (23.2 cm). Japan. Early 17th century C.E. Seattle Art Museum

729. (right, bottom) *Square bowl.* Oribe stoneware with green glaze and iron-oxide geometric decoration under transparent glaze; h. 2¹/₄" (5.6 cm), l. 8³/₈" (21.4 cm), w. 8" (20.4 cm). Japan. Late 16th–early 17th century C.E. Tokyo National Museum

730. *Jar with persimmon tree design.* Karatsu glazed stoneware with iron-oxide painted decoration (E-garatsu); h. 6³/₄" (17.1 cm). Kyushu, Japan. Early Edo period. Idemitsu Museum of Arts, Tokyo

731. *Large bowl.* Arita (also called Imari or Hizen) porcelain with decoration in underglaze blue; h. 5" (12.5 cm), diam. 18" (45.5 cm). Japan. Edo period, 17th century C.E. Yamato Bunkakan, Nara

Karatsu; *fig. 730*). By the middle of the seventeenth century quality began to decline, and later tea wares, save for the few by such individual masters as Kenzan and Koetsu, became mannered exercises in pseudo-amateurism. These inferior wares seem comparable to the monochrome works of the later Kano school of painting.

Individual potters' names become more prominent from the seventeenth century onward. The concept of the artist-potter, first embodied in painters or arbiters of taste who also made ceramics, was in part the result of a genealogical pride paralleling that of the various painting schools, but it also grew out of a peculiarly Japanese respect for the craftsman as an artist in his own right. Most of the finest craft products were proudly signed, even such small and commonplace items as *netsuke* and *inro*. (The *netsuke* is a carved toggle, often of wood or ivory, fastened to the end of the cord binding of an *inro*, which is a small, compartmented, lacquered-wood container for carrying medicines at one's belt.)

Perhaps the most famous of all the ceramic specialists was Nonomura Ninsei (d. c. 1685 C.E.), who worked in Kyoto. He produced superbly finished jars and bowls painted in enamel with sophisticated decorative pictures which conform to the shape of the object (*cpl. 65, p. 527*). Though his preferred medium was stoneware rather than porcelain, his art was certainly not for common use. In technical perfection it rivals the most elegant lacquer work, and where it fails it does so because of a lacquer-like finish and overindulgence in gold or opaque color. His style (based on *rimpa* painting) and his method were continued by numerous Kyoto artists and workshops in ever

732. *Plate.* Kakiemon porcelain with decoration in overglaze colored enamels; h. 2¹/₂" (6.4 cm), diam. 12¹/₈" (46.9 cm). Japan. Edo period, c. 1700 C.E. Cleveland Museum of Art

increasing number and declining taste, particularly in overly meticulous animal and bird figurines.

In 1616 C.E., or perhaps somewhat earlier, porcelain clay (kaolin) was discovered near Arita in the northwestern Kyushu province of Hizen (present-day Saga Prefecture). This discovery is credited to the immigrant

Korean potter Yi Samp'yong (J: Ri Sampei; d. 1655 C.E.). Concurrently Chinese techniques were being deduced from imported Chinese wares, and Korean potters were being settled, both voluntarily and forcibly, in Japan. The result was a flowering of porcelain manufacture. Its starting point was rough white porcelain with underglaze blue decoration in direct imitation of provincial Ming wares or Korean wares of the Choson period.

The first Japanese blue-and-white wares, produced at Arita in the mid-seventeenth century, bear crude, even slapdash landscape and figural designs (*fig. 731*). By the last quarter of the century enameled porcelains of late Ming and the early Kangxi period had made their impact, and the decorative means were at hand to cater to Japanese pictorial tastes. The decorative style in its various manifestations provided the principal motivation for three most important porcelain types—Kakiemon, Nabeshima, and Kutani. The first two were made in the Arita region of Kyushu.

Kutani ware is problematic in its origins. No Old Kutani (Ko Kutani) shards have yet been found in the area of Kutani, in Ishikawa Prefecture of northwest Honshu, though Kutani ware was certainly being made there by the early nineteenth century. Ko Kutani has been attributed to kilns in the Arita region, but the evidence for this is not conclusive. In the Arita region the ascription of wares to a particular kiln is most uncertain because of numerous but often unreliable family traditions of manufacture and the overlapping of decorative techniques from one kiln to another. The various wares, including Kakiemon and Nabeshima, must be thought of as styles, perhaps common to several kilns of the same region. Minor differences in paste and glaze have not yet been thoroughly classified.

Kakiemon ware (*fig. 732*) is named for Sakaida Kizaemon (Kakiemon I; 1596–1666 C.E.), the potter traditionally credited with originating overglaze enameled wares in Japan. Kakiemon ware is closest in technique to the Kangxi *famille verte* enameled porcelains. Overglaze red, green, and blue enamels were sparingly applied to a soft, linen-white ground in a restrained and hazily outlined decoration whose motifs recall the screen painters' decorative adaptations of Chinese academic painting style. Kakiemon ware was coveted in Europe throughout the seventeenth and eighteenth centuries, exported to such royal collections as that of Dresden, and much imitated by the European decorators of Meissen and St.-Cloud. The Kakiemon flavor is sprightly, lyrical, and elegant—hence its popularity in the period of European rococo.

Another Arita porcelain, heavier-bodied and coarser than Kakiemon, is called Imari (*fig. 733*), after the small port north of Arita, in Hizen Province, from which it was shipped. In Japan the term Imari comprises Arita wares decorated in underglaze blue-and-white alone and in underglaze blue combined with overglaze enamels. But in the West the term generally designates pieces with opulent

733. *Vase.* Arita (also called Imari or Hizen) porcelain with decoration of Westerners; h. 22" (55.9 cm). Japan. Edo period, 18th century C.E. Cleveland Museum of Art

designs in underglaze blue, dark enamels, and gilding, with rust red enamel predominating and little of the white body visible.

Much Imari ware shows European subjects, usually Portuguese and Dutch men and ships, drawn from hearsay, from *namban* paintings, or from observations at the trade port of Nagasaki. Imari designs greatly influenced the decoration of Dutch and English porcelain.

Nabeshima wares, on the other hand, seem to conform to a harder, colder, and more perfect taste. Red, green, and yellow overglaze enamels were used with a clear underglaze blue in carefully calculated floral or formal designs that recall the decorative style of Korin's paintings or of contemporary lacquers and textile patterns. The glaze might be clear or celadon; if the latter, it

734. *Dish.* Nabeshima ware with design of tasseled hawks' jesses in underglaze blue and overglaze enamels; diam. 8" (20.2 cm). Saga Prefecture, Japan. Edo period. Suntory Museum of Art, Tokyo

735. *Dish.* Kutani porcelain with decoration of footpaths between rice fields; l. 9¹/8" (23.2 cm). Japan. Edo period, late 17th century C.E. Private collection, Japan

was carefully confined to the undecorated areas of the ceramic. The hawks' jesses that ornament figure 734 allude to a sport much favored by the samurai aristocracy. Contemporary paintings of beautiful women attest that hawks' jesses were also a popular textile motif. Indeed, Nabeshima ware decoration strikingly resembles contemporary textile designs. As Kakiemon seems comparable to Kangxi decorated porcelains, Nabeshima can be compared with the more perfect ceramics of the Yongzheng reign. The Nabeshima daimyo clan monopolized the ware for their personal use, for gifts to other daimyo, and for rewards to vassals. Since it was not exported, it had no influence abroad.

The most daring and original of these porcelains, the most purely Japanese in the best sense, was Kutani ware, especially Ko (Old) Kutani, traditionally produced before 1700 C.E. (*cpl. 66, p. 528*). The porcelain body of this ware is often rough and grayish rather than pure white, and the shapes are warped by imperfect firing, but the overglaze enamel designs of red, green, aubergine, and mustard yellow are somberly powerful. The designs are free and extremely venturesome, combining the daring of Koetsu's vessels with the magnificence of Momoyama screen paintings. No other ware can show so striking a pictorial design

as the bird's-eye view of paths between the rice fields on the square dish in figure 735, or the proud *feng-huang* so skillfully accommodated to the circular shape of the dish in colorplate 66. Ko Kutani combines the best qualities of such tea-ceremony wares as Shino and Oribe with those of the imported porcelain tradition.

Hundreds of other wares were made as time went on, including the infamous "brocaded gold" Satsuma ware produced for the worst Western taste of the Victorian era and now undergoing a revival presumably motivated by camp taste. Small wonder that flagging inspiration and consummate technique conspired to loose a flood of mediocre ceramics and that the most influential wares for the modern Japanese potter are the folk ceramics made for rural consumption. Only recently have the Japanese porcelain manufacturers begun to make well-designed, mass-produced wares for the modern international market. In Japan, as elsewhere in Asia, traditional styles seem meaningful only until the nineteenth century. The present and future of Eastern art is inextricably enmeshed with the modern international style until now originating in Europe and America. Accomplishments since the end of World War II reveal the workings of innovation, tradition, and accommodation.

Notes

1. (p. 41) Wen Fong, ed., *The Great Bronze Age of China: An Exhibition from the People's Republic of China*, exh. cat. (New York: Metropolitan Museum of Art and Knopf, 1980), pp. 198, 205.

2. (p. 54) Burton Watson, ed. and trans., *Columbia Book of Chinese Poetry* (New York: Columbia University Press, 1984), p. 49.

3. (p. 81) Paraphrased from the *Dhamma-Cakka-Ppavattana Sutta* in F. Max Müller, ed., *Sacred Books of the East*, 60 vols. (Oxford: Oxford University Press, 1879–1910); vol. 2: *Buddhist Suttas*, trans. T. W. Rhys Davids, pp. 147–53.

4. (p. 156) Edwin O. Reischauer and John K. Fairbank, *East Asia: The Great Tradition* (Boston: Houghton Mifflin, 1958; reprint, 1960), p. 145.

5. (p. 161) Müller, ed., *Sacred Books of the East*, vol. 21, *The Saddhamma-Pundarika*, or *The Lotus of the Law*, trans. H. Kern.

6. (p. 182) Müller, ed., *Sacred Books of the East*, vol. 49: *Buddhist Mahayana Texts*. Paragraphs 1–3 are quoted from the *Amitayus Dhyana Sutra*, trans. J. Takakusu, part 2, pp. 178–79; paragraphs 4–5 quoted from *The Larger Sukhavati-Vyuha*, trans. F. Max Müller, part 2, pp. 40, 42–43.

7. (p. 196) Stella Kramrisch, *The Hindu Temple*, 2 vols. (Calcutta: University of Calcutta, 1946); vol. 1, pp. 127–28.

8. (p. 229) Ibid., n. 17.

9. (p. 252) From Abu'l-Fazl, historian of the era of Akbar, quoted in Eric Schroeder, "The Troubled Image: An Essay upon Mughal Painting," in *Art and Thought*, ed. K. Bharatha Iyer (London: Luzac, 1947), p. 78.

10. (p. 252) Ibid., p. 85.

11. (p. 253) Ibid., p. 79.

12. (p. 256) Quoted in Ananda K. Coomaraswamy, *Catalogue of the Indian Collections in the Museum of Fine Arts, Boston*, part 6: *Mughal Painting* (Cambridge, Mass.: Museum of Fine Arts, Boston, 1926), p. 42.

13. (p. 259) Ibid., part 5: *Rajput Painting* (Cambridge, Mass.: Museum of Fine Arts, Boston, 1926), p. 42.

14. (p. 259) Ananda K. Coomaraswamy, *Rajput Painting* (London: H. Milford, 1916), vol. 1, p. 44.

15. (p. 290) The lacquer paintings in the Sima Jinlong tomb take their subjects from the *Biographies of Eminent Women* [*Lie Nü Zhuan*], attrib. Liu Xiang (c. 80–c. 7 B.C.E.), and from the *Twenty-four Paragons of Filial Piety*, a rather fluid assemblage of exemplary biographies based on the *Biographies of Filial Sons* [*Xiao Zi Zhuan*], also attrib. Liu Xiang.

16. (p. 292) From Cao Zhi (Zijian, 192–232 C.E.), "The Goddess of River Lo," trans. Hsiao-yen Shih, in "Poetry Illustration and the Works of Ku K'ai-chih," *Renditions*, no. 6 (Spring 1976).

17. (p. 350) Lady Murasaki [Murasaki Shikibu], *The Tale of Genji*, trans. Edward Seidensticker (New York: Knopf, 1976), vol. 1, p. 63.

18. (p. 350) My previous discussions of narrative handscroll painting often muddied the waters by referring to *onna-e* pictures as *yamato-e* (a stylistic form) and to *otoko-e* pictures as *emaki* (a term denoting format and type of subject).

19. (p. 360) Guo Ruoxu [Kuo Jo-hsü], *Experiences in Painting*, trans. Alexander C. Soper (Washington, D.C.: American Council of Learned Societies, 1951), p. 21.

20. (p. 370) Translated in Susan Bush and Hsiao-yen Shih, comps. and eds., *Early Chinese Texts on Painting* (Cambridge, Mass.: Harvard University Press, 1985), pp. 204, 224.

21. (p. 379) Arthur Waley, *An Introduction to the Study of Chinese Painting* (London: Benn, 1923), p. 231.

22. (p. 381). Daisetz T. Suzuki, *Essays in Zen Buddhism*, 2nd series (London: Rider, for the Buddhist Society, 1950), pp. 84–85.

23. (p. 392) *Pi Ch'uang So Yu*, trans. in Geoffrey R. Sayer, *Ching-Te-Chen T'ao-lu, or, The Potteries of China* (London: Routledge and Kegan Paul, 1951), pp. 97–98.

24. (p. 394) Chewon Kim and Lena Kim Lee, *Arts of Korea* (New York: Kodansha, 1974), p. 196.

25. (p. 421) R. H. Blyth, *Haiku*, 4 vols. (Tokyo: Kamakura Bunko, 1949–52); vol. 2, pp. 43, 54; vol. 4, pp. 205, 213.

26. (p. 433) Jon Carter Covell, *Under the Seal of Sesshu* (1941; reprint, New York: Hacker Art Books, 1974), p. 85.

27. (p. 436) Ibid.

28. (p. 465) Osvald Sirén, "Shih-t'ao, Painter, Poet, and Theoretician," *Bulletin of the Museum of Far Eastern Antiquities*, no. 21 (Stockholm, 1949): 43.

29. (p. 466) Ni Zan, *Ni Yunlin Shiji* [*Collected poetry of Ni Yunlin*], Si Bu Cong Kan edition (Shanghai, 1922–); vol. 3, appendix pp. 5.2a–b, trans. Susan Bush, in *The Chinese Literati on Painting: Su Shih (1037–1101) to Tung Ch'i-ch'ang (1555–1636)* (Cambridge, Mass.: Harvard University Press, 1971), p. 134.

30. (p. 487) Quoted in Osvald Sirén, *Chinese Painting: Leading Masters and Principles*, 7 vols. (New York: Ronald, 1956–58); vol. 5, p. 10.

31. (p. 491) Huang Yongquan, *Biography of Chen Hongshou* [*Chen Hongshou Nianpu*] (Beijing, 1960), trans. Wai-kam Ho, in *Eight Dynasties of Chinese Painting* (Cleveland: Cleveland Museum of Art, 1980), p. 273.

32. (p. 496) Translated in Osvald Sirén, *A History of Later Chinese Painting* (London: Medici Society, 1938); vol. 2, p. 135.

33. (p. 497) Yuan-Ji [formerly called Dao-Ji], *Hua Yu Lu*, trans. Marilyn and Shen Fu, in *Studies in Connoisseurship: Chinese Paintings from the Arthur M. Sackler Collections*, exh. cat. (Princeton: Princeton University Art Museum, 1973), p. 56.

Bibliography

Note: For works published in Chinese the Wade-Giles romanization of Chinese authors' names and titles in given in brackets following the *pinyin* romanization.

A * denotes a book of special interest.

Periodicals

Ancient India, New Delhi
Annual Bibliography of Indian Art and Archaeology, Leiden
Archaeological Survey of India, Delhi, 1902–16
Archives of Asian Art, New York
Ars Buddhica, Tokyo
Artibus Asiae, Ascona
Arts Asiatiques, Paris
Arts of Asia, Hong Kong
Bijutsu Kenkyu [Journal of art studies], Tokyo
Bijutsushi [Journal of the Japan Art History Society], Kyoto
Bulletin of London University, the School of Oriental and African Studies, London
Bulletin of the Museum of Far Eastern Antiquities, Stockholm
Bulletin of the Museum of Fine Arts, Boston
Bulletin of the Prince of Wales Museum, Bombay
Bulletin of the State Museum of Baroda, Baroda
Burlington Magazine, London
Chanoyu [A quarterly of tea and the arts of Japan], Kyoto

Early China, Berkeley
Eastern Art, 1–3, Philadelphia, 1928–31
Eurasia Septentrionalis Antiqua, Helsinki
Far Eastern Ceramic Bulletin, Ann Arbor
Gu Gong Bowuyuan Yuankan [*Ku-kung po-wu-yuan yuan-k'an*; Palace Museum Bulletin], Beijing, 1958–
Gu Gong Jikan [*Ku-kung chi-k'an*; National Palace Museum quarterly], Taibei
Harvard Journal of Asiatic Studies, Cambridge, Mass.
Indian Archaeology, New Delhi
Journal of Indian Museums, New Delhi
Journal of the American Oriental Society, Baltimore
Journal of the Indian Society of Oriental Art, Calcutta
Kao Gu [*K'ao-ku*; Chinese archaeological reports], Beijing
Kao Gu Dongxin [*K'ao-ku tung-hsin*; Archaeological Society review], 1955–58
Kao Gu Xue Bao [*K'ao-ku hsueh-pao*; Chinese journal of archaeology], Beijing
Kokka, Tokyo
Kunst des Orients, Wiesbaden
Lalit Kala [Journal of Oriental art], New Delhi
Marg [Magazine of architecture and art], Bombay
Mizue [Fine arts], Tokyo
Monumenta Serica, Beijing and Tokyo
Museum [National Museum publication], Tokyo
Oriental Art, Oxford

Orientations, Hong Kong
Ostasiatische Zeitschrift (Publication of the Gesellschaft für Ostasiatische Kunst), Berlin, 1912–
Revue des arts asiatiques, Paris, 1924–39
Roopa-Lekha, New Delhi
Sinologica, Basel
Tosetsu [Publication of the Japan Ceramic Society], Tokyo
T'oung Pao, Paris
Transactions of the Oriental Ceramic Society, London
Wen Wu [Journal of Chinese culture], Beijing
Wen Wu Jing Hua [*Wen-wu ching-hua*; Pictorial art], Beijing
Wen Wu Zan Kao Zi Liao [*Wen-wu tsan-k'ao tzu-liao*; Reference material on Chinese culture], Beijing
Yamato Bunka [Quarterly journal of Eastern art, Museum Yamato Bunkakan], Osaka
Zhongguo hua [*Chung-kuo hua*; Chinese painting], Beijing

General

ACHARYA, Prasanna K. *An Encyclopedia of Hindu Architecture*. New York: Oxford University Press, 1946.
AGRAWALA, Vasudeva S. *Indian Art*. Vol. 1: *A History of Indian Art from the Earliest Times up to the Third Century A.D.* Varanasi: Prithivi, 1965.
———. *India as Described by Manu*. Varanasi: Prithivi, 1970.

AKIYAMA, Terukazu. *Japanese Painting*. Translated by James Emmons. Geneva: Skira, 1961. Reprint. London: Macmillan, 1977.
———; SUZUKI, Kei; and NAGAHIRO, Toshio, eds. *Chugoku Bijutsu* [Chinese art in Western collections]. 5+ vols. Tokyo: Kodansha, 1972–.
ALLAN, Sarah, and COHEN, Alvin P., eds. *Legend, Lore, and Religion in China*. San Francisco: Chinese Materials Center, 1979.
Archaeological Survey of India. *Memoirs*, nos. 1–47. Calcutta, 1919–.
———. *New Imperial Series*. 54 vols. Delhi, 1874–1937.
ARCHER, Mildred, ed. *The India Office Collection of Painting and Sculpture*. London: British Library, 1986.
Arts of China. 3 vols. Palo Alto: Kodansha, 1968–70.
Vol. 1: T. AKIYAMA et al., *Neolithic Cultures to the T'ang Dynasty: Recent Discoveries*; vol. 2: T. AKIYAMA and S. MATSUBARA, *Buddhist Cave Temples: New Researches*; vol. 3: Y. YONEZAWA and M. KAWAKITA, *Paintings in Chinese Museums: New Collections*.
*ASHTON, Sir Leigh, ed. *The Art of India and Pakistan*. Exh. cat., Royal Academy of Arts. London: Faber, 1950.
AUBOYER, Jeannine. *Arts et styles de l'Inde*. Paris: Larousse, 1951.
———. *Rarities of the Musée Guimet*. Exh. cat., Asia House Gallery. New York: Asia Society/Weatherhill, 1975.

————, and GROUSSET, René. *De l'Inde au Cambodge et à Java*. Monaco: Documents d'Art, 1950.

————, et al. *Oriental Art: A Handbook of Styles and Forms*. Translated by Elizabeth and Richard Bartlett. New York: Rizzoli, 1980.

AYERS, John. *The Baur Collection, Geneva: Chinese Ceramics*. 5 vols. Geneva: Collection Baur, 1968–76.

*————. *Far Eastern Ceramics in the Victoria and Albert Museum*. London: Sotheby's, 1980.

BACHHOFER, Ludwig von. *A Short History of Chinese Art*. New York: Pantheon, 1946.

BAJPAI, K. D., ed. *The Geographical Encyclopaedia of Ancient and Mediaeval India*, vol. 1. Varanasi: Indic Academy, 1967.

BARNARD, Noel, and FRASER, Douglas, eds. *Early Chinese Art and Its Possible Influence in the Pacific Basin*. 3 vols. New York: Intercultural Arts, 1972.

*BARRETT, Douglas, and GRAY, Basil. *Painting of India*. Geneva: Skira, 1963. Reprint. New York: Rizzoli, 1978.

*BASHAM, Arthur L. *The Wonder That Was India*. London: Sidgwick and Jackson, 1954.

*BERNET KEMPERS, A. J. *Ancient Indonesian Art*. Cambridge, Mass.: Harvard University Press, 1959.

BEURDELEY, Cecile, and BEURDELEY, Michel. *A Connoisseur's Guide to Chinese Ceramics*. New York: Alpine Fine Arts Collection, 1984.

BHARAT KALA BHAVAN. *Chhavi: Golden Jubilee Volume 1920–70*. Varanasi, 1971.

BHATTACHARYYA, D. C. *Tantric Buddhist Iconographic Sources*. New Delhi: Munshiram Manoharlal, 1974.

BICKFORD, Maggie, et al. *Bones of Jade, Soul of Ice: The Flowering Plum in Chinese Art*. Exh. cat., Yale University Art Gallery. New Haven: Yale University Press, 1985.

BINGHAM, Woodbridge; CONROY, Hilary; and IKLE, Frank W. *A History of Asia*. 2 vols. 2nd ed. Boston: Allyn and Bacon, 1974.

BIRD, Richard, comp. *General Index, Heibonsha Survey of Japanese Art*. New York: Weatherhill, 1979, *General Index*, 1980.

BLACKER, Carmen. *The Catalpa Bow: A Study of Shamanistic Practices in Japan*. London: Allen and Unwin, 1975.

BLASER, Werner. *Japanese Temples and Tea-Houses*. Translated by D. Q. Stephenson. New York: Dodge, 1957.

BODDE, Derk. *Festivals in Classical China*. Princeton: Princeton University Press, 1975.

*BOISSELIER, J. *Le Cambodge*. Paris: Picard, 1966.

BOSCH, Frederick D. K. *The Golden Germ: An Introduction to Indian Symbolism*. New York: Humanities Press, 1960.

————. *Selected Studies in Indonesian Archaeology*. Hague: Nijhoff, 1961.

BOWIE, Theodore, ed. *The Sculpture of Thailand*. New York: Asia Society, 1972.

BOYD, Andrew. *Chinese Architecture and Town Planning*. London: Tiranti, and Chicago: University of Chicago Press, 1962.

BRINKER, Helmut. *Die zen-buddhistische Bildmalerei in China und Japan von den Anfängen bis zum Ende des 16. Jahrhunderts*. Wiesbaden: Steiner, 1973.

————, and FISCHER, Eberhard. *Treasures from the Rietberg*. Exh. cat. New York: Asia Society and Weatherhill, 1980.

BROWN, Roxanna M. *The Ceramics of South-East Asia: Their Dating and Identification*. New York: Oxford University Press, 1977.

*BUHOT, Jean. *Histoire des arts du Japon, dès origines à 1350*. Paris: Van Oest, 1949.

Bukkyo Bijutsu Nyumon [Introduction to Japanese Buddhist arts]. Nara: Nara National Museum, 1959.

BUNKAZAI HOGO INKAI [Commission for the protection of cultural properties]. *Catalogue of Art Objects Registered as National Treasures*. Tokyo: Benrido, 1971.

BUSH, Susan. *The Chinese Literati on Painting: Su Shih (1037–1101) to Tung Ch'i-ch'ang (1555–1636)*. Cambridge, Mass.: Harvard University Press, 1971.

*————, and MURCK, Christian F. *Theories of the Arts in China*. Princeton: Princeton University Press, 1983.

*————, and SHIH, S. Y. *Early Chinese Texts on Painting*. Cambridge, Mass.: Harvard University Press, 1985.

BUSSAGLI, Mario, and SIVARAMAMURTI, Calambur. *5000 Years of the Art of India*. Translated by A. M. Brainerd, chs. 1–3, 5, 8, 9, 11, 12. New York: Abrams, 1971.

Butsuzo to Zonai no Nyuhin ten [Exhibition of Buddhist sculptures and objects preserved inside the sculptures]. Nara: Nara National Museum, 1974.

*CAHILL, James. *Chinese Painting*. Geneva: Skira, 1972.

————. *An Index of Early Chinese Painters and Paintings: Tang, Sung, Yuan*. Berkeley: University of California Press, 1980.

CAMERON, Nigel. *Barbarians and Mandarins: Thirteen Centuries of Western Travelers in China*. New York: Oxford University Press, 1989.

CAPON, Edmund. *Art and Archaeology in China*. South Melbourne: Macmillan, 1977.

CASTILE, Rand. *The Way of Tea*. New York: Weatherhill, 1971.

Catalogue of Selected Objects of Chinese Art in the Museum. Copenhagen: Danish Museum of Decorative Art, 1959.

Ceramic Art of Japan: One Hundred Masterpieces from Japanese Collections. Exh. cat. Seattle: Seattle Art Museum, 1972.

*CHANDRA, Moti. *Stone Sculpture in the Prince of Wales Museum*. Bombay: Prince of Wales Museum of Western India, 1974.

CHANDRA, Pramod. *The Sculpture of India: 3000 B.C.–1300 A.D.* Exh. cat. Washington, D.C.: National Gallery of Art, 1985.

————. *Stone Sculpture in the Allahabad Museum*. Poona, India: American Institute for Indian Studies, 1970.

————, ed. *Studies in Indian Temple Architecture*. New Delhi: American Institute for Indian Studies, 1975.

*CHANG, Kwang-chih. *The Archaeology of Ancient China*. 3rd ed. New Haven: Yale University Press, 1977.

CHEN, Chao-ming, and STAMPS, Richard B. *An Index to Chinese Archaeological Works Published in the People's Republic of China, 1949–1965*. East Lansing: Asian Studies Center, Michigan State University, 1972.

*CHENG, Te-k'un. *An Introduction to Chinese Art and Archaeology: The Cambridge Outline and Reading Lists*. Cambridge, 1972.

CHIANG, Yee. *Chinese Calligraphy*. London: Methuen, 1938.

Chinese Art in the Royal Ontario Museum. Toronto: Royal Ontario Museum, 1972.

Chinese Art Treasures: A Selected Group of Objects from the Chinese National Palace Museum and the Chinese National Central Museum, Taichung, Taiwan. Exh. cat. Washington, D.C.: National Gallery of Art, and Geneva: Skira, 1961–62.

The Chinese Exhibition: The Exhibition of Archaeological Finds of the People's Republic of China and Illustrated Handlist of the Exhibition of Archaeological Finds of the People's Republic of China. Exh. cat. 2 vols. Washington, D.C.: National Gallery of Art, and Kansas City: Nelson Gallery-Atkins Museum, 1974–75.

Chinese Famous Painting. Series 1. 9 vols. Tokyo, 1956–59. See also individual author entries.

Chinese Painters Series. 15 vols. Shanghai, 1958–59. See also individual author entries.

Chuan Guo Jiben Jianxie Gongzheng Zhong Chutu Wenwu Zhenlan Tulu [Ch'uan-kuo chi-ben chien-hsieh kung-cheng chung ch'u-t'u wen-wu chen-lan t'u-lu; Exhibition of Chinese cultural objects excavated at construction sites since 1949]. 2 vols. Beijing, 1955.

*CODRINGTON, Kenneth de B. *Ancient India. . . .* London: Benn, 1926.

COHN, William. *Asiatische Plastik: China, Japan, Vorder-Hinter-indien, Java*. Collection Baron Eduard von der Heydt. Berlin: Cassirer, 1932.

————. *Chinese Painting*. 2nd rev. ed. London: Phaidon, 1951.

COMBAZ, Gisbert. *L'évolution du stupa en Asie*. Bruges: Ste. Catherine, 1937.

COOMARASWAMY, Ananda K. *Catalogue of the Indian Collection, Museum of Fine Arts, Boston*. 5 vols. Boston: Museum of Fine Arts, 1923–24.

————. *The Dance of Shiva*. Rev. ed. New Delhi: Sagar, 1968.

————. *Elements of Buddhist Iconography*. Cambridge, Mass.: Harvard University Press, 1935.

————. *History of Indian and Indonesian Art*. Reprint. New Delhi: Munshiram Manoharlal, 1972.

————. *Mediaeval Sinhalese Art*. Broad Campden, Eng.: Essex House, 1908.

COOPER, Michael, et al. *The Southern Barbarians: The First Europeans in Japan*. Palo Alto: Kodansha, 1971.

CREEL, Herrlee G. *The Origins of Statecraft in China*. Vol. 1: *The Western Chou Empire*. Chicago: University of Chicago Press, 1970.

DAVID, Sir Percival, trans. *Chinese Connoisseurship: The Ko ku yao lun (by Ts'ao Chiao): The Essential Criteria of Antiquities*. With facsimile of the Chinese text of 1388. New York: Praeger, 1971.

*DE BARY, William T. et al. *Sources of Indian Tradition*. 2 vols. Vol. 1 edited by A. T. Embree. New York: Columbia University Press, 1958, 1988.

————, eds. *Sources of Chinese Tradition*. 2 vols. New York: Columbia University Press, 1960.

————. *Sources of Japanese Tradition*. 2 vols. New York: Columbia University Press, 1964.

DEGLURKAR, Gorakhnath B. *Temple Architecture and Sculpture of Maharashtra*. Nagpur: Nagpur University, 1974.

DESAI, Madhuri. *Architectural and Sculptural Monuments of India (Bharat)*. 4th ed. Bombay: Bhulabhai Memorial Institute, 1954.

DEVENDRA, D. T. *Classical Sinhalese Sculpture, c. 300 B.C. to A.D. 1000*. London: Tiranti, 1958.

DIEZ, Ernst. *Die Kunst Indiens*. Potsdam: Akademische Verlagsgesellschaft Athenaion, 1925.

DOWSON, John. *A Classical Dictionary of Hindu Mythology and Religion, Geography, History, and Literature*. 10th ed. London: Routledge, 1961.

DRISCOLL, Lucy, and TODA, Kenji. *Chinese Calligraphy*. Chicago: University of Chicago Press, 1935.

DUMARCAY, Jacques. *The Temples of Java*. New York: Oxford University Press, 1986.

DUTT, Nalinaksha. *Mahayana Buddhism*. Calcutta: Mukhopadhyay, 1973.

DWIVEDI, Vinod P. *Indian Ivories*. Delhi: Agam, 1976.

ECKARDT, Andre. *A History of Korean Art*. Translated by J. M. Kindersley. London: Goldston, 1929.

————. *Koreanische Keramik*. Bonn: Bouvier, 1970.

ECKE, Tseng Yu-ho. *Chinese Calligraphy*. Exh. cat. Philadelphia: Philadelphia Museum of Art, and Boston: Boston Book, 1971.

ELIOT, Sir Charles. *Japanese Buddhism*. London: Arnold, 1935.

ELISSEEFF, Danielle and Vadime. *Art of Japan*. Translated by J. Mark Paris. New York: Abrams, 1985.

————. *New Discoveries in China*. Secaucus: Chartwell, 1983.

Encyclopedia of Eastern Philosophy and Religion: Buddhism, Taoism, Zen, Hinduism. Edited by Stephan Schuhmacher and Gert Woerner. Boston: Shambhala, 1989.

FEDDERSEN, Martin. *Chinese Decorative Art: A Handbook for Collectors and Connoisseurs*. Translated by Arthur Lane. 2nd ed., rev. and enl. London: Faber, 1961.

————. *Japanese Decorative Art: A Handbook for Collectors and Connoisseurs*. Translated by Katherine Watson. New York: Yoseloff, 1962.

*FENG, Xianming [FENG, Hsien-ming]. "Important Finds of Ancient Chinese Ceramics Since 1949." *Wen Wu* 9 (1965): 25–56. Translated by Hin-cheung Lovell. London: Oriental Ceramic Society, 1967.

FERGUSON, John C. *Chinese Painting*. Chicago: University of Chicago Press, 1927.

FIGGESS, John, and KOYAMA, Fujio. *Two Thousand Years of Oriental Ceramics*. New York: Abrams, 1961.

FISCHER, Klaus. *Schöpfungen Indischer Kunst*. Cologne: Schauberg, 1959.

*FITZGERALD, Charles P. *China: A Short Cultural History*. 4th ed., rev. London: Barrie and Jenkins, 1976.

Five Thousand Years of Korean Art. Exh. cat. San Francisco: Asian Art Museum of San Francisco, 1979.

FONG, Wen, ed. *The Great Bronze Age of China: An Exhibition from the People's Republic of China*. Exh. cat. New York: Metropolitan Museum of Art, 1980.

————, and FU, Marilyn. *Sung and Yuan Painting*. New York: Metropolitan Museum of Art, 1973.

*FONTEIN, Jan. *The Sculpture of Indonesia*. New York: Abrams, 1990.

*————, and HEMPEL, Rose. *China, Korea, Japan*. Berlin: Propylaen, 1968.

*FONTEIN, Jan, and HICKMAN, Money L. *Zen Painting and Calligraphy*. Boston: Museum of Fine Arts, 1970.

*————, and WU, Tung. *Unearthing China's Past*. Exh. cat. Boston: Museum of Fine Arts and Greenwich, Conn.: New York Graphic Society, 1973.

The Freer Gallery of Art. 2 vols. Vol. 1: *China*; vol. 2: *Japan*. Washington, D.C.: Freer Gallery, and Tokyo: Kodansha, 1971.

Fujita Bijutsukan Meihin Zuroku [Masterpieces in the Fujita Museum of Art]. Tokyo: Osaka Fujita Museum of Art, 1972.

GARNER, Sir Harry. *Chinese and Japanese Cloisonné Enamels*. 2nd ed. London: Faber, 1970.

————, and MEDLEY, Margaret. *Chinese Art in Three-Dimensional Colour*. 4 vols. New York: Asia Society for the Gruber Foundation, 1969.

Gazetteer of Mainland China. 2nd ed. Washington, D.C., 1968.

GEELAN, P. J. M., and TWITCHETT, Denis. *The Times Atlas of China*. New York: Quadrangle, 1974.

GETTY, Alice. *The Gods of Northern Buddhism*. Tokyo: Tuttle, 1962.

GOEPPER, Roger. *Chinesische Malerei: Die ältere Tradition*. Bern: Hallwag, 1960.

*————, and WHITFIELD, Roderick. *Treasures from Korea*. Exh. cat. London: British Museum, 1984.

GOETZ, Hermann. *India: Five Thousand Years of Indian Art*. New York: Crown, 1959.

————. *Study in the History, Religion and Art of Classical and Mediaeval India*. Edited by Hermann Kulke. Wiesbaden: Steiner, 1974.

*GOODRICH, L. Carrington. *A Short History of the Chinese People*. New York: Harper, 1951.

GRANET, Marcel. *Chinese Civilization*. Translated by Kathleen Innes and Mabel Brailsford. New York: Barnes and Noble, 1957.

The Great Eastern Temple: Treasures of Japanese Buddhist Art from Todai-ji. Exh. cat. Chicago: Art Institute of Chicago, 1986.

GRISWOLD, Alexander B., et al. *The Art of Burma, Korea, Tibet*. New York: Crown, 1964.

*GROUSSET, René. *La Chine et son art*. Paris: Plon, 1951.

————. *The Civilizations of the East*. 4 vols. Vol. 2: *India*; vol. 3: *China*; vol. 4: *Japan*. Translated by Catherine A. Phillips. New York: Knopf, 1931–34.

————. *De la Grèce à la Chine*. Monaco: Documents d'Art, 1948.

*————. *Histoire de l'Extrême-Orient*. 2 vols. Paris: Geuthner, 1929.

————. *In the Footsteps of the Buddha*. London: Routledge, 1971.

Gu Gong Bowuyuan [Ku Kung Po-Wu-Yuan; Palace Museum], Beijing. *Zhongguo Lidai Ming Hua Ji* [Chung-kuo li-tai ming-hua chi; Collection of famous Chinese paintings of all periods]. 2 vols. Beijing, 1959–60.

————. *Gu Gong Bowuyuan Cang Hua* [Ku-kung po-wu-yuan ts'ang hua; Paintings from the collection of the Palace Museum]. Beijing: Beijing, 1964.

Gu Gong Ming Hua San Bai Zhong [Ku kong ming hua san pai chung; Three hundred masterpieces of Chinese painting in the National Palace Museum]. Taizhong: National Palace Museum, 1959.

Gu Gong Zhen Wan, Fa Lang Ji, Fa Shu, Ming Hua, Ce Ye, Wen Ju Xuan Cui [Ku Kung chen wan, fa lang chi, fa shu, ming hua, ts'e yeh, wen chu hsuan ts'ui; Masterpieces of Chinese miniature crafts, enamel ware, calligraphy, painting, album painting, and writing materials in the National Palace Museum]. 6 vols. Taibei: National Palace Museum, 1970–71.

GULIK, Robert H. van. *Chinese Pictorial Art as Viewed by the Connoisseur*. Rome: Istituto Italiano per il Medio ed Estremo Oriente, 1958.

GUNSAULUS, Helen C. *Japanese Textiles*. New York: Japan Society, 1941.

GUPTE, Ramesh S. *Iconography of the Hindus, Buddhists and Jains*. Bombay: Taraporevala, 1972.

GYLLENSVÄRD, Bo. *Chinese Gold, Silver, and Porcelain: The Kempe Collection*. Exh. cat. New York: Asia Society, 1971.

HACKIN, Joseph, et al. *Asiatic Mythology*. New York: Crowell, 1932.

————. *Studies in Chinese Art and Some Indian Influences*. London: India Society, 1938.

HALL, John W. *Japan from Prehistory to Modern Times*. New York: Delacorte, 1970.

————, and MASS, Jeffrey P., eds. *Medieval Japan: Essays in Institutional History*. Stanford: Stanford University Press, 1974.

HANSFORD, S. Howard. *Chinese Carved Jades*. Greenwich, Conn.: New York Graphic Society, 1968.

————. *Essence of Hills and Streams: The Von Oertzen Collection of Chinese and Indian Jades*. New York: American Elsevier, 1969.

*————. *Glossary of Chinese Art and Archaeology*. London: China Society, 1972.

HARADA, Jiro. *A Glimpse of Japanese Ideals*. Tokyo: Kokusai Bunka Shinkokai [Society for International Cultural Relations], 1937.

HARADA, Kinjiro. *The Pageant of Chinese Painting*. Tokyo: Otsukakogeisha, 1936.

*HARLE, James C. *The Art and Architecture of the Indian Subcontinent*. New York: Penguin, 1990.

————, and TOPSFIELD, Andrew. *Indian Art in the Ashmolean Museum*. Chicago: University of Chicago Press, 1987.

HÄRTEL, Herbert. *Indische Skulpturen*. Part I: *Die Werke der frühindischen, klassischen und frühmittelalterlichen Zeit*. Berlin: Museum für Völkerkunde, 1960.

*————, and AUBOYER, Jeannine. *Indien und Südostasien*. Berlin: Propyläen, 1971.

HAVELL, Ernest B. *The Ancient and Mediaeval Architecture of India*. London: Murray, 1915. Reprint, New Delhi, 1972.

HAYAKAWA, Masao. *The Garden Art of Japan*. Translated by Richard L. Gage. New York: Weatherhill, 1973.

The Heibonsha Survey of Japanese Art. 31 vols. New York: Weatherhill, 1972–77.

HENDERSON, Harold G., and MINAMOTO, Hoshu. *An Illustrated History of Japanese Art*. Kyoto: Hoshino, 1939.

HIRAI, Kiyoshi. *Feudal Architecture of Japan*. Translated by Hiroaki Sato and Jeannine Ciliotta. New York: Weatherhill, 1973.

Historical Relics Unearthed in New China. Beijing: Foreign Languages Press, 1972.

*HONEY, William B. *Ceramic Art of China and Other Countries of the Far East*. New York: Beechhurst, 1954.

HUCKER, Charles O. *China's Imperial Past*. Stanford: Stanford University Press, 1975.

HUGHES-STANTON, P., and KERR, R. *Kiln Sites of Ancient China: An Exhibition Lent by the People's Republic of China*. Exh. cat. London: Oriental Ceramic Society, 1980.

*HUNTINGTON, S. L. *The Art of Ancient India*. New York: Weatherhill, 1985.

IENAGA, Saburo. *Japanese Art: A Cultural Appreciation*. Translated by Richard L. Gage. New York: Weatherhill, 1979.

The I-li, or Book of Etiquette and Ceremonial. Translated by John Steele. London: Probsthain, 1917. Reprint, Taibei: Ch'en-wen, 1966.

Illustrated Catalog of Chinese Government Exhibits for the International Exhibition of Chinese Art in London, 1935. 4 vols. Nanjing, 1935.

International Symposium on Japanese Ceramics. Seattle: Seattle Art Museum, 1973.

ITOH, Teiji. *Traditional Domestic Architecture of Japan*. Translated by Richard L. Gage. New York: Weatherhill, 1972.

IYER, K. Bharatha. *Indian Art: A Short Introduction*. Bombay: Asia Publishing House, 1958.

I-yuan Ji Jin [I-yüan chi-chin; Selection of fine paintings from the Tianjin Art Museum collection]. Tianjin: Tianjin Art Museum, 1959.

Japanese Ceramics from Ancient to Modern Times, Selected from Collections in Japan and America. Exh. cat. Edited by Fujio Koyama. Oakland: Oakland Art Museum, 1961.

JENYNS, R. Soame. *A Background to Chinese Painting*. London: Sidgwick and Jackson, 1935. Reprint, New York: Schocken, 1966.

*KAGEYAMA, Haruki. *The Arts of Shinto*. Translated by Christine Guth. New York: Weatherhill, 1973.

————. *Kamigami no Bijutsu: Tokubetsu Tenrankai* [The arts of the Shinto gods]. Exh. cat. Kyoto: Kyoto National Museum, 1974.

————, and KANDA, Christine Guth. *Shinto Arts: Nature, Gods, and Man in Japan*. Exh. cat. New York: Japan Society, 1976.

KAIL, Owen C. *Buddhist Cave Temples of India*. Bombay: Taraporevala, 1975.

Kankoku Bijutsu Zenshu [Arts of Korea]. 15 vols. Seoul, 1974–75.

Kannon Bosatsu: Tokubetsuten [Kannon: special exhibition]. Nara: Nara National Museum, 1977.

Kannon no Kaiga: Sono bi o Reikishi [Exhibition of Kannon painting]. Nara: Yamato Bunkakan, 1974.

KATO, Genchi. *A Historical Study of the Religious Development of Shinto*. Translated by Shoyu Hanayama. Tokyo: Japan Society for the Promotion of Science, 1973.

KATO, Shuichi. *Form, Style, Tradition: Reflections on Japanese Art and Society*. Translated by John Bester. Berkeley: University of California Press, 1971.

KEIKAI, comp. *Miraculous Stories from the Japanese Buddhist Tradition: The Nihon Ryoiki of the Monk Kyokai*. Translated by Kyoko M. Nakamura. Cambridge, Mass.: Harvard University Press, 1973.

KIDDER, J. Edward. *The Art of Japan*. New York: Park Lane, 1985.

KIM, Chewon, and KIM, Won-yong. *Treasures of Korean Art: 2000 Years of Ceramics, Sculpture, and Jeweled Arts*. New York: Abrams, 1966.

*————, and LEE, Lena Kim. *Arts of Korea*. New York: Kodansha, 1974.

*KINGERY, W. David, and VANDIVER, Pamela B. *Ceramic Masterpieces: Art, Structure, and Technology*. New York: Macmillan, 1986.

KITAGAWA, Joseph M., and CUMMINGS, Mark D., eds. *Buddhism and Asian History*. New York: Macmillan and Collier, 1987.

KIYOHIKO, Munakata. *Sacred Mountains in Chinese Art*. Champaign-Urbana: University of Illinois Press, 1991.

KOBAYASHI, Takeshi. *Nara Buddhist Art: Todai-ji*. New York: Weatherhill, 1975.

KOYAMA, Fujio. *Chinese Ceramics: One Hundred Selected Masterpieces from Collections in Japan, England, France and America*. Tokyo: Nihon Keizai, 1960.

————, ed. *Toyo Ko Toji* [Early Oriental ceramics]. 7 vols. Tokyo, 1954–57.

*————, et al. *Sekai Toji Zenshu* [Catalogue of world's ceramics]. 16 vols. Tokyo, 1975–85.

Koyasan: Kobo Taishi Goshotan Sennihyakunen Kinen [Mount Koya on the twelve-hundredth anniversary of the birth of Kobo Daishi]. Exh. cat. Tokyo: Tokyo National Museum, 1973.

*KRAMRISCH, Stella. *The Art of India*. 3rd ed. London: Phaidon, 1965.

————. *The Art of Nepal*. Exh. cat. New York: Asia Society and Abrams, 1964.

————. *The Hindu Temple*. 2 vols. Calcutta: University of Calcutta, 1946.

————. *Indian Sculpture*. New York: Oxford University Press, 1933.

————. *Manifestations of Shiva*. Exh. cat. Philadelphia: Philadelphia Museum of Art, 1981.

KUWAYAMA, George. *New Perspectives on the Art and Ceramics of China*. Los Angeles: Los Angeles County Museum of Art, 1992.

————. *The Quest for Eternity: Chinese Ceramics from the People's Republic of China*. Exh. cat. Los Angeles: Los Angeles County Museum of Art, 1987.

————, ed. *Ancient Mortuary Traditions of China*. Los Angeles: Los Angeles County Museum of Art, 1992.

Kyo No Shaji Meihoten: Tokubetsu Tenrankai [Art treasures of shrines and temples in Kyoto: Special exhibition]. Exh. cat. Kyoto: Kyoto National Museum, 1974.

*LAING, Ellen J. *Chinese Paintings in Chinese Publications, 1956–1968: An Annotated Bibliography and an Index to the Paintings*. Ann Arbor: University of Michigan Press, 1969.

LAUFER, Berthold. *Jade*. 2nd ed. South Pasadena: Perkins, 1946.

LAWTON, Thomas. *Chinese Figure Painting.* Exh. cat. Washington, D.C.: Smithsonian Institution, for the Freer Gallery, 1973.

LEE, Sammy Y. *Oriental Lacquer Art.* New York: Weatherhill, 1972.

LEE, Sherman E. *Chinese Landscape Painting.* 2nd ed., rev. Cleveland: Cleveland Museum of Art, and New York: Abrams, 1962.

———. *Japanese Decorative Style.* Cleveland: Cleveland Museum of Art, and New York: Harper and Row, 1972.

———, et al. *Reflections of Reality in Japanese Art.* Cleveland: Cleveland Museum of Art, 1983.

*LI, Xueqin [LI, Hsüeh-ch'in]. *The Wonder of Chinese Bronzes.* Beijing, 1980.

LIANG, Ssuch'eng. *A Pictorial History of Chinese Architecture.* Edited by Wilma Fairbank. Cambridge, Mass.: MIT Press, 1984; rev. ed., 1989.

LIN, Yutang. *Imperial Peking: Seven Centuries of China.* With an essay on the art of Beijing by Peter C. Swann. New York: Crown, 1961.

LIPPE, Aschwin. *Indian Mediaeval Sculpture.* New York: North-Holland, 1978.

LITTLE, Stephen. *Realm of the Immortals: Daoism in the Arts of China.* Exh. cat. Cleveland: Cleveland Museum of Art and Indiana University Press, 1988.

———. *Visions of the Dharma: Japanese Buddhist Paintings and Prints. . . .* Exh. cat. Hawaii: Honolulu Academy of Arts, 1991.

LIU, L. G. *Chinese Architecture.* London: Academy, 1989.

LOEHR, Max, with HUBER, Louisa G. F. *Ancient Chinese Jades from the Grenville L. Winthrop Collection in the Fogg Art Museum, Harvard University.* Cambridge, Mass.: Fogg Art Museum, 1975.

*———. *The Great Painters of China.* New York: Harper and Row, 1980.

LOUIS-FRÉDÉRIC, pseud. *The Art of Southeast Asia: Temples and Sculpture.* New York: Abrams, 1965.

LOVELL, Hin-cheung. *An Annotated Bibliography of Chinese Painting: Catalogues and Related Texts.* Ann Arbor: University of Michigan, Center for Chinese Studies, 1973.

LOWRY, John. *Tibetan Art.* London: Victoria and Albert Museum, 1973.

LUDOWYK, E. F. C. *The Footprint of the Buddha.* London: Allen and Unwin, 1958.

MALLMANN, Marie-Thérèse de. *Introduction à l'iconographie du Tântrisme bouddhique.* Paris: Maisonneuve, 1975.

*MARCH, Benjamin. *Some Technical Terms of Chinese Painting.* Baltimore: Waverly, 1935.

MASON, Penelope. *History of Japanese Art.* New York: Abrams, 1993.

MAYUYAMA, Junkichi, ed. *Chinese Ceramics in the West: A Compendium of Chinese Ceramic Masterpieces inEuropean and American Collections.* Tokyo: Mayuyama, 1960.

*McCUNE, Evelyn. *The Arts of Korea.* Rutland: Tuttle, 1962.

McNEILL, William H., and SEDLAR, Jean W., eds. *China, India, and Japan: The Middle Period.* New York: Oxford University Press, 1971.

*MEDLEY, Margaret. *The Chinese Potter.* 2nd ed. Ithaca: Cornell University Press, 1986.

———. *A Handbook of Chinese Art.* New York: Harper and Row, 1964.

———, ed. *Chinese Painting and the Decorative Style.* London: Percival David Foundation of Chinese Art, 1976.

MEHTA, R. *Masterpieces of Indian Temples.* Bombay: Taraporevala, 1974.

MICHELL, George. *The Hindu Temple: An Introduction to Its Meaning and Forms.* New York: Harper and Row, 1977. Reprint. Chicago: University of Chicago Press, 1988.

MIKAMI, Tsugio. *The Art of Japanese Ceramics.* Translated by Ann Herring. New York: Weatherhill, 1972.

MINNEAPOLIS INSTITUTE OF ARTS. *Chinese Jades: Archaic and Modern from the Minneapolis Institute of Arts.* Rutland: Tuttle, 1977.

MINO, Yutaka. *The Radiance of Jade and the Clarity of Water: Korean Ceramics from the Ataka Collection.* Exh. cat. Chicago: Art Institute of Chicago, 1981.

———, and WILSON, Patricia. *An Index to Chinese Ceramic Kiln Sites from the Six Dynasties to the Present.* Toronto: Royal Ontario Museum, 1974.

MITRA, Rajendralala. *Buddha Gaya: The Great Buddhist Temple, the Hermitage of Sakya Muni.* Delhi: Indological Book House, 1972.

MIZOGUCHI, Saburo. *Design Motifs.* Translated by Louise A. Cort. New York: Weatherhill, 1973.

*MIZUNO, Seiichi. *Bronze and Stone Sculpture of China from the Yin to the T'ang Dynasty.* Portions translated by Yuichi Kajiyama and Burton Watson. Tokyo, 1960.

MONOD, Odette. *Le Musée Guimet.* Vol. 1: *Inde, Khmer, Tchampa, Thailande, Java, Nepal, Tibet, Afghanistan, Pakistan, Asie Centrale.* Paris: Réunion des Musées Nationaux, 1966.

MORI, Hisashi. *Japanese Portrait Sculpture.* New York: Kodansha, 1977.

MORRISON, Hedda, and EBERHARD, Wolfram. *Hua Shan: The Taoist Sacred Mountain in West China, Its Scenery, Monasteries, and Monks.* Hong Kong: Vetch and Lee, 1973.

Mostra d'arte cinese [Exhibition of Chinese art]. Exh. cat., Doges' Palace, Venice. Venice: Alfieri, 1954.

MUKERJEE, Radhakamal. *The Culture and Art of India.* New York: Praeger, 1959.

MURAKAMI, Hyoe, and SEIDENSTICKER, Edward G., eds. *Guides to Japanese Culture.* Tokyo: Kodansha, 1977.

MURASE, Miyeko. *Emaki.* New York: Asia Society, 1983.

———. *Japanese Art: Selections from the Mary and Jackson Burke Collection.* Exh. cat. New York: Metropolitan Museum of Art, 1975.

———. *Masterpieces of Japanese Screen Painting.* New York: Braziller, 1990.

———. *Tales of Japan: Scrolls and Prints from the New York Public Library.* Exh. cat. New York: Oxford University Press, 1986.

*MURCK, Christian F., ed. *Artists and Traditions: Uses of the Past in Chinese Culture.* Princeton: Princeton University Art Museum, 1976.

NAKATA, Yujiro. *The Art of Japanese Calligraphy.* Translated by Alan Woodhull. New York: Weatherhill, 1973.

Nara Rokudai-ji Taikan [Conspectus of the six great temples in Nara]. 14 vols. Tokyo: Nara National Museum, 1968–73.

NARAZAKI, Muneshige, and SHIMADA, Shujio, eds. *Zaigai Hiho* [Japanese paintings in Western collections]. 6 vols. Tokyo: Gakken, 1969.

Nippon Emakimono Zenshu [Japanese scroll paintings]. 12 vols. Tokyo: Kadokawa Shoten, 1958–59.

Nippon no bunkazai [Cultural properties of Japan]. 2 vols. Tokyo, 1961.

Nippon no Tera [Buddhist Temples in Japan]. 12 vols. Tokyo: Bijutsu Shuppansha, 1958–61.

NISHIKAWA, Kyotaro, and SANO, Emily. *The Great Age of Japanese Buddhist Sculpture, A.D. 600–1300.* Exh. cat. Fort Worth: Kimbell Art Museum, and New York: Japan Society, 1982.

NOBUNARI, Mochizuki, et al. *Nippon Shozoga Zuroku* [Illustrated catalogue of Japanese portrait painting]. Exh. cat., 2 vols. Kyoto: Nara Imperial Museum, 1938.

NOMA, Seiroku. *Artistry in Ink.* Translated by Edward Strong. New York: Crown, 1957.

*OKAZAKI, Joji. *Pure Land Buddhist Painting.* New York: Kodansha, 1977.

OKAZAKI, Takashi, et al. *Chugoku no Toji: Shin Shutsudo no Meihin* [Chinese ceramics from recent discoveries and historical collections]. Tokyo, 1978.

OLSEN, Eleanor. *Tantric Buddhist Art.* Exh. cat., China House Gallery, New York. New York: China Institute in America, 1974.

OOKA, Minoru. *Temples of Nara and Their Art.* Translated by Dennis Lishka. New York: Weatherhill, 1973.

Osaka Shiritsu Bijutsukan-zo Chugoku Kaiga [Chinese paintings in the Osaka Municipal Museum of Art]. 2 vols. Tokyo: Osaka Municipal Museum, 1975.

PAINE, Robert T. *Ten Japanese Paintings in the Museum of Fine Arts, Boston.* New York: Japan Society, 1935.

*———, and SOPER, Alexander C. *The Art and Architecture of Japan.* Rev. ed. New York: Penguin, 1974.

PAL, Pratapaditya. *The Art of Tibet.* New York: Asia Society, 1969.

*———. *The Arts of Nepal.* Vol. 1: *Sculpture,* 1974; vol. 2: *Painting,* 1978. Leiden: Brill, 1974–78.

———. *Indian Sculpture: A Catalog of the Los Angeles County Museum of Art Collection.* 2 vols. Berkeley: University of California Press, 1984.

———. *Light of Asia.* Exh. cat. Los Angeles: Los Angeles County Museum of Art, 1984.

———, ed. *Aspects of Indian Art.* Leiden: Brill, 1972.

PALUDAN, Ann. *The Chinese Spirit Road.* New Haven: Yale University Press, 1991.

PARMENTIER, Henri. *L'art du Laos.* 2 vols. Paris: Imprimerie Nationale, 1954.

PAUL-DAVID, Madeleine. *Arts et styles de la Chine.* Paris: Larousse, 1953.

PETECH, Luciano. *Mediaeval History of Nepal (c. 750–1480).* Rome: Istituto Italiano per il Medio ed Estremo Oriente, 1958.

A Pictorial Encyclopedia of the Oriental Arts: Korea. Edited by Kadokawa Shoten. New York: Crown, 1969.

Proceedings of the International Symposium on Chinese Painting, June, 1970. Taibei: National Palace Museum, 1972.

QIN, Zuyong [CH'IN Tsu-yung]. *Im Schatten des Wu-T'ung-Baumes.* Edited and translated by Roger Goepper. Munich: Hirmer, 1959.

*RAGUE, Beatrix von. *A History of Japanese Lacquerwork.* Translated by Annie R. de Wasserman. Buffalo: University of Toronto Press, 1976.

RAMACANDRA, Kaulacara. *Silpa Prakasa.* Translated and annotated by Alice Boner and Sadasiva Rath Sarma. Leiden: Brill, 1966.

RAMBACH, Pierre, and GOLISH, Vitold de. *The Golden Age of Indian Art, 5th–13th Century.* London: Thames and Hudson, 1955.

RAPSON, Edward J., et al., eds. *The Cambridge History of India.* 7 vols. Supplementary vol.: *The Indus Civilization.* Edited by Mortimer Wheeler. Cambridge: Cambridge University Press, and New York: Crowell, 1922–68.

RAWLINSON, Hugh G. *India: A Short Cultural History.* 3rd ed. London: Cresset, 1954.

*RAWSON, Jessica. *Ancient China.* New York: Harper and Row, 1980.

———. *Chinese Ornament: The Lotus and the Dragon.* London: British Museum, 1984.

RAWSON, Philip S. *The Art of Southeast Asia.* London: Thames and Hudson, 1967.

———. *The Art of Tantra.* Greenwich, Conn.: New York Graphic Society, 1973.

———. *Erotic Art of the East: The Sexual Theme in Oriental Painting and Sculpture.* New York: Putnam,1968.

———. *Indian Sculpture.* New York: Dutton, 1966.

RAY, Nihar Ranjan. *Idea and Image in Indian Art.* New Delhi: Munshiram Manoharlal, 1973.

*REISCHAUER, Edwin O., and FAIRBANK, John K. *East Asia: The Great Tradition.* Boston: Houghton Mifflin, 1958. Reprint. 1960.

RIDELL, Sheila. *Dated Chinese Antiquities, 600–1650.* Boston: Faber and Faber, 1979.

ROBERTS, Laurence P. *A Dictionary of Japanese Artists: Painting, Sculpture, Ceramics, Prints, Lacquer.* New York: Weatherhill, 1976.

ROSENFIELD, John M.; CRANSTON, Fumiko E.; and CRANSTON, Edwin A. *The Courtly Tradition in Japanese Art and Literature: Selections from the Hofer and Hyde Collections.* Exh. cat. Cambridge, Mass.: Fogg Art Museum, Harvard University, 1973.

———, and GROTENHUIS, Elizabeth ten. *Journey of the Three Jewels: Japanese Buddhist Paintings from Western Collections.* Exh. cat. New York: Asia Society/Weatherhill, 1979.

*———, and SHIMADA, Shujiro. *Traditions of Japanese Art.* Cambridge, Mass.: Fogg Art Museum, Harvard University, 1970.

*ROWLAND, Benjamin. *The Art and Architecture of India.* 3rd ed., rev. Baltimore: Penguin, 1967.

———. *Art in East and West.* Cambridge, Mass.: Harvard University Press, 1954.

———. *The Harvard Outline and Reading Lists for Oriental Art.* 3rd ed. Cambridge, Mass.: Harvard University Press, 1967.

ROWLEY, George. *Principles of Chinese Painting.* 2nd ed. Princeton: Princeton University Press, 1974.

SAHAY, Sachidanand. *Indian Costume, Coiffure, and Ornament.* New Delhi: Munshiram Manoharlal, 1975.

SAKANISHI, Shio, trans. *The Spirit of the Brush.* Reprint. London: J. Murray, 1948.

*SANSOM, George B. *Japan: A Short Cultural History.* Rev. ed. Englewood Cliffs: Prentice-Hall, 1962.

*SAWA, Takaaki. *Art in Japanese Esoteric Buddhism.*Translated by Richard L. Gage. New York: Weatherhill, 1972.

*SECKEL, Dietrich. *The Art of Buddhism.* New York: Greystone, 1968.

Selected Catalogue of the Museum Yamato Bunkakan. Nara: Yamato Bunkakan, 1960.

SELIGMAN, Charles G. *The Seligman Collection of Oriental Art.* 2 vols. Vol. 1: *Chinese, Central Asian and Luristan Bronzes and Chinese Jades and Sculptures,* by S. Howard Hansford. Vol. 2: *Chinese and Korean Pottery and Porcelain,* by John AYERS. London: L. Humphries for the Arts Council of Great Britain, 1957–64.

SHANGRAW, Clarence F. *Origins of Chinese Ceramics.* Exh. cat., China House Gallery, New York. New York: China Institute, 1978.

SHIMIZU, Yoshiaki, ed. *Japan: The Shaping of Daimyo Culture 1185–1868.* Exh. cat. Washington, D.C.: National Gallery of Art, 1988.

———, and ROSENFIELD, John M. *Masters of Japanese Calligraphy.* Exh. cat. New York: Asia Society and Japan House Gallery, 1984.

Shina Nanga Taisei [Chinese literati paintings]. 23 vols. 2nd ed. Tokyo, 1937.

*SICKMAN, Laurence, and SOPER, Alexander C. *The Art and Architecture of China.* 3rd ed. Baltimore: Penguin, 1968.

SILBERGELD, J. *Chinese Painting Style.* Seattle, 1982.

SIMPSON, Penny, and SODEOKA, Kanji. *The Japanese Pottery Handbook.* Tokyo: Kodansha, 1979.

SINGH, Madanjeet. *Himalayan Art: Wall-Painting and Sculpture in Ladakh, Lahaul, and Spiti. . . .* Greenwich, Conn.: New York Graphic Society, 1968.

*SIRÉN, Osvald. *The Chinese on the Art of Painting.* Beijing: Vetch, 1936.

*———. *Chinese Painting: Leading Masters and Principles.* 7 vols. New York: Ronald, 1956–58.

———. *Chinese Paintings in American Collections.* 2 portfolios. Paris: Van Oest, 1928.

*———. *Chinese Sculpture from the Fifth to the Fourteenth Century.* New York: Scribner's, 1925.

———. *A History of Early Chinese Art.* 4 vols. London: Benn, 1929–30.

———. *Kinas konst under treårtusenden.* 2 vols. Stockholm: Natur och kultur, 1942–43.

SIVARAMAMURTI, Calambur. *An Album of Indian Sculpture.* New Delhi: National Book Trust, 1975.

———. *The Art of India.* New York: Abrams, 1977.

———. *Sanskrit Literature and Art: Mirrors of Indian Culture.* Delhi: Manager of Publications, 1955.

*SLUSSER, M. S. *Nepal Mandala.* 2 vols. Princeton: Princeton University Press, 1982.

SMITH, Ralph B., and WATSON, W., eds. *Early South East Asia: Essays in Archaeology, History, and Historical Geography.* New York: Oxford University Press, 1979.

SMITH, Vincent Arthur. *A History of Fine Art in India and Ceylon.* 2nd ed., revised by K. de B. Codrington. New York: Oxford University Press, 1930.

SOPER, Alexander C. *The Evolution of Buddhist Architecture in Japan.* Princeton: Princeton University Press, 1942.

SPEISER, Werner. *The Art of China: Spirit and Society.* Translated by George Lawrence. New York: Crown, 1960.

SPULER, Bertold, comp. *History of the Mongols: Based on Eastern and Western Accounts of the Thirteenth and Fourteenth Centuries.* Translated by Helga and Stuart Drummond. Berkeley: University of California Press, 1972.

STAVISKII, Boris I. *Iskusstvo Srednei Azii: drevnii period VI v. do n.e.–VIII v.n.e.* [Art of Central Asia: early period, 6th century B.C.E.–8th century C.E.]. Moscow: Iskusstvo, 1974.

STEINHARDT, Nancy S. *Chinese Imperial City Planning.* Honolulu: University of Hawaii Press, 1990.

STERN, Harold P. *Birds, Beasts, Blossoms, and Bugs: The Nature of Japan.* Exh. cat. Los Angeles: University of California Press, 1976.

SUGIMOTO, Masayoshi, and SWAIN, David L. *Science and Culture in Traditional Japan, A.D. 600–1854.* Cambridge, Mass.: MIT Press, 1978.

*SULLIVAN, Michael. *The Arts of China.* 3rd ed. Berkeley: University of California Press, 1984.

———. *Chinese and Japanese Art.* New York: Watts, 1965.

———. *The Meeting of Eastern and Western Art: From the Sixteenth Century to the Present Day.* Berkeley: University of California Press, 1989.

*———. *Symbols of Eternity: The Art of Landscape Painting in China.* Stanford: Stanford University Press, 1979.

———. *The Three Perfections: Chinese Painting, Poetry and Calligraphy.* London: Thames and Hudson, 1974.

SUNDARAM, K. *Monumental Art and Architecture of India.* Bombay: Taraporevala, 1974.

SUZUKI, Kei. *Comprehensive Illustrated Catalog of Chinese Paintings.* 5 vols. Tokyo: University of Tokyo Press, 1982–83.

———, ed. *Suiboku Bijutsu Taikei.* 15 vols. Tokyo: Kodansha, 1974–78.

SWANN, Peter C. *Art of China, Korea and Japan.* New York: Praeger, 1963.

———. *The Art of Japan.* Rev. ed. New York: Greystone, 1966.

———. *Chinese Painting.* New York: Universe, 1958.

SWARUP, Shanti. *The Arts and Crafts of India and Pakistan.* Bombay: Taraporevala, 1957.

TAJIMA, Shiichi, et al., eds. *Toyo Bijutsu Taikan* [Masterpieces selected from the fine arts of the Far East]. Text by Seigai OMURA. 15 vols. Tokyo: Shimbi Shoin, 1909–20.

TAKEDA, Tsuneo. *Nippon Byobu-e Shusei* [Complete collection of Japanese screen paintings]. 18 vols. Tokyo: Kodansha, 1977–81.

TAKEJIMA, T. *Ryo Kin Jidai no Kenchiku to Butsuzo* [Buddhist architecture and sculpture of the Liao and Jin (Chin) dynasties]. Tokyo, 1944.

TAKI, Seiichi. *Three Essays on Oriental Painting.* London Quaritch, 1910.

TANAKA, Ichimatsu. *Toyo Bijutsu* [Asiatic art in Japanese collections]. 6 vols. Tokyo: Asahi Shimbun, 1967–69.

TANGE, Kenzo, and GROPIUS, Walter. *Katsura: Tradition and Creation in Japanese Architecture.* New Haven: Yale University Press, 1960.

1000 Jahre Chinesisches Malerei. Exh. cat. Munich: Haus der Kunst, 1959.

TAZAWA, Yutaka. *Biographical Dictionary of Japanese Art.* Tokyo, 1981.

———, and OOKA, Minoru. *An Illustrated History of Japanese Art.* Tokyo: Iwanami, 1934.

THORP, Robert L. *Son of Heaven: Imperial Arts of China.* Seattle: Son of Heaven Press, 1988.

A Thousand Cranes: Treasures of Japanese Art. Seattle: Seattle Art Museum, and San Francisco: Chronicle, 1987.

TISSOT, Francine. *Les arts anciens du Pakistan et de l'Afghanistan.* Paris: Desclée de Brouwer, 1987.

TOKIWA, Daijo, and SEKINO, Tadashi. *Shina Bunka Shiseki* [Cultural monuments of China]. 12 vols. Reprint. Tokyo, 1939–41.

Tokyo Kokuritsu Hakubutsukan [Catalogue of the Tokyo National Museum]. Tokyo: Kodansha, 1966.

TOMITA, Kojiro. *Portfolio of Chinese Paintings in the Museum (Han to Sung Periods).* Cambridge, Mass.: Harvard University Press, for the Museum of Fine Arts, Boston, 1933.

———, and TSENG, Hsien-Chi. *Portfolio of Chinese Paintings in the Museum, Yüan to Ch'ing.* Boston: Museum of Fine Arts, 1961.

TOYO BIJUTSU KOKUSAI KENKYUKAI [Society of Friends of Eastern Art], comp. *Index of Japanese Painters.* 1940. Offset reprint. Rutland: Tuttle, 1958.

TREGEAR, Mary. *Chinese Art.* New York: Oxford University Press, 1980.

———. *Guide to the Chinese Ceramics.* Oxford: Ashmolean Museum, 1966.

TRUBNER, Henry; RATHBUN, William J.; and KAPUTA, Catherine A. *Asiatic Art in the Seattle Art Museum.* Seattle: Seattle Art Museum, 1973.

TUCCI, Giuseppe. *Stupa: Art, Architectonics and Symbolism.* New Delhi: Aditya, 1988.

*TWITCHETT, Denis, and FAIRBANK, John K., eds. *The Cambridge History of China.* New York: Cambridge University Press, 1978.

UNESCO. *Japan: Ancient Buddhist Paintings.* Introduction by Takaaki Matsushita. Greenwich, Conn.: New York Graphic Society, 1959.

VAKIL, Kanaiyalal H. *Rock-Cut Temples around Bombay: Elephanta and Jogeshwari, Mandapeshwar and Kanheri.* Bombay: Taraporevala, 1932.

*VALENSTEIN, Suzanne G. *A Handbook of Chinese Ceramics.* 2nd rev. ed. New York: Metropolitan Museum of Art, 1989.

VANDERSTAPPEN, Harrie A., ed. *The T. L. Yuan Bibliography of Western Writings on Chinese Art and Archaeology.* London: Mansell, 1975.

*VARLEY, H. Paul. *Japanese Culture: A Short History.* New York: Praeger, 1973.

VILLA HÜGEL, ESSEN. *5000 Years of Art from India.* Exh. cat. Essen: Villa Hügel, 1959.

*VOGEL, Jean P. *Buddhist Art in India, Ceylon, and Java.* New York: Oxford University Press, 1936.

WAGNER, Frits A. *Indonesia: The Art of an Island Group.* Translated by Ann E. Keep. New York: Crown, 1959.

WALEY, Arthur. *An Introduction to the Study of Chinese Painting.* London: Benn, 1923.

WANG, Shijie [WANG, Shih-chieh], et al., comps. *A Garland of Chinese Paintings.* 5 vols. Kowloon: Cafa, 1967.

WARNER, Langdon. *The Craft of the Japanese Sculptor.* New York: McFarlane, Warde, McFarlane/Japan Society, 1936.

*———. *The Enduring Art of Japan.* Cambridge, Mass.: Harvard University Press, 1952. Reprint. New York: Grove, 1958.

WATSON, William. *Art of Dynastic China.* New York: Abrams, 1981.

———. "A Cycle of Cathay. China: The Civilization of a Single People." In Stuart PIGGOTT, et al., eds., *The Dawn of Civilization.* New York: McGraw-Hill, 1961.

———. *Early Civilization in China.* New York: McGraw Hill, 1972.

———. ed. *Artistic Personality and Decorative Style in Japanese Art.* London: Percival David Foundation of Chinese Art, 1977.

———, et al. *Mahayanist Art after A.D. 900.* London: Percival David Foundation of Chinese Art, 1971.

WATT, James C. Y. *Chinese Jades from Han to Ching.* New York: Asia Society, 1980.

———, ed. *The Translation of Art: Essays on Chinese Painting and Poetry.* Hong Kong, 1976.

WELLS, Wilfrid H. *Perspective in Early Chinese Painting.* London: Goldston, 1935.

WENG, Wan-go. *Chinese Painting and Calligraphy: A Pictorial Survey.* New York: Dover, 1978.

———, and YANG, Boda. *The Palace Museum: Peking.* New York: Abrams, 1982.

WHEELER, Sir R. E. Mortimer. *Early India and Pakistan to Ashoka.* New York: Praeger, 1959.

———. *Five Thousand Years of Pakistan.* London: Royal India and Pakistan Society, 1950.

WHITE, William C. *An Album of Chinese Bamboos.* Toronto: University of Toronto Press, 1939.

WILHELM, Richard. *A Short History of Chinese Civilization.* Translated by Joan Joshua. New York: Viking, 1929.

*WILLETTS, William. *Chinese Art.* 2 vols. London: Penguin, 1958.

WINSTEDT, Sir Richard O., ed. *Indian Art.* New York: Philosophical Library, 1948.

WOOD, Nigel. *Oriental Glazes.* London: Pitman/Watson Guptill, 1978.

XIE, Zhiliu [HSIEH, Chih-liu], ed. *Tang Wu Dai Song Yuan Ming Ji [T'ang Wu-tai Sung Yüan ming-chi; Famous paintings of Tang, Five Dynasties, Song, and Yuan].* Shanghai, 1957.

YASHIRO, Yukio. *2000 Years of Japanese Art.* Edited by Peter C. Swann. New York: Abrams, 1958.

*———, ed. *Art Treasures of Japan.* 2 vols. Tokyo: Kokusai Bunka Shinkokai, 1960.

———, ed. *Nihon Bijutsu Taikei* [Outline of Japanese arts]. 11 vols. Tokyo: Kodansha, 1959–61.

YOSHIDA, Tetsuro. *Japanische Architektur.* Tübingen: Wasmuth, 1952.

*YOSHIKAWA, Itsuji. *Major Themes in Japanese Art.* Translated by Armin Nikovskis. New York: Weatherhill, 1976.

*ZHENG, Zhenduo [CHENG, Chen-to]. *Wei DA DE Yi shu chuan Tong Tulu* [*Wei-ta ti i shu ch'uan t'ung t'u-lu*; The great heritage of Chinese art]. 2 vols. Shanghai: Shanghai san lien shudian, 1954.

Zhongguo Gudai Shi Kehua Xianji [*Chung-kuo Ku-tai shih k'e-hua hsien-chi*; Selections of earlier Chinese stone carving]. Beijing, 1957.

Zhongguo Gu Wenwu [*Chung-kuo Ku Wen-wu*; Antiquities of China]. Beijing, 1962.

Zhongguo Li Dai Ming Hua Ji [*Chung-kuo li-tai ming-hua-chi*; Chinese paintings of all periods (from the collection of the Palace Museum)]. 5 vols. Beijing: Palace Museum, 1959–60, 1964–65.

Zhong Hua Congshu Wei Yuan Hui [*Chung-hua ts'ung-shu wei yüan hui*; Art of China]. 6 vols. Taibei: National Palace Museum and National Central Museum, 1955–56.

*ZIMMER, Heinrich R. *The Art of Indian Asia*. 2 vols. Completed and edited by Joseph Campbell. New York: Pantheon, 1955.

———. *Myths and Symbols in Indian Art and Civilization*. Edited by Joseph Campbell. New York: Pantheon, 1946. Reprint. Princeton: Princeton University Press, 1971.

Part One

Early Culture and Art: The Stone Age, the Bronze Age, and the Early Iron Age

1. Urban Civilization and the Indus Valley; Neolithic and Pre-Shang China; Ban Chieng Culture

AGRAWAL, Dharma P., and GHOSH, A., eds. *Radiocarbon and Indian Archaeology*. Bombay: Tata Institute of Fundamental Research, 1973.

AIKENS, C. M., and HIGUCHI, T. *Pre-history of Japan*. New York: Academic Press, 1982.

ANDERSSON, J. G. "Researches in the Pre-history of the Chinese." *Bulletin of the Museum of Far Eastern Antiquities* 15 (1943).

BROOKS, Robert R. R., and WAKANKAR, Vishnu S. *Stone Age Painting in India*. New Haven: Yale University Press, 1976.

CHANDRA, Rai G. *Studies of Indus Valley Terracottas*. Varanasi: Bharatiya, 1973.

CHENG, Te-k'un. *Archaeological Studies in Szechwan*. Cambridge: Cambridge University Press, 1957.

*———. *Archaeology in China*. Vol. 1: *Prehistoric China*. Toronto: University of Toronto Press, 1959.

CHILDS-JOHNSON, E. *Ritual and Power: Jades of Ancient China*. New York: China House, China Institute in America, 1988.

*CREEL, Herrlee G. *Studies in Early Chinese Culture. . . .* Baltimore: Waverly, 1937.

*FAIRSERVIS, Walter A., Jr. *The Roots of Ancient India: The Archaeology of Early Indian Civilization*. New York: Macmillan, 1971.

HO, Ping-ti. *The Cradle of the East*. Chicago: University of Chicago Press, 1975.

JAMES, Jean M. "Images of Power: Masks of the Liangzhu Culture." *Orientations* (June 1991): 46–55.

JOUVEAU-DUBREUIL, Gabriel. *Vedic Antiquities*. 2nd ed. Hyderabad: Akshara, 1976.

KIDDER, Jonathan E., Jr. *Prehistoric Japanese Arts: Jomon Pottery*. Palo Alto, 1968.

LOEHR, Max. *Chinese Bronze Age Weapons*. Ann Arbor: University of Michigan Press, 1956.

MA, Cheng yuan. *Ancient Chinese Bronzes*. Edited by Hsiao-yen Shih. Hong Kong: Oxford University Press, 1986.

*———. *Early Indus Civilization*. 2nd ed. London: Luzac, 1948.

MACKAY, Ernest. *Chanhu-Daro Excavations, 1935–36*. New Haven: Yale University Press, 1943.

MARSHALL, Sir John. *Mohenjo-Daro and the Indus Civilization*. London: Probsthain, 1931.

MODE, Heinz. *Das Frühe Indien*. Stuttgart, 1959.

*PIGGOTT, Stuart. *Prehistoric India*. London, 1950. *The Rise of a Great Tradition: Japanese Archaeological Ceramics from the Jomon through the Heian Periods*. Exh.cat., Japan Society Gallery. New York: Japan Society, 1990.

*WHEELER, Sir R. E. Mortimer. *Early India and Pakistan: To Ashoka*. New York: Praeger, 1959.

*———. *The Indus Civilization*. Cambridge: Cambridge University Press, England, 1953.

YANG, Xiaonang. *Sculpture of Prehistoric China*. Hong Kong.

2. Chinese Art from the Shang through the Middle Zhou Period

BAGLEY, Robert W. *Shang Ritual Bronzes in the Arthur M. Sackler Collections*. Washington, D.C.: Sackler Foundation, and Cambridge, Mass.: Harvard University Press, 1987.

———. "A Shang City in Sichuan Province." *Orientations* (November 1990): 52–67.

BARNARD, Noel. *Bronze Casting and Bronze Alloys in Ancient China*. Canberra: Monumenta Serica, 1961.

———, and SATO, Tamotsu. *Metallurgical Remains of Ancient China*. Tokyo: Nichiosha, 1975.

*CHANG, Kwang-chih. *The Archaeology of Ancient China*. 4th ed. New Haven: Yale University Press, 1987.

*———. *Shang Civilization*. New Haven: Yale University Press, 1980.

———, ed. *Studies of Shang Archaeology*. New Haven: Yale University Press, 1986.

CHASE, W. T. *Ancient Chinese Bronzes*. New York: Chinese Art Society of America, 1991.

*CHENG, Te-k'un. *Archaeology in China*. Vol. 2: *Shang China*. Cambridge: Heffer, 1961.

CONSTEN, Eleanor von Erdberg. *Das alte China*. 2nd ed. Stuttgart: Cotta, 1962.

CREEL, Herrlee G. *The Birth of China*. New York: Reynal, 1937. Reprint. New York: Ungar, 1954.

D'ARGENCE, René-Yvon Lefebvre. *Bronze Vessels of Ancient China in the Avery Brundage Collection*. San Francisco: Diablo, 1977.

Gu Gong Tong Qi Tulu [*Ku-kung t'ung-ch'i t'u-lu*; Illustrated catalogue of the bronzes of the Palace Museum]. 2 vols. Taibei: Joint Administration Department, National Palace Museum and Central Museum, 1958.

HSU, Chin-hsiung. *Oracle Bones from the White and Other*

Collections. Toronto: Royal Ontario Museum, 1979.

KARLGREN, Bernhard. *A Catalogue of the Chinese Bronzes in the Alfred F. Pillsbury Collection*. Minneapolis: University Of Minnesota Press, 1952.

———. "New Studies on Chinese Bronzes." *Bulletin of the Museum of Far Eastern Antiquities* 9 (1937).

*———. "Yin and Chou in Chinese Bronzes." *Bulletin of the Museum of Far Eastern Antiquities* 8 (1936).

*LI, Chi. *Anyang*. Seattle: University of Washington Press, 1977.

———. *The Beginnings of Chinese Civilization: Three Lectures Illustrated with Finds at Anyang*. Seattle: University of Washington Press, 1957.

LODGE, John E.; WENLEY, Archibald G.; and POPE, John A. *A Descriptive and Illustrative Catalogue of Chinese Bronzes*. Washington, D.C.: Freer Gallery, 1946.

*LOEHR, Max. *Ritual Vessels of Bronze Age China*. Exh. cat. New York: Asia Society, and Greenwich, Conn.: New York Graphic Society, 1968.

*MIZUNO, Seiichi. *Bronzes and Jades of Ancient China* [*In Shu Seidoki to Tama*]. Translated by J. O. Gauntlett. Tokyo: Nihon Keizai, 1959.

PALMGREN, Nils. *Selected Chinese Antiquities from the Collection of Gustaf Adolph, Crown Prince of Sweden*. Stockholm, 1948.

*POPE, John A., et al. *The Freer Chinese Bronzes*, vols. 1–2. Washington, D.C.: Freer Gallery of Art, Smithsonian Institution, 1967, 1969.

RAWSON, Jessica. *Western Zhou Ritual Bronzes from the Arthur M. Sackler Collections*. Washington, D.C.: Sackler Foundation, and Cambridge, Mass.: Harvard University Press, 1990.

SALMONY, Alfred. *Archaic Chinese Jades from the Edward and Louise B. Sonnenschein Collection*. Chicago: Art Institute of Chicago, 1952.

———. *Carved Jade of Ancient China*. Berkeley: Gillick, 1938.

UMEHARA, Sueji. *Shina-kodo Seikwa* [Selected relics of ancient Chinese bronzes from collections in Europe and America]. 5 vols. Osaka, 1933.

———. *Shina Kogyuku Zuroku* [Selected specimens of Chinese archaic jade]. Kyoto, 1956.

———, ed. *Shinshu Sen'oku Seisho* [Collection of old bronzes of Sumitomo]. 2 vols. Kyoto, 1971.

WATSON, William. *Ancient Chinese Bronzes*. 2nd ed. London: Faber, 1977.

*———. *Archaeology in China*. London: Parrish, 1960.

*———. *China before the Han Dynasty*. New York: Praeger, 1962.

WHITE, William C. *Bone Culture of Ancient China*. Toronto: University of Toronto Press, 1945.

———. *Bronze Culture of Ancient China: An Archaeological Study of Bronze Objects from Northern Honan. . . .* Toronto: University of Toronto Press, 1956.

XIA, Nai [HSIA, Nai]. "Workshop of China's Oldest Civilization." *China Reconstructs* 6, no. 12 (December 1957): 18–21.

*YETTS, W. Perceval. *The Cull Chinese Bronzes*. London: Courtauld Institute of Art, University of London, 1939.

3. The Late Zhou Period

ANDERSSON, J. G. "The Goldsmith in Ancient China." *Bulletin of the Museum of Far Eastern Antiquities* 7 (1935).

———. "Hunting Magic in the Animal Style." *Bulletin of the Museum of Far Eastern Antiquities* 4 (1932).

*BOROVKA, Gregory. *Scythian Art*. Translated by V. Gordon Childe. New York: Stokes, 1928. Reprint. New York: Paragon, 1960.

BUNKER, Emma C.; CHATWIN, C. Bruce; and FARKAS, Ann R. *Animal Style Art from East to West*. Exh. cat. New York: Asia Society, 1970.

CARTER, Dagny O. *The Symbol of the Beast*. New York: Ronald, 1957.

*KARLGREN, Bernhard. "Huai and Han." *Bulletin of the Museum of Far Eastern Antiquities* 13 (1941): 1–126.

LAWTON, Thomas. *Chinese Art of the Warring States Period*. Exh. cat. Washington, D.C.: Freer Gallery of Art, Smithsonian Institution, 1982.

———, et al. *New Perspectives on Chu Culture during the Eastern Zhou Period*. Washington, D.C.: Sackler Gallery, Smithsonian Institution, 1991.

LI, Xueqin. *Eastern Zhou and Qin Civilizations*. New Haven, 1985.

*MINNS, E. H. *The Art of the Northern Nomads*. London: Milford, 1944.

*———. *Scythians and Greeks*. Cambridge: Cambridge University Press, 1913.

*RICE, Tamara T. *The Scythians*. New York: Praeger, 1961.

*ROSTOVTZEFF, Mikhail I. *The Animal Style in South Russia and China*. Princeton: Princeton University Press, 1929.

SALMONY, Alfred. *Sino-Siberian Art in the Collection of C. T. Loo*. Paris: C. T. Loo, 1933.

TROUSDALE, William. *The Long Sword and Scabbard Slide in Asia*. Washington, D.C.: Smithsonian Institution, 1975.

UMEHARA, Sueji. *Rakuyo Kinson Kobo Shuei* [Catalogue of selected relics from the ancient tombs of Jin Cun, Luoyang (Chin-ts'un, Loyang)]. Kyoto, 1937.

WEBER, George W. *The Oraments of Late Chou Bronzes: A Method of Analysis*. New Brunswick: Rutgers University Press, 1973.

WHITE, William C. *Tomb Tile Pictures of Ancient China*. Toronto: University of Toronto Press, 1939.

———. *Tombs of Old Lo-yang*. Shanghai: Kelly and Walsh, 1934.

4. The Growth and Expansion of Early Chinese Culture through the Han Dynasty; Korea and Japan

Arts of the Han Dynasty. Exh. cat. New York: Chinese Art Society of America, 1961.

BULLING, A. "The Decoration of Mirrors of the Han Period: A Chronology." *Artibus Asiae*, suppl. 20, Ascona, 1960.

Changsha Mawangdui Yi Hao Han Mu [*Ch'ang-sha Ma wang-tui i hao Han-mu*; Han Tomb No. 1 at Mawangdui, Changsha]. Beijing: Changsha Provincial Museum and Institute of Archaeology, 1973.

*CHAVANNES, Edouard. *Mission archéologique dans la Chine septentrionale*. 3 vols. Paris: Leroux, 1909–15.

———. *La sculpture en pierre en Chine au temps des deux dynasties Han*. Paris: Leroux, 1893.

EBERHARD, Alide and Wolfram. *Die Mode de Han und Chin-Zeit*. Antwerp: De Sikkel, 1946.

EGAMI, Namio. *The Beginnings of Japanese Art*. New York: Weatherhill, 1973.

FAIRBANK, Wilma. *Adventures in Retrieval: Han Murals and Shang Bronze Molds*. Cambridge, Mass.: Harvard University Press, 1972.

GOEPPER, Roger, and WHITFIELD, Roderick. *Treasures from Korea*. Exh. cat. London: British Museum, 1984.

HAMADA, Kosaku. *The Tomb of the Painted Basket of Lolang*. Seoul: Chôsens koseki-kenkyu-kwai [Society for Study of Korean Antiquities], 1934.

JANSE, Olov R. T. *Archaeological Research in Indo-China*. Cambridge, Mass.: Harvard University Press, vol. 1, 1947; vol. 2, 1951.

*KIDDER, Jonathan E., Jr. *Japan before Buddhism*. 4th rev. ed. New York: Praeger, 1966.

———. *The Jomon Pottery of Japan*. Ascona: Artibus Asiae, 1957.

———. *Prehistoric Japanese Arts: Jomon Pottery*. Tokyo: Kodansha, 1968.

KIM, Chong-hak. *The Prehistory of Korea*. Translated by Richard J. and Kozue Pearson. Honolulu, 1978.

KOBAYASHI, Yukio. *Haniwa* [Clay figures]. Tokyo, 1960.

LEE, Sherman E. "Early Chinese Painted Shells with Hunting Scenes." *Archives of the Chinese Art Society in America* 11 (1957).

LUBO-LESNICHENKO, Evgenii I. *Ancient Chinese Textiles and Embroideries, 5th Century B.C.–3rd Century A.D. in the Collection of the State Hermitage*. Leningrad, 1961.

MIKI, Fujio. *Haniwa* [Clay figures]. Translated by Gina I. Barnes. New York: Weatherhill, 1974.

MIZUNO, Seiichi. *Painting of the Han Dynasty*. Tokyo, 1957.

———. *Nippon Koko-Ten* [Japanese archaeology exhibition documenting development during the past 25 years]. Tokyo: Tokyo National Museum, 1969.

NOMA, Seiroku. *Haniwa*. New York: Asia Society, 1960.

PEARSON, Richard J. "The Archaeological Background to Korean Prehistoric Art." *Korean Culture* 3, no. 4 (December 1982): 18–29.

PHILIPPI, Donald L., trans. *Kojiki*. Princeton: Princeton University Press, 1969.

RUDOLPH, Richard, with YU, Wen. *Han Tomb Art of West China*. Berkeley and Los Angeles: University of California Press, 1951.

Stories from China's Past: Han Dynasty Pictorial Tomb Reliefs and Archaeological Objects from Sichuan Province. Exh. cat. San Francisco: Chinese Culture Foundation of San Francisco, 1987.

UMEHARA, Sueji. *Kokyo Zuroku* [Catalogue of ancient mirrors of the Kohichi Kurokawa Collection]. Osaka, 1951.

WANG, Zhongshu. *Han Civilization*. Translated by K. C. Chang. New Haven: Yale University Press, 1982.

*WATANABE, Yasutada. *Shinto Art: Ise and Izumo Shrines*. Translated by Robert Ricketts. New York: Weatherhill, 1974.

WU, Hung. *The Wu Liang Shrine*. Stanford: Stanford University Press, 1989.

Xi Han Si Hua [*Hsi Han ssŭ-hua*; Western Han paintings on silk]. Beijing: Beijing Cultural Objects Press, 1972.

Part Two

The International Influence of Buddhist Art

5. Early Art in India

ARCHAEOLOGICAL SURVEY OF INDIA. *Archaeological Remains, Monuments and Museums*. 2 vols. New Delhi: 26th International Congress of Orientalists, 1964.

AUBOYER, Jeannine. *The Art of Afghanistan*. Translated by Peter Kneebone. London: Feltham, Hamlyn, 1968.

BARRETT, Douglas. *A Guide to the Karla Caves*. Bombay: Bhulabai Memorial Institute, 1957.

———. *Sculpture from Amaravati in the British Museum*. London: Trustees of the British Museum, 1954.

BARTHOUX, Jules J. *Les fouilles de Hadda*. Paris: Editions d'Art et d'Histoire, 1930.

BHATTACHARYYA, Benyotosh. *The Indian Buddhist Iconography, Mainly Based on the Sadhanamala and Cognate Tantric Texts of Rituals*. 2nd ed. Calcutta: Mukhopadhyay, 1958.

COOMARASWAMY, Ananda K. "The Origin of the Buddha Image." *Art Bulletin* (June 1927).

CZUMA, Stanislav. *Kushan Sculpture: Images from Early India*. Exh. cat. Cleveland: Cleveland Museum of Art, 1985.

DAVIDS, Caroline A. F. R. *Buddhist Birth-Stories (Jataka Tales)*. New Delhi, 1925. Rev. ed., Varanasi, 1973.

DEHEJIA, Vidya. *Early Buddhist Rock Temples: A Chronological Study*. Ithaca: Cornell University Press, 1972.

*DEYDIER, Henri. *Contribution à l'étude de l'art du Gandhâra*. Paris: Adrien-Maisonneuve, 1950.

DHAVALIKAR, M. K. *Sanchi: A Cultural Study*. Poona: Deccan College Postgraduate and Research Institute, 1965.

FOUCHER, Alfred C. *L'art gréco-bouddhique du Gandhâra*. 2 vols. Paris: Leroux, 1905–18.

———. *The Beginnings of Buddhist Art*. Translated by L. A. and F. W. Thomas. Paris: Geuthner, 1918.

Gandhara Sculpture. Karachi: Department of Archaeology, National Museum of Pakistan, 1956.

GANGOLY, Orun C. *Andra Sculptures*. Hyderabad, 1973.

GODARD, A.; GODARD, Y.; and HACKIN, J. *Les antiquités bouddhiques de Bâmiyân*. Paris: Van Oest, 1928.

HACKIN, Joseph. *Recherches archéologiques à Begram*. 2 vols. Paris: Editions d'Art et d'Histoire, 1939.

———, and CARL, J. *Nouvelles recherches archéologiques à Bâmiyân*. Paris: Van Oest, 1933.

JOSHI, Nilakanth P. *Mathura Sculptures: A Hand Book to Appreciate Sculptures in the Archaeological Museum, Mathura*. Mathura: Mathura Archaeological Museum, 1966.

KAR, Chintamoni. *Classical Indian Sculpture, 300 B.C. to A.D. 500*. London: Tiranti, 1950.

*KROM, Nicolaas J. *The Life of Buddha on the Stupa of Barabudur, According to the Lalitavistara Text*. Hague.

1926. Reprint. Varanasi: Bhartiya, 1974.

LOHUIZEN-DE LEEUW, Johanna E. van. *The Scythian Period: An Approach to the History, Art, Epigraphy and Palaeography of Northern India from the 1st Century B.C. to the 3rd Century A.D.* Leiden: Brill, 1949.

*MARSHALL, Sir John H. *The Buddhist Art of Gandhara*. Cambridge: Cambridge University Press, for the Department of Archaeology in Pakistan, 1960.

*———. *Taxila*. 3 vols. Cambridge: Cambridge University Press, 1951.

———, and FOUCHER, Alfred. *The Monuments of Sanchi*. 3 vols. London: Probsthain, 1940.

MITRA, Debala. *Sanchi (Department of Archaeology, India)*. New Delhi: Director General of Archaeology in India, 1958.

PARANAVITANA, S. "The Significance of Sinhalee 'Moonstones.'" *Artibus Asiae* 17, nos. 3–4 (1954).

RAMACHANDRA RAO, P. R. *Andhra Sculpture*. Hyderabad, 1984.

RAY, Nihar Ranjan. *Maurya and Sunga Art*. Calcutta: University of Calcutta, 1945.

*ROSENFIELD, John M. *The Dynastic Arts of the Kushans*. Berkeley: University of California Press, 1967.

ROWLAND, Benjamin. *Art in Afghanistan: Objects from the Kabul Museum*. London: Allen Lane, 1971.

SINGH, Sarva D., and SINGH, Sheo B. *The Archaeology of the Lucknow Region*. Lucknow: Paritosh, 1972.

SIVARAMAMURTI, Calambur. *Amaravati Sculpture in the Madras Government Museum*. Madras: Government Press, 1942.

SMITH, Vincent A. *The Jain Stupa and Other Antiquities of Mathura*. Allahabad: Government Press, 1901.

*SOPER, Alexander C. "Recent Studies Involving the Date of Kanishka." *Artibus Asiae* 33, no. 4 (1971), and 34, no. 1 (1972).

STERN, Philippe, and BENISTI, Mireille. *Evolution du style indien d'Amaravati*. Paris: P.U.F., 1961.

THOMAS, Edward J. *The Life of Buddha as Legend and History*. 3rd ed. New York: Barnes and Noble, 1960.

6. The International Gupta Style

AGRAWALA, V. S. *Sarnath (Department of Archaeology, India)*. 2nd ed. New Delhi: Manager of Publications, 1956.

The Arts of Thailand: A Handbook of the Architecture, Sculpture, and Painting of Thailand (Siam) and a Catalogue of the Exhibition in the United States in 1960–61–62. Bloomington: Indiana University, c. 1960.

BARRETT, Douglas. *A Guide to the Buddhist Caves of Aurangabad*. Bombay: Bhulabai Memorial Institute, 1957.

BERNIER, Ronald M. *Temples of Nepal*. Kathmandu: Voice of Nepal, 1971.

BHATTACHARYYA, Tarapada. *The Bodhgaya Temple*. Calcutta, 1966.

BOWIE, Theodore; DISKUL, M. C. S.; and GRISWOLD, A. B. *The Sculpture of Thailand*. Exh. cat. New York: Asia Society, and Greenwich, Conn.: New York Graphic Society, 1972.

BURGESS, James. *The Rock Temples of Ajanta*. 2nd ed. New York, 1970.

DAS GUPTA, Rajatananda. *Nepalese Miniatures*. Varanasi, 1968.

GHOSH, A. *Nalanda (Department of Archaeology, India)*. 4th ed. New Delhi: Manager of Publications, 1959.

GRISWOLD, Alexander B. "The Buddhas of Sukhodaya." *Archives of the Chinese Art Society of America* 7 (1953).

———. *Dated Buddha Images of Northern Siam*. Ascona: Artibus Asiae, 1957.

———. "A New Evidence for the Dating of Sukhodaya Art." *Artibus Asiae* 19, nos. 3–4 (1956).

*HARLE, James C. *Gupta Sculpture: Indian Sculpture of the Fourth to Sixth Centuries A.D.* New York: Oxford University Press, 1974.

HOWARD, Angela F. *The Imagery of the Cosmological Buddha*. Leiden: Brill, 1986.

HUNTINGTON, John and Susan L. *Leaves from the Bodhi Tree*. Seattle: University of Washington Press, 1990.

HUNTINGTON, Susan L. *The Origin and Development of Sculpture in Bihar and Bengal, c. Eighth–Twelfth Centuries*. Ann Arbor, 1972.

JACKSON, David, and JACKSON, Janice. *Tibetan Thangka Painting*. London: Serindia, 1984.

KAK, Ram Ch. *Ancient Monuments of Kashmir*. London: The Indian Society, 1933.

KROM, Nicolaas J. *Barabudur: Archaeological Description*. Hague, 1927.

LE MAY, Reginald. *A Concise History of Buddhist Art in Siam*. Cambridge University Press, 1938. Reprint. Rutland: Tuttle, 1962.

LOWRY, John. *Burmese Art*. London: Her Majesty's Stationery Office, Victoria and Albert Museum, 1974.

LUCE, Gordon H. "Old Burma–Early Pagan." *Artibus Asiae*, suppl. 25 (Locust Valley, N.Y.).

MALLERET, Louis. *L'archéologie du Delta du Mékong*. Paris, 1962.

MITRA, Debala. *Ajanta (Department of Archaeology, India)*. 2nd ed. New Delhi, 1958.

MODE, Heinz. *Die Skulptur Ceylons*. Basel: Frobenius, 1942.

*MUS, Paul. *Barabudur*. Hanoi, 1935.

PAL, Pratapaditya. *Art of Tibet*. Los Angeles: Los Angeles County Museum of Art, 1990.

———. *Bronzes of Kashmir*. New York: Hacker, 1975.

———. *The Ideal Image: Gupta Sculptural Tradition and Its Influence*. Exh. cat. New York: Asia Society, 1978.

———. *Nepal: Where the Gods Are Young*. Exh. cat. New York: Asia Society/Weatherhill, 1975.

PARANAVITANA, S. *Art and Architecture of Ceylon, Polonnaruva Period*. Colombo(?), 1954.

RAY, Amita. *Art of Nepal*. New Delhi: Indian Council for Cultural Relations, 1973.

RHIE, Marylin, and THURMAN, Robert. *Wisdom and Compassion: The Sacred Art of Tibet*. New York: Abrams, 1991.

SAHNI, Daya R. *Guide to the Buddhist Ruins of Sarnath*. 3rd ed. Simla, 1923.

SCHINGLOF, Dieter. *Studies in the Ajanta Paintings*. Delhi, 1987.

SINGH, Madanjeet. *India: Paintings from Ajanta Caves*. New York: New York Graphic Society, 1954.

*SNELLGROVE, D. L. *Indo-Tibetan Buddhism*. 2 vols. Boston, 1987.

SPINK, Walter M. "Ajanta to Ellora." *Marg* 20, no. 2 (1967).
STRATTON, Carol. *The Art of Sukhothai, 13th to 15th Centuries.* New York, 1980.
STRACHAN, Paul. *Imperial Pagan: The Art and Architecture of Old Burma.* Honolulu: University of Hawaii, 1990.
VITALI, R. *Early Temples of Central Tibet.* London: Serindia, 1990.
WILLIAMS, J. G. *The Art of Gupta India.* Princeton: Princeton University Press, 1982.
*YAZDANI, Ghulam, et al. *Ajanta.* 4 vols. Oxford: Oxford University Press, 1931–55.

7. The Expansion of Buddhist Art to East Asia

Along the Ancient Silk Routes. Exh. cat. New York: Metropolitan Museum of Art, 1982.
BEAL, Samuel. *Chinese Accounts of India.* Translated from the Chinese of Hiuen Tsiang. 4 vols. Calcutta: Susil Gupta, 1957–58.
———, trans. *Travels of Fah-Hian and Sung-Yun: Buddhist Pilgrims from China to India.* London, 1869. Reprint. N.p.: Trübner, 1964.
DAVIDSON, LeRoy. *The Lotus Sutra in Chinese Art.* New Haven: Yale University Press, 1954.
Dunhuang cai su [Tun-huang ts'ai-su, Polychrome sculptures at Dunhuang]. Beijing: Dunhuang Research Institute, 1960.
Dunhuang yi shu hua ku [Tun-huang i-shu hua-k'u; Dunhuang art collection]. 13+ vols. Beijing, 1958–.
DYAKONOVA, N. V., and SOROKIN, S. S. *Khotan Antiquities: Catalogue of Khotan Antiquities . . . in the Hermitage—Terracotta and Stucco.* Leningrad, 1960.
GABBERT, Gunhild. *Die Masken des Bugaku: Profane japanische Gesichtsmasken der Heian und Kamakura Zeit.* 2 vols. Wiesbaden, 1972.
Gong Xian shi ku si [Kung-hsien shih-k'u-ssü; Buddhist cave-temple in Gong Xian]. Beijing: Art and Archaeological Work Team, Henan Cultural Department, 1963.
GORDON, Antoinette K. *The Iconography of Tibetan Lamaism.* 2nd rev. ed. New York: Columbia University Press, 1959.
*GRAY, Basil, and VINCENT, J. B. *Buddhist Cave-Paintings at Tun-huang.* London: Faber, 1959.
The Great Eastern Temple: Treasures of Japanese Buddhist Art from Todai-ji. Exh. cat. Chicago: Art Institute of Chicago, and Bloomington: Indiana University Press, 1986.
HENDERSON, Gregory, and HURVITZ, Leon. "The Buddha of Seiryo-ji—New Finds and New Theory." *Artibus Asiae* 19, no. 1 (1956).
Horyu-ji Kenno Homotsu [Illustrated catalogue: Former imperial treasures from Horyu-ji]. Tokyo: Tokyo National Museum, 1975.
HWANG, Su-young. *Kankoku butsuzo no kenkyu* [Studies of Korean Buddhist images]. Kyoto, 1978.
KLEINSCHMIDT, Peter. *Die Masken der Gigaku, der ältesten Theaterform Japans.* Wiesbaden, 1966.
KOBAYASHI, Takeshi. *Nara Buddhist Art, Todai-ji.* Translated by Richard L. Gage. New York: Weatherhill, 1975.
KURATA, Bunsaku. *Horyu-ji: Temple of the Exalted Law.* New York: Japan Society, 1981.
Longmen Shi Ku [Lung-men shih-k'u; Stone caves at Longmen]. Beijing: Longmen Administration, 1961.
MATSUBARA, Saburo. *Chugoku Bukkyo Chokoku Shi Kenkyu* [Chinese Buddhist sculpture]. 2nd rev. ed. Tokyo, 1966.
MIZUNO, Seiichi. *Asuka Buddhist Art, Horyu-ji.* Translated by Richard L. Gage. New York: Weatherhill, 1974.
*———. *Chinese Stone Sculpture.* Tokyo: Mayuyama, 1950.
———, and NAGAHIRO, Toshio. *The Buddhist Cave Temples of Hsiang-t'ang-ssu.* Kyoto: Academy of Oriental Culture, 1937.
*———. *Yun-kang, the Buddhist Cave-Temples of the Fifth Century A.D. in North China: Report of . . . Survey . . . by Mission of Tohobunka Kenkyusho, 1938–45.* 16 vols. Kyoto, 1952–56.
NAGAHIRO, Toshio. "Wei-ch'ih I-seng." *Oriental Art* 1, no. 2 (Summer 1955).
*NAITO, Toichiro. *The Wall Paintings of Horyu-ji.* Edited by William R. B. Acker and Benjamin Rowland, Jr. Baltimore: Waverly, 1943.
NATORI, Younosuke. *Mai-chi-shan Sekkutsu* [Maiji Shan caves]. Tokyo: Iwanami, 1957.
PELLIOT, Paul. *Les grottes de Touen-Houang.* 6 vols. Paris: Geuthner, 1914–24.
PRIEST, Alan. *Chinese Sculpture in the Metropolitan Museum.* New York: Metropolitan Museum of Art, 1944.
*ROWLAND, Benjamin. "The Colossal Buddhas at Bāmiyān." *Journal of the Indian Society of Oriental Art* 15 (1947).
———. *The Wall Paintings of India, Central Asia and Ceylon.* Boston: Merrymount, 1938.
———. SEKINO, Tadashi, and TAKEJIMA, T. *Ryo Kin Jidai no Kenchiku to Butsuzo* [Buddhist architecture and sculpture of the Liao and Jin dynasties]. 2 vols. Tokyo, 1934.
SIRÉN, Osvald. "Chinese Marble Sculptures of the Transition Period." *Bulletin of the Museum of Far Eastern Antiquities* 12 (1940).
———, ed. *Chinese Sculpture in the Van der Heydt Collection.* Zurich, 1959.
SOPER, Alexander C. *Literary Evidence for Early Buddhist Art in China.* Ascona: Artibus Asiae, 1959.
———. "Northern Liang and Northern Wei in Kansu." *Artibus Asiae* 21, no. 2 (1958).
———. "Notes on Horyuji and the Sculpture of the Suiko Period." *Art Bulletin* 33, no. 2 (June 1951).
*STEIN, Sir Mark Aurel. *Innermost Asia: Detailed Report of Explorations in Central Asia and Westernmost China.* 5 vols. Oxford: Oxford University Press, 1928. Reprint. New Delhi: Cosmo, 1981.
———. *Ruins of Desert Cathay: Personal Narrative of Explorations in Central Asia and Westernmost China.* 2 vols. 1912. Reprint. Delhi: B.R., 1985.
*———. *Serindia: Detailed Report of Explorations in Central Asia and Westernmost China.* 5 vols. Oxford: Oxford University Press, 1921. Reprint. Delhi: Motilal Banarsidass, 1980–83.
SUGIYAMA Jiro. *Classic Buddhist Sculpture, the Tempyo*

Period. Translated and adapted by S. C. Morse. Tokyo: Kodansha and Shibundo, 1982.
*SULLIVAN, Michael. *The Cave Temples of Maichishan.* Berkeley: University of California Press, 1969.
TOKIWA, Daijo, and SEKINO, Tadashi. *Shina Bukkyo Shiseki Tosaki* [Buddhist monuments in China]. 6 vols. Tokyo: Bukkyo Shiseki Kenkyu-kwai, 1925–38.
TUCCI, Giuseppe. *The Religions of Tibet.* Translated by Geoffrey Samuel. Berkeley: University of California Press, 1980.
WARNER, Langdon. *Japanese Sculpture of the Suiko Period.* New Haven: Yale University Press, 1923.
———. *Japanese Sculpture of the Tempyo Period: Masterpieces of the Eighth Century.* Edited by James M. Plumer. Cambridge, Mass.: Harvard University Press, 1964.
WECHSLER, Howard J. *Mirror to the Son of Heaven: Wei Cheng at the Court of T'ang T'ai-tsung.* New Haven: Yale University Press, 1974.
WEINSTEIN, Lucie R. *The Horyu-ji Canopies and Their Continental Antecedents.* New Haven: Yale University Press, 1978.
WEINSTEIN, Stanley. *Buddhism under the T'ang.* Cambridge, 1987.
WHITE, William C. *Chinese Temple Frescoes.* Toronto: University of Toronto Press, 1940.
WHITFIELD, Roderick, and FARRER, Anne. *Caves of the Thousand Buddhas: Chinese Art from the Silk Route.* Exh. cat. London: British Museum, 1990.
ZANG, Shuhong [Tsang, Shu-hung]. *Wall Painting of Tun huang.* Tokyo, 1958.
ZHENG, Zhenduo [Cheng, Chen-to]. *Maiji Shan Shi Ku* [Mai-chi-shan shih-k'u; The stone grottoes of Maiji Shan, "Wheatstack Hill"]. Beijing, 1954.
ZÜRCHER, E. *The Buddhist Conquest of China: The Spread and Adaptation of Buddhism in Early Medieval China.* 2 vols. Leiden: Brill, 1959.

Part Three

The Rise of National Indian and Indonesian Styles

8. Early Hindu Art in India

*BANERJEA, Jitendra N. *The Development of Hindu Iconography.* 2nd ed. Calcutta: University of Calcutta, 1956.
BERKSON, Carmel, et al. *Elephanta: The Cave of Shiva.* Princeton: Princeton University Press, 1983.
BRUHN, Klaus. *The Jina-Images of Deogarh.* Leiden: Brill, 1969.
CHANDRA, Pramod. *A Guide to the Elephanta Caves (Gharapuri).* Bombay: Tripathi, 1964.
CZUMA, Stanislaw J. "The Brahmanical Rashtrakuta Monuments of Ellora." Ph.D. diss., University of Michigan, 1969.
DESAI, Madhuri. *The Gupta Temple at Deogarh.* Bombay: Bhulabhai Memorial Institute, 1958.
GUPTE, Ramesh S. *The Art and Architecture of Aihole: A Study of Early Chalukyan Art through Temple Architecture and Sculpture.* Bombay: Taraporevala, 1967.
KRAMRISCH, Stella. "The Image of Mahadeva in the Cave Temple on Elephanta Island." *Ancient India* 2 (July 1946).
*NEFF, Muriel. "Elephanta: Architecture, Sculpture." *Marg* 13 (September 1960).
RAJASEKHARA, Sindigi. *Early Chalukya Art at Aihole.* New Delhi: Vikas, 1985.
*RAO GOPINATHA, T. A. *Elements of Hindu Iconography.* Madras: Law Printing House, 1914–16.
RAWSON, Philip. "The Methods of Indian Sculpture." *Oriental Art* 4, no. 4 (Winter 1958).
SIVARAMAMURTI, Calambur. "Geographical and Chronological Factors in Indian Iconography." *Ancient India* 6 (January 1950).

9. Early Medieval Hindu Art in South and Central India

BALASUBRAHMANYAM, S. R. *Early Chola Art.* Part 1. Bombay and New York: Asia Publishing House, 1966.
———. *Early Chola Temples: Parantaka I to Rajaraja I, A.D. 907–985.* Part 2. Bombay: Orient Longman, 1971.
———. *Middle Chola Temples.* Part 3. Faridabad: Thomson, 1975.
*BARRETT, Douglas. *Early Chola Architecture and Sculpture.* London: Faber, 1974.
*———. *Early Chola Bronzes.* Bombay: Bhulabhai Memorial Institute, 1965.
*———. *Hemavati.* Bombay: Bhulabhai Memorial Institute, 1958.
*———. *Mukhalingam Temples.* Bombay: Tripathi, 1960.
———. *The Temple of Virattanesvara at Tiruttani.* Bombay: Bhulabhai Memorial Institute, 1958.
———. *Ter.* Bombay: Bhulabhai Memorial Institute, 1960.
BERKSON, Carmel. *The Caves at Aurangabad: Early Buddhist Tantric Art in India.* New York: Mapin, 1986.
COLLINS, Charles D. *The Iconography and Ritual of Siva at Elephanta.* Albany: State University of New York Press, 1988.
COOMARASWAMY, Ananda K. *Bronzes from Ceylon.* Ceylon: Colombo Museum, 1914.
DEHEJIA, Vidhya. *Art of the Imperial Cholas.* New York: Columbia University Press, 1990.
GANGOLY, Ordhendra C. *South Indian Bronzes.* London: Luzac, 1915.
*GRAVELY, F. H., and RAMACHANDRAN, T. N. "Catalog of the South Indian Hindu Metal Images in the Madras Government Museum." *Madras Museum Bulletin* 2, no. 1 (1932).
HARI RAO, V. N. *The Srirangam Temple: Art and Architecture.* Tirupata: Sri Venkateswara University, 1967.
JOUVEAU-DUBREUIL, Gabriel. *Archéologie du sud de l'Inde.* Paris: Geuthner, 1914.
*———. *Iconography of Southern India.* Translated by A.C. Martin. Paris: Geuthner, 1914.
*KAR, Chintamoni. *Indian Metal Sculpture.* London: Tiranti, 1952.
KREISEL, Gerd. *Die Siva-Bildwerke der Mathura-Kunst: Ein Beitrag zur Frühhinduistischen Ikonographie.* Wiesbaden, 1986.

NAGASWAMY, R. *The Art of Tamilnadu.* Tamil Nadu, 1972.
NATARAMAN, B. *The City of the Cosmic Dance: Chidambaram.* New Delhi: Orient Longman, 1974.
PATTABIRAMIN, P. Z. *Andhra.* Pondicherry: Publications de l'Institut Français d'Indologie, 1971.
RAMA RAO, M. *Early Calukyan Temples of Andhra Desa.* Hyderabad: Government of Andhra Pradesh, 1965.
———. *Select Andhra Temples.* Hyderabad: Government of Andhra Pradesh, 1970.
REA, Alexander. *Chalukyan Architecture.* 1896. Reprint. Delhi: Indological Book House, 1970.
SIVARAMAMURTI, Calambur. *Indian Bronzes.* Bombay: Marg, 1962.
*———. *Kalugumalai and Early Pandyan Rock-cut Shrines.* Bombay: Tripathi, 1961.
*———. *Mahabalipuram* [Mahamallapuram] (Department of Archaeology, India). 2nd ed. New Delhi: Manager of Publications, 1955.
———. *South Indian Paintings.* New Delhi: National Museum, 1968.
SRINIVASAN, K. R. *Cave Temples of the Pallavas.* New Delhi, 1964.
THAPAR, D. R. *Icons in Bronze: An Introduction to Indian Metal Images.* New York: Asia Publishing House, 1961.

10. Later Medieval Hindu Art

ARCHER, William G. *Central Indian Painting.* London: Faber, 1958.
———. *Garhwal Painting.* London: Faber, 1954.
———. *The Hill of Flutes: Life, Love, and Poetry in Tribal India, A Portrait of the Santals.* Pittsburgh: University of Pittsburgh Press, 1974.
*———. *Indian Miniatures.* Greenwich, Conn.: New York Graphic Society, 1960.
———. *Indian Painting.* New York: Oxford University Press, 1957.
———. *Indian Painting in Bundi and Kotah.* London: Victoria and Albert Museum, 1959.
*———. *Indian Painting in the Punjab Hills.* London: Her Majesty's Stationery Office, 1952.
———. *Indian Paintings from the Punjab Hills.* 2 vols. New York: Sotheby's, 1973.
———. *Indian Paintings from Rajasthan.* London: Arts Council of Great Britain, 1957.
———. *Kangra Painting.* 2nd ed. London: Faber, 1956.
———. *The Loves of Krishna in Indian Painting and Poetry.* New York: Macmillan, 1957.
———. *Pahari Miniatures: A Concise History.* Bombay, 1975.
———. *Visions of Courtly India: The Archer Collection of Pahari Miniatures.* Washington, D.C.: International Exhibitions Foundation, 1976.
———, and RANDHAWA, M. S. "Some Nurpur Paintings." *Marg* 8 (1955). *Art and the East India Trade.* Exh. cat. London: Victoria and Albert Museum, 1970.
BABAR. *Memoirs of Babur, Emperor of India: First of the Great Moghuls.* Abbreviated version. London: Humphreys, 1909.
BANERJI, Adris. *Archaeological History of Southeastern Rajasthan.* Varanasi: Prithivi, 1971.
———. "Illustrations to the Rasikapriya from Bundi Kotah." *Lalit Kala* (1956–57).
———. "Kishengarh Historical Portraits." *Roopa-Lekha* 25 (1954).
———. "Kishengarh Paintings." *Roopa-Lekha* 25 (1954).
———. "Malwa School of Paintings." *Roopa-Lekha* 26 (1955).
———. "Mewar Miniatures." *Roopa-Lekha* 30 (1959).
BARRETT, Douglas. *Painting of the Deccan, 16–17 Century.* London: Faber, 1958.
BEACH, Milo C. *Early Mughal Painting.* Cambridge, Mass.: Harvard University Press, for the Asia Society, 1987.
BHATTACHARYA, Asok K. *Technique of Indian Painting: A Study Chiefly Made on the Basis of the Silpa Texts.* Calcutta: Saraswati Library, 1976.
BHATTACHARYA, Bholanath. *Krishna in the Traditional Painting of Bengal.* Calcutta: Banerjee, 1972.
BINNEY, Edwin, 3rd. *Indian Miniature Painting from the Collection of Edwin Binney, 3rd.* Portland, Ore.: Portland Art Museum, 1973.
BONER, Alice, trans. *New Light on the Sun Temple of Konarka.* Varanasi: Chowkhamba Sanskrit Series, 1972.
BURGESS, James. *Report on the Elura Cave Temples and the Brahmanical and Jaina Caves in Western India . . . the Fifth, Sixth and Seventh Seasons . . . of the Archeological Survey, 1877–80.* Varanasi: Indological Book House, 1970.
———. *The Rock Temples of Elura or Verul.* Bombay: Thacker, 1977.
CHANDRA, Moti. "Amaru-Sataka." *Bulletin of the Prince of Wales Museum* 1, 2 (1951, 1952).
*———. *Mewar Painting in the Seventeenth Century.* New Delhi: Lalit Kala, 1957.
———. "The Paintings of Bundi." *Western Railway Annual.* Bombay, 1953.
———. *Studies in Early Indian Painting.* New York: Asia Publishing House, 1975.
———, and SHAH, Umakant P. *Documents of Jaina Painting.* Bombay, 1975.
CHANDRA, Pramod. *Bundi Painting.* New Delhi: Lalit Kala, 1959.
———. *The Cleveland Tuti-nama Manuscript and the Origins of Mughal Painting.* Graz: Akademische Druck und Verlagsanstalt, 1976.
———. "A Ragamala Set of the Mewar School in the National Museum of India." *Lalit Kala* (1956–57).
COOMARASWAMY, Ananda K. *Catalogue of the Indian Collections in the Museum of Fine Arts, Boston.* Part 5: *Rajput Painting.* Cambridge, Mass.: Museum of Fine Arts, Boston, 1926.
*———. *Rajput Painting.* New York: Oxford University Press, 1916.
CROWE, Sylvia; HAYWOOD, Sheila; JELLICOE, Susan; et al. *Gardens of Mughal India.* London: Thames and Hudson, 1972.
DAS GUPTA, Rajatananda. *Eastern Indian Manuscript Painting.* Bombay: Taraporevala, 1972.
DEVA, Krishna. *Khajuraho.* New Delhi: Archaeological Survey of India, 1967.

DEVAKUNJARI, D. *Hampi.* New Delhi: Archaeological Survey of India, 1970.
DICKINSON, Eric, and KHANDALAVALA, Karl. *Kishangarh Paintings.* New Delhi: Lalit Kala, 1959.
DONALDSON, Thomas. *A Study of the Hindu Temple Art of Orissa with Particular Reference to the City of Bubaneshwar.* Leiden: Brill, 1986–87.
EASTMAN, Alvan C. *The Nala-Damayanti Drawings: A Study of a Portfolio of Drawings Made for Raja Samsar and of Kangra (1774–1823) . . . Now in the Museum of Fine Arts, Boston.* Boston: Museum of Fine Arts, 1959.
EBELING, Klaus. *Ragamala Painting.* Basel: Ravi Kumar, 1973.
EGGER, Gerhard. *Hamza Nama.* 2 vols. Graz: Akademische Druck und Verlagsanstalt, 1983.
FABRI, Charles L. *History of the Art of Orissa.* Bombay: Orient Longmans, 1974.
FALK, Toby, and ARCHER, Mildred. *Indian Miniatures in the India Office Library.* London: Sotheby–Parke Bernet, 1981.
GANGOLY, Ordhendra C. *Critical Catalogue of Miniature Paintings in the Baroda Museum.* Baroda: Mankad, 1961.
GHOSH, Ajit, ed. *Jaina Art and Architecture.* 3 vols. New Delhi: Bharatiya Jnanpith, 1974–75.
GLUCK, Heinrich. *Die Indischen Miniaturen des Haemzae-Romanes. . . .* Zurich: Amalthea, 1925.
GOETZ, Hermann. "The First Golden Age of Udaipur: Rajput Art in Mewar during the Period of Mughal Supremacy." *Ars Orientalis* 2 (1957).
———. "The Kachwaha School of Rajput Painting." *Bulletin of the Baroda State Museum* 4 (1946–47).
———. "The Marwar School of Rajput Painting." *Bulletin of the Baroda State Museum* 5 (1947–48).
GOSWAMY, B. N. *Painters in the Sikh Court.* Wiesbaden, 1975.
*GRAY, Basil. "Painting." In *The Art of India and Pakistan.* Edited by Leigh Ashton. Exh. cat. London: Royal Academy of Arts, Faber, 1950.
———. *Rajput Painting.* New York: Pitman, 1949.
———. *Treasures of Indian Miniatures in the Bikaner Palace Collection.* 2nd ed. Oxford: Cassirer, 1955.
HARLE, James C. *The Brahmapurisvara Temple at Pulla-mangai.* Bombay: Bhulabhai Memorial Institute, 1958.
KAUFMANN, Walter. *The Ragas of North India.* Bloomington: Indiana University Press, for the International Affairs Center, 1968.
*KHANDALAVALA, Karl J., and CHANDRA, Moti. *New Documents of Indian Painting: A Reappraisal.* Bombay: Prince of Wales Museum of Western India, 1969.
*———; GANGOLY, Ordhendra C.; CHANDRA, Pramod; et al. "Problems of Rajasthani Painting" and "General Survey of Rajasthani Styles." *Marg* 2 (1958).
———, and STOOKE, H. *The Laud Ragamala Miniatures.* Oxford: Cassirer, 1953.
KRISHNA, Anand. *Malwa Painting.* Varanasi: Bharat Kala Bhavan, Banaras Hindu University, 1963.
KRISHNADASA, Rai. *Mughal Miniatures.* New Delhi: Lalit Kala, 1955.
LAL, Kanwar. *Temples and Sculptures of Bhubaneswar.* Delhi: Arts and Letters, 1970.
LEACH, Linda Y. *Indian Miniature Paintings and Drawings.* Cleveland: Cleveland Museum of Art, 1986.
LEE, Sherman E. *Rajput Painting.* Exh. cat. New York: Asia Society, 1960.
MAJUMDAR, Manjulal R. *Gujarat: Its Art Heritage.* Bombay: University of Bombay, 1968.
MITRA, Debala. *Bhubaneswar* (Department of Archaeology, India). New Delhi: Director General of Archaeology, 1958.
———. *Konarak.* New Delhi: Archaeological Survey of India, 1968.
NAGASWAMI, R. *The Kailasanatha Temple: A Guide.* Tamil Nadu: Madras State Department of Archaeology, 1969.
PAL, Pratapaditya. *Krishna: The Cowherd King.* Los Angeles: Los Angeles County Museum of Art, 1972.
PATIL, D. R. *Mandu.* New Delhi: Archaeological Survey of India, 1971.
PINDER-WILSON, Ralph H. *Paintings from the Muslim Courts of India.* London: World of Islam, 1976.
*RANDHAWA, M[ohindar] S. *Basohli Painting.* New Delhi: Ministry of Information and Broadcasting, 1959.
———. "Kangra Artists." *Roopa-Lekha* 27 (1956).
———. "Kangra Paintings Illustrating the Life of Shiva and Parvati." *Roopa-Lekha* 24 (1953).
———. "Kangra Ragamala Painting." *Roopa-Lekha* 29 (1958).
———. *Kangra Ragamala Paintings.* New Delhi: National Museum, 1971.
*———. *Kangra Valley Painting.* Rev. ed. Delhi: Ministry of Information and Broadcasting, 1972.
———. *The Krishna Legend in Pahari Painting.* New Delhi: Lalit Kala, 1956.
———. "Paintings from Nalagarh." *Lalit Kala* (1955–56).
———. "Some Inscribed Pahari Paintings with Names of Artists." *Roopa-Lekha* 30 (1959).
RAY, Nihar-Ranjan. *Mughal Court Painting: A Study in Social and Formal Analysis.* Calcutta: Indian Museum, 1975.
REIFF, Robert. *Indian Miniatures: The Rajput Painters.* Rutland: Tuttle, 1959.
RIZVI, Saiyid A. A., and FLYNN, Vincent J. A. *Fathpur-Sikri.* Bombay: Taraporevala, 1975.
SEN GUPTA, R. *A Guide to the Buddhist Caves of Elura.* Bombay: Bhulabhai Memorial Institute, 1958.
SHAH, Umakant P. *Akota Bronzes.* Bombay: Department of Archaeology, 1959.
SHARMA, Y. D. *Delhi and Its Neighborhood.* 2nd ed. New Delhi: Archaeological Survey of India, 1974.
SHIVESHWARKAR, Leela. *The Pictures of the Chaurapanchasika: A Sanskrit Love Lyric.* New Delhi: National Museum, 1967.
SKELTON, Robert. *Indian Miniatures from the 15th to 19th Centuries.* Exh. cat. Venice: Neri Pazza, 1961.
———. "The Tod Collection of Rajasthani Paintings." *Roopa-Lekha* 30 (1959).
SMITH, Vincent A. *Akbar the Great Mogul, 1542–1605.* Reprint. Delhi: S. Chand, 1966.
SPINK, Walter M. *The Quest for Krishna: Painting and Poetry of the Krishna Legend.* Ann Arbor, 1972.
STAUDE, Wilhelm. "Les artistes de la cour d'Akbar et les

illustrations du Dastan i-Amir Hamzah." *Arts Asiatiques* 2, nos. 1–2 (1955).

Tantra. Exh. cat. London: Hayward Gallery, Arts Council of Great Britain. 1971.

VIDYA, Prakash. *Khajuraho: A Study in the Cultural Conditions of Chandella Society.* Bombay: Taraporevala, 1967.

WELCH, Stuart C. *The Art of Mughal India: Painting and Precious Objects.* Exh. cat. New York: Asia Society and Abrams, 1963.

————. *A Flower from Every Meadow: Indian Paintings from American Collections.* New York: Asia Society, and Greenwich, Conn.: New York Graphic Society, 1973.

————. *Indian Drawings and Painted Sketches: 16th through 19th Centuries.* Exh. cat. New York: Asia Society/Weatherhill, 1976.

————, and BEACH, M. C. *Gods, Thrones, and Peacocks.* Exh. cat. New York: Asia Society and Abrams, 1965.

ZANNAS, Eliky, and AUBOYER, Jeannine. *Khajuraho.* Hague, 1960.

11. The Medieval Art of Southeast Asia and Indonesia

BAZACIER, Louis. *Le Viet-Nam: De la préhistoire à la fin de l'occupation chinoise.* Paris: Picard, 1972.

BÉNISTI, Mireille. *Rapports entre le premier art khmèr et l'art indien.* Paris: Ecole Française d'Extrême-Orient, 1970.

*BRIGGS, Lawrence P. *The Ancient Khmer Empire.* Philadelphia: American Philosophical Society, 1951.

CORAL RÉMUSAT, Gilberte de. *L'art khmèr: Les grandes étapes de son évolution.* Paris: Editions d'Art et d'Histoire, 1940.

DUMARÇAY, Jacques. *Borobudur.* Translated by Michael Smithies. Kuala Lumpur: Oxford University Press, 1978.

DUPONT, Pierre. *La statuaire pré-angkorienne.* Ascona: Artibus Asiae, 1955.

FONTEIN, Jan; SOEKMONO, R.; and SULEIMAN, Satyawati. *Ancient Indonesian Art of the Central and Eastern Javanese Periods.* New York: Asia Society, and Greenwich, Conn.: New York Graphic Society, 1971.

*GITEAU, M. *Khmer Sculpture and the Angkor Civilization.* New York: Abrams, 1966.

GROSLIER, Bernard, and ARTHAUD, Jacques. *Angkor: Art and Civilization.* Rev. ed. New York: Praeger, 1966.

LE BONHEUR, Albert. *La sculpture indonésienne au Musée Guimet.* Paris, 1971.

LEE, Sherman. *Ancient Cambodian Sculpture.* New York: Asia Society, 1969.

O'CONNOR, Stanley J. "Hindu Gods of Peninsular Siam." *Artibus Asiae,* suppl. 27 (Ascona, 1972).

*STERN, Philippe. "Le Bayon d'Angkor et l'évolution de l'art khmèr." *Annales du Musée Guimet.* Paris: Geuthner, 1927.

————. *Les monuments khmèrs du style du Bayon et Jayavarman VII.* Paris: P.U.F., 1965.

Part Four

Chinese, Korean, and Japanese National Styles and Their Interplay

12. The Rise of the Arts of Painting and Ceramics in China

*ACKER, William R. *Some T'ang and Pre-T'ang Texts on Chinese Painting.* Leiden: Brill, 1954.

CHIN, Tsu-ming. *Yueh Ware Kiln Sites in Chekiang.* London, 1976.

FONTEIN, Jan, and WU, Tung. *Han and T'ang Murals Discovered in Tombs in the People's Republic of China and Copied by Contemporary Chinese Painters.* Exh. cat. Boston: Museum of Fine Arts, 1976.

GRAY, Basil. *Early Chinese Pottery and Porcelain.* London: Faber, 1953.

GYLLENSVÄRD, Bo. "T'ang Gold and Silver." *Bulletin of the Museum of Far Eastern Antiquities* 29 (1957).

*HARADA, Jiro. *English Catalog of Treasures in the Imperial Repository Shosoin.* Tokyo, 1932.

HAYASHI, Ryoichi. *The Silk Road and the Shoso-in.* Translated by Robert Ricketts. New York: Weatherhill, 1975.

JULIANO, Annette. *Art of the Six Dynasties: Centuries of Change and Innovation.* Exh. cat., China House Gallery, New York. New York: China Institute in America, 1975.

————. "Teng-hsien: An Important Six Dynasties Tomb." *Artibus Asiae,* suppl. 37, Ascona, 1980.

LINDBERG, Gustaf. "Hsing-yao and Ting-yao." *Bulletin of the Museum of Far Eastern Antiquities* 25 (1953).

MAHLER, Jane G. *The Westerners among the Figurines of the T'ang Dynasty of China.* Rome: Istituto Italiano per il Medio ed Estremo Oriente, 1959.

MINO, Yutaka. *Pre-Sung Dynasty Chinese Stonewares in the Royal Ontario Museum.* Toronto, 1974.

MORI, Hisashi, and HAYASHI, Kenzo. *Shosoin no Gigakumen* [Gigaku masks in the Shosoin]. Nara, 1972.

NISHIKAWA, Kyotaro. *Bugaku Masks.* Translated by Monica Bethe. Tokyo: Kodansha, 1978.

OSHIMA, Yoshinaga, ed. *Shosoin Gyobutsu Zuroku* [Catalogue of the imperial treasures in the Shosoin]. 18 vols. Tokyo, 1929.

ROWLAND, Benjamin. "A Note on Wu Tao-tzu." *Art Quarterly* 17, no. 2 (Summer 1944).

*SOPER, Alexander C. "Early Chinese Landscape Painting." *Art Bulletin* 23 (June 1941).

————. "The First Two Laws of Hsieh Ho." *Far Eastern Quarterly* 8 (August 1949).

*————. *Kuo Jo-hsu's Experiences in Painting.* Washington, D.C.: American Council of Learned Societies, 1951.

*————. "Life-motion and the Sense of Space in Early Chinese Representational Art." *Art Bulletin* 30 (September 1948).

————. "Some Technical Terms in the Early Literature of Chinese Painting." *Harvard Journal of Asiatic Studies* 11 (June 1948).

*SULLIVAN, Michael. *The Birth of Landscape Painting in China.* Los Angeles: University of California Press, 1962.

*————. *Chinese Landscape Painting in the Sui and T'ang Dynasties.* Berkeley: University of California Press, 1980.

————. "On Painting the Yun-t'ai-shan, a Reconsideration of the Essay Attributed to Ku K'ai-chih." *Artibus Asiae* 17, no. 2 (1954).

————. "On the Origin of Landscape Representation in Chinese Art." *Archives of the Chinese Art Society of America* 7 (1953).

————. "Pictorial Art and the Attitude toward Nature in Ancient China." *Art Bulletin* 36 (March 1954).

Tang Li Zhongrun Mu Bihua [T'ang Li Chung-jun mu pi-hua; Mural paintings in the tomb of Tang Prince Li Zhongrun]. Beijing: Shenxi [Shensi] Municipal Museum, Xi'an (Hsi-an), 1974.

Tang Mu Bihua [T'ang mu pi-hua; Mural paintings in the tombs of the Tang dynasty]. Shanghai: Shenxi Provincial Museum, 1963.

**Tang Yongtai Gongzhu Mu Bihua Ji* [T'ang Yung-tai kung-chu mu pi-hua-chi; Collection of wall paintings of the tomb of Tang Princess Yongtai]. Beijing: Shaanxi Provincial Museum, 1963.

VANDIER-NICOLAS, Nicole. *Bannières et peintures de Touen-Houang conservées au Musée Guimet.* Paris: Mission Paul Pelliot, 1976.

WATSON, William, ed. *Pottery and Metalwork in T'ang China: Their Chronology and External Relation.* London: University of London, 1971.

WRIGHT, Arthur F., and TWITCHETT, Denis, eds. *Perspectives on the T'ang.* New Haven: Yale University Press, 1973.

13. The Beginnings of Developed Japanese Art Styles

BROWER, Robert H., and MINER, Earl. *Japanese Court Poetry.* Stanford: Stanford University Press, 1961.

CHANDRA, Lokesh. *The Esoteric Iconography of Japanese Mandalas.* New Delhi: International Academy of Indian Culture, 1971.

Daigo-ji Mikkyo Bijutsu ten [Esoteric Buddhist arts from Daigo-ji]. Exh. cat. Kyoto: Kyoto National Museum, 1975.

Exhibition of Japanese Buddhist Arts. Tokyo: Tokyo National Museum, 1956.

FUJISHIMA, Gaijiro, ed. *Chuson-ji.* Tokyo, 1971.

*FUKUYAMA, Toshio. *Heian Temples: Byodo-in and Chuson-ji.* Translated by Ronald K. Jones. New York: Weatherhill, 1976.

Heian Jidai no Bijutsu [Fine arts of the Heian period]. Exh. cat. Kyoto: Kyoto National Museum, 1958.

*HEMPEL, Rose. *The Golden Age of Japan, 794–1192.* Translated by Katherine Watson. New York: Rizzoli, 1983.

Hieizan: Tendai-no-hiho [Mount Hiei: the secret treasures of the Tendai sect]. Exh. cat. Tokyo: Tokyo National Museum, 1974.

Hokkekyo no Bijutsu [Arts of the Lotus Sutra]. Exh. cat. Nara: Nara National Museum, 1979.

*IENAGA, Saburo. *Painting in the Yamato Style.* Translated by John M. Shields. New York: Weatherhill, 1973.

*Izumi, Shikibu. *The Izumi Shikibu Diary: A Romance of the Heian Court.* Translated by Edwin A. Cranston. Cambridge, Mass.: Harvard University Press, 1969.

Jodo Kyo Kaiga; Tokubetsu Tenrankai [Buddhist paintings of the Jodo sect; special exhibition]. Kyoto: Kyoto National Museum, 1973.

KIDDER, Jonathan E., Jr. *Early Buddhist Japan.* London: Thames and Hudson, 1972.

Kokin Wakashu: The First Imperial Anthology of Japanese Poetry; with Tosa Nikki and Shinsen Waka. Translated and annotated by Helen C. McCullough. Stanford: Stanford University Press, 1985.

Kyozuka ihoten [Exhibition of Buddhist relics excavated from sutra mounds]. Nara: Nara National Museum, 1973.

McCULLOUGH, Helen C. *Okagami: The Great Mirror, Fujiwara Michinaga (966–1027) and His Times.* Princeton: Princeton University Press, 1980.

————, ed. *Tales of Ise: Lyrical Episodes from Tenth-Century Japan.* Stanford: Stanford University Press, 1968.

McCULLOUGH, William H., and McCULLOUGH, Helen C. *A Tale of Flowering Fortunes* [Eiga Monogatari]. 2 vols. Stanford: Stanford University Press, 1980.

MORRIS, Ivan, ed. and trans. *The Pillow Book of Sei Shonagon.* New York: Columbia University Press, 1967.

————. *The Tale of Genji Scroll.* New York: Kodansha, 1971.

**Murasaki Shikibu: Her Diary and Poetic Memoirs.* Edited and translated by Richard Bowring. Princeton: Princeton University Press, 1982.

*MURASAKI, Shikibu. *The Tale of Genji.* Translated by Edward Seidensticker. New York: Knopf, 1976.

*————. *The Tale of Genji.* Translated by Arthur Waley. 6 vols. London: Allen and Unwin, 1926–33.

OMORI, Annie S., and DOI, Kochi, trans. *Diaries of Court Ladies of Old Japan.* Boston: Houghton Mifflin, 1920.

Poetic Memoirs of Lady Daibu. Edited and translated by Phillip T. Harries. Stanford: Stanford University Press, 1980.

READ, Louisa M. "The Masculine and Feminine Modes of Heian Secular Painting and Their Relationship to Chinese Painting." Ph.D. diss., Stanford University, 1976.

ROSENFIELD, John M. *Japanese Arts of the Heian Period.* Exh. cat. New York: Asia House Gallery, 1967.

SAKANISHI, Shio. *The Spirit of the Brush.* London: Murray, 1939.

*SAWA, Takaaki. *Art in Japanese Esoteric Buddhism.* New York: Weatherhill, 1972.

SAYRE, Charles F. "Illustrations of the *Ise-monogatari:* Survival and Revival of Heian Court Culture." Ph.D. diss., Yale University, 1978.

SOPER, Alexander C. "Illustrative Method of the Tokugawa Genji Pictures." *Art Bulletin* 37 (March 1955).

*————. "The Rise of Yamato-e." *Art Bulletin* 24 (December 1942).

TAHARA, Mildred M., trans. *Tales of Yamato: A Tenth-Century Poem-Tale.* Honolulu: University Press of Hawaii, 1980.

TAKATA, O., ed. *Wall-Paintings in Daigo-ji Pagoda.* Tokyo, 1959.

TODA, Kenji. "Japanese Screen Paintings of the Ninth and Tenth Centuries." *Ars Orientalis* 3 (1959).

TOGANO, Shozui M. "Symbol System of Shingon Buddhism." Ph.D. diss., University of Michigan, 1980.

14. Chinese Art of the Song Dynasty and Korean Ceramics of Koryo

BARNHART, Richard. *Marriage of the Lord of the River: A Lost Landscape by Tung Yuan.* Ascona: Artibus Asiae, 1970.

CAHILL, James. *The Art of Southern Sung China.* New York: Arno, 1962.

————. *Chinese Paintings, 11–14 Centuries.* New York: Crown, n.d.

Ceramic Art of Southeast Asia. Exh. cat. Singapore: Southeast Asian Ceramic Society, 1971.

CHAPIN, Helen B. *A Long Roll of Buddhist Images.* Revised by Alexander C. Soper. Ascona: Artibus Asiae, 1972.

The Charles B. Hoyt Collection: Memorial Exhibition. Boston: Museum of Fine Arts, 1952.

Chinese Arts of the Sung and Yuan Periods. Tokyo: Tokyo National Museum, 1961.

FONG, Wen. *The Lohans and a Bridge to Heaven.* Washington, D.C.: Freer Gallery of Art Occasional Papers, 1958.

GERNET, Jacques. *Daily Life in China on the Eve of the Mongol Invasion.* Stanford: Stanford University Press, 1970.

GOMPERTZ, G. St. G. M. *Chinese Celadon Wares.* 1959. Reprint. Boston: Faber, 1980.

————. *Korean Pottery and Porcelain of the Yi Period.* New York: Praeger, 1968.

Gu Gong Cang Hua Liao Hua Ji [Ku-kung ts'ang-hua liao hua chi; Flower and bird paintings in the Palace Museum]. Beijing: Beijing Palace Museum, c. 1960.

Ju Ware of the Song Dynasty. National Palace Museum, Taizhong. Hong Kong, 1961.

LACHMAN, Charles. *Evaluations of Sung Dynasty Painters of Renown.* Monographies du T'oung Pao, vol. 16. Leiden: Brill, 1989.

LE COQ, Albert von. *Buried Treasures of Chinese Turkestan.* London: Allen and Unwin, 1928. Reprint. Hong Kong: Oxford University Press, 1985.

LEE, Sherman E., and FONG, Wen. *Streams and Mountains without End.* Ascona: Artibus Asiae, 1955.

LOEHR, Max. *Chinese Landscape Woodcuts from an Imperial Commentary to the Tenth-Century Printed Edition of the Buddhist Canon.* Cambridge, Mass.: Harvard University Press, 1968.

MAEDA, Robert J. *Two Twelfth Century Texts on Chinese Painting: Translations of the* Shan-shui ch'un ch'üan chi *by Han Cho and Chapters Nine and Ten of* Hua-chi *by Teng Ch'un.* Ann Arbor: University of Michigan, Center for Chinese Studies, 1970.

MATSUMOTO, Eiichi. "Caractère concordant de l'évolution de la peinture de Fleurs et d'Oiseaux et du développement de la peinture monochrome sous les T'ang et les Song." *Arts Asiatiques* 5, no. 1 (1958).

MINO, Yutaka. *Ceramics in the Liao Dynasty North and South of the Great Wall.* New York: China Institute in America, 1973.

————. *Freedom of Clay and Brush through Seven Centuries in Northern China.* Bloomington: Indiana University Press, 1980.

————, and TSIANG, Katherine R. *Ice and Green Clouds.* Bloomington: Indiana University Press, 1986.

MUNAKATA, Kiyohiko. *Ching Hao's Pi-fa-chi: A Note on the Art of the Brush.* Ascona: Artibus Asiae, 1974.

PLUMER, James M. *Temmoku: A Study of the Ware of Chien.* Tokyo, 1972.

ROWLAND, Benjamin. "Hui Tsung and Huang Ch'üan." *Artibus Asiae* 17, no. 2 (1954).

————. "The Problem of Hui Tsung." *Archives of the Chinese Art Society of America* 5 (1951).

SHIMADA, Shujiro, and YONEZAWA, Yoshio. *Painting of the Sung and Yuan Dynasties.* Tokyo: Mayuyama, 1952.

SPEISER, W. *Meisterwerke chinesischer Malerei.* Berlin: Safari Verlag, n.d.

SUZUKI, Kei. *Li Tang, Ma Yuan, Xia Gui; Suiboku Bijutsu Taikei* [Li T'ang, Ma Yuan, Hsia Kuei . . . ; complete collection of ink monochrome painting]. Vol. 2. Tokyo: Kodansha, 1974.

TAMURA, Jitsuzo. *Tomb and Mural Paintings of Ch'ing-ling. Liao Imperial Mausoleums of the 11th Century A.D. in Eastern Mongolia* [Keiryo no hekiga]. 1952–53. Reprint. Kyoto: Dohosha, 1977.

TODA, Teisuke. *Mu Qi, Yu-Jian. Suiboku Bijutsu Taikei* [Mu Ch'i, Yü-chien; Complete collection of their ink monochrome paintings]. Vol. 3. Tokyo: Kodansha, 1973.

*TREGEAR, Mary. *Song Ceramics.* New York: Rizzoli, 1982.

WHITFIELD, Roderick. "Chang Tse-tuan's Ch'ing-Ming Shang-Ho T'u." Ph.D. diss., Princeton University, 1965.

WIRGIN, Jan. *Song Ceramic Designs.* Stockholm: Museum of Far Eastern Antiquities, 1970.

ZHANG, Heng [CHANG, Heng], ed. *Liang Song Ming Hua Ce* [Liang-sung ming-hua ts'e; Album paintings of the Northern and Southern Song dynasties]. Beijing, 1963.

ZHANG, Zeduan [CHANG, Tse-tuan]. *Qing Ming Shang He Tu* [Ch'ing Ming shang ho tu; Qing Ming festival along the Bian River]. Plates in portfolio. Beijing, 1958.

15. Japanese Art of the Kamakura Period

Confessions of Lady Nijo. Edited and translated by Karen Brazell. Stanford: Stanford University Press, 1973.

Emaki: Tokubetsu ten [Illustrated narrative handscrolls; special exhibition]. Tokyo: Tokyo National Museum, 1975.

FOARD, James H. *Ippen Shonin and Popular Buddhism in Kamakura Japan.* Ann Arbor: University of Michigan, 1977.

GRILLI, Elise. *Japanese Picture Scrolls.* New York: Crown, 1958.

Hogen Monogatari [Tale of the Disorder in Hogen]. Edited and translated by William R. Wilson. Monumenta Nipponica monograph. Tokyo: Sophia University, 1971.

Kamakura no Bijutsu [Fine arts of Kamakura]. Exh. cat. Tokyo: Tokyo National Museum, 1958.

LA FLEUR, William R. *Saigyo the Priest and His Poetry of Reclusion.* Chicago: University of Chicago Press, 1973.

MASON, Penelope E. *A Reconstruction of the Hōgen-Heiji Monogatari Emaki.* New York: Garland, 1977.

MASS, Jeffrey P. *The Kamakura Bakufu: A Study in Documents.* Stanford: Stanford University Press, 1976.

McCULLOUGH, Helen, ed. and trans. *The Taiheiei: A Chronicle of Medieval Japan.* Rutland: Tuttle, 1959.

*MORI, Hisashi. *Sculpture of the Kamakura Period.* Translated by Katherine Eickmann. New York: Weatherhill, 1974.

MURASE, Miyeko, et al. *Count and Samurai in an Age of Transition.* Exh. cat. New York: Japan Society, 1990.

Narrative Paintings of Japan. Exh. cat. Kyoto: Kyoto Municipal Museum, 1960.

*OKUDAIRA, Hideo. *Narrative Picture Scrolls.* Translated by Elizabeth ten Grotenhuis. New York: Weatherhill, 1973.

*SECKEL, Dietrich. *Emakimono: The Art of the Japanese Painted Hand-scroll.* Photographs and foreward by Akihisa Hase. New York: Pantheon, 1959.

The Tale of the Heike. Translated by Hiroshi Kitagawa and Bruce T. Tsuchida. Tokyo: University of Tokyo Press, 1975.

TANAKA, Ichimatsu, ed. *Nippon Emakimono Zensho* [Japanese scroll painting]. 24 vols. Tokyo: Kadokawa Shoten, 1958–69.

TODA, Kenji. *Japanese Scroll Painting.* Chicago: University of Chicago Press, 1935.

Tokubetsu ten: Kamakura Jidai no Chokoku [Special exhibition: Japanese sculpture of the Kamakura period]. Tokyo: Tokyo National Museum, 1975.

Tokubetsu ten: Nippon no Buki, Bugu [Special exhibition: Japanese arms and armor]. Tokyo: Tokyo National Museum, 1976.

16. Japanese Art of the Muromachi Period

ARAKAWA, Koichi. *Zen Painting.* Translated by John Bester. Tokyo: Kodansha, 1970.

CASTILE, Rand. *The Way of Tea.* New York: Weatherhill, 1971.

COLLCUTT, Martin. *Five Mountains: The Rinzai Zen Monastic Institution in Medieval Japan.* Cambridge, Mass.: Harvard University, Council on East Asian Studies, 1981.

COOPER, Michael, comp. and annot. *They Came to Japan: An Anthology of European Reports on Japan 1543–1640.* Berkeley: University of California Press, 1965.

CORT, Louise A. *Shigaraki: Potters' Valley.* New York: Kodansha, 1979.

COVELL, Jon C. *Under the Seal of Sesshu,* New York, 1941. Reprint. New York: Hacker, 1974.

*————, and YAMADA, Sobin. *Zen at Daitoku-ji.* New York: Kodansha, 1974.

CUNNINGHAM, Michael. "Paintings of Unkoku Togan and Their Historical Setting." Ph.D. diss., University of Chicago, 1978.

————. *The Triumph of Japanese Style: 16th Century Art in Japan.* Cleveland: Cleveland Museum of Art, 1991.

FUJIOKA, Ryoichi. *Tea Ceremony Utensils.* Translated by Louise A. Cort. New York: Weatherhill, 1973.

HAKUIN, Zenji. *The Embossed Tea Kettle. Orategama and Other Works of Hakuin Zenji.* Translated by R. D. M. Shaw. London: Allen and Unwin, 1963.

*HAYASHIYA, Seizo, et al. *Chanoyu: Japanese Tea Ceremony.* Exh. cat., Japan House Gallery. New York: Japan Society, 1979.

HAYASHIYA, Tatsusaburo; NAKAMURA, Masao; and HAYASHIYA, Seizo. *Japanese Arts and the Tea Ceremony.* Translated by Joseph P. Macadam. New York: Weatherhill, 1974, 1980.

HOLBORN, Mark. *The Ocean in the Sand: Japan—From Landscape to Garden.* Boston: Shambhala, 1978.

LEE, Sherman E. *Tea Taste in Japanese Art.* Exh. cat. New York: Asia Society, 1963.

*MATSUSHITA, Takaaki. *Ink Painting.* Translated by Martin Collcutt. New York: Weatherhill, 1974.

McCULLOUGH, Helen C., trans. *Yoshitsune: A Fifteenth Century Japanese Chronicle.* Stanford: Stanford University Press, 1966.

Muromachi Jidai Shoga [Painting and calligraphy of the Muromachi period]. Exh. cat. Kyoto: Kyoto National Museum, 1961.

NAKAMURA, Yasuo. *Noh: The Classical Theater.* Translated by Don Kenny. New York: Walker/Weatherhill, 1971.

NOMA, Seiroku. *Sesshu* [The masterpieces of Sesshu]. Tokyo: Benrido, 1956.

SCHAARSCHMIDT-RICHTER, Irmtraud, and MORI, Osamu. *Japanese Gardens.* Translated by Janet Seligman. New York: Morrow, 1979.

SHIMIZU, Yoshiaki, and WHEELWRIGHT, Carolyn, eds. *Japanese Ink Paintings from American Collections: The Muromachi Period.* Exh. cat. Princeton: Princeton University Art Museum, 1976.

STANLEY-BAKER, Patrick. "Mid-Muromachi Paintings of the Eight Views of the Hsiao and Hsiang." Ph.D. diss., University of Michigan, 1980.

TANAKA, Ichimatsu. *Japanese Ink Painting: Shubun to Sesshu.* Translated by B. Darling. New York: Weatherhill, 1972.

TANAKA, Sen'o. *The Tea Ceremony.* New York: Kodansha, 1973.

17. Later Chinese Art: The Yuan, Ming, and Qing Dynasties

ADAMS, Edward B. *Palaces of Seoul: Yi Dynasty Palaces in Korea's Capital City.* Seoul: Taewon, 1972.

**The Arts of the Ming Dynasty.* Exh. cat. London: Arts Council of Great Britain. 1958.

BARNHART, Richard, et al. *Painters of the Great Ming: The Imperial Court and the Zhe School.* Exh. cat. Dallas: Dallas Museum of Art, 1993.

BARTHOLOMEW, Terese T. *I-hsing Ware.* Exh. cat. New York: China Institute in America, 1977.

BAUR, Alfred. *The Baur Collection, Geneva: Chinese Jades and Other Hardstones.* Geneva: Collection Baur, 1976.

BEURDELEY, Cecile and Michel. *Giuseppe Castiglione: A Jesuit Painter at the Court of the Chinese Emperors.* Translated by Michael Bullock. Rutland: Tuttle, 1972.

The Bishop White Gallery: Shansi Wall Paintings and Sculptures from the Chin and Yuan Dynasties. Toronto: Royal Ontario Museum, 1969.

BRINKER, Helmut, and LUTZ, Albert. *Chinese Cloisonné: The Pierre Uldry Collection.* New York: Asia Society, 1989.

BROWN, Claudia, and CHOU, Ju-hsi. *The Elegant Brush.* Phoenix: Phoenix Art Museum, 1992.

————. *Transcending Turmoil: Painting at the Close of*

China's Empire, 1796–1911. Phoenix: Phoenix Art Museum, 1992.

CAHILL, James. The Compelling Image: Nature and Style in Seventeenth Century Chinese Painting. Cambridge, Mass.: Harvard University Press, 1982.

*———. The Distant Mountains. New York: Weatherhill, 1982.

———. Fantastics and Eccentrics in Chinese Paintings. Exh. cat. 1967. Reprint. New York: Arno, 1976.

*———. Hills beyond a River: Chinese Paintings of the Yuan Dynasty, 1279–1368. New York: Weatherhill, 1976.

*———. Parting at the Shore: Chinese Painting of the Early and Middle Ming Dynasty, 1368–1580. New York: Weatherhill, 1978.

*———, ed. The Restless Landscape: Chinese Painting of the Late Ming Period. Exh. cat. Berkeley: University of California Art Museum, 1971.

CARSWELL, John. Blue and White: Chinese Porcelain and Its Impact on the Western World. Exh. cat. Chicago: Smart Gallery, University of Chicago, 1985.

CHENG, Te-k'un. Painting as a Recreation in China: Some Hsi-pi Paintings in the Mu-fei Collection . . . : Hong Kong: Chinese University of Hong Kong, 1973.

CHOU, Ju-Hsi, and BROWN, Claudia. The Elegant Brush: Chinese Painting under the Qianlong Emperor, 1735–1795. Exh. cat. Phoenix: Phoenix Art Museum, 1985.

Chugoku no Min Shin Jidai no Hanga [Chinese woodcuts and etchings of the Ming and Qing dynasties]. Nara: Museum Yamato Bunkakan, 1972.

CLAPP, Anne de Courcey. The Painting of T'ang Yin. Chicago: University of Chicago Press, 1991.

———. Wen Cheng-ming: The Ming Artist and Antiquity. Ascona: Artibus Asiae, 1975.

*CONTAG, Victoria. Die beiden Steine: Beitrag zum Verständnis des Wesens chinesischer Landschaftsmalerei. Brunswick: Klemm, 1950.

———. Chinese Masters of the 17th Century. Translated by Michael Bullock. Rutland: Tuttle, 1970.

*———. Die sechs berühmten Maler der Ch'ing-Dynastie. Leipzig: Seemann, 1940.

———, and WANG, Chi-ch'ien, comps. Seals of Chinese Painters and Collectors of the Ming and Ch'ing Periods. Rev. ed. Hong Kong: Hong Kong University Press, 1966.

DUBOSC, Jean Pierre. Great Chinese Painters of the Ming and Ch'ing Dynasties, 15th to 18th Centuries. Exh. cat. New York: Wildenstein, 1949.

ECKE, Tseng Yu-ho. Chinese Folk Art in American Collections: Early 15th through Early 20th Centuries. New York: China Institute in America, 1976

EDWARDS, Richard. The Art of Wen Cheng-ming (1470–1559). Exh. cat. Ann Arbor: University of Michigan, 1976.

ELLSWORTH, Robert H. Chinese Furniture: Hardwood Examples of the Ming and Early Ch'ing Dynasties. New York: Random House, 1971.

Exhibition of Paintings of the Ming and Ch'ing Periods. Hong Kong: Hong Kong City Museum and Art Gallery, 1970.

Fahai Si Ming Dai Bihua [Fa-hai-ssŭ Ming-tai pi hua; Wall paintings of the Ming dynasty at Fa-hai Buddhist Temple in Beijing]. Beijing, 1958.

FRASCHÉ, Dean F. Southeast Asian Ceramics: Ninth through Seventeenth Centuries. Exh. cat. New York: Asia Society/Weatherhill, 1976.

FU, Marilyn and Shen. Studies in Connoisseurship: Chinese Paintings from the Arthur M. Sackler Collections. Princeton: Princeton University Art Museum, 1973.

*GARNER, Harry. Chinese Lacquer. London: Faber, 1979.

*———. Oriental Blue and White. 2nd ed. New York: Yoseloff, 1964.

———. Ryukyu Lacquer. London: University of London, 1972.

GEISS, James P. Peking under the Ming (1368–1644). Princeton University Press, 1979.

Gendai Doshaku Jinbutsuga, Tokubetsu Tenkan [Chinese paintings of the Yuan dynasty of Buddhist and Daoist figure subjects]. Tokyo: Tokyo National Museum, 1975.

GIACALONE, Vito. The Eccentric Painters of Yangzhou. Exh. cat. New York: China House Gallery, China Institute of America, 1992.

*GOODRICH, L. Carrington, and FANG, Chaoying, eds. Dictionary of Ming Biography, 1368–1644. New York: Columbia University Press, 1976.

HO, Wai-ching, ed. Proceedings of the Tung Ch'i-ch'ang International Symposium. Kansas City: Nelson-Atkins Museum of Art, 1991.

HO, Wai-kam, ed. The Century of Tung Ch'i-ch'ang: 1555–1636. 2 vols. Kansas City: Nelson-Atkins Museum of Art, 1992.

*JENYNS, Soame. "Chinese Lacquer." Transactions of the Oriental Ceramic Society 17 (1939–40).

———. Later Chinese Porcelain. London: Faber, 1971.

*———. Ming Pottery and Porcelain. New York: Pitman, 1954.

KATES, George N. Chinese Household Furniture. New York: Dover, 1948.

LEE, Sherman E., and HO, Wai-kam. Chinese Art under the Mongols: The Yuan Dynasty (1279–1368). Exh. cat. Cleveland: Cleveland Museum of Art, 1968.

LI, Chu-tsing. The Autumn Colors on the Ch'iao and Hua Mountains: A Landscape by Chao Meng-fu. Ascona: Artibus Asiae, 1965.

———. A Thousand Peaks and Myriad Ravines: Chinese Paintings in the Charles A. Drenowatz Collection. Ascona: Artibus Asiae, 1974.

———; CAHILL, James; and HO, Wai-kam, eds. Artists and Patrons. Lawrence: University of Kansas, Nelson-Atkins Museum of Art, and University of Washington Press, 1989.

*———, and WATT, James C. Y., eds. The Chinese Scholar's Studio: Artistic Life in the Late Ming Period. Exh. cat. New York: Thames and Hudson, 1987.

LIANG, Ch'i-ch'ao. Intellectual Trends in the Ch'ing Period. Translated by Immanuel E. Y. Hsü. Cambridge, Mass.: Harvard University Press, 1970.

LIAO PING, ed. The Yongle Palace Murals. Beijing: Foreign Languages Press, 1985.

LIPPE, Aschwin. "Kung Hsien and the Nanking School." Oriental Art 2, no. 1 (Spring 1956), and 4, no. 4 (Winter 1958).

*LOW-BEER, Fritz. "Chinese Lacquer of the Early 15th Century." Bulletin of the Museum of Far Eastern Antiquities 22 (1950).

———. "Chinese Lacquer of the Middle and Late Ming Period." Bulletin of the Museum of Far Eastern Antiquities 24 (1952).

MATSUSHITA, Takaaki, and CH'OI, Sun-u. Richo no Suibokuga [Ink monochrome painting of the Yi dynasty, Korea]. Tokyo: Kodansha, 1977.

*MEDLEY, Margaret. Yüan Porcelain and Stoneware. London: Faber, 1974.

MOSS, Hugh M. By Imperial Command: An Introduction to Ch'ing Imperial Painted Enamels. Hong Kong, 1976.

NAGAHARA, Oriji. Shi-Tao and Bada Shanren [Shih-t'ao and Pa-ta-shan-jen]. Tokyo: Keibunkan, 1961.

PAINE, Robert T. "The Ten Bamboo Studio." Archives of the Chinese Art Society of America 5 (1951).

PICARD, René. Les fusions à la cour de Chine. Grenoble: Editions des Quatre Seigneurs, 1973.

*POPE, John A. Chinese Porcelains from Ardebil Shrine. Washington, D.C.: Freer Gallery, Smithsonian Institution, 1956.

*———. 14th Century Blue and White: A Group of Chinese Porcelains in the Topkapu Sarayi Muzesi, Istanbul. Washington, D.C.: Freer Gallery, 1952.

ROGERS, Howard. Masterpieces of Ming and Ch'ing Painting from the Forbidden City. Lansdale, Pa.: International Arts Council, 1988.

SAYER, Geoffrey R. Ching-Te-Chen T'ao-Lu; or, The Potteries of China. London: Routledge and Keegan Paul, 1951.

SIRÉN, Osvald. The Walls and Gates of Pekin[g]. London: John Lane, 1924.

Tokubetsu Ten: Toyo no Shikko gei [Special exhibition: Oriental lacquer arts]. Tokyo: Tokyo National Museum, 1977.

TSCHICHOLD, Jan. Chinese Colour Prints from the Ten Bamboo Studio. London, 1972.

VAN OORT, H. A. Chinese Porcelain of the 19th and 20th Centuries. Lochem, 1977.

VANDERSTAPPEN, Harrie. "Painters at the Early Ming Court (1368–1435) and the Problem of a Ming Academy." Monumenta Serica 15, no. 2 (1956), and 16, nos. 1–2 (1957).

WANG, Fangyu and BARNHART, Richard. Master of the Lotus Garden: The Life and Art of Bada Shanren. New Haven: Yale University Press, 1990.

WANG, Kai. Mustard Seed Garden Manual. Edited and translated by Mai-mai Sze. Princeton: Princeton University Press, 1956.

WATSON, William, ed. The Westward Influence of the Chinese Arts from the 14th to the 18th Century: A Colloquy on Art and Archaeology in Asia. London: University of London, 1972.

WHITFIELD, Roderick. In Pursuit of Antiquity: Chinese Paintings of the Ming and Ch'ing Dynasties from the Collection of Mr. and Mrs. Earl Morse. Addendum by Wen Fong. Princeton: Princeton University Art Museum, 1969.

WILSON, Marc, and WONG, Kwan S. Friends of Wen Cheng-ming: A View from the Crawford Collection. New York: China Institute in America, 1974.

Wu Pai Hua Jiushi Nian [Wu-p'ai-hua chiu-shih-nien; Ninety years of Wu school painting]. Taibei: National Palace Museum, 1975.

XIE, Zhiliu [HSIEH, Chil-liu]. Zhu Da [Chu Ta]. Shanghai, 1958.

YONEZAWA, Yoshiho. Painting in the Ming Dynasty. Tokyo: Mayuyama, 1956.

18. Later Japanese Art: The Momoyama and Edo Periods

ABRAMS, Leslie E. Japanese Prints: A Bibliography of Monographs in English. Chapel Hill: 1977.

ADDISS, Stephen. The Art of Zen. New York: Abrams, 1989.

———. Nanga Paintings. London: Sawyers, 1975.

———. Uragami Gyokudo: The Complete Literati Artist. Vols. 1 and 2. Ann Arbor: University of Michigan, 1977.

———, and HURST, G. Cameron, III. Samurai Painters. Tokyo: Kodansha.

AKABOSHI, Goro, and NAKAMURA, Heiichiro. Five Centuries of Korean Ceramics: Pottery and Porcelain of the Yi Dynasty. Translated by June Silla, New York: Weatherhill, 1975.

BAEKELAND, Frederick. Imperial Japan: The Art of the Meiji Era, 1862–1912. Exh. cat. Ithaca: Johnson Museum of Art, Cornell University, 1980.

BARKER, Richard, and SMITH, Lawrence. Netsuke: The Miniature Sculpture of Japan. London: British Museum, 1976.

*BINYON, Laurence, and SEXTON, J. J. O'Brien. Japanese Colour Prints. Edited by B. Gray. 2nd ed. London: Faber, 1960.

BOXER, Charles R. Jan Compagnie in Japan, 1600–1817: An Essay on . . . Influence Exercised by the Hollanders in Japan. . . . New York, 1968.

BUSHELL, Raymond. The Inro Handbook: Studies of Netsuke, Inro, and Lacquer. New York: Weatherhill, 1979.

———. Netsuke, Familiar and Unfamiliar: New Principles for Collecting. New York: Weatherhill, 1975.

*CAHILL, James. Scholar Painters of Japan: The Nanga School. Exh. cat. 1972. Reprint. New York: Arno, 1976.

COMPTON, Walter A., et al. Nippon-to: Art Swords of Japan. Exh. cat. New York: Japan Society,1976.

CORT, Louise A. Seto and Mino Ceramics. Washington, D.C.: Freer Gallery of Art, Smithsonian Institution, 1992.

COULLERY, Marie-Thérèse, and NEWSTEAD, Martin S. The Baur Collection: Netsuke. Geneva, 1977.

COVELL, Jon C. Masterpieces of Japanese Screen Painting: The Momoyama Period. New York: Crown, 1962.

*DOI, Tsugiyoshi. Momoyama Decorative Painting. Translated by Edna B. Crawford. New York: Weatherhill, 1977.

DOMBRADY, Geza S. Watanabe Kazan, ein Japanischer Gelehrter des 19. Jahrhunderts. Hamburg, 1968.

DOTZENKO, Grisha F. Enku: Master Carver. New York: Kodansha, 1976.

*FRENCH, Calvin L. The Poet-Painters: Buson and His Followers. Exh. cat. Ann Arbor: University of Michigan Art, 1974.

———. Shiba Kokan: Artist, Innovator and Pioneer in the Westernization of Japan. New York: Weatherhill, 1974.

*———. Through Closed Doors: Western Influence on Japanese Art 1639–1853. Rochester, Mich., 1977.

GRAY, Basil. Japanese Screen Painting. London: Faber, 1955.

GRILLI, Elise. The Art of the Japanese Screen. New York and Tokyo: Walker/Weatherhill, 1970.

———. Golden Screen Paintings of Japan. New York: Crown/Elek, 1959.

GUNSAULUS, Helen C. The Clarence Buckingham Collection of Japanese Prints: The Primitives. Chicago: Art Institute of Chicago, 1955.

HAKUIN. The Zen Master Hakuin: Selected Writings. Translated by Philip B. Yampolsky. New York: Columbia University Press, 1971.

HARADA, Jiro. Gardens of Japan. London, 1928.

*HAUGE, Victor and Takako. Folk Traditions in Japanese Art. Exh. cat. Washington, D.C.: International Exhibitions Foundation, 1978.

HICKMAN, M., and SATO, Y. The Paintings of Jakuchu. New York: Asia Society, 1989.

HILLIER, Jack R. The Art of Hokusai in Book Illustration. Berkeley: University of California Press, 1980.

———. The Harari Collection of Japanese Paintings and Drawings. 3 vols. London: Lund Humphries, 1970–73.

———. Japanese Prints and Drawings from the Vever Collection. New York: Rizzoli, 1976.

———. The Uninhibited Brush: Japanese Art in the Shijo Style. London: Moss, 1974.

———. Utamaro: Colour Prints and Paintings. Oxford, 1979.

HOSONO, Masanobu. Nagasaki Prints and Early Copperplates. Translated by Lloyd R. Craighill. Tokyo: Kodansha, 1978.

IVES, Colta F. The Great Wave: The Influence of Japanese Woodcuts on French Prints. Exh. cat. 2nd ed. New York: Metropolitan Museum of Art, 1980.

Japanese Prints, Buncho to Utamaro, in the Collection of Louis V. Ledoux. New York: Weyhe, 1948.

Japanese Prints by Harunobu and Shunsho in the Collection of Louis V. Ledoux. New York: Weyhe, 1945.

Japanese Prints by Hokusai and Hiroshige in the Collection of Louis V. Ledoux. Princeton: Princeton University Press, 1951.

Japanese Prints of the Primitive Period in the Collection of Louis V. Ledoux. New York: Weyhe, 1942.

Japanese Prints, Sharaku to Toyokuni, in the Collection of Louis V. Ledoux. Princeton: Princeton University Press, 1950.

JENKINS, Donald. Ukiyo-e Prints and Paintings: The Primitive Period, 1680–1745. Exh. cat. Chicago: Art Institute of Chicago, 1961.

*JENYNS, Soame. Japanese Porcelain. London: Faber, 1965.

KEYES, Roger S., and MIZUSHIMA, Keiko. The Theatrical World of Osaka Prints: A Collection of 18th and 19th Century Japanese Woodblock Prints in the Philadelphia Museum of Art. Philadelphia: Philadelphia Museum of Art, 1973.

KIRBY, John B. From Castle to Teahouse: Japanese Architecture of the Momoyama Period. Rutland: Tuttle, 1962.

KONDO, Ichitaro. Japanese Genre Painting: The Lively Art of Renaissance Japan. Translated by Roy A. Miller. Rutland: Tuttle, 1961.

———. Kitagawa Utamaro. Translated by Charles S. Terry. Rutland: Tuttle, 1956.

KONO, Motoaki. Ogata Korin. Tokyo: Shueisha, 1976.

Korin Ten [Korin: exhibition catalogue in commemoration of his 300th birthday]. Tokyo: Tokyo National Museum, 1958.

LANE, Richard D. Images from the Floating World: The Japanese Print. New York: Putnam, 1978.

LINK, Howard, and SHIMBO, Toru. Exquisite Visions: Rimpa Painting from Japan. Exh. cat. Honolulu: Honolulu Academy of Arts, 1980.

LINK, Howard, et al. Primitive Ukiyo-e . . . in the Honolulu Academy of Arts. Honolulu: University Press of Hawaii, 1980.

Maruyama-Shijo-Ha Kaiga Ten: Okyo to Rosetsu [Okyo, Rosetsu, and the Maruyama-Shijo school of Japanese painting]. Exh. cat. Tokyo: Tokyo National Museum, 1979.

MEECH-PEKARIK, Julia. Momoyama: Japanese Art in the Age of Grandeur. Exh. cat. New York: Metropolitan Museum of Art, 1975.

MICHENER, James A. Japanese Prints from the Early Masters to the Modern. Rutland: Tuttle, 1960.

*MILLER, Roy A. Japanese Ceramics. Japanese text by Seiichi Okuda, Fujio Koyama, and Seizo Hayashiya. Rutland: Tuttle, 1960.

MINAMOTO, Toyomune, and HASHIMOTO, Ayako. Tawaraya Sotatsu. Tokyo: Shueisha, 1976.

*MIZUO, Hiroshi. Edo Painting: Sotatsu and Korin. Translated by John M. Shields. New York: Weatherhill, 1972.

Momoyama Edo no Bijutsu [Japanese art from the Momoyama to the Edo period]. Tokyo: Tokyo National Museum, 1967.

Momoyama Jidai Konpeki Shohekiga [Colored screen paintings in the Momoyama period]. 2 vols. Tokyo: Bijutsu Kenkyusho [Institute of Art], 1937.

Momoyama Jidai no Kogei [Handicrafts of the Momoyama period]. Exh. cat. Kyoto: Kyoto National Museum, 1977.

MORAOKA, Kageo, and OKAMURA, Kichiemon. Folk Arts and Crafts of Japan. Translated by Daphne D. Stegmaier. New York: Weatherhill, 1977.

MURASE, Miyeko. Byobu: Japanese Screens from New York Collections. Exh. cat. New York: Asia Society, 1971.

———. Masterpieces of Japanese Screen Painting. Vol. 1. New York: Braziller, 1990.

NAITO, Akira. Katsura: A Princely Retreat. Translated by Charles S. Terry. Tokyo: Kodansha, 1977.

NARAZAKI, Muneshige. The Japanese Print: Its Evolution and Essence. Translated by C. H. Mitchell. Tokyo: Kodansha, 1966.

———. Masterworks of Ukiyo-e. Tokyo: Kodansha. Vol. 1, Early Paintings. Translated by Charles A. Pomeroy, 1968. Vol. 3, Hokusai: "The Thirty-six views of Mount Fuji." Translated and adapted by John Bester, 1972. Vol. 5, Hiroshige: Famous Views. Translated and adapted by Richard L. Gage, 1968. Vol. 7, Hokusai: Sketches and Paintings. Translated and adapted by John Bester, 1969. Vol. 9, Kiyonaga. Translated and adapted by John Bester, 1970. Vol. 10, Hiroshige: The 53 Stations of the Tokaido. Translated and adapted by John Bester, 1969. Vol. 11, Studies in Nature: Birds and Flowers by Hokusai and Hiroshige. Translated and adapted by John Bester, 1974.

———, and KIKUCHI, Sadao. Masterworks of Ukiyo-e. Vol. 4: Utamaro. Tokyo: Kodansha, 1968.

NISHIMURA, Tei. Namban Art, Christian Art in Japan, 1549–1639. Tokyo: Kodansha, 1958.

OKAKURA, Kakuzo. The Book of Tea. Rutland: Tuttle, 1956.

*OKAMOTO, Yoshitomo. The Namban Art of Japan. Translated by Ronald K. Jones. New York: Weatherhill, 1972.

OKAWA, Naomi. Edo Architecture: Katsura and Nikko. Translated by Alan Woodhull and Akito Miyamoto. New York: Weatherhill, 1975.

Okyo and the Maruyama-Shijo School of Japanese Painting. Exh. cat. St. Louis: St. Louis Art Museum, 1980.

PAINE, Robert T., Jr. Japanese Screen Painting. Boston: Museum of Fine Arts, 1935.

RANDALL, Doanda. Korin. New York: Crown, 1960.

Rimpa: Soritsu Hyakunen Kinen Tokubetsu Ten Zuroku [Korin school: The special exhibition catalogue of the centennial]. Tokyo: Tokyo National Museum, 1973.

ROBINSON, Basil W. The Arts of the Japanese Sword. Rutland: Tuttle,1961.

SATO, Masahiko. Kyoto Ceramics. Translated by Anne O. Towle and Usher P. Coolidge. New York: Weatherhill, 1973.

SHONO, Masako. Japanisches Aritaporzellan im sogenannten "Kakiemonstil" als Vorbild für die Meissener Porzellan-manufaktur. Munich, 1973.

STERN, Harold P. The Magnificent Three: Lacquer, Netsuke, and Tsuba: Selections from the Collection of Charles A. Greenfield. Exh. cat. New York: Japan Society, 1972.

———. Master Prints of Japan. Exh. cat., University of California, Los Angeles, Art Galleries. New York: Abrams, 1969.

———. Rimpa: Masterworks of the Japanese Decorative School. Exh. cat. New York: Japan Society, 1971.

SUZUKI, Juzo. Masterworks of Ukiyo-e. Vol. 2: Sharaku. Translated by John Bester. Tokyo: Kodansha, 1968.

SUZUKI, Susumu. Poet-Painter Buson. Tokyo: Nihon Keizai Shimbun, 1958.

SUZUKI, Takashi. Hiroshige. New York: Crown, c. 1958.

TAKAHASHI, Seiichiro. The Evolution of Ukiyo-e: The Artistic, Economic, and Social Significance of Japanese Wood-block Prints. Various translators, c. 1955.

———. Masterworks of Ukiyo-e. Vol. 6: Harunobu. Translated by John Bester. Tokyo: Kodansha, 1976.

———. Traditional Woodblock Prints of Japan. Translated by Richard Stanley-Baker. New York: Weatherhill, 1972.

TAKEUCHI, Melinda. Taiga's True Views: The Language of Landscape Painting in Eighteenth Century Japan. Stanford: Stanford University Press, 1992.

TANI, Shin'ichi, and SUGASE, Tadashi. Namban Art: A Loan Exhibition from Japanese Collections. Washington, D.C.: International Exhibitions Foundation, 1973.

THOMPSON, Sarah. Undercurrents in the Floating World: Censorship and Japanese Prints. Exh. cat. New York: Asia Society, 1991.

TSUNEO, Takeda. Kano Eitoku. Translated and adapted by H. Mack Horton and Catherine Kaputa. New York: Kodansha and Shibundo, 1977.

VLAM, Grace A. Western-Style Secular Painting in Momoyama Japan. Ann Arbor: UMI Research Press, 1980.

VOLKER, T. The Japanese Porcelain Trade of the Dutch East India Company after 1683. Leiden: Brill, 1959.

WATERHOUSE, David B. Harunobu and His Age: The Development of Colour Printing in Japan. London: British Museum, 1964.

———. Images of Eighteenth-Century Japan. Exh. cat. Toronto: Royal Ontario Museum, 1975.

WEISBERG, Gabriel; CATE, P. Dennis; et al. Japonisme: Japanese Influence on French Art, 1854–1910. Exh. cat. Cleveland: Cleveland Museum of Art, 1975.

*YAMADA, Chisaburoh F., ed. Dialogue in Art: Japan and the West. Tokyo: Kodansha, 1976.

YAMANE, Yuzo. Koetsu, Sotatsu, Korin. Tokyo: Kodansha, 1975.

*———. Momoyama Genre Painting. Translated by John M. Shields. New York: Weatherhill, 1973.

YONEMURA, Ann. Japanese Lacquer. Exh. cat. Washington, D.C.: Freer Gallery, Smithsonian Institution, 1979.

*YONEZAWA, Yoshiho, and YOSHIZAWA, Chu. Japanese Painting in the Literati Style. Translated by Betty I. Monroe. New York: Weatherhill, 1974.

ZOLBROD, Leon. Haiku Painting. New York: Kodansha, 1982.

Index

Artists' names are shown in CAPITAL letters. Chinese entries are alphabetized according to their *pinyin* spelling, with Wade-Giles spelling following in brackets. Japanese, Korean, and Sanskrit entries are cited in simplified form as in the text, followed by transcription with full diacritical marks in brackets. In each case, if brackets are absent, the transcriptions are identical. The alternate form in brackets is supplied only for the principal term in each entry. Pages and scenes from larger works are indexed under the title of the larger work. References to figure and colorplate (*cpl.*) numbers appear in *italic* type following the references to text page numbers.

Credits

The author and the publisher wish to thank the libraries, museums, galleries, and private collectors named in the picture captions for permitting the reproduction of works of art in their collections and for supplying the necessary photographs. Additional photographic source information is gratefully acknowledged below.

Archeological Survey of India, New Delhi: 2. Archeology Department of Indonesia: 354, 355, 360. Mr. William Archer and the Victoria and Albert Museum, London. © The Board of Trustees of the Victoria and Albert Museum, London: 313–15, 322, 324, 509. Editions B. Arthaud, Grenoble: 246, 287, 332, 336, 346, 347. The Art Institute of Chicago: 140, 496 (Robert Hashimoto © 1993), 725. Asia Society, New York (Otto E. Nelson): 162, 177, 311, 494, 622, colorplate 10, top (Sheldan Collins). Asian Art Museum, San Francisco: 30. Asuka-en, Nara: 198, 199, 214, 217, 219, 236, 237, 359, 414–20, 422, 445, 516, 520, 522, 524, 527, 528, 530, 532, 536, 545. © Dirk Bakker: 109, 181, 357. Banpo Museum: 10. Benrido, Kyoto: 102, 719. Bharat Kala Bhavan, Hindu University, Varanasi: 245. Mr. Jean Boisselier and Mr. Pierre Dupont: 330. Reproduced by courtesy of the Trustees of the British Museum, London: 59, 139, 172, 338, 339, 368, 397, colorplate 15, 20. Buffalo Society of Natural Sciences: 13 (C. E. Simmons). Mr. James Cahill: 462, 464, 481, 482, colorplate 26. Mr. Frank Caro: 491. Pramod Chandra, Prince of Wales Museum of Western India: 247, 252. Reproduced with permission of China Pictorial Publications, Beijing: 71. The Chinese Embassy, Washington, D.C.: 23, 87, 91. The Cincinnati Art Museum: 598. The Cleveland Museum of Art: 8, 19 (Purchase from the J. H. Wade Fund): 20 (Purchase, Leonard C. Hanna, Jr., Bequest): 29, 34, 44, 45, 55, 65, 69 (left: Gift of Mr. and Mrs. Harold T. Clark in memory of Flora L. Terry; right: Gift of Homer F. Tielke, Sr.), 70, 104, 143, 161, 163 (Purchase from the J. H. Wade Fund), 164 (Purchase from the J. H. Wade Fund), 166, 175, 203, 207, 222, 234, 242, 249, 310, 312, 317, 320, 321, 323, 325, 326 (Edward L. Whittemore Fund), 328, 338, 339, 341, 351, 365, 367, 382, 395, 410, 460, 467, 469, 489 (Purchase from the J. H. Wade Fund), 493, 495, 498, 501, 503, 508, 510, 518, 538, 550–52, 557, 558 (John L. Severance Fund), 566, 569, 583–87, 591, 603, 605, 609, 615, 619, 620, 623, 625, 632 (John L. Severance Fund), 633–36, 644, 647, 648, 651–53, 659, 663–66, 668, 670–72, 678, 679, 682, 699, 714, 723, 724, 727, 732, 733, colorplate 4, 10, bottom, 18 (gift of George P. Bickford), 21–23, 24 (gift of George P. Bickford), 25, 37, 39, 43, 46, 47 (Mr. and Mrs. William H. Marlatt Fund), 48, 51, 53–55, 58. Mrs. Ananda K. Coomaraswamy: 194. A. C. Cooper, Ltd., London: 604, 661. Cultural Properties Commission, Tokyo: 220. Mr. Lance Dane, Madras: 309. Percival David Foundation of Chinese Art, London: 93, 507, 621, 622, 624, 680, 681, colorplate 38. Mr. Leroy Davidson: 608. Professor K. Doi, Kyoto: 696. Mr. Eliot Elisofon, New York: 125, 150, 152, 153, 155, 157, 158, 189, 190, 257, 260, 261, 265–67, 271, 274, 276, 283–85, 290, 295, 337, 342, 344, 345, 348, 350. Courtesy of Eskenazi Ltd., London: colorplate 5. Professor Wen Fong, Princeton University, Department of Art: 78, 612. Freer Gallery of Art, Smithsonian Institution, Washington, D.C.: 25, 40, 43, 46, 47, 53, 57, 62, 92, 318, 319, 340, 468, 506, 514, 537, 590, 599, 700, colorplate 2, 19, 52. Mr. G. M. Gompertz, England: 512. Government of India, Department of Archeology: 1, 105, 111, 113–16, 120, 129, 132, 133, 136, 146–49, 154, 239, 240, 241, 248, 253, 254, 256, 258, 259, 263, 273, 277, 279–81, 287–89, 291, 296, 297, 299, 300, 302, 304–9. Dr. Alexander B. Griswold: 179, 180. Mr. Bernard P. Grosier, Paris: 340. The Hermitage Museum, St. Petersburg: 50, 51, 94. Historical Museum, Beijing: 39, 56, 61, 77, 86, colorplate 6. From *Historical Relics Unearthed in New China*, Foreign Languages Press, Beijing, 1972: 9. Mr. Walter Hochstadter, Zurich: 667. Honolulu Academy of Arts: 669. John Huntington: 165, 227, 228, 592, colorplate 9. Idemitsu Museum of Arts, Tokyo: 88, 730. Imperial Household Collection, Tokyo: colorplate 62. The Institute for Art Research, Tokyo: 391, 452, 485, 487, 519, 531, 534, 544, 545, 547–49. Iwanami Shoten, Tokyo: 689. The Kern Institute, Leiden: 183–88, 353, 358, 361–64. Kimbell Art Museum, Fort Worth, Texas: 135, 329. Kochukyo Company,

Tokyo: 505. Professor Stella Kramrisch: 119, 124, 278. Kyongju National Museum: 95, 97. Kyunghee University Museum: 16. Li Chi, Academia Sinica, Taiwan: 26, 36. From L. G. Liu, *Chinese Architecture*, Rizzoli, New York: 229. Dr. J. E. van Lohuizen, Amsterdam: 182. Los Angeles County Museum of Art (Nasli and Alice Heeramaneck Collection): 168, 169. Magellan Geographix SM/Santa Barbara, California: maps on pages 14–15, 31, 93. Collection of Claude de Marteau, Brussels: 141. Mr. Junkichi Mayuyama, Tokyo: 80, 81, 98–101, 211–13, 221, 225, 226, 230–32, 235, 373, 384, 385, 392, 398–409, 411–13, 424, 425, 429–31, 434, 436–42, 444, 446–50, 454–56, 478, 483, 486, 500, 502, 517, 523, 525, 526, 535, 542, 553–55, 561, 562, 568, 574–76, 580, 582, 595–97, 654–56, 683–88, 691, 695, 697, 702, 704, 705, 707–13, 715–17, 735. Mr. J. V. Mehta, Bombay: 262, 298. The Metropolitan Museum of Art, New York: 28, 58, 504, 541, 677, 721, 722, colorplate 45. The Metropolitan Museum of Art, New York, on loan from the People's Republic of China: 90 (Seth Joel). Mingei-kan (Folk Art Museum), Tokyo: 540. The Minneapolis Institite of Art: 45, 49, 54. Professor S. Mizuno, Kyoto, and Mr. Junkichi Mayuyama, Tokyo: 202. Musée Cernuschi, Paris: 88. Musée Guimet, Paris; © R.M.N., Paris: 117, 126, 144, 145, 205, 264, 327, 330, 331, 333–35, 349, 352, 356, 366. Museum of Eastern Art, Oxford: 64. Museum of Fine Arts, Boston: 6, 60, 82, 142, 178, 191, 192, 204, 208, 316, 380, 427, 471, 497, 511, 638, 649 (Keith McLeod Fund), 726, colorplate 14, 36, 42. Museum of Oriental Ceramics, Osaka: 513, 515, 654. Nanjing Museum: 12. Nara National Museum: 529. National Collection of Fine Arts, Smithsonian Institution, Washington, D.C.: 27. National Museum, New Delhi: 3–5, 7, 106, 241. National Museum of Korea, Seoul: 209, 210, 243, 655. National Palace Museum, Taibei: 461, 473, 600, 601, 604, 607, 608, 610, 611, 613, 637, 643, 661, 674. National Palace Museum, Taibei, and Mr. Henry Belville, Washington, D.C.: 386. Nelson-Atkins Museum of Art, Kansas City, Missouri: 42, 342, 376 (Anonymous Gift); Nelson-Atkins Museum of Art (Nelson Fund): 14, 24, 63, 74, 223, 374, 378, 463, 465, 480, 490, 606, 639–41, 645, 646, 673, 692 (and jacket), colorplate l7, 50, pages 2, 3, 17, 189, 285. Nezu Art Museum: 474, 539, 567, 706. NHK, Tokyo: colorplate 12. Okamoto Shigeo: 690. From Qian Hao, et al., *Out of China's Earth*, Abrams, New York, 1981: 52, 394, colorplate 28. From Jean Louis Nou, *L'art en Inde*, Citadelles and Mazenaud, Paris: 159. Palace Museum: Beijing: 67, 89, 377, 387, 457–59, 472, 589, 594, 602, 617, 660, 675, 676, colorplate 27, 35. People's Republic of China: 11, 22, 75, 76, 78, 379, colorplate 6, 44. Mr. and Mrs. A. Dean Perry Collection, Cleveland: 657. Provincial Museum, Canton: 84. Rietberg Museum, Zurich: 667. Professor John M. Rosenfield, Harvard University: 121, 137. Dr. Benjamin Rowland and the Fogg Art Museum, Harvard University: 107, 108, 112, 118, 123, 127, 130, 134, 151, 171, 176, 238, 251, 255, 268, 272, 282. The Royal Ontario Museum, Toronto: 375, 396, 626. Richard Rudolph Collection, California: 83. St. Louis Art Museum: 492. Sakamoto Manschichi Photo Research Laboratory: 215, 423, 466, 560, 572, 577–79, colorplate 3, 13, 29–33, 40, 41, 49, 56, 57, 59–61, 63–66. The late Professor Alfred Salmony and the Institute of Fine Arts, New York University: 110, 128, 131, 286, 301. Mr. John D. Schiff, New York: 627, 628, 630, 631. Gary Schwindler: 303. Seattle Art Museum: 33, 38, 48 (Paul Macapia), 66, 96 (Paul Macapia), Gift of Frank S. Bayley III), 368, 453, 484, 701, 703, 728, colorplate 1. Sen'oku Hakkokan (Sumitomo Collection), Tokyo: 35, 37, 666. Dr. P. C. Sestieri, Soprintendente alle Antichità, Salerno: 170, 173. Mr. Inosuke Setsu, Tokyo: 581. Shaanxi Provincial Museum: 71, 84. Mr. Laurence Sickman: 616. Staatliche Museen zu Berlin—Preussischer Kulturbesitz: Museum für Ostasiatische Kunst (B.P.K.): 31, 650. Staatliche Museen zu Berlin—Preussischer Kulturbesitz: Museum für Völkerkunde (B.P.K.): 195, 196. Suntory Museum of Art, Tokyo: 734. © Wim Swaan: 167. Tokyo National Museum: 18, 98, 99, 475, 499, 565, 694, 729. Tsunan-machi Board of Education, Niigata Prefecture: 17. University Museum, University of Pennsylvania: 206, 381. Mr. William E. Ward, Cleveland: 32, 156, 224. Mr. Wang-go H. C. Weng, New York: 658. Yamamoto Masakatsu: 244.